THE ART COLLECTIONS OF
GREAT BRITAIN AND IRELAND

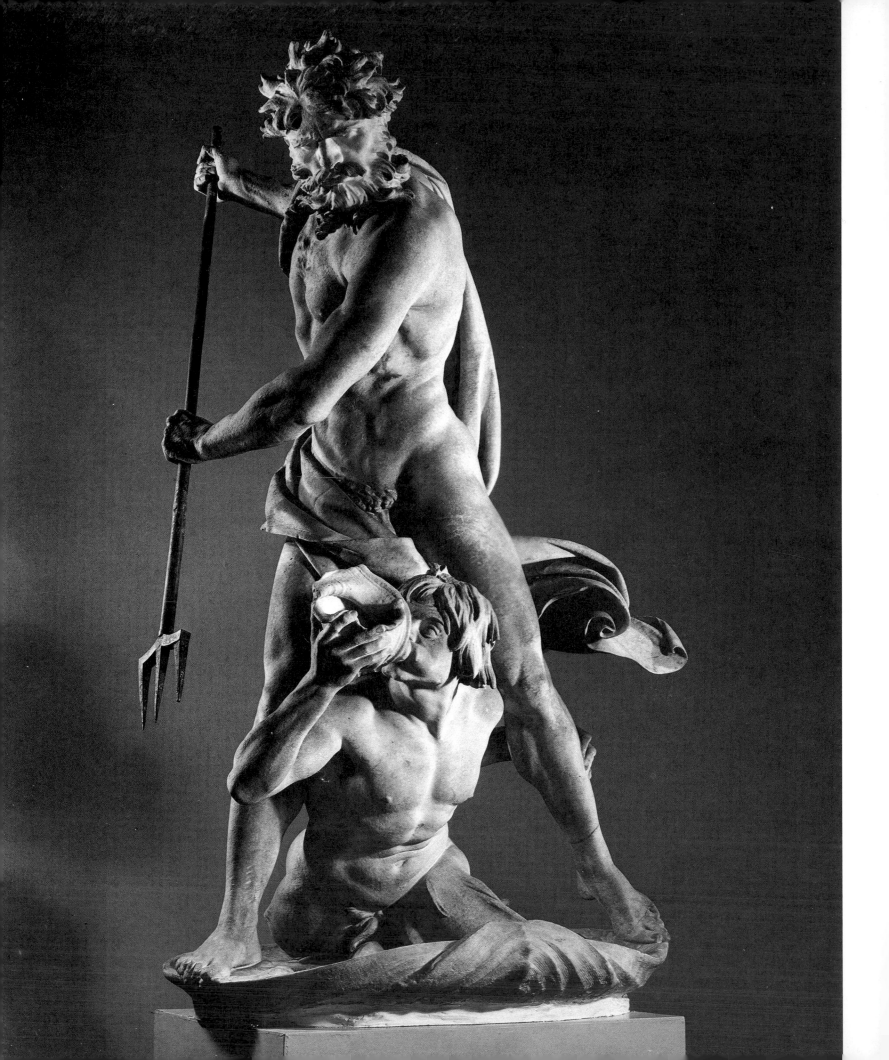

The National Art-Collections Fund
Book of Art Galleries and Museums

THE ART COLLECTIONS OF GREAT BRITAIN AND IRELAND

WRITTEN AND EDITED BY

Jeannie Chapel and Charlotte Gere

WITH AN INTRODUCTION BY SIR JOHN SUMMERSON

PICTURE RESEARCH, SUB-EDITING AND INDEXES BY CAROLINE CUTHBERT,
JANE SHOAF TURNER AND FRANCIS GRAHAM

HARRY N. ABRAMS, INC., PUBLISHERS

NEW YORK

A large quarry of heraldic glass with the rebus of
John Islip, d. 1532, Abbot of Westminster, 16thc
(Burrell Collection, Glasgow, Scotland)

Frontispiece: Neptune and Glaucus marble group by
Giovanni Lorenzo Bernini, *c.* 1622
(Victoria and Albert Museum, London)

Library of Congress Cataloging-in-Publication Data

Chapel, Jeannie.
 The art collections of Great Britain and Ireland.

 Includes index.
 1. Art—Great Britain. 2. Art—Ireland. 3. Art
museums—Great Britain. 4. Art museums—Ireland.
1. Gere, Charlotte. II. Title.
N1020.C49 1986 708.2 85-18674
ISBN 0-8109-0941-3

Printed and bound in Italy

Contents

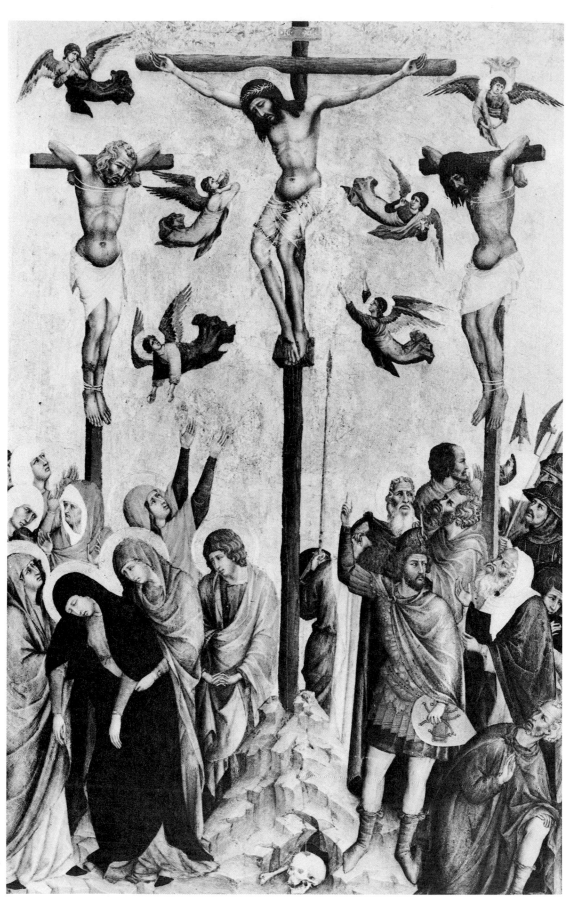

Crucifixion attributed to Duccio di Buoninsegna, Sienese, 14thc (Manchester City Art Gallery)

Foreword

THE MARQUIS OF NORMANBY

This book aims to give an idea of the great riches of fine and decorative art in the public museums and galleries of Britain and Ireland. Most people are aware of what they might see in our great national museums, and for many their local museum is known and loved since childhood and has nurtured a life-long love of the arts. However, many of us are unconscious of the wealth of treasures possessed by the smaller museums, or even by the great regional or university museums and galleries. I hope that this book will entice you to investigate these.

For the greater part of this century, since its foundation in 1903, the National Art-Collections Fund has assisted the museums and galleries of the country, and now the houses of the National Trust, to build up their collections, and to retain many of the works of art in danger of being dispersed. Over three hundred museums have benefited from NACF help, and the major part of the illustrations in this book are of works of art acquired with NACF support. Over the years, this has contributed to the transformation of many of our regional museums so that they can now claim to possess collections of international importance.

Our museums and galleries need further resources to provide better displays, conservation and additions to their collections. At a time of rapidly rising prices for increasingly rare works of art of museum quality, the resources required are daunting, as is the task of the NACF in helping to preserve the Nation's treasures.

This book is a first attempt to provide a well illustrated and comprehensive view of the fine and decorative art in our museums and galleries in such a way that the visitor or reader can discover at a glance where, for example, collections of early Italian painting, of sculpture, or 18th-century porcelain or of Art Deco furniture may be found, but its main purpose is to attract you to unknown and unexpected treasures.

This book was made possible by most generous sponsorship from Lex Service plc (and Volvo Concessionaires Ltd), who contributed towards the editorial costs. This sponsorship was supplemented by a grant from the Government. Without these sponsors the book could not have been undertaken and profits will go to the National Art-Collections Fund.

Editorial Note

PHOTOGRAPHIC ACKNOWLEDGEMENTS

The editors wish to thank the following for their permission to reproduce photographs belonging to them: Her Majesty the Queen for gracious permission to use *The Lady with the Virginals and a Gentleman* by Jan Vermeer and *The Vase Bearer* by Andrea Mantegna, all the museums who supplied photographs of their works of art, and the Trustees of the British Museum, the Governors of Dulwich Gallery, the Visitors of the Ashmolean Museum, the Syndics of the Fitzwilliam Museum and Messrs Sothebys.

The painting of the interior of the National Gallery by Giuseppi Gabrielli (see cover) is owned by the Government Art Collection. We would like to thank Dr Wendy Baron, Dr Mary Beal, Mr Jonathan Bourne, Mrs Margaret Clark, Mr Trevor Galloway and Miss Eileen Tweedy for their assistance in obtaining the photograph and for permission to use it.

The Museums which have been included in this necessarily selective book do not include those which are run by the National Trust, the Department of the Environment or other associated bodies. The National Trust already publishes very full information about its properties in which the fine and decorative collections are described. Similarly, most of the others are well served with excellent guidebooks. Largely due to the constrictions of space, regimental museums and collections have been omitted since they are concerned primarily with their own history and therefore the artistic merit of their holdings—often very conspicuous—is incidental. The same is true of the local history collections held by museums throughout the country; where these are mentioned, they are rarely described in any detail. In view of the space limitations which were inevitable in dealing with such a large subject in a single volume, the illustrations and their captions have been used to supplement the text rather than simply to complement it.

The book is divided into three large sections: first London with the museums in alphabetical order by name, e.g. Geffrye Museum comes under 'G'; secondly the provincial museums in alphabetical order by town, and then by alphabetical order of name within each town. Thirdly, Scotland, Wales, Northern Ireland and the Republic of Ireland, starting with Scotland, are arranged in the same way—alphabetically, of towns and names within the towns.

We are grateful to the staff of the museums who have helped us to compile this guide and who have kindly checked our draft entries for errors. While every effort has been made to ensure the greatest possible degree of accuracy, visitors wishing to view a specific work of art are urged to telephone in advance. Opening times in particular are susceptible to seasonal variation and administrative decisions beyond the control of the staff.

Even as we go to press a number of important projects are in the pipeline, and by the time this book appears there may indeed be a firm opening date for the Clore Gallery, which is to house the Turners, bequeathed by the artist to the Nation, but distributed among a number of institutions since his death. No mention has been made of the Tate Gallery in the north, the Sainsbury extension to the National Gallery, or the return of the ethnographical division to the British Museum in Great Russell Street, since plans for these are not yet sufficiently advanced. The status of collections can also change surprisingly rapidly: the acquisition of a gift or bequest can transform a local museum from a primarily archæological and natural history collection into a repository of a significant fine or decorative art collection. Similarly, the very thematic character of, for instance, the Newmarket Collection of Sporting Art or the Pollock's Toy Museum may be transcended by an acquisition of great artistic importance.

Our colleagues at the National Art-Collections Fund office and our museum friends and associates all deserve special thanks for their help and support, as we had constantly to ask for information needing an immediate response. We are particularly grateful for the thoughtful and patient help of Miss Johanna Awdry, our editor at Weidenfeld and Nicolson and to Mr Trevor Vincent, who has realised our vision in his elegant and sympathetic design of the book. Other burdensome demands fell upon the following: Mr Ronald Alley, Mr John Gere, Dr Catherine Gordon, Mr Lionel Lambourne, Mrs Daphne Montgomery, Mr Sean Popplewell, Lady Stevens, Miss Angela Summerfield, Miss Eileen Tweedy, Mr Giles Waterfield, Mrs Frank White and Mr John Woodward. Finally, the credit for inaugurating the whole project must go to Sir Peter Wakefield, Director of the National Art-Collections Fund, whose inspiration it was. His constructive criticism and encouragement—given in approximately equal measure—have been invaluable throughout.

The Architecture of British Museums and Art Galleries

JOHN SUMMERSON

The quest for a 'first' museum or art gallery is likely to be vain, so unstable are the meanings of these expressions. In Britain, there is a good case for calling the old Ashmolean at Oxford 'the first' museum. It was certainly built between 1679 and 1683 for the preservation and public display of the antiquities and curiosities collected by the elder John Tradescant and absorbed into the hoard of Elias Ashmole who presented the whole to the University. It was a purpose-built 'cabinet of curiosities' to which there were earlier parallels on the Continent, but none, it seems, in Britain.

The Ashmolean had no immediate successors. It is not until we come to the 19th century that the word 'museum' comes to be identified with buildings of a peculiar character—buildings with classical Antique references, of a certain solemnity and some pedagogical intention, with almost windowless walls, and mostly lit from the roof. Professor Mordaunt Crook has drawn attention to the original Hunterian Museum at Glasgow, built in 1804 and demolished sixty years later, as an almost forgotten prototype (*The British Museum*, 1972, p. 63). With its Doric portico, its dome, its relief panels in lieu of windows in the upper storey, it was the epitome of much that was to follow.

In England, it might be said that the rear gallery of the Soane Museum, built in 1808, was the first haunt of the enlightened museum spirit. It contained a library, a 'plaister room' and, in the basement, a 'catacomb', and was called a *museum* to distinguish it from the house which Soane, four years later, built in front of it, facing Lincoln's Inn Fields. The gallery is entirely top-lit and the exterior towards Whetstone Park (the narrow back street between Holborn and the north side of Lincoln's Inn Fields) is blind except for attenuated round-headed recesses and a 'primitivist' brick cornice. It is nothing much to look at, but Soane was very self-conscious about it and felt he was creating something.

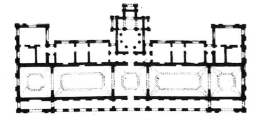

Soane had the real museum mind and it was appropriate that he should have been chosen to design the gallery at Dulwich for which Noel Desenfans left a bequest and which was built in 1811 as an appendage to Dulwich College. It consists of one continuous suite of top-lit galleries, with side rooms which were originally almshouses, and a projecting mausoleum in which the founder's corpse is laid up. The style of architecture is Soane's own. Few liked it at the time and the gallery had no imitators. The next picture gallery to be built in the metropolitan area was the National Gallery in Trafalgar Square.

Dulwich Picture Gallery, with ground plan (Photo: Sir John Soane's Museum)

At this point it is already necessary to take account of the rising tide of middle-class provincial culture—the 'Lit. and Phil.' movement. Many provincial galleries originated as 'Institutions', either 'Literary and Philosophical' or 'Artistic', supported by subscribers. Of these, one of the earliest and architecturally by far the most imposing, was the Royal Institution of Fine Arts at Manchester (now the Manchester City Art Gallery). In 1824 Charles Barry, then aged twenty-nine, won a limited competition for this building, defeating J. B. Papworth, Francis Goodwin, John Foster and Lewis Wyatt. At that point in his career Barry was in the unhappy position of having acquired prime expertise in the Greek and Italian styles but being unprepared for the sudden overwhelming demand for Gothic. He nevertheless won competitions for churches in the Manchester area with rather laboured Gothic designs; these gave him standing in Manchester and admitted him to the Royal Institution competition. For this the appropriate style was the classical, but the interesting thing about Barry's design is that it was not so much English 'Greek Revival' as an essay in 'Modern French', considerably influenced by the published designs of A. L. Dubut. Most of his interiors have been remodelled, but the entrance hall, rising into the externally conspicuous lantern from which it receives its light and surrounded at first floor level by a gallery supported on Doric columns, typifies the spatial sense of the new French school. Its recent redecoration has brought out its delicacy and sense of surface.

In the year before Barry started his Manchester building, the Trustees of the British Museum had approved a design for the total rebuilding of Montagu House in Bloomsbury, where the British Museum had been housed and (nominally at least) accessible to scholars since the Act of 1753. This was a great and innovative national enterprise. The original holdings of the Museum were the Cotton, Harley and Sloane collections, but since 1753 the Trustees had been obliged to accept and store the Towneley collection, the Elgin marbles, George II's library and a great deal else. The building of a structure commensurate with such vast material wealth was inevitable and the Government placed the responsibility in the hands of Robert Smirke. Smirke was one of the Board of Works triumvirate; he and his colleagues Nash and Soane each had his allotted area of responsibility, and Montagu House was in Smirke's. This was fortunate, because Nash was seventy and heading for trouble with Buckingham Palace while the architecture of the sixty-nine-year-old Soane was getting odder and odder. Smirke was only forty-three and at the top of his form; a cool man, well versed in the newly revealed architectural classics of Asia Minor, a great constructor and a faultless administrator.

Smirke has never had quite enough credit for the powerful, lucid, perfectly detailed building which, designed in or before 1823, only reached completion in 1847: the younger generation of the 1840s, watching the laborious erection of the Prienian colonnade when they believed that 'pure Grecian' was over and done with, probably felt a certain understandable nausea. The Museum was 'copyist', 'cold' and 'dead', an indictment that has never been quite extinguished.

The first part of the Museum to be built (1828) was the east wing, containing the King's Library. A Corinthian order rules these great rooms but its columns hide discreetly in recesses, with only the rich entablature running round to support the coffered ceilings and crown the almost continuous revetment of the subtly detailed bookcases. All Smirke's galleries have a strong, thoughtful character. So have the entrance hall and staircase, where a Greek Doric order binds the components into strenuous continuity. Smirke's way of extending the Greek *anta* to the modelling of piers and window-surrounds is much in evidence, and the hall must have been a marvellous spectacle before his polychromatic decoration was obliterated.

Smirke's plan was less successful in the central court which was bleak, almost sunless, and quite useless. Happily, it provided a space for the erection of Panizzi's circular Reading Room whose giant dome of cast iron was designed by Smirke's younger brother Sydney and built in 1854–57.

While the British Museum was slowly rising, nourished by spasmodic Treasury grants, the National Gallery went up fairly quickly between 1834 and 1838 on the north side of what was to become Trafalgar Square. By this time the old Board of Works had been dissolved and the award of the commission to William Wilkins was, it seems, largely the result of the vigorous propaganda he conducted on his own behalf. The building housed in one wing the Angerstein Collection (the nucleus of the National Gallery) and in the other, until its removal to Burlington House in 1866, the Royal Academy of Arts.

The National Gallery's exterior is one of the outstanding non-successes of British architecture. It is a stylistic hybrid and the bits and pieces of which it is made up relate

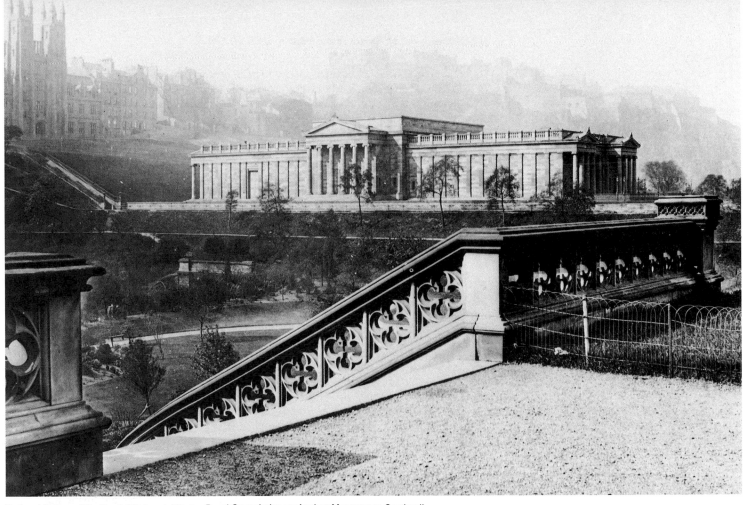

National Gallery of Scotland, Edinburgh (Photo: Royal Commission on Ancient Monuments, Scotland)

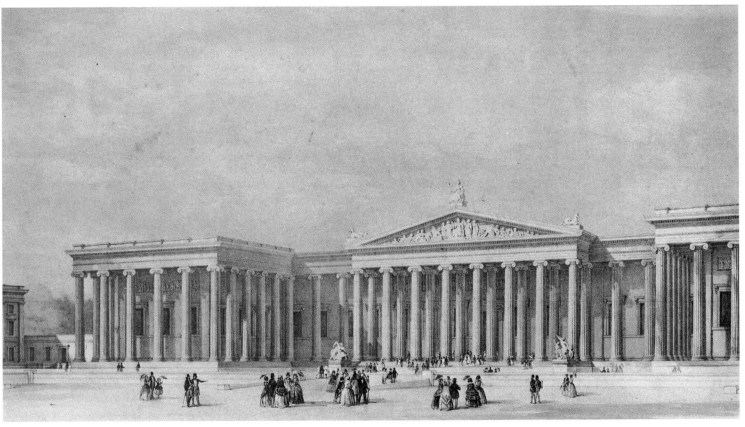

The British Museum, main entrance front (Photo: British Museum)

badly to each other and worse to the whole. The architect who inaugurated the Greek Revival with the perfectionist achievement of Downing College, Cambridge, and who went on to build the museum of the Yorkshire Philosophical Society in the grounds of St Mary's Abbey at York in 1827–30, ought to have done better. The obligatory reuse of the columns from the portico of the demolished Carlton House cannot have made his task easier; and while the steps before the portico are well managed, the dome is a sadly misconceived object which nobody has ever tried to defend.

The failure of the National Gallery marks the collapse of the Greek revival in England. In Scotland it continued to thrive. The Royal Institution on the Mound in Edinburgh, designed by William Playfair in 1822, had more Greek Doric columns than even the Royal High School on Calton Hill and acquired still more when it was lengthened and the portico doubled in 1832. This is the building now occupied by the Royal Scottish Academy. Its companion building on the Mound, the National Gallery of Scotland, was also built by Playfair, but at the end of his life: he just lived to finish it before his death in 1857. The style is Greek Ionic, with two adjacent porticos on the north side, their duality signifying the original joint occupancy of the building. The Royal Scottish Academy had one half and the National Gallery the other. It was not until 1906 that the National Gallery took over the whole building.

1857 is a late date for a 'pure' Greek Revival building, but the Scots were tenacious of neo-classicism and, as we shall see, their tenacity was to have an effect in England. In London, Barry's *cinquecento* had swept the board clear of the Grecian orders, while Pugin's followers were moving in an altogether different direction. The next museums to claim our attention are at the ancient universities—the Fitzwilliam at Cambridge (1836–45) and the new Ashmolean at Oxford (1841–45), and neither can qualify as wholly Greek.

The Fitzwilliam was built from the magnificent bequest of Viscount Fitzwilliam, who not only left the whole of his collection of works of art to the University but in addition more than £100,000 for the erection and maintenance of a museum. With such resources, the British Museum could be outpaced and the National Gallery eclipsed. A competition was held in 1834, for which twenty-seven architects submitted designs. That of George Basevi, then aged forty, was chosen.

Basevi took full advantage of the opportunity for uninhibited exterior display, though it flags a little in the side elevations. He took from Smirke the idea of a continuous colonnade turning abruptly outwards to make an eight-column portico and then going back into line. But Basevi's colonnade is less protracted than Smirke's and has a happier ending: instead of vanishing round the corner, as Smirke's does, it is halted at each end by hollow pavilions whose clustering pilasters give a Baroque sense of depth to the whole frontispiece. The hall and staircase constitute another grandiose set piece; indeed, portico, colonnade and entrance hall between them take up nearly half the total area of the original building. The other half is occupied by the galleries, those on the main floor being top-lit. Basevi was a pupil of Soane and if one looks for the old man's influence it is found in the lantern-light of Gallery III, where a second lantern rides on top of the first as do Soane's lights in the Westminster Law Courts.

After Basevi's fatal fall from a scaffold at Ely Cathedral in 1845, C. R. Cockerell took over and altered the staircase design, introducing the barrel-vaulted bays over the side galleries—an imaginative borrowing from Wren's church in Piccadilly.

At Oxford we meet Cockerell again, in the building commonly known as the Ashmolean which is entirely of his design. It consists, in fact, of two buildings. The block towards St Giles contains the Taylorian Institute for foreign languages provided for in the bequest of the well-known architect and Sheriff of the City of London, Sir Robert Taylor, who died in 1788. The corresponding block on the south is part of the Museum and the two are linked by a lower block, forming a gallery of antiquities, with a central four-column portico. This was felt to be an unusual and controversial disposition, and critical opinion is divided on the merits of this curious building. Russell Hitchcock, who calls the plan incoherent, is shocked by the competing Greek and Italian cornices and the 'unbelievably awkward' junction of the low centre and high end blocks. David Watkin defends this last feature as a deliberate gesture of 'dislocation' and quotes with approval Fergusson's verdict on the whole building: 'There is perhaps no building in England on which the refined student of architecture can dwell with so much pleasure, there is not a moulding or chisel mark anywhere which is not the result of deep study, guided by refined feeling' (*The Life and Work of C. R. Cockerell, RA*, 1974, p. xix). Cockerell perceived a subtle affinity between the Grecian profiles he had

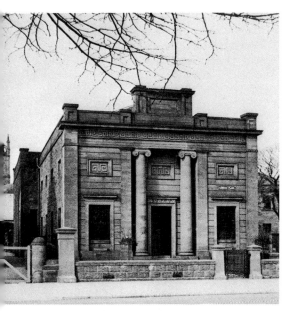

Montrose Museum, Scotland (Photo: Royal Commission on Ancient Monuments, Scotland)

been discovering and those characteristic of certain kinds of Italian Mannerism; the brilliant play of these two apparently opposed modes amply justifies Fergusson's enthusiasm.

Both the Fitzwilliam and the Ashmolean were substantially completed in 1845. There followed a period when few museums were built, and when their social function was being critically examined. In 1845 Parliament passed an 'Act for enabling Town Councils to establish Public Museums of Art and Science'. The purpose of such museums was not academic but 'for the instruction and entertainment of the inhabitants'. The bill had been introduced by William Ewart, an advanced Liberal who had been associated with the Report of 1836 which led to the creation of the Government Schools of Design. It was strongly supported by Joseph Hume, the radical Member of Parliament for Montrose where, as it happened, a most elegant little museum had been built in 1836.

This Act, which enabled local authorities to purchase land, erect buildings and accept gifts for museum purposes, imposed a condition that entry to public museums should not exceed one penny. It was superseded by the Act of 1850 which insisted that entry should be free; and it was the adoption of this latter Act which enabled so many towns and cities to receive benefactions in the shape of museums and galleries and maintain them out of the rates. One of the first rate-maintained museums was at Warrington in Lancashire. Created by Warrington's first mayor on the premises of the Warrington Natural History Society, it was given a site by a wealthy citizen. The still standing, neat, classical building is after a design by the famous John Dobson of Newcastle, executed in a simplified form in 1855. In the following year Liverpool moved in the same direction, accepting the gift of a library and museum at the hands of Alderman William Brown. A competition was held, the winner being Thomas Allom, better known as a draughtsman than an architect. His building (now the Merseyside County Museum) has a six-column Corinthian portico echoing, rather shyly, the majesty of St George's Hall across the road.

Most museums up to 1860 were in some version of the classical (the Tudor Gothic museum at Saffron Walden, 1834, is a curious exception). The first serious departure was caused by a competition held by the University of Oxford in 1854 for a Museum of Physical Sciences. Although this was not a museum of art, no museum ever made a greater stir in the art world of its time than the building which emerged as the winner, the work of the Dublin partnership, Deane and Woodward. There was nothing romantic or spectacular about this quiet, symmetrical building with its low central tower and its flavour of Ruskin's *The Stones of Venice*. What was controversial was the courtyard behind the main block which was covered in iron and glass—an equivalent of Gothic in 19th-century technology. The Oxford Museum was what the Ruskinians and the Pre-Raphaelites were looking for and *Building News* did not hesitate to name it 'the greatest civil building of our day'. It was completed in 1858.

The Oxford Museum's influence on museum design was not very extensive. It can be traced perhaps in the Royal Albert Memorial Museum at Exeter, for which a competition was held in 1869, and which is the best example of a Gothic museum of the 'high' revival period. Planned to contain a school of art and a free library as well as a museum, it is a polychrome affair in brick and stone and has a grand staircase with a statue of Prince Albert in a niche on the first landing. The designer was a local man, John Hayward. A better piece of Gothic is (Sir) Gilbert Scott's Albert Institute at Dundee, built as a 'Lit. and Phil.' in 1865–69. This has a distinct likeness to the Oxford Museum but is more elaborate and vigorous in its detail and is remarkable for the Gothic reinterpretation of the Renaissance perron leading to the first floor.

Few museums and galleries of later years attempted the Gothic, but G. R. Crickmay's modest County Museum building at Dorchester, 1881–83, with gables, battlements and a brave assortment of windows, deserves a mention. On a different level altogether is the John Rylands Library at Manchester, 1890–1910, the queen of all secular Gothic buildings in Britain of the 1890s. It is more of a library than a museum or gallery and, with its vaulted nave, aisle passages and clerestory, is more of a church than either; which, after all, is appropriate to John Rylands's main interests which were theology and early printed bibles. The architect was Basil Champneys.

From about 1860 the lead in museum design and construction was taken by South Kensington. The South Kensington story is long and complicated and is recorded with admirable lucidity in Vol. 38 of the *Survey of London*. We shall not attempt even to summarise it here, merely offering some observations on the kind of architecture it produced. The earliest architectural creations on the Government's South Kensington property were sponsored by the Department of Science and Art, set up in 1852 and directed by (Sir) Henry Cole. Until

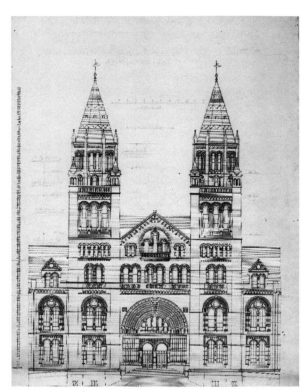

Natural History Museum, main entrance
(Photo: RIBA Drawings Collection, B.A.L.)

1884 this department was responsible for all designing at South Kensington and it developed a style which, whenever it is found, is clearly recognizable as the 'South Kensington' style. It is basically engineering (mostly in iron) with an *appliqué* of sculptural ornament, sometimes of high quality, and a tendency to adopt architectural forms deriving from North Italian Renaissance models. Terracotta and ceramics were favoured materials. The Gothic/classic dilemma is evaded by placing both styles under tribute. The style may be seen today in the South Court (1862) of the Victoria and Albert and in the buildings surrounding the Quadrangle. Outside London it may be seen in two buildings erected by the Department: the Royal Scottish Museum in Chambers Street, Edinburgh and, in exceptionally palatial form, at the National Gallery, Dublin.

The originator of the 'South Kensington' style cannot be very precisely named but the leader of the group of artists who produced it was certainly Captain Francis Fowke. He was an officer in the Royal Engineers and in so far as he was an architect was self-taught. Cole's strong prejudice against professional architects rendered the collaboration successful, especially since Fowke seems to have been a sympathetic and intelligent collaborator with artists and craftsmen.

The Museum of Art was not the only cultural institution claiming accommodation in the South Kensington precinct. The British Museum's vast accumulation of Natural History specimens required a home where it could expand and where the didactic ideas of (Sir) Richard Owen could be promoted. The buildings housing the Exhibition of 1862 were considered but dismissed as unworthy, and the site was given over to two joint projects—a Natural History Museum and a Museum of Patents. For these two purposes a vast palace was envisaged and a competition organised. Fowke, who had designed the original Exhibition buildings, entered for the competition and, to nobody's surprise—except allegedly the assessors'—won it with a design in the North Italian Renaissance style, with French-type pavilions and a good many domes.

But in the following year Fowke died, at the early age of forty-two. The question at once arose whether his design should be executed and if so by whom. Doubts were resolved when Alfred Waterhouse accepted the invitation to erect Fowke's building but with ample latitude to revise not only the plans but also the elevations. The proposal for a Museum of Patents was dropped and the project became more manageable. Waterhouse decided to alter the style

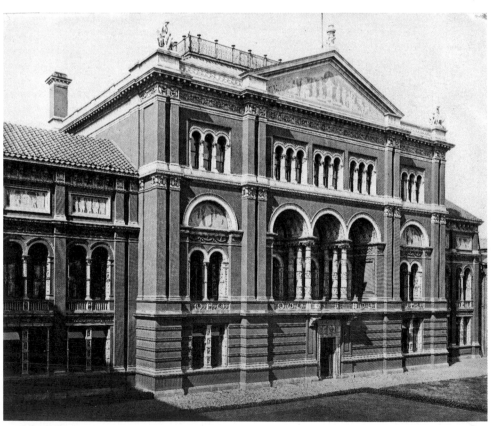

Victoria and Albert Museum, the quadrangle in 1878
(Photo: Victoria and Albert Museum)

from 15th-century North Italian Renaissance to 12th-century German Romanesque. He removed the central element with its clustered domes and replaced it with a Romanesque Cathedral 'west front' with twin towers and a great portal. In spite of these ruthlessly radical 'revisions', a good deal of Fowke's work still remains in the design and disposition of the pavilions, in the general pattern of the fenestration, and even in some decorative details. It could be said that much that seems, and indeed is, original in the present building is the result of the re-thinking of Fowke's Renaissance in terms of Waterhouse's Romanesque.

The Natural History Museum was by far the largest and most impressive building, apart from the British Museum, to be built for museum purposes in Britain. It was well received and its architect became the most respected as well as the most affluent of British practitioners, constantly in request not only as executant but also as assessor in architectural competitions— a capacity in which he was exceedingly influential.

Outside London the pace of museum-building increased from the 1860s onwards. At least seven went up in the 1870s, twice that number in the 1880s, and twenty at least in the 1890s. Thereafter numbers declined. In the ascendant years no very distinct types emerged either in style or arrangement. To local councillors art was always in itself slightly suspect and was felt to be best dealt with in combination with some practical purpose like a library or a school of art or science, or some other municipal enterprise. Moreover, the fact that neither a picture gallery nor a museum could be justified unless there was something to put inside it required a benefactor who had something ready to hand. The architecturally significant museums and galleries are those that were dependent on the gift of a substantial and worthwhile collection.

The 1870s saw the erection of museums at Blackburn, Liverpool (the Walker Art Gallery), Derby, Southport, York and Sunderland, all except York finding their architects through competition. The York Gallery, designed by Edward Taylor in 1879, is memorable for its quaintly detailed Florentine loggia, but the most gloriously independent freak of the 1870s is the Bowes Museum at Barnard Castle. This is a colossal French château designed in the late 1860s by a French architect, originally for a site near Calais but hastily re-sited in Co. Durham when war threatened on the Continent. The founders were John Bowes of Streatlam and his French wife, Joséphine. The architect was Pellechet. A latter-day Château-de-Maisons in the Tees valley is a wonderfully improbable event but most assuredly welcome. How one wishes that more English architects of the 1870s had had the technical competence of Pellechet.

The last two decades of Queen Victoria's reign saw the foundation of many of the principal museum and gallery buildings in London and the provinces. Thus, in chronological order, we have Ipswich, 1875–81; Birmingham, 1881–85; Preston (Harris), 1882; Wolverhampton, 1884; Sheffield (Mappin), 1887; Leeds, 1886–88; London (Tate), 1892; Manchester (Whitworth), 1894–1900; London (National Portrait Gallery), 1896. Nearly all these buildings are classical, in the broad sense of the word. None are defiantly non-classical but a few escape in a non-committal 'Renaissance'. Wolverhampton is still in the Barry tradition, while Ipswich pins its faith to Norman Shaw. In quality of design there are wide variations and architectural competence does not always correspond with worthy social intentions.

The Birmingham story is a case in point. The century's best governed and most progressive city had not, up to 1880, done much about art. But in that year came a challenge. George and Richard Tangye, the industrial engineers, offered £5,000 for the purchase of works of art if the Corporation would at once take measures to build an art gallery and a further £5,000 if a similar sum were publicly subscribed. The challenge was accepted. The Corporation, under its ambitious mayor, Joseph Chamberlain, had lately acquired the local gas company and the gas offices required accommodation. A site adjoining the recently built Council House was therefore acquired in the joint interests of gas and art. Gas below, art above: a nice model of the fruits of industry supporting the achievements of the imagination.

The architecture in Colmore Row and Chamberlain Square reflects the story. We have the energetic, ebullient, slightly amateurish façade of the Council House with its pompous centrepiece dome and sculptured pediments, the work of the Birmingham architect Yeoville Thomason. Turning the corner we find the Art Gallery continuing the design but dignified by a double portico. Perched on the Edmund Street corner is a rather absurd clock-tower with a red tile roof. The architecture is not of the quality of Barry at Manchester or Elmes at Liverpool but it has an unembarrassed jollity which exactly matches the mood of Birmingham in the 1880s.

Preston presents an altogether different picture. The Harris Museum and Art Gallery is

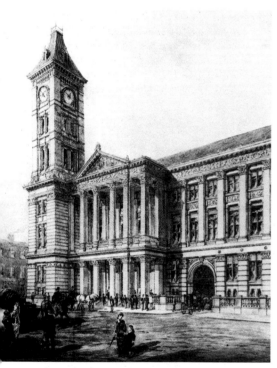

Birmingham, City Art Gallery & Museum
(Photo: Birmingham, City Art Gallery & Museum)

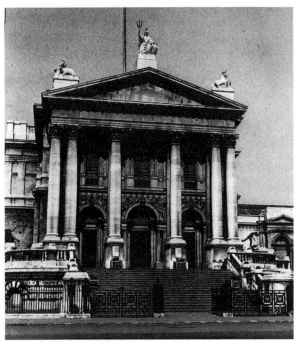

The Tate Gallery (Photo: The Tate Gallery)

one of the most striking monuments of the Greek Revival, but it happens to have been built forty years after the Revival was over. It is an almost incredible anachronism. Little is known of its architect James Hibbert, except that he was a Preston alderman who eventually filled the office of mayor. He seems to have taken the view in 1882 that nothing serious had happened in architecture for forty years. Nor did he feel it necessary to adopt ideas outside his own county: his exterior elevations, at least, can be accounted for in terms of Manchester and Liverpool monuments. Nevertheless, this building has an irresistible vitality of its own.

The Mappin Art Gallery at Sheffield looks like another belated survival. Designed in 1886 by the very able Sheffield architects, Flockton and Gibbs, it is as Greek as it can be but somehow not strictly in the 'Greek Revival' taste. It has more the air of a genteel imitation of von Klenze's work in Munich.

Then there is the Tate Gallery. It is difficult to fit this building into the British classical tradition. It seems to have come about in a curiously muddle-headed way, but the fact is that it is one of the first specimens of the new kind of classicism that was making itself felt in competition-entries from about 1890 that was in full flood by the turn of the century, and which is usually miscalled 'Edwardian Baroque'. In 1890 Henry Tate, the sugar magnate, offered his collection of modern British art to the Nation with a gallery to contain it provided that the Government would give the site. Eventually the site of the Millbank Penitentiary was made available and the offer accepted. No competition was held and the commission was put in the hands of thirty-three-year-old Sydney R. J. Smith, of whom nobody had ever heard but who had for some years been associated with Henry Tate. Tate had come to live at Streatham and had found an outlet for his philanthropic instincts in the free library movement which the Lambeth vestry was trying to promote. By 1888 one library had been built by the Vestry, at Knights Hill, of which Smith was the architect. It is still there: a tiny building, plain inside but equipped externally with a two-storey loggia, ornaments in a rich variety of styles and materials, carved heads of great writers and a heavy French roof. That library was paid for out of the rates, but the next, in South Lambeth Road, was the gift of Henry Tate who went on to present three more, all with Smith as architect. It was natural, therefore, that Tate should invite Smith to make sketches for the Gallery of British Art.

The first published design for the British Gallery is the sad little elevation reproduced in the *Building News* for 1892: an unpromising five-part classical building with a glass dome over the centre block and loggias extended along the wings. Then, in 1893, comes a well-drawn perspective by C. W. English of something altogether different. There are now seven domes: five grouped together in the centre (rather like a Russian church) and one on each of the end pavilions. A section shows the beginnings of something like the executed design. After this, Smith was put to a great deal of trouble and suffered much disappointment. The executed design, we are told, 'was the fifth made by the architect, each successive design revealing a shearing-off of projecting members and of purely ornamental features, owing to the paramount necessity felt by many for an even distribution of the masses of building so as to ensure the maximum of light'. The cruellest sacrifice was the lopping off of the high central dome.

After all the shearings and loppings we are left with a plausible if not very refined classical building which has a faintly Beaux-Arts flavour. Sydney Smith's architectural pilgrimage from Knights Hill to Millbank was hard going and earned him little credit; and when Duveen's offer of a new Turner Gallery was accepted in 1908 the Office of Works took the project over without even bothering to consult him.

The other major gallery to be built in London before 1900 was the National Portrait Gallery. The finance was provided by a benefactor, W. H. Alexander, who was presumably responsible for choosing the architect, Ewan Christian: a curious choice in view of the fact that Christian had spent his long life building almost nothing but Gothic churches. Part of the Gallery was necessarily a continuation of Wilkins's National Gallery, and this Christian handled with discretion. For the north block, however, facing up Charing Cross Road, he reverted to 15th-century Florence. The very queer spacing of the upper windows detracts from what would have been a noble mass, in the Medici spirit but with a leaning to the Romanesque.

We must now turn again to the great South Kensington enterprises. The Natural History Museum was opened in 1881, but the Art Museum was at a standstill. It was not until 1890 that the Government decided to complete it and to select the architect by limited competition. Once again the problem of style arose. There was a growing desire to return to academic classicism and John Belcher's spectacular Baroque design was much applauded. Other

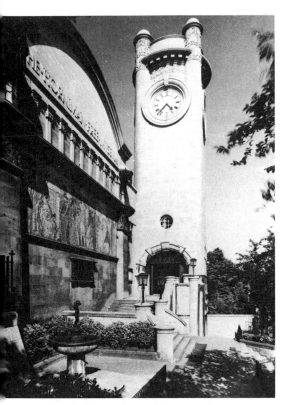

The Horniman Museum
(Photo: The Horniman Museum)

competitors felt their way gingerly to something still safely 'Renaissance' but moving in a classical direction. A factor which had some bearing on the choice of style was that the assessor was Alfred Waterhouse whose own Natural History Museum would form a group with the new museum. The only entrant who took this requirement seriously was the young Aston Webb, and it was he who won the competition. His design was diabolically clever, for it succeeded in capturing the feel of Waterhouse's building without overtly imitating it: Renaissance but without columns or pilasters, woven into it were various Waterhousean elements, including a type of traceried window which Waterhouse had taken from Fowke.

Between the winning of the competition and the start of the building eight years elapsed. Changes of various kinds were imposed and Webb himself had many second thoughts, especially about the Cromwell Road façade. In the competition design the entrance was in the base of a modest central tower. By 1899 the tower had vanished and a hugely elaborate portal—a Renaissance equivalent of what Waterhouse had done at the Natural History Museum—had taken its place. Above this rose an attic storey which somehow resolved itself into a podium supporting an enormous quasi-lantern tower of two storeys. This seems to have been inspired by the Certosa at Pavia; at the very top, however, comes a 'crown spire' paraphrasing the uniquely British examples at Newcastle-upon-Tyne, Edinburgh and Aberdeen.

Aston Webb's reputation has not been enhanced in recent reappraisals of the architecture of the early 1900s. He was enormously clever, a marvellous blender of styles, and he executed a vast number of national buildings; but he rarely succeeds in touching the imagination. At the Victoria and Albert by far the most appealing feature is the handling of the two staircases, each contained within an open-arched 'cage' of masonry, brilliantly modelled and providing a series of perspectives of considerable charm. Of the other galleries it is difficult to find much to say that is kind.

The opening of the Victoria and Albert by Edward VII in 1909 rounded off a decade of more architectural excitement in museum and gallery building. It was the decade of the Free Style flutter as well as of Neo-Georgian consolidation and Baroque adventure. 'Free Style' is the term by which we must describe the two galleries designed by C. Harrison Townsend at the turn of the century—the Whitechapel Art Gallery and the Horniman Museum at Forest Hill (both finished in 1901). Internally, both buildings provide simple, practical answers to problems of display. Outside, they are straining to tell us something new, which is (or was) that architecture can have a life of its own, independent of 'the styles'. The idea did not really catch on in 1901 and Harrison's buildings immediately became museum pieces, which they still are, their value enhanced by time and a better appreciation of what was really what at the turn of the century.

The new classicism had got its foot in the door by 1900, so that a building like Glasgow's Kelvingrove Gallery, a dazzling mix of French and Spanish Renaissance which won the competition of 1891, found itself out of date even before it was built. The architects, John W. Simpson and E. J. Milner Allen, promptly changed their style and won the Cartwright Hall, Bradford, competition of 1903 with a design characterised by a Baroque silhouette and much solemn fun with rustication. The assessor in both events was Alfred Waterhouse, as capable as anybody else of moving with the times. In 1905 came the Bristol Art Gallery, presented to the City by the tobacco millionaire, Sir W. H. Wills, with his relative, Frank Wills (later Sir Frank, Lord Mayor of Bristol) as the architect. This was another Baroque explosion, technically weak but making an effective exclamation at the top of Park Street.

The one incontestible masterpiece of the decade is the Edward VII gallery on the north side of the British Museum, begun in 1905 and completed in 1914. It is the work of John James Burnet, a Glaswegian whose native genius was disciplined by a Paris training. It was inevitable that the new rear elevation of the Museum should answer Smirke's colonnaded front with something of comparable scale and splendour. Burnet's order is Ionic, but of a slightly more plastic kind than Smirke's. And it is not free but attached at either end to a 'battered' pylon which it just overlaps, while an attic storey connects the two pylons, above and behind the order. There is more here of Schinkel than of Smirke, and also something of Paris and something of 'Greek' Thomson, all fitted together with the greatest care and subtlety (e.g. the axes of the tapering columns are slightly tilted inwards so that the flutes are vertical where they die into the wall). A strong dramatic touch is the entrance feature which, instead of being emphasised to make an impression, is deliberately understated to remind the visitor of his own insignificance in the presence of the achievements of the past.

In 1910 came the competition for the National Museum of Wales, with Aston Webb, Burnet

and Edwin T. Hall as assessors. This was not only an important building in itself but was to be sited in Cardiff's Cathays Park, next to E. A. Rickards's sensationally successful City Hall completed in 1904. In contrast to Rickards's Baroque virtuosity, the winners of the Museum competition, Dunbar Smith and Cecil Brewer, took a sober neo-classical line, with a shapely plan and simple detailing. The transatlantic influence of McKim, Mead and White probably accounts for this as it does also for the classicism of the Lady Lever Art Gallery at Port Sunlight which William and Segar Owen designed for Viscount Leverhulme a few years later. Both the Welsh Museum and the Port Sunlight Gallery were interrupted by the War, the latter being opened in 1922 and the former not until 1927.

American influence pervaded the inter-war years and is found in the Ferens Gallery at Hull (S. N. Cooke, 1927) and in a Georgianised form in the Williamson Gallery at Birkenhead (Hannaford and Thearle, 1938) and also in the new additions to the British Museum and the Tate Gallery, both presented by Lord Duveen and designed by the American Russell Pope.

The Science Museum and the Geological Museum at South Kensington belong to this period. Essentially they are plain concrete carcases, screened from the street by Portland stone façades in a style of architecture which a President of the R.I.B.A. once appropriately described as 'stale chocolate'.

Two spirited inter-war buildings are worth a mention. One is Sir Reginald Blomfield's Usher Gallery at Lincoln, designed to house a small private collection made over to the City by James Ward Usher. Built in 1927, it is one of Blomfield's most personal works, a piece of Francophil design with, as always, a very strong English accent.

The second building, the Barber Institute at Birmingham University, is something altogether different, combining the functions of an art gallery and a postgraduate school of art history. This was a new type of institution, inviting fresh architectural ideas. In the 1930s, when the Barber Trust appointed Thomas Bodkin as director and Robert Atkinson as architect they looked for original thought from both these professionals and it was forthcoming. Atkinson's unusual plan, with the auditorium locked into a square of galleries, the projecting lecture theatre and off-centre entrance, put conventional classicism out of the question. Atkinson adopted a kind of Anglo-Swedish classic, allowing complete freedom of movement while retaining traditional elements and the use of traditional building materials. The Barber Institute represents better than almost any other building (except, perhaps, the R.I.B.A. in Portland Place) the spirit of English architecture in the 1930s.

Since the Second World War between twenty and thirty new museums have been built in Britain. Some have been so discreetly merged with existing buildings as hardly to deserve the epithet 'new' and very few indeed stand out as memorable pieces of architecture in their

The Sainsbury Centre, plan and elevation
(Photo: Norman Foster Associates)

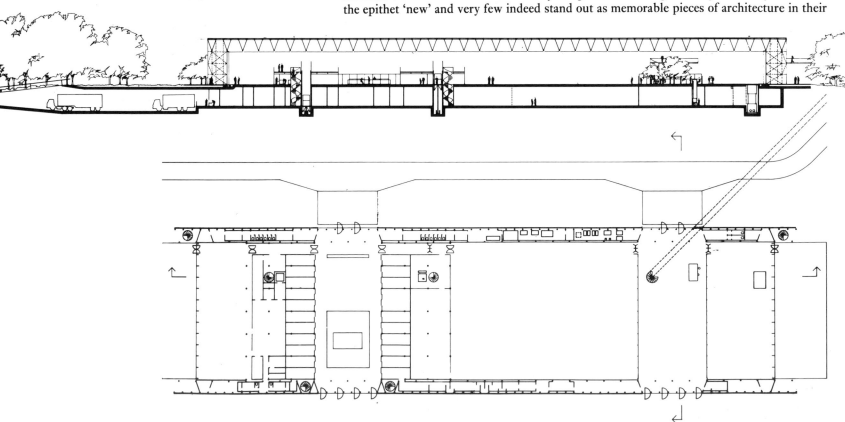

The Burrell Collection (Photo: Barry Gasson Architects)

own right. There is no modern equivalent of the Fitzwilliam at Cambridge or of Glasgow's Kelvingrove Gallery. This is, no doubt, as it should be. We have not lost the feeling generated by the Modern Movement, the sense of withdrawal from architectural exhibitionism and of limiting the architect's function to the protection and display of the exhibits. In practice it can, of course, never be simply left at that; however much the architect may pursue the anonymous and the negative, he is placing on the ground a positive statement which will be judged as architecture.

In the past ten years two remarkable buildings have been built illustrating the museum and gallery problem as it is seen by two different kinds of modern architect. One is the Sainsbury Centre at the University of East Anglia by Norman Foster and the other the Burrell Museum at Glasgow by Barry Gasson. Both are intended to house gifts by wealthy collectors, one to a university, the other to a city, and in both cases the buildings were part of the gift and intended to enclose and service the donors' collections rather than to attract additional works of art. Their functions are not exactly similar: the Sainsbury includes a pedagogical element associated with a Department of Art History (as in the Barber Institute), while the aim of the Burrell is more in line with the purpose broadly defined in the 1845 Act, 'the instruction and entertainment of the inhabitants'. The Sainsbury has an exhibition area with a flexible arrangement of screens; the Burrell is designed more as a close-fitting shell into which some of the exhibits are incorporated. Nevertheless, they are near enough in general purpose to admit legitimate comparison of their respective approaches to design. The Sainsbury has become the most celebrated British example of 'High Tech.', which is to say that the architect's approach has been through engineering and industrial techniques rather than the traditional repertory of the building trades. The Burrell, on the other hand, tends to exploit the values inherent in natural materials and traditional methods of construction.

The Sainsbury Centre looks at first sight like an aircraft hangar, being in effect a long rectangular shed of steel construction with external and internal cladding, arbitrarily sited on the perimeter of the university buildings. It does not immediately declare its purpose nor seduce the eye, and it is only when the interior has been explored that its spatial relationships and sensitive precision of detail begin to be appreciated. The Burrell is more relaxed; its plan derives from a comfortable relationship with the site and it invites leisured movement through its various elements. A feature of both is a consciousness of their natural environment. At the Sainsbury, both ends of the 'hangar' are glazed and the landscape is a living picture filling the whole structural frame. At the Burrell nature draws alongside—a forest scene on the north and a meadow on the south are glimpsed at intervals. The buildings represent two different approaches to the enjoyment of art and nature and neither approach is wrong.

To these two approaches we may add a third which will be illustrated by the Clore Gallery at the Tate, now under construction. This seems likely to challenge the policy of self-effacement and withdrawal seen in so many modern galleries. James Stirling's design is nothing if not positive: a witty, paradoxical, irresponsibly good-humoured creation—a museum piece in its own right. The Turner paintings will be perfectly at liberty to speak for themselves, but the building itself is not going to be excluded from the dialogue with which the visitor will be entertained. It is an imaginative endeavour to make architecture, once again, something more than an envelope of space, to make the solid eloquent: in short, to render the Gallery as critically challenging as the material it contains. There does not seem much wrong with that.

Museum Location Maps

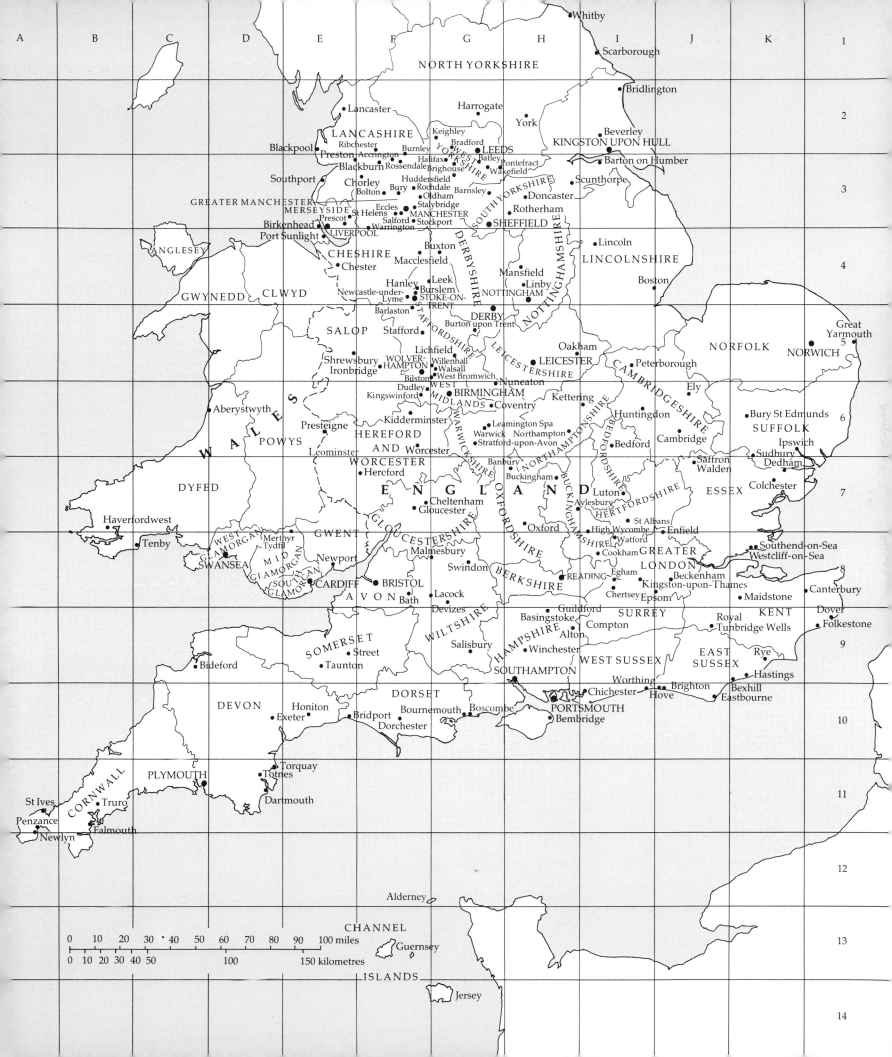

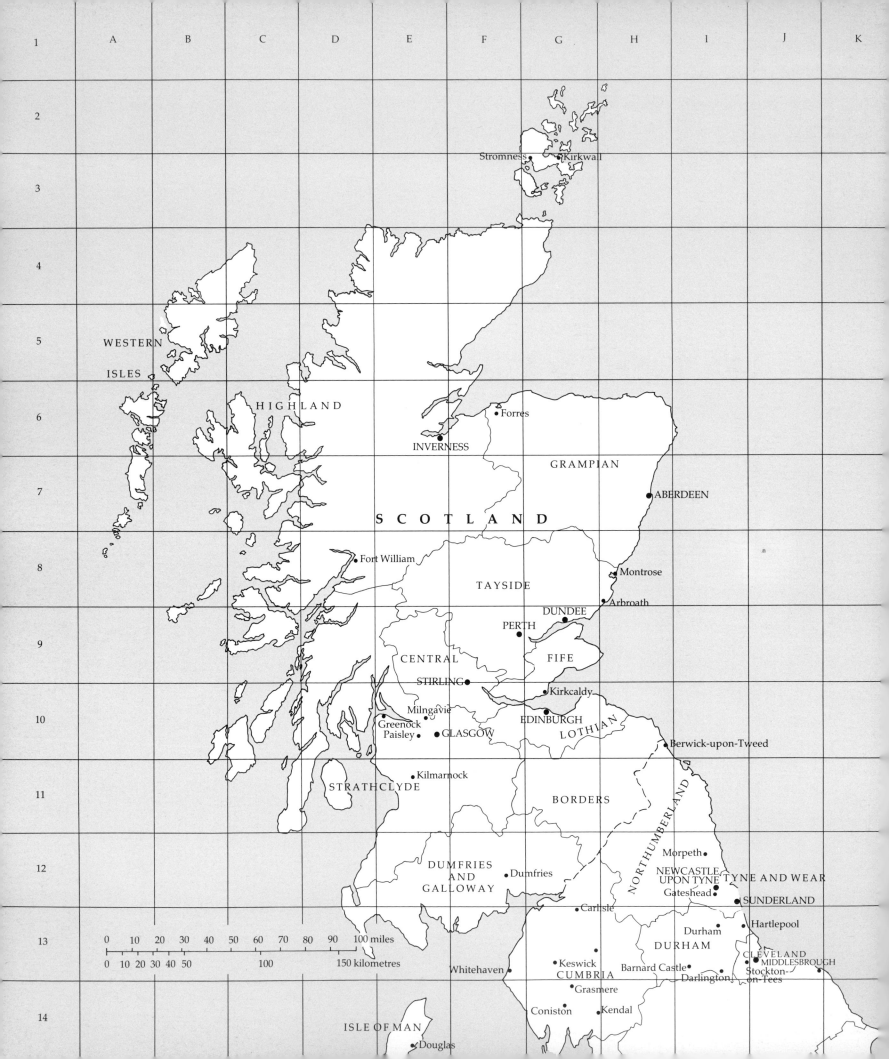

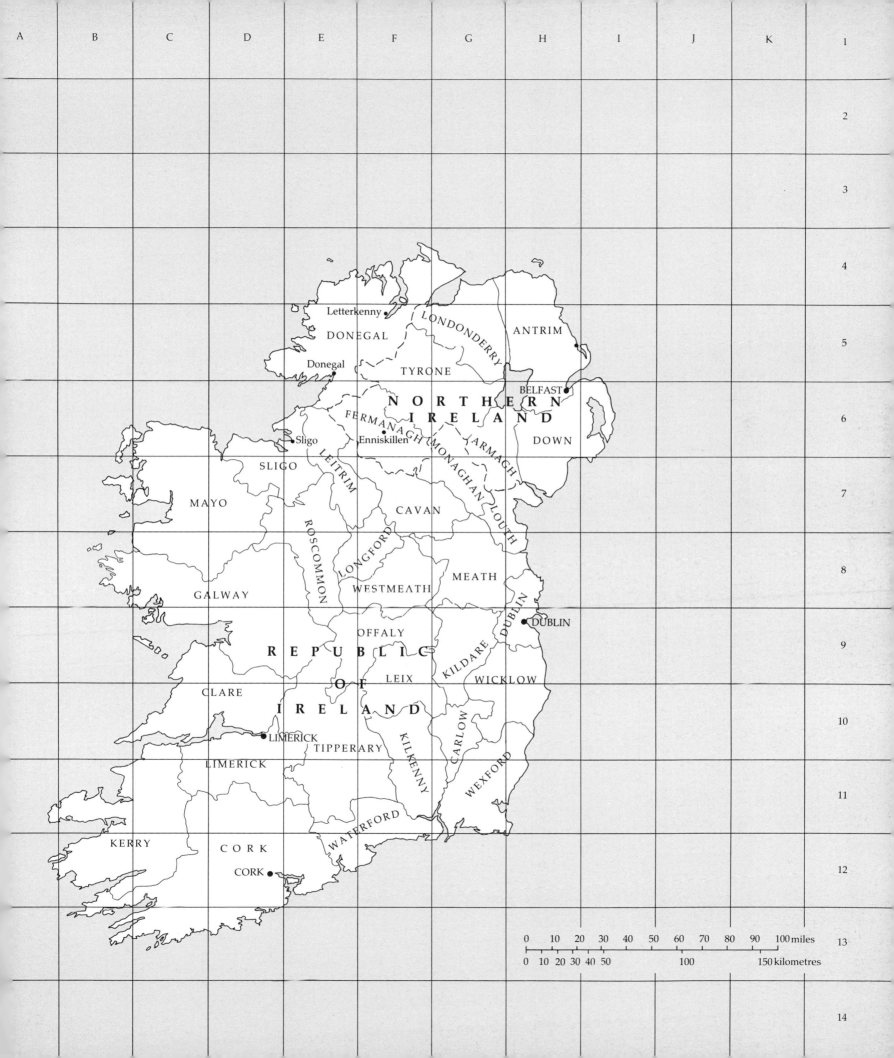

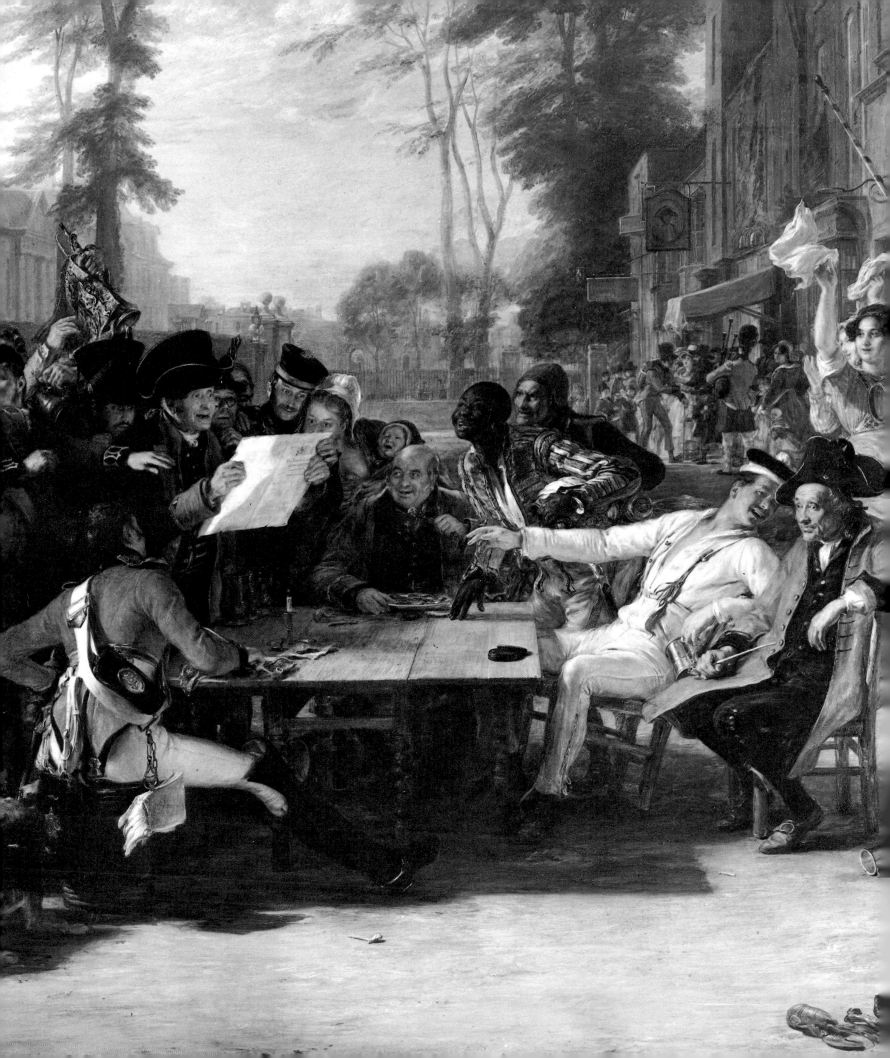

Greater London

Apsley House, The Wellington Museum

London residence of the 1st Duke of Wellington (1769–1852) with contents and other associated items.

European Paintings (17thC–19thC), porcelain and silver (19thC)

Apsley House, 149 Piccadilly, London W1 tel. 01-499 5676

Tues–Thurs, Sat 10–6 pm; Sun 2–6 pm

Admission charge

Apsley House was opened as a museum to the public in 1952. Originally known as 'No. 1 London', being the first house after passing through the Knightsbridge toll gate, it was built by Robert Adam (1728–92) for Henry Bathurst, Baron Apsley, in 1771–78. It was purchased in 1807 by the Marquess Wellesley, who employed the architects James Wyatt (1746–1813) and Thomas Cundy (1765–1825) to make improvements. In 1817 he in turn sold Apsley House to his brother, the Duke of Wellington, who in 1828–29 employed Benjamin Dean Wyatt (1775–1850) and Philip Wyatt (d. 1836) to face the house with Bath stone and add the portico, pediment and extension on the west side.

The 2nd Duke of Wellington first opened the house to the public, three days a week after written application, from 1853. The house and its contents were presented to the Nation by the 7th Duke in 1947. Since 1976, when the Department of Furniture and Woodwork at the Victoria and Albert Museum took over responsibility, it has been restored as near as possible to its appearance during the 1st Duke's time. Detailed watercolours of the interiors executed by Thomas Shotter Boys in the 1850s greatly helped in returning the house to its former glory.

The interiors are particularly fine: remaining from the Adam period are the marvellous decorated staircase, the Piccadilly Drawing Room and the Portico Room. The original plasterwork by Bernasconi and George Jackson & Sons, the metalwork supplied by J. Bramah & Sons and the furniture by Thomas Dowbiggin & Co. also survive.

The plate and china have now been rearranged in a room in the south-west corner of the house in new showcases, which contain, for example, the huge Wellington Shield designed by Thomas Stothard c. 1822 and two magnificent candelabra by Benjamin Smith of 1816–17, all of which were presented to the Duke by the Merchants and Bankers of the City of London. Of special note from the outstanding collection of Sèvres is the famous and recently acquired Egyptian dessert service of 1809–12, consisting of an impressive centrepiece in hard-paste porcelain mounted on *tôle peinte*, based on the Temples of Karnak, Dendera and Philae, and thirty other pieces. Made for the Empress Josephine's divorce present, it was refused by her and given by Louis XVIII to the Duke of Wellington in 1818. Also to be seen is the extensive Prussian service made at the Berlin factory in 1816–19 with sixty-four plates illustrating the Duke's achievements, as well as pieces from the Saxon service of Meissen porcelain and the Austrian service of Vienna porcelain. A large number of silver parcel gilt items from the Deccan service and two silver centrepieces by Paul Storr of 1810–11 and 1811–12 are on display, as are the Duke's many Orders, including the famous diamond-set George from the Order of the Garter, and a number of gold and silver snuff boxes, swords and daggers and other mementoes.

In the staircase hall is one of the house's most memorable works, the over-life-size—more than eleven feet high—nude statue by Canova, of Napoleon holding in his hand a gilt statuette of Victory, made in 1802–10 and installed in 1817, having been rejected by Napoleon. It was purchased by the British Government and given to the Duke by the Prince Regent.

The collection of paintings is essentially a magnificent private one, with very good Dutch and Flemish pictures, including works by Paul Bril, Teniers the Younger, Elsheimer, Nicolaes Maes, Jan Steen, Pieter de Hooch, Wouvermans, etc., many of which are hung in the Piccadilly Drawing Room.

Among the portraits by French artists on view in the Portico Drawing Room are those by Robert Lefèvre of *Pope Pius VII*, 1805, and *Pauline Bonaparte* and *Empress Josephine*, both of 1806; *Joseph Bonaparte* by Gérard and additional portraits by Lefèvre are among the paintings hung in the Yellow Drawing Room.

By far the most impressive group of paintings is in the Waterloo Gallery, which has been rehung to reflect the original arrangement of the paintings as recorded in an 1852 watercolour by John Nash. The Gallery was designed in 1828 by Benjamin Dean Wyatt for the Duke's collection of paintings, many of which, including works by Rubens and Mengs, came into his possession after the Battle of Vitoria, 1813. Some 200 canvases (removed from their stretchers and rolled up) had been taken from the Spanish Royal Collections by Joseph Bonaparte, then King of Spàin, and were discovered by the Duke when the King's coach was stopped on fleeing the country. Learning of their royal provenance in 1814, the Duke

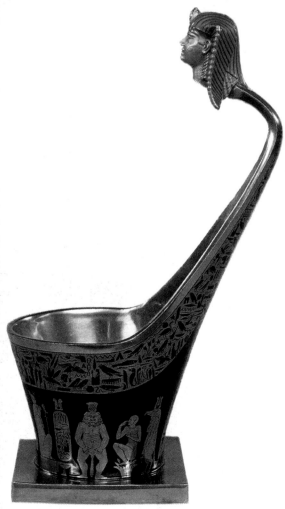

Sèvres porcelain *Sucrier* from the 'Egyptian' service designed by Jean-Charles-Nicholas Brachard, 1810–12 (Apsley House)

Opposite] David Wilkie, detail from *Chelsea Pensioners reading the Waterloo Despatch*, 1822 (Apsley House)

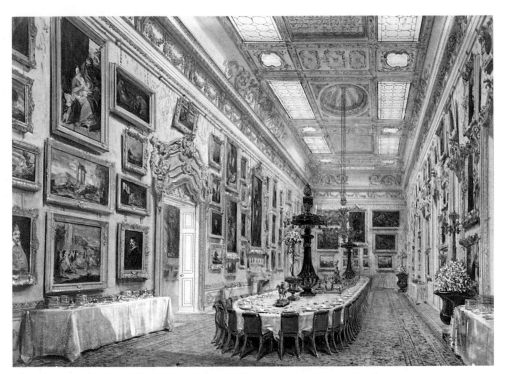

Joseph Nash, watercolour of *The Waterloo Gallery*, 1852

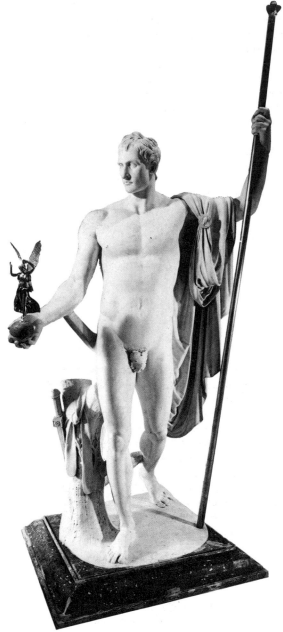

Marble statue of Napoleon I holding a figure of Victory by Antonio Canova, 1802 (Apsley House)

not only had the pictures restored but also offered to return them to the new King of Spain, who, though grateful for the gesture, refused to deprive the Duke of what he had acquired by honourable means. Of particular importance are the Velasquez *The Waterseller of Seville*, *c*. 1620, and the wonderful small Correggio *Agony in the Garden, c.* 1525, which is said to have been the Duke's favourite painting. By contrast, the Duke disliked Goya's *Equestrian Portrait* of him and thus kept it stored during his lifetime. The three large portraits above the chimneypieces, *Charles I* by Van Dyck, *The Emperor Rudolf II* by Hans von Aachen and *Queen Mary Tudor* after Antonio Mor, have elaborate frames designed by Wyatt. Other fine portraits in the house include the *1st Marquess of Anglesey* by Lawrence of 1818 and Wilkie's *George IV* of 1830 and *William IV* of 1833. Also of interest are *Chelsea Pensioners Reading the Waterloo Despatch*, 1822, by Wilkie, and *The Battle of Waterloo, 1815* by Sir William Allan of 1843.

Displayed in the Dining Room on the mahogany table is a massive centrepiece in silver and silver-gilt from the Portuguese service designed by D. A. de Sequeira for the Duke of Portugal and made in Lisbon in 1812–16. It stretches the full length of the twenty-six-foot table, and originally the dancing figures lining the edge were joined by swags of silk flowers.

Apsley House has an Association of Friends. There is a shop in the hall, which sells an excellent guidebook by Simon Jervis and Maurice Tomlin, published in 1984.

Bethnal Green Museum of Childhood

Toys, games, dolls, dolls' houses, puppets and children's costume

Cambridge Heath Road, London E2
tel. 01-980 2415/3204/4315

Mon–Thurs, Sat 10–5.50 pm; Sun 2.30–5.50 pm. Closed Fri

Admission free

The core of the structure of this Museum was the old 'Iron Museum' (the 'Brompton Boilers') at South Kensington. There is a detailed account of its transformation in John Physick's book, *The Building of the Victoria & Albert Museum*, 1982. The iron structure of the Museum is remarkably delicate and the impression of space and light reinforces the colourful gaiety of the display of toys and games.

The Bethnal Green Museum was opened in 1872 as a branch of the South Kensington Museum with the intention of spreading the riches of that great institution to other less privileged parts of London. It was never planned as a local history museum; the specialist orientation towards childhood and children's interests only dates from 1915. The then director

Hand puppets, ⌐
c. 1922 (Bethn⌐

Manuscrip⌐
countries a⌐
present da⌐
maps; larg⌐
music

British M⌐
London ⌐
tel. 01-63⌐

Mon–Sa⌐
Christm⌐
Day, Go⌐

Admission free

realised that in wartime many schoolchildren who might have been able to go away to the ⌐ be confined to London in the summer. Out of the activities and amusements ⌐ years came the idea of a children's exhibition, which ⌐ permanent 'Children's Section', which expanded under ⌐ the Museum was renamed to recognise the fact that ⌐ with artefacts relating to childhood.

⌐ a display of Continental decorative art, many pieces ⌐ Some of the more elaborate furniture is more ingenious ⌐ the Viennese Thonet's patent furniture are particularly ⌐ ll eventually find its way to the Victoria and Albert

⌐,000 toys in the collection: over 1,400 dolls, 60 complete ⌐ uremberg' house of 1673, puppets and puppet theatres, ⌐ marionette theatre and the recent acquisition of a rare ⌐ ts, carved and painted c. 1922 by David Jones for Eric ⌐ oo items of children's costume.

⌐ stock calculated to interest the child visitors who are

⌐ of the British Library was formed from the library ⌐ um and other library organisations and is housed within ⌐ a very small proportion of the collection is on exhibition ⌐ e most outstanding items in the Library's collections are ⌐ h Library galleries in the Museum—the Grenville Library, ⌐ g's Library and the Map Gallery. Temporary exhibitions ⌐ wford Room, off the Manuscript Saloon.

⌐ are exhibited in the Grenville Library in two parts: MSS ⌐ the Continent. English examples shown include the Luttrell ⌐ Psalter, the Rutland Psalter and the Psalter and Hours of ⌐ ereford. On the Continental side, these range from the Harley ⌐ , probably made at the court of the Emperor Charlemagne, ⌐ e books from Italy and Flanders.

The ⌐ primarily devoted to MSS of historical and literary interest. Famous items include two of the four surviving copies of King John's Magna Carta (1215) and the Lindisfarne Gospels (c. AD 698). Royal autographs are prominent among the historical letters and documents, and almost every major literary figure is represented in the section given to English literature. There arc also displays of Bibles, heraldry, maps and music.

In the King's Library are illuminated MSS in Oriental languages, including Hebrew, from mediæval Europe, bibles and lectionaries of the Oriental Christian churches, illuminated Korans and Persian MSS, and palm leaves and paper from India and South-East Asia, as well as Chinese and Japanese printed books.

There is an exhibition of fine book-bindings from the 16thc to the present day, both British and Continental, and a case of documents and books on Shakespeare and displays of notable examples of book illustration from 1780 to 1960.

The history of printing is illustrated by notable early specimens, including the world's earliest dated example, the Diamond Sutra from China of AD 868. The forty-two-line Gutenberg Bible (c. 1455) and the first books printed in English and in the British Isles by William Caxton can also be seen. Displays on the history of music printing and of famous English children's books are shown.

In the Map Gallery the display of maps, charts, globes and atlases is changed periodically.

Small topical exhibitions from the collections of the Official Publications Library and the Newspaper Library are mounted from time to time.

The British Library Board is funded by the Office of Arts and Libraries and exercises authority under the British Library Act of 1972. It has close connections with the Friends of the National Libraries.

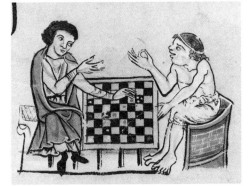

Marginal illumination from the Rutland Psalter, chess-players, 13thc–15thc (British Library)

British Museum

Antiquities: Oriental (i.e. China, India and Japan), Egyptian, Western Asiatic (i.e. Palestinian and Assyrian, etc.), Greek, Roman, Prehistoric and Romano-British, and Byzantine; fine and decorative works of art and archæology from the Middle Ages to the present day (Medieval and Later Antiquities); coins and medals; clocks and watches; the national collection of Western graphic art (Prints and Drawings Department)

Great Russell Street, London WC1
tel. 01-636 1555

Mon–Sat 10–5 pm; Sun 2.30–6 pm

Admission free, except for some special exhibitons

The statistics of the British Museum are awe-inspiring: the site itself covers no less than $11\frac{1}{2}$ acres and is visited by more than three million people in a year; in many of the departments the holdings are numbered in millions; twenty-five tons of paleolithic flints await the attentions of the rare specialists who wish to study them; the relatively recently-formed collection of American prints is the best outside America; the Egyptian collection is the largest outside Egypt; and, thanks to a recent bequest, the collection of Islamic pottery is the most representative anywhere; it is estimated that four centuries of man-hours will be needed to put all items in the Prints and Drawings Department onto a computerised register; the oven-baking of the vast collection of sun-dried Assyrian cuneiform tablets, a quarter of them from the Library of King Assurbanipal at Nineveh, has been going on for years and may take thirty more. Mere numbers cannot alone convey the flavour of this unique institution: faced with such riches and such diversity it is impossible to itemise all the noteworthy exhibits in the collections.

The present Museum grew out of a much more broadly based assemblage of every kind of rarity and curiosity, natural and artistic, amassed by the great antiquaries of the past. The names of the early patrons of the Museum constitute a roll-call of the most eminent, among them Sir Hans Sloane (1660–1753); the Tudor antiquary, Sir Robert Bruce Cotton (1571–1631); Sir Joseph Banks (1743–1820); Sir William Hamilton (part of whose vast collection was bought in 1772); Lord Elgin (of the Elgin marbles); Charles Towneley (whose collection came to the Museum in 1805); Richard Payne Knight (1750–1824); the great 19thc archæologist, Sir Henry Layard, and many others. Their collections ranged over the finest antiquities, from the Elgin Marbles and the Bassae frieze to the famous Towneley Marbles; the sculptures from Nimrud, the lost city of the Assyrians rediscovered by Layard; the most impressive books and manuscripts, notably the twelve thousand volumes from the old Royal Library presented by King George II, which had been built up by the sovereigns of England since the 15thc; large collections of natural curiosities and ethnographic items, as well as coinage, medals, and even postage stamps from the massive collection of King George V.

The British Museum was founded, like the National Gallery, as the result of a purchase, in this case the library and collections of artistic and natural curiosities amassed by Sir Hans Sloane, which in accordance with his will were offered to the Nation in 1753 for £20,000, although they had cost him, it was estimated, £50,000 and were said to be worth £80,000. To the Sloane Collection were added the Cotton and Harley libraries, after an act of Parliament in 1753. The money for these purchases and for the procuring of a building in which to house these treasures was raised by a lottery. At that moment Montagu House in Great Russell Street became available on very liberal terms, and the house being repaired and the appropriate cabinets and bookshelves having been installed, the new British Museum opened to the public in January 1759. The whole expenditure on the premises amounted to less than £30,000, as an Account from the Trustees shows: £10,250 for the purchase of Montagu House, £14,484 for repairs, £4,076 for furniture, etc., down to £140 for fire engines.

Apart from the very important collections of antique sculpture housed in the Townley and Elgin galleries and the fine historical manuscripts, books and charters from Hans Sloane, Burleigh's state papers and the Lansdowne Collection, a great part of the display was once given over to 'a miscellaneous collection of articles from all parts of the world, arranged, as nearly as possible, in geographical order' (*Synopsis of the Contents of the British Museum*, 1808).

Thirty thousand of the 'natural curiosities' came from Sir Hans Sloane's collection; but the exhibits accumulated rapidly, from Captain Cook (through Sir Joseph Banks), among others, who brought back numerous items from the South Sea Islands, Australasia and North America, and there were also exhibits of mineral ores, lavas and other geological specimens taken from 'a large store deposited in a less conspicuous part of the house' (see *Public Buildings in London*, 1823). The Trustees had also purchased 'Greenwood's collection of stuffed birds', which would have looked perfectly appropriate to a display that also included stuffed giraffes. At the very time when the description to accompany Augustus Pugin's illustrations of Montagu House for *The Public Buildings of London* was being written, Robert Smirke (1781–1867) was already at work on extensions to the house and in the autumn of 1823 the first tenders were sought for the progressive reconstruction of the Museum buildings by Smirke. The final result is the great neo-classical building that we know today; the façade is practically

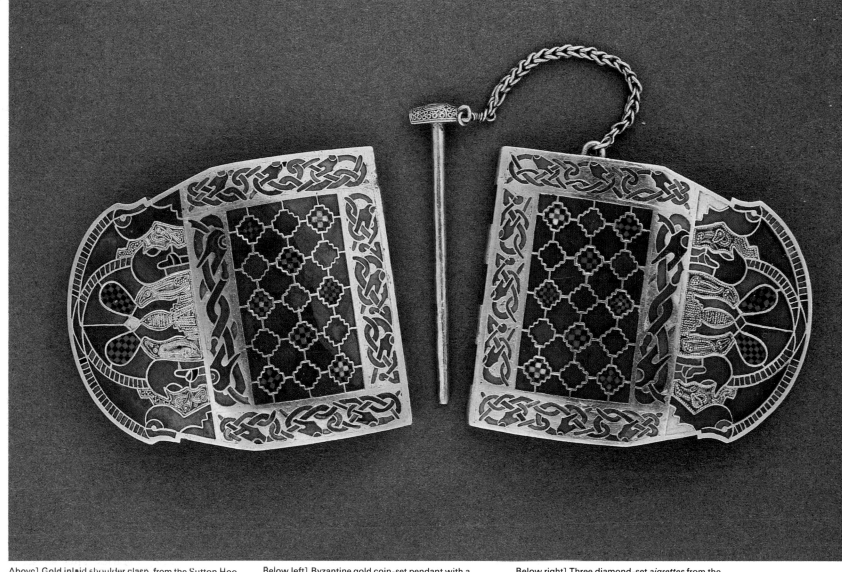

Above] Gold inlaid shoulder clasp, from the Sutton Hoo ship burial, 7thc AD (British Museum, Medieval and Later Antiquities)

Below left] Byzantine gold coin-set pendant with a double-*solidus* of Constantine the Great, 324–88 AD (British Museum, Medieval and Later Antiquities)

Below right] Three diamond-set *aigrettes* from the Hull Grundy Gift, 18thc and early 19thc (British Museum, Medieval and Later Antiquities)

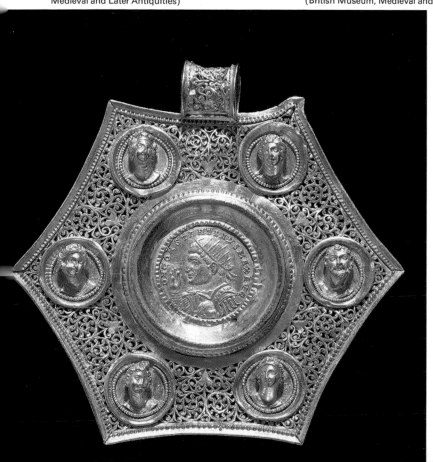

unaltered since it was completed. Internally the quest has been for space, and to that end the quadrangle was filled in to provide the great round Reading Room. The extensions at the back, named the Edward VII Galleries, were carried out by J. J. Burnet (1857–1938) in the early years of this century and were formally opened by George V in May 1914. The Duveen Gallery, paid for by Lord Duveen and designed to house Elgin's Parthenon sculptures, was completed in 1939 and shattered by bombs one night in 1940; only in 1962 was the reconstruction completed. The most recent extension is that by Colin St John Wilson. Progressive modernisation has eliminated much of Smirke's original decoration and furnishing, and the continuing trend towards an unobtrusive 'background' treatment of the interior was highlighted recently by the decision to proceed with a monochrome scheme for the repainting of the Front Hall despite representations from conservationists for a return to the early 19thC polychrome scheme. The drawing for this survives, made by a firm of decorators named Collman in the 1840s, and was used in more than one periodical to illustrate closely-argued recommendations to recreate it. Some years ago the then controversial return to the original rich and dark colour scheme at the Fitzwilliam Museum, Cambridge (q.v.), paved the way for the redecoration of Manchester City Art Gallery (q.v.), which successfully reconstructed the contemporary appearance of Barry's fine building and which has been hailed as an outstanding achievement.

The most effective way of producing more space was, of course, not to build, but to devolve. Gradually over the last hundred years, a great purification process has taken place as the collections of natural history, geology, ethnography and so forth were each rehoused separately. Even in 1824 Sir Robert Peel had recognised the anomolous character of the Museum's collections: 'what with marbles, butterflies, statues, manuscripts, books and pictures, I think the museum is a farrago that distracts attention' he remarked to Sir Humphrey Davy. The British Museum (Natural History) was founded in 1881 (q.v.); the Geological Museum (q.v.), opened in 1935, now shows such things as fossils, mineral ores, lava and other specimens, which were such a remarked feature of the British Museum's early display; most of the periodical publications are now out at Colindale, a presage of the greatest decentralisation of all, the removal to a special site of the whole of the British Library (q.v.); the Department of Ethnography has been in Burlington Gardens only since 1970. The character of the Museum has therefore changed out of all recognition from the '*pêle-mêle inextricable, une confusion fâcheuse*' described by Count Léon de Laborde in 1845; even in the last thirty years the crowded, soaring displays, familiar to many a schoolboy, lingering in the galleries illuminated by unscreened sunlight, have given way to designer displays, didactic and educative, of a very different kind.

COINS AND MEDALS The Coins and Medals Department holds a comprehensive collection of coinage and paper money from the earliest times up to the present day, as well as artists' medals and commemorative and memorial medals. It covers a number of different cultures, and there are therefore displays of appropriate material in the relevant galleries, for example, Greek and Roman in the 'Life Room' of that department; Far Eastern coins in the Oriental Department; and there are Renaissance medals as well as Byzantine and Anglo-Saxon coins in the Medieval and Later display, and so on. The Coins and Medals gallery has a selection of material relating to the British Isles from pre-Roman times to the 20thC. Small special exhibitions are arranged to show different aspects of the collections, but the bulk of this enormous holding is available only by appointment.

EGYPTIAN ANTIQUITIES Although early descriptions of the Museum are obsessively concerned with the Greek and Roman Antiquities, the first Egyptian objects entered the collections in the 18thC. However, it was not until the early 19thC, with the publicity accorded to the Napoleonic excavations, that serious collecting began. Among the antiquities gathered by the French expedition and ceded to the British at the collapse of the Egyptian campaign was the Rosetta Stone. The decipherment of the characters incised into the stone transformed the study of ancient Egypt and it is hard now to imagine approaching the art of this civilisation without the knowledge thus gained.

The Egyptian Sculpture Gallery, recently reinstalled after decoration and extensive examination and restoration of the exhibits, is remarkable for the grandeur of the colossal granite figures of King Amenophis III; the red granite lions from the temple at Soleb in the Sudan; the massive head, now thought to be yet another representation of Amenophis III; the great bust which is the upper part of a colossus of Ramesses II; and vast sarcophagi

Egyptian carved limestone relief,
a King and his daughter, 11th Dynasty
(British Museum, Egyptian Antiquities)

Egyptian papyrus sheet showing Chapter 110 of the *Book of the Dead*, 18th–19th Dynasties
(British Museum, Egyptian Antiquities)

with closely packed decorations and inscriptions. It is easy to imagine the awe that these pieces inspired when seen for the first time: the evidence of Egyptian influence on 19thC decorative art and architecture is still around us.

Painting and the decorative arts show a remarkable sophistication of technique and inventive pattern-making in the ornamentation of mummies and tomb furniture. The Museum's collection of both funerary objects and domestic items is unrivalled and shown in a way that highlights the individuality of treatment within this highly formalised and hier-archical art form: the delineation by the Egyptian craftsmen of features, the observation of animal and plant forms and the modelling of everyday agricultural activities is lively and informative. The idealised but life-like mummy portraits are surprising in this context and bridge the gap between the formality of Egyptian representation and the studied naturalism of Hellenistic art.

GREEK AND ROMAN ANTIQUITIES The collection of Greek and Roman Antiquities is one of the finest in the world with outstanding individual works and a complete coverage from the point of view of both date and type of every aspect of Greek and Roman art. This Department had as its basis antiquities from the Sloane Collection, Sir William Hamilton's Collection, the Elgin Marbles and the Towneley Marbles. In the early 19thC came the frieze from the Temple of Apollo at Bassae; it was followed thirty years later by the findings from the tombs of Lycia, including the Nereid Monument with its beautiful draped figures of

Greek bronze figure of a bearded banqueter possibly from Dodona, the Sanctury of Zeus, *c.* 520 BC
(British Museum, Greek and Roman Antiquities)

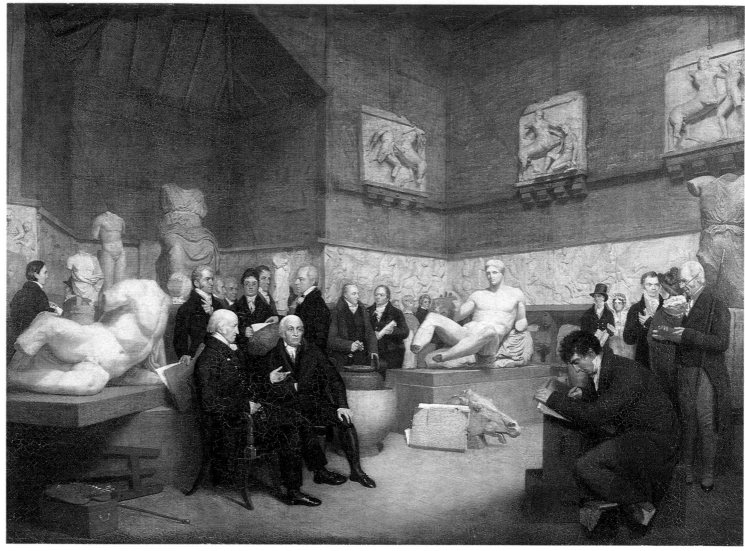

Archibald Archer, *The Temporary Elgin Room in 1819* (British Museum)

Roman gold 'snake' bracelets, 1stC AD
(British Museum, Greek and Roman Antiquities)

sea nymphs. Other treasures of this Department are the Caryatid from the Erechtheion; the colossal figure from the Mausoleum at Halicarnassus, known in antiquity as one of the Seven Wonders of the World; the sculpture from the Temple of Artemis at Ephesus (also one of the Seven Wonders); and the bronze head of Sophocles. From the Roman world come such rare survivals as the Portland Vase, which was shattered by a deranged visitor in 1845 but is now carefully repaired; and the exquisite representation of an idyllic landscape on the small fresco panel from a villa near Pompeii. Roman portrait sculpture is well represented and reminds the visitor of the uncompromising realism with which the artists of antiquity viewed their subjects.

The collection of Greek vases is exceptionally representative: modern scholarship has greatly advanced knowledge in this particular area, which is now seen as the dawn of the history of drawing in the West. The collection of small sculptures is very extensive, both of the well-known Tanagra figures and of the lesser-known field of bronzes.

Precious metal vessels and ornaments, jewellery and coins are all incorporated into the display in the informative Greek and Roman Life Room.

MEDIEVAL AND LATER ANTIQUITIES The Department of Medieval and Later Antiquities holds such very diverse material that it is impossible to encapsulate it in a brief description. Here are kept the Byzantine, Anglo-Saxon, mediæval, renaissance and later goldsmiths' work and jewellery; the national collection of engraved gems, many of which came from the collection of Sir Hans Sloane, but also examples as important as the magnificent Lothar

32

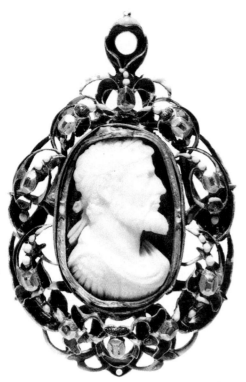

French gold pendant jewel set with an onyx cameo bust of Lucius Verus, *c.* 1630 (British Museum, Medieval and Later Antiquities)

Crystal, or as commonplace as a Tassie glass-paste cast; the ceramic collections, which encompass the enormous group of mediæval floor-tiles, as well as the most exquisite productions of the Continental 18thC porcelain factories; a large collection of Wedgwood jasperware, and glass from many centuries and centres of production, particularly Venice; the national collection of clocks and watches; and a fascinating assemblage of personal and historical relics including Dr Dee's magician's mirror and a gold box given by Napoleon I to Lady Holland.

The cream of the departmental holdings is on display in a suite of galleries which forms a loop at the south-east corner of the upper level, above the manuscript saloon and the King's Library (both part of the devolved British Library, q.v.). Here can be seen that miracle of technical expertise, the late Roman Lycurgus glass cage-cup. Cut from a single block of pea-green glass, which has the unusual quality of changing to a rich ruby in transmitted light, it was probably carved in Rome in about 400 AD. A great treasure of 14thC goldsmiths' work and enamelling is the Royal Gold Cup of the Kings of France and England, secured for the Museum by a former keeper of this Department, Sir Augustus Woollaston Franks, who also gave his name to the walrus-ivory casket, carved with religious and mythological scenes and runic inscriptions. Also of walrus-ivory are the famous 12thC Lewis Chessmen, found on the Isle of Lewis in 1831.

The focal point of the whole display, and the most popular exhibit, is the treasure from the Sutton Hoo Ship Burial of about 625–40 AD, which stands out by virtue of the number and diversity of the objects found at this site. An elaborately wrought helmet is counterpointed by plain and massive metal vessels, and the immaculate workmanship of the garnet-set jewellery is a revelation of the sophisticated craftsmanship of East Anglia at this date.

The very highly decorated goldsmiths' work in the Waddesdon Bequest is arranged to give an idea of the way in which such showpieces would have been displayed by their original owners. This room is the closest thing that we have to a Continental *schatzkammer*.

The display of clocks and watches, only a small part of the Department's comprehensive collection, shows all kinds of mechanisms with the most informative explanatory diagrams. Many are in full working order and are kept wound regularly. George III's watch, which he made himself, is here: the achievement is somewhat reminiscent of Louis XVI's locksmithing skills.

The Hull Grundy Gift of jewellery and goldsmith's work is displayed in the middle of a gallery which has ceramics and glass from the Department's extraordinarily varied holdings in showcases around the walls. Just off this room a recently installed exhibit shows the best of the 19thC and 20thC collection. The collections have been expanded into this area of the decorative arts only within the last few years and it will be a long time before any sort of representative coverage is achieved.

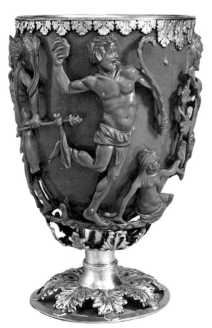

Roman pea-green glass 'Lycurgus' cage-cup, *c.* 400 AD (British Museum, Medieval and Later Antiquities)

Spanish ivory amulet or *hija* against the evil eye, in the form of a hand, 16thC (British Museum, Medieval and Later Antiquities)

ORIENTAL ANTIQUITIES The Department of Oriental Antiquities covers the cultures of the whole of Asia from the Neolithic period to the present day with the exception of the ancient civilisations of the Near East and Persia before the founding of Islam in 622 AD.

The Indian collection is dominated by the very fine sculpture with examples from all over the subcontinent in a variety of materials, for example, sandstone, ivory and wood, bronze, gilt-bronze or inlaid bronze, granite and volcanic stone. Almost all surviving pieces were once part of the decoration or equipment of temples and monasteries: secular works of art are rare since the dead were not buried but cremated, so none was made to furnish a tomb as in other cultures. Both Buddhist and Hindu are very well represented: the Gandhara sculptures are some of the finest in the world, and the collection of Hindu sculptures from Western India includes a mother and child dating from the 7thC AD, as well as the impressive image of the elephant-headed Ganesha from the 8thC AD. A very fine 12thC bronze Buddha from Burma illustrates the spread of Indian forms of society, religion and art into neighbouring countries.

The world of Islam, on the other hand, is principally represented by wonderfully decorated vessels in metal, glass and pottery. The technically superb gilded and enamelled Syrian glass is matched by the bold patterned pottery wares of Turkey and Persia. In the 12thC AD the city of Herat was famous for its inlaid bronze and brass vessels. The recent bequest of the Godman Collection of Islamic pottery has transformed the ceramic display into one of the finest and largest in the world.

Chinese art was enormously sophisticated in the Bronze Age, and the great ritual vessels of the Shang dynasty are among the most astonishing from any culture. There are fine examples of early bronze vessels with the most complex decoration from this early date, as well as from the Eastern Zhou period (770–221 BC). The Museum has an excellent collection of tomb figures of horses and camels from the Tang period, examples of Chinese art which for many people exemplify the most characteristic achievement of this culture. The later ceramic vessels, notably the porcelains with their blue and white or polychrome decoration, are of the finest quality. The technical ability of Japanese artists in lacquer and enamel remained at the highest level into very recent history, some of the Edo period (1614–1867 AD) work being the most complex ever attempted. The collection of export wares from China and Japan provides the link with European taste of the 18thC and 19thC, a link that can be pursued in the display of European ceramic material in the Medieval and Later Galleries.

PREHISTORIC AND ROMANO-BRITISH ANTIQUITIES The Department of Prehistoric and Romano-British Antiquities was formed in 1969 with material that was once in the hugely unwieldy 'British and Medieval Department'. The holdings comprised objects from the whole of human history—from man's first appearance nearly two million years ago until nearly the present day. Now the Department of Medieval and Later Antiquities retains the exhibits dealing with Western decorative art in the Christian Era, and the responsibility of this Department ends with the history of Britain when it was a province of Rome. Some

Chinese stoneware vase of Cizhou Ware, Song Dynasty, 12thC AD (British Museum, Oriental Antiquities)

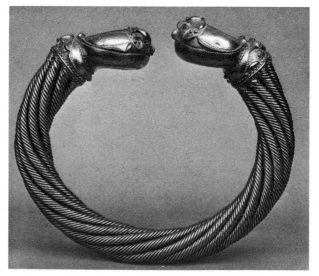
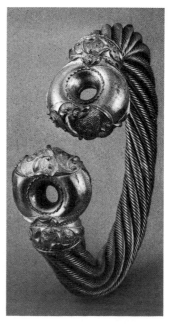

Two views of the electrum Snettisham Torc, *c.* 50 BC (British Museum, Prehistoric and Romano-British Antiquities)

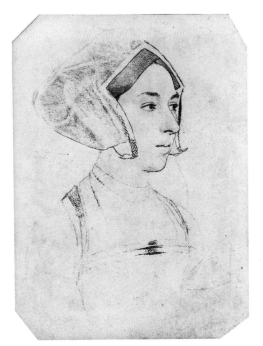
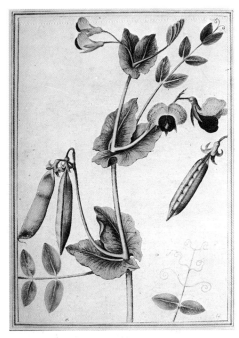

Hans Holbein the Younger, chalk drawing of a Lady, sometimes called 'Anne Boleyn', *c.* 1535 (British Museum, Prints and Drawings)

Jacques le Moyne de Morgues, leaf from a watercolour album of flowers, 1585 (British Museum, Prints and Drawings)

of the finest objects in the Department are the examples of Celtic metalwork, for instance, the Snettisham Torc, the Desborough Mirror and the Witham Shield. In this Department is also the important Romano-British Mildenhall Treasure, consisting of thirty-four superb pieces of highly wrought silver tableware, perhaps the most impressive item in the collection. A great romantic attraction attaches to these treasures as they were often found by chance while land was being ploughed.

PRINTS AND DRAWINGS The Department of Prints and Drawings has an exhibition gallery which was redesigned and reopened in 1971, and it is here that selected items from this vast collection can be seen in the shows illustrating particular themes that are mounted about three times a year. Only two prints and drawings which are too large to be stored are displayed permanently: Michelangelo's *Epifania*, the only known complete cartoon by him, and Dürer's huge woodcut of the *Triumph of Maximilian*. The permanent exposure of drawings and prints is not desirable since they are easily damaged by light, but the special exhibitions cover such a wide spectrum of subjects and artists that assiduous attendance would enable the interested visitor to see a very large number of the most notable examples from all areas of the collections.

In recent years exhibitions devoted to single names have included: Michelangelo (eighty drawings from the Museum combined with loans from other British collections); Turner (from the twenty thousand items in the Turner Bequest which is to be transferred to the Tate Gallery); Dürer, Claude (the dismembered *Liber Veritatis*); Watteau; Rubens; Goya (mounted on receipt of the unrivalled Tomás Harris Collection of Goya's prints), and Raphael (the Museum's forty examples combined with loans from other collections in this country which comprise a third of the surviving drawings by this master).

These exhibitions, as well as those on general themes (for example, landscape, portraits, recent acquisitions, etc.) demonstrate that this collection, though relatively small in comparison with some of the great Continental accumulations such as those in the Louvre and in the Uffizi, is one of the most representative in the world. The group of Mantegna's work is outstanding; Botticelli's *Abundance* or *Autumn* is one of the most beautiful surviving renaissance drawings; Leonardo da Vinci is represented by twenty-one drawings, a significant complement to the enormous group in the Royal Collection; the representation of artists from Raphael's studio is of great importance to the study of the period; from a later date Canaletto's view from his own window exemplifies the best in the 18thc Venetian style. The Northern Schools are exceptionally well covered, often with the best collection of the artist outside his own country, for example, Dürer and Rembrandt. The French School is uneven, but two of the most eminent masters, Claude and Watteau, can be seen here more completely represented than anywhere else. This part of the collection was greatly enriched in 1968

35

Pieter Bruegel I, drawing of *The Calumny of Apelles*, 1565 (British Museum, Prints and Drawings)

William Blake, watercolour of *Judgment of Paris*, 1817 (British Museum, Prints and Drawings)

by the César Mange de Hauke Bequest of sixteen important French 19thC drawings, including works by Delacroix, Degas and Seurat.

The small collection of Spanish School drawings is dominated quite appropriately by Francesco Goya; one of the seven works by him is the red chalk portrait of the Duke of Wellington made after the Battle of Salamanca in 1812.

There is no question of trying to describe the British School in detail. The collection is inevitably larger than any other school. Every artist of any importance is included, from the origins of the English watercolour tradition in the 'stained' drawings of the 17thC to the present day. The landscape drawings are particularly fine and various in approach and have been the subject of two large-scale special exhibitions within the last thirty years. Perhaps less well known is the extensive selection of portrait drawings and the many good examples of the satirical and humorous by Rowlandson and Gillray. The group of drawings by the Pre-Raphaelite painters and their associates is choice, recently expanded by important purchases: Rossetti's *Dante and Beatrice* and *Arthur's Tomb*, and one of Millais's highly detailed subject drawings, *Married for Love*, of 1854.

A policy similar to that adopted by the Medieval and Later Antiquities Department has extended the acquiring activities of Prints and Drawings to examples of the graphic art of the present day, and the representation of the contemporary scene has therefore been radically transformed.

The Print collection is literally indescribable—in only one area is it less than entirely representative, that is, ornament prints which are, in any case, primarily the concern of the Victoria and Albert Museum. Otherwise it can be assumed that the history of printmaking in the West is comprehensively covered, with very few gaps which are filled whenever the opportunity presents itself. Special collections of historical portraits and London topography are a great help to the researcher, as are the fascinating and historically illuminating political and personal satires. The Department also holds a set of three thousand photographs made by Benjamin Stone for the *National Photographic Record*; Lady Charlotte Schreiber's collections of playing cards and fans and fan-leaves, and the Franks and Viner Collections of book-plates.

WESTERN ASIATIC ANTIQUITIES The Department of Western Asiatic Antiquities contains items from many different civilisations from the lands east of Egypt and west of Pakistan. The exhibits range in date from the sixth millennium BC to the 7thC AD; only the Department of Prehistoric and Romano-British Antiquities has earlier objects.

The fabulous sculptures of Assyria, discovered at Nineveh by Sir Henry Layard in the mid-19thC, are some of the most spectacular exhibits in this Department. The sculptured reliefs depict in the most remarkable detail scenes of war and the chase, court and religious activities, and supernatural beings.

Equally imposing are the Sumerian treasures from the Royal Tombs of Ur from southern Mesopotamia excavated by Sir Leonard Woolley in the 1920s. The fine objects on display date from about 2500 BC, but the cemetery had been used for centuries and yielded much evidence of fine craftsmanship in gold, silver, stone and shell.

The Oxus Treasure, a hoard of fine objects, mainly Achaemenian of the 5thC BC, includes gold armbands with griffin-head terminals, a model chariot drawn by four ponies, several finger-rings and a series of gold plaques for sewing onto garments.

The cuneiform tablets and the impressions taken from cylinder seals appear so modest that they are often overlooked, but they repay attention as they give a fascinating picture of the early history of preserving and conveying information.

Only a proportion of the vast accumulation of objects can possibly be exhibited, but all the departments have facilities for showing objects from the reserves to members of the public by appointment, or, as is the case of the Prints and Drawings Department, on production of a valid student's ticket issued by the Department. Opinions as to the date of antiquities or relevant works of art—but *not* assessment of value—are given on stated weekday afternoons; enquiries should be made to the department concerned.

The Museum has a licensed self-service restaurant. A wide range of books, postcards, replicas and other products are available from the Museum shops adjacent to the Front Hall. These are run by British Museum Publications Ltd. The shops close fifteen minutes before the galleries. There is also a mail order service.

Sumerian Harp in gilded and painted wood
(British Museum, Western Asiatic Antiquities)

British Museum, Museum of Mankind

Ethnography Department of the British Museum, one of the world's greatest collections from the indigenous peoples of Africa, North and South America, Australia and the Pacific Islands, and parts of Europe and Asia

6 Burlington Gardens, London W1
tel. 01-437 2224

Mon–Sat 10–5 pm; Sun 2.30–6 pm

Admission free

The first objects were acquired by Sir Hans Sloane (1660–1753), whose collections formed the basis of the British Museum. Later benefactions came from Sir Joseph Banks (1743–1820), (including important material collected on Captain Cook's voyages), members of the Royal Family, Henry Christy (1810–65) and Sir Augustus Wollaston Franks (1826–97).

The Museum occupies a fine neo-classical building designed by James (later Sir James) Pennethorne (1801–71), the adopted son and pupil of John Nash. Two of the most distinctive features of the building are the grand central staircase, and the elaborate plaster ceiling in what is now the Students' Room. The entrance hall and staircase have been redecorated in ways sympathetic to the Victorian architectural form and detail.

Ancient as well as recent and contemporary cultures are represented in the collections. Especially noteworthy are the pre-Columbian mosaics from Mexico, the large collection of Benin bronzes and the Benin ivory mask, sculpture from Central and West Africa, Hawaiian feather cloaks, New Guinea carvings and North American Indian artefacts.

The many notable additions made over the years to the Museum's collections include the following: the Sir John Barrow collection of Eskimo art (donated in 1855); the collection made by A. P. Maudslay of Mayan sculpture and casts; the Beving collection of Javanese and African textiles (acquired in 1934); the Beasley collection, particularly strong in artefacts from the Pacific (bequeathed in 1944); and the gift in 1954 of some 20,000 items, over half of which are from Africa, from the Trustees of the Wellcome Historical Medical Museum.

A wide variety of books, slides, postcards and reproductions of items in the collections are on sale in the Museum shop. In the Students' Room (open weekdays 1–4.45 pm) visitors may consult records of the collections, and also bring ethnographic objects for identification. Unexhibited items in the Museum's collections may be viewed by prior appointment at the Museum's storehouse in Shoreditch. The Museum of Mankind also has one of the best anthropological libraries in the world, open weekdays 10–4.45 pm (times subject to change).

Pre-Columbian gold pectoral in the form of an anthropomorphic figure, 1000–1500 AD (Museum of Mankind)

Baluba carved wood headrest, from the Belgian Congo (Museum of Mankind)

38

Georg Dionysius Ehret, *Chelidonium*, drawing, *c.* 1740 (Natural History Museum)

John Gerrard Keulemans, watercolour of exotic birds (bee-eaters), late 19thc (Natural History Museum)

British Museum, Natural History Museum

One of the world's most extensive collections of natural history specimens, i.e., animals, plants, fossils and minerals—more than 50 million items in all

Cromwell Road, London SW7
tel. 01-589 6323

Mon–Sat 10–6 pm; Sun 2.30–6 pm

Admission free

PUBLICATIONS
William T. Stearn, *The Natural History Museum at South Kensington*, 1981
Mark Girouard, *Alfred Waterhouse and the Natural History Museum*, 1981
Greenwood, Forey and Cocks, *Chance, Change and Challenge*, 1981
Whitehead and Keates, *The Natural History Museum, London*, 1981
Sims and Hollis, *Animal Identification: A Reference Guide*, 1981

The Museum began as part of the British Museum in Bloomsbury in 1753, one of the founding collections being that of Sir Hans Sloane (1660–1753). The original collections grew very quickly until it was necessary to find additional accommodation; a new museum was built for the natural history collections on the site of the International Exhibition at South Kensington from 1873 to 1881. Designed by Sir Alfred Waterhouse (1830–1905), the style of architecture is a recreation of the German Romanesque style. The huge symmetrical building of over 670 ft (205 m) in length is faced with terracotta and is richly decorated both inside and outside. The prolific ornamentation throughout is quite splendid and represents hundreds of different kinds of animals based on real forms, living and extinct. The ceilings are decorated with floral patterns. A full history of the building has recently been published.

The Museum's purpose is twofold: to educate the public and to pursue scientific research into classification and relationships of animals, plants, minerals and fossils, and is, as such, a great international source of information. 'Dinosaurs and their Living Relatives', 'Introducing Ecology', 'Human Biology: an Exhibition of Ourselves' and 'Origin of Species' are examples of recent permanent exhibitions; the elephants, Chi-Chi the giant panda and the blue whale are some of the most popular exhibits. The botanical and natural history drawings in the Museum's large collection are often beautiful as well as scientifically informative.

In 1937 Walter, 2nd Baron Rothschild, bequeathed to the Museum the Zoological Museum at Tring, Hertfordshire. The Tring Museum, containing collections of mammals and birds, reptiles, fishes, insects and other invertebrates, is open to the public.

Following the passing of the British Museum Act of 1963, the Natural History Museum became completely independent of the British Museum and now has its own governing body of twelve trustees.

During the past three years thirty-seven souvenir booklets, guides (one of which is in full colour), handbooks, wallcharts and gallery leaflets have been produced. The Museum has three shops: the bookshop, which carries a wide range of popular books on all aspects of natural history; a gift shop; and a souvenir shop, which stocks many items related to natural history. There is also a small cafeteria and a snack bar.

Courtauld Institute Galleries

Old Master paintings and drawings;
French Impressionist and Post-
Impressionist paintings;
British paintings and sculpture,
furniture and pottery (20thc);
West African sculpture

Woburn Square, London WC1
(due to move in 1986–87)
tel. 01-580 1015

Mon–Sat 10–5 pm; Sun 2–5 pm

Admission charge

The Galleries house a number of magnificent collections bequeathed and presented to the Courtauld Institute since 1932. They were established as a university museum and opened as such in 1958 in Woburn Square, and are governed by the University of London to serve a similar purpose to the museums in Oxford and Cambridge. The collections are currently in a building designed by Charles Holden (1875–1960), with interiors furnished with cassoni and period furniture. It is hoped to move to the Fine Rooms in the North or Strand Block of Somerset House, as the present galleries can only show about forty per cent of the permanent collections.

The collections started in 1931 with a major gift from Samuel Courtauld (1876–1947), industrialist and the first to exploit the use of synthetics for fabrics, and founder of the Courtauld Institute of Art, which was followed by more of his collection on his death in 1947. He was also responsible for establishing the Home House Society Trustees, a body through which the Courtauld Institute of Art could administer his and future bequests. Viscount Lee of Fareham (1868–1947) bequeathed his collection to the Institute on his death with a life interest in the collection to his wife, who surrendered her claim in 1958 when the first stage of the Galleries was opened to the public. They had in the meantime received further bequests and gifts of the highest quality—particularly those of Roger Fry (1866–1934), painter and critic, and the Old Master drawings belonging to Sir Robert Witt (1872–1952). These were followed in 1966 by the bequest of Mark Gambier-Parry (d. 1966), who had inherited the collection of his grandfather, Thomas Gambier-Parry (1816–88), which consisted mainly of early Italian works. The following year the Galleries received the bequest of William Wycliffe Spooner (d. 1967), which includes some fine English watercolours. Two more recent bequests are those of Dr Alistair Hunter (1909–83), formerly Hon. Keeper of 20thc painting at the Fitzwilliam Museum, who collected British artists (Ben Nicholson, Ivon Hitchens, Graham Sutherland, Keith Vaughan, John Hoyland, etc.), and that of Count Antoine Seilern (1901–78). The latter, known as the Princes Gate Collection, is a major bequest of paintings, drawings, prints and an extensive art library with some rare books.

The collections generally are immensely rich and cover a wide range of subject and period. Some of the earlier pictures came from the Gambier-Parry bequest, such as the Lorenzo Monaco's *Coronation of the Virgin* and Pesellino's *Annunciation*, as well as some fine sculpture, French ivories, maiolica and enamels. The Princes Gate Collection spans over six hundred years, the earliest examples being the Bernardo Daddi altarpiece of 1338 and a Netherlandish

Paul Gauguin, *Nevermore*, 1897 (Courtauld Institute Galleries)

panel painting by the Master of Flémalle. There is an outstandingly good selection of Italian and Flemish pictures, both paintings and drawings, including thirty-two pictures and twenty-three drawings by Rubens and twelve paintings and over thirty drawings by Tiepolo. Also represented are works by Parmigianino, for example, *The Virgin and Child*, Bruegel's *Landscape with the Flight into Egypt* and drawings by Bellini, Mantegna, Leonardo and Michelangelo. No fewer than thirty works illustrate the draughtsmanship of Rembrandt, and Claude, Watteau, Fragonard, the later painters of the 19thC Barbizon School and the Impressionists, particularly Pissarro, Manet, Cézanne, Renoir and Degas, are represented.

The Impressionists and Post-Impressionists added to the Courtauld bequest, which contains some of the more famous paintings of Manet, for instance, *A Bar at the Folies-Bergères*, Cézanne's *Mont Sainte Victoire*, Seurat's *A Young Woman Powdering Herself*, Pissarro *Lordship Lane Station*, Gauguin's *Nevermore*, also Daumier, Degas, Sisley, Van Gogh, Monet and many more. The Courtauld bequest includes examples of the British School, such as Gainsborough's *Portrait of the Artist's Wife* of *c.* 1779, and works by Vanessa Bell, Glyn Philpot and a small collection of sculpture, drawings and engravings.

The Witt Collection of Old Master drawings numbers about four thousand of British, Italian, Dutch, Flemish and French Schools with major examples of some of the best-known artists. Of particular interest from Roger Fry's collection is the decorated furniture and pottery produced by the Omega Workshops, which flourished from 1913 until 1919, founded by Fry to provide employment for young artists. Works by Fry himself, Vanessa Bell, Duncan Grant, Nina Hamnett and others are included, as well as some examples of African and Oceanic sculpture. Two further benefactions were received recently: from Lillian Browse and architectural drawings from Anthony Blunt.

There is a small sales counter and a shop.

PUBLICATIONS
General Catalogue, revised 1979
A Private Collection of Late 19th and 20th Century Paintings and Sculpture, 1983

Exhibition catalogues:
Lee Collection, 1962
Gambier-Parry Collection, 1967
Courtauld Collection Centenary, 1976
Princes Gate Collection, 1981
Mantegna to Cézanne: Master Drawings from the Courtauld, 1983
The Great Impressionists (exhibition at the Australian National Gallery, Canberra), 1984

Dulwich Picture Gallery

European paintings
(17thC–18thC)

College Road, London SE21
tel. 01-693 5254

Tues–Sat 10–1 pm, 2–5 pm; Sun 2–5 pm

Admission charge

The Gallery was one of the first art galleries to be opened to the public in Europe and the first in this country. It pre-dates the National Gallery by ten years. It was designed by the neo-classical architect Sir John Soane (1753–1837) and is a most original purpose-built building, which also incorporates a mausoleum for the three founders. Completed in 1814, the Gallery, situated in a large garden, is top-lit and simple in plan and decoration. Formerly the building incorporated almshouses for old ladies, but these were made into extra gallery space during the 19thC. After the building was badly damaged in the War, Soane's designs were reinstated, and more recently the Gallery has been redecorated to its former glory, as has the mausoleum.

The earliest of the collections dates back to 1626 when thirty-nine pictures were given by the founder of Dulwich College, Edward Alleyn (1566–1626), who was an actor and theatrical manager. This was followed in 1686 with the bequest of 239 pictures (of which about eighty are now identifiable) belonging to William Cartwright (1606/7–86?/7), bookseller and actor. The most important gift of pictures was that of Sir Francis Bourgeois (1756–1811), which marked the foundation of the Picture Gallery proper in the year of his death. The collection had been begun by a French picture dealer and Consul-General for Poland in England, Noel Joseph Desenfans (1745–1807). It was through his connection with Michael Poniatowski, Prince Primate of Poland and brother of King Stanislaus, that Desenfans was commissioned to purchase a collection for a projected National Gallery in Warsaw. Following the partition of Poland and the abdication of the King in 1795, the collection that Desenfans had built up for him was left without a home. Having first tried in 1799 to establish a National Gallery in London with the collection, Desenfans then offered a total of 188 pictures for sale at an exhibition in London three years later. Those not sold were added to until 1807, the year in which Desenfans died. He left all his pictures to his friend Sir Francis Bourgeois in the hope that in their entirety they would form the nucleus of a public collection.

Sir Francis Bourgeois RA, born in London of Swiss extraction, trained as a painter under de Loutherbourg and was appointed painter to the King of Poland in 1791 and later landscape painter to George III. He spent the latter part of his life in the organisation of Desenfans's collection, and when he died in 1811, from a fall from his horse, he bequeathed 371 pictures and an endowment of £12,000 for their upkeep to Dulwich College. The Gallery was

Stephen Poyntz Denning, *Portrait of Queen Victoria, aged four*, 1823 (Dulwich Picture Gallery)

Sir Anthony Van Dyck, *Venetia Stanley, Lady Digby on her deathbed*, 1633 (Dulwich Picture Gallery)

PUBLICATIONS
Peter Murray, *Dulwich Picture Gallery: A Catalogue*, 1980 (an abbreviated *Handlist* is also available)
Giles Waterfield, *Guidebook*, 1982
Giles Waterfield (ed.), *Collection for a King: Old Master Paintings from the Dulwich Picture Gallery* (exhibition in Washington and Los Angeles), 1985

Furniture and woodwork
(*c.* 1600–1950s)

Kingsland Road, London E2
tel. 01-739 8368/9893

Tues–Sat 10–5 pm; Sun 2–5 pm.
Closed Mon, except Bank Holidays
10–5 pm

Admission free

completed by Soane in 1814, and the following year the remains of Mr and Mrs Desenfans and Sir Francis Bourgeois were deposited in the mausoleum. The Gallery was opened to the public on a daily basis from 1817, by admission card obtainable at various printsellers in central London, e.g. Colnaghi.

Outstanding in the collection are the 17thC pictures, particularly those by Poussin, for example, *The Nursing of Jupiter*, Claude's *Jacob with Laban and his Daughters*, Rubens's *Hagar in the Desert*, Rembrandt's *Girl at a Window*, Murillo's *The Flower Girl*, Van Dyck's *Venetia Stanley, Lady Digby, on her Death-bed*, and Teniers's *A Winter Scene*. Between 1831 and 1835 the Gallery acquired a fine group of portraits by Gainsborough of the Linley family, see particularly *The Linley Sisters (Mrs Sheridan and Mrs Tickell)*. Other 18thC pictures include works by Reynolds, Hogarth, Lawrence, Watteau, Canaletto and Tiepolo. One of the most charming of the 19thC pictures is the *Portrait of Queen Victoria, aged Four* by S. P. Denning, a later acquisition. Further gifts and bequests have been added over the years to the collection, of which the most important were the forty-six pictures given between 1911 and 1919 by Charles Fairfax Murray (1849–1919), artist and collector, who specialised in collecting British 17thC and 18thC pictures.

The furniture in the Gallery was bequeathed by Mrs Desenfans and includes some fine pieces of the 17thC and 18thC, both English and French.

The Gallery has an active association of Friends and is staffed by volunteer guides. There is a shop, and car-parking is available.

Geffrye Museum

This most attractive building which houses the Museum is an outstanding example of early 18thC architecture and is listed Grade 1. It was formerly the Ironmongers' Almshouses, built in 1713–14 with funds bequeathed to the Company by its one-time Master, Sir Robert Geffrye (1613–1704). The former chapel is preserved virtually intact. The Museum was founded by the London County Council and opened in 1914 as a Woodwork and Furniture Museum, with a financial contribution from the Shoreditch Borough Council.

The Museum's collection of pictures, which has been built up over the past fifteen years, is intended to complement the collections of furniture and woodwork, mainly arranged as a series of period rooms. It features a wide range of artists, including Francis Wheatley, C. R. Leslie, G. E. Hicks, Rebecca Solomon, John Finnie, Frank Holl, T. C. Dugdale, Muriel

Alice Squire, watercolour of a *Young Girl reading in an attic bedroom*, 1861 (Geffrye Museum)

42

Minter and Rupert Shepherd. Portraits have also been acquired, principally to illustrate costume, and the collection includes works by Mary Beale, Arthur Devis, George Dance the Younger, William Crosbie and Edward Wolfe. The display of the Museum's most important piece of furniture, John Evelyn's ebony cabinet made for him in Paris in 1652, was based on the study of his own inventory of 1702, preserved at Christ Church College, Oxford. Similarly, the restoration and redecoration of the late Georgian Room have involved extensive research into colours, textiles and carpets in an effort to increase the room's authenticity. The choice of pictures was based on inventories of middle-class houses in the East End. There is a considerable holding of costume, a selection from which is on display.

The Museum is currently owned by the Greater London Council and administered on its behalf by the Inner London Educational Authority. It has an association of Friends. There is a shop and coffee bar.

PUBLICATIONS
Jeffery Daniels, Geffrye Museum *Handbook*, 1975
Neil Burton, *The Geffrye Almshouses*, 1979

Exhibition catalogues since 1979:
John Ball, *Keith Vaughan: Images of Man*, 1981
Rosamond Allwood, *George Elgar Hicks: Painters of Victorian Life*, 1982
Rosamond Allwood and Kedrun Laurie, *R. D. Russell and Marian Pepler*, 1983

Geological Museum

The Museum was founded in 1835 by Sir Henry Thomas de la Beche (1796–1855) and originally housed at Craig's Court, Whitehall, where specimens collected during the geological survey of Great Britain could be inspected by 'suitably qualified persons'.

The present building dates from 1929 and was designed by J. H. Markham and Sir Richard Allison. The newly installed museum was opened in 1935, appropriately marking the centenary of the survey. The specialist collections are exclusively concerned with the subject of geology, i.e., rocks, fossils and minerals, but in the display devoted to gem material and decorative stones a number of worked objects are included to demonstrate their application in the field of decorative art. One of the most handsome of these is a diamond-studded casket presented to Sir Roderick Murchison, Director of the Museum 1855–70, by Alexander II, Tsar of Russia. There are examples of gem engraving in onyx and other layered stones, and of the decorative use of 'landscape marble', moss-agates or ornamental fossils such as ammonites, for setting in boxes or jewellery.

The Museum has a shop for geological literature, including maps and an interesting handbook to the gem collection, postcards, slides, hammers and casts of fossils. Lectures and films are provided on several days of the week to complement the instructive displays.

Rocks, fossils and minerals;
decorative art objects worked with gems and precious stones

Exhibition Road, London SW7
tel. 01-589 3444

Mon–Sat 10–6 pm; Sun 2.30–6 pm

Admission free

Diamond-studded gold presentation box given to the Director of the Museum, Sir Roderick Murchison by the Tsar of Russia, *c.* 1870 (Geological Museum)

London topographical paintings and drawings (18thC–19thC); genre and landscape paintings (19thC)

Guildhall Yard, London EC2
tel. 01-606 3030, ext. 2856
Address for correspondence:
Guildhall Art Gallery,
Aldermanbury, London EC2

Mon–Sat 10–5 pm. Closed Sun

Admission free

Guildhall Art Gallery, Corporation of London

In 1880 Bernard Evans (1843–1922) and Sir Francis Wyatt Truscott (1824–95, Lord Mayor 1879–80) founded the City of London Society of Artists, with the aim of encouraging local artists and of establishing a Gallery in the City. They held exhibitions in Skinners' Hall from 1880 to 1883, and in 1884 Sir Francis persuaded the Corporation to lend them the disused Law Courts to the east of Guildhall. These were subsequently adapted and enlarged by the Corporation as a public art gallery for its own collection and opened in 1886. At the foundation of the Gallery, the Corporation already owned 288 works of art, which were later transferred to the care of the Library Committee.

The Gallery, a popular and well-known public amenity, was destroyed by bombing in the War. A 'temporary' structure was erected, and for many years selections from the permanent collection (now numbering, with loans and deposits, some 3,500 items) were displayed there from time to time. The main function, however, and since the late 1970s the Gallery's only function, has been as a venue for temporary art exhibitions organised by art societies and similar organisations. In recent years the Corporation's only facility for the display of the collection has been the Barbican Art Gallery, although that institution's main function is also primarily a temporary exhibition venue. It is hoped that Guildhall Art Gallery may be rebuilt and its collections shown to the public on a larger scale than the Barbican's space will allow, but financial stringencies have so far prevented this. Those items not currently on display at the Barbican are housed in a number of locations—in store at Guildhall or on loan within and without the Corporation. It is usually possible to arrange inspection of items on loan provided some notice is given.

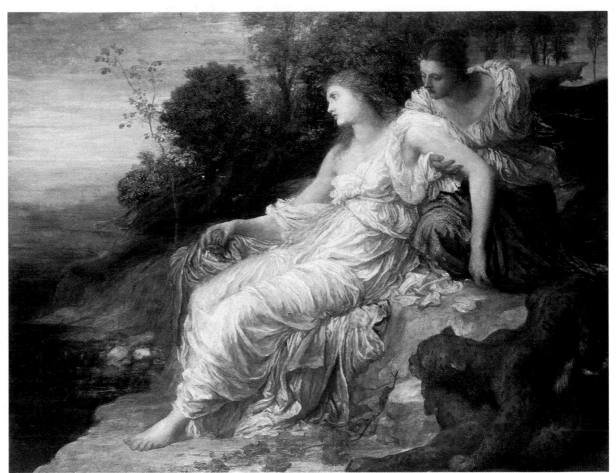

George Frederic Watts, *Ariadne in Naxos*, 1875 (Guildhall Art Gallery)

The Beresford presentation sword with a gold,
enamelled and gem-set hilt, 1805 (Guildhall Library)

PUBLICATIONS
Barbican Art Gallery, *The City's Pictures*
(brief history of the collection), 1982.
Barbican Art Gallery, *The City's Pictures*
(handlist of exhibition), 1982.
The City's Pictures (illustrated handbook
of 54 items in the collection), 1984

A catalogue of all existing items (i.e., excluding those
destroyed in the War or otherwise lost) in the Art
Gallery collection is projected for publication in 1986,
its centenary year

The Guildhall collection is a fascinating one and contains a wide variety of works. The
earliest paintings date from the 16thc and 17thc, and the portraits of two of the chief judges
by John Michael Wright, commissioned following the Great Fire of London in 1666, are
of interest. Other significant works include a portrait by Reynolds of Sir Charles Pratt, later
Lord Camden, also commissioned by the Corporation of London, and the *Portrait of the
actor John Philip Kemble as Coriolanus* by Lawrence. In the 1790s the Gallery incorporated
much of the collection of Alderman John Boydell (1719–1804), engraver, printseller and
publisher, and founder of the Shakespeare Gallery in Pall Mall, including some important
later 18thc portraits. Another artist to present pictures was Sir John Gilbert (1817–97), who
gave forty-eight in 1893, and whose brother George gave fifty-three more six years later.
A major bequest was that of Charles Gassiot (d. 1902), a City wine merchant from Tooting,
who gave almost his entire collection of 131 pictures.

The collection of later 19thc paintings is particularly worthy of note. It includes *The
Woodman's Daughter*, *My First Sermon* and *My Second Sermon* by Millais, *La Ghirlandata*
by Rossetti, *The Music Lesson* by Leighton, *Too Early*, *The Last Evening* and *The Lord Mayor's
Show* by Tissot and the enormous portrayal of *Israel in Egypt* by Poynter. Two works by
G. F. Watts were presented through the NACF, *Ariadne in Naxos* in 1918 and *Clytie*, from
Lady Battersea the following year. There are many more major examples of the 19thc that
mark the Gallery as being one of the most important centres for the study of that period
of British art. Important, too, is their collection of works particularly relevant to the City,
of portraits and ceremonial scenes. The Corporation's collection also includes upwards of
30,000 prints, drawings and watercolours in the care of Guildhall Library's Department of
Prints, Maps and Drawings, all of which are available to the public.

There is a sales desk situated in the Guildhall Library.

44

Guildhall Library Print Room

Prints and drawings relating to
London life and topography
(15thC–present day)

Aldermanbury, London EC2
tel. 01-606 3030, ext. 2864/2839

Mon–Fri 9.30–5 pm.
Closed Sat–Sun

Admission free

PUBLICATIONS
Selected Prints and Drawings in Guildhall Library, a
three-part catalogue of 1964–69 (now out of print)
*The Chadwyck-Healey Collection: Pencil and
Watercolour Drawings of London by John Crowther*
(n.d.)
Guildhall Library: Guide to the London Collections,
1978

Guildhall Library was founded in the 1420s, although the books were removed by the Duke of Somerset in 1549 and never returned. The Print Room was founded in 1828 by the City of London Corporation and is now housed in a new part of Guildhall built by Sir Giles Scott, Son & Partner in 1974. The former library building of 1870–73, designed in a Gothic style by Sir Horace Jones (1819–87), is now used as a Reception Hall.

Together with the large collection of prints and drawings concerned with London, there is also a considerable collection of historic London maps, photographs, satires, portraits and ephemera, such as trade cards and theatre bills. One of the most important additions to the Library has been a collection of about 2,000 Old Master prints, the bequest of Dr William Hughes Willshire (1816–99). Others include Lord Wakefield's collection of 1,500 topographical prints and drawings of London and Sir C. E. H. Chadwyck-Healey's collection of 437 topographical drawings, mainly watercolours. Also housed in the Library are an unusual collection of 800 historic playing card packs from the Worshipful Company of Makers of Playing Cards, the St Paul's Cathedral Collection of prints and drawings and the Fire Protection Association's Collection of ephemera and prints relating to fires of all places and periods up to 1947.

There is a sales desk.

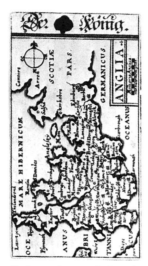 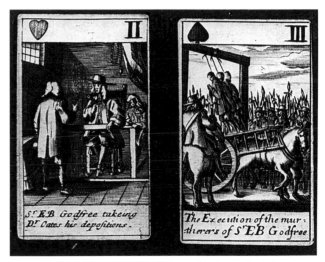

Playing cards, examples from the collection of the Worshipful Company of the Makers of Playing Cards, dating from (*left*) 1678, a German pack by J. Hoffman; (*right*) 1679, the 'Popish Plot' pack (Guildhall Library)

Hammersmith and Fulham Archives Department, Shepherds Bush Library

Local history; Cecil French Bequest of
19thC British paintings

7 Uxbridge Road, London W12
tel. 01-743 0910

By appointment only.
The Cecil French Bequest is not currently
displayed. Access is strictly by prior
appointment

Admission free

The Archives Department combines, in three locations, the functions of Record Office and Local History Library for the London Borough of Hammersmith and Fulham. Its holdings include a small collection of paintings, drawings and artefacts of local historical or topographical interest. The Cecil French Bequest is held as part of the Fulham Local History Collection. It was presented to the Borough in 1954 and comprises fifty-three paintings and drawings from the collection of Cecil French (1879–1953). He had trained as a painter, but became a collector, leaving instructions on his death that his collection should be dispersed among the different galleries and museums (except specifically the Tate Gallery, of which he disapproved); other museums to benefit from bequests include the British Museum, the William Morris Gallery at Walthamstow and the Watts Gallery at Compton.

Among the works in the Fulham Bequest are twenty-five examples by Burne-Jones, who lived locally in North End, Fulham, including watercolours of *Morgan le Fay*, 1862, *Cupid Delivering Psyche*, 1867, and *The Wheel of Fortune*, 1886. Other artists represented include Lord Leighton (six works), William Shackleton, G. F. Watts, C. H. Shannon and Alma-Tadema.

Hampton Court Palace, Lower Orangery

The greatest jewel in the Royal Collection—and possibly the finest renaissance work in this country—is to be seen since restoration in the Lower Orangery at Hampton Court. Andrea Mantegna's *Triumph of Caesar* enjoys the distinction, fully justified, of being shown without any distractions in this carefully planned environment, the only other exhibits being a few pieces of Roman sculpture of the kind that the artist himself would have admired.

The Triumph of Caesar, Mantegna's most remarkable achievement, was painted in the last years of the 15thc and pointed the way towards a new level of artistic perception, the art of the High Renaissance. Commissioned by the Gonzaga family, the theme of the nine paintings which make up the series is a Triumph, the celebration given for a Roman general on his return from a victorious campaign. The specific subject, as can be seen from the inscription, is the Triumph of Julius Caesar on his return from the war in Gaul and shows the bearers of the spoils and the captives preceding Caesar on his chariot. The first composition represents *The Picture Bearers* carrying the paintings depicting the towns and fortresses captured in the campaign. The series continues with *The Bearers of Trophies and Bullion*, *The Vase Bearer*—one of the most striking and impressive images in the scheme—*The Elephants* and *The Corselet Bearers*. The next part (no. 7) is unrestored and even in its ghostly state conveys the pathos of *The Captives*. The last two show *The Musicians* and *Caesar on his Chariot*; this Caesar is depicted as gravely aware of the responsibility of victory.

The Triumph belonged to Charles I; although it was valued at £1,000 after his execution in 1649, it was among the goods reserved for the Council of State. Throughout its subsequent history a number of more or less disastrous attempts were made to restore it after damage had occurred; in 1962 a fresh and this time successful restoration programme was carried out, and only now are we able to see an approximation to Mantegna's original.

At Hampton Court Palace itself there is a large and varied collection of pictures from the Queen's Collection. The Palace is an historic monument administered by the Department of the Environment and is therefore not dealt with in this guide.

Mantegna's series of nine paintings illustrating the *Triumph of Caesar*

East Molesey, Surrey
tel. 01-977 8441

Mon–Sat 9.30–6 pm, Sun 11–6 pm (April–Sept); Mon–Sat 9.30–5 pm, Sun 2–5 pm (Mar and Oct); Mon–Sat 9.30–4 pm, Sun 2–4 pm (Nov–Feb)

Admission charge

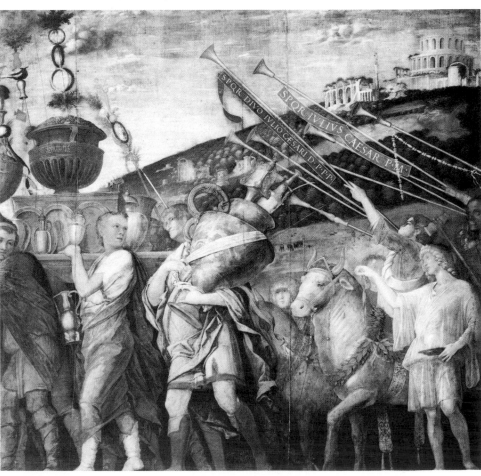

Andrea Mantegna, *The Vase Bearer* from 'The Triumph of Julius Caesar', late 15thc (Hampton Court)

'Whirling Dog', a Navajo sand-painting in powdered
sandstone and charcoal, 20thc (Horniman Museum)

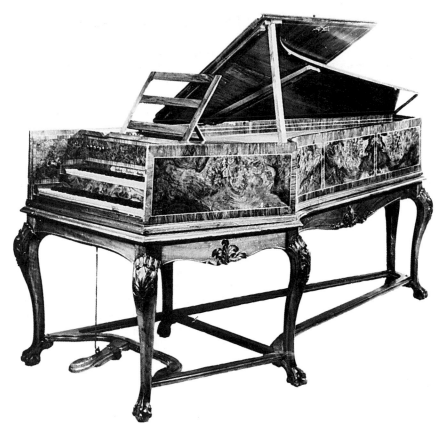

Double-manual English harpsicord, inscribed *'Jacobus Kirckman Londini fecit 1772'* (Horniman Museum)

Horniman Museum and Library

Museum of Man and his environment, with
rich ethnographic collections, including fine
examples of traditional art forms from
Africa, Asia, the Americas and Oceania,
as well as European Folk art; musical
instruments, both ethnic and historic
European

100 London Road (S. Circular), Forest Hill,
London SE23
tel. 01-699 1872/699 2339

Mon–Sat 10.30–6 pm; Sun 2–6 pm. Closed
24–26 Dec

Admission free

The founder of the Horniman Museum, Frederick Horniman (1835–1906), Chairman of the
family tea firm and Member of Parliament for Falmouth, was a widely travelled man who
began a collection of objects acquired on his voyages in the 1870s. He organised his
acquisitions in two houses on his estate as a private museum and opened it regularly to the
public from 1890. In 1897 work started on a purpose-built museum; designed by C. Harrison
Townsend FRIBA (1851–1928), architect of the recently completed Whitechapel Art Gallery,
it is of an idiosyncratic style more reminiscent of Vienna than of London, with an eye-catching
clock-tower and a boldly simplified façade incorporating a large decorative mosaic by Robert
Anning Bell. A bronze plaque at the entrance records that 'the building and its contents
are dedicated to the public for ever as a free museum for their recreation instruction and
enjoyment'.

Although this museum has the reputation for being a paradise for children, anthropological
collections of this importance are of particular interest to the development of the modern
style of art. The discovery of African ritual and tribal objects by such artists as Picasso and
his contemporaries, or Epstein, marks an advance in perception which was to prove of great
significance, a theme that has recently been explored in depth by the Museum of Modern
Art in New York. Indeed, primitive American culture, in this case the delicate, attenuated
forms of Navajo Indian sand-paintings, influenced the abstract-expressionist paintings of
Jackson Pollock.

There are fine Benin bronzes, Indian sculpture and Javanese and Malaysian shadow
puppets, as well as an important textile collection.

Musical instruments were, from the very start of Horniman's collecting career, one of
his many interests, and by the time the Museum was completed in 1901 there was a
representative section with examples from all over the world. In 1947 Adam Carse, the
composer, gave his unique collection of European wind instruments to the Museum in
memory of his son, Edward Adam Carse, who was killed in action in Germany in 1945.
This was joined the following year by the bequest of the Bull Collection of European
instruments. In 1956 Oriental instruments were transferred from the Victoria and Albert

Museum, and in 1963 ethnic examples came from the Church Missionary Society. Since 1981 the Museum has been adding to its internationally acclaimed collection by acquiring examples from the Dolmetsch Collection, a large group of rare and beautiful instruments, which will, it is hoped, eventually find a home at the Horniman as funds become available. In the meantime, the larger part of the Dolmetsch Collection will be displayed at Ranger's House, Blackheath (q.v.).

The Museum has a shop with a particularly informative selection of postcards, gallery guides and exhibition catalogues relating to the folk art and the musical instrument collections. Museum publications dealing with various aspects of the collections include: *Mongolia: Land of the Five Animals*; *Traditional Carpets of Serbia*; *Folk Art of Montenegro*; *Beehive Paintings from Slovenia*; *Folk Art of Romania*; *Man in the Americas*; *Musical Instruments*; *Dolmetsch Collection of Musical Instruments*; and *Wind Instruments of European Art Music*. There is a tea room open in the middle of the day during the week and for longer hours at the weekend.

Imperial War Museum

All aspects of the two World Wars and other conflicts that have involved the British and the Commonwealth since 1914

Lambeth Road, London SE1
tel. 01-735 8922

Mon–Sat 10–5.50 pm; Sun 2–5.50 pm

Admission charge for some special exhibitions only

The building was originally the Bethlem Hospital or 'Bedlam', the wings of which were demolished and a new structure was built by James Lewis (*c.* 1751–1820) from 1812–15. It was enlarged by Sydney Smirke (1798–1877), who added the huge Ionic portico and the dome in 1846. The Museum was founded by the Government in 1917 and established by an Act of Parliament in 1920. The collection of officially commissioned First World War art, amassed by the Ministry of Information, was transferred to the Museum when the Ministry was dissolved in November 1918. During 1939–45, the War Artists Advisory Committee of the reconstituted Ministry of Information collected over 6,000 works, the bulk of which was allocated to the Imperial War Museum in 1945. In 1951, the print collection was enriched by a large gift of First World War European prints, presented by the 5th Marquess of Bute.

The Museum is currently planning a major redevelopment of the building. The three million pounds recently received from the Sultan of Oman will go towards this. The scheme devised by Arup Associates is divided into separate self-contained phases to provide much new gallery space for displays of works of art, documents and exhibits. The basement will house the Museum's main narrative historical displays. Within this new area will be study galleries and a new shop. Work is planned to start in 1986.

Primarily, the Museum concentrates on displays illustrating and recording the history of

Percy Wyndham Lewis, pen and ink drawing, *Walking Wounded*, 1918 (Imperial War Museum)

war since the First World War, and amongst the exhibits of particular interest are Field Marshal Montgomery's campaign caravans, a British Mk V tank, a Battle of Britain Spitfire, a V1 Flying Bomb and a V2 rocket.

The Museum holds an impressive collection of 20thC British paintings, prints, drawings and sculpture, the majority of which was officially commissioned during the First and Second World Wars. The collection contains over 12,000 works and is the largest of 20thC British art outside the Tate Gallery. It includes work by Stanley Spencer and Paul Nash from both world wars (see particularly Spencer's *Travoys Arriving with Wounded*, 1916, *Shipbuilding on the Clyde*, 1940–45, and Nash's *The Menin Road*, 1918, and *Battle of Britain*, 1940), Wyndham Lewis (*Walking Wounded*), William Roberts (*Feeds Round*), C. R. W. Nevinson (*French Troops Resting*), John Nash (*Over the Top*), and works by Bernard Meninsky, Sir William Orpen, Sir John Lavery and John Singer Sargent. Sculptors include Jacob Epstein, Clare Sheridan, Eric Kennington and C. S. Jagger; Sir George Frampton's *Saint George*, 1918, a bronze memorial sculpture to a member of the Mond family, was purchased with the aid of a grant from the NACF in 1984.

The Second World War is most strongly represented by watercolourists, notably Anthony Gross, Eric Ravilious, Edward Ardizzone and Edward Bawden; also represented, in quality if not in quantity, are Graham Sutherland, Henry Moore, and Edward Burra. Among the oil paintings are works by Sir Meredith Frampton, Rodrigo Moynihan and Sir William Coldstream. Merlyn Evans's large painting *The Execution* (the death of Mussolini), painted in 1945, was acquired in 1980 with the aid of a grant from the NACF. In addition to the First and Second World War periods, the Department of Art actively collects contemporary art, both through commissions from the Museum's Artistic Record Committee and by direct purchase. Artists who have been commissioned include Patrick George, Ray Walker, Linda Kitson, Paul Hogarth and Maggi Hambling; purchased work includes sculpture, prints and drawings by Gilbert and George, Colin Self and Michael Sandle, among many others. This area of the collection, however, is not on permanent view at present.

The collection of graphic art in the Department of Art is very large: of approximately 50,000 posters, about 3,000 are available for study in the Department; the majority are held in reserve. The poster collection has British, American and European posters from the First World War to the present day. Designers represented include Brangwyn, Steinlen, Hohlwein, McKnight Kauffer, Games and Eckersley. The Bute collection contains *c.* 3,000 fine First World War patriotic and satirical prints, mainly by French artists. The Department of Art also holds over 1,000 medallions from all the belligerent countries in the First World War, and postcards and other ephemera.

The Museum currently administers three outposts: Duxford Airfield, opened on a daily basis in 1976; HMS *Belfast*, which was merged with the Museum in 1978; and the Cabinet War Rooms, which were reopened in 1984 and are administered by the Museum for the Property Services Agency.

There is a museum shop and refreshment area.

Sir George Frampton, *Saint George*, memorial bronze to Francis Mond, d. 1918 (Imperial War Museum)

PUBLICATIONS (relating to the paintings)
A Concise Catalogue of Paintings, Drawings and Sculpture of the First World War 1914–1918, 1963
A Concise Catalogue of Paintings, Drawings and Sculpture of the Second World War 1939–1945, 1964

India Office Library and Records

Material associated with India, notably Persian and Indian miniatures and drawings

197 Blackfriars Road, London SE1
tel. 01-928 9531

Mon–Fri 9.30–6 pm; Sat 9.30–1 pm

Admission free

PUBLICATIONS
Mildred Archer, *Company Drawings in the India Office Library*, 1972
Mildred Archer, *Indian Popular Painting*, 1977
P. Rohatgi and J. Bastin, *Prints of South East Asia in the India Office Library*, 1979
T. Falk and Mildred Archer, *Indian Miniatures in the India Office Library*, 1981

Founded in 1801, the East India Company was succeeded in 1858 by the India Office. The foundation collection was the group of miniatures acquired by Richard Johnson, an official of the East India Company in India from 1770 to 1790. His collection was purchased in 1807. The areas of specialisation of the collection are items from Southern Asia, Persian and Indian miniatures, drawings of India by Western artists, Company drawings (i.e., drawings by Indian artists for the British) and popular paintings (i.e., drawings by Indian artists at a popular level). It also includes prints of South and South-East Asia, photographs of Indian topography, social life and historical events, and a small collection of oil paintings and sculpture of persons connected with India. Items deserving special mention include the *Ni'mat-namah*, a book on cookery and perfumery of *c.* 1500, and *Dara Shukoh*, an album of Moghul miniatures and calligraphy of 1640–42.

In 1982 the ownership of the collections was transferred from the Foreign and Commonwealth Office to the British Library. The collection is currently housed in an adapted modern office block of no architectural merit.

The Jewish Museum

Judaica, including silver, ceramics, textiles, prints, drawings and paintings

Woburn House, Upper Woburn Place, London WC1
tel. 01-388 4525

Tues–Thurs (and Fri during summer) 10–4 pm; Sun (and Fri during winter) 10–12.45 pm

Admission free

The Museum was founded by a Deed of Trust in 1932 by the Jewish Memorial Council on the initiative of Wilfred S. Samuel. It is at present funded by private subscribers, the Harold H. Wingate Foundation and the Greater London Council.

The collection specialises in Jewish ritual art and Jewish history, especially in England, and includes three major purchases of ritual art, the Arthur Howitt and Arthur Franklin Collections, and the Kahn Collection of Synagogue textiles. The Museum's collection of paintings includes portraits of most of the important Rabbis of the 18thc and three attractive miniatures by Catherine Da Costa (1679–1756), including a fine portrait of her son Abraham, dated 1714. Other notable paintings are *Naphthali and Phila Franks* by Thomas Hudson; *Daniel and Judith Anne De Castro*, painted in India by Tilly Kettle; *Chief Rabbi Solomon Hirschel* (1802) by Frederick William Barlin; and three portraits by Abraham Solomon.

Objects in the collection worthy of special mention include an Italian 16thc carved and gilded walnut synagogue Ark; a Sabbath lamp by Abraham Lopes d'Oliveyra, the London silversmith, dated 1734; some fine Italian illuminated marriage contracts; an 8thc Byzantine gold votive medallion; and a collection of Jewish marriage rings.

There is a small Museum shop where the brief illustrated guide to the collections (ed. by Carole Mendleson) can be obtained. A full catalogue of *The Permanent and Loan Collections of the Jewish Museum*, edited by R. D. Barnett, was published in 1974, now out of print.

Italian walnut carved and gilded Synagogue ark, 16thc
(Jewish Museum)

Silver Sabbath lamp by Abraham Lopes d'Oliveyra, 1734
(Jewish Museum)

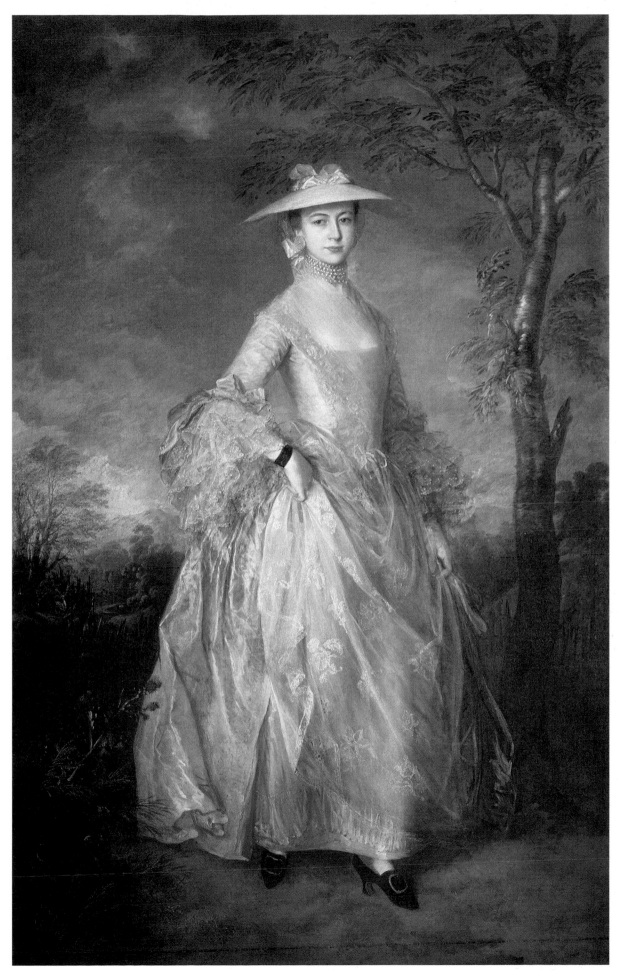

Thomas Gainsborough, *Countess Howe, c.* 1763–64 (Kenwood, the Iveagh Bequest)

Kensington Palace Court Dress Collection

Dress and uniforms worn by the ladies and
gentlemen at the British Court
(18thC–present day)

Kensington Gardens, London W8
tel. 01-937 9561

Please telephone for information about
opening times

Admission charge

Kensington Palace once housed the London Museum, which has since moved into the City,
at the Barbican. Now, in addition to the newly-restored State Apartments (the interior
decoration of which was largely carried out by William Kent), the Palace houses the newly-
formed Court Dress Collection, opened in May 1984.

This collection offers to the visitor a splendid display of over fifty magnificent dresses
and uniforms, which tell the history of the costumes worn at the British Court from the
18thC onwards. The majority of the Dress Collection is set in lavishly furnished room settings
appropriate to the date of the costume. All are displayed on full-length figures, with such
accessories as fans and head-dresses for the ladies and swords for the gentlemen.

The restored rooms have been decorated and furnished in such a way as to reproduce,
as far as possible, the appearance they enjoyed at various dates during the 19thC. They include
the room in which Queen Victoria was born in 1819, the room in which she held her Accession
Privy Council in 1837 and the room used as a Saloon by Queen Mary's parents, The Duke
and Duchess of Teck, in about 1870.

There is a sales counter at the entrance to the Collection, where a lavishly illustrated general
guide and history of the subject of Court Dress is available.

Kenwood, The Iveagh Bequest

Old Master and British paintings; English
neo-classical furniture; shoe buckles and
jewellery (18thC)

Hampstead Lane, London NW3
tel. 01-348 1286

Daily 10–7 pm (April–Sept); 10–5 pm
(Feb–Mar, Oct); 10–4 pm (Nov–Jan).
Closed Good Fri, Christmas Eve and
Christmas Day

Admission charge for special exhibitions
only

Kenwood was originally the home of William Murray (1705–93), Lord Chief Justice and
1st Earl of Mansfield. The early 18thC house was remodelled for him by Robert Adam (1728–
92) between 1764 and 1769 and later modified by the addition of the wings for his nephew,
the 2nd Earl of Mansfield (1727–96), by George Saunders (*c.* 1762–1839) between 1793 and
1796. Saunders also designed the lodge gates and many of the buildings in the grounds.
Adam's south front of 1767 was one of his most innovative designs and the interiors, a
magnificent suite of reception rooms, including the entrance hall, staircase and library, are
considered to be outstanding examples of his work. The Mansfield family sold the estate
after the First World War, and the Kenwood Preservation Council was established in 1922,
which guaranteed the preservation of 100 acres of land but not the house itself, the contents
of which were dispersed in that year. Finally it was purchased in 1925 by Edward Cecil
Guinness, 1st Earl of Iveagh (1847–1927), who bequeathed his collection of paintings and
furniture and about 74 acres of grounds to the nation on his death two years later. The park
and the house are now administered by the Greater London Council as Trustees of the Iveagh
Bequest, Kenwood.

The collection of paintings at Kenwood is an important one. The Old Masters include
Rembrandt's late *Self-Portrait* of *c.* 1665, Vermeer's *The Guitar Player*, and works by Frans
Hals (*Portrait of Pieter van den Broecke*), Cuyp (*A View of Dordrecht*), Snyders and Van
Ostade (*A Canal in Winter*). British 18thC and early 19thC painting is especially well
represented, particularly by Gainsborough's *Countess Howe* and Reynolds's *Kitty Fisher as
Cleopatra*, Romney's *Anne, Countess of Albemarle*, as well as by Hoppner, Raeburn, Lawrence
and Turner, all from the Iveagh Bequest. Subsequent major additions include Gainsborough's
Greyhounds Coursing a Fox from Mentmore, appropriately joining his other major sporting
painting, *Shepherd Boys with Dogs Fighting*, already in the Iveagh Bequest. The *Portrait
of John Joseph Merlin* by Gainsborough was purchased, with the help of the NACF, in 1983;
the sitter was an inventor and musical instrument maker, and this portrait of a member of
the professional classes complements and offsets Gainsborough's 'society beauties' in the
Iveagh Bequest. There is an expanding study collection of prints and drawings, including
topographical works related to the house (as well as to Marble Hill and Ranger's House),
portrait drawings and prints of residents, and prints after or related to paintings in the
collection.

The collection of English neo-classical furniture is also highly important. Under the present
Curator there has been a policy of acquiring such furniture of the highest quality to replace
the original contents. Two recent successes include the acquisition in 1982 of the sideboard
table and flanking pedestals designed by Adam for the dining room. Other major pieces by
Adam include a pair of pier tables, a suite of seat furniture from Moor Park, two window
seats and a plaster cast of *Mercury* from Croome Court.

PUBLICATIONS
Sir John Summerson, *The Iveagh Bequest, Kenwood*,
revised edn 1983 (a short account of its history and
architecture)
Catalogue of Paintings, first edn 1972 (currently out of
print, but being revised)
Bernard and Therle Hughes, *Georgian Shoe Buckles*,
1972

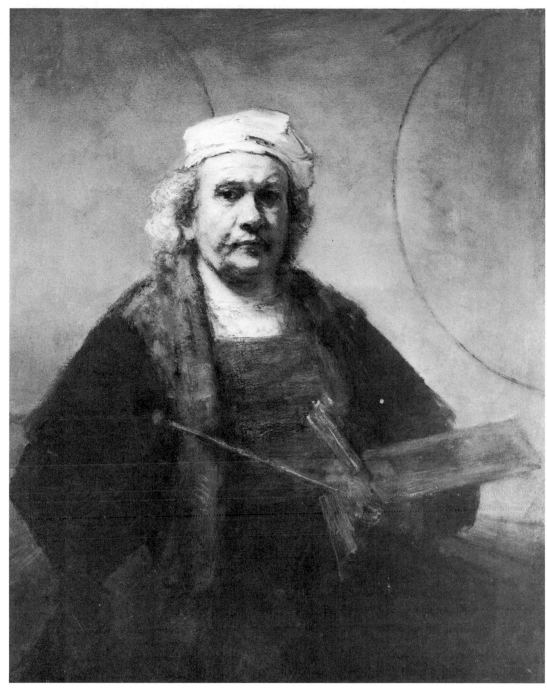

Rembrandt van Rijn, *Self-portrait*, *c.* 1663 (Kenwood, the Iveagh Bequest)

Two fine collections presented recently to Kenwood as being an appropriate context are the 1972 gift of the Lady Maufe collection of over 1,200 shoe buckles, mainly 18thc in date, and the 1974 gift of part of Mrs Anne Hull Grundy's collection of 18thc and early 19thc jewellery. Kenwood also benefited from a small selection of works from the E. E. Cook collection, notably four paintings by Angelica Kauffmann.

Kenwood has an association of Friends. The shop sells guides, catalogues, postcards, posters, slides, a wide selection of art and architectural books, and souvenirs. There is a cafeteria in the coach house and car-parking is available.

53

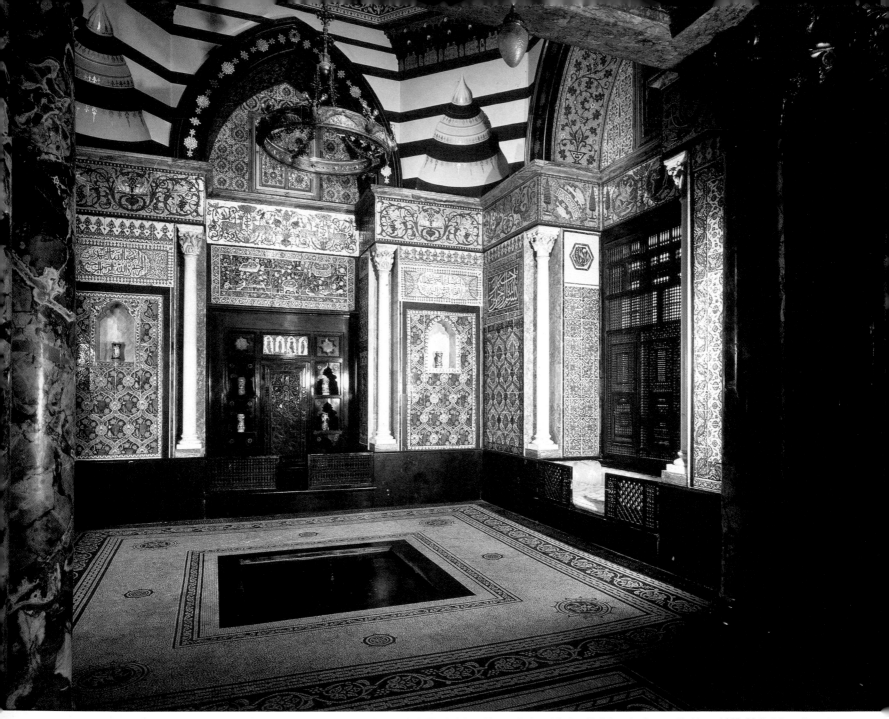

The tiled 'Arab Hall' at Leighton House, designed for Lord Leighton by George Aitchison, 1877–79 (Leighton House)

Leighton House

Paintings, drawings and sculpture
by Frederic, Lord Leighton (1830–96);
unique collection of Isnik
and other tiles

12 Holland Park Road, London W14
tel. 01–602 3316

Mon–Sat 11–5 pm (6 pm Mon–Fri during
exhibitions). Closed Sun

Admission free

Leighton House was built by George Aitchison (1825–1910) in 1865–66 and was the home of Frederic, Lord Leighton until his death in 1896. It was one of a number of large studio houses built for a group of painters during the second half of the 19thc within a short distance of Holland House. Nearby is Tower House, built by the architect William Burges for himself. The original building of the studio house was extended in 1877–79 by the addition of the Arab Hall. Based on the Moorish Palace La Zisa at Palermo, this splendid confection includes friezes by Walter Crane, carvings by Edgar Boehm and column capitals by Randolph Caldecott. The two chief creators of the Hall were Aitchison, who designed the architecture, and William De Morgan, who set in place the collection of tiles assembled by Leighton. De Morgan also executed the dark peacock-blue tiles of the ante-room to the Hall. The tiles in the Arab Hall are a unique collection of Isnik and others from Cairo, Damascus, Rhodes,

54

Frederic, Lord Leighton, *Rustic Music*, 1861
(Leighton House)

British paintings (early 18thC);
English Palladian and Rococo furniture

Richmond Road, Twickenham
tel. 01-892 5115

Daily (except Fri) 10–5 pm (Feb–Oct);
10–4 pm (Nov–Jan).
Closed 24–25 Dec

Admission free

PUBLICATIONS
M. P. G. Draper and W. A. Eden, *Marble Hill House
and its Owners*, 1970
Alexander Pope's Villa, exhibition catalogue, 1980
*Marble Hill House: A Short Account of its History and
Architecture*, 1982

Southall Library,
Osterley Park Road,
Southall, Middlesex
tel. 01-574 3412

Tues, Thurs–Fri 9–7.30 pm;
Wed, Sat 9–4.45 pm.
Closed Sun–Mon

Admission free

Sind and elsewhere. The interiors form one of the earliest examples of the 'aesthetic' style in England, particularly the extensive use of lacquered and gilded woodwork.

The Museum houses a study collection of six hundred of Leighton's finished and preparatory drawings, together with some forty paintings and sculptures. This includes some major works on loan, as well as a series of particularly fascinating landscape sketches, which demonstrate another aspect of Leighton's work. Paintings and sculpture by his contemporaries include works by Burne-Jones, Walter Crane, G. F. Watts, Val Prinsep and Millais, among others. In the garden are more pieces of sculpture by Leighton himself and Thomas Brock.

The whole of the house is being restored to its original appearance of 1895, a project planned to be completed in 1986. The Museum was founded in 1896, the year of Leighton's death, by the Leighton House Association, with Earl Percy as President, Lionel Cust as Chairman and Emily Barrington as Secretary. In 1926 it was transferred to the Borough of Kensington and is now administered by the Royal Borough of Kensington and Chelsea Libraries and Arts Service.

Leighton House has an association of Friends, and joint events are presented by them with the Victorian Society and the William Morris Society. There is a sales desk, with a good selection of slides, postcards and gallery publications.

Marble Hill House

A 'textbook example', this Palladian villa designed by Colen Campbell (d. 1729) for Henrietta Howard, Countess of Suffolk (*c.* 1688–1767), mistress of George II, is illustrated in the third volume of his *Vitruvius Britannicus* of 1725. It was built by Roger Morris (1695–1749) in 1724–29 and stands beside the River Thames. The Great Room, inspired by Inigo Jones's Cube Room at Wilton, with carvings by James Richards (successor to Grinling Gibbons as carver to the King) and paintings by G. P. Panini of 1738, was described by Alexander Pope to Lady Suffolk as 'the most delightful room in the world except that where you are'. The extensive grounds were laid out by the royal gardener, Charles Bridgman, with advice from Pope, and include a grotto decorated by Lady Suffolk. During the 1790s it was the home of Mrs Fitzherbert, secret wife of the Prince of Wales, and later in the 19thC General Peel, the brother of the Prime Minister, lived there. The house was purchased by the London County Council in 1902 and was used as tea-rooms for the park until 1966 when it reopened as an historic house museum, the contents having been purchased by the Greater London Council. It is now administered by the Iveagh Bequest, Kenwood.

Marble Hill contains some very fine paintings by Gravelot (*Le Lecteur*), Richard Wilson (*The Thames at Marble Hill*), Reynolds, Hayman, Hogarth and Hudson. The overmantel and overdoors by Panini have recently been restored to their settings in the Great Room. The English furniture includes the 'Northey suite', a settee and six mahogany chairs of *c.* 1760 with magnificent needlework by Anne Northey, and two chairs from the earlier Glemham Hall suite of *c.* 1722, covered with a copy of the original 'Bizarre' brocade.

There is a sales desk for catalogues, postcards, souvenirs, etc., and a café in the stable block open from April to September. There is a car-park at the Richmond end of the Marble Hill park.

Martinware Pottery Collection

The collection of over four hundred pieces is made up solely of the work of the Martin brothers and was established in the early 1930s at Southall. Robert Wallace and Walter Frazer Martin, later joined by brothers Charles Douglas and Edwin Bruce, specialised in producing a salt-glazed stoneware. They began production in 1873 in Fulham in what had been John Dwight's famous pottery, later moved to Shepherds Bush and then to Southall, hence the local connection. They drew their inspiration from the fields and hedgerows along the canal. Production ceased in 1914. Southall holds a comprehensive collection, including grotesque faces and birds for which the Martin brothers became famous. The NACF helped buy several pieces of pottery in 1934 and 1963.

Wallpaper designs for the Silver Studio, *c.* 1900 (Middlesex Polytechnic, Silver Studio Collection)

Middlesex Polytechnic, The Silver Studio Collection

Designs, wallpapers, textile samples,
reference library and documents

Bounds Green Road, London N11
tel. 01-368 1299, ext. 339

By appointment only

Admission free

In 1967, through the generosity of Miss Mary Peerless, the contents of the Silver Studio of Design were presented to Hornsey College of Art, which is now part of Middlesex Polytechnic. The Silver Studio, directed by Arthur Silver (1852–96) and later his son, Rex (1879–1965), was opened by the father at 84 Brook Green, Hammersmith, with the aim of 'bringing together a body of men to establish a studio which would be capable of supplying designs for the whole field of fabrics and other materials used in the decoration of the home'. Arthur combined a considerable talent for design with business acumen. He made many useful contacts through the Arts and Crafts Exhibition Society, including William Morris and Walter Crane. It seems likely that it was through the Society that the Studio began designing for the more avant-garde firms of the period, including Jeffrey and Co., Charles Knowles, Morton and Liberty.

The Silver Studio had the services of two brilliant Art Nouveau designers, J. Illingworth Kay and Harry Napper, whose works deserve to be better known. Napper, and later J. R. Houghton, ran the Studio after Arthur's death until Rex was able to take control in about 1900. Although only twenty-one when he began directing the Studio, Rex had already been responsible for a remarkable series of metalwork designs for Liberty's *Cymric* silver.

In all, the collection comprises about 20,000 designs, 2,000 wallpapers, 50 wallpaper pattern books, about 4,000 textile samples, a large library of works on design and related subjects, a collection of visual reference material and approximately 4,000 postcards, letters, trade cards, newspaper cuttings and miscellanea.

As a research collection, its importance is great. The Studio kept meticulous records, so that it is possible to date nearly all of the designs now in the collection and to attribute both designer and purchaser for any given design. In conjunction with the written records, there is an almost complete photographic archive of sold designs, running from *c.* 1890 to 1963.

There is a cafeteria, and car-parking facilities are available.

PUBLICATIONS
Catalogue of the Silver Studio Centenary, 1980
The Decoration of the Suburban Villa, 1880–1940, 1983
(reprint available)

Museum of London

All classes of material pertaining to the history of London and its peoples (prehistoric times–present day), notably an interesting collection of topographical views (1700–present day) in the Department of Prints, Drawings and Paintings, indexed by district and event as well as artist

London Wall, London EC2
tel. 01-600 3699

Tues–Sat 10–5.40 pm;
Sun 2–5.40 pm. Closed Mon

Admission free, except for special exhibitions from time to time

The London Museum, whose collections with those of the Guildhall Museum form the nucleus of the Museum of London, was founded in 1911. It was housed for many years in part of Kensington Palace, but since 1975 has been part of the Barbican complex, which includes commercial offices as well as private accommodation, high-level pedestrian walkways, open spaces (which are particularly vulnerable to inclement weather, sometimes viciously rainswept or raked by biting wind) and the remains of London's City Wall. The present building was designed by Powell Moya and Partners around a central courtyard in an environment that is more sympathetic to the objects than the pictures.

In order to be an accurate record of anything so complex as the biography of an expanding city, the range of material is of necessity, immensely varied. It includes fine and decorative arts, crafts, everyday objects, industrial material, shop fronts, vehicles, costume, printed ephemera and photographs, as well as a considerable collection of archæological finds from the two archæological units associated with the Museum.

The galleries are arranged chronologically by period, with the objects set in their social context and each gallery designed to evoke the atmosphere of the time.

The selected examples below are just some of the notable exhibits in the Museum, several of which have been purchased with the aid of the NACF. The sculptures from the Temple of Mithras are displayed in the Roman Gallery, including a head of Mithras and a relief showing him slaying the bull of evil. In the Mediæval Gallery there is an interesting stone slab, carved in the early 11thc Anglo-Saxon 'Ringerike' style, which comes from a Danish burial at St Paul's. Two outstanding exhibits in the Tudor Gallery are the Parr Pot, made of white striped Venetian-style glass with silver-gilt mounts and the coat of arms of Sir William Parr (uncle and chamberlain to Queen Catherine Parr) on the lid, and the Cheapside Hoard, a collection of jewellery dating from about 1600, with necklaces, rings, hair ornaments, brooches and an emerald watch.

John Ritchie, *A Summer Day in Hyde Park*, 1858 (Museum of London)

The Sudeley Castle jug, called the 'Parr Pot', Venetian latticinio glass with English silver-gilt mounts, 16thc (Museum of London)

PUBLICATIONS
The Museum of London Guide, 1976
Londonium (a descriptive map and guide to Roman London, published jointly with the Ordnance Survey), 1984
J. Schofield, *The Building of London from the Conquest to the Great Fire* (published jointly with British Museum Publications), 1984
J. Clark, *Saxon and Norman London*, 1980
P. Glanville, *Tudor London*, 1979
Pewter: A Handbook of Selected Tudor and Stuart Pieces (published jointly with the Pewter Society), 1983

Special exhibition catalogues include:
C. Fox and A. Ribeiro, *Masquerade*, 1983
T. Murdoch, *London Silver*, 1983
The Quiet Conquest, the Huguenots, 1685–1985, 1985
Robin Gwynne, *The Huguenots in London*, 1985

History of the Order of St John

St John's Gate, St John's Lane, Clerkenwell, London EC1
tel. 01-253 6644, ext. 35

Tues–Fri 10–6 pm; Sat 10–4 pm.
Closed Mon

Admission free, but donations expected

In the Early Stuart Gallery a fine oil painting by Dirck Stoop, *Entry of Charles II into the City on 22nd April 1661*, shows the customary procession of the monarch through the City on the day before his coronation. Near to it is the Dymoke Armour, made in the Greenwich Armouries *c.* 1630–40 and worn by John Dymoke as King's Champion at the coronation of George III in 1761. A display on Samuel Pepys in the Late Stuart Gallery contains an inlaid backgammon board given to him by James II. Also in this gallery is the silver-gilt cup, cover and salver engraved with the coat of arms of the South Seas Company, whose collapse in the 'South Sea Bubble' episode of 1720 brought ruin to many speculators. The Late Stuart interior, containing fine panelling, a painted ceiling and furniture showing the influence of Oriental design, represents the taste of a prosperous merchant of the period. The virginal, made by James White in 1656, is a rare example of this period, particularly as it is still in working order.

Outside the panelled room are two paintings depicting life on the river: *The Horseferry*, after Jan Griffer the Elder and *The River at Chiswick* by Jacob Knyff. Samuel Scott's painting of Covent Garden Piazza and Market, *c.* 1749–58, hangs outside the Georgian Gallery, which, in addition to Canaletto's *Interior of Henry VII's Chapel, Westminster Abbey, c.* 1750, contains fine works by London craftsmen, including furniture, weapons, porcelain and glass.

The magnificent Lord Mayor's Coach is housed in the Museum by courtesy of the Lord Mayor of London and the City Corporation. Made in 1757, it is elaborately carved and gilded and decorated with panel paintings by the Florentine artist Cipriani.

Prints and souvenirs of the Great Exhibition of 1851 are displayed in the 19thc Gallery, and in the following section there is a varied collection of shop fronts and fittings acquired when they were removed to make way for modern development. Here too is *Popularity*, Walter H. Lambert's large group portrait of most of the leading Edwardian music hall performers, 1901–03. With its eye-catching bronze decorative panels depicting flying storks and the Signs of the Zodiac in distinctive Art Deco style, the Selfridge's lift of 1928, in the 20thc Gallery, is a splendid example of the art and craftsmanship of Edgar Brandt and the Birmingham Guild of Metalworkers.

Special exhibitions are held to concentrate on particular aspects of London's history not covered in the permanent galleries or to exhibit items from the Museum's extensive reserve collections.

The reserve collections, which may be studied by students and researchers who arrange for an appointment well in advance, include groups of Bronze Age bronze implements; mediæval pottery and late mediæval artefacts; 16thc–18thc earthenware, stoneware and glass; 18thc Bow and Chelsea porcelain; archives and glass from the Whitefriars glassworks (18thc–20thc); toys; the Suffragette Fellowship Collection of photographs, pamphlets and correspondence; printed ephemera (including the Jonathan King Collection of toy theatre sheets, theatrical portraits and Valentine cards); a wide collection of costume (including everyday and fashionable dress, ceremonial clothing, civil uniforms, royal clothing and theatre costume); 10,000 photographs of a social nature (classified by subject); and some 20,000 original prints in the Port of London Photographic Archive.

There is an excellent shop with a varied and interesting stock and a restaurant, and car-parking facilities are available nearby.

Museum of the Order of St John

The collection is housed in a large gatehouse, built in 1504, which was the southern entrance to the Priory of the Knights of St John, founded in the mid-12thc. Situated across Clerkenwell Road is the Grand Priory Church of the Order (rebuilt 15thc–18thc), with the 12thc Norman Crypt below, the only part of the Priory to survive from the 12thc. A new wing, containing the Chapter House, was added to the gatehouse in 1903 and designed by John Oldrid Scott (1841–1913).

The Museum was established in 1890 and concentrates on the history of the Order of St John and its foundations, St John's Ambulance and the St John Opthalmic Hospital in Jerusalem. It is the most comprehensive collection of items relating to the Order outside Malta and includes paintings, silver, pharmacy jars, coins, medals, furniture, books and manuscripts. Noteworthy items, for example, are the Rhodes Missal of 1504 and the two outer panels from the Weston Triptych of *c.* 1470–80 from Flanders, commissioned by a

French gold and enamelled pendant with a painted cross of the Order of St John (*left*) and St Anthony of Padua (*right*), *c.* 1630 (Museum of the Order of St John)

PUBLICATIONS
Malta Views: Topographical Prints and Drawings of Malta, 1984
Lionel Butler, *The Seige of Rhodes, 1480*, 1980
E. A. Alliott, *The Rhodes Missal: A Commentary*, 1980
Lionel Butler, *The Order of St. John and the Peasants' Revolt*, 1981

Grand Prior of the Order. Various bequests have been incorporated in the Museum, notably the Gollcher Collection of furniture and the Inglefield Collection of 18thc and 19thc Maltese and Neapolitan silver, formerly used by the Order of St John in Malta; the Fraser Collection of early 20thc prints and watercolours of Malta; and the King Collection of Crusader coinage.

The Museum has independent charitable status and is governed by the Order of St John. There is a Museum shop.

National Army Museum

History of the Army

Royal Hospital Road, London SW3
tel. 01-730 0717

Mon–Sat 10–5.30 pm; Sun 2–5.30 pm.
Closed 1 Jan, Good Fri,
May Bank Holiday, 24–25 Dec
The Reading Room is open
Tues–Sat 10–4.30 pm
to readers' ticket holders

Admission free

'Crimea' brooch presented to Florence Nightingale by Queen Victoria, enamelled and set with diamonds, 1857 (National Army Museum)

The Museum, the only one of its kind in the country, was founded by Field Marshal Sir Gerald Templer, who began making plans for it when he was Chief of the Imperial General Staff. It was established by Royal Charter in 1960 to collect, preserve and exhibit objects and records relating to the regular and auxiliary forces of the British Army and to encourage research into their history and traditions. In 1971 the Museum moved from the Royal Military Academy at Sandhurst to a purpose-built home in Chelsea next to Wren's Royal Hospital. The first part, which was designed by William Holford and Partners, was opened to the public in November of that year, and the second phase of the construction, by Carl Fisher and Partners, was completed in June 1980. The funds to build the Museum, one of the very few national museums to be opened in the 20thc, were raised entirely by donations from the public. It is governed by a Council comprising twelve trustees.

The backbone of the Museum's display is a two-gallery survey of the 500-year history of the armies of Britain, the Empire and Commonwealth, from the foundation of the Yeoman of the Guard by Henry VII in 1485 to the victory in the Falklands in 1982. The first of the two galleries covers the period up to the outbreak of the Great War in 1914, some cases illustrating campaigns and battles, while others concentrate on the lives of such important commanders as Wellington, Roberts, Wolseley and Kitchener, and still others on changes in Army organisation and the life of the soldier. Among the exhibits are Marlborough's gold-embroidered saddle-cloth, a contemporary model of an assault barge of the type that ferried Wolfe's army to Quebec in 1759, a French eagle and standard captured at Waterloo in 1815, and the order that sent the Light Brigade to destruction in 1854. A number of these relics came to the Museum when the Royal United Service Institution's collections were dispersed in 1962–63.

The second gallery deals with the years from 1914 until the present day. The life of the soldier at home and abroad, in barracks and on the battlefield, is recreated in life-size reconstructions featuring fully equipped and uniformed figures against realistic backgrounds, linked by dramatic audio-visual displays and specially commissioned dioramas.

The National Army Museum is the home of one of the largest collections of military costume in the world. The pick of 20,000 items can be seen in the Uniform Gallery. Also on view is a selection from the incomparable collection of badges, medals and insignia, including the decorations of HRH the Duke of Windsor and the batons of five field marshals.

The Art Gallery houses the best of the Museum's collection of 17thC–19thC paintings, among which are works by Gainsborough, Reynolds, Romney, Beechey, Raeburn and Lawrence. Portraits are interspersed with scenes of battle and camp life, as well as fine specimens from the collection of 1,000 standards, guidons, colours and flags.

The Weapons Gallery, opened in 1978, is the first systematic attempt by any museum to trace the development of the hand-held weapons used by the British soldier from mediæval times to the present. The weapons on display range from the elegant land pattern arms of the 18thC and extravagantly decorated presentation swords from Napoleonic times to the Lee Enfield rifle and its successors.

The Museum holds a major national archive. The collection includes the papers of the 1st Marquess of Anglesey, Lord Raglan and Lord Roberts, hundreds of letters, journals and memoirs of lesser-known soldiers of all ranks. The Museum's reference library contains over 30,000 books, many of them extremely rare, on British military history. Campaigns, uniforms and all aspects of military life can also be studied in the unrivalled collection of prints and drawings, and in photograph albums dating back to the 1840s. A recent exhibition demonstrated how this specialised collection can illuminate the history of dress in general by showing the relationship between military costume and contemporary fashion.

The Museum has a Society of Friends. The shop holds a substantial stock of books on military history and artefacts, cards, prints, records, cassettes and souvenirs. Current publications include *Army Museum*, an annual magazine outlining the Museum's activities and including articles on subjects specific to the collections. There is a car-park.

George Chinnery, *Portrait of an Officer in Battalion Company 13th Bombay Native Regiment, c.* 1820 (National Army Museum)

National Gallery

European Old Master paintings:
a representative collection of
all major European schools of painting
(late 13thC–early 20thC),
all of which are on view
to the public

Trafalgar Square, London WC2
tel. 01-839 3321

Mon–Sat 10–6 pm; Sun 2–6 pm

Admission free

England, of all the Western European countries, was almost the last to establish a 'National Gallery'; following the example of Vienna (1781), Paris (1793), Amsterdam (1808), Madrid (1809) and Berlin (1823), the London National Gallery was founded in 1824. In that year Lord Liverpool's government purchased thirty-eight paintings from the collection of Sir John Julius Angerstein (1735–1823) for £57,000. Angerstein was a Russian *émigré* banker who had lived in London at 100 Pall Mall for some years before his death. The Gallery first opened to the public in that house in May 1824. Among the pictures were five Claudes; an important Cuyp, *A Hilly River Landscape*; two large landscapes by Gaspar Dughet acquired by Angerstein from Roman collections; two Van Dycks; Hogarth's *Marriage à la mode* series (the six paintings were hung in the Tate Gallery from 1919–50, but have now been returned); Raphael's *Portrait of Julius II*, long considered to be a copy, but lately established as the original, painted for the church of S. Maria del Popolo in Rome and sent there after the death of the sitter in 1513; two Rembrandts; a Rubens, *The Rape of the Sabine Women*; and the Sebastiano del Piombo *Raising of Lazarus* from the Orléans Collection as well as the Titian *Venus and Adonis* (now thought to be a replica of the Prado picture, painted with the help of pupils).

The collection began to grow almost at once. Early bequests included those of 'that giant of amateurs', Sir George Beaumont (1753–1827)—only sixteen works, but among them three Claudes, a Poussin, a Rubens, a Rembrandt and Canaletto's *The Stonemason's Yard*—and the Rev. W. Holwell Carr (1758–1830), a more mixed group with a number of pictures now believed to be the work of followers or assistants of the artists to whom they were once ascribed. The Holwell Carr paintings included, however, Rembrandt's *Woman Bathing in a Stream*, the magnificent triptych by Rubens executed as a modello for the altarpiece of S. Bavo in Ghent and three Domenichinos. Both of these bequests were dependent upon the provision of a suitable building in which to house them. Initially it was planned to hang the Angerstein and Beaumont pictures in the recently-completed East Wing of the British Museum, built to house the King's Library and the natural history collections, but there proved to be too little space, and the construction of a separate building was seen to be essential.

In 1831 the planning of the building for the National Gallery was already under discussion,

Masaccio, detail from *The Virgin and Child*, 1426
(National Gallery)

Lorenzo Lotto, *A Lady as Lucretia*, first half of the 16thc
(National Gallery)

and in the following year the commission for it went to William Wilkins (1778–1839) as the result of a competition. Wilkins won, it was said, by 'jobbery', over the heads of John Nash and C. R. Cockerell, both of whom submitted designs. The work occupied Wilkins until nearly the end of his life, being completed in 1838. Since then there have been many additions, among them by E. M. Barry (1870s), Sir John Taylor (1880s) and the PSA, who built the Northern Extension in 1975.

The dignified, but somewhat uninventive neo-classical façade on Trafalgar Square is distinguished by the magnificent corinthian columns from Carlton House; the interior is spacious, with elaborate gilded decorative detail in the 19thc rooms, reflecting the taste of the period. An often overlooked curiosity is the mosaic floor, designed in the 1920s by Boris Anrep, at the top of the first flight of stairs in the Main Entrance.

It is impossible to itemise all the notable works in this great collection. Unlike most of the major Continental galleries, which have as their foundation a former royal collection, the National Gallery is remarkable in being the product of bequests, donations and purchases over less than two centuries. Apart from the early patrons, the collections have benefited from the generosity of such outstanding collectors as George Salting and Alfred Mond. Queen Victoria presented a number of early Italian works, which are a reminder of Prince Albert's part in the revival of interest in this area. A number of perceptive and energetic Directors enriched the collections by purchases, none more pertinently perhaps than Sir Charles Eastlake (Director 1855–65); it was he who was responsible for adding to the collection the Piero della Francesca *Baptism of Christ*, Veronese's *Family of Darius before Alexander*, Paolo Uccello's *Battle of San Romano*, and the Titian *Noli me tangere*. Sir Edward Poynter (Director 1894–1905), like Eastlake a painter of considerable reputation, secured, for example, the *Virgin of the Rocks* by Leonardo, the Velasquez *Portrait of Philip IV of Spain*, Van Dyck's *Equestrian Portrait of Charles I*, and the magnificent *Ambassadors* by Holbein. Sir Charles Holroyd (Director 1906–16) added to the already impressive coverage of the Early Italian School the monumental *Madonna and Child with Angels* by Masaccio bought for the then large sum of £9,000, of which half was provided by the NACF. Notable in the present century are the additions made by Kenneth Clark (Lord Clark, who died in 1983), including Rembrandt's *Saskia as Flora* and Poussin's *The Worship of the Golden Calf*, and the present Director, Sir Michael Levey, who recently acquired for the Gallery their first painting by Jacques-Louis David, a scintillating portrait of *Jacobus Blauw*.

The remarkable range of the collection is neatly demonstrated by a recent publication, *100 Great Paintings: Duccio to Picasso* (Dillian Gordon, 1981), and a visit that included a look at each of these masterpieces could not fail to be an immensely rewarding experience. The jewel-like quality of works from the early period—for example, the *Wilton Diptych* of *c.* 1595 or Pisanello's *Vision of St Eustace*—broadens in the early Renaissance to encompass the wider vision of Piero della Francesca, Verrocchio, Botticelli and the monumental but delicate quality of Leonardo, as exemplified by one of the most famous paintings in the world,

Diego Velasquez, *The Toilet of Venus (The 'Rokeby Venus')*, *c.* 1648–51 (National Gallery)

Rembrandt van Rijn, *Belshazzar's Feast, c.* 1635 (National Gallery)

The Virgin of the Rocks. The collection then moves on to the finest achievements of the High Renaissance with Raphael's *Ansidei Madonna*, the great unfinished *Entombment* ascribed to Michelangelo, and the works from all phases of Titian's long career which give some idea of the ungraspable quality of his genius.

The Northern School is represented by Van Eyck's mysterious *Arnolfini Marriage*, the subject of many attempts at precise interpretation, Memling's *Donne Triptych*, Cranach's *Cupid Complaining to Venus*, a painting also full of complex symbolism, and a magnificent group of works by Rubens, including the ravishing *Chapeau de Paille*, a powerful *Samson and Delilah* and one of the most beautiful of the landscapes, *The Watering Place*.

The grandeur of Royal portraiture in the 17thc is demonstrated by Van Dyck's huge equestrian *Charles I* and the richly detailed *Philip IV of Spain* by Velasquez.

With the 18thc the English School comes into its own, and apart from the Hogarth series mentioned above, the collection includes some well-known portraits of the period, Gainsborough's *Morning Walk*, for example, and *Queen Charlotte* by Lawrence. For the 18thc in France, two relatively recent purchases have greatly enriched the representation of portraiture from this period: the magnificent Drouais of *Mme de Pompadour*, a fitting foil to Ingres's *Mme Moitessier*, and the Perronneau of *Jacques Cazotte*, which corrects the over-sweet impression given by the famous *Girl with a Kitten*. The coverage of the French 19thc is affected by the movements of the Hugh Lane Bequest (see below), but even when these pictures are absent there is much of importance to be seen, from two exquisite early landscapes by Corot to Monet's *Waterlily Pond*, and the disturbing fragmentary pieces from Manet's *Execution of Maximilian*. The purchase in 1964 of Cézanne's *Bathers* caused some controversy and received unwelcome public criticism in the press. This important painting has advanced to the very brink of abstraction. The first really abstract work to be acquired by the National Gallery, Picasso's *Still Life with a Bowl of Fruit, Bottle and Violin*, is an affirmation of this artist's status as a future Old Master.

Holbein's *Duchess of Milan* and Velasquez's *Rokeby Venus* were both the subject of dramatic rescue operations in the early years of the NACF, in 1909 and 1906 respectively. The appeal to save the Leonardo cartoon of *The Virgin and Child with St Anne and St John the Baptist* dominated the Fund's activities in 1962; in 1972 the purchase of the late Titian of the *The Death of Actaeon* marked a watershed in the Fund's grant giving, when £100,000 was allotted to a single purchase for the first time.

One peculiar circumstance has governed the exact extent of the National Gallery's collections in the past: the fact that for over half a century the Tate Gallery was part of the same institution. Only in 1954 was the Tate made independent, establishing it as the home of the British School and the Modern Collection. Some attempt was made to rationalise the collections by 'shuffling the pack', so to speak, but since 1963 only a few transfers have taken place and the present state of both collections admits of an 'accepted overlap'.

The Gallery has a spacious shop selling those publications listed separately here, as well as many others produced by them and a small selection of related publications of a popular nature. There are excellent postcards and greeting cards, a very large choice of good quality slides and an efficient photographic service. *The Illustrated General Catalogue* is an invaluable work of reference, but for a more detailed account of the history and provenance of the pictures it is necessary to go to the Gallery's special catalogues for each school of painting.

There is a licensed self-service restaurant, which received a favourable recommendation from Egon Ronay in his book *Just a Bite*, 1983.

PUBLICATIONS
Illustrated General Catalogue, 1980
Dillian Gordon, *100 Great Paintings : Duccio to Picasso*, 1981
Martin Davies, *Early Netherlandish School*, 1968
Neil MacLaren and Allan Braham, *Spanish School*, 1970
Cecil Gould, *16thC Italian and Venetian Schools*, 1975
Michael Levey, *17th and 18thC Italian Schools*, 1971

National Maritime Museum and Queen's House

The National Maritime Museum traces its origins back to the Royal Naval Museum in Somerset House in the 18thc, to the picture collection of King Charles I and to the institution of the Royal Observatory by Charles II in 1675. The most notable benefactor was Sir James Caird (1864–1954), a Scottish shipowner who devoted much of his life and most of his fortune to the preservation of important maritime and scientific historical material. Almost every department in the Museum is indebted to him, but especially the picture, library and manuscript sections.

An appeal for funds was launched in 1921, and in 1926 official government recognition was given to a scheme for a national maritime museum. The Board of Trustees, set up in 1926 under the chairmanship of the 7th Earl Stanhope, organised the acquisition of various collections, including the MacPherson collection of maritime paintings, prints, drawings and atlases, the Greenwich Hospital collection of pictures and the collections of the Royal Naval College. The Museum was formally established by Act of Parliament in 1934.

The Queen's House was designed by Inigo Jones. The Great Hall, the spiral staircase (known familiarly but erroneously as the 'tulip staircase') and the Queen's bedroom are special features worthy of note. The East and West Wings, linked to the Queen's House by colonnades, are the work of Daniel Asher Alexander (1768–1846) and were built between

History of the Royal Navy, and the shipping industry; Dutch marine paintings; the history of astronomy, time-determination and measurement, navigation and hydrography; maritime prints, drawings and historic photographs

Greenwich, London SE10
tel. 01-858 4422/5

Mon–Fri 10–6 pm (summer),10–5 pm (winter); Sat 10–6 pm (summer), 10–5.30 pm (winter); Sun 2–5.30 pm (summer), 2–5 pm (winter)

Admission charge

Wilhelm van de Velde, *The Battle of the Texel*, 1687 (National Maritime Museum)

1807 and 1811. In 1862 the additional West Wing was built by Philip Hardwick, followed by Neptune Hall, the work of Colonel Clark in 1873. A further wing was added in the west end of the site in 1876 by Colonel Charles Pasley, Royal Engineers.

When King Charles II founded his own Royal Observatory in 1675, Sir Christopher Wren was architect of the original building, of which the Octagon Room is the central feature of the design. The building is called Flamsteed House, after Sir John Flamsteed, the first Astronomer Royal. Successive Astronomers Royal extended eastwards and southwards to accommodate additional instruments and staff, employing various architects.

In the Neptune Hall there is a full-sized steamship, the paddle-tug *Reliant*, and glittering royal state barges of the 17thC and 18thC are in the Barge House. The archæological gallery contains full-scale reconstructions of digs at Ferriby, Graveney and Sutton Hoo.

The Museum is a major art gallery: its collection of 17thC Dutch marine paintings is the largest and most comprehensive in the world, with examples by Hendrik Cornelisz. Vroom, Andries van Eertvelt, Simon de Vlieger, Ludolf Bakhuizen, as well as a remarkable group by the Van de Veldes, father and son, who sailed with the Anglo-French fleet in 1673. Among these is the five-by-ten-foot *Battle of the Texel 1673*, thought to be the finest battle-piece ever painted by Willem van de Velde the Younger. Earlier works in the collection include rare 16thC pictures of shipping represented in the anonymous *Spanish Armada 1588* and *The Arrival of the Infanta Beatriz of Portugal at Villefranche 1522* from the School of Joachim Patinir. By the 18thC an English school of marine painting had developed, and there are examples of Samuel Scott, Charles Brooking, Francis Swaine, Nicholas Pocock and Dominic Serres. The 19thC and 20thC are represented by G. Chambers, E. W. Cooke, Clarkson Stanfield, John Brett, W. L. Wyllie, Samuel Cough, James Webb, Alma Burlton Cull, John Everett and Charles Dixon. Also on view are such masterpieces of the British School as Turner's *Battle of Trafalgar* (1805), and de Loutherbourg's *The Glorious First of June 1794*.

The portrait collection is also distinguished, with works by John Bettes the Younger, John de Critz, William Dobson, Sir Peter Lely, Michael Dahl, Sir Joshua Reynolds (no less than eighteen portraits), George Romney (nine examples), Thomas Gainsborough, John Copley, Tilly Kettle, Sir William Beechey, John Hoppner and Henri-Pierre Danloux. In 1941 the Museum acquired a *Portrait of Nelson* by Lemuel Abbot. Allegedly one of the few authentic portraits 'from life', it was offered to the Maritime Museum at a special price of £1,000.

The Print Room has a comprehensive collection of maritime prints and drawings, including an important group of drawings by the Van de Veldes, and the historic photographs number approximately half a million images.

In addition, there are collections of silver, porcelain and glass, uniforms (including that worn by Nelson at Trafalgar), swords, medals, charts and navigational instruments (including all four Harrison chronometers). The Old Royal Observatory houses displays relating to astronomy and the measurement of time, with the famous Airy Transit Circle, which defines the prime meridian of the world.

The Museum has an Association of Friends. There are two Museum shops with an interesting and varied stock, including a very large number of specialist publications. For a good general account of the collections see: *The National Maritime Museum*, ed. Dr Basil Greenhill, 1982. There is a licensed restaurant and a café.

Nicholas Hilliard, miniature of Sir Walter Raleigh, *c.* 1585 (National Portrait Gallery)

National collection of historic and contemporary portraits of eminent British men and women. Paintings, miniatures, drawings, prints, illustrations from periodicals and photographs

St Martin's Place, London WC2
tel. 01-930 1552

Mon–Fri 10–5 pm; Sat 10–6 pm; Sun 2–6 pm

Admission free, except for special exhibitions

National Portrait Gallery

In 1856 the Portrait Gallery was founded by Treasury Minute following a vote of £2,000 per annum, sanctioned after a debate in the House of Commons at which Lord Palmerston, then Prime Minister, was the principal speaker. The idea had the support of Prince Albert and was promoted by Philip, 5th Earl Stanhope (1805–75), who was the first Chairman. The present premises, purpose-built by Ewan Christian (1814–95) in a heavy dignified neo-classical style much influenced by German gallery design of the period, opened in 1896.

As part of the extensive collection of Tudor portraits, the miniatures are of particular note, especially the group of beautiful Hilliards, which includes Elizabeth I, Drake and Raleigh. The artistic quality of the works becomes particularly apparent in the Stuart age, and the galleries displaying this part of the collection have recently been redecorated and redesigned. The display covers the period from the accession of James I in 1603 to the death

Allan Ramsay (studio), *Charlotte Sophia of Mecklenberg-Strelitz, Queen of George III, c.* 1762 (National Portrait Gallery)

George Hayter, *Caroline of Brunswick, Queen of George IV*, a study for 'The Trial of Queen Caroline', 1820 (National Portrait Gallery)

of Queen Anne in 1714 and is a vivid record of this most dramatic period in British history. Themes include Charles I and the Civil War, the Restoration of Charles II and the Glorious Revolution in 1688, the birth of modern parliamentary government and the party system. The Arts and Sciences are treated in far greater depth than before, as is the role of women in the period. Among important recent acquisitions on view are Van Dyck's newly discovered portrait of *Charles II when Prince of Wales*; his exquisite small portrait of *Lady Digby as Prudence*; two powerful miniatures of *Oliver Cromwell* by Samuel Cooper; and the attractive group portrait, John Michael Wright's *The Vyner Family*, showing Charles II's banker with his family in their Middlesex garden—a brilliant costume-piece. Portraits recently cleaned include the playwright *Ben Jonson* by Abraham van Blyenberch, *The Duchess of Portsmouth*, Charles II's stylish French mistress, by Mignard, and the diarist *Samuel Pepys* by John Hayls. The display also contains important works by Rubens, Honthorst, Mijtens, Lely and Kneller, as well as superb miniatures, sculpture, commemorative medals, and a great many contemporary engravings which constitute a unique visual record of some of the most crucial events of the time.

Very recently one of the most charming 18thc group portraits from the age of the 'conversation piece' was added to the collection: it represents the leading harpsichord maker *Burkat Shudi (1702–73) and his Family*, painted by the German artist and architect Marcus Tuscher, who lived in London from 1741–43. Shudi's daughter married John Broadwood, who was working for her father, and Shudi's workshop thus became the house of Broadwood. The painting, which featured in the Rococo exhibition at the Victoria and Albert Museum in 1984, was sold by the Broadwood Trust.

Other items worthy of special mention are the Holbein cartoon for the portraits of Henry VII and Henry VIII in the fresco in the Privy Chamber of Whitehall Palace; a good group of 18thc portraits by Sir Joshua Reynolds of, for example, Laurence Sterne, Warren Hastings, Dr Johnson and James Boswell; impressive large-scale representations of Queen Victoria, including the plaster model by John Theed of his sculptured group for the Royal Mausoleum at Windsor, showing her with Prince Albert in their costumes for the Plantagenet Ball in 1842; forty-two of G. F. Watts's 'portraits of eminent contemporaries', as well as the ravishingly beautiful *Choosing* of the young Ellen Terry; an excellent representative showing of members of the Pre-Raphaelite circle; and the intriguing and much-reproduced *Private View of the Old Masters Exhibition at the Royal Academy 1888* by H. J. Brooks, which was given to the Gallery by the artist in 1919 and which portrays fifty-eight figures, including many leading artists of the day such as Millais, Leighton, Orchardson, as well as the aesthetic *beau monde*, for example, Lady Granby and Oscar Wilde.

The Brooks is interestingly paralleled by a recent acquisition, Leonard Rosoman's *Royal Academy Council Meeting 1984*, which is part of the newly-opened display for the 20thc. This consists not only of paintings and drawings, but also photographs of eminent contemporaries by distinguished photographers. There is a particularly interesting group of artists' self-portraits, which includes revealing works by Gwen John, a bravura oil of *c.* 1900 (bought by the NACF in 1965 for £1,500 and presented to the Gallery to mark Sir Alec Martin's eightieth birthday), fine drawings by Mark Gertler (*c.* 1909–11), Henri Gaudier-Brzeska (1912), Wyndham Lewis (1932) and Henry Moore (1982), paintings by John Minton (*c.* 1953) and Lucian Freud (1962), as well as prints by Richard Hamilton (1970) and David Hockney (1973). The stunning Laura Knight *Self-Portrait* closes the vista at one end of the display, an unforgettable image with the black hat and bright red jacket. Another recent addition is the fine Ben Nicholson *Self-Portrait with Barbara Hepworth* (1933). The 20thc display also includes a number of portraits of living sitters commissioned by the Trustees, a new departure for the Gallery. The latest addition is a group of three members of the Trades Union Council (Lord Gormley, Sid Weighell and Tom Jackson) by Hans Swartz. *Lord Wilson of Rievaulx* by Ruskin Spear was not a special commission, unlike the controversial Bryan Organ of the *Princess of Wales*.

The paintings collection is matched by a small but choice group of portrait sculpture, for example, Roubiliac's terracotta of Hogarth and a group of busts by Sir Francis Chantrey, as well as the famous head of Virginia Woolf by Stephen Tomlin said to have caught her expression more accurately than any photograph.

In addition to the works from the permanent collection normally shown, the Gallery has mounted a series of exhibitions devoted to the lives of great historical figures, which in the past have included Samuel Pepys and Sir Thomas More. The exhibition scheduled for 1985–86 marks the 300th anniversary of the birth of George Frederick Handel, arguably Britain's

PUBLICATIONS
Souvenir Guide, 1977 (2nd edn 1982)
National Portrait Gallery in Colour, 1979
Roy Strong, *Tudor and Jacobean Portraits*, 1969
David Piper, *Catalogue of the 17th Century Portraits
in the National Portrait Gallery, 1625–1714*, 1963 (out
of print)
John Kerslake, *Early Georgian Portraits*, 1977
Richard Ormond, *Early Victorian Portraits*, 1974
Richard Walker, *Regency Portraits*, 1985

Recent exhibition catalogues include:
Thomas Lawrence: Paintings and Drawings, 1979
John Singer Sargent: The Edwardian Age, 1979
*Norman Parkinson: Fifty Years of Portraits and
Fashion*, 1981
Van Dyck in England, 1982
Bill Brandt Portraits, 1982
William Dobson, 1611–46, 1983
*Glyn Philpot, 1884–1937: Edwardian Aesthete to
Thirties Modernist*, 1984

greatest composer, to include not only portraits of the musician, his contemporaries and patrons, but also musical instruments, scores and autographs in Handel's own hand, as well as views of 18thc London and its theatres.

Since 1980, the Gallery has also organised, in association with Imperial Tobacco Ltd (now John Player) a series of annual portrait awards for painters under forty years of age. As part of the prize, the winners of the Player Award receive commissions for portraits. The 1982 winner, Emma Sargeant, has painted Lord David Cecil and Lord Olivier; Humphrey Ocean, winner in 1983, is represented by the popular—in both senses of the word—portrait of Paul McCartney.

There is an excellent gallery shop, with the most helpful and well-run slide and photographic department, well-chosen books and a good selection of postcards.

The Gallery has two outstations in the country, both accommodated in National Trust houses. About 100 portraits of the Tudor and Jacobean period are at Montacute House in Somerset, and about the same number are at Beningbrough Hall, near York.

Orleans House Gallery

Paintings, watercolours, drawings and prints with views of Richmond and Twickenham

Riverside, Twickenham, Middlesex
tel. 01-892 0221

Tues–Sat 1–5.30 pm (April–Sept),
1–4.30 pm (Oct–Mar);
Sun and Bank Holidays 2–5.30 pm
(April–Sept), 2–4.30 pm (Oct–Mar)

Admission free

PUBLICATIONS
Carolyn Bloore, *Hugh Welch Diamond, 1808–1886:
Doctor, Antiquarian, Photographer*, 1980
T. F. Friedman, *James Gibbs Architect, 1682–1754:
'A man of great fame'*, 1982
*Blest Retreats: A History of Private Gardens in
Richmond upon Thames*, 1984
A History of Orleans House, Twickenham, 1984

The Gallery is situated adjacent to the Octagon of *c.* 1720 by James Gibbs (1682–1754) built for the Hon. James Johnstone (1655–1737), Secretary of State in Scotland. The design of the building is restrained, being built of plain yellow brick with rubbed vermilion brick pilasters and Portland stone dressings. The plasterwork interior is richly decorated in the baroque style, reflecting Gibbs's training in Rome, and was executed by two renowned *stuccatori*, Guiseppe Artari and Giovanni Bagutti. The chimneypiece incorporates two reclining female figures in plaster and above each of the two original doorways a pair of putti frolic on the pediments. It has been suggested that these figures may be the work of Michael Rysbrack. The buildings, land and picture collection were bequeathed to the Borough of Twickenham on the death of the Hon. Mrs Nellie Ionides in 1962, and the Gallery opened in 1972, administered by the Borough of Richmond upon Thames Library and Information Services.

The permanent collection of oil paintings, watercolours, drawings and prints depicts mainly local views in the 18thc and 19thc. Works of particular note include *The Thames at Pope's Villa* by Samuel Scott, *Orleans House, Twickenham* by William Marlow, a watercolour of the *View from Richmond Hill* by Peter de Wint, an oil of the same subject by Leonard Knyff and *Richmond Riverside* by Pieter Andreas Rysbrack.

There is a sales desk that sells catalogues, postcards, prints, etc. Car-parking is available.

Passmore Edwards Museum

Archæology, local history, biology and geology of the historic/geographical County of Essex (i.e. including the five London boroughs east of the River Lea and north of the River Thames)

Romford Road, Stratford, London E15
tel. 01-519 4296/534 4545, ext. 5670

Mon–Fri 10–6 pm;
Sat 10–1 pm, 2–5 pm. Closed Sun

Admission free

The Museum, founded in 1898 and purpose-built by the architects J. G. S. Gibson and S. B. Russell, was opened by the Countess of Warwick, noted for her philanthropic activities and her socialist views. The principal patron was J. Passmore Edwards MP (1823–1911), who put up half the capital and of whom it was said that he would supply funds for almost any worthy institution except churches. Passmore Edwards was born in Cornwall and made for himself an enterprising career—and a considerable fortune—in the popular newspaper boom of the 1860s and 1870s. He lived modestly in Hampstead and lavished money on charitable projects (see also South London Art Gallery, p. 76 and Newlyn Art Gallery, p. 227).

Of particular interest and usually on display is the group of Bow porcelain, the 14thc Waltham Abbey Bible, illuminated letters patent of Edward VI and the Brentwood and Theydon Mount treasure trove hoards.

Recently the Museum has made two important purchases of paintings to supplement the visual side of the local history collection. The rare group portrait by Sir Godfrey Kneller representing six members of *The Harvey Family*, who once inhabited the nearby Rolls Park at Chigwell (now demolished), was bought in 1983 and *The Prospect of the Park and House at Wanstead from the North* by Charles Catton in 1984. This extensive view shows the house and gardens at Wanstead as they were in the 18thc, with the Palladian mansion, demolished

Charles Catton (Snr or Jnr), *A Prospect of Wanstead Park and House*, mid-18thc (Passmore Edwards Museum)

Chinese wine jar with reticulated panels and flowers painted in red and blue, Yuan Dynasty (Percival David Foundation)

53 Gordon Square, London WC1
tel. 01-387 3909

Mon 2–5 pm; Tues–Fri 10.30–5 pm;
Sat 10.30–1 pm (except in August).
Closed on Bank Holidays and preceding Sats

Admission free

in the 1820s, in the middle distance. The gardens became a popular resort of the period on account of their proximity to London; in 1724 Daniel Defoe remarked: '. . . it has become the general diversion of the citizens to go out and see them.' The Park has survived as a public open space.

There are a number of Museum publications on various aspects of local history, for example *Church Road, Layton: Excavation*; *Introduction to the Thames Sailing Barge*; *M.11 Motorway Excavations, 1970–75*; *Roman Pottery Kilns at Rettendon*; *St Mary's Church Woodford*; and *Three Mills Industrial History Walk*. These are available from the small Museum shop.

Percival David Foundation of Chinese Art, University of London

The Foundation is based on the collection of Sir Percival David, Bt (1892–1964), who in 1950 gave about 1,500 items of early Chinese ceramics and his library of Chinese and Western books concerning the art and culture of China. In 1952 the collection was enriched by the gift from the Hon. Mountstuart Elphinstone (1871–1955) of 171 pieces of later monochrome wares, mostly 18thc.

The collection contains pieces from the Song, Yuan, Ming and Qing Dynasties, some of which came from Chinese Imperial Collections. Celadons from the Song Period are particularly well represented, as are the blue and white wares of Ching-te-Chen, such as the temple vases of 1351, the earliest known pieces of blue and white. This very fine collection deserves to be better known.

There is a sales counter. The illustrated catalogue to the collection is in six sections.

Petrie Museum of Egyptian Archæology, University of London

University College London,
Gower Street, London WC1
tel. 01-387 7050, ext. 6170

Normally Mon–Fri 10–12 pm, 1.15–5 pm.
Closed one week at Christmas and Easter
and in the absence of the Beadle.
Parties by appointment

Admission free

The premises of the University's Department of Egyptology were destroyed during the War, since when the collections have been housed in former brewery stables. A new museum is currently being planned. The original bequest to the University came from Miss Amelia B. Edwards (1831–92), who left her small collection of Egyptian antiquities. She founded the Chair of Egyptology at University College, the first holder of which was Professor Sir W. M. Flinders Petrie (1853–1942), whose interest in Egyptology began in 1880 with his excavations at the Giza Pyramids. He exhibited his findings from each summer's dig, organised by the British School of Archæology in Egypt, and a selection of these grew into the collection acquired by the College in 1913. Since 1953 the British School has been incorporated into the University Department. Further acquisitions have come from the Egypt Exploration Society and Egyptian and Sudanese antiquities from the collection of Sir Henry Wellcome (1853–1936). Because much has been dispersed to other institutions specialising in Egyptology, the Museum remains a teaching, research and study collection rather than an art museum.

The collection ranges from the Palæolithic and Neolithic periods to the Islamic period, with emphasis on pottery, and a fine representation of stelae, reliefs, sculpture, glass and textiles.

Postcards, slides, posters and books are on sale. The Museum has a comprehensive assortment of publications (dating from 1883) relating to the Museum for the use of research visitors. There is a guide to the Museum, revised and reprinted in 1984.

The Queen's Gallery, Buckingham Palace

Changing exhibitions drawn from
the exceptionally rich material
in the Royal Collections,
including paintings, miniatures, the Old
Master drawings in the Royal Library,
sculpture, works of art, furniture
and Fabergé precious objects
from Sandringham

Entrance in Buckingham Palace Road,
London SW1
tel. 01-930 4832

Tues–Sat 11–5 pm; Sun 2–5 pm.
Closed Mon and Bank Holidays

Admission charge

In spite of the tragic dispersal of a large part of the Royal collections after the death of Charles I by the Commonwealth Government, the British Royal Collection of pictures and works of art is of unrivalled richness, unequalled by any private collection in the world and, indeed, better than most public collections. In the generations since the Restoration in 1660 there have rarely been Royal owners of the collections who were quite indifferent to art, and several have been impassioned and persistent collectors, notably George III, George IV and the Prince Consort.

George III chose shrewdly in buying, virtually *en bloc*, the works of art assembled by the pertinacious Consul Smith, whose purchases in Italy were on such a scale as to ensure that no other collection could boast a more impressive holding of, for example, the work of his contemporary, Canaletto, as well as important Old Master paintings and drawings. The paintings by Canaletto, newly cleaned and catalogued, filled the Gallery for a special exhibition in 1980–82. The drawings by Leonardo da Vinci are legendary and have been the subject of an exhibition in the Gallery. Large groups of highly important works by Michelangelo and Raphael have in recent years been lent to the relevant exhibitions at the British Museum. The miniature collection is outstanding, with a group of examples by Holbein, Isaac Oliver, Samuel Cooper, and the great miniaturists of the 18thc. The Royal holdings of porcelain are vast and of the most superb quality; the Gallery was barely large enough to display the exhibition of examples from only one factory, that of Sèvres.

The Gallery was constructed in 1962 in the space once occupied by the Private Chapel of the Palace, destroyed by bombing in 1940. It is run by the Lord Chamberlain's Office on behalf of the Queen and is open for special exhibitons only; there is no permanent display open to public view.

PUBLICATIONS
Sir Oliver Millar, *The Tudor, Stuart and Early Georgian Pictures in the Royal Collection*, 1963
Michael Levey, *The Later Italian Pictures* . . ., 1964
Sir Oliver Millar, *Later Georgian Pictures* . . ., 1969
Haswell Miller and N. P. Dawnay, *Military Drawings and Paintings* . . ., 1970
Andrew Martindale, *The Triumph of Caesar by Mantegna* . . ., 1979
Christopher White, *The Dutch Pictures* . . ., 1982
John Shearman, *The Early Italian Pictures* . . ., 1983
Lorne Campbell *The Early Flemish Pictures* . . ., 1983

Catalogues of the whole collection have been appearing for many years; those already published are listed here. There is a shop attached to the Gallery with a good selection of postcards and guidebooks. Excellent general information on the Royal Collection will be found in *The Queen's Pictures* by Sir Oliver Millar and *Royal Heritage* by J. H. Plumb and Huw Wheldon.

Ranger's House, Blackheath

Suffolk collection of Jacobean
and later portraits

Chesterfield Walk, Blackheath,
London SE10
tel. 01-853 0035

Daily 10–5 pm (Feb–Oct), 10–4 pm
(Nov–Jan). Closed Good Fri, 24–25 Dec

Admission free

Formerly Chesterfield House, this handsome early 18thC red brick villa was built for Admiral Hosier (1673–1727) in *c.* 1723. The Gallery was added in 1749–50 for Philip, 4th Earl of Chesterfield (1694–1773), probably by Isaac Ware (d. 1766), the architect of Lord Chesterfield's town house in South Audley Street, and has a fine Palladian interior. The house was later occupied by the mother of Queen Caroline, the Duchess of Brunswick, and from 1815 was used as the residence of the Ranger of Greenwich Park. In 1974 the Greater London Council created an art gallery there, initially with the collection of the Earls of Suffolk and Berkshire, which was presented to them by the Hon. Greville and Mrs Howard in the same year.

This collection includes a magnificent series of full-length Jacobean portraits by William Larkin, as well as portraits by William Peake, Cornelius Johnson and Daniel Mijtens. There is also a group of Stuart paintings by Kneller, Lely, Wissing and others and some 18thC portraits. A few Old Masters from the same collection, amongst which was once Leonardo's *Virgin of the Rocks*, still survive, including Abraham Bloemaert's *Prodigal Son as a Swineherd* of 1637 and Ferdinand Bol's *Falconer* of 1647.

The Dolmetsch collection of musical instruments, recently purchased by the Horniman Museum and on long-term loan to Ranger's House, is displayed in the first floor rooms, which have not previously been open to the public. The instruments consist of 17thC–18thC examples owned by Arnold Dolmetsch, a pioneer of the revival of early music in this country and also those made by him based on earlier models.

It is intended to acquire appropriate furniture for the house and to furnish it according to the two inventories from 1728 and 1782. Major recent acquisitions have included an important pair of George II side tables from St Giles House, Dorset, possibly by Henry Flitcroft, a bust of Queen Caroline, who was Ranger of Greenwich Park, and a fine Feraghan carpet for the Gallery to represent Lord Chesterfield's penchant for Oriental carpets.

PUBLICATIONS
The Suffolk Collection: Catalogue of Paintings, 1974
(being revised for republication)

A Guidebook to the history and architecture of the
house and its collection is in preparation

The House is in the process of forming an association of Friends. There is a sales counter for catalogues, postcards, slides, books and souvenirs.

Royal Academy of Arts

Diploma collection of paintings, sculptures,
engravings and architectural drawings
18thC–20thC

Piccadilly, London W1
tel. 01-734 9052

Daily 10–6 pm

Admission charge for exhibitions

Since 1868 the Royal Academy of Arts has been at Burlington House, Piccadilly, having previously occupied premises in Pall Mall from 1768–80, in Somerset House, designed by Sir William Chambers (1723–96), and in Trafalgar Square, shared with the National Gallery, from 1837–68. Burlington House was first built in the 1660s but was redesigned in the Palladian style by Colen Campbell (d. 1729) and others for the 3rd Earl of Burlington in *c.* 1717 and altered again by Samuel Ware (1781–1860) for Lord George Cavendish in 1815. In 1854 it was purchased by the Government, and the main part of the house and gardens was leased to the Academy in 1865, at a peppercorn rent, for 999 years. A condition of the lease was that the Academy should build exhibition galleries, at its own expense, on the gardens to the north of the house, and add a third storey to the house itself, to match the height of the new buildings erected for various learned societies around the courtyard on the Piccadilly front. These changes were carried out by Sydney Smirke (1798–1877).

The first floor of Burlington House still contains a series of rooms in the Palladian style going back to the 3rd Lord Burlington's rebuilding; these Private Rooms, though somewhat modified in the 19thC, still contain fine decorative plaster and woodwork as well as paintings by Sebastiano Ricci and William Kent which were originally commissioned for them.

Founded in 1768 by George III, with Sir Joshua Reynolds as its first President, the Royal Academy has enjoyed the patronage, protection and support of successive sovereigns. It is a self-governing body of artists dedicated to the practice and promotion of the fine arts. An independent autonomous association comprising fifty Academicians and thirty Associates, painters, sculptors, architects and engravers, it has Trustee status and is registered as a charity. Subject only to the authority of the sovereign, it is governed by a Council of fourteen Members who serve in rotation, and by a General Assembly of all the Academicians and Associates. The Officers of the Academy are the President, Keeper, Treasurer and Secretary, the first

Johannes Vermeer, *Lady at the Virginals with a Gentleman, c.*1665 (Queen's Gallery, Buckingham Palace)

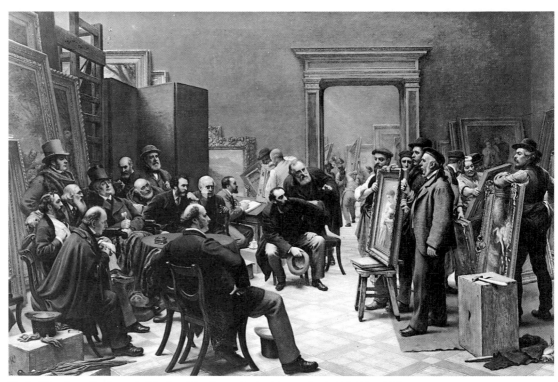

Charles West Cope, *The Council of the Royal Academy selecting Pictures for the Exhibition*, 1876
(Royal Academy of Arts)

John Gibson, marble relief of *Cupid and Psyche*,
mid-19thc (Royal Academy of Arts)

PUBLICATIONS
Post Impressionism, 1980
Stanley Spencer, 1980
British Art Now, 1981
A New Spirit in Painting, 1981
Great Japan Exhibition, 1981–82
Painting in Naples, 1982
Treasures from Ancient Nigeria, 1982
Murillo, 1983
The Genius of Venice, 1983
The Orientalists, 1984
Chagall, 1985
Elisabeth Frink 1985
Peter Greenham, 1985

three of whom are elected from among the membership. It receives no regular grant or other financial assistance from the Government or from any public source. At Burlington House the Academy runs a mainly postgraduate art school, holds an open exhibition of the work of living artists each year, the Summer Exhibition, and organises major loan exhibitions throughout the year.

The Royal Academy's principal collection comprises the Diploma works deposited by each Academician on his election as a 'specimen of his abilities'. These include paintings, sculptures, engravings and architectural drawings. In addition, it holds important works acquired by gift, bequest or purchase. Pre-eminent among the latter are Michelangelo's *Tondo* (Madonna and Child with the Infant St John), Constable's *Leaping Horse* and Stubbs's drawings for *The Anatomy of the Horse*.

The Friends of the Royal Academy are a large and active organisation and important for the continuing survival of the Academy. The shop sells postcards, prints, posters, artists' materials, a wide selection of art books and a range of gifts designed by Members of the Royal Academy. There is also a mail order catalogue, and works of art may be purchased or hired through Business Art Galleries. The restaurant serves light refreshment throughout the day and hot and cold lunches.

All aspects of the history of the Royal Air Force and its predecessors

Aerodrome Road, Hendon, London NW9
tel. 01-205 2266

Mon–Sat 10–6 pm; Sun 2–6 pm.
Closed Christmas Day, Boxing Day,
New Year's Day and May Day

Admission free to main museum

Royal Air Force Museum

The Museum was established in 1963 and opened in 1972. It was designed by Geoffrey Bodker and is situated at the old aerodrome at Hendon in ten acres of grounds; two 1915 hangars are used as the Aircraft Hall. The Gallery displays illustrate the development of British Aviation, both military and civil. The numerous exhibits include aero engines, propellers, armaments, instruments, navigation aids, models, photographs, uniforms, decorations, memorabilia and trophies. In the Aircraft Hall over forty aircraft are displayed from the Museum's total collection of more than 150 machines.

The Museum also holds an interesting collection of paintings, drawings and sculptures by many notable artists, among them Dame Laura Knight, Sir Jacob Epstein, Sir William

Russell Flint, C. R. Nevinson, John Piper, Graham Sutherland, Sir William Rothenstein, Dame Elisabeth Frink, Michael Ayrton and Paul Nash. The NACF assisted in the purchase of six portrait drawings by Sir William Rothenstein and a sketch by Rex Whistler of an air battle. The Museum also acts as custodian for some 460 works of art commissioned by the War Artists Advisory Committee (1939–45). It has an extensive archive, including the papers of Imperial Airways and British Airways.

The Dermot Boyle Wing houses occasional exhibitions, and the main Museum is supplemented by the Battle of Britain and Bomber Command extensions.

The Museum has a Society of Friends. A shop stocks a wide range of books, periodicals, posters, postcards and model kits. There is a fully licensed restaurant and a free car and coach-park.

Sir William Rothenstein, red-chalk drawing of
Wing Commander P. M. Brothers, DFC, 1943
(Royal Air Force Museum)

Nearly 500 musical instruments
(16th–20thC)

Prince Consort Road, London SW7
tel. 01-589 3643

Wed 11–4 pm, during term-time,
by appointment with the Curator

Admission charge

PUBLICATIONS
E. A. K. Ridley, *The Royal College of Music, Museum of Instruments, Catalogue Part 1: European Wind Instruments*, 1982
The Royal College of Music, Museum of Instruments, Guide to the Collection, 1984
Full-scale working drawings of eleven instruments, 1974 onwards

Royal College of Music, Museum of Instruments

The Museum, designed by Philip Radinger in 1970, is housed in the Royal College of Music, which was founded in 1883 by the Prince of Wales and moved to the present site in 1894. The architect was Sir Arthur Blomfield (1829–99). Sir George Grove (1820–1900), editor of the four volumes of the *Dictionary of Music and Musicians*, was the first Director of the College until 1894.

The collection, which includes mainly European keyboard, wind and stringed instruments and some from Asia and Africa, has been built up since the opening of the College. It has been formed from individual gifts as well as whole collections, the first of which was a collection of Indian instruments presented by the Maharajah Sourindro Mohun Tagore (1840–1914), a musicologist and patron of Indian music. This was followed in 1894 by the collection of Sir George Donaldson (1845–1925), collector and art dealer, who designed the museum to house it (now the Library Reading Room) and who presented more instruments in 1900. Edward VII gave his collection consisting mostly of Asian instruments in 1909, and another major collection, that of A. J. Hipkins (1826–1903) whose main interest was in early keyboard instruments, was presented by his children in 1911. The Museum was to benefit further in 1968 when E. A. K. Ridley gave his large collection of wind instruments, which had been housed in Luton Museum.

Amongst the more important pieces in the collection are an anonymous South German clavicytherium of *c.* 1480, which is thought to be the earliest surviving stringed keyboard instrument, a harpsichord by Alessandro Trasuntino made in Venice in 1531; virginals by G. Celestini of 1593, also Venetian; Handel's spinet and Haydn's clavichord; a Regal organ of 1629; a chitarrone by Magnus Tieffenbrucker of 1608 and many more early and rare examples.

Anon., school of Turin, *Portrait of Gaetano Pugnani, c.*
1754 (Royal College of Music, Department of Portraits)

Felix S. Moscheles, *Portrait of Sir George Henschel*,
1880 (Royal College of Music, Department of Portraits)

Royal College of Music, Department of Portraits

Portraits of musicians

Address as above

Mon–Fri 10–5 pm, by appointment only

Admission charge

This collection contains several thousand prints and photographs of musicians, as well as some two hundred original portraits, including *Farinelli* by Nazari, *Haydn* by Thomas Hardy and *Paderewski* by Burne-Jones. Amongst the sculptures are portrait busts of *Gluck* by Houdon and *Sir George Grove* by Gilbert.

Both the Museum of Instruments and the Department of Portraits are governed by the Council of the Royal College of Music.

There is a cafeteria at the College.

Royal Hospital Museum, Chelsea

Material associated with the Hospital and its In-Pensioners.

Royal Hospital Road, Chelsea, London sw3
tel. 01-730 0161

Mon–Fri 10–12 noon, 2–4 pm;
Sun 2–4 pm (April–Sept)

Admission free

This small museum can be visited as part of a general tour of the Royal Hospital. It is situated in the Secretary's Office, which was part of Sir John Soane's (1753–1837) additions of 1809–20 to Wren's main building of the hospital, founded in 1682 by Charles II. The Museum itself was founded in 1960 and is administered through the Hospital, which is a grant-aided Crown body managed by a Board of Commissioners.
 There are collections of medals and badges, uniforms, prints and memorabilia relating to the Royal Hospital and its In-Pensioners.

The Museum has a souvenir shop.

Royal Institute of British Architects,
The British Architectural Library: Drawings Collection

Architectural drawings (16thc–present day)

21 Portman Square, London w1
tel. 01-580 5533

Visitors' appointments
Mon–Fri 10–1 pm;
telephone enquiries 9.30–5 pm.
Heinz Gallery: Mon–Fri 11–5 pm;
Sat 10–1pm

Admission free

The RIBA was founded in 1834 and the Drawings Collection was originally part of their Library. From the beginning members of the Institute contributed generously to the Library. Gifts were made of drawings, medals, portraits and building samples, as well as books and pamphlets. Major donations from members and their families have continued to this day.

PUBLICATIONS
John Harris, *The Palladians*, 1981
Gavin Stamp, *The Great Perspectivists*, 1982
Jill Lever, *Architects' Designs for Furniture*, 1982
Margaret Richardson, *Architects of the Arts and Crafts Movement*, 1983
David Dean, *The Thirties: Recalling the English Architectural Scene*, 1983

Exhibition catalogues:
Maya Hambly, *Drawing Instruments*, 1982
Robert Elwall, *Bricks & Beer: English Pub Architecture, 1830–1939*, 1983
Jill Lever and Margaret Richardson, *Great Drawings from the Collection of the Royal Institute of British Architects*, 1983
Jill Lever and Margaret Richardson, *The Art of the Architect*, 1984

C. R. Cockerell, *'Branch of England Bank Manchester as Executed'*, a drawing from the Goodchild-Cockerell Album, 1833–59 (Royal Institute of British Architects)

In 1971 the Collection was moved to the house at 21 Portman Square built by James Adam (1730–94) in *c.* 1772, where it has its own small gallery, the Heinz Gallery, and mounts an average of six exhibitions every year. Although their subjects are invariably architectural, they have ranged from a review of the work of Alfred Waterhouse, to the 50th Anniversary of the Victorian Society, to the work of the Seifert partnership and Norman Foster Associates.

The Drawings Collection includes work by the architects Palladio, Inigo Jones and John Webb from the Burlington-Devonshire Collection. There are drawings by Robert and John Smythson and large collections from the offices of 19thc and 20thc architects, such as C. R. Cockerell, Alfred Waterhouse, George Gilbert Scott and Lutyens.

The Library's excellent publications and postcards are on sale at the entrance desk.

Royal Naval College

Interior of architectural and decorative interest

Greenwich, London SE10
tel. 01-858 2154

Daily (except Thurs and Good Friday) 2.30–5 pm (closure at short notice may be dictated by operational circumstances)

Admission free

As part of the complex of buildings which includes the Maritime Museum and the Queen's House, the Royal Naval College is well worth a visit for the Painted Hall and the Chapel. Founded by Charter of William and Mary in 1694 as a hospital for old and disabled seamen, it was known originally as The Royal Hospital. The architect of the building was Sir Christopher Wren (1632–1723), who was also responsible for the magnificent English baroque decoration of the Painted Hall. The painting of the Hall is by Sir James Thornhill and took him twenty years to complete; it is one of his finest achievements. The stone carving of the interior was designed by Nicholas Hawksmoor. The Chapel, completed in 1789, is the work of James 'Athenian' Stuart (1713–88).

There is a small shop in the Painted Hall selling souvenirs and postcards.

The Science Museum, The National Museum of Science and Industry

Historic scientific and technological objects

South Kensington, London SW7
tel. 01-589 3456

Mon–Sat 10–6 pm; Sun 2.30–6 pm

Admission free, except for occasional special exhibitions

The foundation of the Museum was established by the Commissioners of the Great Exhibition of 1851 and the Department of Science and Art, a forerunner of the Department of Education and Science. The first site was the old refreshment rooms left over from the International Exhibition of 1862 on the western side of Exhibition Road. By 1899 the 'non-art' collections of the South Kensington Museum (now the Victoria and Albert Museum) became known as the Science Museum and were divided from the main collections, which remained on the eastern side. Since 1857 the 'non-art' collections were gradually built up. These were designated 'Foods, Animal Products, Materials for Building and Educational Apparatus'; the first two collections included such things as 'culinary curiosities from China and Siam' (for example, birds' nests, sharks' fins, sea-slugs and other delicacies), and subsequently ship models, marine engines, machine tools, etc. A major contribution was received in 1876 with the international Loan Collection of Scientific Apparatus. The Patent Museum, assembled by Bennet Woodcroft on behalf of the Commissioners of Patents, was transferred in 1884 to the Department of Science and Art, thereby broadening the compass to give the status of a national museum of science and industry.

In 1912 the Bell Committee recommended new accommodation for the continually expanding collections, and the East Block, designed by Sir Richard Allison (1869–1958) and built 1913–28, was the first public building in London to use reinforced concrete. The centre block, by W. Kendall, was completed in 1958 and the East Block extension in 1977. In the same year the Wellcome Museum of the History of Medicine, the collection of Sir Henry Wellcome (1853–1936), was transferred to the Museum, which increased its coverage of the history of science and technology by the addition of the history of medicine and provided facilities for the collections previously unavailable.

The Museum holds extensive collections of paintings, prints, drawings and photographs. This material is primarily of iconographic interest, recording and illustrating aspects of the history and development of physical science and technology. Among the paintings are P. J. de Loutherbourg's *Coalbrookdale by Night* (1801), Stanhope Forbes's *The Munition Girls* (1918), J. Lucas's *The Birthplace of the Locomotive* and *Portrait of Robert Stephenson* and

The 'Adams' silver compound microscope, made for the Prince of Wales in the 1780s (Science Museum)

Philip James de Loutherbourg, detail from a painting of *Coalbrokedale by Night c.* 1780 (Science Museum)

L. S. Lowry's *A Manufacturing Town* (1922). There is a collection of ballooning prints and decorative ceramics from the Penn-Gaskell collection of Aeronautica. The 'Gallery of Portraits of Inventors, Discoverers and Introducers of the Useful Arts', begun by Bennet Woodcroft in the 1850s and first displayed in the original Patent Office Museum, forms the nucleus of the Museum's extensive portrait collection. Thomas Hudson's portrait of the celebrated clockmaker *George Graham FRS* (*c.* 1740) is from Woodcroft's original Gallery.

In many galleries are objects whose quality of craftsmanship is such that they would be treasured in a museum of decorative art. There is a fine group of 10thc Islamic glass distillation apparatus; astrolabes from the 16thc Louvain workshops of the Arsenius family and 17thc German table clocks, which exhibit the finest precision metalworking of their period. The two largest concentrations of 'decorative' artefacts are to be found in the King George III Collection of Scientific Instruments and the Wellcome Museum of the History of Medicine. In the former are the instruments and apparatus amassed by George III and used in the education of his children. Particularly interesting is a large compound microscope finished in silver, made for the Prince of Wales in the 1780s and decorated in the neo-classical style. As might be expected, the very extensive Wellcome collections include a wide range of medical ceramics such as alborello vases, pharmacy jars and apothecary tiles. In addition, there are important collections of medically related artefacts from antiquity and non-European civilisations. These include faience amulets from Egypt and Roman statuettes in ivory, marble, bronze and silver.

The Museum has the following outstations: The National Railway Museum, York (q.v.); The Concorde Exhibition, Yeovilton; and the National Museum of Photography, Film and Television, Bradford (q.v.)

A museum shop sells guides, books, posters and souvenirs, plus a large number of other Museum publications, including recent exhibition catalogues. There is a tea bar.

PUBLICATIONS
J. T. van Riemsdijk, *Full Colour Guide,* 1980
G. B. L. Wilson, *The Children's Gallery Booklet,* 1979
Sir David Follett, *The Rise of the Science Museum under Henry Lyons,* 1978
Dr Brian Bracegirdle, *Wellcome Museum of the History of Medicine,* 1981

Sir John Soane's Museum

Assorted collection belonging to
Sir John Soane (1753–1837), including
important architectural drawings

13 Lincoln's Inn Fields, London WC2
tel. 01-405 2107

Tues–Sat 10–5 pm. Closed Sun, Mon and
Bank Holidays

Admission free

The architect Sir John Soane RA (1753–1837), famous for his work at the Bank of England, built a house for himself at 12 Lincoln's Inn Fields in 1792–94. In 1812 he added the neighbouring no. 13, which became the entrance façade, and finally in 1824 he rebuilt no. 14, making a disparate appearance to the three houses. He made continual alterations to the interiors and exteriors, which became his domestic quarters, drawing office and museum, with a splendid and unusual variety of internal spatial elements. The interiors brilliantly reflect the diverse range of the contents of the house, none of which fits a conventional pattern, and this very diversity adds lively interest to the fascinating and unique Museum. It was opened to the public on Soane's death in 1837 under a private Act of Parliament, which he had secured in 1833, with the intention of promoting 'the study of Architecture and the Allied Arts'.

Soane's large collection, begun in 1790, includes a considerable variety of works of art of all kinds: paintings, watercolours, drawings, engravings, sculpture, furniture, stained glass, architectural fragments, models, drawings and prints, Egyptian, Greek, Roman, Oriental and mediæval objects. His excellent library contains illuminated and other manuscripts, as well as over 7,000 volumes. The main emphasis of the collection is on architecture, there being some 40,000 drawings in the Study Room which may be inspected by appointment. Over 8,000 of the drawings are from the studio of Robert Adam. The most interesting aspect of the Museum is the collection seen as a whole in its original context.

Of particular note amongst the paintings in the Museum are the two series by Hogarth, the eight pictures of *The Rake's Progress* of 1732–33 from the Beckford Collection and the four pictures of the *Election* of *c.* 1754 from the Garrick Collection. Other works include paintings by Canaletto, Watteau, Reynolds, Turner, Eastlake, Francis Danby, Hilton, Lawrence (a *Portrait of Soane*) and Callcott. Amongst the many architectural drawings are works by Piranesi, Clérisseau, J. M. Gandy, J. R. Cozens and a large number by Soane himself. There is some fine sculpture: models for monuments, portrait busts and works by Flaxman, Banks, Westmacott, Chantrey, Gibson and others.

One of the outstanding items in the Museum is the alabaster sarcophagus of Seti I, discovered by Belzoni at Thebes and refused by the British Museum. It was obtained by Soane in 1824 for his museum and housed in the Sepulchral Chamber built in 1808–09.

The Museum is governed by four life Trustees and five others, representing the City of London, the Royal Society, the Royal Academy, the Society of Antiquaries and the Royal Society of Arts. There are postcards and slides for sale on the premises and *A Short Description* and *A New Description* (revised edn 1981), both by Sir John Summerson.

South London Art Gallery

British painting 19thC–20thC;
British prints (20thC)

Peckham Road, London SE5
tel. 01-703 6120

Tues–Sat 10–6 pm; Sun 3–6 pm.
Closed Mon

Admission free

The Gallery was opened in 1891 as a result of the endeavours of a local shopkeeper, William Rossiter, who, with the support of the painters Frederic, Lord Leighton (1830–96) and G. F. Watts (1817–1904) and the actor manager Sir Henry Irving (1838–1905), established the purpose-built gallery independently from the South London Working Men's College, with which it had formerly been connected. The building, whose façade was added by Maurice Bingham Adams (1849–1933) in 1902, was financed by the newspaper owner and philanthropist J. Passmore Edwards (1823–1911).

The Gallery holds regular exhibitions, showing selections from their permanent collection: an impressive assortment of about 300 Victorian paintings, with examples by such artists as Val Prinsep, Ford Madox Brown, Leighton and Watts. A small collection of 20thC paintings begun in 1953 includes work by Martin Bloch, Duncan Grant, Alan Reynolds and Christopher Wood, and from 1960 British 20thC original prints by Ayrton, Piper, Sutherland, etc., have been added annually. There is also a comprehensive collection of about 500 topographical paintings and drawings of Southwark.

Catalogues from recent exhibitions are available on the premises.

Tate Gallery

National collections of British art and Modern art

Millbank, London sw1
tel. 01-821 1313;
Recorded information: 01-821 7128

Mon–Sat 10–5.50 pm; Sun 2–5.50 pm

Admission free, except for major loan exhibitions

The Gallery was founded in 1897 by Sir Henry Tate (1819–99), who made a large fortune in London in the 1880s with his patented invention of 'Tate's cube sugar'. His collection of contemporary British paintings as well as the funds to build a gallery were offered as a gift to the Nation on condition that the Government should find a site for the gallery. The National Gallery of British Art (even then known as the 'Tate Gallery') was erected on ground formerly occupied by Millbank prison before its demolition in 1893. Tate chose as his architect Sydney J. R. Smith and in 1899 also paid for the Gallery's first extension. Subsequent extensions were funded by Sir Joseph Duveen to house the Turner paintings and drawings (1910), and by [Lord] Duveen for modern foreign art (1926) and sculpture (1937); in 1979 the Calouste Gulbenkian Foundation contributed to a major extension which increased the Gallery's exhibition space by 50%; and in 1980 the Clore Foundation announced a provision of £6 million to build the Clore Gallery for the Turner Collection, currently under construction.

Having started as a satellite of the National Gallery at the time of its foundation, the British Collection at the Tate does, to a certain extent, interweave with that at Trafalgar Square. The rationalisation, as far as was possible, took place after the Tate became a separate institution, which was not until 1954. The Tate has published a complete catalogue of works in the British and Modern collections annotated with the titles of works by the same artists in the National Gallery, demonstrating most clearly the extent to which the collections complement each other. It also reveals the importance of the Tate's British collection, with its much wider coverage of all periods from the Tudor to the present day.

Works in the collections at the Gallery total over 13,000, but only a proportion of these can be shown at any one time; it should be noted that over 6,500 of the works are prints and other graphics.

THE BRITISH COLLECTION This consists of works by British artists from the 16thC to *c.* 1900, including paintings and a selection of sculpture, watercolours, drawings and engravings. All the great names of British painting are represented. There is a particularly strong showing of the following: William Hogarth, William Blake, George Stubbs, John Constable and J. M. W. Turner. The Pre-Raphaelites are also well represented.

Marcus Gheeraerts, *Captain Thomas Lee*, 1594 (Tate Gallery)

William Hogarth, *The Graham Family*, 1742 (Tate Gallery)

Joseph Mallord William Turner, *Snow Storm: Steam-Boat off a Harbour's Mouth*, 1842 (Tate Gallery)

George Stubbs, *The Haymakers*, 1784 (Tate Gallery)

The earliest works are mainly portraits of the Tudor period, for instance, the beautiful *Portrait of a Lady* of 1569 (anon., British School) showing the twenty-one-year-old sitter decked with jewels. In 1979 six Elizabethan and Jacobean portraits, which had been on loan from Captain Loel Guinness since 1953, finally entered the permanent collection. Particularly arresting is the Gheerhaerts of *Captain Thomas Lee* wearing the masque costume of an Irish Knight. His legs and feet are bare to facilitate his progress through the watery bogs of Ireland. The charming group portrait by David Des Granges of *The Saltonstall Family* (*c.* 1636–37) shows Sir Richard Saltonstall bringing his two other children to the bedside of his wife Elizabeth, who has just been delivered of a baby.

There is a very good representative group of Hogarth's work, including two of the most popular of his paintings, *The Graham Children* and the study of the heads of six of his servants. For many years the six canvases of *The Marriage Contract* hung in the Tate, but in 1950 they were returned to the National Gallery. Stubbs is represented by a number of characteristic subjects, such as *Mares and Foals in a Landscape*, as well as the beautiful pair of paintings *Reapers* and *Haymakers*. Executed when he was sixty, they show the artist at his most classical and formalised. All three works were included in the large monographic exhibition devoted to Stubbs which was held at the Gallery in 1984–85. The style of English landscape painting in the 18thC was transformed from a dependence on 17thC Dutch models by Richard Wilson and his pupil, the too-little-known Thomas Jones, whose work will be a revelation to anyone seeing it for the first time.

The most attractive works by Constable are the landscape sketches: the exquisite and minute oil-painting *Brightwell Church and Village* was added as recently as 1980. Since 1906 an increasing number of the oil paintings and oil sketches bequeathed to the Nation by J. M. W. Turner have been transferred to the Tate from the National Gallery. These now occupy such a large part of the gallery space in the British section that the most radical changes will take place once the new Clore Gallery for the Turner Bequest is opened as a self-contained addition to the Tate. Some 19,000 drawings and watercolours also included in the Turner Bequest have, for reasons of space, been on deposit since 1930 at the British Museum, but they will rejoin the paintings and oil sketches in the Clore Gallery. The William Blake Collection is also unrivalled and occupies a specially darkened gallery of its own.

William Blake, watercolour of *The Entombment, c.* 1808 (Tate Gallery)

John Singer Sargent, *Claude Monet Painting at the Edge of a Wood*, 1888 (Tate Gallery)

John Everett Millais, *Christ in the House of his Parents*, 1850 (Tate Gallery)

Hilaire-Germain-Edgar Degas, *Petite danseuse de
quatorze ans*, bronze, 1880–81 (Tate Gallery)

Pre-Raphaelite painting is exemplified by a range of work from all the important figures associated with the movement, including the members of the original Brotherhood, latecomers such as Burne-Jones, and such peripheral figures as William Dyce, John Brett and James Smetham. The works by Rossetti are particularly fine, with a group from his patron George Rae. Many of the fringe Pre-Raphaelite pictures border on the complementary category of narrative painting. The Tate has outstanding examples of this genre, notably *The Last Day in the Old Home* by Robert Martineau, replete with significant detail; even more full of detail and incident is Frith's *Derby Day* of 1856. *Past and Present* by Augustus Egg uses a favourite Victorian device of painting a series of episodes, in this case on three canvases. Abraham Solomon contents himself with two for *Waiting for the Verdict* and *The Acquittal*, outstanding examples of mid-Victorian social realism.

It is not always remembered that the Tate is the home of some of the most popular Academic paintings of the 19thc. Three of these, Stanhope Forbes's *The Health of the Bride*; John Reid's *A Country Cricket Match*; and Dendy Sadler's *Thursday* (or the alternative and even better-known title *Tomorrow will be Friday*) were part of the original collection of more than sixty works presented by Sir Henry Tate. Most of the others, however, came through the Chantrey Bequest. The first purchases with the Chantrey money were made in 1877; by 1896 more than eighty works had been bought, and in the following year these were transferred from the South Kensington Museum and some provincial galleries to the Tate. As an indication of contemporary taste the Chantrey purchases are illuminating, but with few exceptions—as for example, Sargent's *Carnation, Lily, Lily, Rose*, Frank Bramley's *Hopeless Dawn*, Charles Furse's *Diana of the Uplands* and William Strang's *Bank Holiday*—they are not as well known as they might be. It is conceivable that, when given the opportunity, a present-day audience might come to admire John Collier's *The Last Voyage of Henry Hudson*

or *Between Two Fires* by Francis Davis Millet. In addition to Sargent's previously mentioned *Carnation, Lily, Lily, Rose*, remarkable for its subtle evening lighting, which could only be captured for a few minutes each day, there is his series of Wertheimer family portraits; two elegant male portraits, of Lord Ribblesdale and Graham Robertson; and the impressionistic study of *Claude Monet Painting at the Edge of a Wood*. The late 19thc is represented by impressive works by all the important Academic painters, but the Tate also wisely acquired works by Whistler while they were still unfashionable. As early as 1905, through the NACF, they added *Nocturne in Blue and Gold: Old Battersea Bridge*.

Only a very small part of the Tate's rich holdings of 19thc and 20thc sculpture is shown. The rest is for the moment in store.

THE MODERN COLLECTION This consists of works by British artists born from 1860, together with foreign works from Impressionism onwards. It incorporates the most extensive survey of British art of its period in any public collection and extends to selected examples of very recent art in the recently formed Gallery of New Art.

Since it includes artists who were active in the 1880s, this part of the collection to a certain extent overlaps with that of the British Collection, with the great realist subjects and the group of works by John Singer Sargent.

The luminous Wilson Steer beach scenes on the coast of France and in East Anglia date from the end of the 1880s, his *Interior with Mrs Cyprian Williams and her Two Little Girls* from 1891. From the 1890s come the earliest of a remarkable group of Sickerts, including the largest version of *Ennui*, which in subject matter and to a certain extent in treatment recalls Degas' *Sulking*, as well as the arresting image of *St Mark's, Venice* (1895–96). William Rothenstein's *The Doll's House* dates from 1899; from the following year comes the restrained and introspective *Self-Portrait* by Gwen John.

From the first decade of the new century come Orpen's *The Mirror* and James Pryde's *The Doctor*. Just pre-war, 1910–14, saw the finest 'Camden Town' works, of which the Tate has important examples, notably Bevan's *Cab Horse*, Gilman's *Canal Bridge, Flekkeford* of 1913, Ginner's *Victoria Embankment Gardens* (1912) and Gore's *The Cinder Path* (1912). Henry Lamb's *Portrait of Lytton Strachey* painted a year later strikes a startlingly original note with its formalised landscape and attenuated figure. By the beginning of the Great War the Vorticists—notably Bomberg—and Bloomsbury artists were experimenting with Abstraction. With the work of Ben Nicholson, Paul Nash, Henry Moore, Barbara Hepworth and others in the inter-war years, British art creeps towards the non-figurative viewpoint already well-established on the Continent. The English landscape tradition survived in the work of Graham Sutherland and the Neo-romantics.

From the post-war period come some remarkable groups: Francis Bacon and Stanley Spencer are well represented, Spencer with a number of the important religious subjects like the *Resurrection, Cookham* and the very large *Resurrection, Port Glasgow*. There are works by the Euston Road painters, Coldstream, Rogers, Graham Bell and Pasmore, whose aim was to return to everyday reality; all phases of Victor Pasmore's career are included, and it is most instructive to follow his progress into total abstraction. There is also a representative group of L. S. Lowry's work.

One can usually see examples of the definitive movements of the post-war period: 'Abstract' (Bridget Riley), 'Pop' (for example, Hockney's *Mr and Mrs Clark and Percy*, and Kitaj), 'Minimal', 'Conceptual' and New Art. There are important examples of British post-1960 art by Auerbach, Freud, Hodgkin, Long, and Gilbert and George.

The sculpture collection contains a great diversity of works: Alberto Giacometti, Jacques Lipchitz and Henry Moore are owned in depth and usually on view. These important groups are backed up by outstanding carvings and bronzes by Gaudier-Brzeska, Epstein, Gill and Hepworth and works by Dobson, Butler, Armitage and Paolozzi. There are also Degas's *La petite danseuse de quatorze ans* (1880–81), Rodin's *The Kiss* (1901–04) and Maillol's *The Three Nymphs* (all three purchased with NACF help); examples by Boccioni, Duchamp-Villon, Calder and Dali's surrealist *Lobster Telephone*, as well as abstract sculpture by Caro. New Art is well represented: Baselitz's *Adieu*, for example, and Beuys's *Felt Suit* (1970), four *Blackboards* (1972) and three recent *Vitrines*.

Buying the work of contemporary, and often highly experimental, artists has met with predictably mixed reactions from the public and press, but the furore over Carl Andre's 'Bricks' (*Equivalent VIII*, 1966) marked a limit of incredulity and now the group of minimal works by Judd, Hesse and Lewitt are generally admired.

Max Beckmann, *Carnival*, 1920 (Tate Gallery)

The acquisitions in 1983 for the modern collection are so wide-ranging stylistically that it is difficult to make generalisations; a vast work by Stephen Cox contrasts with no less than sixteen of Paul Maitland's small and exquisitely low-key urban landscapes, presented in memory of Terence Rattigan. Meredith Frampton's *Marguerite Kelsey* (1928), an apparently unambiguously precise representatation of the subject, which also contrives to be enigmatic, was given by the Friends of the Tate Gallery.

The development of painting abroad over the past century is traced in the foreign side of the modern collection, from Impressionism through Cézanne, Gauguin, Van Gogh, Bonnard, Matisse, Picasso, Braque, Futurism, Dada and particularly Surrealism (Ernst, Dali, de Chirico), to post-war European and American art, which includes works by the Abstract Expressionists Jackson Pollock, Willem de Kooning, Sam Francis, Robert Motherwell and Morris Louis. The Gallery in which hang the large, luminous canvases of Mark Rothko

George Grosz, *Suicide*, 1916 (Tate Gallery)

Pablo Picasso, *Nude Woman in a Red Armchair*, 1932 (Tate Gallery)

82

conveys the impression of power and richness, as well as of spirituality, a contrast to the group of American 'Pop' artists, Warhol, Lichtenstein (*Whaam!*), Jasper Johns and Rauschenberg.

Starting, like the modern British, with artists active in the 1880s and 1890s, the coverage of French Impressionism and Post-Impressionism remains remarkable in spite of the transfer to the National Gallery of works by Degas, Monet, Pissarro and Seurat (the very fine *Bathers, Asnières*) among others.

The history of the 20thC is charted through the experiments with perception by Bonnard and Vuillard, both represented by particularly beautiful interiors, as well as an example of one of Bonnard's *Bath* scenes; Picasso and Braque, both with Cubist works in addition to representational figure studies and still-lifes; Matisse with examples of early Fauvist composition and with the vast *papiers collées* of the last years; and Mondrian with his austere abstractions. The German Expressionist Room is dominated by Max Beckmann's *Carnival* (1920). The Ecole de Paris and Tachiste painters, de Staël and Dubuffet, and two COBRA artists, Constant and Jorn, lead up to the American experiments of Abstract Expressionism and 'Post-Painterly Abstraction'.

The present-day obsession with the conceptual and minimal shows some signs of giving way to a representational revival, but the Tate collection will reveal this tendency as it grows.

The Print Collection is part of the Modern Collection and contains about 6,500 prints by British and foreign artists. They date mostly from the mid-1960s to the present, but there are some examples from the earlier 20thC. Some prints are generally on view in the Gallery, and the Print Room is open through an appointment system for studying works not on exhibition.

The Tate has an active and well-subscribed association of Friends who enjoy certain privileges such as entry to the Gallery on some Sunday mornings. The money raised through the Friends has funded some significant purchases.

The Tate Gallery shop is very well stocked with publications, both their own, which are consistently excellent, and a large choice of related books on subjects covered by the collections. There are postcards, reproductions, slides and posters.

The Gallery restaurant, which has been completely refurbished to the designs of Jeremy Dixon, and its charming decorations by Rex Whistler recently restored to their full glory, is one of the few to offer a service comparable in quality and price to a commercial restaurant, including a serious wine-list. The Coffee Shop is quick, convenient and reasonably competitive in price. Both are apt to be crowded, a reflection of their quality in a part of London not well supplied with comparable amenities.

Pablo Picasso, costume design for the ballet *Parade*, *c.* 1917 (Theatre Museum)

PUBLICATIONS
The Publications Department of the Gallery publishes a wide range of material relating to the collections including the following:
Concise Catalogue of the Collections of the Tate Gallery, updated periodically
The Tate Gallery: an Illustrated Companion, updated periodically
The Tate Gallery Biennial Report, 1982–84 (latest published)
The Tate Gallery: Catalogue of Acquisitions, 1980–82 (latest published)

At present: Victoria and Albert Museum, London SW7
tel. 01-589 6371
From 1987: Flower Market, Covent Garden, London WC2

At present: Mon–Thurs, Sat 10–5.50 pm; Sun 2.30–5.50 pm. Closed Fri

Admission free

PUBLICATIONS
Spotlight, 1981
Catherine Haill, *Victorian Illustrated Music Sheets*, 1981
Images of Show Business, ed. by James Fowler, 1982
Stravinsky Rehearses Stravinsky: Photographs by Laelia Goehr, 1982
Catherine Haill, *Theatre Posters*, 1983
April FitzLyon and Alexander Schouvaloff, *A Month in the Country*, 1983
Oliver Messel, ed. by Roger Pinkham, 1983

Theatre Museum

The Museum was founded in 1974 and is at present housed at the Victoria and Albert Museum, but is closed to the public except for the Study Room, which is open by prior appointment. Towards the end of 1986, the Theatre Museum will move to its own premises in the old Flower Market, Covent Garden, where it will have three exhibition galleries.

The main areas of specialisation of the Museum are those concerned with the theatre, opera, ballet, dance, mime, pantomime, music hall, variety, puppets, circus and rock'n'roll, and its particular strengths are the history of London and British performing arts, Italian Renaissance, Gilbert & Sullivan operas, Diaghilev and the *Ballets Russes*, world circus and British theatre design.

Various collections have been incorporated since its foundation; of particular importance are the Arts Council of Great Britain and the British Council collections of theatre design, the British Puppet and Model Theatre Guild collection of puppets and the Society for Theatre Research collection. The Museum also has a Reference Library comprising 25,000 books, over 600 periodical titles and thousands of performance texts.

The Museum has an Association of Friends. Available is a continuing series of Theatre Museum Cards (98 published), each on a different topic, two or four sides punched and ready for binding in a Theatre Museum binder.

The Thomas Coram Foundation for Children, Foundling Hospital Art Treasures

Paintings, prints and sculpture (18thC–19thC)

40 Brunswick Square, London WC1
tel. 01-278 2424

Mon–Fri 10–4 pm. Closed weekends, Bank Holidays and at other times. Visitors are advised to telephone in advance

Admission charge

The Hospital was founded by Captain Thomas Coram (1668–1751), philanthropist, sea captain and trader, after a long struggle to establish a hospital for the 'maintenance and education of exposed and deserted young children'. It was built in Lamb's Conduit Fields in 1742. This building was demolished after the Hospital was sold in 1926, although later the Governors bought back part of the original site, and the present building, of which the architect was J. M. Sheppard, was completed in 1937. It incorporates the Governor's Court Room and staircase from the original building. The principal patrons of the Hospital were George II, William Hogarth (1697–1764) and George Frederick Handel (1685–1759).

The Foundation's collections came about after Hogarth had presented his *Portrait of Thomas Coram* of 1740, which inspired other artists to provide paintings for the Court Room and Picture Gallery. These include works by Gainsborough (*The Charterhouse*, painted when he was twenty-one), Reynolds (*2nd Earl of Dartmouth*), Richard Wilson (*St George's Hospital* and *Foundling Hospital*), Ramsay (*Dr Richard Mead*) and by Hudson, Highmore and Hayman, as well as earlier and later works. There is a fine bust by Roubiliac of *Handel* of 1739 and an interesting relief by Rysbrack of *Charity* of 1746. Handel presented an organ to the Chapel, which he inaugurated, and composed the Foundling Hospital version of the *Messiah* and the Foundling Hospital *Anthem*, the scores for which survive.

PUBLICATIONS
The major reference work, *The Treasures of the Foundling Hospital*, by Benedict Nicolson, 1972 is out of print

The art collection and Museum are incidental to the main work of the children's charity, which is funded partly by endowments and partly by local authority grants. There is a small sales desk where pamphlets on the collection are available.

The Tower of London, The Armouries

Arms and armour (early Middle Ages–20thC)

H.M. Tower of London, London EC3
tel. 01-480 6358

Mon–Sat 9.30–6 pm,
Sun 2–5.30 pm (Mar–Oct);
Mon–Sat 9.30–4.30 pm.
Closed Sun (Nov–Feb)

Admission charge for entry to Tower of London, but no additional charge for entry to Museum; charges may be made for special exhibitions

The Armouries occupy the following buildings within H.M. Fortress and Palace of the Tower of London: The White Tower, begun about 1078 by William the Conqueror and built by Gundolf, Bishop of Rochester (structural repairs and alterations were carried out between 1663 and 1709 under the superintendence of Sir Christopher Wren); Bowyer Tower, built in the mid-13thC, incorporating Roman vestiges (upper storeys rebuilt in the mid-19thC); New Armouries, built about 1664 by Thomas Norfolk, Bricklayer to the Board of Ordnance, and John Scott, Carpenter to the Board of Ordnance; and Waterloo Barracks, built by the Royal Engineers in 1845.

The Armouries of the Tower of London is the oldest public museum in Britain and now constitutes the national museum of arms and armour, one of the most important and comprehensive in the world. It shows armour and weapons, both European and Oriental, for war and sport, in a display furnished with excellent explanatory panels and in an environment, the historic atmosphere of which greatly enhances the exhibits.

The present collection was begun in the reign of Henry VIII and was already being shown to visitors in the reign of Elizabeth I. From the accession of Charles II, in 1660, it was open to the public. As well as the individual, often elaborately decorated, examples of arms and armour, there is on display a comprehensive collection of the armour and weapons used by the British soldier and sailor from the 16thC to the 19thC.

The most curious part of the display is the remains of the exhibition of the Line of Kings set up by Charles II, in which specially created wooden dummies and horses—two by the great Grinling Gibbons himself—were dressed up in armours of the 16thC and 17thC to represent the kings of England and later of Britain, from the Conqueror to Charles II, in order to demonstrate the continuity and legitimacy of the British Monarchy.

In the same room is a showcase that acts as a reminder of the old fanciful arrangement of the Spanish Armoury, which purported to show arms and instruments of torture captured from the Spanish Armada, a predictably popular exhibit.

Also of special interest are the personal armours of Henry VIII and several prominent Tudor courtiers and soldiers, many of them made in the Royal Workshops at Greenwich. On view as well are the armour of Charles I—its small size is startling—Charles II and James VII and II. Other notable armours are the 'Lion' armour, probably made in Italy or France *c.* 1550, which is richly decorated with embossing and damascening. An etched

Anon, English School, *Portrait of Henry Hastings KG, 3rd Earl of Huntingdon*, 1588 (Tower of London Armouries)

horse-armour, made for Count Pio Capodilista *c.* 1580, is interesting for having been reused for the Eglinton Tournament in 1839, and another example of animal armour is the unique elephant armour, which dominates the Oriental Gallery and which is thought to have been captured by Robert, Lord Clive, in the Battle of Plassey in 1757. Another remarkable exhibit is the 'Giant' armour, possibly made in Brunswick *c.* 1535 for a man approximately 6 ft 10 in. tall. At the opposite end of the scale is an armour, only 37½ in. high, which may have belonged to Jeffrey Hudson, dwarf to Charles I's consort, Queen Henrietta Maria, and two foot-combat armours for small boys from the 16thC armoury of the Dukes of Saxe-Altenburg on display in the Tournament Gallery, where there are weapons and armours for jousts and tournaments from the 15thC to the early 17thC.

In the Bowyer Tower there is a small collection of instruments of torture and punishment, including the block and axe used for the execution of Lord Lovat, as well as the notorious 16thC 'Scavenger's Daughter', which was used to compress the bodies of prisoners to extract confessions from them.

The grim nature of the objects in the collection, while perhaps riveting to schoolboys of a certain age, often leads the casual visitor to overlook the amazing artistry of the decorated exhibits. Gun stocks and barrels are ornamented with inlay in metal and ivory of the most exquisite delicacy; sword hilts of precious metal are wrought with chasing and engraving, decorated with enamelling and even set with precious stones.

The Crown Jewels at the Tower of London are displayed in the Jewel House. One of the most popular sights on the tourist's London route, these treasures need no further recommendation, but the often neglected aspect of this collection is that it contains important examples of historic metalwork which are hardly paralleled elsewhere. There would be more were it not for the lamentable pillage at the time of the Commonwealth when Charles I's execution was followed by the systematic destruction of the Royal ornaments, some of which seem to have dated from the early Middle Ages, and even possibly from the time of Edward the Confessor.

The crowns, orbs and sceptres and all the rest of the regalia—including the Imperial State Crown (used for State occasions and containing the great Ruby given to the Black Prince in the 14thC), St Edward's Crown (with which the Sovereign is crowned), Queen Victoria's small crown and the lovely small crown and diadem of Mary of Modena—are obviously the basis upon which the fascination of the collection lies, but the ornamental plate, with its association with Royal ceremony, is of great interest to the history of taste. Although most of the pieces in the treasure house are of 17thC or later origin, the Ampulla and Spoon, used for the anointing of the new Sovereign with holy oil at the most solemn moment of the coronation ceremony, are far older, possibly late 12thC (the Spoon) and late 14thC (the Ampulla). The banqueting plate no longer has any function in the Ceremony but is preserved and displayed with the regalia; the oldest piece is the so-called Queen Elizabeth's Salt made in 1572. The castellated Exeter Salt and the Plymouth Salt were accession presents to Charles II. The last occasion on which a banquet formed part of the ceremony was the coronation of George IV.

Experienced visitors will know that the time to view the Jewel House is in winter; at any other time there will be queues of varying length.

A large selection of publications and postcards are sold at the Tower.

Suit of armour made for the 3rd Earl of Southampton *c.* 1595 (Tower of London Armouries)

Stock of a flint-lock sporting gun ornamented by Jean Conrad Tornier, *c.* 1650 (Tower of London Armouries)

Tower of London, The Heralds' Museum

Heraldry

H.M. Tower of London, London EC3
Administrative address:
The Heralds' Museum,
College of Arms, Queen Victoria Street,
London EC4
tel. 01-584 0930

Mon–Sat 9.30–6 pm;
Sun 2–5.30 pm (April–Sept)

Admission charge included in entry fee for
the Tower of London

The Museum, founded by the College of Arms Trust, was opened in 1980. It is housed in a splendid Victorian building of about 1850, the architect of which is unknown. Once called Wellington Barracks (the foundation stone having been laid by the Duke of Wellington), it is now called Waterloo Building; it quartered about a thousand men.

The Museum demonstrates the development of heraldry from the 12thc onwards. Heraldry, as we now understand it, did not begin to evolve until the 12thc, the first true Coat of Arms being that of Geoffrey Plantaganet, Count of Anjou, which dates from about 1127. Exhibits of applied heraldry include fine examples of MSS, glass, precious metals, porcelain, textiles and other artefacts. Particularly fascinating are the highly coloured and gilded crowns and crests and the painted shields and banners of famous men.

The Museum is administered by the Trustees of the College of Arms Trust. It has a shop that sells heraldic books, as well as postcards and souvenirs with heraldic relevance.

United Grand Lodge of England, Library and Museum

Items associated with Freemasonry,
regalia, medals, glass, porcelain and plate

Freemasons' Hall,
Great Queen Street, London WC2
tel. 01-831 9811

Mon–Fri 10–5 pm. Closed Sat, Sun
and public holidays

Admission free

The Museum was formed in 1837 from a small collection of artefacts in Freemasons' Hall, where it is still housed, although the present Hall is the third such building in Great Queen Street. It was built in 1927–33 as a memorial to all the members killed in the First World War. The architects were H. V. Ashley (1872–1945) and Winton Newman (d. 1953) who submitted the winning design in an international competition under the auspices of the RIBA with a panel of judges chaired by Sir Edwin Lutyens.

In the Museum are examples of British and foreign Masonic regalia—principally embroidered (silks, beadwork and wirework), engraved and hand-painted aprons—as well as Masonic medals and British and Continental drinking glasses and decanters with Masonic

Meissen porcelain figure of a Freemason, after a model
by J. J. Kändler, late 18thc (United Grand Lodge)

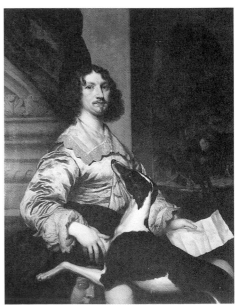

William Dobson, *Sir John Valence, c.* 1660
(Valence House)

decoration from the mid-18thC to the present day. Rarities include Beilby fired enamel glasses and a rare Bristol blue decanter of *c.* 1770 decorated with gilt.

The Grand Lodge owns large collections of English transfer printed creamware, Sunderland lustre-ware, an important collection of Quianlong export porcelain, Meissen and Berlin figures, examples of Worcester, Wedgwood, Doulton, Crown Derby, Continental and American commemorative plates and a small collection of Goss porcelain.

The plate collection includes presentation pieces in silver, silver-gilt and Sheffield plate, with salvers, loving cups and candelabra. They also own an important massive silver centrepiece of 1838 by Robert Garrard, an Indian silver presentation casket to the Prince of Wales of 1875 (later Edward VII) and a Dutch parcel gilt beaker.

The collection of datable jewelled and enamelled badges identifying the different Lodges constitutes a valuable documentary group of examples of workmanship in gem-cutting and setting, and enamelling techniques.

Of historical curiosity is a collection of Prisoner of War relics, *c.* 1790–1945, including items by Napoleonic prisoners of war.

PUBLICATIONS
Sir James W. Stubbs and T. O. Haunch, *Freemasons' Hall: Home and Heritage of the Craft*, 1984

Valence House Museum

English painting (portraits of the Fanshawe family from *c.* 1525–1941)

Becontree Avenue, Dagenham
tel. 01-592 2211

By appointment Mon–Fri 10–5 pm; Sat 10–12 pm. Closed Sun

Admission free

PUBLICATIONS
The Fanshawe portraits have been fully catalogued, *Fanshawe Family and Other Portraits*, by James Howson, published for the Museum by the London Borough of Barking and Dagenham, 1983

Valence House is a 17thC manor house standing on an ancient moated site which was established as a Museum of Local History in 1938. It contains a remarkable series of portraits of members of the Fanshawe family who owned the manors of Parsloes in Dagenham and Jenkins in Barking for some 350 years. These range in date from the reign of Elizabeth I to 1941, with a large group concentrated in the 17thC and early 18thC. The portraits, including works by Marcus Gheerhaerts, William Dobson, Sir Peter Lely, Sir Godfrey Kneller and others hang in panelled rooms, with appropriate period furniture loaned by the Victoria and Albert Museum. There are some other English portraits, notably *Carew Harvey Mildmay* by Jonathan Richardson, *c.* 1730–40. The local history collections include a number of pictures of Barking painted by Thomas Wakeman (1812–78) who also worked in America.

There is limited parking space at the house, but a free public car-park is only 200 yards away.

Victoria and Albert Museum

Comprehensive display of Western and Oriental decorative and applied arts (antiquity–present day); prints and drawings; paintings; sculpture; costumes; jewellery

Cromwell Road, London SW7
tel. 01-589 6371

Mon–Thurs, Sat 10–5.50 pm; Sun 2.30–5.50 pm. Closed Fri

Admission free, except for some special exhibitions

The Museum was the brain-child of Prince Albert, the Prince Consort, and came into being in 1852 in the aftermath of the Great Exhibition of 1851. It is a permanent memorial to his preoccupation with the improvement of design and manufactures in a way that the Exhibition, by its very temporary nature, could never be. As constituted in the present day, however, the Victoria and Albert is less than a century old. It was only at the end of the 19thC that the organisation of the Museum was rationalised and the inappropriate departments housed elsewhere, notably the Sciences, which were to form the nucleus of the new Science Museum across the road.

The original establishment which had been conceived as a Museum of Manufactures—shortly renamed the Museum of Ornamental Art—was soon submerged beneath the weight of works of art such as paintings and master drawings, whose inclusion in the collections is often anomalous, the accident of a sympathetic conjunction between curator and donor, rather than of rational planning according to the original conception.

The complex history of the evolution of the Victoria and Albert through its various metamorphoses—as the South Kensington Museum, for instance—has often been told, recently and in great detail by John Physick in *The Building of the Victoria and Albert Museum* (1982), as well as more briefly in Anna Somers Cocks's *The Victoria and Albert Museum: The Making of a Collection* (1980). Involved in the decoration of the structure were Philip Webb and E. Burne-Jones (the Green Dining Room), E. J. Poynter (the Grill Room), Frederic, Lord Leighton (the frescoes in rooms 102 and 109), Owen Jones and Godfrey Sykes, who provided a wealth of ornamental detail to clothe the building with 'the craftsmanship

Agostino di Duccio, marble relief of the *Virgin and Child*, mid-15thc (Victoria & Albert Museum)

and humanist idealism of the Renaissance'. The present main façade on Cromwell Road, surmounted by a colonnaded open cupola, is the work of Sir Aston Webb (1849–1930), who was chosen as a result of a National Competition in 1890. The foundation stone was laid by Queen Victoria and the task of bringing order to the heterogeneous collection of galleries began in 1899 and was completed after nearly ten years in 1908. Most of the alterations and additions in the 20thc have been within the original structure and consist of, for instance, adapting the old boilerhouse to house the Conran Foundation which concentrates on the manufactures of the present day, a long overdue return to the spirit of Prince Albert's original conception.

Recently, too, many of the most striking original internal features, such as the tiled Grill and 'Gamble' rooms and Morris and Co.'s Green Dining Room, which had been allowed to deteriorate when they were no longer required to fulfil their original functions, have been carefully restored. The new concern with 19thc schemes in interior decoration in purpose-built museums has led to the preservation of many elaborate decorative details which had been under threat. Since the early plans for the Museum included a display of building materials and ornamental details, which are incorporated into the fabric, the building is as much a museum as its contents, as had been intended by Prince Albert and his fellow planners Sir Henry Cole (1808–82) and Captain Fowke (1823–65). The remaining evidence of these early intentions is the small but uniquely valuable display of architectural fragments and decorative details tucked away beside the shop on the ground floor where it is often overlooked.

The exhibits of decorative and applied arts are housed, broadly speaking, in either 'primary' galleries, many of which are arranged as room-settings (or period rooms which should be regarded as exhibits in their own right), in an historical or cultural sequence; or in the subsidiary study collections categorised, to conform with many of the curatorial departments, by manufacturing material, i.e., woodwork, metalwork, ceramics, textiles, etc. A special display is devoted to the Jones Collection of the arts of France, largely consisting of 18thc French furniture, which was bequeathed to the Museum in 1882 on the condition that it remained intact. Such well-known objects as the Great Bed of Ware or the polychrome marble sculpture by Matthew Digby Wyatt of the Dog Bashaw are in the primary galleries of the appropriate date. These displays are dominated by the Museum's unrivalled furniture collection. Fine examples of documented 18thc pieces by William Kent and William Vile are matched in the 19thc by the immaculate workmanship of Gillows and Crace, or the Gothic inventions of Pugin and Burges and the proto-Arts and Crafts designs of William Morris. The most elaborate 19thc pieces come from the International Exhibitions of the period. Recently constituted is a new primary gallery containing the display concerned with the 20thc, a study collection of unparalleled comprehensiveness.

The National Art Library has been part of the Museum since the very early days in the 1850s.

On loan from Her Majesty the Queen are the Raphael Cartoons, used by the Mortlake Tapestry Works in the 17thc, which are housed in the specially built Cartoon Court.

Owing to the enlightened collecting policy of Sir J. C. Robinson, the Museum's first Curator, the Sculpture Department has the best collection of Italian Renaissance sculpture outside Italy. As early as 1858 he bought Rossellino's *Virgin and Laughing Child*, still today one of the most popular exhibits in the Department. Other purchases included the Gherhardini Collection of artists' sketch models, then alleged to contain several works by Michelangelo, of which only one has survived the test of modern scholarship. The Gigli-Campana Collection yielded further great treasures, including works by, for example, Donatello—the ravishingly beautiful *relievo stiacciato* (shallow relief) *Ascension with Christ Giving the Keys to St Peter* and the large marble relief of the *Dead Christ Tended by Angels*—Verrocchio, Sansovino and Luca della Robbia, the *Labours of the Months*. The collection of Renaissance bronzes, medals and plaquettes, begun by Robinson, expanded by two of his successors, Eric Maclagen and Sir John Pope-Hennessy, and greatly enriched by items from the Salting Bequest, is remarkably comprehensive. There are fine examples of Riccio (the famous *Shouting Horseman* from Salting), Vittoria, Giovanni da Bologna, Pisanello and the recent major addition in 1976 of *The Chellini Tondo* by Donatello. A bust of Giovanni Chellini, a Florentine doctor, by Antonio Rossellino is also in the collection. The large-scale marble sculptures include the Giovanni da Bologna group *Samson Slaying the Philistine* and the marvellous Bernini bust of Thomas Baker. Recently the group of life-size Rodin bronzes given by the artist to the Museum has been returned from Bethnal Green (q.v.).

Comparable in comprehensiveness and quality with the Italian Renaissance material is

Detail from the border of an Elizabethan embroidered table-cover, late 16thc (Victoria & Albert Museum)

Paul de Lamerie, the 'Newdegate' centrepiece
(Victoria & Albert Museum)

the section devoted to British sculpture. Notable are the Flaxman sketch models for memorials and the examples of monumental and decorative schemes by Alfred Stevens.

Also part of the sculpture collection are the European works in carved ivory, alabaster, wood and mother-of-pearl; modelled wax and engraved gems are also included.

The Cast Court, which was one of the great features of the original foundation, has recently been restored to its full polychrome glory.

The fine collection of costume is shown in a recently redesigned display in the Costume Court and is exceptional for the number of rare early examples of complete suits of clothes in excellent condition, as well as the overall coverage of the history of this subject right up to the present day. The outstanding Devonshire Hunting Tapestries dominate the Gothic Tapestry Court.

The textile collection is noted for the fine group of William Morris's work, but it is rich in many other areas, particularly early embroidery and tapestry weaving. The lace collection has recently been catalogued and is revealed as one of the largest and finest in the world (Santina Levey, *Lace: A History*, 1983).

The metalwork collections cover all branches of manufactures in metal from the Middle Ages onwards, including clocks whose cases are of metal and such bronze vessels as have escaped the label of 'fine art'. Thus the earliest known dated English clock of 1588 is here because it is of gilt brass ornamented with engraving in the manner of Etienne Delaune and Abraham de Bruyn, whereas wood- or buhl-cased clocks are in the Department of Furniture and Woodwork. Similarly, bronze mortars or bells are kept in the Metalwork Department unless their makers are of sufficient importance to be of interest to the Department of Architecture and Sculpture.

The metalwork collection is now so bewilderingly rich and comprehensive in its coverage of the subject that it is curious to reflect that the first object acquired by the Department was an insignificant and certainly mundane pair of hinges (described as 'Hinges, pair of Turned iron') and some of the very early acquisitions (i.e., before 1851) were equally humble. From the time of the Great Exhibition, however, the character of the purchases changed dramatically, and the foundations of the unrivalled display of gold- and silversmiths' work, church plate and domestic wares, inlaid work (i.e., arms and armour), metal-cased clocks and watches, jewellery and *objets de vertu* were laid. The policy of purchasing from the 19thc International Exhibitions has ensured that the Department holds a number of documented pieces which can often be used to establish the authenticity of related material. It has also meant that, ahead of almost all other museums in this country, the Victoria and Albert Museum had a nucleus of important 19thc objects.

Diamond-set aigrette in the form of a flower bouquet,
late 18thc–early 19thc (Victoria & Albert Museum)

In the jewellery gallery are shown over 5,000 objects in precious materials, ranging in date from a small and not particularly distinguished group of Greek, Etruscan and Roman pieces to the work of contemporary craftsmen and designers. Some of the finest Renaissance jewellery outside European collections is exhibited: the 15thc and 16thc material is of amazingly high quality considering the relatively short space of time in which it has been amassed and that it does not have a nucleus of a Royal or princely collection as in the main European *Schatzkammers*. Notable English jewels include the 'Armada' jewel, the 'Barbor' jewel and the 'Danny' jewel. Important documentary items from all periods include a part of the famous 'Cheapside Hoard' (see also Museum of London, p. 57); the group of dated Spanish jewellery from the shrine of the Virgin of the Pillar, purchased in 1871; marked Russian 18thc diamond jewellery from the Imperial collection; Pugin's 'Marriage' jewellery, designed for his third wife in 1849 and shown at the 1851 Exhibition; a very important group of English Arts and Crafts jewellery; and signed pieces by René Lalique bequeathed by Sir Claude Phillips. One of the best-known pieces in the collection, the baroque pearl and gold merman pendant known as the 'Canning' jewel, has a mysterious history: bought in Delhi after the Mutiny by Lord Canning (Governor General, then Viceroy of India), it is of European 16thc manufacture and its previous provenance is still unexplained. In 1975 the collection on loan from Dr Joan Evans, one of the most eminent scholars in the field, was converted into an outright gift, thus greatly enriching the coverage of the 17thc and 18thc. The collection of finger-rings, many of them documentary, is one of the most important in the world.

The 18thc collection is unrivalled for its variety. The large collection of inscribed memorial jewellery provides a useful body of documentary material, as does the large group of local and traditional jewellery; the separation of this latter category is unique outside the context of a folk museum and is wide-ranging in its coverage.

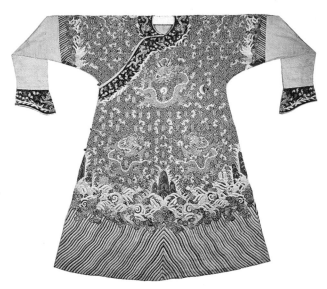

Tapestry-woven Imperial Sacrificial robe worn by the Emperor for the Sacrifice to the Earth, Yong-zheng 1723–35 (Victoria & Albert Museum)

Chinese porcelain dish with pea-fowl design in underglaze blue, Yuan Dynasty, mid-14thC (Victoria & Albert Museum)

The collection of domestic and ecclesiastical plate covers all important developments since the 16thc; the Museum is now able to concentrate its purchasing efforts on items of particular significance or rarity. Among these must be numbered the exquisite Burghley Nef of 1542; the Christian van Vianen silver dish of 1635 worked in *repoussé* with monstrous fish; G. M. Moser's *Apollo and Daphne* candlesticks (for which the designs exist in the Prints and Drawings Department); the Walpole Salver, believed to have been engraved by Hogarth, which was made by Paul de Lamerie in 1728–29; also by de Lamerie, the Newdegate centrepiece (acquired in 1919, the first piece by this maker to enter the collection); the centrepiece in the form of a trellis-pierced tureen borne on the backs of finely chased and modelled kids by Nicolas Sprimont, a very rare work by this Liègeois silversmith who later became part proprietor of the Chelsea Porcelain factory; and the fantastic Gothic-style silver mounted decanter, designed by William Burges and made in 1865, which incorporates Greek and Roman Coins, panels of malachite, carved ivory and gemstones into the elaborately wrought silver mounts.

As well as the primary displays of Indian, Near Eastern and Far Eastern art, where the Museum's most notable items are shown, the textile and ceramic study collections include large groups of Chinese, Japanese and Persian material. This is one of the largest accessible displays in the West: the Chinese collection is very broadly based and includes the export ceramics and late porcelain of the Qing Dynasty. The Japanese ceramics include early tea-wares and some examples from the Joman period (2ndc AD).

The Chinese primary collections are based on a chronological display from the Neolithic period (2nd millennium BC) to the present day. Notable are the very fine Tang tomb figures, horses and a camel, and this is the best collection of Chinese hardwood furniture on display anywhere in Europe. Some costume is also included, but the textile study collection has rare examples of woven silk, mainly patterned, and embroideries, i.e., Chinese export shawls. A rarity in this country is the Korean art, comprising a small display mainly of ceramics. There is a study display of carvings in stone, bamboo and jade, and a large collection of snuff bottles. Chinese glass is a great rarity, and this is the only place in the British Isles, with the exception of Bristol, where it may be seen. The greater part of the Japanese collection is made up of the decorative arts post 1600 AD. The lacquer collection is exceptional, as are the textiles, and the display of netsuke is composed of approximately 150 of the most choice from a vast collection. There is a rotating display of Japanese prints.

The Indian primary galleries reflect the Western taste for sculpture, miniatures, rugs and Mogul hardstone carving. The emphasis is on incredibly refined execution, and a very simple and uncluttered arrangement permits careful examination of the workmanship.

The European ceramics collection is comprehensive in its coverage and in the variety of examples from every factory of any consequence right up to the present day. The strength of the 18thc holdings is in part due to Lady Charlotte Schreiber (1812–95), whose famous collection was presented to the Museum in 1885. Some of the French porcelain is shown with the Jones Collection of which it forms a part. There are glass vessels of all countries and periods from the 15thc BC to the 20thc AD, as well as stained glass from England, France, Germany, Holland and Flanders from the 13thc–19thc.

The Theatre Museum collections, which until recently were part of the Museum, are at last to be appropriately housed in a specially converted building in Covent Garden.

HENRY COLE WING The large Prints and Drawings Department contains more than a million items, with the emphasis on decoration and design, but incorporating very fine miniatures, particularly of the Tudor period, and the national collection of watercolours. There is a massive amount of related material, including prints, a recently constituted specialist collection of photographs, as well as posters and wallpapers.

A full account of the national collection of watercolours would amount to a history of the British watercolour school; all the major artists are well represented, with, notably, the unrivalled group of three hundred Constable watercolours, drawings and sketchbooks.

It should not be overlooked what a very important 20thc collection of drawings and watercolours has been built up, mainly since 1960. The adventurous buying policy has recently secured works by Soulages, Plackman, de Staël, Penck, Bruce McLean, Beuys, etc., to add to the existing holding of early 20thc watercolours by members of the Aesthetic movement such as Rackham, Ricketts and Dulac, and of the New English Art Club: Derwent Lees, J. D. Innes, Sargent and Wilson Steer. The Slade School artists are represented (Gwen and

John Constable, *Watermill at Gillingham, Dorset*, 1827 (Victoria & Albert Museum)

A GARDEN BY THE SEA

Page from a manuscript, poems illuminated by
William Morris for Lady Burne-Jones
(Victoria & Albert Museum)

Augustus John, McEvoy and Orpen); and there are characteristic watercolours by Bevan, Gilman, Ginner and Gore, all founder members of the Camden Town group.

The group of works by the Vorticists is notable for the twenty-six outstanding watercolours and pastels by Wyndham Lewis, covering the crucial years 1909–17, collected by Captain Lionel Guy Baker with the help of Ezra Pound. The European schools include Cézanne's *Study of Trees* (1887–89), Derain's *Dancers* (c. 1905–07) and watercolours by Leger, Exter, Sonia Delaunay and Klucis; Nolde represents German Expressionism, as do Kirchner, Pechstein, Kokoschka, Schlemmer and Rohlfs. There are also works by Matthew Smith, Paul Nash, Henry Moore and Stanley Spencer, and Surrealist images by Burra, Tunnard, Armstrong, Wadsworth and Banting.

Among the abstract works are constructivist compositions by Ben Nicholson, Merlyn Evans, etc. Landscape artists such as Bawden, John Nash, Ravilious, Piper and Sutherland are represented. Watercolours by the American abstract expressionists Francis, Gottlieb, Jenkins and Helen Frankenthaler illumine the close links with their English contemporaries: Roger Hilton, Peter Lanyon and Terry Frost, as well as William Scott, Heron and Hoyland.

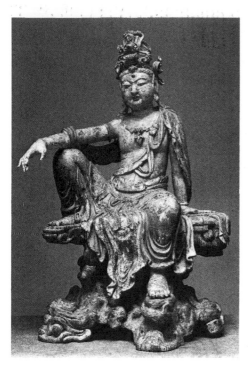

Chinese painted and gilt wood Guan-Yin, Song Dynasty (Victoria & Albert Museum)

Thomas Gainsborough, moonlight landscape painted on glass and lit from a show-box behind, early 1780s (Victoria & Albert Museum)

The pioneers of Pop Art, Paolozzi and Peter Blake, are represented by collages and from the 1960s there are some by Kitaj, Tilson and Boshier, and pin-ups by Allen Jones. Works by Oldenburg, Jasper Johns and Larry Rivers are included from the American School. Finally, there are meticulously executed drawings and watercolours by David Hockney, some photo-realist works, a conceptual *Map Walks* by Tom Phillips and abstract watercolours and gouaches by John Walker.

The Museum also covers designs for all the decorative arts of the 20thC and all aspects of commercial graphics, from posters to letter headings and sugar wrappers.

The vast and useful collection of decorative drawings is enhanced by the inclusion of watercolours and Old Master drawings which have slipped into the collection in bequests, especially that of Alexander Dyce (1869), or through the buying policy of earlier curators who chose to overlook the Museum's decorative bias. There are, however, designs for tapestries, jewellery and virtuosi goldsmiths' work by artists from the circle of Raphael, i.e. Giulio Romano, Perino del Vaga and Polidoro. The large collection of architectural drawings includes important works by most of the major English architects: Wren, Hawksmoor, Vanbrugh, Adam, Chambers, Soane, etc., as well as Seddon and Godwin. The decorative art collection is of incalculable value to the historian; it covers every conceivable aspect of decorative and applied art and design and is backed up by prints, both original and reproductive.

Beautiful miniatures from the Salting Bequest were added in 1909, including a great rarity, the *Portrait of Anne of Cleves* by Holbein, and Hilliard's best-known work, *The Young Man Among Roses*. The collection of miniatures is enormous, containing representative examples of 18thC and 19thC work as well as the earlier treasures.

The decision to incorporate the fast-growing specialist collection of photographs into the Department of Prints and Drawings was taken in 1977 and already more than four thousand examples have been accumulated, ranging from masterpieces of early photography by, for instance, Fox Talbot and Julia Margaret Cameron, to the innovators of the present century, Cecil Beaton, Bill Brandt, etc., and the highly experimental, technically sophisticated work of the present day.

The greatest decorative arts museum in the world is not the most appropriate place for paintings and those that they have, now housed with the prints and drawings in the Henry Cole building, represent the most space-consuming anomaly in the collections. Apart from the outstanding and unequalled group of Constable oil sketches, the oil paintings are with few exceptions not remarkable in the context of a national museum, though there are some interesting and curious items. John Sheepshanks (1787–1863) gave his collection of contemporary British paintings to the Museum in 1857, including works by Wilkie, Mulready, Landseer, Frith, Parris and Redgrave, as well as six paintings by Constable, one of which, *Salisbury Cathedral*, is among the finest in the collection. The nucleus of the national collection of watercolours also came from Sheepshanks, who gave 298 examples with his paintings collection. Several of these watercolours are highly finished 'exhibitable' works of art and are classified as paintings.

One of the only surviving panoramas in this country, an extensive view of Rome by L. Caracciolo, dated 1826, is exhibited in a specially-built circular gallery. Also exhibited in a back-lit showcase are Thomas Gainsborough's landscape transparencies painted on glass. Another aspect of landscape, painted *sur motif* directly from nature, is exemplified by a series of minute oil-sketches by Benjamin West.

In 1864 J. C. Robinson bought what is undoubtedly the most impressive painting in the Museum and among the earliest, the twenty-one-foot high Spanish altarpiece of *St George*, attributed to Marzal de Sas (*fl.* 1393–1410). Robinson was aware of its marginal relevance to the Museum's decorative art collections but justified the purchase by stressing its 'architectural and ornamental character.' This is one of the very few paintings not displayed in the Henry Cole Wing.

Bequests from the Rev. Chauncy Hare Townshend (1869) and J. M. Parsons (1870) gave the Museum a group of mainly 19thC foreign paintings, supplemented in 1882 by the French 18thC paintings in the Jones Collection. The Townshend Bequest includes a group, unique in this country, of 19thC landscapes by Swiss artists, A. Calâme being the most distinguished. In 1900 the bequest of the Ionides Collection was to bring to the Museum its most important foreign works, Botticelli's *Portrait of Simeralda Bandinelli* which had belonged to Rossetti, an early Rembrandt, the *Landscape with Peasants* by Louis le Nain, a Delacroix, a Millet and a great Degas theatre subject, *The Ballet Scene from the Opera, Robert le Diable*, dating

from 1876. The Ionides connection with the Pre-Raphaelites and other contemporary British artists is reflected in the choice of works by Watts, Burne-Jones and Rossetti.

Both buildings, the main Museum and the Henry Cole Wing, have shops. The small Henry Cole shop sells only catalogues, museum publications and postcards, but the main shop is altogether more ambitious and is the nearest thing in this country to the well-stocked American museum shop. Once located in the main entrance hall, it has recently been moved to a gallery on the left side, thereby restoring the original entrance hall vista. But the move has in no way diminished the variety of the shop's stock. As well as the Museum's own publications and postcards, a large selection of art books, replicas and children's craft packs is available. The list of publications is so extensive that it cannot be reproduced here; it is available on request from the Museum.

The Museum has an excellent cafeteria, which, though large, is very well used and is apt to be crowded. There is an active and rapidly growing Friends Association.

In addition to Apsley House (q.v.), the Bethnal Green Museum (q.v.), and the Theatre Museum (q.v.), the Victoria and Albert Museum also administers as outstations Ham House and Osterley Park, both of whose furniture collections are augmented by appropriate items from the Museum itself.

Wallace Collection

British and Continental painting and miniatures and Continental furniture (16thc–19thc); sculpture, decorative metalwork, pottery, enamels and jewellery (14thc–18thc); French furniture and porcelain (18thc); European and Oriental arms and armour

Hertford House, Manchester Square, London W1
tel. 01-935 0687

Mon–Sat 10–5 pm; Sun 2–5 pm

Admission free

Quite unlike any other major collection in this country, the Wallace Collection has a fascinating and singular history of its conception. It ranks as one of the most important collections of three centuries of European fine and decorative arts in the world and is displayed in surroundings which still retain the ambiance of a private house. Hertford House, formerly Manchester House, was built by Joshua Brown from 1776 to 1788 for the 4th Duke of Manchester in the square he owned, and which had good duck shooting nearby. The 2nd Marquess of Hertford took the lease in 1797 and made some additions to the house. It was subsequently used as the French Embassy until 1851, after which it remained unoccupied for twenty years. Sir Richard Wallace resumed occupation of the house after an obscure architect, Thomas Ambler, had made considerable alterations from 1872–75 to house his rapidly increasing collections. The house was converted into a museum between 1897 and 1900 and more recently air-conditioning has been incorporated and a comprehensive redecoration has taken place.

The contents of the Wallace Collection reflect the preferences of several generations of collectors, and closely mirror the taste of the period, with the emphasis on Italian 16thc painting and sculpture, Dutch and Flemish 17thc painting and French 18thc paintings, fine furniture and porcelain. The 18thc Italian paintings—that is, the Canalettos of Venice—and the British portraits come from the more random accumulations of earlier generations.

Richard Seymour-Conway, 4th Marquess of Hertford (1800–70), having chosen to live in Paris at the age of thirty-five, proceeded seven years later to build up a collection in a determined fashion with over £250,000 to spend a year. His father, grandfather and great-grandfather before him had collected, and in 1834, at the death of the 2nd Marchioness, Hertford House was adequately embellished with an assortment of works of art. The 4th Marquess's predominant interests were in French 18thc furniture and in his collection of paintings, works of outstanding quality and distinction, which he chose with skill and acumen. His principal means of purchase was through an agent, Samuel Moses Mawson (1793–1862), whom Lord Hertford trusted implicitly. Often Lord Hertford himself never saw the works before they were bought in sales and rarely made a personal appearance, living in Paris as a recluse. The fascinating correspondence between the two has been published and covers a period of activity from 1848 to 1861. This was a crucial moment in the history of collecting, with some spectacular sales taking place both in Paris and in London. Lord Hertford's funds were rivalled only by the Rothschilds, not by any national gallery.

Lord Hertford's illegitimate son, Richard (Jackson) Wallace (1819–90), was also his heir after he had changed his will, which had originally been in favour of Lord Henry Seymour, the Marquess's younger half-brother. Richard Wallace was brought up in Paris by his grandmother, the 3rd Marchioness, and later became secretary to Lord Hertford. He began

One of a pair of French bronze garden vases from the Château de Bagatelle, 17thc (Wallace Collection)

to form a collection on his own account, which, however, he was forced to sell in 1857, having run badly into debt. In 1870, on the death of Lord Hertford, Richard Wallace inherited his magnificent collections and all his property. In the same year Wallace made a name for himself in connection with large sums of money which he gave for victims of the Prussian siege and occupation of Paris during that winter. In 1871 Wallace, created a baronet by Queen Victoria, began to move his collections to London and continued to add to them, in particular the acquisition of the extensive and splendid collection of Renaissance decorative art and arms and armour from the Comte de Nieuwerkerke (1811–92). At the same time he bought significantly from the famous collection of arms and armour of Sir Samuel Meyrick (1786–1848). On the whole, Wallace's choice was remarkably similar to that of Lord Hertford (Lord Hertford had even bought pictures from Wallace's sale in 1857). He and Lady Wallace, whom he had married in Paris in 1871, moved to London in 1872. The collections, meanwhile, were exhibited temporarily at Bethnal Green Museum for three years and attracted five million visitors. In 1875 they were returned to Hertford House and the Wallaces moved in and lived there and at Sudbourn Hall in Suffolk. Later Wallace lived at Bagatelle, the small château he inherited in the Bois de Boulogne, a recluse like his father. He died there in 1890, his son Edmond Richard having predeceased him by three years. He bequeathed everything to his widow and she in turn left those of his collections housed on the ground and first floors of Hertford House to the Nation on her death in 1897. Under her will there were stringent conditions attached to the bequest, most notably that the collection be kept together, 'unmixed with other objects of art, and shall be styled the *Wallace Collection*', and that new premises be built on a site provided by the Government. In 1897 plans were proposed to house the collection to the west of the National Gallery. However, the lease on Hertford House was secured and alterations were made. It was officially opened to the public by the Prince of Wales in 1900.

The very first sight to greet the visitor to the Wallace Collection is the main staircase with its magnificent balustrade of forged iron and bronze, chased and gilded, made between 1733 and 1741 for the Palais Mazarin, now the Bibliothèque Nationale in Paris. It was sold as scrap-iron when the Palais Mazarin was reconstructed (1855–62), but is now regarded as the finest example of French iron and bronze work of the period.

The ground floor galleries contain most of the early decorative works from the 14thc–18thc, with, in Gallery 3, the emphasis on bronzes and other sculpture, Limoges enamels and glass, and, in Gallery 4, earthenwares (with maiolica prominent) and stoneware from the 15thc as well as Isnik wares. The arms and armour collections are also on the ground floor. The strength of these are in elaborately decorated 'parade' pieces and in the comprehensive spread of Oriental armour and weapons unmatched elsewhere in this country.

The Old Master paintings, the best-known—and best-loved—of which is Hals's *Laughing Cavalier*, are outstanding, with Titian's *Perseus and Andromeda* (of ravishing quality revealed by recent cleaning); early portraits by Rembrandt; Rubens's *Rainbow Landscape*; Velasquez's *Lady with a Fan*; Poussin's *Dance to the Music of Time*; and important Venetian views by Canaletto and Guardi. But it is the coverage of two centuries of French taste which fills a noticeable gap in the fine and decorative museum collections in this country. One gallery on the first floor contains what is believed to be the finest collection of French 18thc furniture and paintings to be seen in a single room. Pictures by Watteau, his two followers Lancret and Pater, by Boucher and Greuze, and by Fragonard, line the walls. With such a choice it is difficult to pick especially notable examples, but the display includes some of the most famous works by these artists: Watteau's *Music Party* and *Gilles and his Family*; Fragonard's *The Swing*; Lancret's *Mlle Carmago Dancing*; Boucher's *La Modiste*, etc. The furniture is of great documentary importance, demonstrating the highest level of sophistication reached by the sculptors of the ornamental *bronzes d'ameublement* so fashionable in the mid-18thc. There are no less than three pieces made by Reisener for Marie-Antoinette.

The galleries following on from this one contain works in the same style, including a very fine Boucher of *Mme de Pompadour* and the Greuze portrait known as *Sophie Arnould*. The collection of gold boxes is particularly choice, reflecting very well the fashion of the period for fine chasing, enamelling and hardstone setting and cutting. One box, set with hardstones, in the manner of Neuber of Dresden, with an intaglio of Leda and the Swan in the lid, has a secret compartment only recently discovered containing a double-sided panel with portraits of Voltaire and the marquise de Châtelet. In a downstairs gallery the same vein continues with paintings by Oudry, Nattier and Van Loo, sculptures by Clodion and Sèvres porcelain, some made for Catherine the Great.

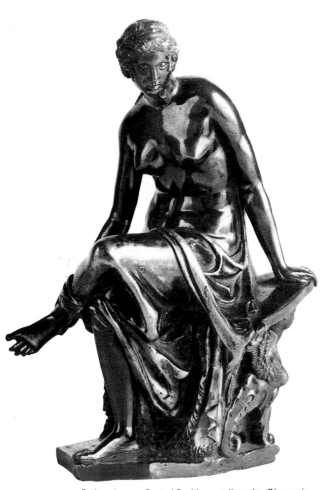

Paduan bronze *Seated Goddess*, attributed to Giovanni Fonduli, second half of the 16thc (Wallace Collection)

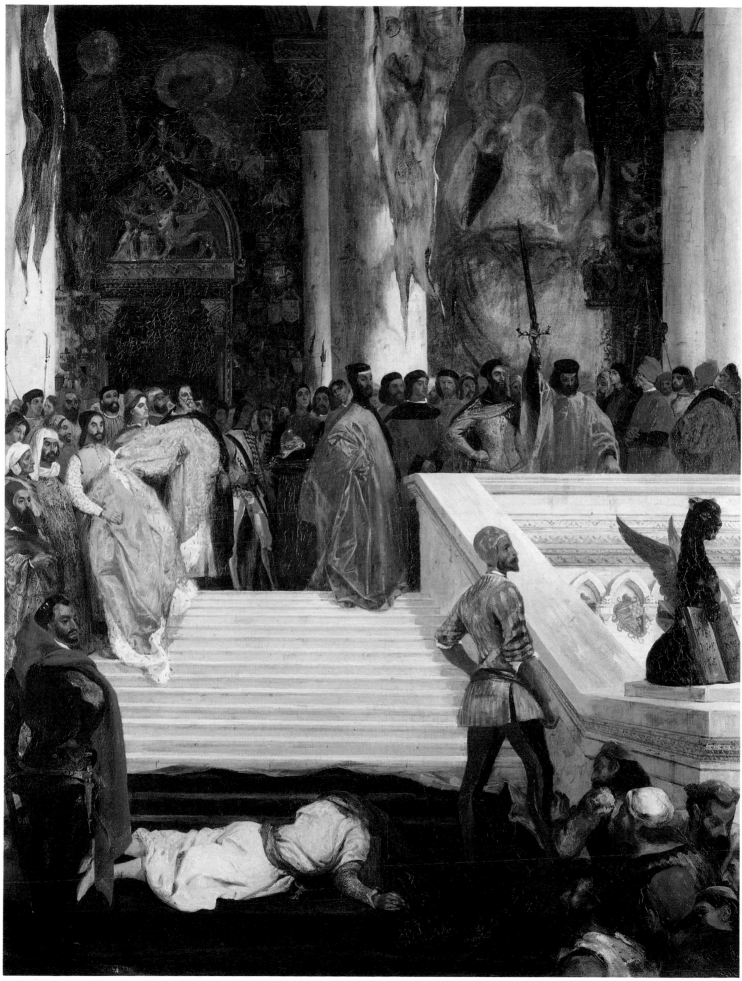

Eugène Delacroix, *The Execution of Doge Marino Faliero*, 1827 (Wallace Collection)

French enamelled gold box, made in Paris by
J. Ducrollay, 1743–44 (Wallace Collection)

The works from the French 19thC are even more valuable for filling a gap in the public collections in this country. French *Salon* painting of this period has never been collected systematically and the period after 1860, which is not covered by the Wallace Collection, is still almost unrepresented. This is one of the few places where Orientalist subjects by Horace Vernet, Alexandre Decamps—one an unspeakable depiction of the torture of the hooks—and Prosper Marilhat can be seen.

In a class by itself is the arresting Delacroix of the *Execution of Doge Marino Faliero*. Complementing the Oriental scenes are Meissonier's 18thC costume pieces and the small, exquisitely romantic *Duel after the Masked Ball* by Thomas Couture. The marvellous collection of works by Bonington fits exactly into this French early 19thC framework; indeed, his short working life was centred on Paris, where, for a while, he shared a studio with Delacroix.

The group of 17thC Dutch cabinet paintings is justly celebrated, many of them bought by the 3rd Marquess, a close friend of the Prince Regent and Vice-Chamberlain of his Household, whose predilection for this School, as well as for French 18thC furniture and Sèvres porcelain, he shared. There are, for example, no less than four works by Hobbema; Jan Steen's charming *Harpsichord Lesson*; and examples from the rare painter Esias Boursse, *Interior with a Woman Cooking* (1656) and three Ruisdaels.

There is an excellent shop selling first-rate publications relating to the contents and a good selection of reproductions, postcards and colour slides.

William Morris Gallery and Brangwyn Gift, Walthamstow

Items associated with William Morris (1834–96), designer, writer and socialist; paintings, drawings, prints, furniture and ceramics by Sir Frank Brangwyn (1867–1956)

The Water House, Lloyd Park,
Forest Road, Walthamstow, London E17
tel. 01-527 5544, ext. 4390

Tues–Sat 10–1 pm, 2–5 pm; first Sun in month only 10–12 pm, 2–5 pm. Closed Mon

Admission free

PUBLICATIONS
The William Morris Gallery: Introductory Notes, 1985
Richard Tames, *William Morris*, 1972
A. H. Mackmurdo and The Century Guild, 1967
Sir Frank Brangwyn, 1974
Christopher Whall: Arts & Crafts Stained Glass Worker, 1979

Recent exhibition catalogues include:
Paul Woodroffe (1875–1954): An Exhibition of Stained Glass, Drawings, Designs and Printed Work, 1982
Talwin Morris and the Glasgow Style, 1983

This 18thC house, the boyhood home of William Morris, has in its collections a wide range of items associated with his life and work, for example, textiles and embroideries—including the unique *Woodpecker* tapestry—furniture, stained glass, illuminated MSS, ceramics, designs, wallpapers and so on, as well as a full set of books printed at Morris's Kelmscott Press.

The collections also include works by Morris's Pre-Raphaelite associates, such as the beautiful early watercolour by E. Burne-Jones of *St George and the Dragon* (1868), and other 19thC and early 20thC British and Continental painters. The principal patrons concerned with the setting up of a gallery to commemorate Morris and his associates were Sir Frank Brangwyn and A. H. Mackmurdo; the Brangwyn Gift of 1934 and the Mackmurdo Bequest of 1942 ensure that the display also presents an important picture of the Arts and Crafts Movement, which itself owed so much to Morris's influence. There are textiles, furniture and metalwork by Mackmurdo and other members of his Century Guild, including Selwyn Image and Herbert Horne, and printing blocks and a complete set of the issues of the Century Guild magazine, *The Hobby Horse*. The ceramics collection includes examples by William De Morgan and the Martin Brothers. There is furniture by C. F. A. Voysey, Sidney Barnsley and Ernest Gimson, as well as rare examples by Brangwyn himself, and an important collection of stained glass designs and cartoons by Christopher Whall and his assistants.

The collection has been catalogued in a useful publication with excellent explanatory notes, which is being revised. A sales-point at the Gallery has postcards, reproductions, greetings cards, slides and wrapping paper and some related publications.

England: The Provinces

Tiffany 'Favrile' glass, a paperweight vase with blue decoration, iridescent millefiori vase and Samian red decorated vase (Haworth Art Gallery, Accrington)

ACCRINGTON, *Lancashire*

Haworth Art Gallery

Tiffany glass; Victorian paintings and watercolours

Haworth Park, Manchester Road, Accrington
tel. 0254-33782

Sat–Thurs 2–5 pm. Closed Fri, Sun

Admission free

The Art Gallery is housed in Hollins Hall, the former home of William and Anne Haworth, children of Thomas Haworth (1819–91), a local cotton manufacturer. It was built in 1909 in a neo-Jacobean style by Walter H. Brierley (1862–1926) of York. The Hall, which was bequeathed to the Corporation by the Haworths in 1920 and opened as a museum in the following year, stands in thirteen and a half acres of parkland and has fine views over the moors.

The most important collection in the Gallery is that of Tiffany 'Favrile' (or hand-made) glass, which was presented in 1933 by Joseph Briggs, an Accringtonian who emigrated to America and became the Design Director for Louis Comfort Tiffany. There are about 130 pieces, making it the largest single collection in Europe and one of the finest in the world. There are examples of lustre and agate ware, as well as Cypriote, lava, reactive, cameo and millefiori glass.

There is a good collection of Victorian pictures, most of which were presented by local industrialists and many of which formed part of the Haworth Bequest. It includes works by Leighton, Herring, Shayer and Cooper, and also an interesting group of watercolours, with examples by Birket Foster, Cox, Prout, Sandby, Copley Fielding and William Henry Hunt. One of the Gallery's treasures is a painting by Claude Joseph Vernet of *Storm off the French Coast (The Tempest)*.

The Gallery has an Association of Friends. There is a sales counter where postcards and guides to the Gallery and nature trail are for sale, as well as items from the regular temporary exhibitions. Car-parking is available.

ALDERNEY, *Channel Islands*

The Alderney Museum

High Street, Alderney
tel. 048 182-3222

Mon–Sat 10–12.30 pm. Closed Sun

Admission charge

Exhibits trace the island's history to the present day. There are displays of archæology, natural history, medal and stamp collections, and material from maritime history, folk life and from the German occupation of the Island.

A shop sells books, postcards, stamps and souvenirs.

ALTON, *Hampshire*

Curtis Museum and Allen Gallery

Museum: local history; dolls;
dolls' houses and dolls' furniture;
toys and games
Gallery: English ceramics (15thc–20thc);
silver

High Street, Alton
tel. 0420-82802

Mon–Sat 10–5 pm (Museum);
Tues–Sat 10–5 pm (Gallery)

Admission free

The Curtis Muscum is named after the Quaker Curtis family. It was originally founded in 1856 by Dr William Curtis (1803–81), a cousin of the botanist William Curtis whose work is displayed there. The Museum on Crown Hill, designed by Charles E. Barry (1824–1900), was completed in 1880. It went through various transformations before being transferred to the Hampshire County Council, who appointed their first curator in 1950. The Allen Gallery is a little way from the Museum on the other side of the High Street. The buildings were bequeathed to the Museum in 1957 by a member of the Curtis family, but the name commemorates a bequest of money from William Herbert Allen, a former principal of the Farnham School of Art, which made the necessary alterations possible.

Apart from the local history displays in the Museum and the constantly changing programme of exhibitions in the Gallery, the collections of interest are of dolls, very fine dolls' houses and furniture, as well as toys and games in the Museum; and the English ceramics and silver in the Allen Gallery. A display in the Gallery illustrates the history of English ceramics from 1485 to the present day. The collection is renowned for its fine pottery, especially the tin-glazes and cream ware. A recent addition is an early Staffordshire tea-jar in red stoneware with its original silver cover, attributed to the brothers David and John Elers of Staffordshire, *c.* 1690–98. This early piece of teaware complements the existing collection of English and Oriental tea and ornamental wares of the early 18thc. The silver collection is also shown in the Gallery, and it is interesting to study it in an appropriate conjunction with a comprehensive ceramic collection since these two materials share so many common design sources. Notable items from this collection include the Tichborne spoons— twelve silver-gilt spoons by Christopher Wace of London, dated 1592–93, with finial figures of the nine Worthies which are known as the 'Tichborne Celebrities'—and the Wickham Communion Set. Made in London in 1646–47, this is the earliest known complete communion set in Hampshire.

There is a sales area for a guidebook, leaflets and postcards.

Tichborne silver-gilt spoon with Queen Elizabeth finial, by William Cawdell, 1592 (Curtis Museum and Allen Gallery, Alton)

Archæology; English costume;
studio pottery (20thc)

Church Street, Aylesbury
tel. 0296-82158/88849

Mon–Fri 10–5 pm;
Sat 10–12.30 pm, 1.30–5 pm. Closed Sun

Admission free

AYLESBURY, *Buckinghamshire*

Buckinghamshire County Museum

The Museum was founded by the Buckinghamshire Archæological Society in 1862 and is housed in a fine, basically 18thc brick building with a good plaster ceiling and some exposed 15thc roof timbers in the interior. Part of it was formerly the Grammar School, which was established in the 16thc.

The collections are primarily of local interest, including geological and archæological items, social, history and topographical paintings, watercolours and prints. Of particular significance are the finds from the Roman villa at Hambleden and a Celtic bronze mirror. There is a collection of 17thc Buckinghamshire tokens, nine 18thc paintings of the gardens of Hartwell by E. B. Nebot, a good collection of English costume and a collection of 20thc Studio pottery.

There is a sales counter where publications are available.

BANBURY, *Oxfordshire*

Banbury Museum

8 Horsefair (opposite Banbury Cross),
Banbury
tel. 0295-59855

Mon–Sat 10–5 pm (May–Sept), closed Sun;
Mon, Wed–Sat 10–4 pm, closed Tues, Sun
(Oct–Mar)

Admission free

An exhibition of works of art and items of local interest, *A Changing Landscape—Banbury and the Cherwell Valley*, illustrates the history and character of the locality.

There is a Museum bookshop and tourist information centre, and a coffee bar.

BARLASTON, *Staffordshire*

The Wedgwood Museum

Ceramics (especially early Wedgwood)

Josiah Wedgwood & Sons Ltd, Barlaston,
Stoke-on-Trent
tel. 078 139-4141

Mon–Fri 9–5 pm (Sat 10–4 pm,
April–Oct only). Closed Sun

Admission charge

The Wedgwood Museum was established as the result of the discovery of original documents and wares at Etruria, Stoke-on-Trent, in 1906 and is now at Barlaston in the complex which includes displays, as well as a demonstration area where visitors can see the making of pottery in ways almost unchanged since the time of the firm's founder, Josiah Wedgwood IFRS. (1730–95).

The Museum has the most comprehensive collection in the ceramics industry and the largest and most varied collection of early Wedgwood in the world. There are some 20,000 pieces in the collection, and the archives contain an important collection of documents—pattern, experiment and recipe books, business and personal letters in the handwriting of Josiah Wedgwood—which amount in all to some 75,000 items. The earliest pieces date from 1754 when Josiah Wedgwood was in partnership with the famous 18thc potter, Thomas Whieldon. In the art gallery can be seen original paintings of members of the Wedgwood family by such artists as Joshua Reynolds and George Stubbs.

Notable examples of Wedgwood ware include three copies of Wedgwood's first edition 'Portland' vases, as well as two of the six 'First Day Vases' thrown by Wedgwood himself on the opening day of the Etruria factory, and pieces from the famous Queen's Ware service made for Catherine the Great of Russia.

Publications available on the premises include the guidebook *The Wedgwood Museum at Barlaston* and an exhibition catalogue, *Wedgwood in London* (1984).

Black basalt plaque of *The Frightened Horse*, modelled by George Stubbs for Wedgwood, 1780 (The Wedgwood Museum, Barlaston)

European paintings (15thc–19thc);
European decorative and applied arts
and furniture (16thc–19thc); porcelain
(18thc); special display of toys and
automata

Barnard Castle, Co. Durham
tel. 0833-37139

Mon–Sat 10–5.30 pm (May–Sept),
10–5 pm (March, April, Oct), 10–4 pm
(Nov–Feb); Sun 2–5 pm

Admission charge

BARNARD CASTLE, *Co. Durham*

The Bowes Museum

The Bowes Museum has been called 'the Wallace Collection of the North', but architecturally, and to a certain extent culturally, it should perhaps be described more accurately as the 'Waddesdon Manor' of the region. It was built by John Bowes and his wife Josephine (née Josephine Benoite-Coffin-Chevallier) as a museum for their art collection. It is in the style of a magnificent and highly ornamented French château, and in choosing as their architect the Parisian Jules Pellechet (1829–1903), the patrons ensured that something quite outside the indigenous experience of the district rose like a large-scale Château de Chambord above the little town of Barnard Castle. Pevsner called it 'that bold incongruity, looking exactly like the town hall of a major provincial town in France. In scale it is just as gloriously inappropriate for the town to which it belongs (and which it gives some international fame) as in style.' The scale of the building is indeed vast: a hundred yards long and a hundred feet high, topped with three pavilions, each large enough to contain an average-sized house, it matches the imposing background of the Pennines on the horizon. But in spite of its size, the Museum is so discreetly sited that it does not dominate the town, but sits in a world of its own, surrounded by a spacious park, the landscaping and planting of which is now being returned to its 19thc formality.

John Bowes was born in 1811, the son of the 10th Earl of Strathmore and Mary Millner: his parents were only married when the Earl was on his deathbed in 1820. In English law at that date the belated marriage did not legitimise the child. Nonetheless, John Bowes was

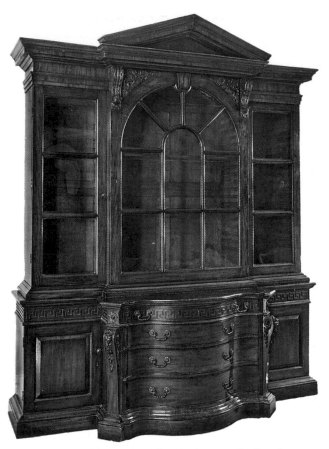

Mahogany break-front bookcase possibly from the
workshop of William Hallett, *c.* 1760
(The Bowes Museum, Barnard Castle)

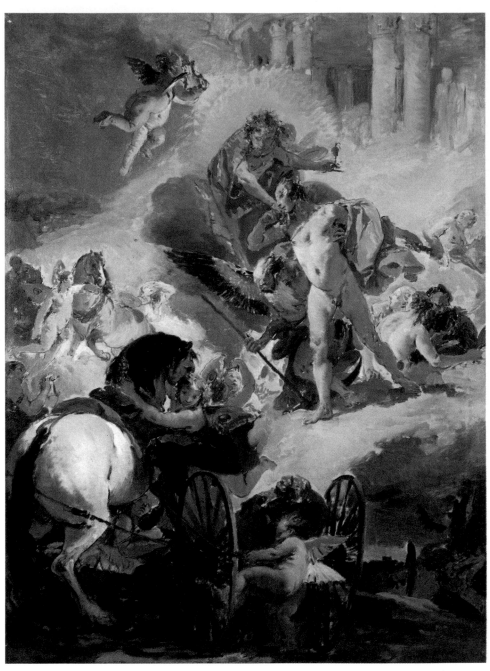

Giovanni Battista Tiepolo, *The Harnessing of the Horses of the Sun, c.* 1730 (The Bowes Museum, Barnard Castle)

St Cloud porcelain pot-pourri jar, mid-18thc
(The Bowes Museum, Barnard Castle)

the acknowledged son of the Earl, and his heir, and was therefore possessed of ample funds
to collect and to build the palatial Museum. Bowes's wife, whom he married in 1852, was
French and an artist of some competence. Although Bowes himself was a natural collector
with acquisitions of note to his credit before their partnership, it was later to be pointed
out by Bowes himself that the land at Barnard Castle for the Museum and its park was 'bought
for Mrs Bowes and indeed with her money'.

The foundation stone of the Bowes Museum was laid in 1869. Pellechet, who had been
employed by the Boweses in France, was the designer of the original plan, but the actual
task of supervising the work over the years of building fell to the Newcastle upon Tyne
architect, John Edward Watson. The design incorporated borrowings from buildings in the
French Renaissance style, notably the Tuilleries in Paris and the Hôtel de Ville at Le Havre.
In 1871 an article on 'Mrs Bowes's Mansion and Galleries at Barnard Castle, Durham'
appeared in *The Builder*, but the building was by no means completed, and fourteen more

Fragment of a Flemish 17thc tapestry with an eagle perched on a trophy (The Bowes Museum, Barnard Castle)

years were to elapse before the last touches were put to the interior decorations. Ironically, neither of the founders lived to see it. Josephine Bowes had died in 1874, only two weeks after the celebrations for the roof-raising had taken place. Bowes himself died eleven years later, with the work still not entirely finished and the mass of contents in a state of considerable disarray. Future generations were not to be disappointed once the displays were finally put into order, and the massive doors were opened 'amid tumultuous cheering and waving of hats' in June 1892.

The paintings collection—now over a thousand works—contains good treasures of European art from the late 15thc onwards. Unique to any public collection in this country is the large, delicately coloured *Rape of the Sabines* by Guiseppe Salviati, which came from the Orléans Collection and which cost Bowes twenty-four guineas. When he was only nineteen years old he bought his first picture, *The Temptation of St Anthony* by Cornelius Saftleven; thereafter the collection grew apace. It now encompasses two Goyas, a portrait and a study of a prison interior, and an El Greco, which Bowes bought for £8 only as an afterthought in a deal involving a number of paintings by lesser artists; unusual for this country, the Spanish School is noticeably well-represented in the Bowes Collection. The 18thc is also particularly well-represented, with Venetian pictures by G. B. Tiepolo (*The Harnessing of the Horses of the Sun*) and a pair of fine Canalettos, as well as French paintings by François Boucher, three by Hubert Robert and five examples by Pierre-Henri de Valenciennes, whose works are rare in this country. Josephine Bowes understandably showed a predilection for the landscape painting of her contemporaries, since this was the field in which she herself practised. There are paintings by Courbet (*View of Ornans*), Boudin and Fantin-Latour. The attractive sculptures enhance the displays.

There is a collection of Old Master drawings and English watercolours, but it is in the field of decorative art where the resemblance to the Wallace Collection is marked. The textiles, and most outstandingly, the tapestries, are very fine; the ceramic and glass collections contain rare examples, as well as a representative holding of the leading factories such as Meissen and Sèvres. The furniture is of somewhat uneven quality: in the period rooms pieces used by the Boweses have a personal interest, and there are some fine examples of early carving and marquetry inlay, as well as attractive French 18thc documentary cabinet work, including a dressing-table made for Marie-Antoinette from the Château de Trianon.

Last but not least is the Bowes Museum's most celebrated exhibit, the famous silver swan: so fragile now that it can only be activated once a day, the bird, made entirely of silver, is fitted with an elaborate mechanical movement which allows it to simulate the action of catching and swallowing a fish. The swan takes pride of place in the centre of the great entrance hall, but should not distract the visitor from the great treasures in the galleries of the Museum.

There is a shop, self-service café (April–Sept), drinks machine (Oct–Mar) and car-parking.

BARNSLEY, *South Yorkshire*

Cannon Hall Museum [1]

British furniture (18thc);
British glass (18thc–20thc);
British pottery (19thc–20thc);
Dutch and Flemish paintings (17thc–18thc)
(National Loan Collection Trust)

Cawthorne, Barnsley
tel. 0226-790 270

Mon–Sat 10.30–5 pm; Sun 2.30–5 pm.
Closed 25–27 Dec and Good Friday

Admission free

Cannon Hall and the surrounding parkland were purchased by the County Borough of Barnsley from the Spencer-Stanhope family in 1951. To the original austere 17thc house, five bays wide and two and a half storeys high, John Carr of York (1723–1807) added two wings in 1765–67, which he heightened in 1804–05. There is a fine moulded ceiling in the dining-room by James Henderson of York executed in the 1790s. A panelled ballroom was added in 1891, with a fireplace designed by Sir Walter Spencer-Stanhope containing two painted panels by Roddam Spencer-Stanhope. The surrounding parkland was landscaped by Richard Woods in the 1760s.

Since 1957, when the house was opened to the public as a museum with the contents arranged in period rooms, the collections have been continually increased, the original contents having been dispersed. In particular the quality of the furniture is very high, with works in oak dating from the 17thc. The 18thc is very well represented by a fine rococo table and glass of *c.* 1745, a pair of neo-classical wine coolers on pedestals and a side-table of *c.* 1775, and a Regency pedestal sideboard in the Egyptian revival style. During the 18thc clockmaking was a thriving local business, and there are a longcase clock and barometer of *c.* 1720 by John Hallifax of Barnsley, one of the famous clockmaking family.

English engraved glass goblet with the Orange Nassau coat of arms, 1727 (Cannon Hall Museum, Barnsley)

British paintings (19thC);
French and Italian paintings (18thC–19thC)

Church Street, Barnsley
tel. 0226-242 905

Tues 1–5.30 pm; Wed–Sun 10–5.30 pm.
Closed Mon

Admission free

Local history, geology and archæology;
porcelain (18thC–19thC)

Baysgarth Park, Caistor Road,
Barton on Humber
tel. 0652-32318

Thurs–Sun and Bank Holidays, except
Christmas and New Year's Day, 10–4 pm.
Closed Mon–Wed

Admission free

Glass has been produced locally from the late 17thC, and there is a wide-ranging collection in the house, from Roman and Syrian pieces of the 1stC and 2ndC AD to the present day. The 18thC is particularly well represented by wine glasses, decanters, table glass and decorative pieces, and a collection of glass made by James Powell & Sons of Whitefriars was recently added. There is a good collection of pottery from the second half of the 19thC to the 1930s. Many of the leading Doulton artists are included, among them Hannah and Florence Barlow, George Tinworth and Mark V. Marshall. Also represented are the Martin brothers, William De Morgan, William Moorcroft and Charles Vyse.

Cannon Hall houses the National Loan Collection Trust pictures, put together by William Harvey of Barnsley (d. 1867) from 1840 to 1860. For some time they travelled extensively but have since 1976 found a more permanent home in Barnsley through the auspices of the NACF. The emphasis of the collection is on 17thC Dutch and Flemish pictures, amongst which are the charming Caesar van Everdingen *Child Holding an Apple*, Metsu's *Music Lesson* and Willem van de Velde's *Calm*. The Museum also holds a small collection of paintings by Constable, John Wootten, Morland, Mercier, Highmore and David Roberts. There is also a collection of local topographical drawings of 1809 by J. C. Nattes, drawing master of the children of Sir Walter Spencer-Stanhope.

There are a good guidebook to the Museum and a catalogue of the National Loan Collection Trust for sale on the premises. There is a car-park nearby.

Cooper Gallery [2]

Formerly the Holgate Grammar School (from 1660), the Church Street buildings were purchased by Samuel Joshua Cooper (1830–1913) in 1912 to be used as an art gallery that would bear his name and house his collection of paintings. When he died, a charitable trust was set up to oversee the Gallery, which was opened to the public in 1914. The Fox family paid for the building of a new wing in 1934. This was to house the bequest of mainly English 19thC paintings bequeathed by Thomas Fox JP in that year.

Cooper's bequest comprised mainly 18thC and 19thC French and Italian paintings, together with a small but fine group of 17thC Dutch pictures. Of particular note is the *Landscape with a Bridge* by Roelant Savery.

In 1931 a fine collection of English drawings and watercolours was bequeathed by Sir Michael Sadler through the NACF, including works by Cotman, John and Alexander Cozens, Turner, Jacob Kramer, Augustus John, Nevinson, Stanley Spencer and many others.

The Museum received a bequest in 1977 from Mrs Thirsk in memory of her first husband, Captain Roland Addy, a local industrialist; it consisted largely of British works, including some fine watercolours by Turner and David Roberts.

A sales counter stocks postcards and local council publications. A checklist of the British pictures in the Cooper Collection is in preparation.

BARTON ON HUMBER, *Humberside*

Baysgarth Museum

Opened in 1981 and housed in a mid-18thC house, the collections include items of geology, archæology and history of the Glanford District. The geological collection includes specimens of local rocks, minerals and fossils donated by British Steel. The archæological material comes from numerous local sites, particularly a 7thC Anglian cemetery at Barton, and there are local coin hoards from Burwell Farm and Deepdale dating to the 3rdC and 4thC AD. There is a fine collection of 18thC and 19thC English and Oriental porcelain and a small number of examples of 19thC Continental porcelain and 18thC delftware.

There is a shop selling postcards, booklets and greetings cards. An information leaflet on the history of Baysgarth House and estate is in course of preparation. There is free car-parking.

BASINGSTOKE, *Hampshire*

The Willis Museum

Clocks and watches; embroidery

Old Town Hall, Market Place, Basingstoke
tel. 0256-65902

Tues–Fri 10–5 pm, Sat 10–4 pm

Admission free

Since 1984 the Museum has been in the original Town Hall, which was built in 1831 and refaced in 1865. Previously in the Mechanics Institute, it opened in 1931 with funds from T. B. Allnutt and with G. W. Willis as its first curator, after whom it was renamed in 1945 in recognition of his services.

The Museum concentrates on local history, archæology and natural history of the area. It also has specialist collections of clocks and watches and historic embroidery.

There is an association of Friends. A shop sells postcards, and a guide is scheduled for publication in 1986.

BATH, *Avon*

The American Museum in Britain [1]

American furniture in period settings;
patchwork quilts, coverlets and rugs

Claverton Manor, Bath
tel. 0225-60503

Tues–Sun 2–5 pm (Mar–Oct). Closed Mon

The American Museum is housed in a fine country house designed by Sir Jeffry Wyatville (1766–1820) in 1840, in the Greek Revival style. It is constructed of Bath stone and ornamented on the garden front with a pediment and an order of four Ionic columns.

The display in the interior consists of eighteen period rooms, ranging in date from the 17thC Keeping Room of *c.* 1680 to a mid-19thC New Orleans bedroom. The Greek Revival Room, which complements the architectural style of the house, is a New York dining-room of *c.* 1825–35, furnished with examples of the work of the American neo-classical designer Duncan Phyfe. For the immediately preceding period at the turn of the 18thC, in a sophisticated room of the Federal period (*c.* 1790–1820), can be seen decoration and furniture influenced by Robert Adam, Hepplewhite and Sheraton. The Deming Parlour contains fine furniture showing the influence in America of Thomas Chippendale. The Early Colonial Room has furniture once owned by the Pilgrim Fathers and the Shaker Room contains examples of the simple wooden shapes that were a seminal influence on the formation of the Arts & Crafts style. There are examples of the stencilling of walls and floors with coloured patterns that were once particularly idiosyncratic of American decoration and have lately become very fashionable over here.

Notable exhibits include the very fine collection of quilts, coverlets and rugs, an aspect of textile art at which the Americans have always excelled, as well as a gallery devoted to 18thC and 19thC glass.

The Museum has recently completed an American garden consisting of an arboretum, fernery and apple orchard designed to show the variety of trees, shrubs and ferns which English gardens owe to the North American continent. In the grounds there is also a gallery devoted to American Folk art.

Founded in 1961 by John Judkyn and Dallas Pratt, the Museum is one of only two in the whole of Europe devoted to American cultural history. There is a very active association of Friends and Members on both sides of the Atlantic, and the collection continues to expand.

The Museum has published a variety of books and pamphlets related to the collections and to early American cultural life, including cooking recipes and the uses of herbs. There is a guidebook to the Museum illustrated in colour. Other publications include: Sheila Betterton, *Quilts and Coverlets* and Sheila Betterton, *Rugs*, both with text and coloured illustrations relating to the Museum's collection.

These publications are available in the Museum Shop, and herbs from the garden can also be bought. There is a free car-park and a cafeteria at which special luncheons or dinner can be arranged.

Shaker Brothers Rocking Chair, *c.* 1820
(The American Museum, Bath)

Holburne of Menstrie Museum [2]

Dutch and Flemish paintings (17thc);
English paintings (18thc); Italian paintings
(18thc); English drawings, watercolours
and miniatures (17thc–19thc); Italian and
French sculpture (16thc–17thc); Dutch,
German, English and Irish silver (17thc–
18thc); Italian maiolica (16thc–17thc);
English and Continental porcelain (18thc);
Wedgwood; Oriental porcelain (17thc–
18thc); English furniture and musical
instruments (17thc–18thc)

Great Pulteney Street, Bath
tel. 0225–66669

Mon–Sat 11–5 pm; Sun 2.30–6 pm.
Closed Mon (Nov–Easter) and entire month
of Jan

Admission charge

The nucleus of the collections now in the Holburne of Menstrie Museum was formed by Sir William Holburne (1793–1874), who added to his inheritance of family silver and porcelain, books, paintings and miniatures, with judicious purchases at sales—notably the Christie's sale in 1843 of pieces from the Duke of Sussex Collection and the famous Lansdown Tower sale of 1845 of items from William Beckford's collection—gaining for himself a reputation as a connoisseur of note. The collections were left to Sir William's younger sister, who conceived the idea of establishing the Museum and of including in its name a reference to Menstrie Castle in Scotland where the family had lived in the 17thc.

After several false starts, the old Sydney Hotel at the end of Great Pulteney Street was puchased. Originally designed by Charles Harcourt Masters and built 1796–97, the elegant classical building was converted to its present use as a museum by Sir Reginald Blomfield (1856–1942) in 1911–15. In 1977 the Crafts Study Centre was installed in part of the ground floor, with its collection of work by 20thc British artist-craftsmen in textiles, pottery, furniture and calligraphy.

The taste of Sir William Holburne is very apparent in the picture collection: the representation of the 17thc and 18thc Dutch and Flemish Schools includes works by Pieter Bruegel the Younger, Eliasz. Pickenoy and J. Backer. The Italians include A. Casali, G. B. Panini and G. B. Langetti. Holburne admired Thomas Barker of Bath, of whom he had a romantic self-portrait, and the group from Holburne's collection was complemented in 1939 by the purchase of a portrait of the artist's wife. In 1955 items from the E. E. Cook Collection, presented through the NACF, made significant additions to the English 18thc holdings, with portraits by Gainsborough, Raeburn and Allan Ramsay, as well as a beautiful group portrait by Stubbs, *Rev. Robert Carter Thelwall and his Family*. From the same source came two George Morlands, a John Russell fancy picture entitled *Love Songs and Matches*, in the manner made popular by Gainsborough, and a Turner of *Pembroke Castle*, dated 1829. One of the highlights of the collection of Italian and French bronzes is *The Kneeling Woman Bathing* by Antonio Susini after Giambologna, which was once in the French Royal Collection.

One of the finest items in the silver collection is a superb example of 17thc embossed and repoussé work in the form of a rosewater dish, made in London in 1616, which once belonged to Frederick, Duke of York, and was bought by Holburne in 1843 at the Duke of Sussex sale at Christie's for £60. 4s. 9d. Holburne also took a particular pride in his

Bow porcelain figures of Kitty Clive and
Henry Woodward, *c.* 1750
(Holburne of Menstrie Museum, Bath)

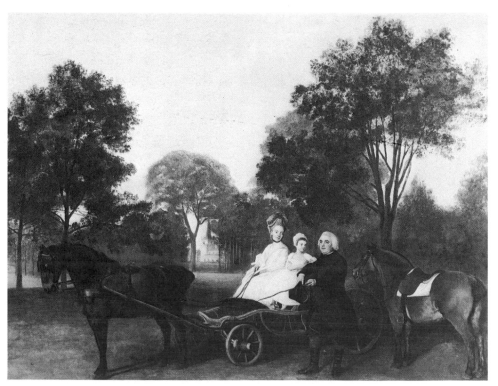

George Stubbs, *Rev. Robert Carter Thelwall and his Family*, 1775 (Holburne of Menstrie Museum, Bath)

collection of Apostle and seal-top spoons dating from the 16thc to the mid-17thc. Of the decorative items, one of the most impressive is the two-handled cup and cover made by Charles Frederick Kandler in 1736, with assymetrical handles cast in the form of male and female Bacchic figures, lavish flat-chasing and repoussé work in high relief.

The ceramic collections are notable for groups of Italian maiolica and Wedgwood, as well as some outstanding porcelain, both from the nucleus in the Holburne Collection and more recent bequests. A particularly refined Meissen bottle and stopper in the Chinese taste was bequeathed by J. MacGregor Duncan in 1964. Related Bow porcelain figures of Kitty Clive and Henry Woodward as the Fine Lady and the Fine Gentleman in the farcical play called *Lethe* by David Garrick entered the collection more than twenty years apart in 1946 and 1967 respectively. The furniture collection includes as a very recent addition a fortepiano by J. Schantz of Vienna, which is in playable condition and is used for recitals.

Friends of the Holburne help to fund particular projects and act as volunteer attendants. There is a bookshop for books on arts and crafts, and postcards. A number of recent exhibition catalogues have largely concentrated on the material in the Crafts Study Centre, an important development for the Museum. A *Guide to the Collection* (1978) is also available. A licensed teahouse in an open colonnade in the Museum grounds is open from April to September. There is a free car-park.

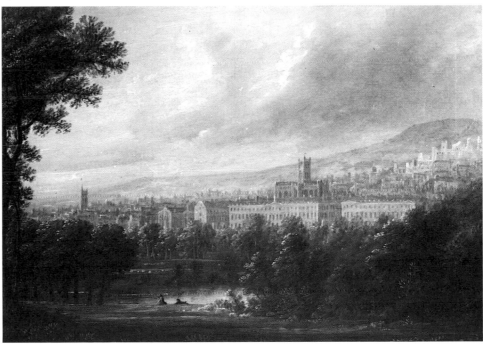

Edmund Garvey, *View of Bath in the 18th Century* (Number 1 Royal Crescent, Bath)

Items from the Holburne of Menstrie Museum can be seen on loan to:

Number 1 Royal Crescent [3]

Bath Preservation Trust
1 Royal Crescent, Bath
tel. 0225-28126

Tues–Sat 11–5 pm;
Sun 2–5 pm. Closed Mon

Admission charge

The thirty terrace houses of the Royal Crescent, set superbly in a semi-elliptical curve, were designed by John Wood the Younger (1728–81) and completed in 1774. No. 1 was bought by Bernard Cayzer in 1967 and presented by him to the Bath Preservation Trust with an endowment for its restoration, it then being in urgent need of repair. It was opened as a Museum in 1970. The interiors have been furnished with 18thc paintings and furniture in keeping with the period.

The shop sells a booklet on the house.

Museum of Costume [4]

Costume (16thC–present day)

Assembly Rooms, Bennett Street, Bath
tel. 0225–61111

Mon–Sat 9.30–6 pm (March–Oct),
10–5 pm (Nov–Feb); Sun 10–6 pm
(March–Oct), 11–5 pm (Nov–Feb)

Admission charge

The Museum was founded in 1963 by Mrs Doris Langley Moore and is housed on the lower ground floor of the New Assembly Rooms built by John Wood the Younger (1728–81) from 1769–71.

The Museum holds one of the largest and most comprehensive collections of costume for men, women and children in this country. The displays include accessories to dress, babies' clothes, underwear, millinery, royal and ceremonial clothes and children's dolls, toys and games. There is a particularly fine collection of early garments which include late 16thC and early 17thC embroidered shirts, jackets, coifs and gloves and a rare 1660s woman's dress of silver tissue. From the 18thC there are several outstanding women's court dresses, a man's coat of *c.* 1720 of brown cloth embroidered in silver with the original silver embroidered stockings to match, and an important collection of fans. There are extensive holdings of 19thC and 20thC fashionable dress including the work of many distinguished designers such as Worth, Vionnet, Schiaparelli, Christian Dior, Balenciaga, Yves Saint Laurent and Jean Muir, which is kept up to date.

There is a shop which sells postcards and slides. Recent publications, all by Penny Byrde, Keeper of Costume, include: *Museum of Costume Brochure* (1980); *Fashion Outlines* (*1800–1879, 1880–1913, 1914–1968*;) *A Frivolous Distinction. Fashion and Needlework in the Works of Jane Austen* (1979); and *Making a Splash. 100 Years of Bathing Clothes* (exhibition catalogue, 1984).

Affiliated to the Museum of Costume is:

Fashion Research Centre [5]

4 Circus, Bath
tel. 0225–61111, ext. 425

Mon–Fri 10–1 pm, 2–5 pm.
Closed public holidays

Admission free

The Centre has a library of books, periodicals, trade catalogues, fashion plates, photographs, paper patterns, designs and other archival material on the history of dress and related subjects. Of particular importance are the *Sunday Times* Fashion Archive (fashion photographs from 1957 to 1974) and part of the Worth and Paquin archives. There is also a Study Collection of costume, accessories to costume, textiles and needlework from the 18thC to 20thC which may be examined by students and visitors by appointment.

The Royal Photographic Society
National Centre of Photography [6]

Major collection concerned with the history of photography

The Octagon, Milsom Street, Bath
tel. 0225–62841

Mon–Sat 10–4.45 pm. Closed Sun

Admission charge

The Royal Photographic Society was founded after a public meeting at the Royal Society of Arts in 1853 and is now a registered charity. The RPS National Centre of Photography was established when the Society moved its headquarters to Bath in 1980. It is situated in the Octagon, originally a proprietory chapel built by Thomas Lightoler (d. 1770s) in 1767; the iron gates of the Sanctuary are still to be seen.

The history of photography is extremely well illustrated in the collection of photographic prints which includes one of the first known photographs of 1827. Two important collections of cameras are in the Museum, those of William Henry Fox Talbot (1800–77), the well-known pioneer of photography and the first to take an instant photograph in 1851, and John Newton (1916–80) whose Leicas form a unique group. The Museum's holdings are being continually added to by major photographers.

There is a shop with a large stock of photographic books, including copies of *The Photographic Journal*, *The Journal of Photographic Science* and *Photographic Abstracts*.

Victoria Art Gallery [7]

British paintings, drawings and
watercolours, mostly topographical
(18thC–20thC); prints (17thC–20thC);
English porcelain and glass

Bridge Street, Bath
tel. 0225-61111

Mon–Sat 10–6 pm. Closed
Sun & Bank Holidays

Admission free

The Victoria Art Gallery is Bath's municipal gallery and was founded in 1900 as a tribute—
soon to be memorial—to Queen Victoria. The building was paid for by a bequest from Mrs
Arabella Roxburgh, supplemented by public subscription. It was designed by James Brydon
(1840–1901), in the characteristic late neo-classical taste for which he was renowned, around
a fine rotunda with a decorated dome and a complementary classical interior ornamented
with a cast of the Parthenon frieze.

The collections comprise some European Old Master paintings, of which the highlight
is certainly the fine *Adoration of the Magi* attributed to Hugo van der Goes, which is not
to be missed. The majority of the holdings, however, are devoted to the work of English
artists of the 18thC–20thC, notably the Bath artists Thomas Barker (known as Barker of Bath)
and his son Thomas Jones Barker, and also includes oil-sketches by William White Warren,
self-styled 'follower of Constable', another native of Bath. Walter Sickert's years in Bath
are commemorated by several works and there is an impressive *Portrait of a Youth* by Gilbert
Spencer. Of topographical interest is a rare interior, *The Pump Room* by Humphry Repton,
as well as Thomas Malton's famous large watercolour views of the city. The representation
of graphic work includes an important group of engravings and etchings, namely the Kimball
Collection given to the City of Bath in 1946, which spans the 17thC–20thC, but mainly dates
from the late 19thC/early 20thC 'etching revival'.

In 1962 the pictures once owned by the Bath Royal Scientific and Literary Institution
came to the Gallery.

The decorative art collections include two special groups, the Trapnell Collection of Bristol
and Worcester porcelain and the Carr Collection of English glass.

There is a recently-founded Association of Friends of the Victoria Art Gallery. Several leaflets
on the collection are available, including one on the history of the Gallery and its collections.

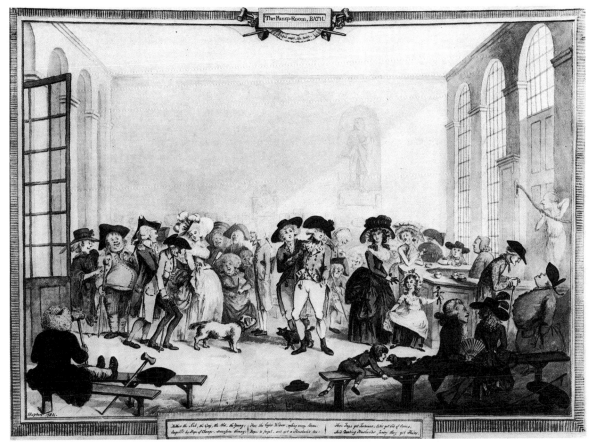

Humphry Repton, watercolour of *The Pump Room, Bath*, 1784 (Victoria Art Gallery, Bath)

BATLEY, *West Yorkshire*

Bagshaw Museum [1]

Egyptology; ethnography;
Chinese ceramics; local history

Wilton Park, Batley
tel. 0924-472514

Mon–Sat 10–5 pm; Sun 1–5 pm

Admission free

This Victorian Gothic house was built as a private home by George Sheard, a local mill-owner, in 1876. It was opened as a museum in 1911 by Walter Bagshaw JP.

Notable amongst the collections are the Hilditch collection of Oriental ceramics and the Imperial Institute's Indian collection.

There is a shop and a car-park.

Oakwell Hall Country Park [2]

17thC & 18thC furniture

Nutter Lane, Birstall, Batley
tel. 0924-474926

Mon–Sat 10–5 pm; Sun 1–5 pm

Admission free

Oakwell Hall, now sited in a developing country park, is a stone manor house built in 1583. The house retains its fine screen, gallery, hall window and much 17thC oak panelling. It is furnished with items of 17thC and 18thC furniture, some of Yorkshire style.

There is a visitor centre, shop and car-park.

BECKENHAM, *Kent*

The Bethlem Royal Hospital and the Maudsley Hospital Archives and Museum [1]

Paintings and other works of interest in the fields of psychiatry, psychology, etc., mainly those by artists whose work has been influenced in some way by mental disorder

Monks Orchard Road, Beckenham, Kent
tel. 01-777 6611

Mon–Fri 10–5.30 pm by appointment only

Admission free

The Hospital is the only exclusively postgraduate psychiatric teaching hospital in the country. It was formed in 1948, on the introduction of the National Health Service, by the union of the Bethlem Royal Hospital (the original 'Bedlam' founded in 1247) and the Maudsley Hospital, Denmark Hill (a LCC mental hospital opened in 1923). The Institute of Psychiatry began life as the medical school and research laboratories of the Maudsley Hospital and still serves that function for the Joint Hospital as it is constituted today. It is therefore appropriate that a collection such as this should be housed there.

The Archives Department was set up in 1967, and the Museum developed from about 1970 when the new archives building was opened. The space for exhibiting works and background material is very limited, but it was recently agreed that an extension would be built for a new museum and gallery if part of the cost could be raised from outside sources.

Works of particular interest are thirteen watercolours by Richard Dadd and pictures by Jonathan Martin, both of whom were patients in Bethlem Hospital. Recently the Hospital has taken over the Guttmann-Maclay Collection from the Institute of Psychiatry, which was begun by Dr Eric Guttmann and the Hon. Dr Walter Maclay when working at the Maudsley Hospital in the 1930s and 1940s. This now forms the main bulk of the picture collection and includes a quantity of works unconnected with the Hospital. It contains pictures by Vaslav Nijinsky, William Kurelek, Louis Wain, Charles Sims and many unknowns, much of whose work will always be primarily of clinical interest.

Central to the collection are the two massive stone figures of *Raving Madness* and *Melancholy Madness*, both of *c.* 1676 by Caius Gabriel Cibber. Recently on loan to the Victoria and Albert Museum, they are now permanently installed at the Hospital. Originally from the old Bethlem Hospital at Moorfields, built in 1675–76 by Robert Hooke (1635–1703), they were placed on top of the two piers of the entrance gates on either end of the broken pediment, in the style of Michelangelo's Medici tombs.

The collection is governed by the Bethlem Royal Hospital and the Maudsley Hospital Health Authority. The Archives and Museum Department is financed out of the Hospital's endowment funds, of which the Health Authority is the trustee.

There is ample car-parking in the grounds.

William Hamilton, *John Philip Kemble as Richard III*, 1788 (The Raymond Mander and Joe Mitchenson Theatre Collection, Beckenham)

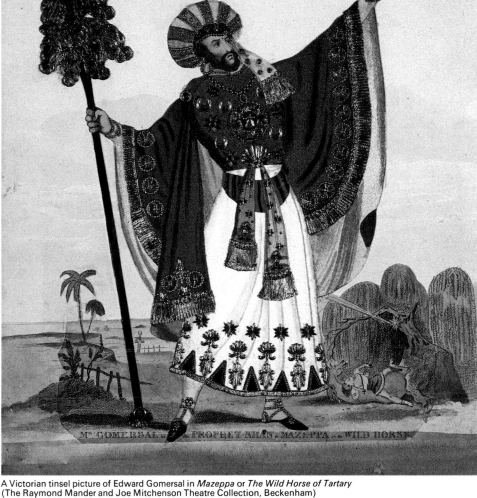

A Victorian tinsel picture of Edward Gomersal in *Mazeppa* or *The Wild Horse of Tartary* (The Raymond Mander and Joe Mitchenson Theatre Collection, Beckenham)

The Raymond Mander and Joe Mitchenson Theatre Collection [2]

History of the theatre (18thC–20thC)

5 Venner Road, London SE26
(moving to Beckenham Place, Beckenham, Kent)
tel. 01-778 6730

By appointment at present

Admission charge

In 1944 Raymond Mander and Joe Mitchenson announced their intention of leaving their extraordinarily rich theatrical collection to the Nation, and in 1977 a charitable trust was set up, with Lord Olivier as President, to enable the collection to be properly housed and displayed. It has now found a permanent home at Beckenham Place, a house built by John Cator (1728–1806) in the 1760s with some fine rooms, where it is expected to move shortly.

The collection was built up over the years by Mander and Mitchenson when they were in repertory touring the country. Mander started his career as a semi-professional entertainer and Mitchenson as a dancer. They exhibited selections from their collection in theatres over the country. All aspects of the theatre are represented—opera, dance, music, singing and dancing from the earliest time to the present day. It is notably strong in late 18thC, 19thC and 20thC items, with an unrivalled porcelain and china collection, particularly earthenware statuettes. Of the numerous oil paintings of interest are William Hamilton's magnificent *John Philip Kemble as Richard III* (1778), Mather Brown's *Anne Brunton and Joseph Holman in Romeo and Juliet* (exhibited Royal Academy 1786) and a portrait of *Mabel Terry-Lewis* by the Hon. John Collier. There is a large photographic archive, as well as theatrical models and designs, costumes, scripts, programmes, letters, etc.

An Association of Friends is being established. Slides can be borrowed.

BEDFORD

Cecil Higgins Art Gallery and Museum

English & Continental glass (17thC–19thC); English and European porcelain; British watercolours and drawings (18thC–20thC); European prints; British furniture and decorative arts (18thC–20thC)

Castle Close, Bedford
tel. 0234–211222

Tues–Fri 12.30–5 pm;
Sat 11–5 pm; Sun 2–5 pm

Admission charge

The Museum opened in 1949 and in 1975 an extension was added to the mid-1840s mansion, Castle Close, once the family home of Cecil Higgins. Cecil Higgins (1856–1941) bequeathed to Bedford his fine and assorted collection and an endowment for further acquisitions, thus making it possible to expand the holdings. The collection of watercolours and drawings, for example, is now one of the finest and most representative outside London. It covers a period from the late 17thC, early topographical drawings and those from the romantic and the Victorian periods, including Pre-Raphaelites, to paintings of the present day. There are some exceptionally distinguished paintings in the collection—a number of beautiful Cotmans, Turner's study for *A First Rate taking in Stores* (1818), Ford Madox Brown's design for *Chaucer Reading his Poem at the Court of Edward III* (1845), Dadd's *The Flight* (1855) executed whilst at Bethlem Hospital, Beardsley's frontispiece for *Venus and Tannhäuser* (*c.* 1895) and Stanley Spencer's *Flight out of Egypt* (*c.* 1913). The Museum's European print collection is also of the highest quality. When Cecil Higgins collected he did so with the forming of a museum in mind, hence the remarkably wide range of glass, both Continental and English, a total of 361 pieces, dating from the 1670s to the 1830s. The many forms of drinking glasses are of particular interest. Equally, Higgins collected British and European ceramics in a systematic way and consequently the 1,100 pieces chosen for the Museum after his death form a representative collection ranging from the end of the 16thC to the early years of the 19thC, with a strong emphasis on the 18thC. There is a fine collection of Chelsea red anchor tureens. The collection has been further augmented since 1972 when 102 pieces were purchased from the Charles and Lavinia Handley-Read collection. These bring the Museum's holdings up to date by their representation of the 19thC and 20thC, examples from the Gothic Revival, the Arts and Crafts Movement and Art Nouveau.

Higgins also collected furniture and chose exceedingly fine English 17thC and 18thC walnut pieces, for example, a veneered Tompion long-case clock of *c.* 1700 and a bureau cabinet and scrolled legged table decorated with seaweed marquetry. Similarly, since 1972 this part of the Museum's holdings has greatly benefited from forty-two acquisitions from the Handley-Read collection, again representing the 19thC and early part of the 20thC. Handley-Read particularly admired pieces designed by architects and there are a bed and dressing-table by William Burges.

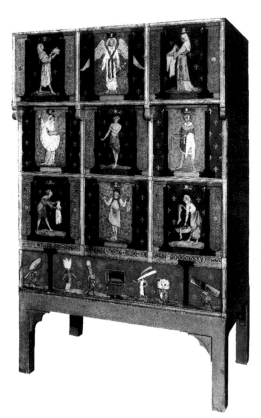

Painted cabinet by William Burges, 1875
(Cecil Higgins Art Gallery and Museum, Bedford)

Joseph Mallord William Turner, *A First Rate taking in Stores*, 1818 (Cecil Higgins Art Gallery and Museum, Bedford)

Aubrey Beardsley, drawing for the frontispiece for
Venus and Tannhäuser, c. 1895 (Cecil Higgins Art
Gallery and Museum, Bedford)

Material by or associated with
John Ruskin (1819–1900)

Bembridge School, Isle of Wight
tel. 0983-872101

By appointment

Admission charge

In 1974 the Museum was presented by Professor and Mrs John Hull Grundy with more than a hundred pieces of jewellery from the late 18thC to the 20thC. There is also a collection of metalwork, Higgins's domestic silver, and also thirty-three pieces from the Handley-Read collection, in particular a superb glass decanter with silver mountings and antique gems and coins designed by William Burges in 1865. In 1973 the Museum purchased (with NACF help) the extremely rare and beautiful St Agnes Tazza from the Church of St Agnes, near Perran in Cornwall, made 1579–80.

A collection of 19thC objects has been brought together in Victorian room settings, including a drawing-room, dining-room, library, guest bedroom and nursery, featuring items from the Handley-Read collection. The William Burges furniture is also brought together in a room decorated in his style. Lace, including the Thomas Lester collection, is also on display.

The Museum has won five awards for initiative since 1977.

There is a shop, and refreshments are available on request only for organised parties. The publications for sale on the premises include an account of the founder entitled *Cecil Higgins— Collector Extraordinary.*

BEMBRIDGE, *Isle of Wight*

Ruskin Galleries

The largest single Ruskin collection is concentrated here around an extensive holding of Ruskin's literary MSS, notebooks and sketchbooks, twenty-six volumes of diaries and several thousand letters. There are portraits of Ruskin, of his father and of Rose La Touche. An extensive library contains various editions of books by Ruskin, books about him and books from his own library. Apart from these documentary items, the collection has no less than eight hundred drawings and watercolours by Ruskin himself and about six hundred by artists associated with him. Ruskin used drawing and painting not as a medium of artistic expression but as a means of recording the precise appearance of architecture and nature. Intense observation combined with great facility in the use of pencil and brush resulted in works of great beauty which transcend the simple didactic purpose for which they were intended. Notable are the drawings of Switzerland and Italy and those connected with his great work, *The Stones of Venice.* The range of his work, from the slightest sketches to highly finished watercolours, make this collection of importance to Ruskin scholars and it has been drawn on for many publications.

Ruskin's contemporaries are represented by the work of Millais, Richmond, Arthur Severn, W. H. Hunt, T. M. Rooke, E. Burne-Jones and Kate Greenaway, among others.

Among the MSS in the collection are several volumes of notes and sketches for *The Stones of Venice,* parts of the MS of *Fors Clavigera* and other works as well as a rarity, part of the MS of *Praeterita,* Ruskin's autobiography.

The collection was begun about the turn of the century, just as Ruskin himself died, by John Howard Whitehouse, the founder of the Bembridge School. He had become interested in the life and teaching of John Ruskin in the 1890s and as opportunities presented themselves he began to build a library and archive of Ruskin material. During the early 1930s he bought many important drawings, and he continued to collect up until his death in 1955. In 1929 the gallery was built, attached to his house which had been designed by M. H. Baillie Scott and built a few years earlier. The design of the gallery was almost certainly devised by Whitehouse himself, in collaboration with his builder, in a style to match the house.

The present curator is secretary and founder of the Ruskin Association and editor of the *Ruskin Newsletter,* as well as author of the two leaflets about the Galleries and the Ruskin drawings, listed with brief titles and dates, which are available from the Ruskin Galleries.

John Ruskin, watercolour of *Rose La Touche, c.* 1860
(Ruskin Galleries, Isle of Wight)

BERWICK-ON-TWEED, *Northumberland*

Berwick Museum and Art Gallery

French paintings (19thc); Dutch brass and pewter; Chinese and Japanese ceramics; Delft pottery; Roman and Venetian glass

The Clock Block, The Barracks, Ravensdowne, Berwick-on-Tweed
tel. 0289-306332/304493

Mon–Fri 10–1 pm, 2–5 pm;
Sat 9–12 noon (June–Sept)

Admission free at present

Berwick Museum is housed in part of the 1719 Barrack block built around a square, one of the earliest in Britain, which is attributed to Sir John Vanbrugh (1664–1726).

The Berwick Art Gallery benefited from the generosity of the great collector Sir William Burrell (1861–1958) who lived nearby at Hutton Castle in the latter years of his life. In 1949 he presented to the town a collection of paintings which, like the more widely known holdings of the Burrell Museum in Glasgow (q.v.), concentrate on the French 19thc with works by Géricault (*Wounded Cavalry Officer*), Degas (*Danseuses Russes*) and the landscapists Daubigny, Georges Michel and Boudin. Apart from the Burrell paintings there are 18thc portraits by, for example, Hudson, Ramsay and Raeburn, as well as a rarity in the form of a French 17thc *Group of Peasants* attributed to the Le Nains. Local antiquities, Chinese and Japanese ceramics, Delft pottery, Dutch brass and pewter and Roman and Venetian glass are also displayed.

BEVERLEY, *North Humberside*

Beverley Art Gallery and Museum

Champney Road, Beverley
tel. 0482-882 255

Mon–Wed, Fri 9.30–12.30 pm, 2–5 pm;
Thurs 9.30–12 noon; Sat 9.30–4 pm

Admission free

Founded in 1909 by John E. Champney and William Spencer, both of Beverley, the Museum has a comprehensive collection of the work of the local artist Frederick Elwell (1870–1958), who mostly painted scenes from country life. Many of the Museum exhibits have now been transferred to the Museum at Skidby Mill, Cottingham.

Car-parking is available nearby.

BEXHILL-ON-SEA, *East Sussex*

Bexhill Manor Costume Museum

Manor Gardens, Old Town, Bexhill-on-Sea
tel. 0424-215361

Tues–Fri 10.30–1 pm, 2.30–5.30 pm;
Sat, Sun, Bank Holidays 2.30–5.30 pm.
Closed Mon

Admission charge

The Costume Museum, founded in 1972, is housed in the stables attached to a Manor House of Tudor origin, set in small but attractive gardens. The collection comprises costumes, accessories and related artefacts from 1740 to the present day and a Victorian kitchen.

The Museum has an Association of Friends. A catalogue of the current display is available from the Museum shop, and there are car-parking facilities.

BIDEFORD, *North Devon*

The Burton Art Gallery

Kingsley Road, Bideford
tel. 02372-6711, ext. 315

Mon–Fri 10–1 pm, 2–5 pm;
Sat 10–1 pm. Closed Sun

Admission free

The Gallery was built and opened in 1951 by Thomas Burton (d. 1959) in memory of his daughter and houses his own collections of silver, pewter, Napoleonic ship models and North Devon slip-ware, together with the watercolours and collection of Hubert Coop (1873–1953), himself a watercolour painter and collector. On display are visiting-card cases and porcelain, as well as paintings by Reynolds, Shayer, Clausen, Opie and a good collection of works by Mark Fisher and E. Aubrey Hunt. There is also a collection of watercolours, drawings and dioramas of local topographical or historical interest by Judith Ackland and Mary Stella Edwards, both of whom worked in the district between 1913 and 1965.

The Museum has an Association of Friends. There is a *Catalogue of Exhibits*, which was published in 1982. Car-parking is available.

BIRKENHEAD, *Merseyside*

Williamson Art Gallery and Museum

Watercolours (18thC–20thC);
oil paintings (19thC–20thC);
local porcelain and pottery

Slatey Road, Birkenhead
tel. 051-652 4177

Mon–Sat 10–5 pm; Thurs 10–9 pm;
Sun 2–5 pm

Admission free

The town's first museum and art gallery was opened in 1912 in the old library premises. The present purpose-built gallery was opened in 1928, following an architectural competition, the winners being Liverpool-based architects Leonard G. Hannaford and Herbert G. Thearle. It was financed from bequests made to Birkenhead Corporation in 1917 by John Williamson, a Director of Cunard, and his son Patrick. The Gallery is a single-storeyed building renowned in its time for the innovative methods of natural lighting.

The Gallery holds a major collection of watercolours from the 18thC to 20thC, with works by Turner, Girtin, de Wint, Callcott and many more. The paintings collection includes examples by Cotman, Roberts, Pettie, a good selection (both paintings and drawings) of the local painter Philip Wilson Steer and sixty-six works by another Liverpool painter, John Finnie. There is a also a comprehensive collection of the etchings of Seymour Haden. The holdings also include material on a maritime theme relevant to the town's history as a centre of ship-building, with paintings, prints, a photographic archive and ship models.

The Gallery covers a wide range of decorative arts. The original John Williamson Bequest contained Oriental, Continental and English ceramics, and later bequests included a large collection of 18thC Liverpool porcelain and an extensive collection of Birkenhead Della Robbia pottery. Irish and English glass are well represented, and two other bequests include many Oriental jade pieces, silver, ceramics and furniture.

There is an Association of Friends. Catalogues are available for past exhibitions of Liverpool Porcelain, Della Robbia, Tall Ships, Howarth Windmill and Bidston, as are booklets on Della Robbia and Birkenhead Park. The Gallery publishes a range of postcards of local history and local contemporary artists. There is a Museum shop and a car-park.

Della Robbia pottery wall plaque, made by Charles Collis and painted by Gertrude Russell, *c.* 1900 (Williamson Art Gallery and Museum, Birkenhead)

Furniture (English, 16thC–19thC); pottery (17thC–19thC); porcelain (17thC–19thC); tapestries; textiles; paintings (portraits including Holte family items, topographical works relating to Aston Hall, decorative paintings); heirlooms (Holte family); and silver

Trinity Road, Aston
tel. 021-327 0062

Mon–Sat 10–5 pm; Sun 2–5 pm
(mid-Feb–mid-Dec)

Admission free

BIRMINGHAM, *West Midlands*

Aston Hall [1]

Aston Hall is a large country house built between 1618 and 1635. Attributed to the surveyor John Thorpe (*c.* 1565–1655), it is a building of considerable architectural importance. It retains much Jacobean plasterwork of high quality and contemporary fireplaces and panelling, as well as a great open-well staircase with a strapwork balustrade and an almost unaltered long gallery. There is also some good rococo decoration, but the house has been little altered since 1770. Aston Hall was built for Sir Thomas Holte (1571–1654), 1st baronet, and its last occupant was James Watt (1769–1848), the son of the great engineer.

Its contents were largely dispersed in 1817 and in 1849. The house became a museum in 1858, and passed into the ownership of Birmingham Corporation in 1864, the first historic house in the country to be acquired for this purpose by a local authority. After the opening of the present City Museum and Art Gallery in 1885, Aston Hall was used largely as an annexe for the display of material not considered worthy of exhibition at the former. Since 1950 the Museum and Art Gallery have built up a distinguished collection of furniture, most of which is displayed at Aston Hall, together with appropriate paintings and sculpture. Aston Hall has therefore been a Museum of country house furniture and decoration for the last thirty years. Its contents were reorganised following a restoration programme in 1982–84 and much recent research has been done on its development prior to 1864.

The Holte family heirlooms include portraits by Gainsborough and Romney, family silver and two large embroidery wall-hangings worked by Mary Holte, completed in 1744. Both hangings were bequeathed to Aston Hall in 1872 by Charles Holte Bracebridge. Three embroidered and appliquéd covers (16thC–18thC) from the Alexander gift went to Aston Hall through the NACF in 1955. The collection of English furniture includes a late 16thC marble topped table, a state bed of *c.*1695 from Wraxton Abbey, Oxfordshire, as well as examples of early upholstery and of the Regency 'Elizabethan' revival.

The House was acquired by the Aston Hall and Park Company Ltd in 1858 and was opened to the public as a Museum of art and industry. The Company's patrons included Sir Francis

PUBLICATIONS
Aston Hall: A General Guide, 1981 (Still available but out of date in some particulars)
The Grand Old Mansion: The Holtes and their Successors at Aston Hall (1618–1864), 1984

European paintings (13thC–20thC); European, African and Oriental art objects (Bronze Age–early 20thC); Byzantine seals; Roman and Byzantine coins

The University of Birmingham, Edgbaston
tel. 021-472 0962

Mon–Fri 10–5 pm; Sat 10–1 pm. Closed Sun. Parties by appointment only

Admission free

PUBLICATIONS
Handbook of the Barber Institute of Fine Arts, 2nd edn, 1983
Picture Book I: Landscapes, 1960
A. W. Dunn, *A Handlist of the Byzantine Lead Seals and Tokens and of Western and Islamic Seals in the Barber Institute*, 1983
Catalogue: An Exhibition to mark the Jubilee of the Barber Institute, 1983
Inaugural Lecture: Art in the University: The Early History of the Barber Institute, by Hamish Miles, 2nd edn, 1983

Scott, Bt (1824–63), Charles Holte Bracebridge (1799–1872) and Alderman Thomas Lloyd (1814–90). Following its financial failure, Aston Hall and Park were bought by Birmingham Corporation in 1864.

Guidebooks and other publications, postcards and souvenirs are available at the entrance to the house. There is extensive free car-parking in Aston Park.

Barber Institute of Fine Arts [2]

The Institute was founded in 1932 by Lady Barber in memory of her husband, Sir William Henry Barber, Bt, a Life Governor of the University of Birmingham, to promote the study of fine arts and of music within the University. She bequeathed the residue of her estate to build the Institute, to provide for its maintenance, to make acquisitions and to engage first-class musicians for occasional recitals. The brief for acquisitions was wide: 'works of art' including 'furniture, tapestries, needlework, lace, mediæval manuscripts and finely printed books' but excluding 'pottery or china'. The resulting collection embraces a wide variety of pictures and objects with a huge date span from the Bronze Age to the early 20thC. Notable are the collections of Byzantine seals and of Roman and Byzantine coins.

The Institute was designed by Robert Atkinson (1883–1953), formally opened by Queen Mary on 26 July 1939, and in 1946 won the Architecture Medal of the RIBA.

The collection of paintings is very fine and wide-ranging in its coverage of European art from the 13thC up to the end of the 19thC, bearing out the Founder's stipulation that the Institute should seek out 'works of exceptional and outstanding merit'. From modest beginnings in 1939, when the collection amounted to only thirteen paintings and twenty drawings, it has grown to include among the Italians for instance, work by Simone Martini (*St John the Evangelist*); a 14thC panel representing *St Francis of Assisi* by Ugolino di Nerio; Giovanni Bellini's *St Jerome in the Wilderness*; a Cima *Crucifixion*; a Veronese *Visitation*; and a Guardi *Regatta on the Grand Canal*. The polarities of taste in the Flemish School are exemplified by Jan Gossaert's *Hercules and Deianira* and Rubens's *Landscape at Malines*. The Dutch school includes works by Frans Hals (a *Portrait of a Man Holding a Skull*), Aelbert Cuyp (*Huntsmen Halted*), Jan Steen (*The Wrath of Ahasuerus*) and, for the 19thC, Van Gogh's *Old Woman Digging*. The French School is well represented with works by the greatest artists from the 17thC onwards: Nicolas Poussin's *Tancred and Erminia* was once in the collection of Sir James Thornhill; there is Claude's *Classical Landscape*, one of the few examples of his work outside London; a Le Nain of the *Gamesters*; works by Aubry, Lancret and Hubert Robert; and, for the 19thC, Ingres, Delacroix, Courbet and Manet, who is represented here by an unfinished portrait of his friend and fellow-artist, Carolus Duran. A rare example of the work of a French Symbolist is the Puvis de Chavannes *Beheading of John the Baptist*, of which there is, coincidentally, a larger, unfinished version, with variations, in the Hugh Lane Bequest (see The Hugh Lane Municipal Gallery of Modern Art, Dublin, p. 334). The large *Marriage at Cana* by Bartolomé Murillo is one of the few Spanish pictures, a school not well represented in this country. There are fine English portraits by Reynolds and Gainsborough, with Gainsborough's landscape masterpiece, *The Harvest Wagon*. The works of the 19thC range from a Turner of *c*. 1807 to a lovely Rossetti called *The Blue Bower*, and Whistler's *Symphony in White III*, as well as Sickert's *The Eldorado, Paris*. Recently some 20thC paintings have been acquired, including *The Taste of Sorrow* by René Magritte.

The collection of watercolours and drawings includes some beautiful landscapes, including a *Hill-Town in Tuscany* by Fra Bartolommeo and a beautiful small watercolour of *An English Landscape* by Van Dyck; there is also a group of Rembrandt's drawings and a Rubens of his wife, *Hélène Fourment*. The English School ranges from a miniature by Isaac Oliver to a series of comic drawings by Phil May, one of the most notable of *Punch* artists.

There is a wide-ranging collection of sculpture, including several bronzes after Giovanni da Bologna, which are complemented by examples from the 19thC by Géricault and Degas. There is also a relief ascribed to Giovanni della Robbia and a bust of *Alexander Pope* by Roubiliac. Outside stands the life-size *George I on Horseback* by John van Nost the Elder.

There is a sales counter for posters and publications.

James McNeill Whistler, *Symphony in White III*, 1867 (The Barber Institute of Fine Arts, Birmingham)

Pierre Puvis de Chavannes, *Beheading of St John the Baptist*, 1869 (The Barber Institute of Fine Arts, Birmingham)

City Museums and Art Gallery [3]

British and European painting, sculpture, prints and drawings (14thC–20thC) including important 17thC Italian paintings, 18thC English watercolours, Pre-Raphaelite paintings and drawings and a representative 20thC collection

Chamberlain Square, Birmingham
tel. 021-235 2834

Mon–Sat 10–5 pm; Sun 2–5 pm

Admission free

The Birmingham Museum was founded in 1867. As the result of the bequest from Richard and George Tangye of money for the building of a museum in 1880, the foundation stone for the present premises designed by H. Yeoville Thomason was laid in 1881; the completed galleries were opened to the public in 1885. Twenty years later, through the generosity of John Feeney, son of the founder of *The Birmingham Post*, an upper floor extension was commenced and in 1912 the ten new Feeney Art Galleries were opened. Further galleries and a new entrance in Great Charles Street were added in 1919. The Museum and Art Gallery for one of Britain's most important provincial collections is an impressive example of late Victorian classical architecture with a two-storied portico entrance topped by a sculptured pediment which is somewhat dwarfed by the adjoining clock-tower. At the top of the main stairs is a large Round Room; another notable feature of the interior is the newly-restored Industrial Gallery, a fine example of Victorian cast-iron architecture with a vaulted roof and delicately curling spandrels.

The representative collection of European painting contains great treasures: Simone Martini's *Saint Holding a Book* of *c.* 1333; *The Cornbury Park Altarpiece* by Giovanni Bellini dating from 1505, bought after a successful appeal in 1977; *The Rest on the Flight into Egypt* by Orazio Gentileschi; a rare example of Pierre Subleyras—*The Blessed John of Avila*; Canaletto's *East and West Façades of Warwick Castle* of *c.* 1748 and a powerful early *Roman Beggar Woman* (1857) by Degas. The Pre-Raphaelite collection is justly celebrated, perhaps the finest in the world with very choice examples, notably Ford Madox Brown's *The Last of England*; *The Blind Girl* by J. E. Millais, with its ravishing landscape lit by a rainbow; and Rossetti's *Beata Beatrice* with the features of his wife and most beautiful model, Elizabeth Siddal. Holman Hunt's *The Finding of the Saviour in the Temple* came from J. T. Middlemore in 1896. The 20thC is well represented with works by Sickert, Sir Jacob Epstein (nine bronzes, including the well-known *Lucifer*), Stanley Spencer, Peter Lanyon, Francis Bacon and Henry Moore (*The Warrior* of 1953). A lesser-known branch of the late 19thC/early 20thC painting is illustrated by the selection of works by members of the briefly renowned Birmingham School, Southall, Payne, Meteyard and Gere.

The drawings collection is extensive, with many important English examples, over four hundred of which came from the J. Leslie Wright Bequest in 1954, effectively making the Prints and Drawings department one of the richest repositories of the English Romantic style in this country. The Pre-Raphaelite holding benefited from a body of subscribers who presented drawings by Rossetti and Burne-Jones in 1903 and 1906, and the bequest of J. R. Holliday in 1927. The gallery has built up a representative selection of modern prints by British, Continental and American artist-printmakers made in the last fifty years, including Peter Blake, Patrick Caulfield, Terry Frost, David Hockney, Matisse, Picasso, and so on.

The decorative art collection is wide-ranging with many important individual examples of European and Oriental glass and ceramics, including the Alan Green collection of very fine pieces by William De Morgan decorated with richly coloured lustres. The silver collections, with their many examples of the work of Birmingham makers (i.e. the famous ecclesiastical firm of Hardman's)—this was, after all, the centre of the silver and jewellery trade in the 18thC and 19thC—was greatly enriched in 1965 by the Godman Gift of European Silver. In 1981–84 a carefully chosen selection of jewellery and silver with the emphasis on the Birmingham Arts and Crafts movement, as exemplified by the Gaskins, A. E. Jones, W. Blackband and others, was given by Mrs Hull Grundy as part of her enormous benefaction in this field to a large number of museums in this country. The unique Pinto Collection of Treen formed by Edward and Eva Pinto was acquired in 1965, and is part of the Local History Collection.

The Art Gallery has in recent years run a series of exhibitions highlighting and relating to the collections. Notably in 1985, its centenary year, this will include exhibitions of 'The Holy Grail Tapestries' and 'Beauty from the Colour Box, Parts I and II', 18thC and 19thC drawings from the permanent collection. Many of the catalogues, which include valuable specialist information, are in print, and are obtainable from the Museum shop. Other Museum publications include booklets, pamphlets and catalogues to the collections, as well as a number of catalogues to recent exhibitions. A list may be obtained from the Publications Unit. There is a cafeteria.

Pierre-Hubert Subleyras, *The Blessed John of Avila*, *c.* 1740 (City Museums and Art Gallery, Birmingham)

Peter Paul Rubens, Sketch for the ceiling of the Whitehall Banqueting House, *James I uniting the Kingdoms of England and Scotland*, c. 1632–33 (City Museums and Art Gallery, Birmingham)

Giovanni Antonio Canal, called Canaletto, *Warwick Castle: The East Front, c.* 1748
(City Museums and Art Gallery, Birmingham)

Ford Madox Brown, *Pretty Baa-Lambs*, 1851–59 (City Museums and Art Gallery, Birmingham)

BLACKBURN, *Lancashire*

Blackburn Museum and Art Gallery

Local History and archæology; English watercolours and paintings (18thc–20thc); Japanese prints; illuminated MSS, printed books and coins

Museum Street, Blackburn
tel. 0254-667130

Mon–Sat 9.30–5 pm. Closed Sun

Admission free

Entry into Jerusalem, illuminated page from the Blackburn Psalter, *c.* 1250–60 (Blackburn Museum and Art Gallery)

The Blackburn collection was founded in 1862 and the municipal free library and museum built ten years later. The architects were Woodzell and Collcutt, who designed the building incorporating externally low-relief panels by G. W. Scale, mosaic murals in the porch, and Parthenon-derived friezes in the Art Gallery.

The collections cover a wide range of subjects and interests. The paintings are mostly 19thc British landscape and genre, for example, Albert Moore's *The Loves of the Winds and the Seasons* and Lord Leighton's *Cherries*, although there are some good Dutch pictures, for instance *Pastoral Landscape* by Berchem. There is a particularly strong collection of 19thc watercolours with fine works by Turner, Girtin, Cox, William Henry Hunt and Albert Goodwin.

In 1944 the widow of a local industrialist, T. B. Lewis, presented his large and unusual collection of Japanese prints. It is especially strong in the 19thc and Utagawa School and most major artists are represented. A local rope manufacturer, R. E. Hart, bequeathed his magnificent collection of Western European illuminated MSS from the 13thc to the early 16thc, including the French Peckover Psalter of 1220–40 and the Blackburn Psalter of *c.* 1250. Also in the bequest came printed books, including German and Italian incunabula, and 18thc French illustrations. The excellent English 16thc to 19thc examples include three Caxtons and a Kelmscott Chaucer. Hart also collected some very fine coins; the main examples are from classical antiquity.

Also in the Museum are 18thc and 19thc British ceramics, some domestic glass, Oriental porcelain, metalwork and ivories. There are thirty-one Russian and Greek icons from the 18thc and 19thc, including the Fenwick bequest of 19thc Russian icons presented through the NACF. The local history collections concentrate on the 19thc and the development of the cotton industry and the archæology collection, principally consisting of Egyptian pieces, includes a good Coptic mummy with an encaustic portrait. There is an ethnographical collection and a large amount of ephemera, including the Kathleen Ferrier sheet music collection.

The Museum has an association of Friends. There is a shop which sells publications, including a *Guide to the Hart Collection*, postcards and posters.

Illuminated marginalia from the Blackburn Psalter (Blackburn Museum and Art Gallery)

BLACKPOOL, *Lancashire*

Grundy Art Gallery

British painting (19thc–20thc)

Queen Street, Blackpool
tel. 0253-23977

Mon–Sat 10–5 pm. Closed Sun

Admission free

The Art Gallery was founded by Sir Cuthbert Grundy and John Grundy, local businessmen and philanthropists, in 1911 and was presented to the Blackpool Corporation. The architects of the building were Cullen, Lockwood and Brown.

The painting collection includes work by J. F. Herring, Richard Ansdell, T. S. Cooper, Copley Fielding, Thomas Creswick, Herkomer, Linnell, David Roberts, W. Shayer, Verboeckhoven and B. W. Leader. Other later painters represented are Stanhope Forbes, E. A. Hornel, Augustus John (*Aircraftsman Shaw (T. E. Lawrence)*), Harold Knight, Laura Knight, La Thangue, P. Nash (*Sanctuary Wood*), and E. Ravilious (*The Yellow Funnel*). There is also a collection of 19thc Japanese netsukes and Indian ivories.

There are some catalogues of recent exhibitions available. There is a pay car-park next door.

BOLTON, *Greater Manchester*

Bolton Museum and Art Gallery

British watercolours and drawings
(18thC–20thC); oil paintings (17thC);
British sculpture (20thC); British pottery
and porcelain, including modern; British
furniture (17thC); textiles

Le Mans Crescent, Bolton
tel. 0204-22311 ext. 379

Mon, Tues, Thurs, Fri 9.30–5.30 pm;
Sat 10–5 pm. Closed Wed, Sun

Admission free

PUBLICATIONS
T. Midgely, *The Spinning Mule: An account of the
machine and the life of its inventor, Samuel Crompton*,
1927 (rev. 1979)

Exhibition catalogues:
*Joseph Farrington 1747–1821: Watercolours and
Drawings*, 1979
The Masons: A Dynasty of Potters, 1980
*Albert Goodwin 1845–1932: Watercolours and
Drawings*, 1981
Glazes and Clay: 5 Potters in North Wales, 1981
*Ivor Abrahams: The Garden Image, Prints &
Sculpture*, 1983
Paul Goodwin: Between Africa and Europe, 1983

Bolton's first art gallery was at Mere Hall, a building presented to the Corporation by John Pennington Thomasson (1841–1904) in 1890. The art collections housed here consisted of a small number of oil paintings donated to the Gallery. The nucleus of the fine and decorative art collection was formed in the 1940s as a result of a number of donations and bequests in the previous years, and the provision of a purchase grant after the Second World War.

William Hesketh Lever, Lord Leverhulme (1851–1925), the great soap magnate and art patron was born in Bolton and in 1902 presented the Corporation with the manor house of Hall i'th'Wood, together with an impressive collection of oak furniture and some pictures.

In 1939 a new Museum and Art Gallery in what is now Le Mans Crescent was built by Bradshaw, Gass and Hope of Bolton, with a classical portico, Ionic columns and ornamental pediment. The interior is in Art Deco style, though much changed in recent years.

An important bequest was received of 20thC English paintings from the collection of Frank Hindley Smith, a Bolton mill owner and active patron of the arts. This included Duncan Grant's *The Gossips*, Vanessa Bell's *View in Garden, the open door, Charleston* and William Roberts's *The Wash*. These have been added to by purchases such as Ivon Hitchens's *Still Life with Poppies* and Edward Wadsworth's *Composition 1930*.

The collection of about 750 British drawings and watercolours is a general one with high quality works by many artists and has been the main focus of purchasing activity in recent years. There are works by J. R. Cozens (*The Palazzo Vecchio from the Boboli Gardens, Florence*), Rowlandson (*Feyge Dam and part of the Fishmarket, Amsterdam*), Turner (*On the Upper Rhine*), Lear, J. F. Lewis, de Wint, Wadsworth, Nicholson, Auerbach and Hepworth (*Fenestration—The Magnifying Glass, Stage 2*).

A small group of 17thC Old Master paintings has also been assembled, amongst which are Romanelli's fine early work, *The Adoration of the Shepherds*, and Luca Giordano's *Death of Seneca*.

There is a strong collection of bronzes by Jacob Epstein including *The Slave Hold* and a group of portrait busts. Other British 20thC sculptors represented include Moore, Hepworth and Paolozzi.

There is a fine and extensive collection of early textile machinery and a large collection of antiquities from Ancient Egypt. The textile collections include originals of Hargreave's Spinning Jenny, Arkwright's Water Frame, Crompton's Mule and a good collection of early textile pattern books.

Giovanni Francesco Romanelli, *The Adoration of the Shepherds*, early–mid-1630s (Bolton Museum and Art Gallery)

The smaller collections include British coins and medals, British archæology, Polynesian and Oriental ethnography, 19thc costume and a wide variety of local history items.

The Museum has an Association of Friends. There is a shop in the Library foyer where a handlist for the collection of drawings and watercolours, published in 1984, and exhibition catalogues are for sale. There is a cafeteria, and street parking is available.

BOURNEMOUTH, *Dorset*

Russell-Cotes Art Gallery and Museum [1]

Victorian and Edwardian academic paintings, sculpture and furniture; watercolours, ceramics and glass (18thc–19thc)

East Cliff, Bournemouth
tel. 0202-21009

Mon–Sat 10.30–5.30 pm; Sun 3–5.30 pm

Admission charge

The collections are housed in a late Victorian mansion presented to the town with their own collection of fine and decorative art by Sir Merton and Lady Russell-Cotes. The style of the building is an extravagantly asymmetrical version of an Italianate seaside villa with covered verandas and balconies, and a brightly polychromatic mosaic ornamented hall designed by John Fogerty, built in 1894 when Sir Merton was Mayor of Bournemouth. New art galleries were added to the original private house after Sir Merton's death and were opened in 1919 by HRH the Princess Beatrice, Queen Victoria's youngest daughter, when the collection consisted of 350 pictures and 60 sculptures. The contents now range from 17thc to 20thc paintings, watercolours, sculptures and miniatures, 18thc and 19thc ceramics, including a large group of Wedgwood jasperware; to 19thc furniture; and 18thc and 19thc silver and plate. There are three rooms of Japanese art and the Irving Room of memorabilia of Sir Henry Irving and theatrical relics.

The Russell-Cotes Gallery is still dominated by the taste of the donor in spite of many subsequent additions to the collection. This is partly because the most memorable and spectacular of the Victorian and Edwardian academic pictures are so large and so brightly coloured. Pride of place in this respect should go to Edwin Long, a favourite artist of Sir Merton Russell-Cotes, whose work is exceptionally well represented here, notably by the sixteen-foot-long *Flight into Egypt* which occupies the whole of one wall in the Gallery. Many forgotten or neglected artists from the late 19thc establishment are shown here, including Harold Copping, J. Anderson Hague, John Charlton, A. J. Woolmer, Louis B. Hurt, Sheridan Knowles, Emile Bayard and A. D. Montemezzo. It is startling in this context to find a beautiful 1834 Turner of *St Michael's Mount*. Landscape and seascape are both well represented with works by John Brett, W. L. Wyllie and Benjamin Williams Leader, amongst a host of other artists of the same type whose names are for the moment in obscurity.

The buying policy in the mid-20thc added to the usefulness of this collection as a point of reference for the work of artists below the top rank whose work is not widely represented in other galleries. With the small funds available, the policy adopted was to 'encourage living artists, with some bias towards those who work in the tempera medium, self-portrait and studies of child-life' (Norman L. Silvester, curator writing in 1956). A notable self-portrait is that of John Minton which shows the artist at work reflected in a mirror. W. Graham Robertson has also painted himself at his easel accompanied by an admiring small girl. This policy inevitably produced a number of works which are for the present out of fashion, but attention has recently been focused on the artists of the Birmingham group and followers of the Pre-Raphaelites, such as Joseph Southall, Maxwell Armfield, Henry Justice Ford and Madeline Wells, all of whom are represented here.

In 1945 the acquisition of D. G. Rossetti's splendidly sensuous *Venus Verticordia* made an important addition. It was commissioned by Mr J. Mitchell in 1864 for 300 guineas (in 1945 the Gallery was only asked to pay 350 guineas for it) and shows the red-haired model, Alexa Wilding, against a trellis of massed roses and honeysuckle. The flowers cost Rossetti 'pounds and pounds' and he was forced to borrow money from his long-suffering brother. 'I have done more roses,' he wrote to his mother in 1864, 'and I have established an arrangement with a nursery gardener at Cheshunt, whereby they reach me every two days, at 2/6d for a couple of dozen each time, which is better than paying a shilling a piece at Covent Garden.' Other notable examples from the paintings collection include: George Morland, *The Peasant's Repast*; George Cole, *A Surrey Landscape*; William Etty, *The Dawn of Love* and *Venus and Cupid*; Edwin Landseer, *A Highland Flood*; W. P. Frith, *Ramsgate Sands* (a late version painted in 1905 of the 1854 picture in the Royal Collection); Albert

Maxwell Armfield, *Miss Chaseley on the Undercliff*, 1927 (Russell-Cotes Art Gallery and Museum, Bournemouth)

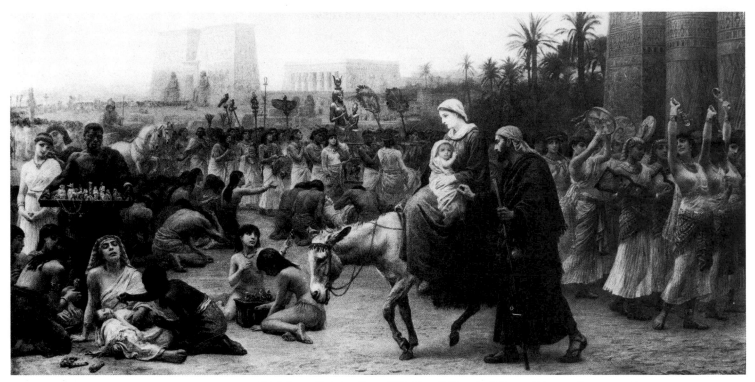

Edwin Long, *Flight into Egypt,* 1883 (Russell-Cotes Art Gallery and Museum, Bournemouth)

Moore, *Midsummer* (an unusually intensely coloured work); Atkinson Grimshaw, *An Autumn Idyll*; Arthur Hughes, *Little One who Straight has come Down the Heavenly Stairs* (a 'symbolist' work of 1888); Joseph Southall, *At the Well in Samaria* and *The Great Bridge at Cahors*; Maxwell Armfield, *Miss Chaseley on the Undercliff*; Anna Zinkeisen, *The Decoration of the Morning Room Ceiling.*

The paintings are complemented by sculpture of the same period and in a similar academic taste. They are of interest mainly in rounding out the picture of Sir Merton Russell-Cotes's collecting activities.

The collection of English watercolours includes examples of the work of Turner, George Barret, David Cox, J. S. Cotman, Peter de Wint, John Varley, Randolph Schwabe and James Clark.

PUBLICATIONS
Richard Quick, *The Life and Works by Edwin Long,* 1931 (repr. 1970)
Selective catalogues of the collection were published in 1924 and 1956

Although the Russell-Cotes, in its remarkable idiosyncratic way, is the most interesting of the museums in Bournemouth, the other collections should not be overlooked.

Casa Magni Shelley Museum [2]

Boscombe Manor, Shelley Park, Beechwood Avenue, Boscombe

For opening times and conditions of admission tel. 0202-21009

This is housed in two rooms on the ground floor of the Bournemouth and Poole College of Art and Design. It is devoted to the poet Percy Bysshe Shelley and centres round an important library of the Romantic period and the Margaret Brown Shelley collection.

Rothesay Museum [3]

8 Bath Road, Bournemouth

For opening times and conditions of admission tel. 0202-21009

The collection in this museum is very varied, including English porcelain; furniture (17thc); Victorian bygones; arms and armour; as well as the Lucas collection of early Italian paintings and pottery, which includes a group of Renaissance maiolica. The British Typewriter Museum is on the first floor. The Museum may remove to another part of Bournemouth during 1985.

BRADFORD, *West Yorkshire*

Bolling Hall Museum [1]

Furniture, ceramics, metalwork and glass in period room settings (17thC & 18thC)

Bowling Hall Road, Bradford
tel. 0274-723057

Tues–Sun 10–6 pm (Apr–Sept),
10–5 pm (Oct–Mar). Closed Mondays
except Bank Holidays

Admission free

Bolling Hall developed from a late mediæval peel tower, with a late 16thC kitchen range, onto which an early 17thC housebody (hall) range and a wing to balance the kitchen range were added. This wing was remodelled in 1779–80 by John Carr of York (1723–1807) and contains an imposing Georgian staircase and a drawing-room with a delicate plaster ceiling in the Adam style. There are a 17thC plaster ceiling with later colours and an original carved oak chimneypiece in a room in the 17thC range. An early 18thC 'parlour' still has its original panelling. The housebody window contains stained glass and heraldic glass, which was recorded as being in the house in 1783. It was removed in 1825 to another house in Yorkshire and restored to its present position in 1963.

John Atkinson Grimshaw, *Fiamella*, 1883 (Cartwright Hall, Bradford; see over)

The development of Bolling Hall as a symmetrical H-plan house, and the use of loosely adapted classical motifs, denote that it was a house of some status. It has derived little from the local 'vernacular' styles.

Internally, it is gradually being redeveloped as a period house with the particular addition of soft furnishings. Certain areas are being restored in a 17thc manner, the John Carr wing to the period 1770–1800, and other rooms, for example the housebody and the 'Ghost Room', are being recreated in a 19thc 'antiquarian' manner. The house is surrounded by small grounds, and a garden, which is undergoing development of its 1920s layout as an 'old English' garden. There is also a herb garden.

Bolling Hall opened as a museum in 1915, having been presented to Bradford three years before by George Paley of the Bowling Iron Company.

The collections include fine 17thc and 18thc furniture, displayed with appropriate ceramics, metalwork, glass and domestic utensils. There are high-quality examples of 17thc regional oak furniture of West Yorkshire and the North-West. The collection of 18thc furniture also includes one of the pair of Croome Court cupboards, designed by Robert Adam and made by John Cobb in 1764–67, and a Couch Bed, supplied by Thomas Chippendale to Harewood House in 1769.

A shop sells postcards, and a guidebook, currently in a temporary form, is being revised. Car-parking is available.

Cartwright Hall [2]

Although the collection was in existence from 1879, the money to build a new art gallery was put forward by Samuel Cunliffe Lister (later Lord Masham; 1815–1906) and was built on the site of his house, Manningham Hall in Lister Park. It was opened in 1904 as a memorial to the inventor of the power loom, Edmund Cartwright (1743–1823). Designed by J. W. Simpson (1858–1933) and E. J. Milner Allen (1859–1912), the entire building is devised in an Imperial Edwardian baroque style. The dramatic and monumental quality is increased by heavy rustication at basement level. The atmosphere is carried through into the interior, particularly into the ground floor sculpture hall. A suite of grand upper galleries culminates in a panelled 'banqueting hall' which reflects the intended dual art gallery and civic function of the building.

The collection is particularly strong in late 19thc 'Olympian' British painting, for example, *An Egyptian Feast* by Edwin Long and *The Golden Fleece* by Herbert Draper. There are works from the early years of the New English Art Club such as *The Boy and the Man* by George Clausen, as well as several works by La Thangue, Stanhope Forbes and others. Sculpture is represented by works by Drury, Frampton and Havard Thomas. There is also a small collection of 18thc portraits, including notably Reynold's *The Brown Boy*. The European paintings from the 16thc and 17thc include works by Guido Reni and Paul Bril. The Gallery owns one of the preliminary studies for James Ward's monumental *Gordale Scar* (Tate Gallery), and both the finished painting and a preliminary oil-sketch by Ford Madox Brown for his celebrated historical work, *Wycliffe Reading his Translation of the Bible to John of Gaunt*. Early 20thc painting is represented by Paul Nash's *View 'S' Mediterranean* of 1934, a view from a window in the Hôtel des Princes in Nice; William Roberts's *Jockeys* (1928); work by Camden Town artists—a Gilman, *Portrait of a Man* (c. 1912) and a Spencer Gore, *Panshanger Park* (c. 1908)—and two landscapes by Stanley Spencer; a Vorticist Edward Wadsworth and examples by the Bradford artist William Rothenstein. There is sculpture by Chadwick—an idiosyncratic interpretation of *Radar*—Dobson, Epstein and Gaudier Brzeska; and drawings by Charles Ricketts, George du Maurier and Sir Bernard Partridge. Late Victorian narrative painting is exemplified by *Signing the Register*, an ambitious realist work of 1896 by James Charles which was included by Graham Reynolds in his *Painters of the Victorian Scene*. Contemporary British art is well represented, especially by another native artist, David Hockney—his early works and *Le Plongeur*. There is a large collection of international contemporary prints including work by Blake, Caulfield, Hockney and others.

Cartwright Hall also houses an important private collection of early 20thc paintings and drawings on loan from a local collector; it includes a fine Robert Bevan of 1913, two paintings by Walter Bayes and two by J. D. Innes.

British and European oil paintings, watercolours, prints, sculpture and ceramics (19thc and 20thc)

Lister Park, Bradford
tel. 0274-493313

Tues–Sun 10–6 pm (Apr–Sept), 10–5 pm (Oct–Mar). Closed Mon except Bank Holidays

Admission free

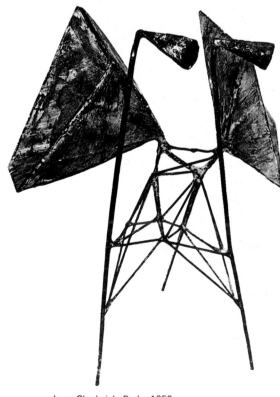

Lynn Chadwick, *Radar*, 1953 (Cartwright Hall, Bradford)

The Art Gallery and Museum forms part of the City of Bradford Metropolitan Council and has an association of Friends. A variety of publications is available at a sales counter, also postcards, ephemera and material related to exhibitions. There is a café on the lower ground floor, and car-parking.

National Museum of Photography, Film and Television [3]

Prince's View, Bradford
tel. 0274-727488

Tues–Sun 11–6 pm. Closed Mon
Special exhibitions open until 7.30 pm

Admission free except for cinema and
IMAX theatre

PUBLICATIONS
Exhibition catalogues:
Yosuf Karsh, *Karsh, A Fifty-Year Retrospective*, 1983
Colin Ford, *André Kertész, A Ninetieth Birthday Celebration*, 1979 (repr. 1984)
Britain in 1984: The Photographers' Gallery, 1984
The Other Eden, Photographs of the English Countryside 1840–1984, 1984
Pioneers of Photojournalism, 1984

The Museum opened in 1983 as an outstation of the Science Museum and is funded through them by the Department of the Environment. It was the brainchild of Dame Margaret Weston, Director of the Science Museum and Gordon Moore of Bradford Council. Richard Seifert (b. 1910) designed the building in the mid-1960s. It was intended as a theatre but left incomplete. In 1984 it was announced that the Kodak Museum, formerly at Harrow, was to be relocated in Bradford. This outstanding collection of over fifteen thousand items of historically important equipment, cameras and about twenty thousand photographs tells the story of photography and cinematography and is housed in a new wing.

The Museum's collections include the Daily Herald Picture Library, the Herschel Album by Julia Margaret Cameron and the earliest known photograph of a photographer at work, a daguerreotype by Jabez Hogg of *c.* 1843, as well as a large number of working models, equipment, dramatic reconstructions and photographs.

The shop stocks an extensive range of books on photography, film and television as well as posters, postcards and souvenirs. Publications include a Jarrolds Guide to the Museum and a Museum Information Pack. Exhibition catalogues are also available at the shop. There is a wine and coffee bar. Parking is available.

Daguerreotype by Jabez Hogg and W. S. Johnson of the photographer at work, *c.* 1843
(National Museum of Photography, Film and Television, Bradford)

BRIDLINGTON, *Humberside*

Bridlington Museum and Art Gallery

Sewerby Hall, Bridlington
tel. 0262-78255/678295

Sun–Fri 10–12.30 pm, 1.30–6 pm;
Sat 1.30–6 pm (Easter–Sept)

Admission free

This museum houses a small permanent collection of paintings, the Amy Johnson Collection of memorabilia and a collection of local history items, and also a small collection of jewellery donated by Mrs Hull Grundy.

BRIDPORT, *Dorset*

Bridport Museum and Art Gallery

South Street, Bridport
tel. 0308-22116

Mon–Wed, Fri 10.30–1 pm, 2.30–4.30 pm
(June–Sept). Closed Thurs, Sat, Sun

Admission charge

An extensive holding of dolls from all over the world dominates the collection which otherwise concentrates on items of local interest, notably those connected with the town's historic rope and net-making trade.

BRIGHOUSE, *West Yorkshire*

Smith Art Gallery

British painting and watercolours (19thC);
Dutch and Flemish paintings (17thC)

Halifax Road, Brighouse
tel. 0484-719222

Mon–Sat 10–5 pm; Sun 2.30–5 pm
(April–Sept only)

Admission free

In 1907 the Gallery opened as two substantial rooms attached to the Free Library. Alderman William Smith donated his collection of morally elevating pictures, put together from 1870 to 1905. Apart from the 17thC Dutch and Flemish paintings, the collection is made up principally of 19thC works, notably Thomas Faed's *The Mitherless Bairn*, Marcus Stone's *Silent Pleading*, Philip Hermogenes Calderon's *Orphan Children* and *Man goeth forth to his Labours*. Religious works and landscape paintings include works by E. J. Niemann, J. B. Pyne and John Atkinson Grimshaw, *A Mossy Glen*. Other artists represented in the collection include Danby, Daniell, Egg, Elmore, Frith, Goodall, Hornel, Horsley, Leighton, Linnell, Stanfield and Woolmer.

BRIGHTON, *East Sussex*

Barlow Collection of Chinese Ceramics, Bronzes and Jades [1]

Bronzes 12thC BC–10thC AD;
jades 2ndC AD–18thC;
ceramics *c*. 3rdC BC–18thC AD

The University of Sussex, Falmer, Brighton
tel. 0273-606755

Tues and Thurs during term
11.30–2.30 pm

Admission free

Sir Alan Barlow, Bt (d. 1968) bequeathed his collection, formed between 1921 and 1964, to the University and it was opened in 1974 in a special gallery designed by James A. Thomas in the library building.

The Collection is one of the most outstanding groups of Chinese objects in Britain outside the major London museums. It includes over four hundred items, many of great rarity and quality. It represents not least a remarkable study collection, being particularly rich in Chinese green-glazed wares (celadons) of the Song dynasty. There is one piece of the extremely rare Ru ware and several examples of *Guan* (official) celadons, made for the Imperial palace. There are also very fine figurines, including Tang camels and horses and a number representing travellers, officials and court ladies. The statuette in porcelain of the goddess Guanyin (Dehua kilns, Fujian province, *c*. 1700) is one of the most perfect to survive. There are good celadons from Korea and a small group from other parts of south-east Asia.

The bronzes are of fine quality and include a *ding* cauldron, two *gu* goblets, and two *jue* wine-pourers, as well as three Daoist mirrors. The jades include a rare white jade *bi* disc (about 1stC AD) and several other pieces of the early centuries AD.

PUBLICATIONS
The Barlow Collection, inaugural lecture by
Prof. Michael Sullivan, 1974
The Spouted Ewer and its Relatives in the Far East,
exhibition catalogue, 1983

Postcards are on sale. There is a restaurant in the Gardner Art Centre and car-parks at the University.

Brighton Museum and Art Gallery [2]

British, Dutch and Flemish, Italian and French paintings (16thc–20thc); British watercolours (18thc–19thc), especially topography and history of Brighton, as well as designs for the building and decoration of the Pavilion; pottery (19thc commemorative) and porcelain; furniture (18thc–20thc), especially Art Nouveau and Art Deco; costume (18thc–20thc); early musical instruments; local history and archæology; ethnography

Church Street, Brighton
tel. 0273-603005

Tues–Sat 10–5.45 pm;
Sun 2–5 pm. Closed Mon

Admission charge for special exhibitions

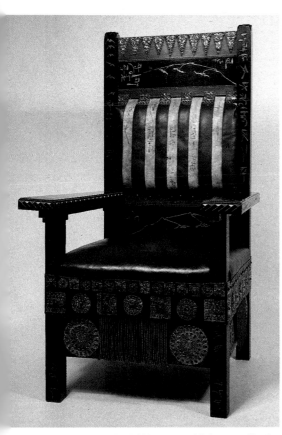

Mahogany chair inlaid in pewter with Japanese floral sprays and inscriptions by Carlo Bugatti, *c.* 1900–10 (Brighton Museum and Art Gallery)

PUBLICATIONS
Handbook and Brief Guide to the Art Gallery and Museums, 1975
Paintings and Drawings—Concise Catalogue, 1982
George Banks, *African Carvings,* 1980
Jessica Rutherford, *Art Nouveau, Art Deco and the Thirties: The Furniture Collections at Brighton Museum,* 1983

Exhibitions of paintings were held in the Royal Pavilion in the mid-19thc. The purpose-built Museum and Art Gallery in Church Street was opened in 1873; Henry Willett (1823–1905) was the leading promoter of the project. The nucleus of the collections is formed by Henry Willett's pictures and his vast collection of commemorative pottery, which was first loaned and then given to the Museum. For some sixty years after its inception the Art Gallery concentrated mainly on buying material covering a wide artistic spectrum, but showing a particularly keen interest in material of relevance to the history of Brighton. As the scope of the acquisitions broadened, the display encompassed an interesting but somewhat conventional glimpse of European culture. The especially representative 20thc decorative art collection is a comparatively recent development.

Designed by Philip Lockwood, the Borough Surveyor, and built in 1871–73, on the site of Queen Adelaide's Stables, in an Oriental style (inclining towards a tiled and denticulated 'Moresque'), the Museum was remodelled 1896–1902. There is much decorative tiling in the interior, manufactured by Craven Dunnill of Shropshire.

There are particularly fine Dutch and Flemish paintings from Henry Willett's collection, notably the unforgettable *The Raising of Lazarus* by Jan Lievens. There is also a rare example of the work of Philippe de Champaigne, *St Veronica's Veil*. Recently, specialist areas have been established which have made the collections of far greater significance; fourteen 18thc Italian oil-sketches and studies by Carlone, Fontebasso, etc., were bought since 1969 with the money left to the Museum by C. F. N. Bergh. The 19thc and 20thc are both strongly represented, and there is a group of paintings by Glyn Philpot. The H. G. Simpkins Collection includes a number of notable Victorian paintings by L. Alma-Tadema (*The Secret* and *The Proposal*), J. Brett, L. Fildes, E. J. Poynter, etc. Edward Lear's *View of Gwalior* in India is the finest recent addition to this group. 'Camden Town' painters are well represented: see particularly Robert Bevan, *Cab Yard at Night* (*c.* 1910); and Charles Ginner, *Leicester Square* (1912). In 1913 the Museum held the first exhibition of the Camden Town artists, opened by Sickert.

The following 16thc–19thc European paintings are also notable: Johann Zoffany, *Portrait of John Madison* and *Mother and Child*; William Hogarth, *Portrait of a Young Woman*; Nathaniel Dance, *Portrait of a Musician*; Joseph Wright of Derby, *Two Portraits*; William Blake, *Adoration of the Kings* (1799); Benjamin Wilson, *Dr Richard Russell FRS* (author of a celebrated book on the use of seawater to cure glandular diseases); Sir Thomas Lawrence, *King George IV in Coronation Robes*; Joos van Cleve or Barent van Orley, *Balthasar, the Moorish King*; Pieter Breughel the Elder, *The Tower of Babel*; Aert de Gelder, *The Marriage Contract*; Luca Giordano, *The Finding of Moses* and *Hercules and Omphale*; Sebastiano Ricci, *Haman Appeals for his Life before Esther and Ahasuerus*; Gaspard Dughet, *Two Landscapes*; J. B. Greuze, *Reading the Bible* (1755); Elisabeth-Louise Vigée-Le Brun, *Self-Portrait*; Glyn Philpot, a group of paintings including *Acrobats Waiting to Rehearse*.

From the point of view of the history of Brighton, the most noteworthy part of the graphic collection is the group of designs and representations of the Pavilion by A. C. Pugin, J. Stephanoff, F. Crace and J. Nash, now the subject of a sumptuous catalogue.

The ceramic collections are extensive and very varied, owing to the collecting activities of Willett, whose commemorative pottery was amassed entirely for the interest of the subject-matter and without undue regard for condition or quality of decoration; and of Mrs Gertrude Stephens, whose interest was in Worcester porcelain of the Dr Wall period.

Apart from these, items of special interest are the musical instruments, the newly-established costume collection and the outstanding display of the 20thc decorative arts. Most of the highly ornamental musical instruments were purchased from a private collector, Mr Albert Spencer, and date mainly from the 18thc and 19thc.

A delightful feature in the Museum is a most evocative re-creation of a 17thc 'Cabinet of Curiosities' which conveys perfectly the flavour of collecting interest at this date.

The costume display is didactic in its approach, drawing attention to class distinctions in the choice of dress. The representation of the 20thc is particularly comprehensive. Brighton's Fashion Gallery was given the Sotheby Prize in the Museum of the Year Award in 1984.

The coverage of the 20thc has been the main purchasing concern of the Museum in recent years, and the collection encompasses work from most of the great names in decorative design

The Royal Pavilion at Brighton. The official guidebook.
The Young Visitor's Guide to the Royal Pavilion
John Dinkel, *The Royal Pavilion*, 1983
John Morley, *The Making of the Royal Pavilion*, 1984

Recent exhibition catalogues:
Fairies, 1980
William Alexander: an English Artist in Imperial China, 1981
Eat, Drink and be Merry, 1982
The Inspiration of Egypt, 1983
Beauty's Awakening: the Centenary Exhibition of the Art Workers Guild, 1984

of the period: for example, Charles Rennie Mackintosh, C. F. A. Voysey, Koloman Moser, Edgar Brandt, Emile Gallé, Jean Dunand, E.-J. Ruhlmann, Bugatti, Syrie Maugham and such firms as Liberty, PEL, and Gordon Russell Ltd.

Local history, archæology, natural history and ethnographical collections are a feature of the Museum. The latter is an unusually strong collection and is beautifully displayed.

The Museum Shop sells a large range of postcards and souvenirs of Brighton and specifically the Pavilion. There are excellent cafeterias in both the Museum and the Pavilion.

Preston Manor (The Thomas-Stanford Museum) [3]

English paintings (Stanford family portraits and other 19thc works, mainly landscape); silver and Sheffield plate (18thc–19thc); pottery, porcelain and glass (18thc–19thc); English furniture (17thc–19thc)

Preston Park, Brighton
tel. 0273-603005

Tues–Sun 10–1 pm, 2–5pm.
Closed Mon, except Bank Holidays

Admission charge

The house and the library were bequeathed to the Corporation of Brighton by Sir Charles Thomas-Stanford in 1932. Eight months later Lady Thomas-Stanford died, leaving the contents of the house to the Corporation as well, and in 1933 it was opened to the public. The Macquoid Bequest of English and Continental furniture and decorative art came to the house in 1939.

The mediæval Manor of Preston has now entirely disappeared beneath the 18thc house, which dates from about 1738 when it was built for Thomas Western, then Lord of the Manor, who probably acted as his own architect. In 1905 Charles Stanley Peach was employed to make substantial additions to the earlier structure. The present arrangement of the house, with its plain exterior and opulent Edwardian interior, illustrates the way of life of a well-off upper-middle-class family in the years immediately before the First World War. The combination of family portraits and fine but not exceptional furniture from the 17thc–20thc reinforces the impression of personal taste in a private house.

The collection at Preston Manor contains an outstanding work of art in the form of Nicolas Poussin's *Virgin and Child* dating from 1625–27. From the 19thc there is a portrait by William Etty of *Arabella Morris*, as well as landscapes by T. S. Cooper, J. Clayton Adams, Abraham Pether and Benjamin Williams Leader. The Percy Macquoid room contains the fine collection of silver, stained glass, pictures, porcelain and furniture collected by Percy Macquoid (1852–1925) the artist, theatrical designer and art expert, as well as author of books on English furniture (notably the three-volume *Dictionary of English Furniture* [1924–27] in collaboration with Ralph Edwards of the Victoria and Albert Museum). The furniture in this room reflects the informed interest of the donor.

A room-by-room guide is at present being revised.

The Royal Pavilion [4]

Regency interior and furniture; memorabilia of Princess Charlotte

Brighton
tel. 0273-603005

Daily 10–5.30 pm (Oct–May);
10–6.30 pm (June–Sept)

Admission charge

Originally a farmhouse, the Royal Pavilion was first rented by the Prince of Wales in 1786, and in the following year enlarged by Henry Holland (1745–1806) into a graceful neo-classical villa. From 1801–03 the firm of Crace was employed to decorate the interiors in a unique rendering of the Chinese style; in 1815 John Nash (1752–1835), the Prince Regent's personal architect, began to clothe the structure in stucco and Bath stone in what was considered to be an 'Oriental' style. The exterior, with its domes and minarets, sets out to exploit the picturesque possibilities of the Mughal style of Indian architecture. The overall effect, both externally and internally, results in making the Pavilion one of the country's most exciting and exhilarating buildings.

The two most magnificent, unusual and elaborate interiors are those of the Banqueting Room and Music Room. The Banqueting Room is decorated with chinoiserie wall-paintings, and a domed sky-blue ceiling where there is an enormous carved dragon, hovering below a canopy of giant plantain leaves and from which is suspended the great gasolier. The Music Room contains the red and gold murals, and a ceiling elaborated with carved and gilded decoration in a splendid profusion of Oriental detail and colour.

The Royal Pavilion was first opened to the public in 1851, the building, its grounds and associated buildings having been purchased by the Town Commissioners the year before.

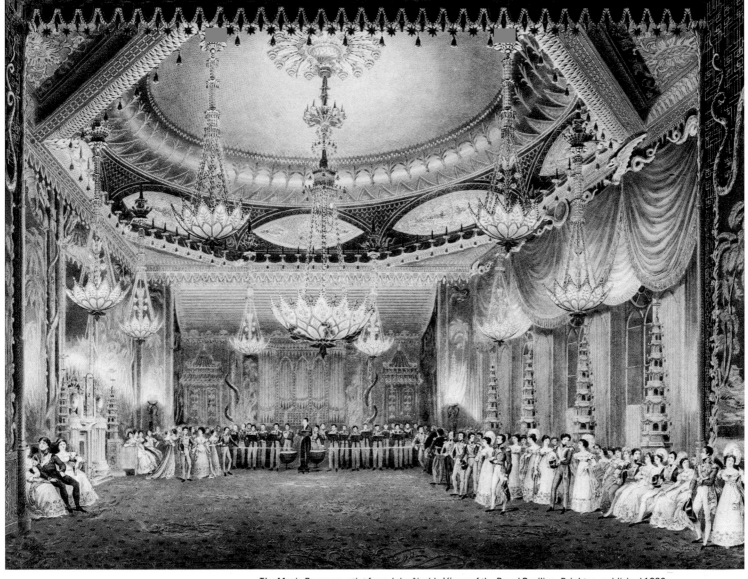

The Music Room, aquatint from John Nash's *Views of the Royal Pavilion, Brighton*, published 1826
(The Royal Pavilion, Brighton)

The collections within the Royal Pavilion reflect a single aim, to recreate as closely as possible the furnishing of the building as it was when it was completed for King George IV in 1823. Many pieces of the original furniture have been returned on permanent loan by H.M. The Queen. A smaller number of original pieces are in the ownership of the Royal Pavilion. The strengths of the permanent collection acquired outright since 1950, when the process was initiated, lie in outstanding Regency furniture appropriate to the original interior schemes with a particular bias towards pieces in the Chinese taste and other Regency exotic styles. Among the highlights is a group of furniture to the designs of Thomas Hope. The collection of Regency silver-gilt and silver, the most splendid public display anywhere, derives predominantly from the collections of the Marquess of Londonderry and the Marquess of Ormonde. The Londonderry Collection was purchased in 1982 with substantial aid from the NACF.

Collections of related material such as caricatures, the Pugin drawings and watercolours, the Crace designs for the original decorations, Princess Charlotte memorabilia, and so on, are administered by the Royal Pavilion, Art Gallery and Museums as an institution and are sometimes on show in the Museum and Art Gallery or in the Royal Pavilion itself.

The Royal Pavilion has an Association of Friends. There is a shop and a tea-room.

Two excellent books on the Pavilion available at the shop are John Dinkel's *The Royal Pavilion, Brighton* (1983) and John Morley's *The Making of the Royal Pavilion, Brighton* (1984), and there is a full colour guide with catalogue and a children's guide to the Pavilion.

BRISTOL, *Avon*

City Museum and Art Gallery [1]

European paintings (15thc–20thc);
'Bristol School' paintings (early 19thc);
European decorative arts, particularly
English Delftware, Bristol porcelain and
English glass; arts of China,
Japan, India and Islam, notably
Chinese ceramics and glass;
local archæology; geology and
natural history

Queen's Road, Bristol
tel. 0272-299771

Mon–Sat 10–5 pm. Closed Sun

Admission free

The Museum was founded by the Bristol Philosophical and Literary Society in 1823. In 1874 a Venetian Gothic building in Queen's Road was built to house the growing collections, but the financial burden of maintaining it proved somewhat beyond the resources of the Bristol Museum and Library Association, successors to the Institution for the Advancement of Science and Art which traces its origins to the Literary and Philosophical Society. In 1893 Sir Charles Wathen paid off their debts and the City Council assumed responsibility for the collections of the Museum. Eleven years later, through the generosity of Sir William Henry Wills, Bt (later Lord Winterstoke), an art gallery was built by Messrs Frank Wills & Sons and Houston & Houston of London, and opened in 1905. An extension was paid for by Sir George Wills, Bt, and this opened in 1930. The H. H. Wills Fund, established in 1922, has provided money for purchases.

The collection of paintings is extensive, representative and of high quality, but the collection of glass transcends this because the Art Gallery received as a bequest through the NACF the H. F. Burrows Abbey Collection of Chinese glass—one of the world's two largest collections of this uncommon art. As well as the Bomford Collection of Pre-Roman and Roman glass there are also very fine ornamented English 18thc drinking glasses from the Lazarus Collection. The 297 Chinese pieces from the Abbey Collection are a fitting complement to the Schiller Collection of Chinese ceramics. Bequeathed in 1947, this collection is particularly strong in the classic wares of the Tang and Song dynasties, including a bowl of the rarest of all, the Ru ware specially made for an Emperor of the early 12thc; there is also excellent jade. Other donations, bequests and purchases have brought the holdings of Oriental art to rank just below those of the two ancient universities. Japan is represented by some 600 prints, with the 18thc masters very well represented and a wisteria screen painted by Maruyama Okyo, as well as netsuke and tsuba. Schiller left Islamic carpets as well as Chinese ceramics, and there is an Islamic textile and costume collection. The Museum's ceramic collections are also strong in local wares, notably the refined Bristol Delftware of which a fine example is the armorial 'Carpenters' Arms Bowl' dated 1709; the local porcelain is represented with, for example, fine and rare documentary pieces from the celebrated collection of Dr Severne Mackenna FSA (sold at Sotheby's in 1957) which were acquired with the help of the NACF.

Two 18thc drinking glasses from the Lazarus Collection (Bristol City Museum and Art Gallery)

Edouard Vuillard, *Interior with Madame Hessel and her dog*, 1910 (Bristol City Museum and Art Gallery)

Francis Danby, *View of Avon Gorge*, 1822 (Bristol City Museum and Art Gallery)

Han or Wei earthenware tomb figure
of an acrobat, Chinese Tang dynasty
(Bristol City Museum and Art Gallery)

The furniture designer and architect E. W. Godwin lived in Bristol, and the Museum has examples of his work.

The paintings collection is well provided with works by Bristol artists, notably Francis Danby and William Muller, Muller's friend Charles Branwhite, Samuel Colman, G. A. Fripp, the delightfully idiosyncratic Rolinda Sharples and so on, but it is by no means parochial in effect since it contains the work of some of the greatest names of British painting—Richard Wilson and Thomas Gainsborough are represented by particularly attractive examples. There is also an impressive array of European masters from the 15thc onwards, for example, Giovanni Bellini's *The Descent of Our Lord into Limbo*; a portrait of Martin Luther by Lucas Cranach; and work by Pieter Claesz, Crespi, Trevisani, Francesco Solimena and Jacob Jordaens. The 19thc is distinguished by the most choice works: the Danbys and Mullers are fine, particularly Francis Danby's charming *View of Blaise Castle Woods* and Muller's *The Carpet Bazaar, Cairo* of 1843; the French School is strong with works by Baron Gros, Delacroix, Couture, Courbet, Gustave Moreau and, from the early 20thc, Edouard Vuillard and Odilon Redon.

The growing 20thc British collection includes a very fine Ben Nicholson; an Edward Wadsworth purchased from the artist's daughter; three paintings by Matthew Smith, including an intensely coloured *Three Pears in a Dish*; a William Scott *Still Life*—not abstract; a Tristram Hillier of a Bristol view; and a Graham Sutherland of a *Flying Bomb Depot*.

The Museum has an Association of Friends. There is a Museum shop with a varied selection of publications and cards.

The Red Lodge, Park Road, a 'period house' museum, is run as a branch of the City Museum and Art Gallery. Containing the only surviving 16thC domestic interior in Bristol, the principal feature is the suite of oak-panelled rooms on the first floor dating from 1590, in particular the Great Oak Room with carved interior porch, carved stone fireplace and plasterwork ceiling. There is 17thC oak furniture, early 18thC walnut and gilt furniture and paintings of the same date.

The Georgian House [2]

English furniture, ceramics and paintings 1745–1820

7 Great George Street, Bristol
tel. 0272-299771

Mon–Sat 10–1 pm, 2–5 pm. Closed Sun

Admission free

The Georgian House is a late-18thC town house in the centre of Bristol. It was built for a prosperous sugar merchant, John Pretor Pinney, probably by William Paty (1758–1800), in 1791 and is furnished in period. The house retains many of its original features, plasterwork friezes and fireplace surrounds as well as a cold-water plunge bath in the basement. The rooms open to view include the kitchen, laundry and housekeeper's room as well as the main rooms on the ground and first floor. The house contains English furniture, ceramics and paintings—in particular, portraits and local views—covering the period 1745–1820. For example, a pair of portraits of Colonel and Mrs Henchman by Daniel Gardner from the Scott Bequest were received through the NACF in 1975. Especially noteworthy are a collector's cabinet of *c.* 1745 attributed to John Channon, the Exeter cabinet-maker whose speciality was to ornament his furniture with decorative brass inlay, and a harpsichord of 1757 made by Jacob Kirckman.

The guidebook to the House is out of print, but is temporarily replaced by a photocopied leaflet.

Harveys Wine Museum [3]

Antique glasses, including fine examples of English drinking glasses (18thC–19thC); decanters; bottles; silverware, including a comprehensive collection of silver and plated decanter labels; corkscrews; coopers' tools and cellar equipment

12 Denmark Street, Bristol
tel. 0272-277661

Fri 10–12 pm, 2–4.30 pm
Mon–Thurs by appointment only

Admission charge and special admission charge for guided tours

This is the Company Museum of the old-established wine company, Harveys of Bristol. A special feature of the building is the 13thC wine cellars, once part of an Augustinian monastery and used by Harveys since 1796.

The collections are entirely concerned with wine and wine-making, but nonetheless include a wide range of different types of exhibits, such as 18thC political cartoons with drinking themes by Gillray, Rowlandson, etc., as well as illustrated books. The glass gallery contains one of the finest private collections of 18thC English drinking glasses and decanters in the country. The history of the wineglass in England dates from the late 16thC, when the metal and horn drinking vessels were superseded by a native product copying the delicate soda-glass ware imported from Venice and other centres in Europe where the Venetian style was imitated. Many early glasses were engraved, and one of the rarest and most interesting examples in this collection is the Russell Amen Glass (*c.* 1750), inscribed with two verses of the Jacobite anthem, one of the few surviving glasses dedicated to Prince Henry, the younger brother of Bonnie Prince Charlie. The beautifully installed displays of decanters and bottles give some idea of the great variety of shapes employed in their design. The silver collection traces the development of the silver decanter label from the rare specimens of 1734–69 to the old Sheffield plate labels of 1775–1850, and also features silver tastevins (or tasting cups), the earliest being one made in Paris in 1677 and a fine example of the William and Mary period of 1690. Recently corkscrews have become the subject of great collecting interest which will be stimulated by the examples in the Museum.

There is a retail shop. As the Wine Museum and shop are licensed premises, visitors must be over eighteen years of age.

PUBLICATIONS
A Guide to Harveys Wine Museum (publicity leaflet)
History of Wine Collection (for touring exhibition)

A touring exhibition, 'Harveys History of Wine Collection', visits private and municipal museums during the year (launched 1977), for which no charge is made.

St Nicholas Church Museum [4]

Ecclesiastical works of art

St Nicholas Street, Bristol
tel. 0272-299771

Mon–Sat 10–5 pm. Closed Sun

Admission free

The Museum is housed in an early Gothic Revival building of the 1740s which was reduced to a shell during the bombing of 1940. It has been converted into a Museum of Ecclesiastical Art and an introduction to the mediæval city of Bristol. The interior is dominated by Hogarth's magnificent altarpiece of the Ascension from the church of St Mary Redcliffe. This is complemented by a collection of church furniture, plate and vestments. A collection of mediæval material from excavations in the city and examples of local topographic watercolours and drawings make an admirable introduction for the visitor intending to explore the city.

A Brass-Rubbing Centre is housed in the remaining part of the mediæval church building.

'Russell' Amen glass, inscribed with royal cipher, *c*. 1750 (Harveys Wine Museum, Bristol)

The Ascension of Christ from the altarpiece by William Hogarth for St Mary Redcliffe, Bristol, 1755–56 (St Nicholas Church Museum, Bristol)

BURNLEY, *Lancashire*

Towneley Hall Art Gallery and Museums

English paintings and watercolours (18thc–19thc); book illustrations (19thc–20thc); Chinese ceramics; pottery (19thc–20thc); glass (18thc); vestments and altarpiece (14thc–15thc); Egyptology, local archæology

Burnley
tel. 0282-24213

Mon–Fri 10–5.30 pm (summer),
10–5.15 pm (winter);
Sun 12–5 pm. Closed Sat

Admission free

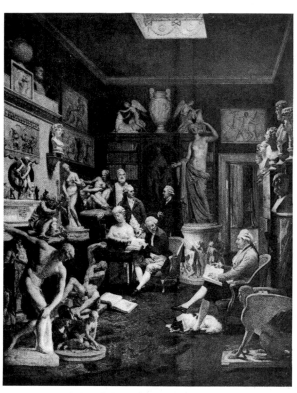

Johann Zoffany, *Charles Towneley and his friends in the Park Street Gallery, Westminster*, 1781–83 (Towneley Hall Art Gallery and Museums, Burnley)

From the 14thc to 1902 the home of the Towneley family, Towneley Hall was purchased by the Burnley Corporation for £17,500 from Lady O'Hagan, the last member of the family to live there. It was almost empty, but opened as an art gallery and museum showing loan exhibitions the following year. In 1921 the Edward Stocks Massey Bequest provided the nucleus of a purchase fund which has frequently been used to acquire objects of relevance to the history of the house and the Towneley family.

The earliest part of Towneley Hall probably dates from the mid-14thc; subsequent enlargements and alterations by John Carr of York (1723–1807) and modernisation by Sir Jeffry Wyatville (1766–1840) have resulted in the plain crenellated stone house of today. The sculptural plasterwork in the interior is the work of Francesco Vassalli and Martino Quadri and dates from *c.* 1729.

The chapel, which dates from the reign of Henry VIII, was until the beginning of the 19thc the only Catholic place of worship for a very wide area and many local people attended Mass there. In the chapel is the Towneley altarpiece, a fine example of Netherlands wood sculpture of *c.* 1500. It was installed there by Charles Towneley (1737–1805), the famous art collector (and benefactor of the British Museum), but was removed at the end of the 19thc to the Convent of Notre Dame at Ashdown Park in Sussex and only returned to the chapel in 1968. The Whalley Abbey vestments were sent to Sir John Towneley in 1536 by Abbot Paslew for safekeeping at the time of the dissolution of the monasteries. The Chasuble and the Dalmatic are made of cloth of gold, worked with a strawberry-leaf pattern. The central panels are older, dating from the early 15thc, and depict scenes from the life of the Virgin Mary.

The rooms of the house, which include a splendid Baroque entrance hall, are furnished in period, as are the kitchen and the servants' dining-room. The fine 17thc panelling is complemented by an impressive display of early oak furniture, predominantly of the 17thc, and a collection of late 17thc English floral walnut marquetry furniture. Recently purchased were the Northumberland House chairs, made for Hugh, 3rd Duke of Northumberland by Morel and Hughes in 1823. They are shown in the Red Drawing-Room, one of the two Regency rooms created by Sir Jeffry Wyatville, 1812–26.

The picture collections include Johann Zoffany's remarkable painting of *Charles Towneley and his Friends in the Park Street Gallery, Westminster* showing Towneley surrounded by works from his great collection of sculpture which is now in the British Museum. Lawrence Alma-Tadema's Olympian *View of a Roman Picture Gallery* provides an interesting contrast in taste. The representative English watercolour collection includes views of the Hall and its environs painted by J. M. W. Turner in the 1790s, as well as a fine William Callow, *Entrance to the Port of Marseilles*, and Frederick Walker's *Marlow Ferry*. There is a collection of English original book illustrations including work by Walter Crane, Kate Greenaway, Randolph Caldecott and the Brooks (Leslie Brook was the creator of the immortal Johnny Crow).

The ceramics collections include a special group of Royal Lancastrian pottery from the Lancashire Pilkington factory, including, for example, a vase designed by Walter Crane; and a group of Lancashire Cliviger pottery.

In the grounds of Towneley Hall there is an Ice House which may be viewed by arrangement, and a nearby former brew-house has been transformed into a Museum of Local Crafts and Industries.

Catalogues and publications related to the Towneley family, such as Susan Bourne's *An Introduction to the Architectural History of Towneley Hall* (1979) and *A Guide to Towneley Hall Art Gallery and Museums* (1984), can be purchased at the reception desk. There is ample free car-parking and a café in the extensive Park which surrounds the house.

BURY, *Greater Manchester*

Bury Art Gallery and Museum

British paintings and watercolours
(19thC, including the Thomas Wrigley
Collection);
Royal Lancastrian pottery

Moss Street, Bury
tel. 061-761 4021

Mon–Fri 10–6 pm; Sat 10–5 pm.
Closed Sun

Admission free

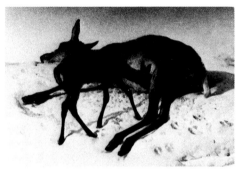

Edwin Landseer, *A Random Shot*, by 1848
(Bury Art Gallery and Museum)

Local history, natural history, archaeology
and decorative artefacts relating to life in
West Suffolk during the last 400,000 years;
Cullum Collection (bequeathed 1925)
portraits, miniatures, porcelain, etc.

Cornhill, Bury St Edmunds
tel. 0284-63233, ext. 236

Mon–Sat 10–1 pm, 2–5 pm (Mar–Oct);
10–1 pm, 2–4 pm (Nov–Feb)

Admission charge

The Art Gallery was built specifically to house the important collection of a leading local industrialist, Thomas Wrigley (1808–80), who made his fortune in the paper trade and whose children donated the collection to Bury in 1897. The neo-classical building was designed by Woodhouse and Willoughby of Manchester in 1899 and opened in 1901 by the Earl of Derby as a memorial to Queen Victoria's Diamond Jubilee.

The main emphasis of the collection is on first-class British 19thC landscape and subject paintings and contains outstanding examples of the work of for example, Turner (*Calais Sands*), Constable (*Hampstead Heath*), David Cox, Landseer (*A Random Shot*, commissioned by Prince Albert but refused for being too gruesome), Samuel Palmer, John Linnell and David Roberts. Others include John Faed (*The Cruel Sister*), Daniel Maclise (*A Student*), Alfred Elmore (*The Novice*), Frederick Goodall and William Mulready. The Museum also contains good examples of 19thC sculpture and several bronzes by Epstein. There is a large collection of Royal Lancastrian pottery. The building also houses a small museum which contains displays concerning local history and items relating to Sir Robert Peel, who was born in Bury.

The Gallery is funded by the Metropolitan Borough of Bury and has an association of Friends.

The catalogue for the Thomas Wrigley Collection, which was published in 1901, is out of print, but other catalogues for recent exhibitions are available at the Museum shop.

BURY ST EDMUNDS, *Suffolk*

Moyses Hall Museum [1]

The Museum is housed in Moyses Hall, a fine example of domestic architecture of the late Norman period. It was built in about 1180 and the original stone vaulting has survived on the ground floor, as have a fine pair of windows in the Great Hall on the first floor. Moyses Hall was a tavern from *c.* 1327 to 1610; in 1626 it became the property of the Guildhall Feoffment (charity) and was used as a workhouse, a bridewell, and ultimately a police station, so it escaped modernisation until the middle of the last century. In 1858 the ground floor windows

Joseph Clarendon Smith, watercolour of *The Fair at Bury St Edmunds* (Moyses Hall, Bury St Edmunds)

Attributed to Mansur of the Mughal school, *A Nilgai*, *c*. 1610 (Fitzwilliam Museum, Cambridge)

Clocks and watches

Angel Hill, Bury St Edmunds
tel. 0284-63233, ext. 277

Mon–Sat 10–1 pm, 2–5 pm (summer),
10–1 pm, 2–4 pm (winter). Closed Sun

Admission free

Terrace Road, Buxton
tel. 0298-4658

Tues–Fri 9.30–5.30 pm; Sat 9.30–5 pm.
Closed Sun

Admission charge for special exhibitions

PUBLICATIONS
These include catalogues from recent exhibitions:
Catherine M. Gordon, *Scott and the Artist: The Lamp of Memory*, 1979
Geoffrey Ashton, *Shakespeare's Heroines*, 1980
Iain Mackintosh and Geoffrey Ashton, *30 Different Likenesses: David Garrick in Portrait and Performance*, 1981
Catherine M. Gordon, *Tales Retold: Boccaccio's 'Decameron'*, 1983

and a clock-tower were added by Sir George Gilbert Scott, the architect of the Albert Memorial, and in 1899 Moyses Hall was acquired by the Borough and turned into a museum.

From the archæological collection, some especially notable objects are the late Bronze Age Isleham hoard, a bronzesmith's stock-in-trade, including his tools. Roman finds include amulets and brooches from Ixworth; there are glass vessels and jewellery from the Anglo-Saxon cemetery at West Stow, and 12thC weapons from the battlefield at Fornham St Genevieve. The Museum also has the 13thC MS of the Chronicle of the great Benedictine Abbey, burial-place of the miracle-working body of St Edmund, the East Anglian king who was killed by the Danes in AD 870. The decorative and applied arts are represented by snuff and scent bottles, pottery, porcelain, models, toys, and embroideries, a mahogany spinning wheel, a rare early recorder by Peter Bressan, the æolian harp made by the Suffolk poet Robert Bloomfield (1766–1828) and a sedan chair on wheels used by the daughter of a Bury tobacconist until her death in 1911. Poignant reminders of Ouida (Louise de la Ramée, a rich and famous Victorian novelist) and her bell and watch, reputedly her only possessions at the time of her death in poverty and obscurity in 1908.

The paintings temporarily in store include portraits of the Cullums of Hardwick Hall, Bury St Edmunds and local dignatories by such eminent painters as Reynolds, Wright of Derby, Angelica Kauffmann, Tissot, etc.

There is an illustrated guide to the Museum which is available at the Museum shop.

Angel Corner (The John Gershom Parkington Memorial Collection of Time Measurement Instruments) [2]

This important collection was bequeathed to the Corporation of Bury St Edmunds by Frederick Gershom Parkington as a memorial to his son, John, who was killed in action in 1941. It is the finest collection of clocks and watches on public view outside London, with the possible exception of the collections in Oxford (in the old Ashmolean Building) and Prescot (q.v.). This collection joined a small group of material, mainly watches by Bury St Edmunds makers, and covers the period from *c*. 1550 to the mid-19thC. It is housed in a fine Queen Anne house of *c*. 1702, appropriately furnished with loans from the Victoria and Albert Museum.

There is a catalogue of the collection and leaflets on important items, as well as on the subject of Pigeons and Pigeon Racing.

BUXTON, *Derbyshire*

Buxton Museum and Art Gallery

The Museum, founded in 1891 and originally in the Town Hall, was moved in 1928 to its present location, a converted hydropathic hotel, a legacy from Buxton's spa era. The Gallery was opened in 1979, but the collections are at present being rehoused in adjacent galleries planned to open in 1985.

The collections are predominantly based on local history and the prehistoric remains from local caves, with many important specimens from local archæological sites—especially from the Roman period. There is a good collection of local minerals, rocks and fossils and also decorative objects of Blue John and Ashford marble, both of which are unique to the Peak District. An Ashford marble table was exhibited at the Great Exhibition of 1851. Another unique collection consists of the libraries, scientific MSS and correspondence of Sir William Boyd Dawkins and Dr J. W. Jackson, both of whom worked extensively in the field of cave prehistory and archæology. The Museum also has a large holding of local maps, engravings and early local photographs. The fine art collections are strong in 19thC English watercolours and 20thC oils and original prints, with works by Morland, Cox, Prout, Brangwyn, Wilson Steer (*Corfe Castle*), Algernon Newton and de Wint.

There is a small museum shop and car-parking nearby.

CAMBRIDGE

Fitzwilliam Museum [1]

Western European paintings; drawings
and prints 14thC–present day;
Egyptian, Greek, Roman and Middle
Eastern antiquities; illuminated MSS
10thC–20thC, chiefly European; foreign
and Oriental arms and armour;
Oriental porcelains, bronzes, hardstones,
and lacquers; ceramics; glass; textiles and
furniture; sculpture in bronze, marble and
terracotta

Trumpington Street, Cambridge
tel. 0223-69501

Tues–Sat 10–2 pm (lower galleries),
2–5 pm (upper galleries); Sun 2.15–5 pm.
Closed Mon (except Easter Mon,
spring and summer Bank Holidays)

Admission free

The Fitzwilliam, though it cannot compare in longevity with the Ashmolean, is one of the oldest public museums in this country. It bears the name of its founder, a rich amateur collector of European music, painting and prints, Richard Fitzwilliam, 7th Viscount Fitzwilliam of Merrion (1745–1816), who was admitted to Trinity Hall, Cambridge, in 1761. His portrait, painted in 1764 by Wright of Derby, hangs in the Museum. Richard Fitzwilliam succeeded his father as 7th Viscount in 1776 and inherited the family seat at Mount Merrion, near Dublin, but he spent much of his time in England at Fitzwilliam House in Richmond. He never married and when he died he bequeathed his library and art collections to the University of Cambridge, 'for the purpose of promoting the increase of learning and the other great objects of that noble Foundation', together with £100,000 to build a museum to house them. Since its foundation in 1816 the Fitzwilliam has been the University's museum of art and antiquities, and later also its numismatic cabinet. It is distinguished by having the finest collection of Korean ceramics outside Japan and Korea itself, and easily the most important collection of prints outside the British Museum. The collection of illuminated MSS is of approximately the same standing as those of the Victoria and Albert Museum and the John Rylands Library in Manchester.

A competition for the design of the present rather plain but noble neo-classical building—it has been described as 'grandiloquent'—was won by George Basevi in 1834, against thirty-five other schemes, but the foundation stone was not laid until 1837. The main galleries were completed before Basevi's death in 1845 as the result of a fall from scaffolding in Ely Cathedral; C. R. Cockerell was called in to finish the building which finally opened in 1848. The younger Barry, in 1870–75, was responsible for completing the decoration of the sombrely magnificent entrance hall with its double staircase, gallery with great Corinthian columns, elaborate mosaic floor and vaulted clerestory with semicircular windows; it retains its original

John Constable, *Hampstead Heath*, c. 1821 (Fitzwilliam Museum, Cambridge)

Onyx cameo showing George IV as Prince Regent, by Benedetto Pistrucci, 1816 (Fitzwilliam Museum, Cambridge)

rich scheme of maroon and gilding. The hall is now used for the display of 18thc and 19thc sculpture, the focal point being John Gibson's *Venus Verticordia* in the original untinted version, which occupies a favoured position between the two arms of the marble and stone staircase.

The founder's collections which form the nucleus round which this 'finest small museum in Europe' has evolved, reflect the tastes of an exceptionally gifted as well as rich English connoisseur of the period, with fine Venetian paintings, for example Veronese and Palma Vecchio, as well as a Titian; Dutch paintings and prints (his collection of Rembrandt etchings was the best in England); mediæval MSS, and, less conventionally, music. One of the greatest musical treasures in an extensive collection is the early 17thc Fitzwilliam Virginal Book, containing the most important contemporary collection of 16thc and 17thc keyboard music.

Since its foundation the Museum has built up an impressive roll-call of benefactors. Among those too numerous to itemise in detail are John Ruskin, who gave twenty-five watercolours by Turner in 1861; Frank McClean, who bequeathed Egyptian, Greek and Roman antiquities, Carolingian and Byzantine ivories, Limoges enamels and more than two hundred illuminated MSS, thus exceeding the founder's collection in scope and variety; Charles Fairfax Murray, who gave over a period of twenty-five years a variety of works of art including many Pre-Raphaelite items, as well as Titian's magnificent *Tarquin and Lucretia* and the charming early

François-Xavier Fabre, *Allen Smith seated above the Arno*, 1797 (Fitzwilliam Museum, Cambridge)

Red-figured Greek pelike vase showing
Ulysses and Eumaeus the Swineherd, c. 480 BC
(Fitzwilliam Museum, Cambridge)

PUBLICATIONS
Catalogues of the permanent collections:
Catalogue of Paintings: vol. I, *Dutch and Flemish*, H.
Gerson and J. W. Goodison; *French, German and
Spanish*, J. W. Goodison and Denys Sutton, 1960.
Vol. II, *Italian Schools*, J. W. Goodison and G. H.
Robertson, 1967. Vol. III, *British School*, J. W.
Goodison, 1977
David Bindman (ed.), *William Blake: An illustrated
catalogue of works in the Fitzwilliam Museum*, 1971
L. Buddle and R. V. Nicholls, *Catalogue of the Greek
and Roman Sculpture*, 1964

Exhibition catalogues:
Cambridge Portraits from Lely to Hockney, 1978
All for Art: The Ricketts & Shannon Collection, 1979
Morris & Company in Cambridge, 1980
English Delftware Dishes from the Glaisher Collection,
1981
John Linnell: A centennial exhibition, 1982

20thC British painting and sculpture

Castle Street, Cambridge
tel. 0223-352124

House: Daily 2–4 pm
Gallery: Tues–Sat 12.30–5.30 pm;
Sun 2–5.30 pm. Closed Mon

Admission free

Gainsborough of *Heneage Lloyd and his Sister*. Like Birmingham Museum (q.v.), the Fitzwilliam received in 1927 a significant share of the collection of drawings, watercolours and engravings mainly by English artists of the 18thC–20thC amassed by J. R. Holliday. J. W. Glaisher, first Honorary Keeper of Ceramics, transformed the Museum's holdings with the bequest of over three thousand specimens of English and Continental pottery and porcelain, which includes many dated examples of English slipware and rare pieces of Staffordshire salt-glaze. A most rewarding and varied collection of antiquities, works of art and Japanese drawings came in 1937 when Charles Hazelwood Shannon bequeathed the antiquities and works of art bought with great prescience and refined taste by himself and his fellow artist, Charles Ricketts. This collection was the subject of a fascinating exhibition in 1979. A fellow artist and near-contemporary, Sir Frank Brangwyn, gave antiquities and a variety of paintings, drawings and prints, including a selection of his own works. The most noticeable benefaction, which occupies a whole gallery, is the Fairhaven collection of flower-paintings, many of them exquisite examples of the genre, but somewhat monotonous in general impression. Very recently the Andrew Gow bequest of French drawings and bronzes enriched the collections with very choice works by Degas—his particular hero—Vuillard, Matisse and Rodin, to mention only a few from this remarkable benefaction. The range of the Degas drawings is extraordinary: the expected, in the form of ballet studies, is complemented by the unexpected, a copy after Veronese's *Finding of Moses*. Just before her death, Mrs Hull Grundy had begun to present to the Museum specially selected items of jewellery and silver; particularly bearing in mind the important holdings of medals and engraved gems—for example, a recent purchase was a very fine portrait cameo of George IV by Pistrucci—she bought some complementary pieces, notably a vase carved all around in the cameo technique by Luigi Isler.

In concentrating on the Museum's benefactors it is possible to lose sight of its own vigorous and successful campaign of purchasing to enlarge the scope of the collections. Recent spectacular additions have been George Stubbs's *Gimcrack*; a ravishingly light-filled Bonington of the coast near Genoa; a Poussin, *Rebecca and Eliezer at the Well*, perhaps his last figure subject; and some interesting furniture, including a strikingly ornamented dwarf cabinet by George Bullock with a bold anthemion frieze of ebony inlaid into pale larchwood.

As a startling contrast of directions it should be mentioned that the Museum has an interesting and growing 20thC holding, as well as the finest public collection of English samplers.

The Fitzwilliam has a long list of publications to its credit, many of them in the form of catalogues of the permanent collections; only a selected sample is given here. These publications form only a part of the varied and interesting stock of the shop, which approaches in its enterprising policy of merchandising the more ambitious efforts of a national museum. The replicas of objects, a field of Museum popularising open to tasteless abuse, are well chosen.

The cafeteria is excellent; as it is small and very inexpensive it is apt to be full, but it is well worth the visit.

Kettle's Yard [2]

Jim Ede gave his house and contents to the University of Cambridge in 1966. An extension and exhibition gallery were designed by Sir Leslie Martin in 1970. His collection is displayed in a most relaxed and comfortable atmosphere. He collected a very large number of fascinating works by Gaudier-Brzeska, sculptures and drawings, and paintings and watercolours by Ben Nicholson. Ede was also particularly interested in the work of the lesser known painters Christopher Wood, Alfred Wallis—the fisherman from Cornwall who began to paint at the age of seventy—and David Jones, the Welsh writer and painter in watercolour.

The gallery has an Association of Friends and arranges frequent loan exhibitions for which a large number of catalogues since 1974 are available. Also on sale is Jim Ede's book *A Way of Life—Kettle's Yard*.

University Museum of Archæology and Anthropology [3]

Ethnography and prehistoric archæology of the world; local Cambridgeshire archæology of all periods

Downing Street, Cambridge
tel. 0223-359 714

Mon–Fri 2–4 pm;
Sat 10–12.30 pm. Closed Sun

Admission free

PUBLICATIONS (recent)
M. D. Cra'ster, *The Cambridge Region and British Archæology*, 1984
Laurel Phillipson, *World Prehistory*, 1984
V. Ebin and D. A. Swallow, *The Proper Study of Mankind*, 1984

The Museum is housed in a purpose-built building of the early 20thC, designed by T. G. Jackson (1835–1924), incorporating the Inigo Jones screen from Winchester Cathedral. It includes several collections obtained during pioneering research by Cambridge scholars. Several Cambridge college collections have now been incorporated within the museum, most notably the Trinity College collection of Oceanian ethnographic materials obtained during the voyages of Captain James Cook. The Museum is particularly rich in material from the Stone Age, Bronze Age, Roman and Anglo-Saxon periods.

The collection was first established by the Cambridge Antiquarian Society in the mid-19thC and transferred to the University of Cambridge in 1884. Through the efforts of the first Curator, Baron Anatole von Hügel (1884–1921), its range and quality was considerably enhanced.

There is a sales desk for publications and an identification service.

Whipple Museum of the History of Science [4]

Scientific instruments (16thC–20thC)

Free School Lane, Cambridge
tel. 0223-358381, ext. 340

Mon–Fri 2–4 pm. Closed Sat, Sun

Admission free

Founded by Robert S. Whipple (1871–1953) in 1944, this is the University of Cambridge Science Museum. The main gallery is a schoolroom of the early 17thC, of which the beamed ceiling survives.

The collection comprises scientific instruments from the 16thC–20thC, with particularly strong groups of sundials, surveying instruments and microscopes, but the subjects covered include astronomy, navigation, mathematics, spectroscopy and so on. A number of collections from the Colleges and Departments of the University of Cambridge, including scientific instruments and apparatus, have been handed over to the Museum.

The Whipple Museum has a number of very well produced and informative illustrated publications on different aspects of the collection, including surveying, balances and weights, astronomy and navigation, spheres, globes and orreries, and spectroscopes, prisms and gratings.

Mezzotint by V. Green after Joseph Wright of Derby, *A Philosopher shewing an experiment on the Air Pump*, 1769 (Whipple Museum of the History of Science, Cambridge)

Asante gold pectoral brooch from Ghana (Cambridge University Museum of Archæology and Anthropology)

James Ward, *View of Reculver, Kent, in 1818* (Royal Museum and Art Gallery, Canterbury)

CANTERBURY, *Kent*

Royal Museum and Art Gallery

Local history; archæology; English and Continental ceramics; 19thc British paintings and drawings

High Street, Canterbury
tel. 0227-452747

Mon–Sat 10–5 pm. Closed Sun

Admission free

Canterbury has had a museum available to the public since the opening in 1825 of the Philosophical and Literary Institution's new museum. Collections from this early period include Greek Pottery from Viscount Strangford, Dutch stained glass and ethnographical and archæological items. The City Council took over responsibility in 1846 and a new building in the High Street was opened in 1899. Designed by the City Surveyor, A. H. Campbell, it was funded from the bequest of Dr James Beaney, a native of the city who had made a certain reputation and fortune as a surgeon and politician in New South Wales.

The building is an elaborately detailed historical pastiche, its façade half-timbered and with fantastic carved brackets, corbels and grotesques with terracotta ornament by Doulton, stained-glass armorials of the principal cities of the Empire and floors of Venetian mosaic.

Queen Victoria consented to the style of Royal Museum and many local benefactors enriched the collections—Colonel Copeland with ceramics, Ingram Godfrey with Old Master drawings and prints, Pugin Thornton with topographical prints, Oxenden Hammond with natural history, John Irving with English and Continental ceramics and glass, Gerard de Zöete with Old Master paintings, and John Brent with East Kent archæology.

A new wing for the Art Gallery was built in 1934 from the Slater family bequests.

Since 1974 the Museum has had an enlarged area of archæological interest, including the Kent coastline from Whitstable to Reculver and some twenty-six villages in the countryside around Canterbury. Currently restoration works are being completed to the magnificent 14thc Poor Priests' Hospital, which is to become a new centre of Canterbury's heritage.

The Royal Museum is building up an interesting collection of paintings and drawings, photographs and prints which record the artists' view of Canterbury and its surroundings, including the French ports. Also of special interest are a Roman silver hoard, Roman and Anglo-Saxon glass and gold, Roman mosaics, paintings and work by Canterbury's Thomas Sidney Cooper, and fine English and Continental ceramics. There are English paintings of the 18thc and 19thc, many with local connections such as Stothard's *Canterbury Pilgrims*, and Opie's *Death of Becket*, both acquired with NACF help, as also the recently purchased Ben Marshall of a local hunstman.

The Museum has an Association of Friends. A sales desk stocks postcards and publications, including a recent exhibition catalogue, *Treasures from Kent Houses* (1984).

CARLISLE, *Cumbria* [1]

Carlisle Museum and Art Gallery

British painting (19thC–20thC);
paintings and prints by Cumbrian artists
(18thC–20thC); British porcelain
(18thC–19thC); costume (19thC–20thC)

Castle Street, Carlisle
tel. 0228-34781

Mon–Fri 9–7 pm; Sat 9–5 pm; Sun, spring
and summer Bank Holidays 2.30–5 pm
(April–Sept). Mon–Sat 9–5 pm;
closed Sun and Bank Holidays (Oct–Mar)

Admission free

The first public museum was opened in 1877, based at the old Academy of Arts. The earliest collections belonged originally to the Carlisle Literary and Philosophical Society whose own museum survived only from 1834–44. In 1890 a public subscription was raised to purchase Tullie House, built 1689, and architect C. J. Ferguson (1839–1904) was employed to convert and extend the building to accommodate a museum, art gallery, library and centre for the study of arts and sciences, which was opened in 1893. The house is a fine example of Jacobean architecture and is the only house of its date and style to survive in Carlisle.

Over six hundred works by 19thC and 20thC British artists were bequeathed by Dr Gordon Bottomley, poet and collector, in 1949. These include work by Cumbrian artists, such as Sam Bough and W. J. Blacklock, as well as Paul Nash and Wyndham Lewis from the 20thC. The collection of Pre-Raphaelite works is particularly notable: this includes a minutely observed study for *Found*, Rossetti's unfinished realist painting; drawings for *Laus Veneris* by Burne-Jones; and examples of the work of Madox Brown and Arthur Hughes. This group was augmented by gifts of Rossetti's *Carlisle Wall* from Mrs Vertue Tebbs and sketches of Burne-Jones at work by George Howard (Lord Carlisle), presented by Lady Aurea Howard.

Development of the collections was also greatly advanced by a policy of purchasing works by promising young British artists. The scheme began in 1933 and had as its honorary advisors Sir William Rothenstein, Edward Le Bas, Carel Weight and Roger de Grey. Artists patronised included Lucien Pissarro, L. S. Lowry, Walter Sickert and Stanley Spencer.

A collection of over eight hundred pieces of 18thC and 19thC British porcelain was bequeathed to the Museum by R. H. Williamson of Seascale in 1940. It is a good representative collection of the major English factories, including Chelsea, Derby, Bow, Worcester, Caughley, Bristol, Plymouth, Longton Hall, Spode, New Hall, Rockingham and Coalport. Studio ceramics of the late 19thC and 20thC are also represented, for example, by the Martin brothers. There is a good collection of 19thC costume and two 18thC mantuas made locally. The other collections represent archæology, natural history and social history.

There is an Association of Friends and a small shop, which sells publications, including catalogues of exhibitions held since 1968, postcards, slides, etc.

The Guildhall [2]

Greenmarket, Carlisle
tel. 0228-34781

Tues–Sat 12–4 pm (mid-May–mid-Sept).
Closed Sun, Mon

Admission free

Guild, civic and local history items, some mediæval, are displayed in an early 15thC half-timbered house with an impressive beamed interior.

CHELTENHAM, *Gloucestershire*

Cheltenham Art Gallery and Museum [1]

Local history and archæology, Arts and
Crafts, especially furniture, metalwork and
jewellery; 17thC–20thC British furniture,
ceramics, glass and pewter; Oriental
ceramics and armour; 17thC Dutch
paintings; 17thC–20thC British paintings

Clarence Street, Cheltenham
tel. 0242-37431

Mon–Sat 10 am–5.30 pm.
Closed Sun, Bank Holidays

Admission free

The Art Gallery opened in 1899 when Baron de Ferrières donated forty-three Dutch Old Master paintings and financial assistance towards the building of an Art Gallery to Cheltenham. The Museum was established in 1907 in the former premises of the Cheltenham Schools of Art and Science, part of the 1889 Library building, adjoining the Art Gallery. The architect of the building was W. H. Knight (*c.* 1814–95).

The Gallery and Museum has received many important bequests which include collections of prints, Chinese ceramics, pewter, costume and miniatures. However, it primarily boasts a superb collection of items from the Arts and Crafts period. Those artists particularly well represented are the so-called 'Cotswold School': Ernest Gimson, Ernest and Sidney Barnsley, Gordon Russell, C. R. Ashbee as well as C. F. A. Voysey. Outstanding examples of their furniture are displayed and the Gallery also owns a huge number of drawings by Gimson. This collection was further augmented by the pieces of jewellery and metalwork donated by Professor and Mrs John Hull Grundy between 1982 and 1984.

The Gallery has a large and good collection of fine art including a number of 17thc Dutch paintings, three centuries of British paintings, a representative collection of late 18thc local topographical prints and a group of portraits by Richard Dighton who spent some time in Cheltenham.

The Gallery has an Association of Friends. There is a shop where Gallery and Museum publications are available, including almost all recent exhibition catalogues.

PUBLICATIONS
Fine Art Collection, Check List Catalogue, 1979
Gimson and Barnsley—Designs and Drawings in Cheltenham Art Gallery & Museum, 1984

Oak 'Swan' chair with fabric seat, designed by C. F. A. Voysey 1883–85 and made in *c*. 1896 (Cheltenham Art Gallery and Museums)

Mahogany inlaid writing cabinet designed by C. R. Ashbee and made by the Guild of Handicraft, *c*. 1898–99 (Cheltenham Art Gallery and Museums)

Cheltenham Borough Council also administers:

Pittville Pump Room Museum, Gallery of Fashion [2]

The Pump Room, one of the town's most handsome Regency buildings, designed by John Forbes in 1825, was opened as a museum in 1983 on the upper floors. The collection contains costume and jewellery *c*. 1760–*c*. 1960; court dress of *c*. 1871; wedding dresses from 1820; and Regency, late Victorian and 1920s evening dresses and accessories, including Indian textiles and a group of dresses with 'beetlewing' embroidery. These are displayed amongst graphic illustrations showing the history of the town. Also exhibited at the Pump Room is the collection of 18thc–20thc jewellery donated by Professor and Mrs John Hull Grundy.

A sales desks stocks a booklet and leaflet about the Pump Room and a catalogue of the Hull Grundy jewellery. Free car-parking is available.

Costume and jewellery (18thc–20thc)

Pittville Park, Cheltenham
tel. 0242-512740

Tues–Sat 10.30–5 pm (Nov–Mar);
Tues–Sun 10.30–5 pm (April–Oct).
Closed Mon (except some Bank Holidays)

Admission charge

Gustav Holst Birthplace Museum [3]

4 Clarence Road, Pittville, Cheltenham
tel. 0242-524846

Tues–Fri 12 noon–5.30 pm; Sat
11–5.30 pm.
Closed Sun, Mon, Bank Holidays

Admission free

The house, built in 1832 possibly by Robert Stokes, was opened as a museum in 1975 to illustrate the life and work of Gustav Holst (1874–1934), the composer and teacher. A number of items formerly owned by him are on display and the Museum also owns an extensive archive.

A sales desk sells a leaflet for the Museum and postcards, books and souvenirs.

CHERTSEY, *Surrey*

Chertsey Museum

The Cedars, 33 Windsor Street,
Chertsey
tel. 09328-65764

Wed, Fri, Sat 10–1 pm, 2–5 pm;
Tues, Thurs 2–5 pm.
Closed Sun, Mon

Admission free

The Museum was established by the Olive Matthews Trust and the Chertsey Urban District Council in 1972 in a late Georgian town-house, 'The Cedars'. The archæological collections include Bronze Age pieces, among them a rare shield and a 10thC Viking-period sword discovered nearby. Olive Matthews's important collection of 18thC and 19thC costume and accessories is on loan to the Museum. The Tulk Bequest includes furniture, some 18thC pieces from the collection of Charles James Fox, who lived locally, clocks and porcelain, as well as a good collection of Wedgwood. The watercolourists John and Edward Hassell are well represented by a group of works from the 1820s.

There is a sales desk for books, postcards, leaflets, and a catalogue, *Costume in the Chertsey Museum, 1700–1800* by Christina Rowley (1976), is available. There is car-parking in the street.

Daniel Maclise, watercolour of *Mrs Anna Maria Hall*, 1833 (Chertsey Museum)

Attributed to R. B. Harraden *A View of Eaton Hall, c.* 1812 (Grosvenor Museum, Chester)

CHESTER, *Cheshire*

Grosvenor Museum

Important local Roman material; mediæval and local history; extensive collection of local 17thC–20thC silver; 19thC and 20thC costumes; coins and medals; ceramics and furniture (in The Georgian House)

27 Grosvenor Street, Chester
tel. 0244-21616

Mon–Sat 10.30–5 pm; Sun 2–5 pm

Admission free

The Museum was built in 1885–86 to the design of Thomas Meakin Lockwood (1830–1900), a Chester architect who undertook many commissions for the 1st Duke of Westminster. The building, in the free Renaissance style, is of red Ruabon brick with string coursing and gables of Grinshill sandstone. The spandrels of the entrance portal are carved with reclining female figures representing Science and Art. The building originally housed the Schools of Science and Art in addition to the Museum. The second floor of the façade is decorated with Ionic pilasters, a corner turret, and two Dutch gables carved with peacocks and flanked by talbots, supporters of the Grosvenor Arms. The top-lit entrance hall has a fine ceramic mosaic pavement and dado. A substantial extension to the building was completed in 1894, and is now linked to two Georgian houses of which one, no. 20 Castle Street, is now furnished with period room displays. This was formerly the town house of the Swettenham family and also the home of Roger Comberbach (died 1771), pronotary of the Palatine Court in Chester Castle.

The Museum was opened by Hugh Lupus Grosvenor, 1st Duke of Westminster, in 1886. It was established as the result of the efforts of the Chester Archæological Society, founded 1849, and the Chester Society of Natural Science, Literature and Art, founded in 1871, at the suggestion of Charles Kingsley, then Canon of Chester Cathedral. The Duke donated a portion of the site and £4,000 towards building costs and over £5,900 was raised by public appeal. The Chester Mechanics Institute had a separate Museum at the Water Tower, some of the collections of which were later absorbed into those of the Grosvenor Museum.

A few paintings were presented to the Museum during the latter years of the 19thC. These included the gift by the 1st Duke of Westminster of a view of Chester, attributed to Pieter Tillemans, and another gift was a painting of a waterfall by the Austrian artist Lorenz Adolf Schonberger. The main interest of the earlier curators was to display the Archæology and Natural History Collections, built up by the founder societies, and few acquisitions were made until 1947 with the exception of a large collection of local watercolours and prints donated by T. Cann Hughes in 1925.

After 1947 the Museum started to build up a watercolour collection, concentrating on views of Chester and North Wales. The first notable acquisitions were a group of works by Moses Griffiths, and this has since been extended with watercolours by Varley, 'Warwick' Smith, Boys, Nash, Nicholson and Solomon. Local artists figure prominently and the Museum has a large holding of the watercolours of Louise Rayner, William Tasker, George Pickering and John Prince Halton.

In 1952 the Museum purchased the Willoughby Gardner Collection of Saxon and Norman coins of the Chester Mint. At almost the same time it acquired most of the hoard of Saxon coins (*c.* AD 960) from Castle Esplanade, Chester. Since then it has steadily enhanced its collections of coins from the Chester Mint, not only of the Saxon and Norman periods, but also of the Civil War and Great Re-Coinage periods (1696–98). Recent acquisitions have included a portion of the Bryn Maelgwyn, North Wales, hoard of Saxon pennies of Canute, and a locally found George I guinea of 1717 of which only one other specimen is known. The Museum also holds a good collection of Roman coins and a growing collection of commemorative medals.

In 1972 the Museum acquired a silver mead jug made by Ralph Walley in Chester in 1690–92. Until then the Museum had had only one piece of Chester assayed silver. The collection has grown rapidly, and now there are over a hundred pieces of Chester silver. The more notable pieces include a tankard by Walley of 1687–90, a caudle cup by Thomas Robinson of 1690–92 and an extensive series of silver made by the Richardson, Walker and Lowe families. Silver is not limited to Chester-made pieces but includes gold and silver-gilt cups presented by the Grosvenor family for the Chester Races in 1766, 1814 and 1815, and two silver punch bowls also used as race prizes. The Museum now houses one of the most extensive collections of silver in a provincial museum. Part of the Marquess of Ormonde's silver was allocated to the Museum in 1982. This strengthened the collections with examples of later 18thC and 19thC silver by London, Dublin and Sheffield makers, rococo candlesticks by William Abdy, a teapot and cream jug by Paul Storr, and a dinner service by Benjamin Smith.

The Museum has more recently built up its collections of oil paintings, both of topographical views and of Cheshire portraits. Notable topographical views include *Beeston*

George III silver punch bowl by Hester Bateman, 1784
(Grosvenor Museum, Chester)

Castle by George Barret Senior, *Chester Castle by Moonlight* by Sebastian Pether, and *Eaton Hall* attributed to Richard Banks Harraden. Notable portraits include *An Unknown Couple* by John Souch, *Sir John Crewe* by John Michael Wright, *Sir John Donne* attributed to Paul van Somer Senior, and *John Arderne* by Arthur Devis. The work of the Chester sporting and topographical artists, Daniel and Henry Clowes is also represented, together with sporting paintings by William Tasker.

The Grosvenor Museum Society plays an active role in supporting purchases. There is a shop where exhibition catalogues are available, and there is car-parking nearby.

PUBLICATIONS
Silver on View at the Grosvenor Museum, 1973
Louise Rayner 1829–1924, 1978
C. N. Moore, *Silver of the City of Chester*, 1979
Two Chester Artists: Louise Rayner 1829–1924 and William Tasker 1808–1852, 1984
Chester Silver, 1984
Daniel and Henry Clowes, 1985

CHORLEY, *Lancashire*

Astley Hall Museum and Art Gallery

Astley Hall is a 16thc mansion built round a central courtyard. It has been successively tenanted by the Charnocks, Brookes and Townley-Parkers. On the death of the second Thomas Townley-Parker in 1906 the Hall passed to Reginald Arthur Tatton, who in 1919 decided to give Astley Hall to Chorley for museum purposes. The Park had been acquired by a War Memorial Committee as a memorial to those who served in the Great War. The Park, Hall and cenotaph were officially opened in 1924.

The Hall, originally two-storeyed and half-timbered, was extensively rebuilt in the second part of the 17thc. The rooms are magnificent, but special mention must be made of the ceilings in the great hall and the drawing-rooms, which are ornately decorated with wreaths and figures of plaster, leather and lead.

Astley Hall is richly furnished with oak furniture mainly *c.* 1600, and boasts three four-poster beds, including the famous Cromwell Bed. It also contains a magnificent collection of family portraits by Kneller, Lucas, James Lonsdale and others.

The Museum has an Association of Friends. There is a guidebook to the Museum available in the shop. Car-parking and a café are adjacent to the house.

17thc British furniture

Astley Park, Chorley
tel. 025 72-62166

Daily 12 noon–6 pm (Apr–Sept);
Mon–Fri 12 noon–4 pm;
Sat 10–4 pm; Sun 11–4 pm (Oct–Mar)

Admission charge

COLCHESTER, *Essex*

Colchester and Essex Museum [1]

The Museum collections are housed in five historic buildings, four of which are open to the public.

THE CASTLE The main collection at Colchester, of archæology from the earliest date to the 17thc, is housed in this fine Norman Castle of *c.* 1076. Probably built by Gundulph, Bishop of Rochester, it was constructed on the vaults of the Temple of Claudius of AD 50. The Museum was founded with the Essex Archæological Society, and now contains an impressive collection of Roman remains: statues, jewellery, coins and glass, as well as Roman military tombstones, notably that of Marcus Favonius Facilis, a centurion of the xxth Legion.

THE HOLLYTREES MUSEUM (1718) Costume, toys, domestic items of the 18thc and 19thc.

NATURAL HISTORY MUSEUM (formerly All Saints' Church, High Street) Natural history of Essex, dioramas, vivaria.

SOCIAL HISTORY MUSEUM (formerly Holy Trinity Church, Trinity Street, with an 11thc tower) Items relating to local life and crafts.

TYMPERLEYS The Mason Collection of Colchester clocks is being prepared for display at this 15thc–16thc house in Trinity Street.

The Museum has an Association of Friends. A shop sells a guide to the Castle and other booklets.

Local archæology

The Castle, Colchester
tel. 0206-712481/2

Mon–Sat 10–5 pm; Sun 2.30–5 pm
(Apr–Sept); Mon–Fri 10–5 pm;
Sat 10–4 pm; closed Sun (Oct–Mar)

Admission free

Embroidered needlework screen of 112 panels made by 100 Essex ladies for Sir George Henry Smyth, High Sheriff of Essex, *c.* 1842–43. (Colchester and Essex Museum, Colchester)

The Minories

[2]

19thC and 20thC British paintings; library belonging to Paul and John Nash

74 High Street, Colchester
tel. 0206-577067

Tues–Sat 11–5 pm. Closed Sun, Mon

Admission charge except Tues

Founded in 1958 in memory of Victor Batte-Lay (1865–1935), the Minories, although mainly concerned with a continuous programme of temporary exhibitions, has a permanent collection which is becoming increasingly important. It has two focal points, the first the works by John Constable, the second the work of 20thC artists with some regional connection. Purchasing concentrates on the latter and recent acquisitions include *Encounter* by Maggi Hambling, *Head* by Edouardo Paolozzi, *Flux* by Leon Underwood and *Sheeps Head* by Peter Coker.

The Library of books of Paul and John Nash gives the collection a speciality that will be built upon in years to come through the purchase of books illustrated by artists.

Temporary exhibitions cover painting, sculpture, printmaking, photography, crafts and the applied arts. The permanent collection provides a counterbalance to these, and there is always a thematic show of work selected from the collection.

The Minories has an Association of Friends. There is a reception area selling postcards, catalogues, books and crafts. Catalogues include: *Colchester's Collection* (catalogue of the Colchester Borough Council collection), *Paul Nash Book Designs*, *Leon Underwood* and *Mark Gertler*. Coffee is available and there is car-parking in a multi-storey car-park at the back of the gallery.

Leon Underwood, *Flux*, bronze, 1924–25
(The Minories, Colchester)

Paul Nash collotype illustration for *Urne Buriall*, 1932
(The Minories, Colchester)

COMPTON, *Surrey*

The Watts Gallery

Principally paintings, drawings and
sculpture by George Frederic
Watts OM, RA (1817–1904), as well as
a few works by his contemporaries

Down Lane, Compton, Nr Guildford
tel. 0483-810235

Mon, Tues, Fri, Sun 2–6 pm (summer);
2–4 pm (winter); Wed, Sat 11–1 pm.
Closed Thurs

Admission free

The Gallery was founded in 1903, just before his death, by Watts and his second wife, Mary (née Fraser Tytler), who lived on until 1938. The gallery was built for the artist in 1903–4 to the designs of Christopher Turnor, a protégé of Sir Edwin Lutyens, in a romantic version of the Surrey vernacular style. The studio collection from the artist himself has been added to through the generosity of Mrs Michael Chapman, adopted daughter of the Wattses, who died in 1972 in her 93rd year. Other paintings, many not by Watts himself, came from the Percy French collection.

Close to the Watts Gallery is the remarkable Watts Mortuary Chapel, erected by Mrs Watts and elaborately ornamented by herself and the local villagers in a Celtic-inspired version of the Art Nouveau style. The graves of G. F. and Mary Watts are in front of the cloisters above the Chapel.

The representation of the artist spans the whole of his career, beginning with a portrait of his father executed when he was sixteen and including the ravishing picture of his patron, Lady Holland, resting on a day-bed, as well as many other portraits and very late works begun at the end of his life and still unfinished at his death.

Watts was also a sculptor, and the Gallery owns a bronze cast of his famous bust of *Clytie*, and the original gessoes for the large equestrian figure of *Physical Energy* and the statue of Tennyson at Lincoln.

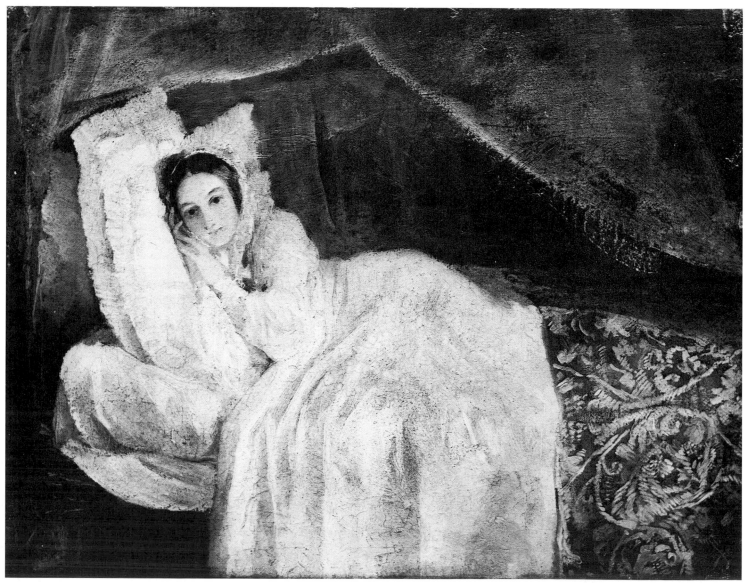

George Frederic Watts, *Lady Holland*, 1844 (The Watts Gallery, Compton)

The Gallery is run by a Board of Trustees, the Chapel by the Compton Parish Council.

There is a brief catalogue of the collection and short description of the Watts Mortuary Chapel, available from the Gallery. Postcards are sold in the Gallery. All the books on Watts are out of print, but the most recent full-scale biography, by the Gallery Curator, Wilfred Blunt, entitled *England's Michelangelo*, was published as recently as 1975 and should be readily available in libraries.

W. G. Collingwood, *John Ruskin in his study at Brantwood*, 1882 (Ruskin Museum, Coniston)

Life and work of John Ruskin
(1819–1900)

The Institute, Coniston
tel. 0966 41-387

Daily 9.30–5 pm (or dusk) (Mar–Dec).
Closed Jan–Feb, but can be visited
by arrangement with the Curator

Admission charge

CONISTON, *Cumbria*

Ruskin Museum

This museum was founded in 1901 by two artists, long-time associates of John Ruskin, W. G. Collingwood, who was also his secretary and biographer, and Arthur Severn, who married Joan, Ruskin's niece and companion of his old age.

The Museum houses a collection of pictures by Ruskin himself and his circle, part of Ruskin's famed collection of minerals, examples of Ruskin lacework, as well as some local history items.

Nearby is Brantwood, Ruskin's beloved lakeland home from 1872 until 1900. The interior still contains furniture and works of art which belonged to the great critic and writer; many of his own paintings and drawings are also in the house, but the Turner watercolours which once lined his bedroom walls are now dispersed, some to Oxford. Ruskin's travelling coach, built to his own specifications, is still here, as is his boat, which he had specially adapted for observing sunsets. He is buried at Coniston.

Works by Sir Stanley Spencer RA
(1891–1959)

King's Hall, Cookham-on-Thames
tel. 06285-24580

Open daily 10.30–1 pm, 2–6 pm
(Easter–Oct); Sat, Sun,
Bank Holidays only 11–1 pm,
2–5 pm (Nov–Easter)

Admission charge

COOKHAM-ON-THAMES, *Berkshire*

Stanley Spencer Gallery

The Gallery, devoted exclusively to the work of this most fascinating artist, was established in 1962 and is housed in a Victorian Methodist Chapel at the end of Cookham High Street where Spencer was taken to worship as a child. It is unique as the only gallery in Britain devoted exclusively to an artist in the village where he was born and spent most of his working life.

The collection includes a fine group of early religious paintings: *The Betrayal* (1914), *The Last Supper* (1920), *St Veronica Unmasking Christ* (1921), and *Christ Overturning the Money Changers' Table* (1921). The Gallery also owns figure paintings from the 1930s, e.g. *The Beatitudes of Love: Contemplation* (1937), portraits and later works. The drawings collection includes *The Fairy on the Waterlily Leaf* (*c.* 1909), two studies for the Sandham Memorial Chapel at Burghclere (1923), studies for the Chatto and Windus Almanack of 1927, drawings made as a War Artist during the Second World War for the *Shipbuilding on the Clyde* series, and portrait drawings.

In addition there are a number of major works on long-term loan. These include the five paintings of Englefield house and garden of 1948–55, landscapes, *Christ Preaching at Cookham Regatta: Listening from Punts* (1954), *Christ Preaching at Cookham Regatta* (1953–59), and a number of drawings, e.g. a changing selection from Viscount Astor's collection of scrapbook drawings and studies for *Christ Preaching at Cookham Regatta*.

The Gallery owns the Chute letters written by Spencer to Desmond Chute at the time of the First World War, and other documents.

The Sir Stanley Spencer Memorial Trust is a charitable trust administered by four trustees aided by a Committee of Management. The Gallery is self-supporting and has no endowment or regular grant income. There is an Association of Friends.

A shop stocks books, facsimile drawings, colour reproductions, postcards, etc., and catalogues for the two exhibitions held each year concerning the life and work of Spencer, e.g., *Shipbuilding on the Clyde* (1980) and *Scenes from Life of Christ* (1984). There is a guide to the permanent collection, published in 1981. There is a car-park.

COVENTRY, *West Midlands*

Herbert Art Gallery and Museum

British watercolours (*c.* 1750–present day);
British figure drawings (20thC);
British painting and sculpture (20thC);
Graham Sutherland's studies for the
Coventry Cathedral Tapestry;
English furniture (*c.* 1710–80)

Jordan Well, Coventry
tel. 0203-25555

Mon–Sat 10–5.30 pm; Sun 2–5 pm

Admission free

The Herbert Art Gallery and Museum was founded as a result of a generous gift made by Sir Alfred Herbert (1866–1957), a local industrialist whose machine tools were world-famous. Work on the original building was begun in 1939, only to be interrupted by the Second World War. After the War, the present building was begun, on a site close by, with additional funds made available by the City Council. The foundation stone was laid by Sir Alfred in 1954 and the building opened in 1960. The Gallery was designed by Messrs Alfred Herbert & Son, relatives of Sir Alfred.

The first post-war local authority art gallery and museum to be built in the country, it is managed by the Coventry City Council Leisure Services Committee and is notable mainly for its modern appearance in step with the large-scale post-war redevelopment of the city. As a purpose-built institution, it has several internal design features lacking in many other museums, for example, a proper loading bay with service lift, adaptable lighting arrangements in the public galleries and specialised storage and workroom areas.

The principal collections are those of British watercolours, including works by J. W. Abbott, D. Cox, Dr T. Monro, J. M. W. Turner and J. Varley; British figure drawings, with examples by D. Bomberg (*Man and Woman*, 1919), E. Burra (*Fruit Market Marseilles*), J. Epstein, M. Gertler, R. Hamilton, A. John, H. Moore, W. R. Sickert, S. Spencer and C. Wood; and 20thC British painting and sculpture, including important items by R. Bevan, J. Epstein, B. Hepworth, L. S. Lowry (*Ebbw Vale*, 1960), P. Nash, B. Nicholson, J. Piper (*Cathedral Ruins*, 1940), M. Smith and C. Weight. There are also collections of local topography, and an important section devoted to Lady Godiva, with works by an unknown Flemish artist (1586), J. Collier, E. Landseer and A. J. Woolmer.

Also of particular interest are two important collections: Graham Sutherland's studies for the Coventry Cathedral Tapestry which were presented to the Art Gallery in 1964 by Lord Iliffe of Yattendon; and the Poke Collection, a long-term loan of English furniture (*c.* 1710–80) and Queen Anne and Georgian silverware, collected by Frederick Poke (1884–1974), a local industrialist.

The Art Gallery, located on the first floor, has, in addition to the permanent collection,

Edwin Landseer, *Lady Godiva's Prayer, c.* 1865
(Herbert Art Gallery and Museum, Coventry)

John Collier, *Lady Godiva, c.* 1898 (Herbert Art Gallery and Museum, Coventry)

Walnut side-table attributed to William Kent, *c.* 1735
(Herbert Art Gallery and Museum, Coventry)

Graham Sutherland drawing of a calf for the Coventry
Cathedral tapestry, 1952–58 (Herbert Art Gallery and
Museum, Coventry)

a lively programme of temporary exhibitions. In recent years these have included 'Lady Godiva: Images of a Legend in Art and Society' (1982) and 'The Nude: Approaches through Drawing' (1983), together with various one-man shows and touring exhibitions. On the ground floor there is an important permanent display, 'Phoenix: Coventry's Story', which outlines the history of the city from prehistoric times until the present day. Particularly interesting are the sections dealing with mediæval life, the 19thC expansion, and the redevelopment of the city, especially after the Second World War. Also on the ground floor is an informative permanent display devoted to 'Animal Movement', which features a vivarium.

The Art Gallery and Museum have a small shop which sells related items together with publications on various aspects of the collections. Art Gallery publications include: *Warwickshire Watercolours* (1972), *Catalogue of the Visual Art Permanent Collection* (1981), *Lady Godiva* (1982) and *The Nude* (1983). There is also a variety of postcards. In addition, the curatorial staff provides an Enquiry Service for the public. There are plans for a small cafeteria in the future.

DARLINGTON, *Durham*

Darlington Art Gallery [1]

Northern paintings and watercolours
(19thC–20thC)

Crown Street, Darlington
tel. 0325–462034

Mon–Fri 10–8 pm; Sat 10–5.30 pm.
Closed Sun

Admission free

The collection consists mainly of oils and watercolours, with a representative selection of 19thC northern artists. It is particularly strong in topographical watercolours and has the basis of a collection representing British artists of the 1940s and 1950s (e.g., Prunella Clough). Quality ranges from amateur works to those by artists with established reputations such as Graham Sutherland, Spencer Gore, William Russell Flint, Frank Brangwyn, J. W. Carmichael and James Peel.

The Art Gallery building once housed the Public Library, founded in 1884 as the result of a bequest of £10,000 from Edward Pease (1834–80). In 1933 the Library moved into an extension to the original building, and the Art Gallery was founded. The nucleus of the collection, consisting of twenty pictures acquired by donation, has since been added to by purchase, donation, bequest and loan to reach the present figure of 350.

The Gallery, designed by G. G. Hoskins, is a distinctive brick and red sandstone Renaissance revival building, floridly decorated with appropriate ornament. The extension was built in the same style, and so successfully merged that it is nearly impossible to tell the new part from the old.

The catalogue of the permanent collection published in 1980 is out of print.

John Dobbin, watercolour of *The Opening of the Stockton and Darlington Railway 1825*, 1871
(Borough of Darlington Museum)

Darlington Museum [2]

Tubwell Row, Darlington
tel. 0325–463795

Mon–Wed, Fri 10–1 pm, 2–6 pm;
Thurs, Sat 10–1 pm, 2–5.30 pm. Closed
Sun

Admission free

A small local museum in a 19thC town house with varied collections relating to social and natural history, with particular emphasis on Darlington and the surrounding rural areas. As well as a few drawings, including comic works by George du Maurier and Bernard Partridge, there is a most interesting local item, an 1825 watercolour by John Dobbin showing *The Opening of the Stockton and Darlington Railway*.

Souvenirs and gifts are on sale.

DARTMOUTH, *Devon*

Dartmouth Town Museum

Ship models; ancient maps;
watercolours of local interest

6 The Butterwalk, Dartmouth
tel. 08043–2923

Daily 11–5 pm (Apr–Oct);
2.15–4 pm (Nov–Mar)

Admission charge

The Museum is housed in what was originally a merchant's house, one of a group of four such houses built between 1635 and 1640 and considered to be one of the finest extant examples of 17thC Devonian domestic architecture. The Butterwalk was formerly a market-place for farmers to sell butter, eggs and cream under the colonnades. The Museum was established there on 14 April 1954 by Percy Russell FSA (and subsequently managed by Trustees) in three fine rooms, one of which has its original pine panelling, plaster ceiling and a carved fireplace with the royal coat of arms commemorating a visit by Charles II in 1671.

The Museum holds a magnificent and various collection of large and small ship models, including the Lewis Stock Collection, as, for example, a large model of the *Golden Hind*, ivory models of Chinese pleasure boats and bone models of ships of the line made by French

prisoners of war between 1802 and 1814. The Museum also has a collection of ancient maps, including the first printed map of Devon of 1575 by Saxton. There is a collection of watercolours, amongst which are some interesting local views.

The Museum is staffed on a volunteer basis by an association of Friends. There is a shop where a pamphlet about the Museum is available and a public car-park nearby.

DEDHAM, *Essex*

The Sir Alfred Munnings Art Museum

Works by Sir Alfred Munnings (1878–1959)

Castle House, Dedham, Colchester
tel. 0206–322127

Sun, Wed, Bank Holiday Mon 2–5 pm (5 May–6 Oct); also Thurs, Sat 2–5 pm (Aug). Closed Mon, Tues, Fri (May–Oct), daily (Nov–Apr)

Admission charge

Sir Alfred Munnings began painting at an early age and started his career with a firm of lithographers in Norwich as a poster artist. His first Royal Academy exhibit was in 1898; this was followed by over two hundred in unbroken succession until ten years before he died. Munnings's great passion was for painting horses, particularly racehorses, and he was fascinated by their movement. He was elected President of the Royal Academy in 1944 and knighted in the same year.

The Museum was established by Lady Munnings as a Private Trust in 1965 in the part Tudor, part Georgian house which Munnings had bought for himself in 1919. It contains a considerable number of his studies and sketches as well as many paintings and some sculpture, arranged around the walls, galleries and in the studios.

There is a brochure by Stanley Booth, *The Munnings' Collection*, published in 1976, and also a book by him on Munnings, both for sale on the premises. Free car-parking is available.

DERBY

Derby Museum and Art Gallery [1]

Archæology; social and natural history (18thC–20thC); Derby porcelain and pottery; paintings and drawings by Joseph Wright of Derby (1734–97)

The Strand, Derby
tel. 0332–31111, ext. 782

Tues–Sat 10–5 pm; Mon, enquiries only. Closed Sun

Admission free

The earliest museums at Derby date back to the 1820s and 1830s and were private. The Town and County Museum and Natural History Society were established in 1836. A new

Joseph Wright of Derby, *Virgil's tomb by Moonlight*, 1782 (Derby Museums and Art Gallery)

building was erected from 1876–79 to the design of R. K. Freeman (1838–1904) of Bolton and the Museum was founded by Michael Thomas Bass (1799–1884), brewer, benefactor and local Liberal Member of Parliament. Extensions have subsequently been added.

The majority of the collections are locally orientated, pictures by local artists or of local topography, Derby porcelain and pottery from local factories, archæology, social and natural history.

The Joseph Wright collection of twenty-eight paintings and a number of studies and drawings is outstanding. It includes major paintings representing the various aspects of this 18thC Derby artist's work, scientific and industrial scenes (for example, *The Blacksmith's Shop*), subjects from literature (*Romeo and Juliet* and the enigmatic *Miravan Breaking open the tomb of his Ancestors*), portraits (both of himself and commissioned sitters, *Erasmus Darwin*, *Jedediah Strutt* and the group of *The Rev. Ewes Coke and his Family*) and landscapes. The centrepiece is *A Philosopher Lecturing on the Orrery* (1766) showing a group of people in a darkened room watching the demonstration of the orrery, a type of 18thC planetarium.

The Derby porcelain collection consists of figures, decorative and table ware produced from the founding of the Derby factory in the 1750s to the present day. The collection features work by notable china artists, Andrew Planché figures from the earliest period of the factory, and porcelain decorated by Quaker Pegg, William Billingsley, Jockey Hill, Zachariah Boreman and others.

In addition to these local collections, there is the Frank Bradley collection of toy and model theatres and juvenile drama material given to the Museum in 1977.

The Museum has recently acquired another building, an attractive town house in Friar Gate, designed and built by Joseph Pickford for himself in the 1770s. He previously worked at Kedleston under Robert Adam and also built the Assembly Rooms and St Helen's House in Derby. This will display period rooms, social history and decorative arts, including examples from the Museum's costume collection, which ranges in date from the mid-18thC to the present day.

The Museum has an Association of Friends. A shop sells books and booklets, information sheets, prints, postcards and slides, as well as jewellery, souvenirs and recreational material.

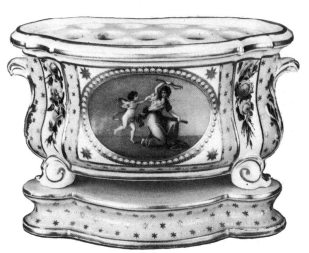

Derby porcelain bough pot with panels painted by James Banford, William Billingsley and probably Zachariah Boreman, *c.* 1790
(Derby Museums and Art Gallery)

Derby porcelain (18thC–20thC)

194 Osmaston Road, Derby
tel. 0332–47051

Mon–Fri 9–4 pm. Closed Sat, Sun

Admission free

The Royal Crown Derby Museum [2]

This private museum, owned and adminstered by Royal Doulton Ltd, was opened by the Duchess of Devonshire in 1969, and traces the history of this renowned company from 1748 to the present day. Royal Crown Derby is the only factory permitted to use both the words 'crown' and 'royal', a double honour conferred by George III in the 18thC and Queen Victoria in the 19thC. The Museum has examples of Derby porcelains from the foundation of the company to the present day, including the early figures produced by the Huguenot, Andrew Planché—notably the five 'Senses' and the four 'Elements' with their elegant flower-sprigged decoration—as well as a range of the wares produced under the direction of the Duesbury family when the Derby porcelain manufactory became the most important in Britain. From this period comes the sketchbook of William Pegg, known as 'Quaker' Pegg, who came to Derby in 1796, and was perhaps the finest natural flower painter in the history of the manufactory. Other rarities include a George III Coronation Tankard; the famous 'Kedleston' vase commissioned by Lord Scarsdale *c.* 1790; and a mug of 1820 by William Dixon painted with a panel showing grotesque men fighting after one of the 'Lancashire Dialect Prints' by 'Tom Bobbin'. The highly accomplished technical achievements of the 19thC and 20thC include raised gilding, lace-like piercing and minutely detailed naturalistic painting.

The Museum has published a booklet, *The Story of Royal Crown Derby China*, a guide to the history of Derby china and some other pieces in the display. There is a car-park, and tours of the factory can be arranged by appointment. As a service to the public the Museum runs an 'open day' on the first Tuesday of every month when advice can be sought on pieces of porcelain and china.

Joseph Wright of Derby, *Miravan Breaking open the tomb of his Ancestors*, 1772 (Derby Museums and Art Gallery)

Devizes Museum (The Museum of the Wiltshire Archæological and Natural History Society)

Archæology, natural history, local history

41 Long Street, Devizes
tel. 0380–77369

Tues–Sat 11–1 pm, 2–5 pm
(winter 2–4 pm). Closed Sun, Mon

Admission charge

Founded in 1853 by Willian Cunnington (1754–1810), antiquary and archæologist and the 'Gentlemen of the Wiltshire Quarter Sessions', the Museum occupies three 18thc and 19thc houses. These have fine original staircases and floors. Recently a purpose-built extension has been added to house the Natural History Collection and Art Gallery.

The Museum is located in the centre of a region which was of considerable importance in prehistoric times and its extensive and unique collections are of international significance. They include the finds from the excavations of such well-known sites as Woodhenge, the Sanctuary, Marden and West Kennet Long Barrow. Of more striking interest is the Stourhead Collection which includes the grave goods from the many Bronze Age barrows of the Wessex phase excavated in the early 1800s by Sir Richard Colt Hoare (1758–1838) and William Cunnington. This includes unique and dramatic objects in gold, bronze, amber, jet, shale and glass, together with a very wide range of neolithic, beaker and Bronze Age pottery. The later prehistoric collections include the finds from major sites such as All Cannings Cross and the recently discovered Late Bronze Age settlement at Potterne. The centrepiece is undoubtedly the Marlborough bucket, one of the finest surviving pieces of Celtic La Tène metalwork from Southern England.

The Roman displays illustrate life in the countryside during the Roman occupation and include three fine Romano-Celtic stone heads. The Saxon collections include a very wide range of decorative metalwork and jewellery difficult to parallel in any other provincial museum. The mediæval and recent collections are also extensive and include a series of replicas of prehistoric pottery commissioned from Wedgwood by Sir Richard Colt Hoare as well as a good series of coins, medallions and tokens struck in or relating to Wiltshire.

Apart from the Stourhead Collection, the private collection of Sir Richard Colt Hoare, the Museum includes the private collections of a number of Wiltshire antiquaries, archæologists or historians, including those of Joshua Brooke, Owen Meyrick, H. G. O. Kendall and T. H. Chandler.

The collection of topographical drawings and watercolours, some twelve thousand items in all, was started at the formation of the Society by the acquisition of a number of albums and extra-illustrated books from the library of the antiquary John Britton (1771–1857).

John Piper *Stained-Glass cartoon*, 1982
(Devizes Museum)

Anthony Vandyke Copley Fielding, watercolour of *Sunset on Stonehenge*, 1818 (Devizes Museum)

Further substantial additions were made at the part disposal of the Stourhead library of Sir Richard Colt Hoare, culminating in the purchase of his collection of watercolours by John Buckler, of churches and country houses in the county, in ten large folio volumes. Since then the collection has been steadily built up by gift and purchase, especially from members of the Goddard and Cunnington families. These acquisitions include the Pridham drawings of Fonts, the Goddard drawings of Church Plate, the Kemm drawings of churches in the south of the county, and a very large number of individual drawings by artists such as Prout, John Martin, Cattermole, Copley Fielding, Sir Richard Colt Hoare, W. J. Muller, and many others.

The collections of prints, maps, photographs and portraits have been developed. There are now about two thousand maps, five thousand portraits, about fifteen thousand prints and a large number of photographs, including some by Fox Talbot, who lived at Lacock, not far from Devizes.

A shop sells replicas, souvenirs and publications, including the Society's annual *Wiltshire Archæological & Natural History Magazine*, a *Guide Catalogue of the Neolithic & Bronze Age Collections in Devizes Museum* by F. K. Annable and D. D. A. Simpson, and *An Introduction to the Collections in Devizes Museum*.

Free street parking is available.

DONCASTER, *South Yorkshire*

Doncaster Museum and Art Gallery

The collection was moved to a new purpose-built museum in 1964 (built by the Doncaster Borough Architect L. J. Tucker), having previously been located in Beechfield House, Waterdale, a large mansion house, since 1909. In that year the Doncaster County Borough established the Museum with the collections of the Doncaster Scientific Society and with the support of the Doncaster Art Club, with the principal aim of housing the Cottrell-Clarke collection of archæological and ethnographical material.

British and European paintings, drawings and watercolours (19thC–20thC); porcelain and pottery (18thC–19thC, especially Yorkshire); glassware (17thC–19thC); French and British commemorative medals; jewellery and costume (late 18thC–20thC); sporting pictures and material associated with horse-racing

Chequer Road, Doncaster
tel. 0302–734287

Mon–Thurs, Sat 10–5 pm;
Sun 2–5 pm. Closed Fri

Admission free

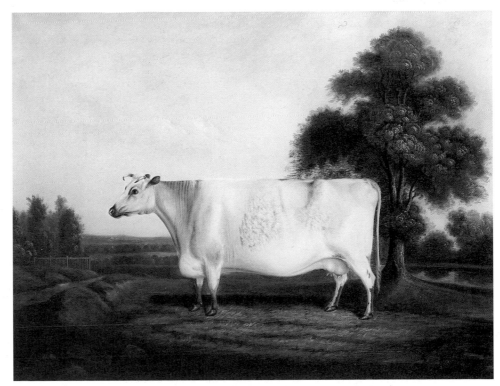

George Bailey, *Lavinia, a Short-Horned Cow*, 1822 (Doncaster Museum and Art Gallery)

Swinton Cream Ware tankard with the arms of the
Marquis of Rockingham, *c.* 1770
(Doncaster Museum and Art Gallery)

Local history, literature, natural history,
geology and archæology

High West Street, Dorchester
tel. 0305–62735

Mon–Fri 10–5 pm;
Sat 10–1 pm, 2–5 pm. Closed Sun

Admission charge

The collection consists of 19thC and 20thC British and European oil paintings, drawings
and watercolours, and includes many interesting items acquired from the collection of Sir
Edward Marsh, the great connoisseur and friend to artists.

The Museum also houses on loan works collected by the British Rail Pension Fund, some
of which were exhibited at Agnews in 1984.

There is an important collection of 18thC and 19thC porcelain and pottery which includes
items from local Yorkshire potteries, especially examples from the factories of Don and
Rockingham at Swinton, both of which were closely associated with the Leeds pottery and
porcelain manufacturers. Doncaster was a centre of pottery manufacture since Romano-
British times. Glassware, which has been manufactured in South Yorkshire since the 17thC,
is also well represented. The Museum also has French and British commemorative medals
and a large collection of jewellery and costume representing the period from 1790 to 1945
which includes the Hull Grundy Gift of Whitby jet and associated mourning jewellery
materials such as 'French' jet, *bois durci* and bog-oak. Horse-racing at Doncaster is represented
by a fine collection of sporting pictures, particularly those by J. F. Herring who was employed
in the town as a painter of heraldic devices on coaches and later as a driver of stage-coaches
locally, before his talent as a sporting artist was recognised. Other items associated with horse-
racing include magnificent silver race cups and silver admission tickets for the racecourse
and betting rooms.

The Museum has published a *Catalogue of Oil Paintings*. There is a sales counter and a
refreshment room, and car-parking is available.

DORCHESTER, *Dorset*

Dorset County Museum

The Dorset County Museum belongs to the Dorset Natural History and Archæological
Society, and its governing body is the Council of that Society. The first President was Lord
Ashley, and the High Sheriff, C. Porcher Esq., was the first Chairman.

The Museum was built in 1881–83 by Crickmay and Son of Weymouth, the architect
being G. R. Crickmay himself. The style adopted for the street front was lavishly
Perpendicular; within, an exhibition hall with elaborately detailed cast-iron columns, arches,
clerestory and roof, has recently been restored to the bright colour scheme originally intended
by the architect. A modern addition was designed by Michael Brawne and built in 1968–70.

The collections are confined entirely to the local history, literature, natural history, geology
and archæology of the County of Dorset. Works by artists associated with the area, or local
views and portraits, are supplemented by several special collections of MSS, books and letters
by Dorset authors: the Thomas Hardy Memorial Collection, the Sylvia Townsend Warner
and Valentine Acland collection and the William Barnes collection.

Recent additions to the small but growing art collection include a rare Thornhill item,
the painted panel of a travelling coach. Sir James Thornhill was born in Melcombe Regis
and died at Weymouth. A Gainsborough portrait of John Bragge has joined four marble
busts from the workshop of Michael Rysbrack from St Giles's House, Wimbourne, of the
3rd, 4th and 6th Earls of Shaftesbury and the 1st Earl of Eldon, and adds to the representation
of local figures.

The Museum has a shop selling publications mainly devoted to the archæology and natural
history of the area.

DOUGLAS, *Isle of Man*

Manx Museum

Manx history, art and archæology

Kingswoodgrove, Douglas
tel. 0624–5522

Mon–Sat 10–5 pm. Closed Sun

Admission free to the Manx Museum; small charge for the Nautical Museum, Folk Museum and the Rural Life Museum

The 'Calf of Man' Crucifixion executed on Manx slate in low-relief, 8thc (Manx Museum, Douglas)

The complex of museums administered by the Manx Museum and National Trust concentrates exclusively on Manx history, artistic, archæological and social. The Manx Museum was established in its present premises, the former 'Noble's Hospital' building in 1922, but the original foundation by the Ancient Monuments Trustees, a statutory body of the Manx Government (Tynwald) dates back to 1886.

The particular strengths are the Celtic and Norse stone carvings and memorial crosses. There are examples of ogham and runic inscriptions. A notable exhibit is the late Celtic (8thc) 'Calf of Man' crucifixion stone. A carving of the Crucifixion in the 'Irish Vernacular Style', executed in low-relief on a slab of the local Manx slate, it was found in 1773 in the ruins of a *keeill*, or Celtic chapel, on the Calf of Man, a small island off the south-west coast of the Isle of Man. No close parallel is known, either in subject or form. The plain lower half of the slab was evidently intended to be set in the ground, or in a masonry base, and the carving may have formed the central panel of a masonry altar. There is a collection of work and archive material relating to the Manx-born designer, Archibald Knox, who revolutionised the metalwork offered by the London store, Liberty's, at the turn of the century. Knox came into contact with Liberty's in about 1897 through the architect M. H. Baillie Scott. He worked for them for a number of years, producing many designs for metalwork, jewellery, pottery, carpets and textiles, and specialising in the Celtic forms which were so much in vogue then.

The national archive and photographic repository form part of a strong collection of Manx folk-life material.

The Manx Museum also administers the following:

CREGNEASH VILLAGE FOLK MUSEUM Founded in 1938, this consists of a group of traditional crofters' buildings in the southern part of the village. One of these, 'Harry Kelly's Cottage', is fully furnished as a 19thc crofter's house.

GROVE RURAL LIFE MUSEUM This was founded as the result of the generosity of the Misses Gibb of 'The Grove', in Ramsey, in 1978. This Victorian shipping merchant's house has been fully refurbished and contains much of the original furniture. There are displays of Victorian costume and traditional agricultural equipment in the outbuildings.

NAUTICAL MUSEUM This was founded in 1951 and centres round a beautifully preserved late 18thc armed yacht, *Peggy*, in her original boathouse in Castletown. There is also a reconstructed sailmaker's loft and a fine collection of photographs of Manx maritime history.

All these allied museums offer a range of books, guides, postcards and slides in their shops, as well as car-parking facilities, and at Cregneash and Ramsey there are restaurants/cafés.

Silver tea-service designed by Archibald Knox and made by Liberty & Co., 1921 (Manx Museum, Douglas)

DOVER, *Kent*

Dover Museum

Local history; Victorian furniture

Ladywell, Dover
tel. 0304–201066

Daily, except Wed and Sun, 10–4.45 pm

Admission free

The Dover Museum and Philosophical Institute founded the Museum in 1836, and it is now housed in the old prison, a building of *c.* 1867, the previous premises having been destroyed by enemy action in 1944. The building is next to Dover's Maison Dieu (now the Town Hall) which was built in 1203 as a pilgrims' hospital.

Dover Museum is a fairly typical local small museum with items mainly relating to the history of Dover but also with a small Oriental collection, some natural history, ceramics, clocks and watches. There is a fairly large collection of Victorian furniture with needlework decoration.

The Museum is run by the local district Council. There is a public car-park 25 yds from the Museum.

DUDLEY, *West Midlands*

Broadfield House Glass Museum [1]

British glass 18thc–20thc;
Continental glass 19thc and 20thc

Barnett Lane, Kingswinford
tel. 0384–273011

Tues–Fri 2–5 pm; Sat 10–1 pm, 2–5 pm;
Sun 2–5 pm. Closed Mon

Admission charge

The Museum was established in 1980 as a centre for the local glass industry, with donations from the local factories and the County Council. It was voted the Best Small Museum in the following year by the Museum of the Year Awards. The Museum is housed in an 1820s building with an impressive façade.

The Museum is one of only two in the country (the other is Pilkington's Glass Museum, St Helens, q.v.) to specialise in the display and study of glass. After five years the museum is being recognised as a major centre for study and provides library facilities. Major collections have been given to the museum—recently, for instance, five hundred pieces of the Carnival Collection. The total size of the collections is about three thousand pieces, including many local examples from Stourbridge and important pieces of cameo, rock crystal and coloured glass from the 1870s to 1900. There is a good representation of English and Continental glass from the 18thc onwards and a growing collection of Studio glass. The Museum has incorporated two former glass collections, that of Brierley Hill, established in 1935, and Stourbridge, of 1951.

Attached to the Museum are glass-blowing and engraving workshops, the products of which

The Elgin glass vase made by Frederick E. Kny of Thomas Webb & Sons, Amblecote, *c.* 1875 (Broadfield House Glass Museum, Dudley)

Emily Hodgetts, *The Interior of the Richardson Glasshouse c.* 1840–50 (Broadfield House Glass Museum, Dudley)

are for sale. The museum shop also sells postcards and many publications concerning glass, including exhibition catalogues. Specialist Museum publications include: *Glasshouses: Topographical Views of the Glass Industry* (1980); David and Chris Smith, *Cameo Glass* (1982); Diana Newnes, *Engraved Glass* (1984); and *English Rock Crystal Glass 1878–1925*.

Free car-parking is available.

Dudley Museum and Art Gallery [2]

19thC and 20thC British paintings; 18thC–20thC British watercolours; 20thC prints

St James's Road, Dudley
tel. 0384–55433

Mon–Sat 10–5 pm. Closed Sun

Admission free

Established in 1884, the Museum holds an interesting variety in the collections. English oil paintings and watercolours from the 19thC are represented by *Cromwell at Blue Boar* by Ernest Crofts, *Primitive Methodists* by W. H. Y. Titcomb and *Sale of Old Dobbin* by J. R. Reid. The collection of 20thC prints contains over 250. The Museum also houses the Brooke Robinson Collection of painting, ceramics and Oriental art, including some inro and netsuke. These were presented by the local M.P. in 1911. There is also a major collection of geological material. The Museum holds a wide-ranging selection of temporary exhibitions involving everything from crafts to photography.

The sales area, to be expanded, concentrates on geology books and reproductions, and also holds basic lists of the collections.

DURHAM

Durham University Oriental Museum

Major collection of Egyptian, Near Eastern and Chinese objects

Elvet Hill, South Road, Durham
tel. 0385–66711

Mon–Sat 9.30–1 pm, 2–5 pm; Sun 2–5 pm. Closed Sat, Sun (Nov–Feb incl.)

Admission charge

The Museum was founded as a teaching and research collection. However, as the collections grew, plans for a public museum were developed. These had begun as the result of the acquisition in 1950 by the University of Durham of the collection of Egyptian antiquities formed principally by the 4th Duke of Northumberland in the 1840s. To this were added, at first on loan and later purchased, the Chinese ceramics of Malcolm MacDonald and, as a gift, the Chinese jade and hardstone carvings of Sir Charles Hardinge. These three collections form the backbone of the Museum but have been supplemented over the years by other gifts and purchases and most Oriental cultures are now represented in some manner.

A building to house the collections was designed by Middleton Fletcher & Partners of Middlesborough and opened in 1960, and has been much admired for the interesting terraced open-plan galleries.

The Northumberland collection of Egyptian antiquities comprises many fine pieces, particularly a delicately carved boxwood figure of a servant girl, a painted linen-chest and a handsome sphinx of Tuthmosis IV (originally incorrectly identified and therefore used as the model for the large bronze sphinxes which flank the obelisk of Tuthmosis III, better known as Cleopatra's Needle) along with several other examples of royal statuary and equipment. The Northumberland Collection was considerably supplemented in 1971 by a gift from the Trustees of Sir Henry Wellcome. The Northumberland collection includes an important group of Near Eastern cylinder and stamp seals assembled by another member of the family, Lord Warkworth. To this have been added objects of Biblical interest from excavations in Jericho, Jerusalem and Lachish and a splendid Achæmenid silver bowl. From the Islamic period there is calligraphy, metalwork and ceramics.

The Malcolm MacDonald Collection consists of over four hundred pieces encompassing all the major stages in the history of Chinese ceramics. It includes a number of interesting tomb figures and many fine vessels, including *san-ts'ai*, celadons, blue and white and *blanc de chine* ware. This collection is complemented by the Hardinge jades which are the result of a lifetime's dedication to all branches of this subject. Sir Charles was interested not only in the finer pieces, represented by a striking dragon-vase and an intricately carved 'mountain', but also in the different techniques and materials. This is probably the widest ranging collection of jades in this country. Hardinge's gift was followed by a bequest which enabled the Museum to buy other items to fill some of the more obvious gaps, including examples of lacquer work and metal work.

Mei-ping vase with peony scroll design in cizhou ware, Song dynasty (Durham University Oriental Museum)

Other gifts to the Museum have included paintings, textiles, rubbings and furniture, and it possesses a magnificent Chinese bed, made for a 19thC opium dealer.

Selections from all these collections are on permanent display. From time to time temporary exhibitions of other items in the collections are arranged. These include the Japanese prints and Tibetan *tanqkas* which cannot be permanently displayed until suitable gallery conditions can be developed. Visitors interested in these items should enquire in advance about the temporary exhibition programme.

The shop sells a brochure on the Museum, books, replicas, posters and other items. Catering can be arranged in advance for groups. Free car-parking nearby.

PUBLICATIONS
I. L. Legeza, *The Malcolm MacDonald Collection of Chinese Ceramics*, 1972
W. G. Lambert, 'Near Eastern Seals', and Catalogue in *Iraq* vol. XLI, 1979, pp. 1–45
Arts of Asia, Nov–Dec 1983 (special issue on the Oriental Museum)

EASTBOURNE, *Sussex*

Towner Art Gallery and Local History Museum

Local history; 19thC and 20thC British painting; 20thC original prints

Borough Lane, Old Town, Eastbourne
tel. 0323-21635/25112

Mon–Sat 10–5 pm; Sun 2–5 pm.
Closed Mon (winter)

Admission free

Alderman John Chisholm Towner (1840–1920), after whom the Gallery is named, was a much respected businessman and an outstanding local figure. He was a generous patron of local clubs and institutions and on his death in 1920 he bequeathed twenty pictures, including works by Thomas Sidney Cooper, William Shayer and John Frederick Herring Snr, to the Corporation with £6,000 'to be applied towards the building of an art gallery'. The bequest was first displayed in the Towner Room of the Technical Institute.

The Manor House and grounds were used to house the collection in 1923, a year after the property had been purchased by the Corporation for recreational purposes. Through purchases, loans and bequests since that date the permanent collection now comprises over 1,900 works, principally of 19thC and 20thC British art. Among these the Gallery holds a major collection of works by the Eastbourne artist Eric Ravilious, including some very fine large watercolours of Downland scenes, as well as book illustrations and designs for and examples of the artist's work for Wedgwood ceramics. As a result of the Lucy Wertheim Bequest of 1971 the artist Christopher Wood is also well represented, with works in oil including *PZ 134* and *Fair at Neuilly*, as well as studies in pencil. British 20thC painting is further represented by Edward Burra's *Soldiers' Backs* and Ceri Richards's *Poissons d'Or*. The Gallery has an extensive collection of modern and contemporary prints, including Picasso's *Songe et Mensonge de Franco*. Henri Gaudier-Brzeska's *Sleeping Fawn* in bronze

Eric Ravilious, wood engraving of *Boy birdnesting*, 1927 (Towner Art Gallery and Local History Museum, Eastbourne)

Eric Ravilious, watercolour of *Downs in Winter, c.* 1934 (Towner Art Gallery and Local History Museum, Eastbourne)

forms part of the gallery's varied sculpture collection.

Contemporary art and craft is further represented by the South East Arts Association collection. This comprises recent work by artists living in Sussex, Surrey and Kent, and is permanently based at the Gallery.

The Local History Museum, opened in 1983, shows the history and occupation of Eastbourne and the surrounding area from prehistoric times to the present day.

The Gallery has a Friends association which provides tea on Sunday afternoons. There are two sales points selling books and souvenirs. Car-parking is restricted.

PUBLICATIONS
P. R. Andrew, *Louisa Paris*, 1982
P. R. Andrew, *Eastbourne Centenary Exhibition*, 1983
P. R. Andrew, *The Towner Bequest*, 1983
Concise Catalogue of Maritime Pictures in the Towner Art Gallery, 1982

ECCLES, *Greater Manchester*

Monks Hall Museum

Opened in 1961, the Museum occupies a building whose timber-framing dates back to the 15thC and 16thC, with additions of *c.* 1840. A brick section was added in the 17thC and later alterations and additions include a late 19thC extension.

The permanent displays include items of local interest, e.g. machine tools and engines such as the Nasmyth steam hammer. Another display features dolls and toys.

Temporary exhibitions of arts and crafts are held regularly.

As a branch of Salford Museums and Art Galleries, the Museum is associated with the Friends of the Salford Museums Association.

A sales desk sells postcards, publications and prints. Car-parking is available in a side street.

Items of local interest, dolls and toys

42 Wellington Road, Eccles
tel. 061-789 4372

Mon–Fri 10–5 pm; Sun 2–5 pm.
Closed Sat

Admission free

EGHAM, *Surrey*

Egham Museum [1]

Housed in former assembly rooms, the Egham-by-Runnymede Historical Society was founded in 1967 and the contents of the Museum were transferred to a Trust in 1979. The collection consists of items of local history and archæology from Egham, Englefield Green, Thorpe and Virginia Water.

The Historical Society, a charity, acts as an Association of Friends of the Museum. Local history and Museum publications and postcards are sold in the Museum. Free car-parking is available close by.

Local history and archæology

Literary Institute, High Street, Egham
Written arrangement

Thurs 2–4.30 pm; Sat 10.30–12.30 pm,
2.30–4.30 pm. At other times
by arrangement

Admission free

Thomas Rowlandson, drawing of *A Fishing-Party near Magna Carta Island, from Runnymede*, 1780s (Egham Museum)

Royal Holloway and Bedford New College [2]

18thc and 19thc British paintings

Egham Hill, Egham, Surrey

tel. 87-34455

By appointment with the Conference Officer

Admission free

The College was founded by Thomas Holloway (1800–83), famous for the pills and ointments he concocted to alleviate every possible complaint and which he advertised widely. Having built Holloway Sanatorium at Virginia Water in 1873–85, he proceeded with the same architect, William Henry Crossland (1823–1909), to build the College in a flamboyant French Renaissance style on a huge scale. It was built from 1879–86 and provides a magnificent glimpse of turrets and towers from the A30. Holloway began to buy the paintings, which now hang in the Picture Gallery, formerly the Young Ladies' Recreation Hall, at Christie's in 1881 when he was aged eighty-one. It is unlikely that he ever saw the seventy-seven pictures (only four of which were not bought at auction) before sending his brother-in-law, George Martin-Holloway, to bid for them. He was still buying at the saleroom at the time of his death three years later, his latest purchase being the earliest in date in the collection, Gainsborough's *Peasants Going to Market, Early Morning* of *c.* 1770. The collection is one of the few of that date to have remained intact.

There are some of the most exceptional paintings of the 19thc, for instance, Frith's *Railway Station* (1862), Millais's *The Princes in the Tower* (1878) and its companion, *Princess Elizabeth in Prison at St James's* of 1879, Landseer's memorable and savage *Man Proposes, God Disposes* (1864) and the extraordinary and unlikely subject for a ladies' college, *The Babylonian Marriage Market* of 1875 by Edwin Long. Two further unlikely purchases were those of Fildes's *Applicants for Admission to a Casual Ward* (1874) and Holl's *Newgate; Committed for Trial* (1878). There are a number of works by Scottish painters, in particular the evocative scene by MacWhirter, *Spindrift* (1876), and *Night* of 1874, the intriguing *A State Secret* (1874) by Pettie and *The Missing Boat* (1876) by Erskine Nicol. Two of the important paintings in the College are the full-scale sketch for the *View on the Stour, near Dedham* (*c.* 1821–22) by Constable and *Van Tromp Going about to Please his Masters, Ships at Sea, Getting a good Wetting* (1844) by Turner.

The catalogue by Jeannie Chapel, *Victorian Taste* (1982) and postcards are sold at the College shop. Car-parking is available.

Stained glass panel of *St Luke* designed by Sir Edward Burne-Jones and executed by Morris & Co. for Birmingham Meeting House Chapel, *c.* 1910 (The Stained Glass Museum, Ely)

James Clarke Hook, *Leaving at Low Water*, 1863 (Royal Holloway and Bedford New College, Egham)

ELY, *Cambridgeshire*

The Stained Glass Museum

Stained glass from mediæval times
to the present day

North Triforium, Ely Cathedral, Ely
tel. 0223-60148/0353-5103

Mon–Fri 11–4 pm;
Sat, Bank Holidays 11–4.30 pm; Sun
12–3 pm

Admission charge

The Museum Trust was founded in 1972 with the aim of rescuing threatened glass from redundant churches and other buildings. It has been located in the splendid setting of the North Triforium of Ely Cathedral since 1977 and was opened to the public in 1979. Conservation and restoration work is undertaken on those pieces in need of attention.

One of the earliest pieces is from the Cathedral itself, a 14thC window from the Lady Chapel; also from the 14thC is an Annunciation from Hadzor in Worcestershire. Continental glass from the 14thC–17thC is also displayed. The 19thC is most strongly represented with extremely fine works by Burne-Jones, William De Morgan, Pugin, Clayton & Bell and Heaton, Butler & Bayne. There are examples by Glasgow designers rescued from Scottish buildings. Arts and Crafts movement designers of the early 20thC are represented by Leonard Walker and Karl Parsons, and there are later works by John Piper and Johannes Schreiter.

There is also an historical display of photographs, information on mediæval glass and models of a modern stained glass workshop. A short catalogue is available.

In the Cathedral are a bookshop, with slides and postcards, and a cafeteria. There is a car-park.

ENFIELD, *Middlesex*

Forty Hall Museum

Watercolours and drawings (18thC);
furniture (17thC–18thC);
local history

Forty Hill, Enfield
tel. 01-363 8196

Tues–Fri 10–6 pm, Sat & Sun 10–8 pm
(Easter–Sept); Tues–Sun 10–5 pm
(Oct–Easter). Open Mon Bank Holidays

Admission free

The House was built in 1629 for Sir Nicholas Raynton, a wealthy haberdasher and Lord Mayor of London in 1632. Later owners included the Wolstenholme, Meyer and Bowles families. The architect remains unknown. The handsome plasterwork ceilings and a fine carved hall screen of the early 17thC still survive. In 1955 the house became a museum, devoted particularly to displays of 18thC watercolours and drawings, including works by Sandby and Michael 'Angelo' Rooker, 17thC and 18thC furniture and local history material.

There is an Association of Friends. A sales counter sells a guidebook and catalogues for temporary exhibitions, which are held regularly by sponsoring societies or institutions. There is a cafeteria, and car-parking is available in the grounds. The house is surrounded by a large area of public park with nature trails.

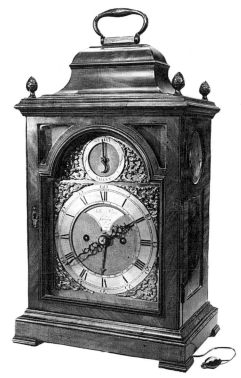

Bracket clock made by John Pratt of Epsom, *c.* 1780 (Bourne Hall Museum, Epsom)

EPSOM, *Surrey*

Bourne Hall Museum

Historic wallpapers; 18thc pipes

Bourne Hall, Spring Street, Ewell, Epsom
tel. 01-393 9573

Mon, Wed, Thurs 10–5 pm;
Tues, Fri 10–8 pm;
Sat 9.30–5 pm. Closed Sun

Admission free

Bourne Hall gets its name from a late 18thc mansion which was demolished in 1962 and which it replaces. The original intention was to provide the local library service with an up-to-date building. The result by A. G. Sheppard Fidler Associates, completed in 1970, is an open-plan circular building with a large unsupported dome.

The Museum has a collection of late 17thc anonymous block-printed wallpaper which has in recent years been recovered from buildings demolished in Epsom. Eight hitherto unknown patterns have come to light.

There is also a group of early 18thc pipes, over two hundred in number, with some forty-five complete examples, which appears to be the largest concentration of dated pipes to be discovered so far.

There are a cafeteria and easy car-parking.

EXETER, *Devon*

Royal Albert Memorial Museum

18thc and 19thc British paintings;
17thc–19thc glass; 16thc–19thc silver;
17thc–19thc British ceramics and pottery;
costume and lace; ethnography;
natural history and archæology

Queen Street, Exeter
tel. 0392-56724

Tues–Sat 10–5.30 pm. Closed Sun, Mon

Admission charge may be dropped

The Museum was designed by John Hayward (1808–91) in 1865–66 in a simple Gothic style with two colours of stone. It was built to accommodate not only the Museum but the School of Art, Public Reading Room and Library, and was considered to be appropriate to the aims of the Prince Consort in whose memory the building was erected. There is a handsome life-size statue of him in his robes as Chancellor of Cambridge University, executed in 1868 by E. B. Stephens, half-way up the staircase. The entrance hall has recently been repainted to its original colour scheme.

The fine art collection is particularly strong in 18thc and 19thc Devon School artists, for example the striking portrait by Thomas Hudson of *Anne, Countess of Dumfries* (1763) and the pair of *The Earl of Albemarle* and *The Countess of Albemarle* (*c.* 1750); there is a large collection of the work of John White Abbott, including a recent acquisition, the pen and ink drawing, *Macbeth*. Lesser known Devon artists such as James Leakey, William Spreat, William Traies, John Gendall, and William and F. J. Widgery are all strongly represented.

Martinware terracotta plaque depicting R. W. Martin potting, 1888 (Royal Albert Memorial Museum, Exeter)

Thomas Patch, *A Caricature Group in Florence*, *c.* 1760 (Royal Albert Memorial Museum, Exeter)

Francis Towne, watercolour of *Berry Pomeroy Castle, Devon*, 1790s (Royal Albert Memorial Museum, Exeter)

There is also a good collection of works by Francis Hayman (*Portrait of the Artist at His Easel*), James Northcote (*Self Portrait of the Artist Painting Sir Walter Scott*), Thomas Patch (*A Caricature Group in Florence*, c. 1760), some fine examples by James and William Gandy, Sir Joshua Reynolds (*Captain Charles Proby of Elton Hall*, c. 1756) and B. R. Haydon, including his fascinating history piece, *Curtius Leaping into the Gulf* (1842).

Apart from the group of Patch oils and a lovely Wright of Derby, *Lake Nemi with a View of Castel Gandolpho* (1792), the 18thc collection was heavily biased towards portraits rather than landscapes, but this has been rectified by the recent purchase of Richard Wilson's *Llyn Peris and Dolbadarn Castle, North Wales*, George Barret's *Llyn Nantlle, North Wales* and J. M. W. Turner's *Buckfastleigh Abbey, Devonshire*. Recent acquisitions of Victorian paintings include W. P. Frith's delightful portrait of his three daughters practising archery, *The Fair Toxopholites* (1872), Frank Holl's moving study of girls sewing, *The Song of the Shirt*, and Francis Danby's rich depiction of *Dead Calm—Sunset at the Bight of Exmouth* (1855), which gives a panoramic view across the Exe estuary. There is also an interesting and striking oil by Lucy Kemp-Welch of a scene from the Boer War, *In Sight—Lord Dundonald's dash on Ladysmith* (1901) and a very evocative First World War painting attributed to Walter Bayes, *Victoria Station, Troops Leaving for the Front* (c. 1915). Since 1968 the Museum has acquired a good group of Camden Town paintings by Bevan, Sickert, Gilman, Gore, Ginner and Manson. Other works acquired are those by Gowing, Grant, Michael Ayrton, Paul and John Nash, William Roberts, Frank Dobson and a group of St Ives works representing Patrick Heron, Terry Frost and William Scott. All these, plus a certain number of original contemporary prints, have built up the representation of 20thc British art which was virtually non-existent before 1968. A notable gift was the Barbara Hepworth mixed media drawing, *Trio* (1948).

The watercolour collection is more generally representative than the oils of British 18thc–20thc art, and there is a particularly strong group of West Country associated artists such as Towne, Payne and Prout. Two albums of drawings by Constable and B. R. Haydon are

both extremely interesting and contain some fine examples of their work.

The decorative arts collections are large and cover a wide variety of interests. The earliest gifts were the extensive collections of English and Continental lace given by Mrs Treadwin, a Royal lace-maker, and Mrs Bury Palliser, the author of *A History of Lace* published in 1865. In the 1920s and 1930s Theodore Charbonnier gave a large documented collection of 17thC–19thC North Devon pottery. English 18thC and 19thC ceramics are also well represented. The large costume collection was greatly enhanced by the bequests of Mrs Franks in 1929 and Miss Freda Wills in 1972. This is now one of the largest collections of middle-class clothes in the country with many unusual items of 18thC costume, including robes, hats, shoes and men's waistcoats.

The silver collection is strongest in local examples from the 16thC–19thC, and greatly benefited from the acquisition of a notable collection of early West Country spoons in 1973. In recent years many pieces of silver and English pottery and porcelain have been acquired with funds from the bequest of S. Reynolds Chard. The glass collection ranges from the 17thC, including the 'Exeter' flute of *c.* 1660, to the 19thC. There are collections of musical instruments and furniture.

The Museum's other collections of natural history, ethnography and archæology are all extremely important, in depth and range probably more so than the fine and applied art. For instance, the natural history collections are world-wide in scope and cover most biological groups and, in conjunction with a wide variety of geological material, are amongst the foremost in the British Isles.

The Museum has an Association of Friends. Publications for sale on the premises include: *Catalogue of Oil Paintings, Watercolours, Drawings and Sculpture* (1978); *Francis Towne/John White Abbott* (1971); *Honiton Lace* (1971, being reprinted); *Clocks and Watches* (1975, a catalogue of the Museum's important horological collections); *Early West Country Spoons* (catalogue of the Corfield Collection); *Catalogue of Exeter and West Country Silver* (1978); *Redmen of North America* (1974); *Yoruba: Archæology and Art* (1970); *Arts of Polynesia* (1973); *Towards the Pole* (1976); *Devon in Prehistory* (1979); *Melanesia* (1982) and *Australia* (1982, catalogues of the Ethnographical collection). There is also a selection of information sheets and catalogues from recent exhibitions held at the Museum.

FALMOUTH, *Cornwall*

Falmouth Art Gallery

19thC and 20thC British paintings and drawings; 18thC and 19thC maritime paintings and prints

Municipal Buildings, The Moor, Falmouth
tel. 0326-313863

Mon–Fri 10–1 pm, 2–4.30 pm.
Closed Sat, Sun

Admission free

The Art Gallery is housed in one of the many buildings in Cornwall, London and elsewhere paid for by J. Passmore Edwards MP (1823–1911), the newspaper tycoon. It was built in 1894.

The bulk of the collection was presented to the town between 1923 and 1939 by Alfred de Pass (1861–1952), the South African art collector and benefactor, whose Old Master drawings went to the Royal Institution at Truro (q.v.). Due to shortage of space, it is not possible to exhibit items from the Gallery's permanent collection throughout the year; priority is given to temporary exhibitions of contemporary art, travelling exhibitions, and subjects of particular local interest. However, every effort is made to ensure that access to the permanent collection is not unduly restricted. Individual items can be seen in store by interested members of the public.

The emphasis of the painting collection is on 19thC and 20thC British works and includes three studies by Burne-Jones for *The Lady of Shalott* (*c.* 1894), *The Bouquet* by Waterhouse, six pictures by the local painter, Henry Scott Tuke, and *Behind the Scenes* by Laura Knight. There is also a good and wide range of prints, including two by Dürer, a Rembrandt and a Piranesi.

There is a checklist for the permanent collection and catalogues for recent exhibitions are available, such as that for *Henry Scott Tuke* in 1980 and *Hereward Hayes Tresidder*, another local painter, in 1983.

FOLKESTONE, *Kent*

Folkestone Museum and Art Gallery

Local history, natural history
and archæology

Grace Hill, Folkestone
tel. 0303-57583

Mon, Tues, Thurs, Fri 9–5.30 pm;
Wed 9–1 pm; Sat 9–5 pm. Closed Sun

Admission free

Founded in 1868 to house the collections of the Folkestone Natural History Society, mostly fossils, the Museum moved to its present building in 1888. Described by Pevsner as 'red brick with terracotta bits, a fussy affair', it was designed by Brightwen Binyon of Ipswich as both the Museum and Public Library.

The collections have a local emphasis, on natural history, archæology, particularly from Folkestone Roman Villa, and items connected with the history of the town; there are also paintings, drawings, prints, coins and china in the collection. Temporary exhibitions are held regularly.

GATESHEAD, *Tyne and Wear*

Shipley Art Gallery

British painting and watercolours
(18thc–20thc); Dutch and Flemish painting
(16thc–17thc); Italian painting
(17thc–18thc); crafts (20thc)

Prince Consort Road, Gateshead
tel. 091-4771 495

Mon–Fri 10–5.30 pm; Sat 10–4.30 pm;
Sun 2–5 pm

Admission free

The Gallery was founded by Joseph Ainsley Davidson Shipley (1822–1909), a solicitor from Newcastle whose fortune was the result of a specialisation in conveyancing. He amassed a huge and fairly indiscriminate collection of about 2,500 works—of which 504 remain—mostly through local agents who bought for him in London. Shipley also made a provision of £30,000 in his will for the building of a museum either in Newcastle or Gateshead, and after much wrangling and a sale of several hundred pictures, a building designed by A. Stockwell of Newcastle was erected in Gateshead in 1915–17. The Gallery was an instant success.

The more remarkable of Shipley's purchases were among the 17thc Dutch paintings, and it is thought that his interest lay in the subject-matter of the pictures rather than their attribution. Among those of note are the Joachim Wttewael *Temptation of Adam and Eve* (1614), a pair of paintings on copper by Jan van Kessel the Elder of *Concert of Birds*, and the later acquisition of 1955 of the David Teniers *Tavern Scene* (c. 1650). Shipley was also interested in 19thc British paintings; he owned three by the Leeds painter Atkinson Grimshaw, one of which is *Autumn Regrets* (1882), an evocative scene set in a park; as well as Richard Redgrave's *The Poor Teacher* (1845) and Walter Deverell's *Scene from 'As You Like It'*. Also

Joachim Anthonisz Wttewael, *The Temptation of Adam and Eve*, 1614 (Shipley Art Gallery, Gateshead)

David Teniers the Younger, *Tavern Scene, c.* 1650 (Shipley Art Gallery, Gateshead)

in the collection are Italian paintings by Sebastiano Ricci and Canaletto, and Tintoretto's *Christ Washing the Feet of the Disciples*.

Recently a collection of contemporary British craft has been started and has become one of the largest collections in the provinces. Examples of glass, textiles, ceramics, jewellery, furniture and metalwork are displayed in a newly-built gallery.

PUBLICATIONS
Christopher Wright, *Dutch and Flemish 16th and 17th Century Paintings from the Shipley Collection*, 1979

The Museum has an Association of Friends. A small shop sells publications. Free parking is available.

GLOUCESTER

Gloucester City Museum and Art Gallery

Archæology; 18thc British painting; 18thc furniture, silver, glass and pottery

Brunswick Road, Gloucester
tel. 0452-24131

Mon–Fri 10–5 pm. Closed Sat, Sun

Admission free

The Museum was founded in 1860 by the Gloucester Literary and Scientific Association and transferred to Gloucester City Council in 1896. The building, turreted and of honey-coloured stone in the Elizabethan style, was designed by F. S. Waller & Son and opened in 1893. It cost 5,000 guineas and was given by Mrs Margaret Price, a patron of science, in memory of her husband.

In 1965 an extension was opened to house the Tidswell Bequest of porcelain (1939) and the incredibly rich Marling Bequest of 18thc painting and applied art (1963). Since then the collections have been augmented by numerous purchases and gifts, notably of work by local artists of national stature such as William Rothenstein, Hubert Wellington and Lynn Chadwick. There are also works by Richard Wilson, Gainsborough, Joseph Farington, William Turner of Oxford and Wilson Steer.

In the decorative and applied art collection are 18thc walnut furniture, barometers by Daniel Quare and his successors, clocks, domestic silver, 'Bristol blue' glass and Staffordshire pottery. The Museum is well-known for its archæological holdings and has a rich collection including the Birdlip engraved mirror (Iron Age), sculptures of gods and goddesses (Roman), the St Oswald's Priory grave-slab (Anglo-Saxon) and the St Nicholas's Church closing-ring (mediæval).

The Museum has an Association of Friends. There is a shop where Museum publications are available, including *Catalogue of Romano-British Sculptures in Gloucester Museum* and *Twelve Portraits of Gloucester Benefactors*.

There is car-parking close by.

Engraved and enamelled bronze Birdlip Mirror, Iron Age, *c.* AD 25 (Gloucester City Museum and Art Gallery)

William Turner of Oxford, *Newnham-on-Severn from Dean Hill*, first half of 19thc (Gloucester City Museum and Art Gallery)

GRASMERE, *Cumbria*

Dove Cottage and Wordsworth Museum

Grasmere, Nr Ambleside
tel. 09665-544

Daily 9–5.30 pm, Sun 11–5.30 pm
(Apr–Sept); 10–4.30 pm, Sun 11–4.30 pm
(Oct–Mar)

Admission charge

In this early home of the poet William Wordsworth, from 1799–1808, a collection has been built up of manuscripts and first editions, as well as objects illustrative of local rural life in the poet's lifetime. Recent acquisitions include an extensive view of *Grasmere* by George Fennel Robson and an album of forty-nine *Views of the Lake District* by the Rev. Joseph Wilkinson, first illustrator of Wordsworth's *Guide*.

GREAT YARMOUTH, *Norfolk*

Exhibition Galleries [1]

Central Library, Tolhouse Street,
Great Yarmouth
tel. 0493-858900

For opening times please telephone

Admission free

These Galleries are run by the Norfolk Museum Service and are used for temporary exhibitions which include exhibits drawn from the Great Yarmouth Museums' collections. They comprise mainly local landscapes, marines and portraits from the 18thc to the 20thc, including some Norwich School works. Due to the lack of a gallery specifically for the collections, only a small number of works are on permanent display at the other museums (see below).

Publications for sale on the premises include Rachel Young's *Treasures of the Yarmouth Museums* (1976) and Charles Lewis's *Pierhead Paintings* (exhibition catalogue, 1982).

The Elizabethan House Museum [2]

Social history; 18thc & 19thc glass
and ceramics

4 South Quay, Great Yarmouth
tel. 0493-855746

Sun–Fri 10–1 pm, 2–5.30 pm
closed Sat (June–Sept);
Mon–Fri 10–1 pm, 2–5.30 pm;
closed Sat, Sun (Oct–May).
Closed Bank Holidays except
end of May & Aug

Admission charge

A period house and social history museum whose interior includes interesting 16thc and 17thc furniture, panelling, fireplaces, plaster ceilings and stained glass *in situ*. The Museum also houses a small collection of decorative arts including glass and china decorated by William Absolon, 18thc and 19thc drinking glasses and Lowestoft porcelain. The pictures on display include *The Dutch Fair* (*c*. 1820) by George Vincent and other Norwich School works.

George Fennel Robson, watercolour of *Extensive view of Grasmere*, 1828
(Dove Cottage and Wordsworth Museum, Grasmere)

George Vincent, *The Dutch Herring Fair at Yarmouth*, early 19thc
(The Elizabethan House Museum, Great Yarmouth)

The Maritime Museum of East Anglia [3]

The Museum's collections include ship models and 'pierhead paintings' (naive ship portraits).

This Museum has an association of Friends.

25 Marine Parade, Great Yarmouth
tel. 0493-842267

Opening times as above

Admission charge

GUERNSEY, *Channel Islands*

Guernsey Museum and Art Gallery [1]

A new structure by Robert Matthew, Johnson-Marshall & Partners of London was built in 1978 to house the original collections founded in 1909, particularly those of the Lukis family. The collection of Frederick Corbin Lukis (1788–1871) was bequeathed to Guernsey in 1907 by his last surviving son, Francis du Bois Lukis. Since then, other bequests have included the Wilfred Carey Bequest of 1929 of European and Oriental porcelain and some European paintings, and the Guille-Allès collection, formerly housed in its own museum in the local library.

The holdings are of a general nature, with a good selection of local archæology and paintings, especially watercolours by Peter Le Lièvre and Paul Naftel of the 1850s.

There is a shop which sells a guidebook to the Museum, books, booklets relating to Guernsey, postcards, etc., and a tea-room in a converted Victorian bandstand.

Local archæology

Candie Gardens, St Peter Port
tel. 0481-26518

Daily 10.30–5.30 pm (summer);
10.30–4.30 pm (winter)

Admission charge

Other museums run as branches are:

172

Castle Cornet [2]

St Peter Port
tel. 0481-21657

A mediæval castle with significant Elizabethan and Georgian additions houses the Guard Museum, the Militia Museum, the Armoury and the 201 RAF Squadron Museum.

Fort Grey Maritime Museum [3]

Rocquaine Bay; St Peter's
tel. 0481-65036

A converted martello tower on an islet, devoted to shipwrecks from 1777 to the present day.

Hauteville House [4]

Victor Hugo (1802–85) drawings; tapestries

38 rue de Hauteville, St Peter Port
tel. 0481-21911

Daily 10–11 am, 2–4.30 pm (April–Sept).
Closed Oct–Mar

Admission charge

Hauteville House, built in 1800, was the home of Victor Hugo from 1855 to 1870 when he was in exile, and was given to the city of Paris by the poet's grandchildren in 1927. The House and the Museum are the property of the City of Paris and are administered from there.

The house has been carefully preserved and contains some fine furniture and ceramics and, more importantly, some exquisite Gobelin tapestries including one which belonged to Queen Christina of Sweden embroidered with pearls and gold. There are family portraits framed by Hugo and drawings by him.

A shop sells guidebooks, a history of the Museum, postcards and slides.

GUILDFORD, *Surrey*

Guildford Museum

Local history and archæology

Castle Arch, Guildford
tel. 0483-503497

Mon–Sat 11–5 pm. Closed Sun

Admission free

The Museum was founded in 1898 with the Surrey Archæological Society and in 1911 Alderman Smallpiece donated a new gallery, the architect of which was Ralph Nevill (1847–1917). The Museum is housed in a tile-hung, hall-and-crosswing house of *c.* 1630, with additions in 1676, 1911 (the new gallery) and 1922. Internally there are fine Jacobean chalk fireplaces decorated with arabesques and grotesque figures.

The Museum houses archæological and historical collections concerned with the county. There is a specialist collection of embroidery and other needlework from the British Isles and overseas. It also holds the Dodgson family collection of 'Lewis Carroll' items and the collection of West Surrey cottage bygones which belonged to the well-known garden designer and writer, Gertrude Jekyll (1843–1932).

Guidebooks and various leaflets are available at a sales desk.

HALIFAX, *West Yorkshire*

Bankfield House

19thc British watercolours;
20thc British painting;
costume and textiles, including Balkan and Burmese items; natural history; toys

Boothtown Road, Halifax
tel. 0422-54823

Mon–Sat 10–5 pm; Sun 2.30–5 pm

Admission free

Bankfield was formerly the home of the important local textile manufacturer, Sir Edward Akroyd. Built in several phases during the 1850s and 1860s, the overall impression is of a large Italianate villa. Internal decorations, executed by Italian craftsmen, include fine wall-paintings on the main stairs and ceiling paintings in the main saloon and the former Library.

Since the foundation of Bankfield as a museum in 1897, the principal area of collecting has been textiles, textile machinery (now housed at Piece Hall and the Industrial Museum, Halifax) and costume. Of particular importance are the collections of Balkan costume and textiles and of Burmese costume and textile equipment.

Two bequests added important works of art to the collections. The Sir John Champney Bequest of 1929 included Albert Goodwin's large oil painting *Amalfi* (1900), Roger Fry's *Poppies* and Ruskin's *St Marks, Venice*.

The bequest of R. E. Nicholson of 1941 added early 19thC British watercolours, including works by Rowlandson and Prout and a group of Old Master drawings. Important 20thC works include *The Young Actress* (1943) by Matthew Smith who was born in Halifax, John Piper's large oil painting *Halifax* (1961) and work by John Nash and Sickert.

The craft collections, begun in the 1930s, include pottery by William Staite Murray, Michael Cardew and Charles Vyse and textiles by Dorothy Larcher and Diane Harrison.

HARROGATE, *North Yorkshire*

Harrogate Art Gallery [1]

Library Buildings, Victoria Avenue, Harrogate
tel. 0423-503340

Mon–Fri 10–5 pm; Sat 10–4 pm. Closed Sun

Admission free

Established since 1930, the Art Gallery displays a selection of paintings from its permanent collection, which also includes watercolours, prints and drawings, and has regular loan exhibitions.

There is a Gallery shop.

Fabric designed and block-printed by Dorothy Larcher and pots by Michael Cardew, Charles Vyse, Irene Browne, Katherine Pleydell-Bouverie and A. G. Hopkins, 1930s (Bankfield Museum, Halifax)

171

Edward Burne-Jones, watercolours of *The Choristers* and *The Musicians*, 1870s (Harrogate Art Gallery)

Harrogate Borough Council also administers:

Royal Pump Room Museum [2]

Local pottery and history;
European and Near Eastern antiquities;
Hull Grundy Collection of jewellery and decorative arts; costumes

Royal Parade, Harrogate
tel. 0423-503340

Mon–Sat 10.30–5 pm; Sun 2–5 pm

Admission charge

Formerly the pump room for the Spa built in 1842 by Isaac Shutt, the building is a domed octagon in a vaguely Græcian style. There is a strong sulphur well in the basement, where one can taste the water. A glass and iron annexe was added in 1913.

The Museum houses the Holland Child Collection, which contains some of the rare examples of Leeds and Castleford pottery of the 18thc and early 19thc, and also includes some Rockingham. The Hull Grundy Collection comprises over five hundred pieces, dating from the 17thc to the 20thc. It was donated by Mrs John Hull Grundy and contains wide-ranging examples of popular jewellery up to the 1940s. The dress collection is of mainly 19thc and 20thc costume and is still being enlarged.

There is a Museum guide available at the sales desk.

HARTLEPOOL, *Cleveland*

Gray Art Gallery and Museum

19thc and 20thc British paintings and watercolours

Clarence Road, Hartlepool
tel. 0429-66522, ext. 259

Mon–Sat 10–5.30 pm; Sun 3–5 pm

Admission free

Formerly The Willows, West Hartlepool, the Museum is one of a number of large villas of the Victorian new town. It was built by a shipbroker in 1856, but the architect is unknown. It was presented to the town by Sir William Cresswell Gray (1867–1924) in 1919 together with a collection of oil paintings to commemorate the safe return of his son from the First World War. It was opened in 1920.

Particularly well represented in the collection are the works by 19thc British painters, such as Maclise (*The Sleeping Beauty*), Clarkson Stanfield (*Coast Scene and Shipping off Harbour*, 1845) and John Callow (*A Breezy Day off the Isle of Man*, 1867); 20thc works include those by Stanhope Forbes (*Evening–Workers Return*, 1904, and *Gala Day at Newlyn*, 1907) and Charles Napier Hemy (*Youth*). There are watercolours by Birket Foster, David Cox, T. M. Richardson and T. B. Hardy.

The current collecting policy of the Museum is directed particularly towards work that has some connection with the town and its surrounding district. John Wilson Carmichael, who worked in Newcastle, is represented by three pictures of shipping and a view of the old town of Hartlepool; Frederic Shields, born there in 1833, by a collection of nineteen paintings and drawings, including two particularly fine watercolours, *Feeding Dimple* and *Whats o'clock*.

Also bequeathed to the Museum in 1930 are a collection of Oriental antiquities and another of netsukes.

The shop sells a guide to the collection and information sheets, and Catalogues of J. W. McCracken (1984) and Frederic Shields (1983).

Car-parking is available.

HASTINGS, *East Sussex*

Hastings Museum and Art Gallery

English, Continental and Oriental ceramics; 18thc and 19thc topographical painting; local ironwork and pottery; American Indian art; ethnography

Johns Place, Cambridge Road, Hastings
tel. 0424-435952

Mon–Sat 10–1 pm, 2–5 pm; Sun 3–5 pm

Admission free

Hastings and St Leonards Museum Association founded the Museum in 1890 and ran it until 1905 when it was taken over by the local Borough. The present Museum was designed as a private house in 1923; it was converted in 1928 to take the collections previously displayed above the Library at the Brassey Institute, and in 1930 the magnificent Durbar Hall was incorporated into the building. This is part of a two-storey Indian palace erected for the Indian and Colonial Exhibition of 1886. It was bequeathed to the Museum by Lord Brassey, together with his collection, in 1919. Lord Brassey was sometime Member of Parliament for Hastings and was an important local benefactor.

White porcelain Ludwigsburg milk-jug with painted decoration by Andreas Phillip Oettner, *c.* 1760 (Hastings Museum and Art Gallery)

Italian maiolica dish made by Allessandro di Giorgio of Faenza and painted by Federigo of Modena, 1500 01 (Hastings Museum and Art Gallery)

The Museum houses a good collection of English, Continental and Oriental ceramics including the Modena Dish, believed to be the largest maiolica plate ever made. There is a representative collection of 18thc and 19thc topographical painting including pencil-sketches by Thomas Girtin, J. C. Nattes and Albert Goodwin. The local collections are various but include examples of Sussex ironwork, especially cast, ornamental firebacks, and pottery. The Museum has greatly benefited from the Edward Blackmore collection of American Indian art, as well as the Brassey ethnographical collections which include items from the Pacific, Australasia, the Far and Middle East and South America. One item on display in the Durbar Hall is a full-length Hawaiian feather cloak.

The Museum has an Association of Friends. There is a small sales desk where a guide, leaflets and recent exhibition catalogues of Sylvia Gosse, Fred Judge and George Woods are available.

There is parking outside the Museum and in the road outside.

HEREFORD

Churchill Gardens Museum and Hatton Gallery [1]

Works by Brian Hatton (1887–1916); costumes; straw-work

Venns Lane, Hereford
tel. 0432-267409

Tues–Sat 2–5 pm; Sun 2–5 pm (summer). Closed Sun (winter) and Mon

Admission charge

Child's smock with cape collar from Herefordshire, *c.* 1880 (Churchill Gardens Museum and Hatton Gallery, Hereford)

English watercolours (late 18thc–early 19thc); textiles

Broad Street, Hereford
tel. 0432-268121, ext. 207

Tues, Wed, Fri 10–6 pm;
Thurs, Sat (summer) 10–5 pm;
Sat (winter) 10–4 pm.
Closed Sun, Mon

Admission free

Penn Grove House, built 1810, later called Churchill Gardens Museum, was purchased by the City Council in 1966. The Hatton Gallery extension was built in 1973 with the assistance of a donation from Miss Marjorie Hatton, the sister of the artist Brian Hatton.

Hatton was born in Hereford. A mainly self-taught painter, he died in action in Egypt in the First World War, aged twenty-nine. His output of oil paintings, watercolours, pastels and drawings from the age of ten years is represented in the Museum. Also on show are works by other artists, notably *Butcher's Row, 1815* by David Cox, *Benjamin Brewster* by Kneller, *The Man of Ross* by Joseph van Aken and Philip Wilson Steer's *Stroud Valley*.

The Museum houses a large costume collection, which is particularly fine and ranges from approximately 1720 to the present day. There is also one of the largest collections of agricultural smocks in the country. Other items of interest include a hat, of *c.* 1700, which is reputed to have belonged to Queen Anne, as well as a fine group of 18thc dresses. The collection is very rich in early 19thc children's costume and accessories. There are also interesting holdings of Oriental robes, shoes and fans.

There are period rooms at the Museum, including late 18thc chinoiserie and early 19thc rooms, a Victorian nursery, a butler's pantry and a Victorian parlour. There is also a collection of straw-work in a newly-opened room which is devoted to the collection presented by the engraver Lettice Sandford of Eye Manor in 1973. It incorporates straw-work from all over the world, as well as a large number of locally made items.

The Museum is situated just outside the town. There is a car-park, and a Museum shop where publications concerning Brian Hatton are available. The Museum is supported by the Friends of Herefordshire Museums and Arts.

Hereford City Museum and Art Gallery [2]

The Museum was founded on 8 October 1874, and the Museum building was the gift of Mr (later Sir) James Rankin, a local Member of Parliament and a prominent member of the Woolhope Club, a society from which the Library, Museum and Art Gallery derived. The building was enlarged by an extension forming the Art Gallery in 1912 due to a bequest of £1,000 from Sir James Pulley MP and a gift of £2,000 from Sir Charles Pulley. The architect F. R. Kempson designed the very Gothic exterior and incorporated much ornamental carving, including animals from five continents and signs of the Zodiac. The interior of the Woolhope Club room has a splendid fireplace.

The principal attraction of the Gallery, its collection of late 18thc and early 19thc watercolours, includes a magnificent selection of works of some of the best known British painters, some of whom were associated with the city or the environs. For example, David Cox, who was drawing master at Miss Croucher's Academy for Young Ladies in Widemarsh

John Scarlett Davis, *Rembrandt in his studio*, 1841 (Hereford City Museum and Art Gallery)

Street until 1827, is well represented, as is Joshua Cristall, three times President of the Old Sketching Society, who lived nearby at Goodrich. The corpus of his work was further enlarged by the Merrick bequest which included many Cristalls. Another local painter, John Scarlett Davis, is represented by both watercolours and oil paintings. Works by J. M. W. Turner include a major early example of the 1790s, *Hereford Cathedral, 1794*, and the much later work, *View Looking North East from Farnley Park* of 1823. The Gallery also houses good examples of the work of Thomas Girtin and Edward Dayes, as well as both John and Cornelius Varley, who were all attracted to Hereford by reason of its proximity to the picturesque possibilities of Wales and the West Country. There are also large numbers of drawings by the Old Sketching Society, including works by Cristall and H. B. Chalon.

The sculpture collection contains works in wood and bronze by 18thC and 19thC Oriental sculptors. The Gallery also has large collections of English pottery and porcelain, particularly Wedgwood, Mason's Ironstone, Worcester (including pieces from the Merrick bequest), 17thC Herefordshire slipwares and a small collection of Staffordshire, Coalport and Sèvres. There is a comprehensive collection of 18thC and 19thC glass, and a large collection of textiles, which includes quilts and locally-made linen. The main costume collection is housed at the Churchill Gardens Museum and Hatton Gallery.

PUBLICATIONS
Adrian Bury, *Hereford Art Gallery: Some Important English Water-Colours and Drawings*, 1959

The Museum has been helped by the Friends of the Art Gallery Fund since 1928, and it has an association of Friends of Herefordshire Museums and Arts. There is a Museum shop.

HIGH WYCOME, *Buckinghamshire*

Wycombe Chair Museum

Development of the furniture industry in High Wycombe 18thC–20thC

Castle Hill House, Priory Avenue, High Wycombe
tel. 0494-23879

Mon, Tues, Thurs–Sat 10–1 pm, 2–5 pm. Closed Wed, Sun & Bank Holidays

Admission free

The Museum originally developed out of the library which was founded in 1875. Set in grounds with the mediæval motte and bailey, the building is of 17thC origin, extended and flint-knapped in the 18thC and added to further in the late 19thC. High Wycombe has been the centre of the chair industry since the 18thC.

The Museum traces the development of the industry, particularly that of the Windsor chair, the tools used as well as associated crafts such as cane and rush seating and locally linked crafts, such as straw plait and lace-making.

There is a shop; parking is limited.

HONITON, *Devon*

Allhallows Museum

Local history; Honiton lace

High Street, Honiton
tel. 040 487-307

Mon–Sat 10–5 pm; closed Sun
(mid-May–Sept). At other times by
appointment

Admission charge

The Museum was started in 1946 by a group of public-spirited citizens who seized the opportunity afforded by the availability of the town's oldest building, the 13thc Allhallows Chapel. Long disused, the chancel serves as a home for the Museum.

This is a museum of local history. Since, however, Honiton is known world-wide for its lace—Queen Victoria's wedding flounce was of Honiton lace and this order revitalised the industry in this area—this material forms the most important feature of the collections. The continually growing collection with a display occupies one of the Museum's three galleries. There are regular demonstrations of lace-making given in the tourist season.

The Museum is a registered charity and run by the Museum Society on a voluntary basis.

There is a sales counter where leaflets and a history of the Honiton lace industry are available. Public car-parks are nearby.

HOVE, *Sussex*

Hove Museum and Art Gallery

British and Continental ceramics and
glass (18thc–19thc); British paintings
and drawings (20thc); furniture
and decorative art (18thc–19thc);
antique toys and dolls; coins and medals;
jewellery (Hull Grundy gift);
local history collection (including
Cosens Collection of Views of Sussex)

19 New Church Road, Hove
tel. 0273-779410

Tues–Fri 10–5 pm; Sat 10–4.30 pm.
Closed Sun, Mon & Bank Holidays

Admission free

The Museum was founded in 1927 and is housed in an Italianate villa of 1873–76 set in a small park. It is known for its ceramic collections, of which the nucleus comes from the Pocock Collection of 18thc and early 19thc British material, and for the display of 20thc British paintings and drawings. Recent purchases in this field include works by Charles Ginner (*Old Houses at Lancaster*), Bernard Meninsky (*Boy with a Cat*, a picture of his son painted in 1925), Malcolm Drummond (*The Stag Tavern*), Gilbert Spencer (*Air Raid Warning*), Anne

Wedgwood Cream Ware plate, hand-painted in purple
and green, late 18thc (Hove Museum and Art Gallery)

Bernard Meninsky, *Boy with a Cat*, 1925
(Hove Museum and Art Gallery)

Gilbert Spencer, *Air Raid Warning*, 1940
(Hove Museum and Art Gallery)

Redpath (*Venetian Altar*) and Edward Burra (*Birdmen and Pots*). There are also works by Henry Lamb, Hilda Carline (Stanley Spencer's wife) and Duncan Grant.

The Pocock Collection includes an interesting group of Wedgwood, varied in scope but with the emphasis on Jasperware. The display includes some English glass, and a small but comprehensive collection of 19thc and early 20thc non-precious jewellery given by Mrs Hull Grundy at the very end of her life.

The local history collection has recently been greatly augmented by the acquisition of the Cosens Collection of Views of Sussex by Richard Henry Nibbs, the local marine painter known for his evocative views of Brighton in the 1870s.

There is a sales counter and plentiful car-parking in and around the Museum forecourt.

Edward Burra, watercolour of *Birdmen and Pots*, 1947 (Hove Museum and Art Gallery)

Francis Bacon, *Figure Study II*, 1945–46 (Huddersfield Art Gallery)

HUDDERSFIELD, *West Yorkshire*

Huddersfield Art Gallery [1]

19thc and 20thc British painting;
20thc British sculpture

Princess Alexandra Walk, Huddersfield
tel. 0484-513808, ex. 202/203

Mon–Fri 10–6 pm;
Sat 10–4 pm. Closed Sun

Admission free

The present gallery on the second floor of the Central Library dates from 1946 and was built by Ashburner. It has two impressive stone figures representing literature and art by James Woodford RA at the entrance. The first art gallery in Huddersfield was established in 1898; in 1974 the fine art collections from Batley and Dewsbury art galleries were incorporated into the collection as a result of local government reorganisation.

The Gallery contains some 18thc watercolours but the strength of the collection is in the group of Camden Town painters, Gilman (*Tea in a Bedsitter, c.* 1913–14), Ginner, Innes, Bevan and Sickert. More contemporary painters are represented by Bacon (*Figure Study II*, 1945–46), Auerbach, Riley, Blackadder (*Still Life with Indian Fan*, 1984) and Naylor, and there is sculpture by Dobson, Moore and Epstein, as well as some contemporary graphics.

Catalogues of recent exhibitions and acquisitions are available on the premises. There is multi-storey car-parking nearby.

18thc & 19thc British glass;
19thc British ceramics; 18thc & 19thc
Sheffield plate; 19thc & 20thc costume

Ravensknowle Park, Wakefield Road,
Huddersfield
tel. 0484-41455/30591

Mon–Sat 10–5 pm; Sun 1–5 pm

Admission free

Dutch painting (17thc);
British painting (17thc–20thc)

Queen Victoria Square, Hull
tel. 0482-222750/222745

Mon–Sat 10–5 pm; Sun 1.30–4.30 pm

Admission free

PUBLICATIONS
Lesley Dunn, *Portraits Catalogue*, 1979
Jennifer Rennie, *Handlist of Watercolour Drawings*,
1982
Sarah Cutler, *Temporary Working Handlist of Painters*,
1984
Helena Moore, *Trial and Innocence: Some of the
Victorian and Edwardian Collection*, 1984
New Acquisitions catalogues for 1973, 1976, 1979, 1981,
1984

Kirklees Metropolitan Council also administers:

Tolson Memorial Museum [2]

The Museum was founded in 1919 and opened three years later by Legh Tolson (1856–1932).
The house, described by Pevsner as 'a wealthy man's villa of 1860, restrainedly Italianate
and only in the stables going gayer', was designed by Richard Tress (1810–75) of London.

There is a sales desk and a car-park.

HULL (KINGSTON UPON HULL), *Humberside*

Ferens Art Gallery [1]

Funds and an endowment were presented to Hull by Thomas Robinson Ferens (1847–1930),
a local industrialist and philanthropist, after he had opened a new art gallery in the City
Hall in 1910. A new building was designed by S. N. Cooke and E. C. Davies of London
from 1924–27. The Gallery has since received a number of important donations and bequests,
including a gift of prints and watercolours from the painter Sir Frank Brangwyn (1867–1956)
in 1933 and three separate contributions from Lord Duveen (1869–1939), who was born
in Hull.

The Gallery holds a collection of portraits from *c.* 1595 to the present day, marine paintings
dating from the 17thc, with emphasis on the local 19thc School, especially John Ward. The
European collection contains work by Frans Hals, Canaletto, Guardi, Ribera and Ruisdael.
The British School represents an interesting variety of works from Cotman, Palmer and Blake
to the early 20thc, including Wilson Steer's *Boulogne Sands, Children Shrimping*, Sickert's
Hotel Royal Dieppe, and *Mr Wyndham Lewis as a Tyro* by Wyndham Lewis, as well as
examples of such post-war painters as Auerbach, Lanyon, Hockney and Bridget Riley.
Modern British sculpture is represented by Moore, Hepworth, Paolozzi and Kenneth
Armitage.

Philip Wilson Steer, *Boulogne Sands*, 1891 (Ferens Art Gallery, Hull)

The Gallery has an association of Friends. A sales desk stocks catalogues, postcards, slides and reproductions, and there is a café. Multi-storey car-parking is adjacent.

Town Docks Museum [2]

History of whaling, fishing and merchant shipping

Queen Victoria Square, Hull
tel. 0482-222737

Mon–Sat 10–5 pm; Sun 1.30–4.30 pm

Admission free

The Museum is housed in a large building with a commanding site built as the Dock Office from 1867–71 by Christopher G. Wray in a diluted Renaissance style. The original collection was transferred from the old Fisheries Museum, founded in 1912 as the result of the benefaction of a trawler owner, Christopher Pickering, and established in the Dock Office in 1975.

The collection includes some fine paintings, glass and pottery, ship models, scrimshaw work (the decorative art of the whaler), personalia and items illustrating the early history of steamships, for instance, the figurehead of P.S. *Sirius*, the first steamship to cross the Atlantic.

The shop sells a guide and a history of the Dock Offices, books on whaling and local shipbuilding and *H. Hudson Rodmell, Marine Artist 1896–1984* by A. G. Credland. There is a coffee shop, and limited parking adjacent but multi-storey car-parking nearby.

Transport and Archæology Museum [3]

East Yorkshire archæology; transport

36 High Street, Hull
tel. 0482-222737

Mon–Sat 10–5 pm; Sun 1.30–4.30 pm

Admission free

The Museum is located close to Wilberforce House in the former Corn Exchange designed by Bellamy and Hardy of Lincoln in 1856.

The archæology collections include the famous Mortimer Collection of prehistoric and later material from the Yorkshire Wolds, presented to the City by Colonel Clarke in 1913. Other material from all archæological periods in East Yorkshire is well represented, and includes the remarkable Bronze Age Roos Carr images, an Iron Age chariot burial from Garton Slack, magnificent Roman mosaics from Rudston, Brantingham and Horkstow villas, Anglo-Saxon grave-goods from Sancton, and material from mediæval Hull.

The transport collections contain a wide range of horse-drawn carriages, early veteran motor vehicles, bicycles, and other items.

A shop sells a variety of publications, including D. J. Smith's *The Roman Mosaics from Rudston, Brantingham and Horkstow*, and postcards. Car-parking is available.

Wilberforce House and Georgian Houses Museum [4]

History of the Slave Trade and life of William Wilberforce (1759–1833)

23–25 High Street, Hull
tel. 0482-222737

Mon–Sat 10–5 pm; Sun 1.30–4.30 pm

Admission free

Founded as early as 1906, the Museum is housed in some of the finest houses in Hull. Wilberforce House is mid-17thc in date. Built in decorative brickwork, it was remodelled in the mid 18thc and the interiors date from both the Jacobean and Georgian periods.

The Museum focuses on the history of William Wilberforce and the Slave Trade, including portraits and material related to the Abolitionist movement. It also displays items of local history, costume and Queen Mary's doll collection.

The sales area stocks a guidebook for the House. Car-parking is available behind the building.

The University of Hull Art Collection [5]

19thc and 20thc British paintings, sculpture, drawings, prints, theatre design and cartoons; 17thc Chinese ceramics

The collection, which was established in 1963 by Dr Malcolm Easton, the first Curator, is displayed in two galleries in Middleton Hall, built in 1967 to designs by Sir Leslie Martin (b. 1908), who was also commissioned in 1958 to design the Faculty of Arts at the University. A bequest from Thomas Robinson Ferens (1847–1930), a local industrialist and benefactor (see Ferens Art Gallery, p. 182) enabled the University to start a small annual purchasing fund. Other public benefactors and private donors, including Kathleen, Lady Epstein, Mrs

The Middleton Hall, University of Hull, Cottingham Road, Hull
tel. 0482-46311

Mon, Tues, Thurs, Fri 2–4 pm;
Wed 12.30–4 pm (term-time only). Closed Sun

Admission free

PUBLICATIONS
Malcolm Easton, *Art in Britain, 1890–1940*, 1967
John G. Bernasconi, *The University of Hull Art Collection Catalogue* (in preparation)

Exhibition catalogues:
George Edmund Street in East Yorkshire, 1981
Some exhibition catalogues from the late 1960s and early 1970s are still available

Pamela Diamond (the daughter of Roger Fry) and Prof. A. G. Dickens have enabled the collection to become a significant one.

Originally the emphasis was placed on the period of painting in Britain from 1890 to 1930, but it has now been extended to 1940. From the 1890s are works by Aubrey Beardsley (drawing of *William Emery*, 1894), Charles Conder (*Design for a Fan*, *c.* 1893–98) and Wilson Steer (*Star and Garter Hotel*, 1893). After the turn of the century comes Augustus John's *Mrs Randolph Schwabe* (*c.* 1915–17), Sickert's *L'Eglise du Pollet* (*c.* 1900) and the Camden Town Painters, Spencer Gore's *Somerset Landscape* (*c.* 1909) and works by Gilman, Ginner and Drummond. Lucien Pissarro, who lived in England from 1890, is represented by *Blossom, Sun and Mist* (1914) and the London-based Scot, Samuel Peploe by *Interior with Japanese Print* (*c.* 1915). Works by Vanessa Bell, Duncan Grant and the other Bloomsbury artists are in the collection, as well as Paul Nash, Ben Nicholson and Stanley Spencer, particularly *Villagers and Saints* (1933).

The sculpture of this period is extremely fine and the collection holds four portrait heads by Epstein, carved reliefs by Eric Gill and Gaudier-Brzeska and Frank Dobson's *Cornucopia*. Also of particular interest are the stage and costume designs by Ernst Stein and Claud Lovat Fraser.

From 1985 the Museum will have on long term loan from Hong Kong the Thompson Collection of Chinese ceramics. This is a collection of over a hundred pieces, chiefly from the 17thC and outstanding for its Fujian white wares as well as Jingdezhan blue and white ceramics.

There is a sales area for catalogues and cards. Refreshments in the Arts Faculty building adjacent and car-parking are available.

Frank Dobson, *Cornucopia* in Ham Hill stone, 1925–27
(The University of Hull Art Collection, Hull)

Robert Walker, *Oliver Cromwell*, c. 1657 (Cromwell Museum, Huntingdon)

HUNTINGDON, *Cambridgeshire*

Cromwell Museum

History of the Cromwellian Rebellion 1640–60

Grammar School Walk, Huntingdon
tel. 0480-52861

Tues–Fri 11–1 pm, 2–5 pm;
Sat, Sun 11–1 pm, 2–4 pm (Apr–Oct);
Tues–Fri 2–5 pm; Sat 11–1 pm, 2–4 pm;
Sun 2–4 pm (Nov–Mar)

Admission free

This most unusual museum was founded in 1962. The idea was that of Dr Powley to establish, in Oliver Cromwell's birthplace, a museum entirely devoted to Cromwelliana. It is housed in what remains of the old infirmary hall of *c.* 1160 of the Hospital of St John the Baptist, founded during the reign of Henry II. It later became the Grammar School which Cromwell himself attended.

The history of the Civil War from the Parliament/Commonwealth point of view is illustrated by portraits, particularly of the Cromwell family, engravings, heraldry and other items of interest of all kinds, including MSS, medals and swords.

There is a sales desk where leaflets relating to Cromwell, a new guidebook and postcards are available. There is a public car-park nearby.

IPSWICH, *Suffolk*

Christchurch Mansion and Wolsey Art Gallery [1]

Architectural fragments 16thC & 17thC from local buildings; 19thC–20thC British painting; 18thC & 19thC British and European ceramics and glass; 14thC–19thC British furniture; clocks

Christchurch Park, Ipswich
tel. 0473-213761

Mon–Sat 10–5 pm, Sun 2.30–4.30 pm.
Closed at dusk in winter

Admission free

Christchurch is a Tudor mansion in a parkland setting. It was built in 1548–50 by the Withipoll family, London merchant tailors, on a monastic site. Later alterations include the magnificent 17thC panelled hall and the state bedrooms added in the 18thC. In 1926 the house was extended by building the Wolsey Art Gallery and incorporating in extensions the magnificent early Renaissance panelling from the house of Sir Anthony Wingfield, Privy Councillor to Henry VIII, and two Tudor rooms which have been reconstructed from timber-framed houses in the town. The Museum was founded in 1894 by Felix Thornley Cobbold who also left an endowment for purchasing works.

The extensive fine art collections mainly consist of work produced in East Anglia or by

John Constable, *Golding Constable's Flower Garden, c.* 1815 (Christchurch Mansion and Wolsey Art Gallery, Ipswich)

185

Thomas Gainsborough, *A Country Cart Crossing the Ford, c.* 1782–84 (Christchurch Mansion and Wolsey Art Gallery, Ipswich)

Ethnography; natural history; archæology

High Street, Ipswich
tel.0473-213761

Mon–Sat 10–5 pm. Closed Sun & Bank Holidays

Admission free

East Anglian artists, with a particular emphasis on Suffolk. There are important works by Gainsborough (*A View near the Coast* and *Rev. Samuel Kilderbee DD*), Constable (*Willy Lott's House, Flatford*), John Collier's *A Glass of Wine with Cesare Borgia*, Wilson Steer, and the English Impressionists, as well as contemporary artists such as Colin Moss and Maggi Hambling. Also represented are artists such as Matisse, Chagall and Picasso, as well as local printmakers. There are also Dutch 17thc and 18thc portraits, still-life, genre pictures and good English portraits dating from the 16thc to the mid-20thc. Also in the collection are portrait miniatures, silhouettes and sporting prints.

In the decorative arts collection is a large group of costumes, jewellery and textiles from *c.* 1750 to 1929. There are extensive holdings of ceramics and glass from the 18thc and 19thc and English furniture, clocks and woodwork ranging from the 14thc to the 19thc.

The Museum has an Association of Friends. A sales counter sells leaflets, pamphlets on specific collections and a guide to the Museum. There is a multi-storey car-park within five minutes' walk.

Ipswich Borough Council also administers:

Ipswich Museum [2]

An entomological collection was formed as early as 1791 and housed in the Town Hall. The Literary Society founded the collections which made up the Museum and which opened in 1847. One of its principal early patrons was Sir Richard Wallace, Bt, (1819–90), son of the 4th Marquess of Hertford (see London, Wallace Collection, p. 93), whose country seat was nearby at Sudbourn Hall. A new Museum was built in 1881, as a result of a competition, by Horace Cheston (1850–1919) in a 17thc style, the exterior in red brick and decorative terracotta illustrating the combination of the arts and sciences which can be seen within, for instance, flowers, fossils and an artist's palette.

The collections consist of natural history with wildlife from all over the globe and an extensive botanical collection, as well as a very good general collection of rocks, fossils and minerals, the palæontology holdings being particularly important. Archæology covers the Stone Age to the Civil War period, and there is a fine ethnography collection covering Africa, Asia, the Pacific and the Americas.

The ethnography collection covers primarily those parts of the world with a former British connection. There are individual specimens of international importance from Polynesia and the north-west coast of America, and large collections from Kenya and Uganda (pre–1914), the eastern region of Australia (pre–1920) and Sarawak (pre–1914). These are of great scientific importance and are the work of individual collectors. Also in the collection are Peruvian pots and a well documented and expanding collection of Indian, Tibetan, Nepalese and Chinese printed ephemera.

The Museum has an Association of Friends. A small shop stocks publications, souvenirs and guides for the *Africa*, *Asia*, *The Pacific* and *Australia and the Americas* collections, and for Roman Suffolk. There is a multi-storey car-park within two minutes' walk.

IRONBRIDGE, *Shropshire*

Ironbridge Gorge Museum Trust

The built environment of the cradle of the Industrial Revolution covering 10 square miles of the Severn Gorge in Shropshire; industrial monuments include the Iron Bridge (1779), the Coalbrookdale Furnace (1638), the Severn Warehouse (1840), the Hay Inclined Plane (1793), the Coalport China Works (1795) and the Craven Dunnill Tile Factory (1871)

The importance of industrial archæology is increasingly recognised. The Science Museums have long demonstrated the interrelationship of art and scientific apparatus but the preservation of the bleak beauty of our industrial heritage is a comparatively recent pre-occupation. The Ironbridge Gorge Museum Trust was founded in 1967; it is still rapidly developing in size and scope.

The most predominant sights of this Museum are not those with which this book is primarily concerned, though the elegant and intricate form of the Iron Bridge itself surely gives it the status of a work of art in the best Ruskinian sense, an object that is believed to be beautiful and known to be useful.

Ironbridge, Telford
tel. 0952-453522

Daily 10–6 pm (summer);
10–5 pm (winter)

Admission charge

James Wilson Carmichael, hand-tinted lithograph of *The Newcastle High Level Bridge*
(Ironbridge Gorge Museum Trust)

Coalport dessert plate, manufactured for J. & T. Staples
by John Rose & Co., Coalbrookdale, for the visit of the
King of Sardinia to the City of London, 1855
(Ironbridge Gorge Museum Trust)

Only two of the many separate sites occupied by the Museum are the concern of this book. The products of the Coalbrookdale iron foundries were many of them devised by well-known 19thC artist/architect/designers like the celebrated Dr Christopher Dresser. Associated with both the Coalport China Works and the Jackfield Tile Museum are large collections of fine 19thC ceramics, also designed in many cases by eminent artists. Notable examples of Coalport china are the series of spectacular painted and gilded banqueting plates, especially painted for state visits to city banquets. Other collections include: Allied Ironfounders Museum, donated in 1970; Elton Collection of Industrial Art, accepted by the Museum from the Government in lieu of death duties in 1978; Thomas Telford Collection, held on behalf of Telford Development Corporation.

There are thirteen Museum sites.

THE IRON BRIDGE The first cast-iron bridge in the world, constructed in 1779, recently restored and interpreted at the Ironbridge Toll House which is also an official Tourist Information Centre with accommodation booking service.

BEDLAM FURNACES Constructed in the 1750s, these were depicted by P. J. de Loutherbourg in his famous oil painting, *Coalbrookdale by Night* (1801, now in the Science Museum, London, q.v.) and were one of the first furnaces in this country to be specifically constructed for coke fuel.

TAR TUNNEL A one thousand-yard-long tunnel constructed in the 1770s as a canal to remove coal from the mines on Blists Hill but eventually used as a plateway to extract the natural bitumen which was found.

COALPORT CHINA WORKS Preserved as a Museum, this building not only houses a magnificent display of Coalport china but also explains the manufacturing processes and the large retail shop offers an outstanding display of modern Coalport.

JACKFIELD WORKS AND TILE MUSEUM Occupying the premises of Craven Dunnill, this building houses the Tile Museum, the Jackfield Tile Company which is involved in the manufacture of Victorian tiles and holloware, and also the Jackfield Conservation Team who are involved in the removal and conservation and replacement of decorative tiles from all over Britain.

BLISTS HILL OPEN AIR MUSEUM This is a fifty-acre industrial site, containing the remains of the Madeley Wood Company Ironworks, canal, inclined plane, brickworks and colliery,

which is being converted into a major Museum of the 19thC with urban manufacturing and rural areas. Each exhibit is operated by a costumed demonstrator. In addition to the existing industrial monuments, the site now contains a reconstructed public house, chemist, butcher, slaughterhouse, printing shop, sweet shop and tea shop, candle factory, sawmill, clay mine, toll house, chapel, squatter's cottage, adit mine and cobbler's shop. Projects under construction include a foundry, blacksmith's forge and a complete Victorian wrought iron works which in 1986 will be manufacturing wrought iron.

SEVERN WAREHOUSE Built on the banks of the River Severn by the Coalbrookdale Company, this 1840s warehouse and wharf have been restored. An audio-visual programme and exhibition in the building provide an introduction to the Ironbridge Gorge and its extraordinary past.

ROSE COTTAGES A group of 16thC half-timbered cottages restored by the Museum, previously used as a boring mill for steam engine cylinders.

COALBROOKDALE MUSEUM OF IRON AND THE OLD FURNACE In the 18thC this valley was the most important iron-making centre of the world. Abraham Darby's furnace, where in 1709 he pioneered the technique of smelting iron ore with coke, is still here. The Museum of Iron illustrates the history of ironmaking and the story of the Coalbrookdale Company, and the adjacent furnace has now been housed in a modern covered building to preserve it for all time. Adjacent to the Furnace Building is the Long Warehouse which now houses the Museum's Library, Art Gallery and Documentation Centre, together with the accommodation for the Institute for Industrial Archæology which is operated jointly by the Museum and the University of Birmingham.

COALBROOKDALE QUAKER HOUSES These two important houses were built for and occupied by the Darby family. Rosehill, with early 19thC period rooms, will open to the public in 1985. Dale House will contain a Friend's Library and meeting room.

CARPENTERS ROW, COALBROOKDALE A typical terrace of workers' cottages built by the ironmasters and now furnished in a variety of styles reflecting different periods of occupation.

The Museum Trust has a growing association of Friends with a current membership of three thousand. Museum shops at all the major sites sell relevant material including tiles and holloware at the factory shop at Jackfield. There is free car-parking at all Museum sites, and a Victorian public house and tea shop at Blists Hill Open Air Museum. There is a Park and Ride service at weekends and on busy days during the summer. Guides are available for booked parties, and there is a field study centre in association with Ironbridge Youth Hostel.

The Museum Trust has issued a number of booklets dealing with the diverse aspects of the collections. A pack containing four of these is available and constitutes a summary guide to the whole complex.

Peacock tile panel made by Maw & Co., *c.* 1910
(Ironbridge Gorge Museum Trust)

Group of tiles made by Maw & Co., 1880s
(Ironbridge Gorge Museum Trust)

Little Boy Blue tile made by Maw & Co., late 19thc
(Ironbridge Gorge Museum Trust)

Glazed earthenware vase designed by Walter Crane and made by Maw & Co., *c.* 1888
(Ironbridge Gorge Museum Trust)

JERSEY, *Channel Islands*

Jersey Museum

Local history; natural history

9 Pier Road, St Helier
tel. 0534–30511/75940

Mon–Sat 10–5 pm. Closed Sun (the
Museum will close for rebuilding in 1985/6;
it is advisable to check before visiting that
it has reopened)

Admission charge

The Societé Jersiaise was founded in 1873 and since then the collections have been established
in a fine early 19thc merchant's house.

The painting collection concentrates on works from the 17thc to the present day by Jersey
artists and local scenes and characters. Of particular interest are *Picture of Health* and *Lily
Langtry* (painted in 1878) by Millais, who spent his early childhood in Jersey; seascapes
by Peter Monamy, prints and paintings by Edmund Blampied the etcher, and Gainsborough's
first known drawing, of a Jersey cow. There are also good representative collections of the
local maritime artist P. J. Ouless, and of local scenes by Malcolm Arbuthnot.

The members of the Societé Jersiaise support the Museum. There is a shop where a large
stock of publications, postcards and maps relating to the island are available.

KEIGHLEY, *West Yorkshire*

Cliffe Castle Museum

Local history; period rooms (mid-19thc)

Spring Gardens Lane, Keighley
tel. 0535-64184

Tues–Sun 10–5 pm. Closed Mon

Admission free

Keighley Museum was opened in 1899. In 1959 it was transferred to Cliffe Castle which
had been rebuilt by Henry Butterfield (1819–1910), local millowner and merchant, who was
also a generous benefactor of Keighley Museum. In 1950 the Cliffe Castle house and estate
were purchased and presented to Keighley Council by Sir Bracewell Smith, Bt (1884–1966),
who later paid for the building to be altered to house the Museum.

The architect of the original building (built *c.* 1880) was George Smith; later Sir Albert
Richardson made additions (*c.* 1956). Special features of the interior include ornate baroque
plasterwork in the ground floor rooms, and stained glass in the landing window by Powell
Bros of Leeds.

Primarily a local museum specialising in natural sciences and local history, Cliffe Castle
contains period rooms furnished in the 19thc French style, to recreate the opulence in which

the original owner, Henry Butterfield, lived. Notable exhibits include a suite of four French glass chandeliers (*c.* 1840) and, purchased from the Mentmore sale, a chair and *tabouret de pied* (*c.* 1850).

There is a Museum shop, and a car-park and café in the grounds; a handbook to the Museum is in preparation.

KENDAL, *Cumbria*

Abbot Hall Art Gallery

The Lake District Art Gallery Trust was founded in 1957 to restore Abbot Hall and convert it into an art gallery to serve the Lake District. Much of the original funding came from the Francis C. Scott Charitable Trust and the Provincial Insurance plc, both of which continue to support the Gallery.

Abbot Hall was built in 1759, reputedly to the design of John Carr of York, for Col. George Wilson. Built of local Westmorland limestone, the house is elegantly proportioned but rather austere from the outside. The interior plan is unusual, featuring a through hall and an axis

English paintings, drawings and sketch-books 18thC & 19thC; topographical landscapes of the Lake District 18thC & 19thC; European paintings and British bronzes 20thC; furniture, silver, porcelain, jewellery, enamels, artists' pottery and wallhangings 18thC–20thC; vernacular furniture; costume

Abbot Hall, Kendal
tel. 0539-22464

Mon–Fri 10.30–5 pm; Sat, Sun 2–5 pm

Admission charge

Allan Ramsay, *Julia Musgrave*, 1740 (Abbot Hall Art Gallery, Kendal)

Lady Anne Clifford aged 15, left-hand panel from *The Great Picture of the Clifford Family*, 1605 (Abbot Hall Art Gallery, Kendal)

George Romney, *The Gower Family*, 1776–77 (Abbot Hall Art Gallery, Kendal)

of honour overlooking the River Kent. The Breakfast Parlour is pine-panelled; the Drawing-Room has some pretty rococo plasterwork. Abbot Hall was the first architect-designed building in Kendal and had a seminal influence on the work of local builders. The upper floor has been converted into four large galleries for the display of temporary exhibitions and/or the permanent collection of contemporary art.

The 18thC paintings include representative holdings of portraits by George Romney, for example the beautiful *Gower Family*, and Daniel Gardner, as well as drawings and sketchbooks by George Romney.

The group of 18thC and 19thC topographical landscapes of the Lake District includes works by John Constable, Anthony Devis, Edward Lear, Julius Caesar Ibbetson and John Harden. Examples from the large collection of pen and ink domestic scenes by John Harden are frequently used to illustrate studies of early 19thC social life and interior decoration. There is also a substantial collection of watercolours and drawings by John Ruskin.

The 20thC paintings include a representative holding of Kurt Schwitters and a collection of Scottish paintings by, for example, Joan Eardley, Anne Redpath, S. J. Peploe, William Gillies and William MacTaggart. English artists include Ben Nicholson, Winifred Nicholson, John Piper, Keith Vaughan and Ivon Hitchens.

There are 20thC British bronzes including examples by Barbara Hepworth, Elisabeth Frink, Austin Wright and Josephine de Vasconcellos.

A representative group of 18thC and 19thC furniture by Gillows of Lancaster and 20thC furniture by the Simpsons of Kendal and by Stanley Davis of Windermere has been built up as a record of an important local activity. Otherwise the decorative and applied art collections consist of 18thC and 19thC jewellery given by Mrs Hull Grundy; 18thC and 19thC silver, porcelain and enamels; 20thC pots by Lucie Rie, Bernard Leach, Hans Coper, Alan Caiger Smith, Eric James Mellon, Jacqueline Poncelet and Geoffrey Swindell; 20thC wallhangings by Alec Pearson, Peter Collingwood, Tadek Beutlich and Verena Warren; 17thC vernacular oak furniture; and 18thC, 19thC and 20thC costume.

The Lake District Museum Trust was founded in 1967 to oversee the conversion of Abbot Hall's stable block into the Museum of Lakeland Life & Industry, which won the first Museum of the Year Award in 1973 and houses displays relating to the social and economic history of the Lake District.

Abbot Hall has an Association of Friends. There is a craft shop selling the best of British craftsman-made items, and a large free car-park and a picnic area in the adjoining parkland.

KESWICK, *Cumbria*

Keswick Museum and Art Gallery

Items associated with the 'Romantic' English poets

Fitz Park, Keswick
tel. 0596-73263

Mon–Sat 10–12.30 pm, 2–5.30 pm;
closed Sun (April–Oct)

Admission charge

The Museum was purpose-built in 1897 by Thomas Hodgson of Keswick, using local stone from the Quay Fort Quarry in Borrowdale. The Art Gallery was added in 1905. It is one of the very few purpose-built Victorian museums still in unaltered condition.

The collection of the Museum is centred on MSS of the Romantic poets, especially Robert Southey, with small groups associated with Wordsworth, Coleridge and others. A notable exhibit is Flintoft's model of the Lake District of 1837 (scale 3 inches to the mile).

Attached is a small Museum shop.

KETTERING, *Northamptonshire*

Alfred East Art Gallery

Paintings, drawings and prints
(19thc–20thc), mainly by Sir Alfred East

Sheep Street, Kettering
tel. 0536-85211

Mon–Wed, Fri, Sat 10–5 pm.
Closed Thurs, Sun

Admission free

The Gallery, which was founded in 1913, has a large collection of paintings, watercolours and prints, mainly landscapes by Sir Alfred East (1849–1913); notable among the larger works are *Autumn in Gloucestershire*, *A Dreary Dawn*, *Early Summer Morning*, *The Lonely Road*, *Midland Meadows* and *A Sunlit Haven*. These are complemented by British School 19thc and 20thc works in various media. Kettering Borough Council has published a summary catalogue of the whole art collection.

There is an association of Friends of Kettering Art Gallery and Museum.

KIDDERMINSTER, *Hereford and Worcester*

Kidderminster Art Gallery and Museum

Prints (18thc–20thc);
works by Sir Frank Brangwyn;
carpets and carpet manufacture

Market Street, Kidderminster
tel. 0562-66610

Mon, Tues, Thurs–Sat 11–4 pm.
Closed Wed, Sun & Bank Holidays

Admission free

The Museum began as part of the Kidderminster Schools of Science and Art. In 1927 it passed to the local authority and was administered until 1974 by the Kidderminster Borough Council and by Wyre Forest District Council since then. Housed in a building designed by G. M. Gething (1830–1919) and built in 1887, the Museum shares its premises with an Arts Centre and the Kidderminster Library.

The permanent collection comprises prints from the 18thc to the present day and a good collection of work by Frank Brangwyn. It also includes a collection of paintings, drawings and prints of local subjects and by local artists and a photographic collection from the 1870s to the present. Other locally orientated collections are those of carpets and carpet manufacture, social history and some archæology.

No catalogue of the collection exists but there are postcards and larger reproductions of pictures from the collections for sale. Parking is available in a multi-storey car-park adjacent to the building.

KINGSTON UPON THAMES, *Surrey*

Kingston upon Thames Museum and Heritage Centre

Local history; photographic material by
Eadweard Muybridge; Martinware pottery

Fairfield West, Kingston upon Thames
tel. 01-546 5386

Mon–Sat 10–5 pm. Closed Sun

Admission free

Founded by the Scottish benefactor Andrew Carnegie (1835–1919), the Museum was opened in 1904 and was built for the Royal Borough of Kingston. It is housed in an attractive purpose-built house of warm red brick and Bath stone, with fine stained glass windows from the old Town Hall. It was designed by Alfred Cox (1868–1944).

The Museum houses general local history and archæological collections and topographical pictures and photographs. It is particularly noteworthy, however, for two special collections—those of Eadweard Muybridge (1830–1904) and Martinware pottery. Muybridge, the famous photographer of movement and pioneer of cinematography, bequeathed his photographic material and moving-picture projector, the zoopraxiscope, to Kingston, where he was born and died. The collection is the subject of an impressive exhibition at the Centre, opened in May 1984 as a gift to the community by Marks and Spencer plc. Ernest Marsh (d. 1945) bequeathed in 1945 a large collection of pottery made by the Martin Brothers at Fulham and Southall in the period from 1890 to 1914. The Museum also holds works by a number of other art potters, including Leach, Wells and Staite Murray.

There are guides and souvenirs to accompany the Eadward Muybridge exhibition. The sales counter also sells books, postcards and information sheets. Car-parking is available nearby.

LACOCK, *Wiltshire*

Fox Talbot Museum of Photography

Photography with special reference to
Henry Fox Talbot

Lacock, Nr Chippenham
tel. 024937-459

Daily 11–6 pm (March–Oct).
Closed Good Friday

Admission charge

Housed inside a 16thc barn, near the gates to Lacock Abbey, which is also open to the public, this Museum was opened in 1975 to commemorate William Henry Fox Talbot (1800–77) of Lacock Abbey, who is recognised as the inventor of photography as we know it. His first cameras and calotypes are on view, together with many of the international awards he won.

The gallery upstairs houses an audio-visual presentation and changing exhibitions. The bookshop is the most comprehensive in Wessex for books about photography.

Special publications for sale include: *The Fox Talbot Museum Catalogue*; *Information Leaflets* nos 1 & 2, *Photogenic drawing*, *The Calotype process*; Robert Lassam, *Fox Talbot Photographer*.

Photogenic drawing, a 'photogram' of lace by William Henry Fox Talbot, *c.* 1835–39
(Fox Talbot Museum of Photography, Lacock)

LANCASTER

Lancaster City Museum and Art Gallery [1]

Local history and archæology;
paintings by local artists;
furniture by Gillows of Lancaster;
British and Oriental pottery and porcelain

Market Square, Lancaster
tel. 0524-64637

Mon–Fri 10–5 pm; Sat 10–3 pm.
Closed Sun

Admission free

The Museum was founded in 1923 by the Lancaster Corporation. The building dates from 1783 and was designed by Major Thomas Jarratt and Thomas Harrison of Chester (1744–1829); it has a tetrastyle portico and is surmounted by a cupola with a clock. Inside, the original 19thc Council Chamber is preserved with its ceiling ornamented with the arms of the City, the Duchy and others.

The collections include a number of paintings by local artists such as Yates, Woodhouse, Birch, Aspinwall, Rampling, Hoggatt, Lonsdale and Henderson. These are supplemented in the local history section by an excellent group of photographs containing the work of the local man, S. Thompson (*c.* 1895–1930). There are archæological displays with Roman, prehistoric and mediæval material from the North-West and the Lake District, including the remarkable Quernmore Burial, a 7thc AD burial in a log coffin with a woollen shroud. The decorative arts collections include furniture from the celebrated local firm, Gillows of Lancaster, and local country pottery from Burton-in-Lonsdale, as well as English earthenware from other regions and Oriental porcelain.

The Museum has a shop selling a large selection of local interest publications as well as replicas, prints, etc., and is hoping to establish an Association of Friends.

Costumed doll, *c.* 1750 (The Judges' Lodgings, Gillow and Town House Museum, Museum of Childhood, Lancaster)

Oak cabinet writing-table made by Gillows of Lancaster, 1823 (Lancashire County Museums Service)

The Judges' Lodgings, Gillow and Town House Museum, Museum of Childhood [2]

Church Street, Lancaster
tel. 0524-32808

Mon–Fri 2–5 pm; closed Sat (Good Friday–30 April); Mon–Sat 2–5 pm (May–June); Mon–Fri 10–1 pm, 2–5 pm; Sat 2–5 pm (July–Sept); Mon–Fri 2–5 pm; closed Sat (Oct). Closed Sun

Admission charge

The Judges' Lodgings is probably the oldest house now standing in Lancaster. It was built in the first half of the 17thc on the site of an older house known as Old Hall. From 1826 until 1975 the house, as it now stands with later additions and alterations, was used regularly as the Judges' Lodgings for the Circuit Judges while the Assizes were being held at the Castle. The Museum was installed in 1976 and has been developed as a Museum of Lancashire Childhood and a Museum of Gillow Furniture. The childhood displays on the top floor of the building include dolls from the Barry Elder Doll Collection, once housed at Carr House, Bretherton, and period rooms depicting Victorian childhood in the county. The ground and first floors of the building have been used to illustrate the history of the house and to display in period setting furniture made by the firm of Gillows of Lancaster.

Abraham Bloemart, *The Prodigal Son with the Swine*, 1637 (Warwick District Council Art Gallery and Museum)

LEAMINGTON SPA, *Warwickshire*

Warwick District Council Art Gallery and Museum

European paintings (16thc–19thc);
British paintings and watercolours
(19thc–20thc); English pottery and
porcelain; drinking glasses (18thc);
domestic glassware (20thc)

Avenue Road, Leamington Spa
tel. 0926-26559

Mon–Wed, Fri, Sat 10–1 pm, 2–5 pm;
Thurs 10–12.45 pm, 2–5 pm, 6–8 pm.
Closed Sun

Admission free

Founded in 1928, the Gallery building was funded half by public subscription and half by the Town Council. There are no particular patrons, but Alderman Alfred Holt, also Mayor of the Borough, was the prime mover in pressing for the building of an Art Galley in Leamington. He was also very generous in his gifts to the Gallery and these formed the nucleus of the Permanent Collection.

The designer of the Gallery was Arthur Charles Bunch (1879–1950), the Warwick County Council architect, who gave his services free. An original feature of the interior is the cruciform plan, rising to a dome with gold Tudor roses in relief round the edge.

The paintings collection includes some Dutch and Flemish masters of the 16thc and 17thc, for example, Abraham Bloemart's *Prodigal Son* and a *Self-Portrait by Candlelight* by Godfried Schalcken. The 20thc collection has work by Stanley Spencer, Duncan Grant, Vanessa Bell, John Piper and L. S. Lowry. There is also a group of oils and watercolours by Thomas Baker (1809–64), a local artist.

As well as the English ceramics and glassware—a holding augmented significantly by the addition of the F. H. Jahn Collection in 1955—the Gallery also received a group of Chinese, Japanese and Thai objects from the W. B. Sutherland Bequest in 1949.

There are publications on both the 18thc drinking glasses collection and the pottery and porcelain collection, as well as a leaflet on the Art Gallery for sale on the premises.

LEEDS, *West Yorkshire*

City Art Gallery

[1]

European painting 19thc–20thc,
with particular emphasis on the 20thc
British School; American 20thc

Municipal Buildings, Calverly Street,
Leeds
tel. 0532-462495

Mon, Tues, Thurs, Fri 10–6 pm;
Wed 10–9 pm; Sat 10–4 pm; Sun 2–5 pm

Admission free

The City Art Gallery was founded in 1888 on the initiative of the Art Gallery Committee of the Leeds City Council, whose Chairman was Col. T. Walter Harding. He was supported by Sir James Kitson (later Lord Airedale), Sam Wilson, Charles Roberts and others. The architect of the building was W. H. Thorpe, who produced what was by this date a conventional, lofty, purpose-built exhibition space. As it stands now the Gallery consists of a Victorian pillared entrance hall and staircase, and spacious, newly refurbished exhibition galleries. The new extension incorporating the Moore sculpture gallery has an imposing entrance front, with a sloping ramp as well as steps. This was designed by the City Architect's Department (John Thorpe) in consultation with Neville Conder, and was opened in 1982.

The City Art Gallery has been greatly enriched by generous benefactions. These include the Sam Wilson collection of Modern British painting. Sam Wilson, a well-to-do Leeds manufacturer and long-time supporter of the Art Gallery, died in 1915. His taste was basically New English Art Club, and he patronised Clausen, Alfred Gilbert (whose only partially successful chimneypiece is the focus of one of the galleries), and Brangwyn. His collection was handed over to the Gallery in 1925.

Sydney D. Kitson, a Leeds architect and the biographer of J. S. Cotman, bequeathed a selection of fine Cotman watercolours to the Gallery, together with his extensive collection of small sketches and working drawings by this artist, in 1938. In 1952 the splendid collection of British watercolours belonging to Agnes and Norman Lupton, who came from Leeds, was bequeathed to the City.

Smaller but important gifts include the watercolours from Sir Michael Sadler, who had given encouragement to the Gallery during his period as Vice Chancellor of Leeds University, before and during the First World War, when Frank Rutter as Curator was trying to promote a change from a Victorian to a more modern collecting policy; Sir Michael promoted the founding of the Leeds Art Collections Fund. Herbert Hepworth, Chairman of the LACF in the 1930s, gave a number of modern British paintings, including a painting and several drawings by Augustus John.

In 1982 the Henry Moore Foundation paid for the creation of the Henry Moore Sculpture Study Centre (which is partly funded by a grant from the Foundation) within the Gallery building. As well as a remarkable representation of British 20thc work, centering on Henry Moore himself and including Jacob Epstein's important carving, *Maternity*, there is a beautiful Canova of the *Medici Venus*, sculpted for the celebrated collector and patron, Thomas Hope.

The collection of British 20thc painting is impressive, with excellent examples of Sickert

Marble statue of *Venus* by Antonio Canova, 1818–20
(Leeds City Art Gallery)

Edward Wadsworth, *Requiescat*, 1940 (Leeds City Art Gallery)

Gustave Courbet, *Les Demoiselles de Village*, before 1851 (Leeds City Art Gallery)

PUBLICATIONS
Leeds City Art Gallery: an anthology of paintings, sculpture, drawings, watercolours and prints, 1976
Concise Catalogue (checklist of paintings, drawings, etc. in the Leeds collections), 1976; supplement 1982
The Agnes & Norman Lupton Collection of Watercolours and Drawings, 1972
The Leeds Arts Calendar (periodical containing articles on the art collections and related topics, published twice a year, available to members of the Leeds Art Collections Fund)

Exhibition catalogues:
Atkinson Grimshaw, 1979
Dutch 17th Century Paintings, 1982
Henry Moore early carvings, 1982

and the Camden Town painters, Bloomsbury Group items, Paul Nash (*The Shore* of 1923), a handsome Wyndham Lewis figure painting and an especially fine representation of Stanley Spencer. There is a memorable Edward Wadsworth (*Requiescat*, in tempera on paper) and interesting examples of Robert Macbryde and Francis Bacon. From an earlier period the very beautiful Gustave Courbet, *Les Demoiselles de Village*, should not be overlooked: it is an outstanding example of a landscape by this important 19thc French painter.

The Leeds Art Collections Fund acts as a very supportive association of Friends, providing significant funds towards the ambitious purchasing policy pursued by the City Art Gallery for itself and for the enlargement of the collections at Temple Newsam House and Lotherton Hall. Recent acquisitions achieved as a result of appeals on a nationwide scale include Turner's Farnley Hall Bird Book and a spectacular and highly ornamental 18thc writing cabinet by John Channon for Temple Newsam House.

A café is planned for the next phase of building.

Leeds City Art Galleries include two important outstations, Temple Newsam House and Lotherton Hall, whose impressive collections amount almost to self-contained museums in their own right, but they represent, as if in separate departments, specific areas of the City's holdings which can thus be housed in suitably spacious surroundings.

197

Lotherton Hall

[2]

Gascoigne family portraits and paintings; furniture (19thC); ceramics (19thC & 20thC); silver; costume and fashion; jewellery and gold boxes

Aberford, Leeds
tel. 0532-813259

Daily 10.30–6 pm

Admission charge
(special rate season ticket)

Lotherton Hall was the gift of Sir Alvary Douglas Gascoigne (1893–1970) and Lady Gascoigne (1888–1979), and included not only the house and its collection, but also an endowment fund for purchasing and displaying further objects, and the surrounding ten acres of gardens and 150 acres of parkland.

The house is mainly Edwardian with many original fittings, but the earlier part, dating from 1828, was designed by the York architects Watson, Pritchett & Watson. The part dating from 1896 is thought to be the work of Chorley & Gribbon of Leeds, and a local architect, T. Herbert Prater of Aberford, provided the 1903 addition.

The exhibits include family portraits and other paintings from the Gascoigne Collection, including the fine Pompeo Batoni showing Sir Thomas Gascoigne which was painted in Rome in 1779 when he was on the Grand Tour. Sir Thomas is shown holding a snuff box with the lid inset with a portrait of Marie Antoinette, reputedly given to him by the Queen herself, which is still in the collection. Members of *The Irish House of Commons* were depicted by Francis Wheatley in 1780. The furniture collection now includes the spectacular high Victorian examples made for Titus Salt by Marsh and Jones in the 1860s. The most impressive piece, the piano, was given by C. J. S. Kyte in 1954. Equally elaborately decorated are the table designed by William Burges in 1867 and Lord Wraxall's painted wardrobe, probably made by Collier and Plucknett

The sculpture collection concentrates on the work of English artists in Rome in the period between 1750 and 1850. Notable is the delicately elegant greyhound by the Leeds sculptor, Joseph Gott. The work of 20thC craftsmen and designers adds a further dimension as part of the endowment is used to enable Leeds to act as a patron of contemporary art and design. The pottery examples are by Hans Coper, Lucie Rie and Alan Caiger-Smith, among others; furniture by John Makepeace matches the achievements of the Victorian makers, and the fashion collection includes extravagant designs by Zandra Rhodes and Bill Gibb.

The Frank Savery Collection of Oriental Ceramics, originally bequeathed to Leeds in 1965, was installed at Lotherton Hall in a specially designed gallery in 1975.

A café/restaurant opened in the park in 1985, and there is a Museum shop in the house. There are large car-parks and picnic areas in the surrounding gardens and an extensive bird garden in the park.

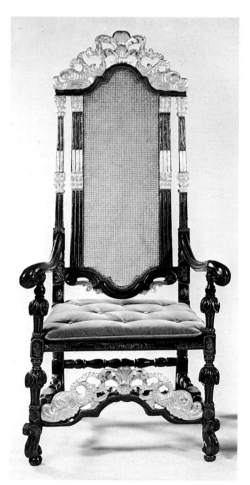

English beechwood armchair with gilded ornament and caned panels made for the Duke of Leeds, *c.* 1700–5 (Temple Newsam House, Leeds)

PUBLICATIONS
Lotherton Hall, a picture book, 1977
Lotherton Hall in bygone times, a picture book, 1984

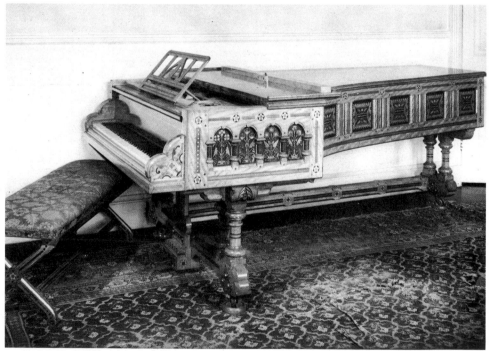

Sycamore grand piano inlaid with various stained woods, instrument by Erard of London and case by Marsh & Jones of Leeds, *c.* 1870 (Lotherton Hall, Leeds)

Temple Newsam House [3]

European painting 18thC;
furniture 17thC & 18thC;
silver, ceramics and gold boxes

Leeds
tel. 0532-647321

Tues–Sun & Bank Holiday Mon 10.30–
6.15 pm (or dusk in winter). Closed Mon

Admission charge (special rate
season ticket)

PUBLICATIONS
Views of Temple Newsam House from a Bygone Age,
1984
Guide book to Temple Newsam House, 1984
C. Gilbert, *Catalogue of Furniture at Temple Newsam
House & Lotherton Hall*, 2 vols, 1978
P. Walton, *Creamware and other English Pottery at
Temple Newsam House*, 1976

Exhibition catalogues:
Thomas Chippendale, 1979
Historic Paper Hangings, 1983
Common Furniture, 1982
Early Photography in Leeds, 1981

Temple Newsam House, which was sold by the Rt Hon. Edward Wood (later Lord Halifax) to the City of Leeds in 1922, concentrates on the collections of English decorative art from *c.* 1530 to *c.* 1830, including part of the Ingram/Temple Newsam collection of paintings and furniture, as well as family portraits by, for example, Philip Mercier and Joshua Reynolds, and seascapes by Marco Ricci.

The furniture collection is particularly remarkable, having been patiently built up over a period of years by carefully planned purchasing of examples of pieces by known makers or of documentary interest in some way. The Duke of Leeds's daybed and sofa, probably made by Philip Guibert in *c.* 1705, have recently been joined by a pair of chairs commissioned by the same patron. The Moor Park Tapestry suite is matched in magnificence by the Hinton four-poster bed with its resplendent damask hangings. The delicate marquetry ornament of the famous Harewood writing desk by Thomas Chippendale contrasts with the geometric Gothic carved ornament of the other writing table of the same period.

The silver collection includes a full tea equipage by Paul de Lamerie, as well as Tudor, Stuart and other Georgian items. The ceramic collection is very rich in examples of Leeds creamware, but there is also a dated slipware dish by Thomas Toft of 1674, and other English pottery pieces.

Valuable benefactions include the Frank Fulford Gift of furniture and gold étui (1939–44); the Hollings Collection of English creamware (1946–47); the Halifax Gift of ancestral Temple Newsam paintings (1948); the Schofield Bequest of furniture (1962); and the Sir George Martin Bequest of furniture (1976).

The House is an early Tudor building, much remodelled by successive owners; in the 18thC William Etty, Daniel Garrett and John Carr worked on parts of the House, and in the 19thC Charles Eamer Kempe, the decorator and stained glass artist who worked on additions and alterations to another Tudor house, Wightwick Manor in Staffordshire, had a hand in the alterations, as did G. F. Bodley. These remodellings have produced within the building itself an interesting history of taste which is complemented by the exhibits; recent research during extensive restoration and redecoration has also brought to light fragments of wallpaper covering almost the whole span of the house's existence. This has been made the basis of a collection of historic wallpapers, adding a further dimension to the significant coverage of the decorative arts.

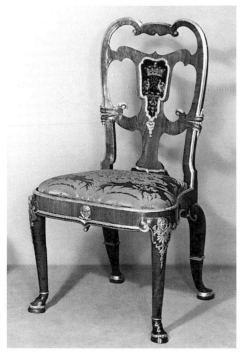

English walnut chair from Sutton Scarsdale, possibly by Thomas How of London, *c.* 1724–28
(Temple Newsam House, Leeds)

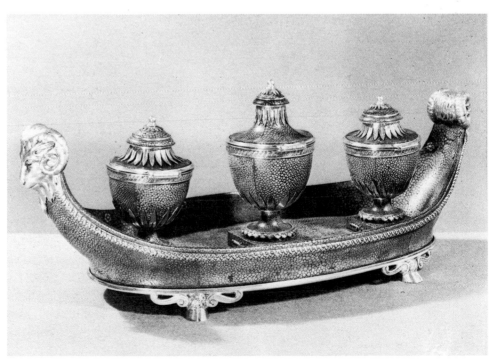

Silver and shagreen inkstand, probably Russian, *c.* 1785
(Temple Newsam House, Leeds)

LEEK, *Staffordshire*

Leek Art Gallery

Nicholson Institute, Leek
tel. 0538-382721

Tues, Wed, Fri, Sat 1–5 pm.
Closed Mon, Thurs, Sun

Admission free

Small permanent collection, which includes work executed by the Leek Embroidery Society, supplemented by changing exhibitions, mainly of local interest.

LEICESTER

Leicestershire Museum and Art Gallery [1]

Italian paintings (from 15thC); German, Flemish and English paintings (from 16thC); French and Dutch paintings (from early 17thC); British sporting art; German Impressionism and Expressionism; Oriental and European ceramics including Chinese, Korean, Japanese, Islamic and British groups; British art and studio ceramics (mid-19thC–present day); Japanese art, including ivories; swords and armour; English glass (17thC–20thC); English silver; Indian arts and crafts; natural history; Egyptology

New Walk, Leicester
tel. 0533-554100

Mon–Sat 10–5.30 pm (but closed Fridays at time of writing due to budget reductions); Sun 2–5.30 pm. Closed Christmas Day, Boxing Day & Good Friday

Admission free but voluntary contribution requested

The oldest part of the building was the original Leicester Town Museum, established in 1847, following the Borough Council's adoption of the Museums Act (1845) in response to petitions from the Leicester Literary and Philosophical Society, the Leicester Mechanics Institute and the Leicester Athenaeum. Of these, the Literary and Philosophical Society, founded in 1835, is still in existence and very active, and is based in the Museum.

With the construction of a substantial building for the Leicester School of Art, adjacent to the Museum, in 1876, and with a large public lecture room shared between the two institutions physically linking the two buildings, public pressure grew locally for the provision of a proper Art Gallery as an extension to the Museum. Following a successful public appeal for funds for both the construction of additional accommodation and the purchase and donation of works of art, two art galleries were built as an extension to the public lecture room and were opened by the Appeal Committee from time to time, both for exhibitions and to raise funds. In 1885, the Corporation accepted full responsibility for the Art Gallery.

The original building was constructed to a simple Doric temple design, in stucco over brick, by Joseph Hansom (1803–82) in 1836, for use as a Nonconformist Proprietory School for boys. However, with the failure of the school within ten years, the building was bought by the Corporation and with only slight adaptations was opened as a Museum in 1849, with the displays occupying most of the two floors of schoolrooms.

Shanton and Baker designed both the Leicester School of Art Buildings, built in local yellow-grey brick, and the matching public lecture room, in 1875–76, and the first art galleries and Council Room constructed between 1880 and 1895 continued this style. However, in 1909 radical and controversial plans were prepared by the local architect and Museum Committee member, Albert Herbert for the gutting of Hansom's two-storey interior, and the creation of a large hall and central wooden staircase, to be surrounded on three sides by two-storey buildings in an Edwardian neo-Classical design. After a public enquiry, the new central hall was created, and the first galleries of Herbert's design were built on the west and south sides of the original building, the work being completed by 1911. Work on the remaining parts of Herbert's plan for the west side was resumed in the 1920s and opened in 1930.

Finally, in order to deal with the severe fire and safety risks resulting directly from Herbert's 1909–11 removal of the original interior, the central block was reconstructed for a second time in 1976–77 by the County Architect, Thomas Locke, putting back a first floor, and providing new staircases in more or less the pre-1909 positions.

The original Museum received a considerable number of objects, particularly in the decorative arts field, during the period before the establishment of the Art Gallery. Between 1876 and 1885, the main emphasis was on contemporary British work, although one of the earliest purchases was a fine landscape by de Loutherbourg bought locally in 1882. However, high Victorian art predominated in the early years, with notable additions including the major Watts *Orlando pursuing the Fata Morgana* donated by the artist in recognition of the work of John Cook of Leicester, the son of Thomas Cook. Important early purchases included Wilkie's *Washington Irving Searching for Traces of Columbus in the Convent of La Rabida* and Egg's *Launce's Substitute for Proteus' Dog* originally painted for Brunel's Shakespeare Room in 1849.

The very large Dudgeon Collection of Old Master prints was received at the beginning of the 20thC, but otherwise the collecting continued to concentrate on contemporary works,

Camille Pissarro, *La Route—Effet de Neige*, 1879 (Leicestershire Museum and Art Gallery)

mostly the decorative arts, particularly artist-craftsman furniture and ceramics, together with historic material from local collections, especially portraits and topography.

Following the establishment of the Friends in 1930 the Gallery began a more adventurous collecting programme. The first Old Master paintings were bought, and important English pictures purchased included the outstanding portrait of *Mrs Catherine Swindell* by Wright of Derby and the unfinished *Portrait of a Gentleman* by Constable. Sisley's enchanting *En Hiver, Moret-sur-Loing* was one of the first important French Impressionist purchases made by any provincial gallery in England, and has been followed by purchases of major works by Degas (*Le Rentrée du Troupeau*) and the outstanding Camille Pissarro winter scene, *La Route—Effet de Neige, 1879*, serving as a perfect foil to the Sisley.

Trevor Thomas, Director in 1940, established a highly innovatory and controversial exhibitions and acquisitions policy. Major exhibitions were held of contemporary Polish and German art, including in 1944 the first important exhibition of German Expressionism in any public gallery outside Germany or New York—the only concession to the War in progress being to title the exhibition 'Mid-European [rather than German] Modern Art'. Thomas persuaded the Corporation to start buying 20thc German art, and one of the greatest of all the works by Frans Marc (co-founder of 'Der Blaue Reiter' with Kandinsky), *Rote Frau*, was bought from the exhibition, together with outstanding works by Nolde and Feininger. From this beginning the Gallery has built up over the past forty years the largest and most comprehensive public collection of German Impressionism and Expressionism in Britain, with almost two hundred works, covering painting, sculpture and all kinds of graphic work, including illustrated books.

The wartime period also saw the foundation of the large collection of English works of the early 20thc by the Camden Town Group, which now includes well-known important works acquired over the past forty years by all of the main figures in the British Post-Impressionist movement, including in particular Sickert, Gilman, Bevan, Spencer Gore, Duncan Grant and Ginner.

The Gallery has acquired over the past half-century contemporary work by the sculptors Jacob Epstein, Henry Moore, Barbara Hepworth and Elisabeth Frink, and paintings by Mark

Gertler, Stanley Spencer, Paul Nash, Ben Nicholson, Graham Sutherland and Francis Bacon.

Since the post-war period the collection of Old Masters has been enriched by paintings by Lorenzo Monaco, Beccafumi, Pittoni and Annibale Caracci, and there is now a strong representation of 17thC Dutch painting, with fine works by Salomon van Ruysdael, Nicholas Maes, Michael Sweerts and a large winter landscape by Aert van der Neer. French paintings include the Venetian period *Death of Sophonisba* by Nicholas Renier, and the newly-discovered Georges de la Tour, *The Choirboy*, bought from a local collection in 1984.

The decorative arts collections are divided between a number of branches, and only the ceramics, glass and silver are regularly displayed at the Museum. The ceramics include a representative coverage of most major countries and periods, with the Japanese 19thC ceramics being particularly noteworthy. The Gallery began collecting studio pottery in the early 1920s, and the collection is particularly strong in this field, including important early works by Bernard Leach, Hamada and Staite Murray, and active collecting continues to the present day, with good collections of post-1945 material, from Hans Coper and Lucy Rie to young contemporary potters of a quite different genre.

The glass collections concentrate on two areas, with a fine collection of English glass from the 17thC and particularly the 18thC, started in the 1940s and based on the Broughton Collection, and artist-craftsmen glass of the 20thC. The Maurice Marinot Collection, given by the artist's daughter in 1974 and since added to by purchase, is the most important of these.

The silver is entirely English, and includes 17thC items bearing the very rare Leicester cinquefoil hallmark, and a few items of pre-1836 Leicester Corporation plate. Another item of particular note is a fine early 17thC steeple cup from the local village church of Braunstone.

The Museum has a total of ten Friends' organisations, covering various interests and geographical areas of the County. The principal organisation for this branch is the Leicester Museums Association.

There is a shop selling a selection of publications. Catalogues of the Painting Collection, Watercolours and Drawings, and Local Portraits, Ceramics, and Japanese Collection dating from the 1950s and 1960s are still in print, although now very incomplete. New comprehensive catalogues are planned on completion of the current computerisation of the Fine Art records. More recent major publications include books on: the Expressionist revolution in German art 1871–1933; Sir George Beaumont of Coleorton, Leicestershire; John Ferneley; Lowesby pottery; and Maurice Marinot.

Parking is very limited, and on weekdays all except disabled drivers should use the nearby multi-storey car-park.

Leicestershire County Council also administers:

Belgrave Hall [2]

The house and gardens were bought by Leicester Corporation for preservation in 1935. Belgrave Hall is a simple, small three-storey farmhouse built in local red brick adjacent to the parish church of the old village of Belgrave (now completely absorbed into the expanding town of Leicester) between 1709 and 1712. In the second quarter of the 19thC it became the home of the Quaker entrepreneur and railway pioneer, John Ellis. At the time that it was saved by the Corporation, the house had been partly gutted prior to demolition, and most of the farm buildings had already been demolished, but the original stable-yard and coach-houses were saved with the main part of the building. The simple middle-class domestic scale of the house is one of its main features of interest and charm; few examples of ten to twelve-room houses (including living rooms) like this are preserved.

Over recent years, extensive research has been carried out on decorating and furnishing styles of the periods during which the house was inhabited, and this is now reflected in the recent refurbishing of the interior. The furnishings mostly relate to the period and style of the house, although a number of the items are really far too grand for such a modest building, particularly the furnishings of the Drawing-Room. These include one of the finest sets of 1720s English carved walnut and embroidery upholstered furniture surviving (twelve chairs and a three-seat settee, all with lion masks carved on their legs), an elaborate Queen

George I Mahogany chair, *c.* 1730
(Leicestershire Museums and Art Gallery)

English furniture and domestic items of the late 17thC–19thC, in mature botanic and historic gardens

Church Road, Thurcaston Road, Belgrave
tel. 0533-666590

Mon–Thurs, Sat 10–5.30 pm;
Sun 2–5.30 pm. Closed Fri

Admission free (voluntary contribution requested)

Anne English red lacquer cabinet, and a splendid clock by Knibb.

There is a sales desk where a guidebook to the Hall and gardens and related publications are for sale. Car-parking is available.

Newarke Houses Museum [3]

Social history; artist-craftsman furniture by Ernest Gimson and his associates; local clocks; portraits

The Newarke, Leicester
tel. 0533–554100

Mon–Thurs, Sat 10–5.30 pm;
Sun 2–5.30 pm. Closed Fri

Admission free (voluntary contribution requested)

PUBLICATIONS
John Daniels, *Leicestershire Clockmakers*, 1975 (out of print)
Annette Carruthers, *Ernest Gimson and the Cotswold Group of Craftsmen*, 1978
G. A. Chinnery, *The Newarke and the Castle*, 1981

The Newarke Houses were originally bought by a group of local antiquarians and architects before the First World War for preservation, and with the long-term aim of establishing a museum.

The oldest part of the building was erected in the early 16thc as the Chantry House of William Wyggeston, and most of the remainder appears to be 17thc, although extensively remodelled and faced with stucco in the Regency period. It reopened in 1953 as a museum of local social history.

The collections include a large and comprehensive collection of clocks from the 17thc–19thc by Leicestershire clockmakers, including the Deacon Family of Barton-in-the-Beans, whose 18thc workshop survived intact to the 1950s and has now been reconstructed in the Museum.

Another special feature is the large collection of furniture and other craft items by the Leicester-born pioneer of the artist-craftsman movement, Ernest Gimson, and his close associates and assistants, the Barnsleys and Peter Waals. The Museum also houses fine 17thc oak panelling rescued from Ragdale Hall before its demolition, and a large collection of musical instruments.

There is a sales desk where publications, postcards, etc., can be bought. Very restricted car-parking is available.

Wygston's House Museum of Costume [4]

English costume and textiles

12 Applegate, St Nicholas Circle, Leicester
tel. 0533-554100

Mon–Thurs, Sat 10–5.30 pm;
Sun 2–5.30 pm. Closed Fri

Admission free (voluntary contribution requested)

PUBLICATIONS
Christopher Page, *Foundations of Fashion*, 1980 (introduction to the history of corsetry)

This is the last remaining late 15thc–early 16thc merchant's house on what was the original High Street of the mediæval town. The original timber-framed hall survives in the centre of the building, but the half-timbered frontage was rebuilt in brick at the end of the 18thc and the rear third was completely reconstructed, again in brick, in the 19thc.

As a major textile centre, especially for the knitting and corsetry trades, Leicester has had a special interest in this field for more than a century. The costume collection includes around five thousand complete outfits, and only a tiny proportion can be shown in the displays, which are regularly changed for conservation reasons. A special feature is the Symington Museum of Corsetry, donated by the Market Harborough Company that was once the largest manufacturer in the Commonwealth, and which represents a comprehensive coverage of the history of the machine-made corset from its origins in the mid-19thc to the present day.

The Museum has a sales desk. Public parking is adjacent.

LEOMINSTER, *Hereford and Worcester*

Leominster Folk Museum

Local history; works by locally born artist John Scarlett Davis (1804–45)

Etnam Street, Leominster
tel. 0568-5186

Mon–Sat 10–1 pm, 2–5 pm. Closed Sun

Admission charge

The idea of the Folk Museum at Leominster was originated as early as 1930 by a group of local friends led by Norman Davis, the present Hon. Secretary of the Trust which runs the Museum, but it did not open finally until 1972. The Museum is housed in a former Mission Hall with a handsome pitch-pine ceiling; a renovated Victorian stable is part of the Museum complex, which houses objects of agricultural and rural interest. There is a collection of the work of the celebrated local artist, John Scarlett Davis (1804–45) which has been built up with the help of the NACF.

There is a Museum bookshop.

LICHFIELD, *Staffordshire*

Samuel Johnson Birthplace Museum

Items associated with Samuel Johnson
(1709–84)

Breadmarket Street, Lichfield
tel. 054-3224972

Mon–Sat 10–5 pm; Sun 2.30–5 pm
(May–Sept); Mon–Sat 10–4 pm; closed
Sun (Oct–April)

Admission charge

Johnson's birthplace was purchased for the City of Lichfield in 1900 by Lt.-Col. John Gilbert; in 1909 the Helen Hay Hunter Johnsonian Library was acquired.

The basis of the Johnson collection was a group of Johnson association items presented to the Museum on its foundation at the beginning of the century. In the last eighty years this has been built up by donations and purchases.

Amongst significant paintings are the portrait of Johnson as a young man, sometimes ascribed to Reynolds; William Hoare's portrait of Gilbert Walmsley; and a group of Johnson buildings and sites by John Buckler and Paul Braddon.

The more interesting association items include the wedding ring of Elizabeth Johnson (Samuel's wife), Samuel's tea service and punch-bowl, and the desk on which he wrote the *Rambler* essays.

Among the important books are the only known presentation copy of a first edition of Johnson's *Dictionary*, Johnson's Latin dictionary, and his atlas. There is also a significant group of letters (some from Johnson to Hester Thrale).

The Birthplace also housed the bookshop of Michael Johnson (Samuel's father), and there are long-term plans to restore this. The Museum is the headquarters of the Johnson Society.

There is a small outlet for the sale of souvenirs and publications, including a guidebook and pamphlets on Johnson and Lichfield.

LINCOLN

Usher Gallery

English and French miniatures and watches
17thC–19thC; English and Continental
ceramics 18thC–19thC;
English silver 17thC–19thC;
18thC & 19thC paintings, drawings & prints;
British 20thC paintings; coin collection

Lindum Road, Lincoln
tel. 0522-27980

Mon–Sat 10–5.30 pm; Sun 2.30–5 pm

Admission charge

The Gallery was founded in 1927 in accordance with the wishes of the Lincoln jeweller and collector, James Ward Usher (1845–1921), who left his collection and the necessary funds to build a gallery for the City. The building was designed in a characteristic French 18thC style by Sir Reginald Blomfield (1856–1942) who had earlier (1906) designed the Lincoln City Public Library building. Blomfield had adopted an increasingly Beaux Arts manner since the beginning of the century, inspired by his researches for his great study of the *History of French Architecture* in four volumes, published in 1911–21. The exterior of the Usher Gallery is mainly of stone, with giant pilasters and swagged bucrania in a pseudo frieze.

Usher, true to his avocation as a jeweller, was a collector with a taste for exquisite workmanship; the watches are many of them by well-known makers, but it is the cases that are so noteworthy. Usher had a great interest in painted enamels—he also collected miniatures— and the collection contains many documented examples.

The other important holding is the large and representative group of paintings, watercolours and prints by Peter de Wint (1784–1849). De Wint was born near Hanley in Staffordshire, the son of a distinguished doctor of Dutch origin who wished him to follow his own profession, but from an early age the boy was determined to pursue an artistic career. De Wint visited Lincoln in 1806, and in 1814 acquired property in the City. His many representations of the locality testify to his attachment to it, and these views in the De Wint collection form the nucleus of a group of paintings and watercolours of Lincolnshire. This also includes a Turner of *Stamford* (1828) as well as a large oil of *Lincoln from Brayford* by E. J. Niemann and J. W. Carmichael, and works by F. Nash, S. G. Prout, W. Logsdail and J. Buckler.

TENNYSON COLLECTION Alfred, Lord Tennyson (1809–92), Queen Victoria's Poet Laureate, was a son of Lincolnshire, born at the Rectory of Somersby, a village in the Wolds between Lincoln and the sea. A room is set aside for the display of portraits, photographs, costume and personal relics relating to the poet and his family.

Musical watch with tiny cylinder playing on 13 teeth, mid-19thC (Usher Gallery, Lincoln)

Peter de Wint, *Lincoln from the South*, after 1814 (Usher Gallery, Lincoln)

LIVERPOOL, *Merseyside*

Merseyside County Museum [1]

Antiquities; ethnography; natural history; decorative and applied arts; costume and textiles; industrial and maritime history of Merseyside; aquarium and vivarium; planetarium

William Brown Street, Liverpool
tel. 051-207 0001

Mon–Sat 10–5 pm; Sun 2–5 pm

Admission free but voluntary contribution welcomed

One of the great Northern cities of the Industrial Revolution, in the first half of the 19thc Liverpool experienced a great cultural upsurge which produced an Academy of Artists, a Royal Botanic Institution with Botanic Gardens and an association to promote the formation of a Library, Museum and Art Gallery. These three institutions were founded and magnificently housed in a tripartite neo-classical series of buildings which have happily survived in a city much devastated by bombing. The County Museum itself was founded as the result of a bequest: in 1851 the 13th Earl of Derby left his vast natural history collection to the city of Liverpool. Only two years later the Derby Museum, as it was named, was opened to the public in the former Union News Room in Duke Street. It was an immediate success with an attendance reaching 150,000 in the first seven months. It quickly became apparent that this accommodation was inadequate, and at the crucial moment another great benefactor, William Brown, a wealthy Lancashire businessman who was also Member of Parliament for South Lancashire, came forward with the necessary funds. The site just to the north of St George's Hall became available and the architect Thomas Allom (1804–72) began work on the Brown Museum in 1857. The building, a temple-like edifice in the Roman style with a portico supported on six massive Corinthian columns, which had been modified by John Weightman, was completed in 1860 and opened a year later. In 1867 the character of the collections was greatly altered and enriched by the gift from Joseph Mayer, a successful Liverpool goldsmith, of his magnificent collection of antiquities, historical relics and pottery—

205

the nucleus, in effect, of the collections with which this particular book is primarily concerned. From Mayer's collection came, for example, the Saxon Kingston Brooch (7thC AD) of gold set with garnets, blue glass and shell, which was found at the Saxon cemetery site of Kingston in Kent. The collection of antiquities was celebrated in the 19thC for the quality of the Anglo-Saxon remains, the consular diptychs, Etruscan jewellery and important Roman items (see *Building News*, 11 June 1875), all of which were owed to Joseph Mayer. Mayer had one of the greatest collections of mediæval ivories in the world; the very early works are unequalled even in the British Museum or the Victoria and Albert in London. The County Museum also has on view some of the spectacular Ince Blundell Marbles, a token selection from the collection of five hundred classical sculptures amassed by Henry Blundell of Ince Blundell in the 19thC. These were given to the Museum in 1959 and are displayed in a setting which was specially devised to recreate the Pantheon constructed at Ince Blundell to house them.

Among the collections of local history, ethnography, botany, zoology, transport, etc., the decorative arts and antiquities form an important and impressive section. Here are, for example, the most comprehensive collection of Liverpool ceramics—a recent addition is a rare tile-picture panel—forming the nucleus of nearly twenty thousand specimens; a fine horology collection with over five hundred clocks, watches and instruments with particular relevance to the Lancashire clock and watch industry (see also the Prescot Museum of Clock and Watchmaking, p. 243); a metalwork department which boasts a copy by Flaxman of the famous Roman 'Theocritus' cup, the 19thC St Luke's communion service, and the Ismay Service; jewellery, costume and textiles; and a musical instrument collection of national importance based on the Rushworth and Dreaper collections.

The Museum has a shop and information centre and the Phoenix Room coffee bar.

Liverpool polychrome painted delftware tile picture composed of 32 tiles, *c.* 1760 (Merseyside County Museums, Liverpool)

PUBLICATIONS
A. M. Jarvis, *High Society : A display of formal dress for fashionable people, 1875–1920*, 1980
A. M. Jarvis, *Liverpool fashion, its makers and weavers : The dressmaking trade in Liverpool 1930–1940*, 1981
A. M. Jarvis, *Brides : Wedding clothes and customs 1850–1980*, 1983
A. Smith, *Liverpool Pottery*, 1967
I. Wolfenden (ed.), *Historic glass from collections in North-West England*, 1979

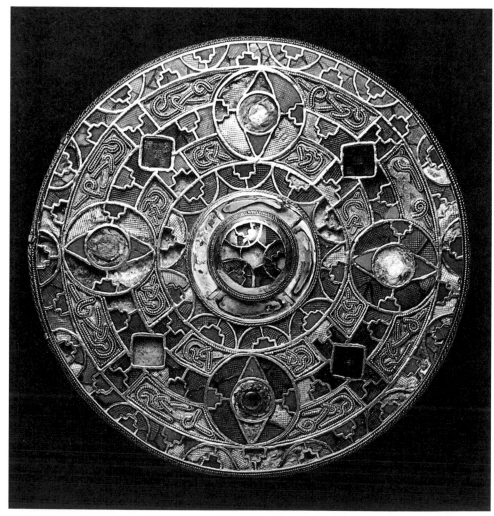

The Kingston Brooch made of gold set with garnets, blue glass and shell, Saxon, 7thC AD (Merseyside County Museums, Liverpool)

Sudley Art Gallery [2]

18thc and 19thc painting, chiefly British, including portraits, landscape and genre, several Pre-Raphaelite works and examples of the High Victorians

Mossley Hill Road, Liverpool
tel. 051-724 3245

Mon–Sat 10–5 pm; Sun 2–5 pm

Admission free (voluntary contribution requested)

PUBLICATION
The Emma Holt Collection, 1971

Sudley Art Gallery occupies a neo-classical house in red sandstone built in about 1820, bequeathed in 1944 by Miss Emma Holt, daughter of the collector George Holt (1825–96), who was a Liverpool ship-owner and a member of a substantial Liverpool merchant family.

This is the only collection of its kind now remaining intact of the many which formerly existed on Merseyside in the houses of the richer merchants. George Holt began collecting in the 1860s, chiefly contemporary British paintings; he then branched out into more important works by earlier artists, in particular J. M. W. Turner, whose *Castle of Rosenau*, 1841, is a highlight of the collection; and finally acquired several 18thc portraits, of which his last purchase, Gainsborough's *Viscountess Folkestone*, is a superb study of old age. His interesting group of Pre-Raphaelite paintings includes the smaller version of W. Holman Hunt's *Finding of Christ in the Temple*.

The collection is displayed in the Holt family house, in fine grounds to the south of Liverpool overlooking the Mersey and the Welsh Hills. Holt bought the estate in the early 1880s from the heirs of the original owner Nicholas Robinson, a corn merchant and former Mayor of Liverpool, who had had it built around 1820 on part of a newly developing area still within carriage distance of Liverpool (Robinson's portrait now hangs in the house). The plain red sandstone house, with its elegant pillared hall and staircase, was enlarged for Holt to include an imposing tower block giving sight of the ships coming up the river.

Catalogues and postcards are available at the house and there is parking space in the grounds.

University of Liverpool Art Gallery [3]

British sculpture, paintings, drawings, furniture, ceramics, silver and glass (late 17thc–present)

3 Abercromby Square, Liverpool
tel. 051-709 6022, ext. 3170

Mon, Tues, Thurs 12–2 pm;
Wed, Fri 12–4 pm. Closed Sat, Sun

Admission free

Derby biscuit porcelain group *Virgins awaking Cupid*, derived from a painting by Angelica Kauffmann, *c.* 1790 (University of Liverpool Art Gallery)

The Gallery, founded in 1977, is in an early 19thc terraced house; efforts have been made to retain the character of a Liverpool merchant's house of the period while adapting it for the purposes of display. The collection is varied, having been formed rather with the intention of the cultural enrichment of the University than as a representative holding of European art works. Among the University's earliest acquisitions from the date of the foundation in 1881 was a group of sculpted portraits of founders and benefactors. The holdings now encompass J. M. W. Turner's *Eruption of the Souffrier*; oils and watercolours by the celebrated bird painter, John James Audubon; and the admirable collections of English watercolours 1750–1850 and English porcelain of the same date bequeathed by Sir Sydney Jones, a shipping merchant. This porcelain collection has representative examples from nearly all the early factories: notable items are a biscuit porcelain group representing *Virgins awaking Cupid*, derived from a painting by Angelica Kauffmann, made at the Derby factory in about 1790. There is also an example of one of the most ambitious Wedgwood jasperware pieces, the two-foot-high black and white 'Pegasus' vase. The silver collection, mostly of English items dating from the 17thc to the present day includes impressive presentation and commemorative pieces associated with Liverpool and specifically with the University.

Contemporary works of art have been acquired for the embellishment of the University buildings, including monumental sculpture by, for example, Barbara Hepworth and Phillip King. The tradition of portraiture has also been continued since the early years, notably with a fine Augustus John of *Professor John Macdonald Mackay*. The display is based on a changing selection from the University's collections diversified by works of art brought in temporarily from other departments to appeal to a wider audience, both within and without the University.

The Art Gallery sells original prints, greetings cards and catalogues, as well as the two publications devoted to the collections: A. Moore, *The University of Liverpool Art Collections: a Selection* and J. Carpenter, *An Introduction to the Art Collections of the University of Liverpool*.

Walker Art Gallery [4]

European paintings and sculpture
14th–20thC

William Brown Street, Liverpool
tel. 051–227 5234, ext. 2064

Mon–Sat 10–5 pm; Sun 2–5 pm

Admission free (voluntary contribution
requested)

The Walker Art Gallery forms part of the complex of neo-classical buildings which includes the County Museum (q.v.) and the Municipal Library. The founder, a great Liverpool benefactor, Sir Andrew Barclay Walker (1824–93), who paid for the building on a site provided by the Liverpool Corporation and for the first extension of 1884, was a wealthy brewer and twice Mayor of Liverpool (1873–74 and 1875–77). He also built the laboratories of Liverpool University College and was knighted in 1877. The building, commenced in 1874, was designed by Cornelius Sherlock; it opened in 1877. A notable contemporary patron is Sir John Moores CBE, widely known for the important John Moores Liverpool Exhibitions of contemporary British art. The Gallery's initial role to house annual autumn exhibitions of modern British painting continued a local tradition stemming from the late 18thC, when an exhibiting Society of Artists was formed. The tradition of major exhibitions of contemporary art continues, as does the acquisition of important European paintings. The nucleus of its superb Old Master collection was formed around the 1800s by the unusual Liverpool solicitor, William Roscoe

Peter Paul Rubens, *The Virgin and Child with St Elizabeth and the Child Baptist, c.* 1632–34
(Walker Art Gallery, Liverpool)

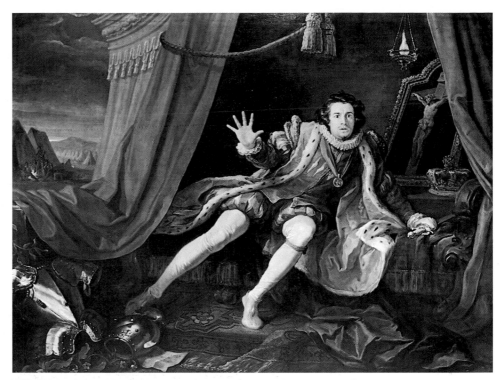

William Hogarth, *David Garrick as Richard III*, c. 1745 (Walker Art Gallery, Liverpool)

Ford Madox Brown, drawing, *Self-portrait*, 1850
(Walker Art Gallery, Liverpool)

(1753–1831); self-educated as a lawyer, he was also a writer and collector, amongst many activities. The portion of Roscoe's collection which later passed to the Liverpool Royal Institution was deposited at the Gallery in the 1890s and presented in 1948. It contains the most precious and earliest paintings in the Gallery: by Simone Martini, Ercole de'Roberti and the Master of the Virgo inter Virgines. In contrast, many Victorian subject pictures were acquired from the Autumn exhibitions; of these Yeames's *And When Did You Last See Your Father?* is the most famous. The flourishing Liverpool School was early represented, most particularly by George Stubbs's horse paintings, and by the 1850s followers of the Pre-Raphaelites whose own association with the earlier Liverpool Academy exhibitions is represented by characteristic works, most particularly J. E. Millais's brilliant, youthful work, *Isabella*.

In the 1930s a broader policy of acquisition was undertaken in which local resources were enhanced by important bequests, gifts from local industry and commerce, and government grants. The broad spectrum of British paintings begins with *Henry VIII* (a contemporary version after Holbein) and includes fine 18thc–19thc works, *David Garrick as Richard III* by Hogarth, *Isabella, Countess of Sefton* by Gainsborough, *Snowdon from Llyn Nantlle* by Richard Wilson, *Molly Longlegs* by Stubbs and *Linlithgow Palace* by J. M. W. Turner. Later European paintings include works by Rubens, Rembrandt and the most recently acquired *Ashes of Phocion* by Nicolas Poussin. A group of French Impressionists includes a delicate study of light effect in a *Woman Ironing* by Degas. 20thc British painting embraces Paul Nash, Walter Sickert and David Hockney. There is a growing watercolour and print section, and sculpture of all periods with particular emphasis on marbles by the 19thc Liverpool-born John Gibson and the later 19thc 'New Sculpture'. The full-size *Mower* by Hamo Thornycroft is a notable example of this school.

Frequent exhibitions cover a broad field but with particular emphasis on new trends, in the alternate biennial John Moores and Peter Moores shows.

Many visitors will find the collections so rich that a single tour of the galleries is not enough; a repeat to visit the more spectacular treasures or items overlooked can prove most rewarding, particularly in the opportunity this provides to assimilate the lesser-known Liverpool School painters, among them William Davis, William Lindsay Windus, Alfred William Hunt, David Alexander Williamson, Mark Anthony and John J. Lee, whose work forms a distinctive group, dominated by landscape subjects, peculiar to the Liverpool Academy. Ford Madox Brown

PUBLICATIONS
Permanent collection catalogues:
Foreign Catalogue, text and plates, 1977; supplement, 1984
Merseyside Painters, People and Places, 1978
Pictures in the Walker Art Gallery, 1979
Old Master Drawings and Prints, 1967
Early English Drawings and Watercolours, 1968

Exhibition catalogues:
The Danson Collection of Paintings by Charles Towne, 1977
English Watercolours from the Collection of C.F.J. Beausire, 1970
John Moores Liverpool Exhibition, biennial catalogues
The Art Sheds, 1981

had close links with many of these Liverpool artists and the representation of his work has very recently been extended by the acquisition of a group of family drawings showing his wife Emma and his young children, often in the form of preparatory studies for such renowned paintings as *Work* (at Manchester City Art Gallery, q.v.) and *Pretty Baa Lambs* (at Birmingham Art Gallery, q.v.).

From a slightly later date comes one of the most impressive works by W. L. Wyllie (*Blessing the Sea*) the marine painter, as well as a late—and large-scale—Royal Academy painting by Albert Moore, *Summer Night*, of 1890.

There is a gallery shop for catalogues, prints, slides, photographs and a selection of art material from other collections, and a cafeteria on Saturdays and Sundays. Parking is available nearby.

LUTON, *Bedfordshire*

Luton Museum and Art Gallery

Local archæology and history; lace; costume; toys and dolls

Wardown Park, Luton
tel. 0582-36941

Mon, Wed–Sat 10–6 pm; Sun 2–6 pm (April–Sept); Mon, Wed–Sat 10–6 pm; Sun 2–5 pm (Oct–Mar). Closed Sun (Dec & Jan), Tues

Admission free

The Museum was founded in 1928 and housed in a large red-brick mansion designed by Thomas Sorby in 1874, set in fifty acres of parkland.

The collections illustrate the archæology, social history and natural setting of the area and include lace-making, furniture, costume, ceramics, glass, toys and dolls, as well as such local subjects as hat-making and straw marquetry. Items worthy of special mention are the Luton Mediæval Guild Book, rare painted wall hangings, 18thc watercolours of Bedfordshire and watches by Thomas Tompion. An almost complete 18thc porcelain tea/coffee set decorated by Fidèle Duvivier is on display in the Applied Art Gallery. The Collection of the Bedfordshire and Hertfordshire Regimental Museum was handed over for safekeeping in 1977 and now forms part of the displays.

The Museum has depended upon the generosity of many benefactors but the main patron was Thomas Bagshawe, whose collection of antiques and decorative art objects was assembled over thirty years.

PUBLICATIONS
Luton and the Hat Industry, 1953; latest repr. 1976
Colour Guide to Museum and Art Gallery, 1978
Pillow Lace in the East Midlands, 1958; repr. 1980
Popular Arts in the Luton Museum, 1982

There is a sales desk in the main hall with an interesting stock of books, replicas and souvenirs including the Museum's own publications; there is ample space for parking beside the house.

MACCLESFIELD, *Cheshire*

West Park Museum

Egyptian antiquities; 19thc English paintings; local history

Prestbury Road, Macclesfield
tel. 0606-41331

Tues–Sun 2–4.30 pm; closed Mon (Easter–Sept); Sat & Sun 2–4.30 pm; closed Mon–Fri (Oct–Easter)

Admission free

PUBLICATION
R. David, *The Macclesfield Collection of Egyptian Antiquities*, 1980

The Museum was opened in 1898, the gift of Marianne Brocklehurst (1832–98) and her brother, Francis Dicken Brocklehurst (1837–1905). It is housed in a purpose-built gallery executed by Roylance & Co. from designs by Caspar Purdon Clarke (1846–1911), then Director of the South Kensington Museum. This is almost a copy of a room at the Whitworth Art Gallery in Manchester (q.v.) and its walls are decorated with casts of the Elgin Marbles. A large part of the collection was given by the Brocklehurst family, the main strength of which is the Egyptian antiquities, mostly acquired by Miss Brocklehurst during several tours of Egypt. There is also a good collection of 19thc English paintings and items of particular local interest, scenes of Cheshire, portraits of the Brocklehurst family and a few works by the Macclesfield-born artist Charles Tunnicliffe.

There is a sales area and very limited parking.

MAIDSTONE, *Kent*

Maidstone Museum and Art Gallery

Archæology; natural history;
17thc & 18thc Dutch and Italian painting;
19thc British watercolours; 17thc–19thc
Oriental prints, ceramics, sword furniture,
armour and lacquer; 17thc–19thc English
pottery and porcelain; ethnography;
costume; arms; musical instruments;
photography

St Faith's Street, Maidstone
tel. 0622-54497

Mon–Sat 10–5.30 pm. Closed Sun

Admission free

The present Museum, though much enlarged, was founded in 1858, following the bequest of 1855 of Thomas Charles's collections and the purchase of his house, Chillington Manor. The central portion of the Museum is Elizabethan, built in 1562; behind is the earlier Tudor Long Gallery. Both have been heavily restored in Victorian and recent times. The wings are mainly Victorian, replacing an earlier building. The Great Hall and withdrawing room above are panelled, the former retaining its screen. The withdrawing room has a fine carved fireplace surround of about 1562.

Japanese iron openwork tsuba of a crayfish with gold eyes, 19thc (Maidstone Museum and Art Gallery)

Japanese ivory inro of two tigers in a bamboo grove during a storm with an ivory netsuke of a group of fishes carved in the round, 19thc
(Maidstone Museum and Art Gallery)

Illuminated frontispiece of the Luton Guild Book of the Confraternity of the Holy Trinity, dissolved 1547
(Luton Museum and Art Gallery)

William Alexander, watercolour of *A Pipe-bearer,*
attendant on the Mandarin of Turon, Cochin, China,
1793 (Maidstone Museum and Art Gallery)

The first substantial gift to the collection was that of Julius Lucius Brenchley (1816–73), a local resident, made in part towards the end of his life and in part by bequest. For twenty years Brenchley travelled throughout America, the Pacific, Asia and Europe. His bequest included the very large collection of ethnographic material from the Pacific and north-west America, oil paintings, Oriental and Russian works of art and a large collection of Pacific shells. The most important gift to the art collection came in 1897, when Samuel Bentlif, another Maidstone resident, presented a large collection of oil and watercolour paintings formed by his brother, George Amatt Bentlif.

In the early years of the present century other local residents made substantial gifts or bequests to build on the existing collections, among them the Hon. Henry Marsham in 1906 (Japanese ceramics and bronzes and South American ethnography), William Carey Hazlitt in 1909 (miniatures of the Hazlitt family and other miniatures by John Hazlitt and relics of the Hazlitt family), and Lady Bearsted in 1919 (a large collection of about 350 Baxter prints). W. H. Samuel, son of Lord Bearsted, gave his father's collection of Japanese prints and sword furniture in 1923, R. Mercer his collection of glass and ceramics in 1934, and G. S. Elgood oil paintings and ceramics in 1944.

In 1960 Gerald Hughes presented a collection of about fifty watercolours of Chinese and English subjects by William Alexander, a Maidstone artist who accompanied Lord Macartney on his embassy to the Chinese court in 1792–94. Martin Holmes gave the large sword collection of sixty-five pieces, formed by J. S. Williams, in 1964, and in recent years the collection of 20thC costume has been enriched by the gift of Lord Brabourne of the wardrobe of his mother, Doreen, Lady Brabourne, ranging from about 1930 to the 1970s. In 1984, Mrs Hull Grundy made generous gifts of Art Nouveau and Art Deco jewellery, silver and medals, as well as sculpture, including a bust by Epstein.

The Dutch and Italian paintings include works by Panini, Strozzi, Storck and van Bloemen.

The archæological collection covers a period in Kent from the Stone Age to mediæval times and includes fine items of jewellery and glass from pagan Anglo-Saxon cemeteries. The Kent Archæological Society's collection is also on display.

There is a small sales area where the Museum's *Foreign Paintings Catalogue* and other publications are available.

MALMESBURY, *Wiltshire*

Athelstan Museum

Cross Hayes, Malmesbury
tel. 066 62-2143

Tues–Sat 10.30–12.30 pm;
closed Sun, Mon (April–Sept);
telephone for winter opening times

Admission free

This Museum, which is concerned with the heritage of this historic hilltop town, was founded by the Malmesbury Borough Council in the mid-1920s and is now housed (since 1979) in the Town Hall in the former Fire Station. There are exhibits covering a wide range of topics, including lace-making, engineering, costume, local personalities, photography, early bicycles and fire-fighting—this last exemplified by a mid-18thC four-man, manual fire engine. Notable in the collection is a drawing by Thomas Girtin of Malmesbury Cross; a contemporary painting of Lawrence Washington, a local magistrate and forbear of George Washington, first President of the United States of America; and a William II penny (Type 2)—one of only two recorded—which was minted in the town.

The Museum has an active society of Friends concerned with raising funds to assist with purchases, and the District Council has plans for the expansion of the Museum and its educational function, including the possibility of publication of a Museum guide and related literature.

MANCHESTER, *Greater Manchester*

City Art Gallery [1]

British painting 18thc–20thc (notably 19thc); Continental paintings from the 14thc (notably Dutch 17thc); Continental and British drawings, watercolours and prints; sculpture; English pottery from the 17thc and porcelain from the 18thc; English silver from the 16thc; furniture

Mosley Street, Manchester
tel. 061–2369422

Mon–Sat 10–6 pm; Sun 2–6 pm

Admission free

Manchester City Art Gallery has only recently reached its centenary, but the history of the collections from which the complex, present-day organisation evolved—the City Art Gallery is only one of seven buildings with museum displays run by the City Council—goes back to the 1820s. In 1823 the Manchester Institution for the Promotion of Literature, Science and the Arts was formed; money was raised by subscription and by the end of 1824 competition entries had been received for a building to house the nascent permanent collections and to provide exhibition space. The design submitted by the youthful Charles Barry was chosen, and from its completion in 1834 Manchester has been distinguished by this fine and rare essay in the Grecian taste, currently being restored to its original elegance and, notably in the interior, its richness. The double-height entrance hall, with its casts of the Parthenon frieze given by George IV, has been spectacularly redecorated to conform with the polychromatic and gilded scheme of 1875.

In 1883 the City Corporation took possession of the building and the fast-growing collections. Since that date they have grown enormously, enriched by a vigorous purchasing policy, and by a series of generous bequests from, for instance, Thomas Tylston Greg (1923, the Greg Collection of English earthenware); Charles Rutherston (1925, comprehensive collection of English art 1900–25); and Mr and Mrs E. Assheton Bennett (1979, the Assheton Bennett Collection of English silver).

The paintings at Manchester span six hundred years, with notable works from all periods, but the particular strength of the collection is in the very fine Pre-Raphaelite and Victorian pictures. Ford Madox Brown's *Work* is one of the best known and complements the remarkable series of decorative wall-paintings in the nearby Town Hall. There are several major works by Holman Hunt, *The Scapegoat*, *The Hireling Shepherd*, a version of *The Light of the World*, and *The Shadow of Death*, but the most vividly evocative of the Brotherhood works is perhaps the pastel portrait of *D. G. Rossetti*, depicted with an intense, glittering

Bernardo Bellotto, *A View of the Castle of Königstein, Saxony, c.* 1756–58 (Manchester City Art Gallery)

Louis Gauffier, *Pygmalion and Galatea*, 1797 (Manchester City Art Gallery)

Medusa's head doorknocker in bronze by Emile-Antoine Bourdelle, 1925 (Manchester City Art Gallery)

but introspective gaze. Rossetti's Pre-Raphaelite style is represented by the relatively early *Dante Meeting Beatrice* (1854), but the the most exquisite examples of his work are the finely wrought drawings, *Boatman and Siren* and the pen and ink portrait of Miss Siddal. Millais's youthful *Death of Romeo and Juliet* is undeservedly little-known, overshadowed no doubt by the immensely popular *Autumn Leaves* and the excellent and impressive group of late works. Later Rossettis also show the artist in command of the lush style which characterises his paintings of the 1860s and 1870s. These examples from the later work of the Pre-Raphaelite painters fit well into the general context of the Victorian Collection which contains such notable items as *Too Early*, a masterly piece of social observation by James Tissot; the vast *Captive Andromache* by Lord Leighton, which dominates one whole wall of the gallery; J. W. Waterhouse's much-reproduced *Hylas and the Waternymphs* (1896); and *The Good Samaritan* by G. F. Watts, presented by the artist to the citizens of Manchester in 1852.

From earlier centuries come such treasures as the 14thc Sienese *Crucifixion* (from the collection of the Earls of Crawford and Balcarres, attributed to Duccio); the symbolic 17thc group portrait by John Souch of *Sir Thomas Aston at the Deathbed of his Wife*; the magnificent George Stubbs of *The Cheetah and Stag with Two Indians*; a 'fancy' picture by Thomas Gainsborough of *A Peasant Girl gathering Faggots in a Wood*; Turner's Claudian mythological

214

Francisco Goya Y Lucientes, etching from *Los Disparates* (*Los Proverbios*), *c.* 1816 (Manchester City Art Gallery)

subject, *Thomson's Aeolian Harp* (1809); and a representative collection of Dutch 17thC and 18thC pictures. The coverage of the 20thC has recently been greatly enriched by the purchase of a major Francis Bacon, *Portrait of Henrietta Moraes on a Blue Couch* (1965).

The highlight of the wide-ranging collection of drawings and watercolours is the group of Turner landscapes, but the field of English watercolour painting is excellently represented well into the 20thC.

The sculpture collection is not large but includes one or two distinguished pieces such as Thorwaldsen's *Shepherd Boy* (1825) and Jules Dalou's subtly modelled *Reader* (1877) from the Ionides Collection, which was presented by Helen Ionides in 1921.

Meissen Chinoiserie inkstand probably by Johann Joachim Kändler, *c.* 1760 (Manchester City Art Gallery)

Fine furniture has become a feature of the collections relatively recently, with the purchase of such important examples as the 17thc gilded Venetian side-chairs, the monumental sideboard by Lamb of Manchester, and the painted escritoire by William Burges. As well as these decorative furnishings and the ornaments placed in the galleries, which have a two-fold function in being both exhibits and an appropriate complement to the paintings, the collections include very fine holdings of pottery and porcelain (the Greg Collection of English earthenware provides a useful study collection for all aspects of this ceramic field), glass, and, most notably, English silver. Apart from the remarkable Assheton Bennett Collection the early items include such outstanding examples of English engraved silver as the Magdalene cup, the Mostyn flagon and Robert Smythier's charming 'Chinoiserie' porringer. As well as fine English wares from the 18thc factories—for example, delicately modelled soft paste biscuit figures from Derby—the porcelain collection includes works from the great Continental factories, for examples a ravishing Rococo inkstand from Meissen; a Sèvres pot-pourri vase and cover of 1766; and a group of Kakiemon-style Chantilly wares also from the 18thc.

The Art Gallery has an active and supportive Association of Friends and Patrons, who have an enterprising programme of special events.

There is a shop selling the Gallery's publications as well as postcards, greetings cards, prints, posters, etc.

PUBLICATIONS

Concise Catalogue of British Paintings, 2 vols, 1976–78
Concise Catalogue of Foreign Paintings, 1980
Concise Catalogue of British Watercolours and Drawings, vol. 1 (text only), 1984
Julian Treuherz, *Pre-Raphaelite Paintings from Manchester City Art Gallery*, 1980

Exhibition catalogues:
Jane Farrington, *Wyndham Lewis*, 1980
From Dürer to Boucher: Old Master Prints & Drawings, 1982
Turner at Manchester, 1982
A Century of Collecting 1882–1982: A Guide to Manchester City Art Galleries, 1983
Jane Tozer & Sarah Levitt, *Fabric of Society: A Century of People and their Clothes 1770–1870*, 1983
Henry Lamb, 1984
Goya Etchings, 1984

Objects produced by local artists
or of local interest

Stenner Lane, Didsbury, Manchester
tel. 061-236 9422

Open for a period during the summer:
telephone for latest information

Admission free

Adolphe Valette, *Old Cab at All Saints*, 1911
(Fletcher Moss Museum and Art Gallery, Manchester)

Fletcher Moss Museum and Art Gallery [2]

Fletcher Moss Museum and Art Gallery was formerly known as the Old Parsonage. It was renamed in honour of Fletcher Moss, who bequeathed it, with the gardens and surrounding parkland, to the City of Manchester in 1919. Although most of the building dates from about 1800, its earlier origins are unknown. Alderman Moss believed the centre part to have been a priest's house in Pre-Reformation times. By 1832 the property was owned by Sam Newall, a curate, who extended the building. Quarrels and rumours of ghosts resulted in a new rectory being built far away from the church *c.* 1850.

Alderman Fletcher Moss (1843–1919) was born in Manchester, the second son of a family of corn merchants who owned premises in Hanging Ditch, Manchester. In the early 1850s the family removed to The Elms, Didsbury, a large house adjoining the Parsonage, and in 1865 they began renting the Parsonage itself. At Newall's death in 1884 Fletcher Moss decided to buy it, as he and his mother had become used to living in 'a roomy, old fashioned house with an abundance of cupboards and closets.'

Most of the paintings are by 19thc artists active in the North-West, notably James Fellowes; the Preston-born portrait painter Arthur Devis; and Thomas Stringer, the most famous of the Knutsford family of animal painters. Portraits of notable men and women include those of Bishop William Chaderton (*c.* 1539–1608), Bishop of Chester and Warden of Manchester College, and Sir Richard Arkwright (1732–92), the engineer and inventor of textile machinery, whose innovations in the field of calico and yarn manufacture did much to establish the North-West as the centre of the cotton industry.

Artistic endeavour and achievement are demonstrated in the paintings and drawings by the Pre-Raphaelite associate Ford Madox Brown, who executed the murals in Manchester's Town Hall, and Frederic Shields, Manchester's most prolific Victorian artist.

The large impressionistic paintings of Edwardian Manchester by Adolphe Valette, the French artist who taught, amongst others, L. S. Lowry at the Manchester School of Art, are of great local interest. Complementary paintings of the period include those by Edward Stott of Rochdale and W. C. Estall; there is furniture by Gillows of Lancaster and by James Lamb, the most important cabinet-maker in 19thc Manchester. There are also displays of Manchester glass and the beautifully decorated and glazed Pilkington's Lancastrian and Royal Lancastrian pottery.

There is a shop and a café, and limited car-parking.

Claude Lorrain, *The Adoration of the Golden Calf*, 1660 (Manchester City Art Gallery)

George Stubbs, *Cheetah and Stag with Two Indians*, 1764–65 (Manchester City Art Gallery)

Heaton Hall [3]

The first house was built on this site *c.* 1685 by Sir John Egerton. Heaton was rebuilt in 1772 by James and Samuel Wyatt for the first Earl of Wilton and incorporated some of the finest features of neo-classical interior decoration and design. It was extended by Lewis Wyatt *c.* 1823, and purchased by Manchester Corporation in 1902. According to Pevsner, it is 'the finest house of its period in Lancashire and one of the finest in the country'. The plasterwork is by Joseph Rose, decorative painting by Biagio Rebecca and Michael Novosielski, and there is a very rare Pompeian room.

Although nothing remains of the original contents of the house, Manchester has been steadily acquiring exceptionally appropriate furniture and fittings while restoring the building to its former splendour. In 1960 Manchester City Art Galleries bought for Heaton Hall a magnificent satinwood breakfront bookcase with display-niches in the upper part, ornamented with bold inlay. The cupboards below are enclosed by four panelled doors, each painted with a nymph on a cloud. This piece resembles *Library Cases* published by Sheraton in both his *Cabinet Dictionary* (pl. 53) and his *Cabinet Maker's Drawing Book* (no. 32, p. 3).

The paintings are from the City's collection of English 18thc masters: Dandridge, Hudson, Reynolds, Wheatley, Copley and Wilson are all represented. The furnishings also include important pieces designed by Adam and Wyatt, as well as items on loan from the Fermor-Hesketh and Milnes-Gaskell collections.

The exhibition rooms contain a high proportion of the City's Oriental holdings: Chinese ceramics from the Han to the Qing dynasties, including a large quantity of export porcelain, ivories from the Sassoon Collection, Japanese prints from the Craven Moore Bequest, arms and armour from the Egerton Collection, a polychrome sculpture of a Boddhisattva from the Song dynasty and a unique Japanese lacquer palanquin. These, as well as displays on the history of the house and family, are subject to change.

The 650-acre park, laid out by William Eames in the 1770s, extended by John Webb *c.* 1810 and much municipalised between the wars, was administered by a separate Corporation department until 1984.

There is a cafeteria and a shop selling postcards and guidebooks, such as James Lomax's *The First and Second Earls of Wilton and Heaton House* (1983). Car-parking is available.

Paintings and prints; furniture (18thc); Oriental decorative arts; Japanese prints

Heaton Park, Prestwich, Manchester
tel. 061-236 9422

Open for period during summer, including Bank Holidays: telephone for latest information

Admission free

English satinwood breakfront bookcase, *c.* 1790 (Heaton Hall, Manchester)

Spencer Collection of early printed books, Bibliotheca Spenceriana; Crawford Collection of MSS, Bibliotheca Lindesiana

Deansgate, Manchester
tel. 061-834 5343

Mon–Fri 10–5.30 pm; Sat 10–1 pm. Closed Sun

Free admission to exhibitions

John Rylands University Library [4]

The Library was built in memory of John Rylands, a cotton merchant who was born at St Helens, Lancashire in 1801 and died in 1888, leaving a very considerable fortune. He was married three times, but left no descendants. His third wife outlived him by twenty years: it is to her that the John Rylands Library owes its existence.

Mrs Rylands employed a London architect, Basil Champneys, who designed one of the finest examples of the neo-gothic style of architecture. No expense was spared, and the ornamental decoration is very fine, notably the ironwork in the Art Nouveau style. The Library was begun in 1890, took ten years to build and opened to the public on 1 January 1900.

In 1892 the most famous of all collections of early printed books, the Althorp Library of the 2nd Earl Spencer, came onto the market. It consisted of over forty thousand choice volumes and is today the most splendid part of the book section of the Library. There were, however, very few MSS, for Earl Spencer's interest centred on the early printed book. In 1901 this deficiency was remedied by the purchase of the collection of MSS, both Eastern and Western, belonging to the 25th Earl of Crawford, which formed part of his renowned Bibliotheca Lindesiana. The amount paid by Mrs Rylands for the two collections was nearly half a million pounds. Until her death in 1908, Mrs Rylands added to the Library by extensive purchases of rare books and MSS. The John Rylands Library merged with the Manchester University Library in 1972, and the Deansgate Memorial Building in the city centre is now the Rare Books and Manuscripts division. The main University Library is two miles to the south on the University campus.

The Library publishes its *Bulletin* twice yearly. Many catalogues of the collections of books and MSS have been published; details are available on request.

French statutes of the Order of St Michael, 16thc (John Rylands University Library, Manchester)

Platt Hall (The Gallery of English Costume) [5]

Rusholme, Manchester
tel. 061-224 5217

Mon, Wed–Sat 10–6 pm; Sun 2–6 pm
(Mar–Oct); Mon, Wed–Sat 10–4 pm;
Sun 2–4 pm (Nov–Feb). Closed Tues

Admission free

Platt Hall in Platt Lane is a plain red-brick Palladian house, built from 1764 by Timothy Lightoler for John Carill-Worsley. The interior has an elegant rococo staircase, starting in one flight and curving back in two, with a good plaster ceiling ornamented with fruiting vines. The dining-room in the centre of the upper floor is also a riot of rococo decoration; fitted into the plasterwork over the chimneypiece is a very fine painting by Richard Wilson, *A Summer Evening*, signed and dated 1764. The entrance hall and staircase have been re-decorated in their original colour scheme, and the dining-room is also being returned to its former combination of textured grey-blue walls with plasterwork in buff flecked with gold.

French fan with the central vignette after an etching by Jean Antoine Watteau, *c*. 1750 (Platt Hall, Manchester)

The costume collection includes clothes which belonged to the first owner, given by his descendant, Mrs Clementia Tindal-Carill-Worsley in 1954.

Platt Hall was opened as the Gallery of English Costume in 1947, and now contains the largest and most comprehensive collection of the history of costume from the 16thC–20thC outside the Victoria and Albert Museum. The nucleus of the collection is approximately four thousand items of costume, being the collection of Dr C. W. Cunnington, which was purchased by the Council in the same year. Occupational costume is particularly well represented, appropriately in a region so profoundly affected by the Industrial Revolution. There is also a good representative collection of about 240 fans, as well as some non-precious antique jewellery dating from the 18thC and 19thC.

There is a shop, and car-parking is available.

Howard Hodgkin, *Interior at Oakwood Court*, 1978–83 (Whitworth Art Gallery, Manchester)

Whitworth Art Gallery [6]

British drawings and watercolours (18thC–19thC); textiles (Coptic cloths to contemporary fabrics); wallpapers; Old Master and modern prints; Japanese colour woodcuts; British paintings, drawings and sculpture (20thC)

University of Manchester, Oxford Road, Manchester
tel. 061-273 4865

Mon–Wed, Fri, Sat 10–5 pm; Thurs 10–9 pm. Closed Sun

Admission free

The Art Gallery was founded by the legatees of Sir Joseph Whitworth (1803–87), one of the leading industrial engineers of Victorian England, as a memorial to him. Gifts and bequests from collectors and scholars such as Sir Charles Robinson (1824–1913), Sir William Agnew (1825–1910), John Edward Taylor (1830–1905), Sir William Flinders Petrie (1853–1942), Sir Thomas Barlow (1883–1964) and Miss Margaret Pilkington (1891–1974) enriched the collections, which, notably in the field of 18thC and 19thC watercolours and of textiles, are among the finest in the country.

The building was designed and built by J. W. Beaumont & Sons (1894–1908), and has a symmetrical façade in red brick, with terracotta decoration and towers at the north and south corners. After the Art Gallery was handed over to the University in 1958, the building was modernised most successfully by John Bickerdike in 1963–68, and now has spacious, well-lit galleries which show the exhibits to great advantage.

The greatest strengths of the collections are in the areas of textiles and of British art. The textile collection encompasses all periods from the Egyptian to the present day and includes an outstanding group of Coptic cloths, as well as Near Eastern tribal rugs, ethnic costume, woven textiles, ecclesiastical vestments and 19thC items, including Morris & Co. tapestries.

The collection of British art is distinguished by the range and quality of the 18thC and 19thC watercolours, including seven sketchbooks by J. R. Cozens, as well as seventeen more highly finished works, some of them associated with the sketchbooks; fifty examples of the work of J. M. W. Turner; the only known example of a sketchboook belonging to Thomas

220

John Robert Cozens, watercolour of *St Peter's from the Borghese*, 1776–79 (Whitworth Art Gallery, Manchester)

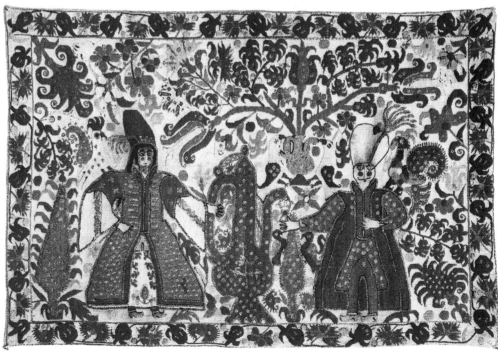

Greek Epirus embroidered silk pillow cover with a wedding scene, 18thc (Whitworth Art Gallery, Manchester)

221

Rembrandt van Rijn, etching of *Landscape with a Cottage and Haybarn*, 1641 (Whitworth Art Gallery, Manchester)

PUBLICATIONS
Guide to the Whitworth, 1979
The Pre-Raphaelites, 1972
Historic Wallpapers in the Whitworth Art Gallery, 1972
*British Watercolours from the John Edward Taylor
Collection*, 1973
Modern British Drawings, 1979
Pollaiuolo to Picasso, 1980
French 19th Century Drawings, 1981
The Draughtsman's Art, 1983
Turner Watercolours in the Whitworth Art Gallery,
1984

Exhibition catalogues:
The Granada Collection, 1983
Fifty Watercolours, 1750–1850, 1983
Norman Foster: Architect, 1984
William Morris and the Middles Ages, 1984

Girtin; and an important group of Pre-Raphaelite works. The representative collection of 20thC British paintings, drawings and sculpture includes important works by Francis Bacon (*Portrait of Lucian Freud*, acquired with NACF help in 1980); Peter Blake; Howard Hodgkin (*Interior at Oakwood Court*, regarded by the artist as one of his finest paintings); Bridget Riley; Lucian Freud (a *Self Portrait*); Henry Moore; Ben Nicholson; Barbara Hepworth; Paul Nash and Edward Burra.

In 1947 the War Artists Advisory Committee gave the Whitworth twenty-four drawings which had been commissioned as part of their scheme for recording operations and service life during the Second World War, 1939–45. This group made an important addition to the Gallery's existing collection of 20thC British drawings.

The gift of Turner's *Liber Studiorum* provided the original impetus for the building of a fine and extensive Old Master and modern print collection. Among the highlights of this collection are Pollaiuolo's *Battle of the Nudes* (one of the many masterpieces presented by George Thomas Clough in 1921); Rembrandt's *Three Crosses*; Dürer's *St Eustace* and *Melancholia*; and fine groups of Piranesi etchings and Japanese woodcuts.

An outstanding collection of historic wallpapers was presented to the Whitworth in 1967 by the Wall Paper Manufacturers Ltd on account of the fact that the Gallery already owned important holdings of prints and textiles.

There is a Gallery shop and a bistro, and car-parking is available.

Wythenshawe Hall [7]

Furniture (16thC–19thC)

Wythenshawe Park, Northenden,
Manchester
tel. 061-998 23331

Opening times variable;
intending visitors are advised to telephone

Admission free

Wythenshawe Hall was the home of the Tatton family for at least four hundred years, the Great Hall and Withdrawing Room of the present building dating from *c.* 1540. The Withdrawing Room is of outstanding architectural interest: wall-paintings of *c.* 1540–70 in imitation of panelling with a High Renaissance frieze decorate one wall, while the remainder are covered by genuine arcaded oak panelling of *c.* 1620. Two wings flanking this central core have been substantially remodelled, principally during the early 1800s when an ante-room with bedroom above was converted from the original chapel and an opulent library wing constructed; the library retains its original suite of bookcases by Gillows of *c.* 1812. This work may have been directed by Lewis Wyatt (1777–1853). During the 1840s antiquarian features were introduced to both the interior and exterior of the hall, possibly by Edmund Blore (1787–1879), including half-timbering of the East Front.

The Hall is being developed as a Country House Museum, with important collections

of 16thc and 17thc furniture, some bequeathed by Robert Tatton, the last surviving direct male descendant of the family, together with Victorian pieces, for example, a library table by Richard Bridgens. An exhibitions Gallery shows temporary displays drawn from the City Art Galleries' collections.

Wythenshawe, together with 250 acres of surrounding parkland, was given to the City of Manchester in 1926 by Lord and Lady Simon, who purchased the Hall from Robert Tatton.

A guide to Wythenshawe Hall is under preparation. There is a shop and a café, and parking is available.

MANSFIELD, *Nottinghamshire*

Mansfield Museum and Art Gallery

Leeming Street, Mansfield
tel. 0623-22561, ext. 264

Mon–Fri 10–5 pm; Sat 10–1 pm.
Closed Sun

Admission free

The Museum and Gallery holds local and topographical collections, watercolours of old Mansfield, and a ceramic collection including Wedgwood, Rockingham, Derby, Pinxton and Nantgarw wares.

A new natural history display, 'The Nature of Mansfield', has recently been mounted.

MIDDLESBROUGH, *Cleveland*

Middlesbrough Art Gallery [1]

British painting (20thc)

320 Linthorpe Road, Middlesbrough
tel. 0642-247 445

Mon–Sat 10–6 pm. Closed Sun

Admission free

One of the best and largest collections (over four hundred works) of 20thc British pictures in the north of England, the Art Gallery, founded in 1937, has been housed in a converted Victorian house since 1958. Important acquisitions are continually made, both of established artists and of those at an early stage of their career.

Works include Bomberg's *The Gorge, Ronda, Spain* (1935), Gaudier Brzeska's *Wrestlers* (1913), Epstein's *Bust of Somerset Maugham*, Gowing's *Miss 'S' of Winlaton Mill*, as well as examples by Patrick Procktor, Anne Redpath, Ceri Richards, Elisabeth Frink, Elizabeth Blackadder and many more.

A catalogue of the collection is available on the premises. There is free parking outside.

Middlesbrough Borough Council also administers:

Captain Cook Birthplace Museum [2]

Material associated with the life of Captain James Cook (1728–79)

Stewart Park, Marton, Middlesbrough
tel. 0642-311 211

Daily 10–6 pm (summer); 9–dusk (winter)

Admission charge

The purpose-built museum was opened in 1978 to mark 250 years since the birth in Marton, near Middlesborough, of James Cook, explorer and circumnavigator of the world. Many items, including paintings and prints, are displayed as sets, for instance, Whitby quayside and Cook's cabin, and other galleries illustrate the ethnography and natural histories of the countries explored by him during his three famous voyages.

NEWCASTLE-UNDER-LYME, *Staffordshire*

Newcastle Borough Museum [1]

The Brampton, Newcastle-under-Lyme
tel. 0782-619705

Mon–Sat 9.30–1 pm, 2–6 pm;
Sun (May–Sept) 2–5.30 pm

Admission free

Housed since 1956 in an Italianate-style detached Victorian house of 1853, the collections include ceramics, weapons, clocks, textiles, natural history and local history.

Hobbergate Art Gallery [2]

The collection contains British watercolours from the 18thC to 20thC, including a small collection of Victorian oil paintings and a local topographical collection. There is a programme of temporary exhibitions.

Car-parking is available.

NEWCASTLE UPON TYNE, *Tyne and Wear*

John George Joicey Museum of Local History [1]

As well as local historical exhibits, the Museum has a collection of furniture and weapons, and wood engravings by Thomas Bewick.

Laing Art Gallery [2]

The Gallery was presented to the City by a Scotsman, Alexander Laing (1828–1905), who, having established a beer bottling firm, developed a highly successful business as a wine and spirit merchant and was a generous benefactor to the city of Newcastle. In 1900 his plans to build an art gallery were put forward to the City Council, drawn up by local architects Cackett and Burns-Dick, and were completed four years later. The Gallery was opened with a large loan exhibition, there being no permanent collection to exhibit. There was initially a charge for entry, except on Sundays, which proved unacceptable and which was quickly abandoned. The Gallery began acquiring objects and receiving important and numerous bequests of fine and applied arts from 1919 onwards.

The holdings of British paintings in the Gallery are very rich in quality and variety. The 18thC is well represented by portraits and landscapes with works by Reynolds, Joseph Wright of Derby, Allan Ramsay and Richard Wilson. There are particularly fine 19thC pictures, amongst which are some of the best works and a unique group by John Martin (who was born nearby in Haydon Bridge), such as *The Bard* of 1817, and the powerful and dramatic *Belshazzar's Feast of c.* 1820. There is a major Maclise, *Alfred in the tent of Guthrum the Dane* of 1852, and three important Landseers, including the huge pictures of *The Wild White Cattle of Chillingham* and *The Deer of Chillingham* commissioned in 1867 by the Earl of Tankerville for Chillingham Castle. The Pre-Raphaelite pictures are many and include Holman Hunt's *Isabella and the Pot of Basil* and Burne-Jones's sumptuous *Laus Veneris* of 1872–75. Later British painting is represented by Stanley Spencer's *The Dustman*, refused by the Hanging Committee of the Royal Academy in 1935, and works by Matthew Smith, Ivon Hitchens, David Bomberg and many more. More recent works include those by such artists as Richard Hamilton and Tom Phillips.

The Laing has a very fine collection of watercolours from the earliest period of watercolour painting, such as Francis Barlow's *The Lion, King of the Animals* and works by Alexander Cozens. Some of the best painters of the 19thC are represented by de Wint, Prout, Cox, Roberts and Lear. There are also interesting local paintings, many by a group of painters who were members of the Northumberland Institution for the Promotion of the Fine Arts (which became the Northern Academy of Arts), established in 1822. Two of its founder members, Thomas Miles Richardson and Henry Perlee Parker, are well represented, with *Excavations for the Railway* and *The Opening of the Grainger Market* of 1835, respectively. William Bell Scott (the first Director of the Government School of Design in Newcastle) and some of his pupils are also represented; the work of Charles Napier Hemy by *Among the Shingle at Clovelly* of 1864 and Henry Hetherington Emmerson by *The Village Tailor* (his father).

The collections of decorative arts are exceptionally fine. Silver was first produced in Newcastle as early as 1423 and the Gallery holds examples of local silver from *c.* 1670 to 1882, two years before the assay office was closed. The silver pieces range from the earliest lidded tankards and porringers to the 19thC tea services. Domestic, ecclesiastical and presentation silver are very well represented: see particularly the church plate made for St Andrews, Newcastle, by John Langlands and Robertson in the 1770s and 1780s and engraved

The Brampton, Newcastle-under-Lyme
tel. 0782-611962

Tues–Fri 2–6 pm; Sat 9.30–1 pm, 2–6 pm.
Closed Sun, Mon

Admission free

City Road, Newcastle upon Tyne
tel. 0632-324562

Mon–Fri 10–5.30 pm, Sat 10–4.30 pm.
Closed Sun

Admission free

British oil paintings and watercolours from the 18thC to the present; collection of paintings by John Martin; British and Tyneside silver, ceramics and glass

Higham Place, Newcastle upon Tyne
tel. 0632-327734/326989

Mon–Fri 10–5.30 pm; Sat 10–4.30 pm; Sun 2.30–5.30 pm; Bank Holidays 10–5.30 pm

Admission free

John Martin, *The Bard*, 1817
(Laing Art Gallery, Newcastle upon Tyne)

Edward Burne-Jones, *Laus Veneris*, 1873–75 (Laing Art Gallery, Newcastle upon Tyne)

by Ralph Beilby and Thomas Bewick. The collection of glass, too, is outstandingly fine as it has been a local industry since 1619. It is perhaps best known for the production by William Beilby (1740–1819) who perfected a method of fusing enamel on to glass, and his work is well represented here. There is also a comprehensive collection of engraved pieces dating from between 1801 and 1880, as well as a good selection of 18thc and 19thc English lead glass and Irish cut glass.

English ceramics too have a place in the history of Tyneside. An early pottery was founded by John Warburton at Pandon Dean in *c.* 1730, and thereafter other potteries flourished until well into this century. Local potteries produced creamwares, lustre, sponged and transfer-printed wares. There are fine examples of soft-paste porcelain, from the Worcester, Caughley, Liverpool and Chelsea factories, as there are of Wedgwood and lustre wares and Victorian Staffordshire portrait figures.

The costume collection numbers about two thousand articles of all kinds ranging from rare Mediterranean embroideries to underwear. A large collection of over a thousand Japanese objects was bequeathed to the Gallery in 1919 by Arthur Higginbottom, a local collector, which includes a large number of prints of some of the best artists of the 18thc and 19thc with a wide range of subject-matter.

The Gallery has an active association of Friends who play an important role in contributing to the collections. There is a Museum shop.

PUBLICATIONS
Collection Handlist—Fine and Applied Art, 1976
British Watercolours in the Laing Art Gallery, 1976
Iain Bain, *Thomas Bewick: An Illustrated Record of his Life and Work*, 1979
A Tyneside Classical Tradition: Classical Architecture in the North East, c.1700–1850, 1980
The Picturesque Tour in Northumberland and Durham, c. 1720–1830, 1982
Capability Brown and the Northern Landscape, 1983
Christopher Wright, *Dutch Landscape Painting*, 1983
Northumbrian Views: Six selected 18th and 19th Century Watercolours, 1983
Charles Napier Hemy RA 1841–1917, 1984
Paul Usherwood, *Art for Newcastle: Thomas Miles Richardson and the Newcastle exhibitions 1822–1843*, 1984

University Greek Museum [3]

Greek and Etruscan art and archæology

The Quadrangle, The University,
Newcastle upon Tyne
tel. 0632-328511

Mon–Fri 10–4.30 pm. Closed Sat, Sun

Admission free

The collection was started in 1956 for teaching purposes, with a grant of £100, on the initiative of C. I. C. Bosanquet, then Rector of King's College, Newcastle, in the University of Durham (the precursor of the present University of Newcastle). Major benefactors have included James Bomford (1896–1979) of Aldbourne, Wiltshire, and London, collector and patron also of the Ashmolean Museum, Oxford (q.v.), and Lionel Jacobson (1905–78) of Newcastle upon

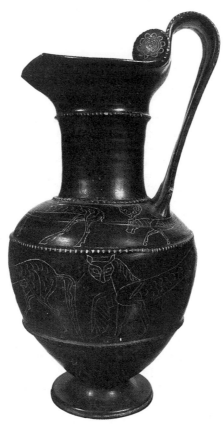

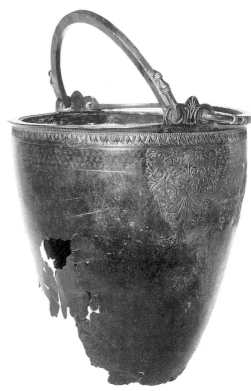

Black pottery Etruscan ewer with incised decoration, 7thc BC (University Greek Museum, Newcastle upon Tyne)

Greek decorated bronze situla, 4thc BC (University Greek Museum, Newcastle upon Tyne)

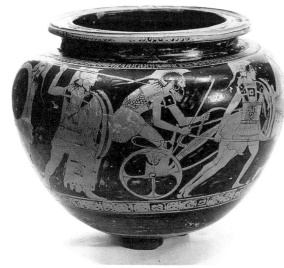
Greek Attic vase with a battle scene in red-figure decoration, *c.* 460–450 BC (University Greek Museum, Newcastle upon Tyne)

PUBLICATIONS
Patricia Foster, *Greek Arms and Armour*, 1978

European paintings, drawings and sculpture, mainly Italian, from the 14thC to the present

The Quadrangle, Newcastle upon Tyne tel. 0632-328511

Mon–Fri 10–5 pm; Sat 10–4.30 pm. Closed Sun

Admission free

Tyne, philanthropist and head of a great national group of firms. In 1982 the Museum received a significant bulk gift of material from the Wellcome Museum, London, and a sizeable and important collection of classical stone sculpture from the same source on permanent loan.

The pottery collection contains vases and fragments illustrating the development from Geometric to Hellenistic, including some fine Attic Red Figure by the Pan Painter, Altamura Painter, Blenheim Painter, Achilles Painter, Splanchnopt Painter, Group of Polygnotos, Manner of Meidias Painter, and is especially strong in Attic 'Black Glaze' of the 5thc and 4thc BC. There are important early Etruscan bucchero and Chiot transport amphoræ.

There are fine architectural pieces in terracotta, especially antefixes from Southern Italy, Sicily and Etruria, East Greek plastic vases, and some good 'Tanagras'.

The collection of bronzes includes arms and armour, early archaic griffin protomes and a Phoenician bowl with Egyptianising frieze. There are outstanding collections of bronze vessels and implements and their handles, including 4thc BC decorated situlæ and small bronzes, animals and human.

Of stone sculpture there is a fragmentary early 4thc BC Attic grave relief. The Wellcome deposit includes a large 4thc BC lionhead spout in marble, Roman reliefs, a porphyry foot of colossal size, some good Græco-Roman pieces and a Palmyrene limestone head.

The range of the Museum is very wide: it includes jewellery, engraved gems, carved amber, pre-Roman glass (Mycenaean to Hellenistic, including a fine cast bowl), faience, a silver bowl (Achaemenid type), and an Etruscan engraved ostrich egg with early archaic orientalising frieze.

The Hatton Gallery [4]

Established in 1926 in memory of Professor R. G. Hatton, the Gallery has a permanent collection of European paintings, drawings and sculpture, with the emphasis on Italian work, from the 14thC to the present day. The most unusual exhibit is Kurt Schwitters's last large relief, *The Elterwater Merzbau*. The Gallery organises a varied programme of changing exhibitions as well as providing the venue for major offerings from the Arts Council. In 1984 the Gallery acquired the Fred and Diana Uhlman gift of African sculpture, an important and artistically influential collection.

NEWLYN, *Cornwall*

Newlyn Art Gallery

19thc–20thc British painting

New Road, Newlyn, Penzance
tel. 0736-3715

Mon–Sat 10–5 pm (Aug 10–6 pm).
Closed Sun

Admission free, except for very special
exhibitions

The Gallery's permanent collection is still being developed and at the same time an ambitious building programme is under way to enlarge the premises to house the collection. The present building was designed in 1895 by James Hicks (d. 1896) for John Passmore Edwards (1823–1911), the newspaper tycoon and benefactor, as an exhibition gallery for the Newlyn School painters. Since 1974 it has operated as an educational charity, the Newlyn Orion, and the intention is to collect paintings with a Cornish connection, in particular the Newlyn School.

The Gallery has an Association of Friends. A shop sells publications, postcards and a good selection of catalogues of recent exhibitions, including *Artists of the Newlyn School 1880–1900* and *Painting in Newlyn 1900–1930*. There is a coffee-room and easy parking.

NORTHAMPTON

Central Museum and Art Gallery [1]

Guildhall Road, Northampton
tel. 0604-34881, ext. 391

Mon–Sat 10–6 pm. Closed Sun,
Good Friday, 24 Dec

Admission free

Established in 1865, the Museum originally opened in the Town Hall and later, in 1884, moved to its present site, formerly the County Gaol, built in 1846. The collections have greatly benefited from bequests, such as that of the Marquess of Northampton (1790–1851) whose splendid County-based geological collection was given to the Museum in 1878. In all, the Museum holds about twenty-five thousand geological specimens of great interest and importance, as is its archæological collection.

The Art Gallery holds a good collection of paintings, most notably *Balshazzar's Feast* by the 18thc Venetian painter Francesco Fontebasso and some earlier Italian works, for example *David and Solomon* attributed to Cima da Conegliano. British paintings include a portrait of the *Stanhope Children* by James Ward, works by Morland and Crome, and later painters, John Nash (*Deserted Sheep Pen*), Sickert, John Bratby and Edward Bawden.

Recently the Museum has been building up a collection of contemporary graphics. The decorative arts are well covered with collections of Staffordshire pottery, Delftware, English porcelain and glass and Oriental ceramics. Northampton's main industry, shoemaking, is illustrated by a huge range of boots and shoes from Roman and mediæval times to the present day, and is the largest collection in the world. Started by Sir Phillip Manfield in 1874, so that workers in Northampton's staple industry could study footwear from all over the world, it is the most important feature of Northampton Museum. It is complemented by a large group of 18thc shoe buckles given by Mrs Hull Grundy.

A shop sells a short guide to the Museum, and catalogues, including that of the centenary exhibition in 1984.

Museum of Leathercraft [2]

Leatherwork from its earliest use to the
present day

60 Bridge Street, Northampton
tel. 0604-34881, ext. 382

Mon–Sat 10–1 pm, 2–5.15 pm.
Closed Sun, Good Friday

Admission free

John W. Waterer, leathergoods designer and author of several books on the history of leather, and Claude Spiers, leather chemist, both died in 1977, and were both prominent among the group responsible for founding the Museum of Leathercraft. The Museum first opened in London, later moved to Walsall and then went to Northampton in 1977 and opened there the following year in a former charity school of 1811.

The collection concentrates on the manufacture and use of leather through the ages, from earliest times to the present day. Areas covered include luggage, harnesses, gloves, sports goods, clothing, bags and purses, musical instruments, bottles, jars and boxes. There are also leatherworking tools from a variety of trades and examples of bookbinding, Spanish leather wall-hangings, fire-fighting equipment and military equipment. Recently acquired is the A. D. Burdett collection of North American Indian material.

The Museum benefits from the Association of Northampton Museums. There is a shop which sells a range of publications on leather, and there are pay car-parks nearby.

NORWICH, *Norfolk*

Norwich Castle Museum [1]

17thc–20thc British painting, especially
Norwich School; ceramics, glass, silver;
17thc Dutch paintings; jewellery and vertu;
local archæology and natural history

Norwich Castle
tel. 0603-611277

Mon–Sat 10–5 pm; Sun 2–5 pm

Admission charge

The Museum began as the Norfolk and Norwich Museum, a private institution, in 1825 and it was not until 1894 that the collections moved to their present location in the Castle and became public. The Keep of the Castle dates from the 12thc, with elaborate arcading on the exterior and a sculptured portal with capitals illustrating hunting scenes. The Castle was the County Gaol from the Middle Ages until 1887. William Wilkins (1778–1839) was responsible in 1824–28 for the rest of the exterior in the castellated style. The radial plan with cell blocks was converted into galleries which determined the Museum's wheel-like plan.

Sir James Smith (1759–1828), botanist and founder of the Linnean Society, led the movement to found the Museum, and John Gurney (1845–87) proposed using the Castle. This was followed by large and important bequests, principally those of Robert Fitch (1802–95) and Jeremiah James Colman (1830–98), founder of the mustard empire, who, with his son, Russell James Colman (1861–1946), gave their magnificent collections of Norwich School paintings; the latter also gave two galleries in which to display them. Colonel E. A. Bulwer (1864–1934) and his wife initiated the ceramic collection and gave their teapots.

The main strength of the collection lies in the paintings and watercolours of the Norwich School of Artists, the only important regional development in British landscape painting. It numbers over two hundred oil paintings and nearly a thousand watercolours. John Crome, founder of the Norwich Society, is represented by some of his best-known paintings, *Yarmouth Jetty* and *Back of the New Mills, Norwich*. Equally, J. S. Cotman's work is superbly represented: *Greta Bridge*, *Devil's Elbow*, *Rokeby Park* and *The Marl Pit* are some of the most memorable. The work of other members of the Norwich School, John Middleton (*Alby, Norfolk*), Crome's son, John Berney, James Stark, George Vincent and Alfred and Joseph Stannard all feature in this magnificent collection.

The Museum holds a fine collection of 17thc Dutch and 18thc English paintings showing the sources of the Norwich School, and includes work by Hobbema, Van der Neer, Richard Wilson and Gainsborough. British watercolourists included for comparison with the Norwich School include Turner, Girtin, Cox, Varley and de Wint. Later British artists include Burne-

English mediæval alabaster, Head of
St John the Baptist, late 15thc or early 16thc
(Norwich Castle Museum)

John Crome, *New Mills: Men Wading, c.* 1812 (Norwich Castle Museum)

228

Jones, Sickert and Gwen John.

Of the decorative arts, the 18thC Lowestoft porcelain is considered to be the best collection. Particularly remarkable here is the 'Elizabeth Buckle' bowl of 1768. The Museum also holds a fine collection of Norwich silver; the assay office existed from 1565 to 1702. Two early pieces are a silver flagon by William Cobbold of *c.* 1580 and a silver gilt-cup of Beeston St Lawrence of 1635–36. The Bulwer collection of 18thC ceramic teapots is matched by that of the Caldwell collection of custard cups.

Works of particular note from the earlier centuries include a black-figure Panathenaic amphora, Celtic gold torcs from Snettisham, a Roman bronze cavalry parade helmet from the river Wensum at Worthing and mediæval English alabasters.

The Museum has an Association of Friends. A shop sells publications, posters, replicas, models and reproductions. There is a cafeteria and fully licensed buttery, and a large public car-park below the Castle.

PUBLICATIONS
Guide to the Castle Museum, 1984
Andrew Moore, *The Norwich School of Artists*, 1985
Sheenah Smith, *Lowestoft Porcelain*, Vol. I *Blue and White*, 1980
Sheenah Smith, *Lowestoft Porcelain*, Vol. II *Polychrome*, 1985
Norwich Silver in the collection of Norwich Castle Museum, 1980

Sainsbury Centre for Visual Arts [2]

The Sainsbury Centre houses the collection which was the gift to the University of Sir Robert and Lady Sainsbury in 1973; it opened to the public in 1977.

The founder of this institution, Sir Robert Sainsbury, set out his philosophy both for the building of his collection and for the form in which he chose to expose it to a wider audience. In a lecture given at the Courtauld Institute of Art in 1977, he said, 'I have never regarded myself as a collector in the most usually accepted sense of the word—that is to say, I have always refused to acquire something merely because it filled a gap, or added to the representations of some particular art form. Rarity, as such, has had no attraction for me. If asked what I am looking for, I always say "I am not looking for anything". On the contrary, I have spent my life resisting temptation. For, although denying that I am a collector, I have to admit that, first as a bachelor and then jointly with my wife, I have, for over forty years, been a passionate acquirer'

In the same lecture Sir Robert explained the reason for establishing a 'Centre for the Visual Arts' rather than a straightforward museum or gallery: 'It is because we wanted to give some men and women—and who better than undergraduates in a School of Fine Arts—because we want to give them the opportunity of looking at works of art in the natural context of their work and daily life'

Although the Sainsbury Centre is a vast space, it is one of the only public buildings in the country housing important works of art to reject entirely the monumental historic style in which the accepted idea of the appropriate environment for fine art is enshrined. It is a single span building of predominantly metal fabric, the absence of internal support columns or decorative details make it seem even larger than it is. The nearest stylistic equivalent is the Beaubourg in Paris with which this exercise in the visible-structure idiom has much in common. In a structure which could happily accommodate the great Blue Whale it is a curious experience to view the often miniscule, mainly sculptural exhibits. The balance of scale is to a certain extent redressed when the University Art Collection is shown, but the Anderson Art Nouveau Collection also abounds in the small and exquisite.

The Sainsbury Collection is particularly strong in two distinct areas: European art of the 19thC and 20thC, with representative groups of Henry Moore, both sculpture and drawings; Giacometti, also sculpture and drawings; Francis Bacon, a remarkable series of paintings; five Picasso drawings; three beautiful Modiglianis; and so on; and secondly, the ethnographical groups based on remarkable holdings of tribal sculptures. There are smaller sections of Oriental, Egyptian and Western Asiatic antiquities as well as a small collection of Greek, Roman and mediæval objects, again mainly sculptural.

The University Collection has been built up since 1970: the works are predominantly abstract—and specifically constructivist—paintings and sculpture, complemented by distinguished examples of 20thC furniture design by, for example, Marcel Breuer.

The Anderson Art Nouveau Collection was given to the University in 1978. It had been built up in the decade 1962–71 and spans most of the characteristic types of Art Nouveau decorative pieces, in glass, ceramic, metalwork, woodwork (i.e. furniture), jewellery and graphics. There are examples of glass by Emile Gallé and René Lalique; fine Rosenburg

Robert and Lisa Sainsbury Collection; 20thC figurative painting and sculpture; Ethnographic sculpture; Pre-Columbian art; Cycladic sculpture; European and Asian Antiquities, notably a collection of Japanese scroll paintings; Anderson Collection of Art Nouveau and the University Collection of abstract art and design

University of East Anglia, Norwich
tel. 0603-56161

Tues–Sun 12–5 pm. Closed Mon

Admission charge

French orchid brooch designed by Georges Fouquet, gold, enamel and baroque pearl, 1898 (Sainsbury Centre for Visual Arts, Norwich)

PUBLICATIONS
Robert and Lisa Sainsbury Collection Catalogue
(opening exhibition), April 1978
Veronica Sekules (ed.), *The University of East Anglia
Collection*, 1984
Penny Johnson, ed. Philippe Garner, *Art Nouveau:
The Anderson Collection*, n.d.

porcelains; Liberty metalwork and impressive pieces of jewellery by Lalique and Georges Fouquet.

The Sainsbury Centre has an Association of Friends. There is a Museum shop selling postcards and various publications, a gallery coffee bar and a restaurant/cafeteria.

NOTTINGHAM

Castle Museum and Art Gallery [1]

European painting 14thc–17thc; British paintings, drawings and watercolours 18thc–20thc; sculpture; mediæval English alabaster carvings; British ceramics, mediæval–present; English domestic silver (18thc–19thc); British and Continental glass (18thc–present); jewellery (mainly 19thc); watches; ethnography and Nottinghamshire archæology

The Castle Museum, Nottingham
tel. 0602-411881

Daily 10–5.45 pm (April–Sept);
10–4.45 pm (Oct–Mar)

Admission free, except for Sundays and Bank Holidays when a small charge is made

Detail of Nottingham alabaster altarpiece with scenes of the Passion, second half of the 15thc (Castle Museum and Art Gallery, Nottingham)

The Castle Museum was constructed within the burnt-out shell of the Duke of Newcastle's Mansion, itself on the site of a ruined Norman castle built by William the Conqueror in 1068. The Mansion was built for the first Duke of Newcastle between 1674 and 1679, but it was not regularly used by the owners after 1700. In 1831 it was burned out by rioters protesting at the rejection of the Reform Bill by the House of Lords. Only the shell remained, until in 1875 the Town Council acquired the building and grounds for conversion into a Museum. The conversion was designed by Thomas Chambers Hine, a local architect, who put on a new roof and reduced the former three storeys to two.

The paintings collection centres around a small but interesting group of Italian and Northern European paintings of religious subjects from the 14thc, 15thc and 16thc bequeathed by Sir Kenneth Muir Mackenzie, son-in-law of the noted 19thc collector and patron of the Pre-Raphaelites, William Graham. There are also Dutch 17thc paintings from the Richard Godson Milnes bequest of 1904; some French works, including the large *Hercules and Diomedes* by Charles Le Brun; British 18thc, 19thc and 20thc items, including good collections of Paul Sandby and Richard Parkes Bonington (both natives of Nottingham), and interesting Pre-Raphaelite and Victorian examples—a *Virgin and Child* by William Dyce, *Marigolds* by Rossetti, *In Love* by Marcus Stone and James Hayllar's *The Old Master*. The 20thc includes work by another Nottingham-born artist, Dame Laura Knight, and there is a group of works by Sir Jacob Epstein in the small sculpture collection.

In the mediæval period Nottingham was an important centre for the production of carved alabaster religious images which were used for altarpieces as well as for private devotional pieces. Small plaques with the head of St John the Baptist were a particular speciality. The Museum has a collection of these Nottingham alabasters including a fine altarpiece of *c.* 1450, divided into five compartments depicting scenes from the Passion.

There is a good, fairly comprehensive collection of British ceramics from the mediæval period to the present day with an emphasis on 18thc earthenware and stonewares. There is also the Felix Joseph collection of Wedgwood, with fine examples of Jasperware, on loan since 1878 and bequeathed in 1892, which is complemented by the Ernest Normand Collection of Wedgwood Basaltware, received by the Museum in 1896. The porcelain collections were greatly enriched in 1967 by the Percy Samson Bequest of early Worcester porcelain, some fifty items mainly of the Dr Wall period.

The fine and varied collection of English domestic silver was assembled by a Nottingham man, Mr Richard Wagstaff Gibbs, a local jeweller, and presented to the Museum by his daughters in 1968. The items in the collection range from highly decorated tea-caddies by Paul de Lamerie and a heavily-chased silver-gilt butter cooler by Paul Storr to a charming group of small novelties and toys, card cases, vinaigrettes, 'harlequin' tongs, a toothpick holder in the form of a pig on wheels, and a cow-creamer.

The Museum has good groups of glass, for example, English 18thc drinking glasses, and an unusual collection of 1870s Salviati & Co. Venetian glass, presented anonymously in 1878, as well as an interesting display of jewellery, mainly 19thc, and some watches.

The numismatic collection is not on display at present, but it includes an outstanding collection of Nottingham tokens and coins of the Nottingham Mint.

The Museum has an Association of Friends, and a number of independent volunteers attend on a regular basis to help in different departments. There is a Museum shop selling postcards, guides and other publications including some catalogues of temporary exhibitions held in the past. An illustrated *Nottingham Castle Museum Guide* appeared in 1984. There is a buttery and bar for light refreshments in a room with a beautiful view.

Museum of Costume and Textiles [2]

Costume 1600–present; fashionable middle-class dress; printed, woven and knitted textiles; European, Chinese, Indian, Persian, etc. embroideries; lace, hand-made 16thC–20thC, machine-made *c.* 1770–20thC

51 Castle Gate, Nottingham
tel. 0602-411881

Daily 10–5 pm

Admission free

In 1974 the costume and textile collections, which illustrate an important aspect of local history for the lace-making centre of Nottingham, were given a separate identity from the main collections of fine and applied art in the Castle Museum (q.v.) when the City Council formed this Museum. Housed in a surviving terrace of three Georgian town houses with many original internal features, the exhibits are displayed in period room settings spanning the period covered by the collections. The rooms also contain items from the Castle Museum's reserve collections of fine and decorative art. Incorporated into the Museum's holding is the Lord Middleton Collection of 16thC–17thC embroideries and costume, and the Nottingham lace industry is represented by three groups acquired over the years, the Spalding Lace Collection (1923), the Mellors Lace Collection (1951) and the Birkin Lace Collection, which came in 1972 from an important local firm. Other items made by local firms have entered the collections, for example, from I. & R. Morley Ltd; Drewry & Edwards; Allen Solly & Co. Ltd; and from local families like the Edges of Strelley, Viscount Galway at Serlby and others.

The Museum has a publication about this important local industry: *Machine Made Lace in Nottingham in the 18th and 19th Centuries*, by Zillah Halls, which can be obtained at the small shop on the premises.

Silk and cotton Leavers lace designed by William Morley and made for the Paris Exhibition of 1900
(Museum of Costume and Textiles, Nottingham)

Newstead Abbey [3]

Material associated with the poet Lord Byron (1788–1824)

Linby, Nottinghamshire
tel. 0623-793557

Daily 1.45–5 pm (Easter–Sept);
Oct–Mar by arrangement

Admission free

Newstead is a country house incorporating a Byron Museum. The collections include items associated with the Byron family and particularly with the poet, Lord Byron, as well as those associated with the history of the house and its owners including the Wildman and Webb families.

The history of the house goes back to its foundation as an Augustinian Priory in *c.* 1170. Many of the claustral buildings still survive, forming the structure of the subsequent conversion by the Byron family who purchased Newstead from Henry VIII in 1540. There is no architect's name associated with the work carried out by the Byrons, but Colonel Wildman's extensive and magnificent restoration in the 1820s was carried out by John Shaw. Matthew E. Hadfield of Sheffield and Charles Alban Buckler carried out work for the Webb family in the second half of the 19thC.

The fine West façade of the 13thC priory church still survives, forming a buttress to the rest of the buildings. Inside, it is on the ground floor that most evidence of the mediæval building survives. The walls of the 13thC chapter house were redecorated in high Gothic style in the 1860s. On the upper floor the mediæval building is well hidden by later plaster and panelling save for the survival of a small fragment of *c.* 1200 wall-painting in the salon, originally the refectory. The salon has a fine 17thC plaster ceiling. A late 17thC ceiling also survives in the Charles II bedroom. The Great Hall was completely and very grandly repanelled by Colonel Wildman in the 1820s and it has a fine minstrel's gallery at its south end. The Henry II room was most beautifully redecorated by the Webb family in the Japanese style with painted Japanese screens of varying dates.

Newstead has an outstanding collection of Byron letters, MSS, first editions, etc. as well as a collection of personal possessions of the poet and some of his Regency furniture. The furniture in his bedroom includes his gilt four-poster bedstead which he used when he was at Trinity College, Cambridge (Fraser Collection). A recent acquisition is the poet's japanned and gilt dressing-table (*c.* 1800), taken away from Newstead in about 1860.

There is a good collection of 18thC and 19thC furniture—some with Newstead associations. A magnificent table (*c.* 1800) with a top inlaid with semi-precious stones was reputedly brought back by Mr Webb's father from an Italian Palace (Fraser Collection). The suite of Charles II Vauxhall mirrored furniture is particularly worthy of note and was purchased from the Gatty collection. A set of twelve gothic oak side chairs (*c.* 1820) was bought with the aid of a grant from the NACF as suitable furnishings for the Newstead of Colonel Wildman's restoration. There is also a collection of some two hundred objects collected during the Crimean War by Colonel Goodlake, brother-in-law of Mr William Frederick Webb, the late 19thC owner of Newstead. It includes some of Goodlake's own uniforms, an early Aquascutum cloak and a uniform of the 5th regiment of Zouaves, as well as many Russian objects.

Few architectural plans of Newstead survive, except for a couple of early 19thC plans showing John Shaw's proposed alteration for Colonel Wildman. A recent purchase is a watercolour (*c.* 1830) showing the salon as it had been decorated by John Shaw with a Willement wallpaper, a copy of which has just been hung on the walls (V&A grant purchase).

Two Victorian photograph albums with original photographs of Newstead from the 1860s, 1870s and 1880s were presented as a gift to the Abbey. Many of the photographs are of the interior.

There is a Museum shop in the Priory kitchen selling books and postcards and souvenirs. The publications and pamphlets on sale include an illustrated *Guide to Newstead Abbey* printed in 1978.

Oak Gothick chair upholstered in green leather, *c.* 1820 (Newstead Abbey, Nottingham)

NUNEATON, *Warwickshire*

Nuneaton Museum and Art Gallery

Ethnography; local archæology and social history

Riversley Park, Nuneaton
tel. 0203–326 211, ext. 473

Mon–Fri 12–7 pm (5 pm in winter);
Sat–Sun 10–7 pm (5 pm in winter)

Admission free

Opened in 1917, the Museum was founded by Alderman Edward F. Melly. It holds a large collection of ethnography and local collections of archæology and social history. Of particular interest is the collection of material associated with the novelist George Eliot (Mary Ann Cross, 1819–80), who was brought up locally. In the fine art collection the most fascinating work is *Before the Deluge*, by the late 16thC Flemish painter Roelant Savery, and there is a group of miniatures given by Lady Stott.

There is a shop.

OAKHAM, *Rutland*

Rutland County Museum

Catmos Street, Oakham
tel. 0575-3654

Tues–Sat 10–1 pm, 2–5 pm;
Sun (April–Oct only) 2–5 pm

Admission free

In a museum largely devoted to local history, with a Victorian shop and an outdoor display of agricultural implements, it is startling to find such an extensive and impressive collection of Anglo-Saxon jewellery, which justifies a special detour.

OLDHAM, *Greater Manchester*

Oldham Art Gallery

British painting (19thC–20thC); graphics (20thC); British watercolours (19thC)

Union Street, Oldham
tel. 061-678 4651

Mon, Wed–Fri 10–5 pm; Tues 10–1 pm; Sat 10–4 pm. Closed Sun

Admission free

Founded in 1885, the Art Gallery was built by Thomas Mitchell and has a wide variety of collections. Principally the emphasis is on British works. There are a number of 19thC paintings, including *The First Madness of Ophelia* by Rossetti; the local painter William Stott of Oldham is also represented. There is a fine display of works by the earlier watercolourists: Turner, Cozens, Girtin, Cox, Prout and Paul Sandby, based on the Charles Lees Collection of watercolours given to the Gallery in 1888. However, more recently the Museum has concentrated on building up its 20thC collection and has an interesting range of paintings, sculpture and particularly prints, including work by Carel Weight, Patrick Heron, Elisabeth Frink and Bernard Meadows.

The Gallery has an Association of Friends. Catalogues are available on the premises for the work of H. H. La Thangue, James Fitton and John Napper. A car-park is adjacent.

OXFORD

Ashmolean Museum [1]

Representative collection of European paintings, drawings and prints from the 15thC to the present day; antiquities, including important classical sculpture; decorative arts (including a large group of finger-rings); Oriental art, notably ceramics; important coin collection

Beaumont Street, Oxford
tel. 0865-512651

Tues–Sat 10–4 pm; Sun 2–4 pm. Closed Mon

Admission free

The Ashmolean Museum owes its name to the historian and antiquary Elias Ashmole (1617–92), the founder, whose specially commissioned foundation portrait, in its magnificent Grinling Gibbons frame, hangs in the Museum to this day. In accordance with the wishes of those great accumulators the Tradescants, father and son, their 'cabinet of curiosities' which came to Ashmole on the death of the younger John Tradescant in 1659, was offered to the University of Oxford in 1678. In 1683 the original Ashmolean building, next to the Sheldonian Theatre (now the Museum of the History of Science), was completed, and the Oxford historian, Anthony Wood, remarked 'twelve cartloads of Tradeskyn's rarities came from Mr Ashmole at London to his new elaboratory at Oxon.' It was the earliest institutional museum in Britain to open to the public.

Few of the remarkable miscellaneous curiosities and rarities that once formed part of the Tradescant collection are still in the Museum: much of the material, in the interests of rationalisation, was dispersed in the 19thC. The fine and decorative arts were hardly associated with the old foundation and it was only in the late 19thC, with the move to C. R. Cockerell's impressive building on Beaumont Street, completed in 1845, that the Ashmolean took on its present-day character, with an extensive and representative collection of Western European and Eastern art and antiquities.

The design for the new Ashmolean Museum and Taylorian Institute was put out to competition. No less that twenty-seven designs had been submitted by the closing date in October 1839, and by the beginning of the following year C. R. Cockerell had been adjudged the winner. The exuberant neo-classical building marks a considerable advance in the use of antique sources, and makes a breathtakingly bold impression to this day: the façade has been widely acclaimed as an outstanding example of the neo-Greek movement. Immediately inside, however, the visitor is brought up abruptly against the constricted space of the present entrance hall, since the spacious hemicycle designed by Cockerell disappeared in 1893.

The exhibits, on the other hand leave nothing to be desired, encompassing as they do Western and Oriental fine and decorative arts: antiquities and archæology and numismatics, as well as the famed Arundel Marbles. The nucleus of the Arundel collection of marbles, dispersed after Lord Arundel's death in 1646 from his house in the Strand, has come together in Oxford from various sources since the late 17thC, and constitutes a unique document in the history of English taste and collecting. It came to the Ashmolean in the course of a long sorting-out of the University collections in the 19thC, when the scientific and ethnological items went from the Ashmolean to the new institutions, the University Museum (1860) and the Pitt Rivers Museum (1865). Other material, Ashmole's MSS, went to the Bodleian. Later, from the Bodleian to the Ashmolean came a miscellany of early items, such as the famous Guy Fawkes Lantern, and in the end some works of art, including Pierce's magnificent bust of Christopher Wren; very valuable drawings; the rare and wonderful Dürer landscape; and

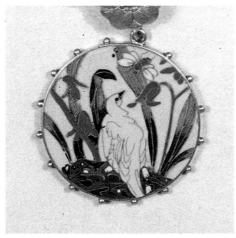
Detail of necklace, gold with cloisonné enamels in the Japanese style, designed by Alexis Falize, 1867 (Ashmolean Museum, Oxford)

Piero di Cosimo, *A Forest Fire*, c. 1488 (Ashmolean Museum, Oxford)

much of the contents of the former 'University Galleries', including the great Fox-Strangways gift of early Italian paintings and the Raphael and Michelangelo drawings once in Sir Thomas Lawrence's collection. Indeed, 'art and archæology' were only united in a formal Ashmolean constitution in 1908, when the two departments of Antiquities and of Fine (now Western) Art were established. Subsequently (1921) the Heberden Coin Room became a third department, and almost all the coin collections from the colleges are now deposited there: in 1961 all the Oriental Collections in the Museums and the old Indian Institute were consolidated together to form the Department of Eastern Art under the Ashmolean flag. There is also the Cast Gallery, a very rich collection of plaster casts of the great masterpieces of classical sculpture, in the care of the Lincoln Professor of Classical Archæology and Art. The Museum is now divided into four departments: Antiquities, Coins, Eastern Art and Western Art.

Coins: 1 & 2, Silver tetradrachm, obverse and reverse, Catana of Apollo, c. 405 BC; 3 & 4, Silver tetradrachm, obverse and reverse, Sicilian Naxos of Dionysus and his attendant satyr, c. 450 BC (Ashmolean Museum, Oxford)

ANTIQUITIES The archæology and art of British and European early history and prehistory; Egypt and the Near East; classical antiquity; British art of the Dark Ages and the Middle Ages; items of local interest, mediæval and later. Amongst these are the surviving nucleus of the early 17thc Tradescant Cabinet of Curiosities in a special display (Powhatan's mantle); the surviving nucleus of the Earl of Arundel's pioneering collection of classical marbles (early 17thc); local archæology; the best collection of Cypriote art outside Greece, and the best collection of Cretan (Knossos) art outside Crete, associated with Sir Arthur Evans's excavations; the Greek vases associated with the name of Sir John Beazley.

WESTERN ART This is one of the major print rooms of the world, including some seventy Raphael drawings and works by Michelangelo, Rembrandt, Dürer, etc., and a fine group of Samuel Palmer including his *Self Portrait*; a representative collection of European and British painting of high quality, for example, Piero di Cosimo's *Forest Fire*, Uccello's *A Hunt in the Forest*, Bronzino, Rubens, Van Dyck, Claude Lorrain, Poussin, Chardin, Watteau, and Tiepolo (the beautiful *Young Woman with a Macaw*). The collection is especially strong in Pre-Raphaelite works, with Millais's *Return of the Dove to the Ark* and Arthur Hughes's *Home from the Sea*. Also in this department are watch-cases, finger-rings; Renaissance bronzes; the Daisy Ward collection of Dutch still-life painting; the Marshall collection of

Soft-paste Worcester plate of the First Period, c. 1770–75 (Ashmolean Museum, Oxford)

234

early Worcester; the Warren collection of English Delftware; and Huguenot silver by de Lamerie and others.

HEBERDEN COIN ROOM This houses the most important collection of the coinages of the world in Britain after that in the British Museum (q.v.), and contains about a third of a million items.

EASTERN ART Here are antiquities mainly from China, Japan and the Indian sub-continent, and Islamic cultures of the Near East. The Department is very strong in Chinese and Japanese ceramics and has a collection of modern Chinese paintings.

There is an active Friends of the Ashmolean, with a membership of approximately 1,900. The Ashmolean has constant help from volunteers (mostly through the Friends). A volunteer guide and education service, a recent innovation, has been enormously successful, and now looks after the Museum's relationship with local schools, television educational contacts, guided parties, and so on.

There is a Museum shop selling publications and postcards. The Museum's publications list is extensive: many of the permanent collections are already catalogued and the excellent catalogues of numerous recent exhibitions are still in print, including that of the Tercentenary Exhibition of 1983. A representative selection from the collections, together with an account of the Museum and its history, is now available in *The Treasures of the Ashmolean Museum* (1985) by Sir David Piper, the former Director.

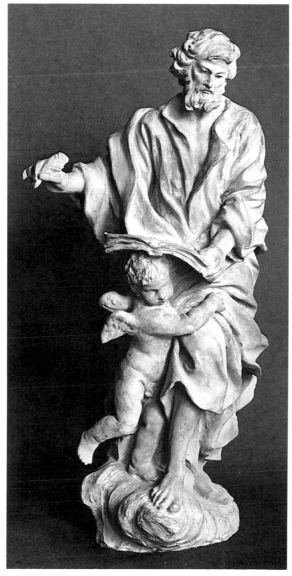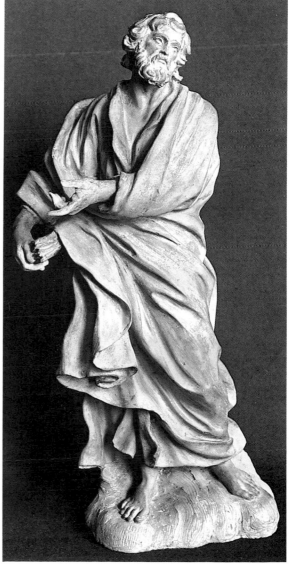

Terracotta bozzetti of *St Matthew* and *An Apostle* by Giuseppe Mazzuoli, *c.* 1679 (Ashmolean Museum, Oxford)

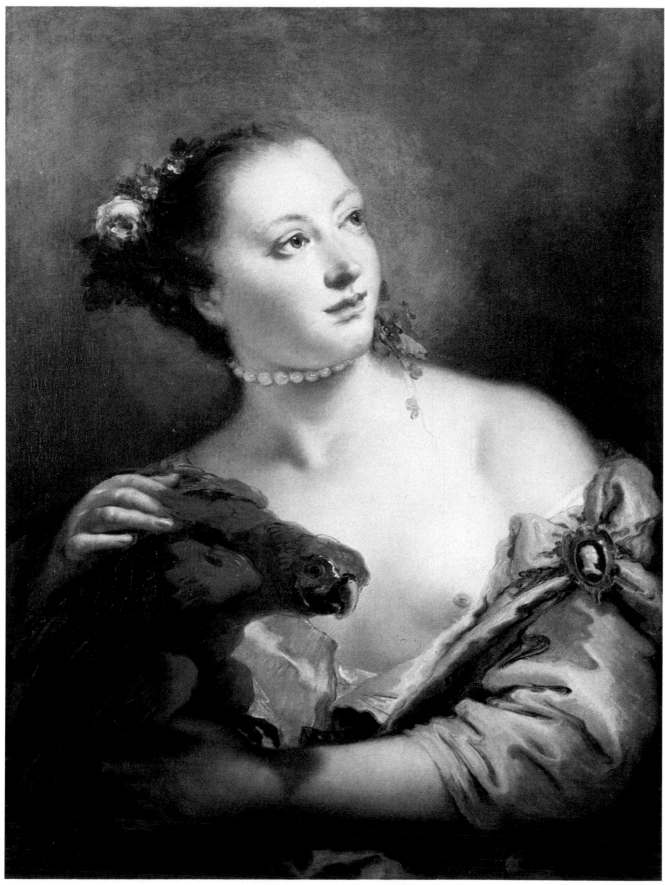

Giovanni Battista Tiepolo, *Young Woman with a Macaw*, *c.* 1756 (Ashmolean Museum, Oxford)

Christ Church Picture Gallery [2]

Mainly Italian paintings and drawings,
14thc–17thc

Canterbury Quadrangle, Christ Church
College, St Aldates, Oxford
tel. 0865-242102

Mon–Sat 10.30–1 pm, 2–5.30 pm
(May–Oct); 10.30–1 pm, 2–4.30 pm
(Nov–April); Sun 2–4.30 pm

Admission charge

This collection of Old Master paintings, and more especially drawings, unique amongst the colleges of Oxford and Cambridge, was founded as a result of a bequest from General John Guise (1682/3–1765).

The Christ Church collection existed for almost two hundred years before a museum was built to house it. Knowledge of Guise's original major bequest encouraged further donations by, for example W. S. Landor (in fact the pictures were actually donated by Landor's great-nieces in 1897) and Fox-Strangways (1828/34). In the 20thc Sir Richard Nosworthy and Major Harding have continued the tradition of bequeathing paintings to Christ Church, and the latest acquisition has been a beautiful pen drawing on vellum by Francesco di Giorgio. This drawing, formerly the property of Baron Hatvany, was allocated to Christ Church by the Treasury in lieu of death duties. The collection has also recently been broadened and enriched by the generous bequest of Mr C. R. Patterson of a number of icons (1977). The Gallery is entirely reliant on gifts and bequests for the enhancement of the collection.

The Guise Bequest (1765) consists mainly of Renaissance, Mannerist and Baroque paintings such as Annibale Carracci's *The Butcher's Shop* and Tintoretto's *Martyrdom of St Lawrence*. The W. S. Landor and Fox-Strangways bequests (19thc) reflect a taste for earlier Italian art and include Filippino Lippi's *Wounded Centaur* and Giovanni di Paolo's exquisite *Crucifixion*. Other important pictures include Van Dyck's early *Continence of Scipio,* given by Lord Frederick Campbell in 1809, the *Deposition* by the Master of Delft, given by the Rev. William Vansittart in 1833, and Frans Hals's late *Portrait of a Lady*.

The Old Master drawings, almost all from the Guise Bequest, represent one of the most important private collections in the country. They include examples of almost all the major, and many minor, Italian masters of the 16thc and many works by 15thc and 17thc Italian artists. There are fine individual examples by northerners such as Dürer, van der Goes, Rubens, Jacob de Gheyn II, as well as interesting Italianate works by northern artists.

In 1964–67, with the aid of a generous benefaction from Sir Charles Forte, Christ Church built a remarkably ingenious award-winning exhibition gallery. The architects, Powell & Moya Ltd, achieved an interesting solution to gallery design. Glass-walled and semi-submerged beneath the Dean's garden, the building was specially designed for the collection and the rooms emphasise the different character of the various bequests. The Print Room is a pioneering design which has influenced, among others, the design of the British Museum drawings display. The top-lighting of the main gallery is an elegant solution to the problem, of great interest to students of modern architecture. This modern building, hidden behind a traditional quadrangle façade, is surprising and beautiful.

Raphael, drawing of *Seven Putti Playing*, 1506–7 (Christ Church Picture Gallery, Oxford)

Museum of the History of Science [3]

Early scientific instruments, clocks and watches

Old Ashmolean Building, Broad Street, Oxford
tel. 0865-243997

Mon–Fri 10.30–1 pm, 2.30–4 pm.
Closed just before Christmas Eve–early Jan, Good Friday and the week following Easter

Admission free

The collections are housed in the Old Ashmolean Building, erected between 1679 and 1683 to house the original Ashmolean Museum, School of Natural History and a chemical laboratory. The original collections were dispersed in the 19thc to the new Ashmolean (q.v.), the Bodleian Library and the University Museum. The present Museum was initiated in 1924 with the presentation of the Lewis Evans Collection of Scientific Instruments. The foundation was assisted by a number of City Companies, including the Goldsmiths' and the Fishmongers'. The building, believed to be by the architect Thomas Wood, is one of the finest examples of 17thc architecture in Oxford, and was perhaps inspired by the plan of a similar building which Sir Christopher Wren was to have built for the Royal Society.

Other collections have been incorporated since the Lewis Evans Collection: the Gunther Loan Collection (scientific instruments and books); the Billmeir Collection (scientific instruments); the Beeson, Barnett and Iliffe Collections (clocks and watches); the Clay Collection (microscopes); and deposits of scientific instruments, books and MSS from many departments and colleges of the University.

The Museum's publications include catalogues of chemical apparatus, watches and drug jars, a brief pamphlet describing the collections, a booklet describing the history of the building and its association with the teaching of science in Oxford, and books published by the curatorial staff on subjects related to the collections. These can be bought from the Museum bookstall.

Brass and silver Eastern Islamic spherical astrolabe by Mûsà, 1480–81
(Museum of the History of Science, Oxford)

English orrery in a silver, ebony and green leather case by Thomas Tompion and George Graham, *c.* 1710
(Museum of the History of Science, Oxford)

Museum of Oxford [4]

History of Oxford City

St Aldates, Oxford
tel. 0865-815559

Tues–Sat 10–5 pm. Closed Sun, Mon

Admission charge

Housed in part of the Town Hall building, designed by H. T. Hare in 1893–97, this is a local history museum which examines the growth of Oxford City and University from the earliest times. Works of the fine and applied arts are limited to items of relevance to the history of Oxford. For example, among the paintings, watercolours and drawings is the 17thc Jan de Wijk's *Siege of Oxford*.

Other notable exhibits include a 10thc gold plaid ring, 16thc clock-jacks and a 17thc civic mace.

There is a Museum shop which sells a publication, *The Story of Oxford*, which integrates the Museum displays with a brief history of the city.

Pitt Rivers Museum and Department of Ethnology and Prehistory

[5]

Archæology; ethnography and folk-life

South Parks Road, Oxford
tel. 0865-512541

Mon–Sat 2–4 pm (parties by arrangement
10.30–12.30 pm). Closed Sun

Admission free

Japanese ivory netsuke from the Hermann Gunther
Collection, 19thc (Pitt Rivers Museum and Department
of Ethnology and Prehistory, Oxford)

Archæology

Priestgate, Peterborough
tel. 0733-43329

Tues–Sat 10–5 pm (May–Sept);
Tues–Sat 12–5 pm (Oct–April).
Closed Sun, Mon

Admission free

The Museum's collections were begun by Augustus Henry Lane Fox, later General Pitt Rivers. His interest was stimulated by his work on the development of firearms for the Army and he began to make his own collection of guns, which now forms one of the permanent exhibits at the Museum. The collection expanded to include all of man's material culture, particularly 'the commoner class of objects . . . which appear to show connection in form'. Pitt Rivers's original scheme of collecting was continued by successive curators and a carefully maintained network of contacts, both in the ethnographical and anthropological fields and in the Colonial service. The University's ethnographical material formerly in the Ashmolean (q.v.) has also been handed over to the Pitt Rivers Museum. The result is a collection of ethnography, archæology and folk-life of international importance, including the Captain Cook Collection (formed by the naturalist Rheinhold Forster on Cook's second voyage); the finest existing collection from the Nagas of Assam; amulets and other magical objects; and one of the three most important collections of musical instruments in the world.

There is an association of Friends who organise an education programme and lectures. According to the wish of General Pitt Rivers, the Museum is also a teaching institution; its publications are scholarly and specialised. A list of the current publications can be obtained from the Administrator, or from the sales point at the Museum.

PETERBOROUGH, *Cambridgeshire*

Peterborough City Museum and Maxwell Art Gallery

Founded in 1880, the Museum essentially holds local collections, especially of archæology, and, unusually, of models in bone and straw-work made by French prisoners-of-war who were interned at Norman Cross nearby, during the Napoleonic campaign between 1797 and 1816. There is also a good collection of glass and porcelain. Included in the fine art section is a painting by Sickert and two by Turner, one of which is *Peterborough Cathedral* of *c.* 1796.

There is a Museum Society. A shop sells publications.

Theodore Nathan Fielding, *View of Stamford*, late 18thc (Peterborough City Museum and Maxwell Art Gallery)

Cookworthy hard-paste porcelain figure of a Continent, *c.* 1770 (Plymouth City Museum and Art Gallery)

Nicholas Condy, *Plymouth's Georgian Guildhall, with a Trial in Progress, c.* 1840–50 (Plymouth City Museum and Art Gallery)

PLYMOUTH, *Devon*

Plymouth City Museum and Art Gallery

British painting (18thC–early 20thC); Old Master drawings; European bronzes; prints; porcelain and pottery (18thC–19thC); English silver (16thC–18thC)

Drake Circus, Plymouth
tel. 0752-668 000, ext. 4378

Mon–Fri 10–6 pm; Sat 10–5 pm. Closed Sun

Admission free

PUBLICATIONS
Exhibition catalogues:
Degas Sculpture, 1982 (out of print)
Old Master Drawings and Bronzes from the Cottonian Collection, exhibited at Sotheby's, 1979
The Clarendon Collection, n.d.
Sir Joshua Reynolds, 1973

Catalogues of the permanent collections are in preparation.

The Museum opened in temporary quarters in 1898 and moved to purpose-built premises in 1910, designed by Thornely and Rooke, local architects. This has been extended in 1938 and 1975. An early benefactor, particularly in the field of decorative arts, was S. T. Whiteford; later, A. de Pass bequeathed several notable oil paintings, among them Italian primitive works and fine drawings by Guardi, Degas and Millais.

There is a good fine art collection with particular emphasis on the 18thC, 19thC and early 20thC schools, such as Camden Town and Newlyn, and a strong representation of South-West artists. The important Cottonian Collection, which includes a small, fine selection of Old Master and English drawings, some European bronzes, a fine collection of prints, as well as a notable library housed in its original Georgian bookcases, was entrusted to the Museum in 1915; it had been formerly housed in the Plymouth Proprietory Library.

The decorative art collection is particularly strong in William Cookworthy's Plymouth and Bristol porcelain. The Hurdle Collection of Plymouth porcelain, English Delftware and porcelain, Chinese porcelain, old Sheffield plate and miscellaneous works of art was bequeathed in 1938, together with money to build a gallery for its display. Other English pottery and porcelain types are well represented, including Martinware and work by Bernard Moore. The collections include a small selection of plate, with some choice pieces, especially the Drake Cup (a silver, parcel-gilt globe cup made by Abraham Gessner of Zurich, *c.* 1595) and the Eddystone Lighthouse Salt (a silver model of the first light by Winstanley). The collection also has important items of late 17thC Plymouth hallmarked silver and early 18thC Exeter hallmarked silver by Plymouth makers. The Museum holds a small collection of 18thC and 19thC glass, and there is a modest collection of costume and lace, again of 18thC and 19thC date, which is almost entirely in reserve but includes notable specimens.

The Museum has an Association of Friends. A sales area (soon to be a proper shop) offers leaflets on the collection, posters, postcards and catalogues for exhibitions since 1965. There is pay-parking nearby.

PONTEFRACT, *West Yorkshire*

Pontefract Museum

The flamboyant Art Nouveau building was originally the Carnegie Free Library, opened in 1904; it was converted to serve as a museum for Pontefract and opened in 1978.

There are displays on the archæology and history of the Town and Castle, including a fine painting of Pontefract Castle as it was before the Civil War, painted in about 1635 by Alexander Keirinx.

Pontefract Museum is administered by Wakefield Metropolitan District Council.

PORTSMOUTH, *Hampshire*

Portsmouth City Museum [1]

The original museum in the High Street opened in 1895, but this building was destroyed during an air raid in 1941. Housed in various locations since then, the Museum has been in its present building since 1972 which was originally part of a large barrack complex of *c.* 1891, possibly by Perry & Co. on behalf of the Army.

The main holding of the collection is of British art and design from the 16thc to the present day, with particular emphasis on the decorative arts, notably artist/designer pieces from the 19thc and 20thc. There are examples of furniture by Pugin, Waterhouse, Christopher Dresser, Heal/Breuer, Frank Lloyd Wright, Duncan Grant and Eileen Gray. The Museum also holds a fine collection of 18thc drinking glasses and an interesting range of 19thc and 20thc glassware.

The studio pottery collection has superb examples of work by De Morgan, Bernard Moore, Michael Cardew, Bernard Leach, Gordon Baldwin and Lucie Rie.

A small but important collection of sculpture has pieces by Leighton, Hepworth, Nick Pope, Alfred Gilbert and Epstein. Notable paintings include *The Belgian Cocottes* by Sickert, *La Marchande de Guimauve* by Sylvia Gosse, *Arched Trees* by Hitchens, *La Rochelle* by Edward Wadsworth, and an important series of paintings by the Cole Family of artists. The collection also includes a wide range of prints.

Topographical views of Portsmouth are well represented in the local history collection with works of exceptional quality by Clarkson Stanfield, Dominic Serres, Thomas Lang and the local sea painter William Wyllie. The grounds include a formal garden with 20thc sculpture.

History of Pontefract, its royal castle and the Priory of St John

Salter Row, Pontefract
tel. 0977-77289

Mon–Sat 10.30–12.30 pm, 1.30–5 pm.
Closed Sun

Admission free

19thc & 20thc British furniture;
18thc–20thc British glass;
local and social history

Museum Road, Old Portsmouth
tel. 0705-827261

Daily 10.30–5.30 pm

Admission charge

Gold and enamel Freedom box made by James Morisset showing the Battle of Cape St Vincent, 1797 (Portsmouth City Museum)

English oak Gothic Tudor chest, *c.* 1520 (Portsmouth City Museum)

The Museum has an Association of Friends. A shop sells contemporary crafts, a wide variety of catalogues from previous exhibitions and a concise catalogue of the Museum's holdings of fine art. There is a licensed refreshment bar, and car-parking is available.

Royal Naval Museum [2]

History of the Royal Navy

H.M. Naval Base, Portsmouth
tel. 0705-822351, ext. 23568

Mon–Sat 10.30–5 pm; Sun 1.30–5 pm

Admission charge

The first museum in the naval base was opened in 1911 as The Dockyard Museum. Its collections included one of the finest collections of warship figureheads in the country and many other varied items of naval interest.

In 1938 a custom-built Georgian-style museum, funded largely by the Society for Nautical Research, was opened alongside HMS *Victory*. It housed the fine figurehead collection and other items relating mainly to Nelson, Trafalgar and the *Victory*.

In 1972 a further expansion was marked by a change of name to the Royal Naval Museum, which is now housed in the original Victory Museum building and three adjacent Georgian red-brick storehouses, the ground floors of which have been converted to receive modern displays.

The Museum is the only one devoted to the overall history of the Royal Navy, and the collections have a special emphasis on social history and on the Nelsonian and Victorian periods, including the Lambert McCarthy Collection of Nelsonian glass, paintings, miniatures and pottery and an English 18thc tortoiseshell tea-caddy given by Nelson to Lady Hamilton and a Bristol cup and saucer which was part of a tea service belonging to Nelson.

Of particular interest is a panorama by Wyllie of the Battle of Trafalgar with full sound effects.

The Museum has an Association of Friends. A shop sells souvenirs, books and pamphlets. There is a buffet available.

PORT SUNLIGHT, *Merseyside*

Lady Lever Art Gallery

Fine and decorative arts; 18thc and 19thc British painting; 18thc furniture, including a superb series of commodes; Chinese porcelain, in particular featuring blue and white; Wedgwood pottery, particularly Jasperware

Port Sunlight, Wirral
tel. 051-645 3623

Mon–Sat 10–5 pm; Sun 2–5 pm

Admission free (voluntary contribution requested)

The Gallery was founded by William Hesketh Lever, 1st Viscount Leverhulme (1851–1925) in memory of his wife, as the centre of his garden village of Port Sunlight. Here the employees of Lever Bros, makers of Sunlight Soap, his great international company, were to enjoy both cultural and amenity benefits of this carefully planned environment. The foundation stone for the Gallery was laid in 1914 by King George V and the Beaux Arts classical stone building, designed by William and Segar Owen, opened to the public in 1922. Since 1978 it has been run by the Merseyside County Council Art Galleries Department.

This is a collection of painting, furniture and the decorative arts which records the taste of one man, Viscount Leverhulme, successful soap manufacturer, millionaire, philanthropist and builder of Port Sunlight and its model village. Initially he bought works of art for his several large houses in London and the country, but by 1911, when he opened Hulme Hall at Port Sunlight as an art gallery, he was buying both for himself and for his public gallery. The Lady Lever gallery was planned in 1913 and opened in 1922, and called after his wife who died in 1913.

Lever rebelled against the ugliness of Victorian furnishings and embarked on the purchase of the finest of 18thc English cabinetwork, initially to be arranged in period rooms in his various homes. The Gallery's many pieces include an unrivalled series of marquetry commodes.

The Chinese porcelain is chiefly of the later 17thc and 18thc of the Kangxi, Yongzheng and Quianlong periods, with particular emphasis on blue and white decorated wares, which the Victorians had rediscovered. There is also much highly-worked enamel, cloisonné and softstone. The Wedgwood pottery reflects Leverhulme's admiration for another pioneer industrialist and concentrates on the 'ornamental wares', in particular the variously coloured jasper: amongst the many fine vases are two examples of the Portland Vase.

The paintings reflect his changing tastes. The early purchases were of contemporary

Sunlight soap advertisement taken from Tayler's
The Wedding Dress, 1889 (Lady Lever Art Gallery,
Port Sunlight)

Albert Chevallier Tayler, *The Wedding Dress*, 1888 (Lady Lever Art Gallery, Port Sunlight)

Victorian subject pictures, some to be used for his soap advertisements. Many were by Royal Academicians, headed by Lord Leighton, whose largest canvas, *The Daphnephoria* (exhibited at the Royal Academy in 1876), and his shimmering *Garden of the Hesperides* (Royal Academy 1892), are here. In the 1890s Leverhulme broadened his tastes to include 18thc English portraiture and landscape, with a series by Reynolds, including the significant *Duchess of Hamilton and Argyll* (exhibited at the Society of Arts in 1760), and Wilson's *Diana and Callisto* (1767). In later years he bought important Pre-Raphaelite paintings as they came onto the market, in particular a version of the *Scapegoat* (1845–55) by W. Holman Hunt. He also admired Napoleon and collected relics and portraits of him.

There is a Gallery shop for catalogues, postcards, etc. The three-volume catalogues of the *Paintings, Furniture, Pottery and Porcelain*, dating from 1920s, are still available.

PRESCOT, *Merseyside*

Prescot Museum of Clock and Watchmaking

The Museum, which is housed in a restored late 18thc building with a typical Georgian frontage, was founded in 1982. It specialises in illustrating the history of the watchmaking industry in this area which existed from 1600 until the 1940s. There is a nationally important collection of watchmaking tools which are displayed in several workshop reconstructions, with a special section devoted to the other local industry of watch tool-making. Notable are the wheel cutting engine by John Wyke (1720–87) and the early watch by Thomas Aspinwall of Toxteth Park, Liverpool, which dates from 1607. Some of the tools from the collection are used to equip a room where handcraft watchmaking methods are demonstrated to interested groups.

A catalogue is in preparation. The Museum shop sells souvenirs and books of local and horological interest.

PUBLICATIONS
Catalogue of Foreign Paintings, Drawings, Miniatures, Tapestries, Post Classical Sculptures and Prints, 1983
Illustrated Guide, 1985

Clocks and watches

34 Church Street, Prescot
tel. 051-430 7787

Tues–Sat 10–5 pm; Sun 2–5 pm.
Closed Mon

Admission free

PRESTON, *Lancashire*

Harris Museum and Art Gallery

18thC paintings, (including Arthur Devis and other members of his family); paintings and watercolours 19thC (Newsham Bequest) & 20thC; 19thC–20thC British and French bronzes; 18thC–19thC British pottery, porcelain and glass; enamels; costumes, accessories and fashion plates; scent bottles; visiting-card cases; archæology; social history of Preston

Market Square, Preston
tel. 0772-58248

Mon–Sat 10–5 pm. Closed Sun

Admission free

Hamo Thornycroft, bronze of *The Mower*, 1888 (Harris Museum and Art Gallery, Preston)

The Harris building was founded as a result of a huge bequest by Edmund Robert Harris (1804–82) to Preston in memory of his father, the Rev. Robert Harris. From a fortune of £300,000 to be distributed to various institutions in the town, £100,000 was to be allocated to the building and furnishing of the Harris Museum. The foundation stone was laid in 1882, and the building opened to the public as the Harris Free Library, Museum and Art Gallery in 1893. The architect of the building was Ald. James Hibbert (1853–1903) of Preston. The Harris is one of the most impressive late neo-classical buildings in Britain. Its exterior, comprising a huge portico of six fluted Ionic columns and sculptured pediment set against a façade of recessed bays with giant pilasters, owes much to early 19thC German neo-classicism, in particular to the designs of K. F. von Schinkel, with an additional elegance derived from James Hibbert's admiration for French architecture. A vast central lantern is the principal architectural feature of the interior and comprises a central rotunda based on the Tomb of Napoleon in Les Invalides, Paris, and several balconies with walls decorated with friezes of casts of the Elgin marbles and sculptured reliefs from Nineveh, from the originals in the British Museum.

The collections at the Harris Museum have been built on a nucleus of important gifts and bequests. Even before the Harris building was completed, the Preston Corporation had received an important bequest of 19thC British paintings from a local banker and mill owner, Richard Newsham, who died in 1883. The Rev. John Haslam (d. 1924) bequeathed a fine collection of English watercolours which were received by the Harris shortly before the death of his widow in 1949. Cedric Houghton (d. 1910) bequeathed a collection of English pottery and porcelain; R. H. Smith gave a collection of English porcelain; Mrs C. A. L. French bequeathed a collection of over 2,500 scent bottles and almost a thousand Victorian card cases in 1964; and Dr H. Taylor gave a collection of about two hundred pieces of glass, mostly 18thC English drinking glasses, in 1945. In addition, the fact that Preston was the birthplace of Arthur Devis has encouraged the acquisition over the years of a representative group of his conversation-piece paintings, a large and comprehensive group of topographical watercolours and oil paintings by Anthony Devis, his half-brother, and a selection of fine portraits by his son, Arthur William Devis.

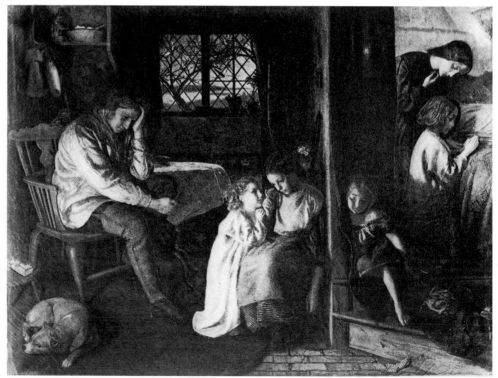

Arthur Hughes, *Bedtime*, 1862 (Harris Museum and Art Gallery, Preston)

Among the artists represented by fine works are Arthur Devis (*Francis Vincent, his Wife Mercy and Daughter Anne, of Weddington Hall, Warwickshire*), William Aikman (*The Third Earl of Burlington and His Wife, 1723*), Francis Danby (*Pharoah and His Hosts Overwhelmed by the Red Sea*), John Frederick Lewis (*The Bey's Garden*), Arthur Hughes (*Bedtime*), J. M. W. Turner (*Kidwelly Castle*), Samuel Palmer (*The Dawn of Life*), J. R. Herbert (*The Judgement of Daniel*), and Frederic, Lord Leighton, John Linnell, David Roberts, David Cox, William Holman Hunt and Sir Edwin Landseer. Among the 20thC artists represented are Walter Sickert (*Two Women*), Spencer Gore (*Garden at Hertingfordbury*), Lucien Pissarro (*Eden Valley*), Stanley Spencer (*Hill of Zion*, from the 'Resurrection' series), Graham Sutherland (*Rocky Landscape with Sullen Sky*), and Paul Nash, Augustus John, Harold and Laura Knight, William Roberts and Sir Alfred Munnings.

The sculpture collection consists mainly of British and French bronzes from the late 19thC and early 20thC, and includes work by Gilbert Bayes (*Sirens of the Ford*), A. Mercié (*Gloria Victris*—one of the most important late 19thC *Salon* sculptures in a British public collection), Hamo Thornycroft (*The Mower* and *Teucer*), Thomas Brock (*Eve*), Jacob Epstein (*Portrait of the Artist in a Storm Cap*), and works by Alfred Gilbert and Alfred Drury.

The collection also comprises works by local artists and includes a large group of watercolours and drawings by John Weld, a local artist and antiquarian who made careful topographical sketches throughout England and on the Continent from the 1830s to 1850s. In addition there is a large group of scenes in and around Preston executed by a local artist, Edwin Beattie, in the 1890s.

In the field of decorative and applied art the ceramics collection forms a survey of the development of pottery and porcelain in England in the 18thC and early 19thC. It includes slipware, tin-glazed wares, salt-glazed stoneware, creamwares, dry body wares and porcelain by all the major factories. The glass collection includes 18thC drinking glasses, 'Nailsea' and other coloured glass from the Seddon Collection. There is also a fine 18thC clock by Romilly of Paris in the form of an ormulu globe supported by three bronze boys (a bequest from Ewart Bradshaw in 1947).

The Museum has an Association of Friends. There is a shop selling publications and postcards.

Arthur Devis, *Elizabeth Faulkner, the Artist's Wife*, c. 1742 (Harris Museum and Art Gallery, Preston)

PUBLICATIONS
The R. H. Smith Collection of English Porcelain, 1954
Drawings by Anthony Devis 1729–1816, 1956
Seddon Glass Collection, 1975

Exhibition catalogue:
Polite Society: Portraits of the English Country Gentleman and His Family by Arthur Devis, 1983

READING, *Berkshire*

Reading Museum and Art Gallery [1]

Founded in 1883, the Museum building was designed by Thomas Lainson: the Art Gallery was added by W. R. Howell in 1897. The exterior of the red-brick building is decorated with a terracotta frieze depicting Ancient Britons, Roman art and industries, and Literature and Science, by the local sculptor W. C. Mays.

The Art Gallery is mainly used for temporary exhibitions, so little of the fine art collection is ever on view. Consequently Reading is an example of a Museum and Art Gallery which would not normally qualify for inclusion in this guide were it not for the exceptional quality of the local archæological finds and the interest of the local artists and the local topographical collection. The comprehensive collection of Roman antiquities from Silchester (excavated 1891–1909) was purchased in 1978 and includes the famous Silchester eagle, the Silchester bronze horse, and gold coins and items of goldsmiths' work.

There is a collection of the work of the local artist William Havell, whose father was a drawing-master at Reading Grammar School. Havell was a watercolourist who painted in the Lake District before making a tour of India where he remained for some years. A recent addition to the topographical collection is a Paul Sandby of the *Reading Abbey Gate*, a site with the additional interest of having housed Miss Latournelle's school, briefly attended by Jane Austen. The British 20thC collection includes work by Paul Nash and John Piper.

The local history collections encompass the fine carved Romanesque capitals from Reading Abbey acquired in 1916, and a collection of Huntley and Palmer biscuit tins, representing an important local industry, which came to the Museum in 1973.

The Museum has an Association of Friends. There is a Museum shop selling a selection of publications, postcards and slides.

Local history and archæology; natural history; local artists and topography; British 20thC painting; Baxter prints

Blagrave Street, Reading
tel. 0734-55911

Mon–Fri 10–5.30 pm, Sat 10–5 pm. Closed Sun and Bank Holidays

Admission free

Bronze horse from the Roman Silchester collection of antiquities, 1stC AD (Reading Museum and Art Gallery)

The Ure Museum of Greek Archæology [2]

Greek painted pottery

Classics Department, Faculty of Letters, University of Reading, Whiteknights, Reading
tel. 0734-875123, ext. 269/358

Mon–Fri 9–5 pm (except when Faculty closed). Closed Sat, Sun

Admission free

This is a small museum, housed in a purpose-built room in the Classics Department of the University. It is used to some extent in teaching, and is open to interested visitors, but its primary importance is as a research source, internationally known in its field. Founded *c.* 1920 by Professor P. N. Ure, first Professor of Classics at the University, and his wife (Dr A. D. Ure), the collection is primarily one of Greek painted pottery. Especially notable are a white-ground lekythos by the Reed Painter, a Paestan bell krater by Python and a 'Pontic' amphora. Boeotian pottery is unusually well represented. The Egyptian material consists partly of gifts from the Petrie excavations at Memphis and Meydum, given to the University *c.* 1910, and partly from Garstang's excavations at Abydos, acquired from Liverpool in the 1920s.

There are car-parks and a cafeteria on campus.

RIBCHESTER, *Lancashire*

Ribchester Museum

Ribchester, near Preston
tel. 025 484-261

Daily 2–5 pm (Feb–May, Sept–Nov); 11.30–5.30 pm (June–Aug). Closed Dec, Jan

Admission charge

The Ribchester Museum is near Preston and contains remains from the Roman site of Bremetennacum, including an excavated area near to the Museum showing part of the granaries.

ROCHDALE, *Greater Manchester*

Rochdale Art Gallery [1]

Esplanade, Rochdale
tel. 0706-47474, ext. 764

Mon, Tues, Thurs, Fri 10–5 pm; Wed 10–1 pm; Sat 10–4 pm. Closed Sun

Admission free

A large collection of British paintings from the 18thc to the present day, including an interesting group of Victorian narrative works, is shown in recently modernised galleries. The changing exhibitions place an emphasis on recent British art.

Paul Tristram Hillier, *Las Lavanderas*, 1965 (Rochdale Art Gallery)

Rochdale Museum [2]

Local archæology; John Bright memorabilia

Sparrow Hill, Rochdale
tel. 0706-47474/49117 (Sat only)

Mon–Fri 12–5 pm; Sat 10–1 pm, 2–5 pm.
Closed Sun & Dec

Admission free

The Museum was originally founded in 1903 and established in its present premises in 1975. The nucleus of the material at the time of its founding was donated by the local Literary and Scientific Society, and it remained in store for many years before the opening in 1975 of the present Local Authority Museum in the old Rochdale Vicarage, an early 18thC brick house with 19thC additions. The collections are mainly concerned with local heritage and history, including a Romano-British torc found near Rochdale in the 19thC. There is a special collection of ceramics presented by John Bright (1811–89), the eminent 19thC politician who was born in Rochdale. He worked in his father's mill, and by 1840 he was Treasurer of the Rochdale Anti-Corn-Law League. In 1843 he began a distinguished political career as Member of Parliament for Durham. The collection includes pieces from the Minton, Wedgwood and Copeland factories, as well as a room devoted to a display of his memorabilia.

The Museum has a small shop selling publications and souvenirs. Car-parking facilities are available.

ROSSENDALE, *Lancashire*

Rossendale Museum

British painting (19thC)

Whitaker Park, Haslingden Road,
Rawtenstall, Rossendale
tel. 0706-217 777/226 509

Mon–Fri 1–5 pm, Wed 6–8 pm
(April–Sept); Sat 10–12 pm, 1–5 pm
(all year); Sun 3–5 pm (April–Oct);
Bank Holidays 2–5 pm (April–Sept)

Admission free

Richard Whitaker, a textile worker for the Hardman Brothers' Mill, who became a successful textile merchant, bought the Hardmans' house, built in the 1840s, from the family and donated it to the Borough of Rawtenstall in 1901 to be the Public Museum and park. It opened the following year.

The collections include some good 19thC paintings, with works by Frith, John Collier, David Roberts, Cox, Collins and William Shayer. There are also collections of decorative arts and furniture, including a 17thC casement chair, porcelain, pottery and glass. There is also a natural history collection.

A sales table stocks publications, a small guide and catalogue for the Museum and works of a local nature. An adjacent café is open in the summer. Car-parking is available.

ROTHERHAM, *South Yorkshire*

Clifton Park Museum

English and European pottery and porcelain (18thC–19thC), especially Rockingham porcelain; English drinking glass (18thC); British, notably Victorian, painting (18thC–19thC)

Clifton Lane, Rotherham
tel. 0709-2121, ext. 3519

Mon–Sat 10–5 pm; Sun 2.30–5 pm
(April–Sept); Sun 2.30–4.30 pm
(Oct–Mar). Closed Fri

Admission free

Clifton House was built in 1783 by John Carr of York for the iron master Joshua Walker, a member of the family of Nonconformist iron founders who brought prosperity to Rotherham in the Industrial Revolution. A modest but pleasing two-storeyed building, the House includes fine floors and chimneypieces of Derbyshire entrochial marble, which were installed by John Platt of Rotherham. The Museum has tried to preserve something of the character of Clifton House by restoring the interior decoration in several of the ground-floor rooms and furnishing them with 18thC furniture, lent by the Victoria and Albert Museum. The old kitchen has also been restored and is presented as a Victorian kitchen.

The Museum has always had a bias towards the decorative arts, largely thanks to its interest in Rockingham porcelain, which was produced at Swinton, near Rotherham, under the patronage of the Rockingham and Fitzwilliam families. Rockingham porcelain has been collected since the Museum's early days, and the collection (of over a thousand pieces) is now acknowledged as the most comprehensive public collection of Rockingham in the country. The highlight of the collection is the spectacular Rhinocerous vase, which was purchased from the Wentworth Woodhouse sale of 1949. Other Yorkshire potteries are well represented in the collection, as are English and European pottery and porcelain in general. The Spurley Hey bequest of fifty pieces of English glass in 1931 gave the Museum a small but delightful collection of 18thC drinking glasses (several pieces were illustrated in W. A. Thorpe's *English Glass*, 1935). The Museum also houses the ecclesiastical silver from four churches in the

Rockingham china tray painted by Thomas Steel,
c. 1830 (Clifton Park Museum, Rotherham)

Local history

Ypres Tower, Gun Garden, Rye
tel. 0797-223254

Mon–Sat 10.30–1 pm, 2.15–5.30 pm;
Sun 11.30–1 pm, 2.15–5.30 pm
(Easter–Oct). Closed Nov–Easter

Admission free

Local history, ethnography

Museum Street, Saffron Walden
tel. 0799-22494

Mon–Sat 11–5 pm (April–Sept),
11–4 pm (Oct–March);
Sun and Bank Holidays 2.30–5 pm

Admission free

vicinity: Rotherham Parish Church, St John's at Hooten Roberts, Holy Trinity at Wentworth and St Francis at Bramley.

The fine art collection is miscellaneous in nature but contains interesting and pleasing pictures. The nucleus of the collection is the Edward Nightingale bequest of sixty-eight Victorian oil paintings and watercolours; this includes work by J. R. Herbert, E. J. Niemann, Paul Marny and George Cattermole. The 18thC is mainly represented by the portraits of the Walker family, which are appropriately displayed in the furnished period rooms. A selection from the Museum's large collection of topographical prints and drawings is always on view.

Specialist publications on Rockingham pottery and Rotherham glass are available from the Museum. Car-parking is also available.

RYE, *East Sussex*

Rye Museum

Ypres Tower, originally built as the Castle of Rye in *c.* 1250, was used as a prison from 1494 to 1865 when it served as a lock-up. It opened as a Museum in 1954, replacing Battery House which had been the Museum premises since 1928 and which was destroyed in an air raid in 1942.

The Rye mediæval ceramics form an important group from a single pottery and are of particular interest, as are the examples from the revived Rye Pottery in the mid-19thC.

The Museum's collection of ephemera includes a large quantity of printed material of the Reform Period which exhibits fine examples of typography current in the mid-19thC.

There is also a collection of 19thC toys, dolls and items of interest for children. Also displayed are objects relating to Rye's maritime history, particularly ship models.

The Museum is private, and is run by the Rye Museum Association from which a management committee is elected annually. It has won a National Heritage Award.

A shop sells museum publications and postcards.

SAFFRON WALDEN, *Essex*

Saffron Walden Museum

The Saffron Walden Natural History Society was founded in 1832 and two years later a building was erected in which to house its collections, and to use for public meetings, at the instigation of the 3rd Lord Braybrooke of Audley End. The architect of the Tudor-style building in red brick is unknown. The principal founders of the Natural History Society were members of the Gibson Family (Jabez, Francis, Wyatt George and George Stacey), John Player, and Joshua and Joseph Clarke. They were also the principal patrons in the early years of the Museum. George Stacey Gibson (1818–83), the botanist and a Quaker banker, aided the development of the Museum greatly in the early 1880s with a bequest which allowed a full-time Curator to be employed.

The major holding of the Museum is the group of ethnographical collections, those from other Essex Museums, Chelmsford, Southend and Colchester having been incorporated during the past twenty years as well as the Cuming Museum from South London. Much of the material originates from expeditions in the 1830s and 1840s and includes some significant and exceptional pieces, especially from Australian Aborigines from Victoria and New South Wales and the North American Indians, such as quill-work and bead-work. Other items of interest include objects from the Pacific Islands, collected between 1821 and 1824, such as a wood figure from the Society Islands and a necklace with bone pendants from the Austral Islands. There are also an 18thC Maori shell trumpet, a Bamboo flute from the New Hebrides, a gourd bottle from Hawaii, all collected during Captain Cook's third voyage, and a wood figure from Sierra Leone.

The collections of ceramics and glass are particularly rich in tin-glazed earthenware; a glass posset pot, dated 1685, and a fine group of 18thc drinking glasses; also Chinese export porcelain, decorated with armorial devices of Essex families.

Amongst the furniture and decorative arts are an early Tudor bed, 17thc, probably Aubusson, tapestries formerly in Latchleys Farm, Steeple Bumpstead, and an English 16thc embroidered glove, traditionally associated with Mary Queen of Scots at her execution. There are also fine examples of 17thc needlework, including stumpwork, an English 18thc lady's riding-dress and four painted panels by Cipriani from the Adam library at Audley End House.

In the natural history collection is Wallace the lion, formerly part of Wombwell's menagerie and the first lion bred in captivity in this country. Born in Edinburgh about 1820, he survived the last recorded lion-baiting contest, between himself and a dog in Warwick in 1825.

There is a Museum Society which organises programmes of lectures and visits. A shop sells a guide to the Museum published in 1975, booklets and postcards. There is a small car-park.

ST ALBANS, *Hertfordshire*

Verulamium Museum

The Museum was founded in 1938 by St Albans City Council, as a result of Sir Mortimer Wheeler's excavations at Verulamium in the early 1930s. Wheeler and his first wife Tessa were formative influences on the Council's decision to build the Museum which was designed by the City Surveyor and Engineer. On the exterior are panels of decorative flint work. A new addition was built in 1962.

Verulamium is the Roman town situated to the west of the Abbey, and the Museum was built in the middle of the site. There is much of interest to be seen, including fine mosaics, painted wall plasters and the Verulamium Venus statuette, as well as pavements, pottery, coins, brooches, rings, glass and jet objects.

On sale at the Museum are a good selection of publications including guidebooks, slides and postcards. There is a car-park adjacent, for which there is a charge at weekends only.

ST HELENS, *Merseyside*

St Helens Museum and Art Gallery [1]

Founded in 1892, the Museum holds collections of local and social history, 19thc watercolours, Doulton art wares and 19thc glass.

The Museum has an Association of Friends. Various items are available for sale, postcards, greetings cards, leaflets and souvenirs. There is a large car-park quite near.

Pilkington Glass Museum [2]

The Museum, which was founded in 1964, is owned by the world renowned glassmaking firm, Pilkington Brothers plc, and shows the evolution of glassmaking techniques. The Museum building is part of the main office complex, designed by Maxwell Fry of Fry, Drew and Partners. The displays were designed by James Gardner of James Gardner Studios, London, who is widely acclaimed for his museum work.

The historical development of glassmaking processes over four thousand years is illustrated in a comprehensive collection of glassware from the earliest times, the oldest piece in the collection being an Egyptian amphora of 1430–1340 BC. Other examples of ancient glassware include a Roman bottle of the 1stc AD, a Persian bowl of the 5thc AD and a sprinkler bottle

Roman bronze statuette of the Verulamium Venus (Verulamium Museum, St Albans)

Roman archæology; Iron Age and mediæval material

St Michael's Street, St Albans
tel. 0727-54659/59919

Mon–Sat 10–5.30 pm; Sun 2–5.30 pm (April–Oct); Mon–Sat 10–4 pm; Sun 2–4 pm (Nov–Mar)

Admission charge except for local residents

College Street, St Helens
tel. 0744-24061, ext. 2572

Mon–Fri 10–5 pm; Sat 10–1 pm. Closed Sun

Admission free

History and technique of glassmaking

Prescot Road, St Helens
tel. 0744-692499

Mon–Fri 10–5 pm; Sat, Sun & Bank Holidays 2–4.30 pm

Admission free

Enamelled Humpen, probably made in Nuremberg, 1691 (Pilkington Glass Museum, St Helens)

Sculptures of Barbara Hepworth

Barnoon Hill, St Ives
tel. 0736-796226

Mon–Sat 10–5.30 pm (summer);
10–4.30 pm (winter). Closed Sun

Admission charge

19thC & 20thC British painting

Peel Park, The Crescent, Salford
tel. 061-736 2649

Mon–Fri 10–1 pm, 2–5 pm; Sun 2–5 pm.
Closed Sat

Admission free

from Jurgan, Persia, of the 12thC AD. The technical facility of the 19thC is demonstrated in the exhibits of such great innovators as Apsley Pellatt, the inventor of the 'Crystallo Ceramie' technique of glass incrustation; and the Bohemian, Friedrich Egermann, devisor of the heavy stone-like Lithyalin glass. Other complex techniques include cameo work (the layered technique by which the famous Roman 'Portland' vase was produced), exemplified by a signed cameo vase by George Woodall of T. Webb, Stourbridge, the best known 19thC exponent; and millefiori, the characteristic multi-coloured ornament used for decorative paperweights. A rare example of an enamelled Humpen, or large beaker, bears the date 1691 and was probably made in Nuremberg.

The Museum has a sales counter where visitors can buy the large selection of publications, booklets and postcards devoted to the subject of glassmaking, as well as a selection of decorative glassware.

ST IVES, *Cornwall*

Barbara Hepworth Museum and Sculpture Garden

The Museum, which has been administered by the Tate Gallery in London (q.v.) since 1980, is entirely devoted to the work of the celebrated sculptor, Barbara Hepworth. The forty sculptures and eight paintings span the period from 1928 to 1974, the year before she died. The Museum was set up in 1976, in accordance with the wishes of the artist herself. The environment is designed to create, as faithfully as possible, the feeling that Trewyn Studio had in the 1950s when she was living and working there. As well as the sculptures, there are photographs, documents, statements about art, and other memorabilia, including some unfinished woodcarvings and artists' tools.

One of the more popular exhibits is the *Infant* of 1929 carved in dark Burmese wood, modelled on Paul, her firstborn child. In the studio is the 1974 marble abstract, *Fallen Images*; and in the garden a group of six bronzes, *Conversation with Magic Stones* of 1973.

The sculpture garden is at the back of the Museum and is of interest in its own right. It is very luxuriant, planted with sub-tropical vegetation, in pointed contrast to the austere forms of the sculptures.

The publications range from two booklets to the full-scale *Complete Sculptures of Barbara Hepworth 1960–69*. A useful illustrated booklet shows all the works by Barbara Hepworth owned by the Tate Gallery and the Museum in St Ives.

SALFORD, *Greater Manchester*

Salford Museum and Art Gallery [1]

Formerly Lark Hill, the residence of Colonel Ackers and later William Garnett, the house has a complicated building history. It opened as a museum in 1850 with Queen Victoria as patron. Wings were added in 1853 and 1857 (architect: the firm of Travis & Mangnall) and a further wing in 1878 (architect: Henry Lord). The wing opened in 1938 replaced the original Georgian building and was designed by W. A. Walker, City Engineer. Early patrons included Thomas Agnew (1827–83), the Manchester picture dealer who gave paintings between 1850 and 1875, and E. R. Langworthy (1797–1874) a former Mayor and member of the Borough Council, who gave a donation in 1857 and left an endowment in 1874.

The main collection of the Art Gallery is that of the local painter, L. S. Lowry, and is the largest public collection of his work. The first Lowry work was purchased in 1936 and the collection, which grew by a combination of purchase and donation by the artist, numbered over 160 works at the time of his death. A further 150 works were bought from the artist's estate.

The collection of 19thC paintings includes *The Execution of the Marquis of Montrose* and

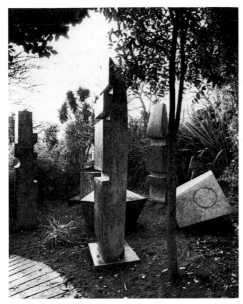

The Last Sleep of the Earl of Argyle by E. M. Ward. These works are the originals for the frescoes on the walls of the House of Lords. There is also *The Meeting of Jacob and Esau* by G. F. Watts, and works by Daniel Maclise, Henry Le Jeune, Philip Calderon, William Shayer, J. F. Herring and George Clausen.

The 20thc generally is represented by two fine paintings by William Roberts, *The Control Room* and *Munitions Factory*, an example of the thorn figures by Graham Sutherland and still-life paintings by Ivon Hitchens, Duncan Grant, Vanessa Bell and Matthew Smith, as well as works of Henry Lamb, Frank Dobson, Augustus John and Sickert.

Paintings and drawings devoted to the subject of mining have been collected primarily for the Museum of Mining, also in Salford. The sculpture collection is mainly composed of Victorian marbles.

The displays in the period rooms in the Museum draw on the extensive social history collections, and outstanding items shown include a longcase clock by Joseph Knibb (*c.* 1680), a papier mâché chair (*c.* 1844) and an early letterbox of 1857.

Also on display in the Art Gallery is a carved oak cabinet designed by A. W. N. Pugin and J. Crace for Abney Hall, Cheshire, *c.* 1847 and exhibited at the Great Exhibition, 1851.

Barbara Hepworth, *Conversation with magic stones*, 1973 (Barbara Hepworth Museum, St Ives)

L. S. Lowry, *Man Lying on a wall*, 1957 (Salford Museum and Art Gallery)

The Museum has an Association of Friends. A sales desk stocks prints, guides and postcards. Two publications on L. S. Lowry for sale here are: *L. S. Lowry—His Life and Work*, a guide to the permanent exhibition, and *L. S. Lowry—The Salford Collection*, a catalogue of the collection. Car-parking is available.

The City of Salford also administers:

Ordsall Hall Museum [2]

Local and social history

Taylorson Street, Salford
tel. 061-872 0251

Mon–Fri 10–5 pm; Sun 2–5 pm.
Closed Sat

Admission free

Described by Pevsner as 'the most important remaining timber-framing building of Manchester and Salford', the house was acquired by the City in 1959 and opened as a Museum in 1972. The Great Hall dates from about 1520 and this, together with the 14thc and 17thc sections, underwent restoration in 1896/7 and the 1960s.

The displays include items from Salford Museum in the Great Hall and Star Chamber. A Social History Room illustrates everyday life, and there is a Local History Room.

The Museum is associated with the Friends of Salford Museum. Publications are available from the attendant at the desk. There is street parking outside the Museum.

SALISBURY, *Wiltshire*

Salisbury and South Wiltshire Museum

Archæology, notably of Stonehenge (the Museum receives all Stonehenge material) and South Wiltshire, Old Stone Age–10thc AD; Pitt Rivers Collection, including Cranbourne Chase excavations; paintings and prints of local topography; ceramics, including local factories; costume and the local Downton lace

The King's House, 65 The Close, Salisbury
tel. 0722-332151

Mon–Sat 10–5 pm (April–Sept); 10–4 pm (Oct–Mar); Sun 2–5 pm (July & Aug).
Closed Sun (Sept–June)

Admission charge

The stimulus for the founding of the Salisbury Museum came from nothing more than work on the improvement of the main drainage system. In 1849 a severe cholera epidemic forced the filling-in of the open street channels, and in the course of the work a large quantity of mediæval material came to light. A local desire to preserve this and other historic material related to Salisbury and its environs led to the founding in 1860 of the Museum in St Ann Street, which has only recently (1981) moved to the present location in the Close. The 13thc King's House, built for the Abbots of Sherborne, had many later additions, mainly Tudor and Stuart, including a 15thc porch and 17thc plasterwork ceilings. The Museum is renowned for its important archæological collections, partly on account of the Stonehenge material

George Beare, *Miss Fort of Alderbury House, Wiltshire,* 1747 (Salisbury and South Wiltshire Museum, Salisbury)

English School, *A Panoramic View of Ashcombe, Wiltshire, c.* 1770 (Salisbury and South Wiltshire Museum, Salisbury)

gathered from what must be the most celebrated site in the British Isles. These collections were enhanced in 1975 when, for the first time, the Government accepted a complete collection—that of Lieut.-General Pitt Rivers which had been on display in his own private museum at Farnham in Dorset—in lieu of estate duties, and gave it to the Salisbury Museum as being the most appropriate institution. Although the emphasis is on archæology, the diversity of the General's interests is demonstrated here as it also is in Oxford (q.v.).

Notable in the mediæval collections are the *Giant and Hob-nob*, otherwise known as the *Salisbury Giant* (St Christopher), originally the pageant figure of the Guild of Merchant Tailors: first recorded in 1496, it is a unique survival in this country.

The topographical collection contains great treasures in the form of watercolours, the interior of Salisbury Cathedral and a view of Salisbury from Old Sarum, both by J. M. W. Turner. There are, of course, a number of representations of Stonehenge, among them a charming view by John Bridges. There is also an 18thC panoramic view, *Salisbury from the North East*.

The ceramic collection includes 18thC pieces from the Chelsea, Worcester and Bristol factories as well as a rare set of *The Five Senses*, modelled at Bow. The costume and textile collection includes examples of the local Downton lace. In the 19thC a famed curiosity was 'the doll', a toy reputedly made by Marie-Antoinette for one of her children during her last days in prison.

The funds needed to enable the Museum to survive independently and to move to the present building were raised by the Patrons of Salisbury Museum Appeal (1979–82). There is an active association of Friends and an Archæological Research Group, and volunteers help in many spheres of Museum activity.

There is a Museum shop selling publications, cards, prints and replica jewellery, as well as a coffee shop open from April to September.

PUBLICATIONS
Hugh Shortt, *The Giant and Hob Nob* (revised by Tiffany Hunt and John Chandler), 1982
Mark Bowden, *General Pitt Rivers: the Father of Scientific Archæology*, 1984
L. V. Grinsell, *The Stonehenge Barrow Groups*, 1978
Marjorie Nisbett, *Pottery and Porcelain*, 1973
C. N. Moore and M. Rowlands, *Bronze Age Metalwork in Salisbury Museum*, 1972
Donald Mackreth, *Roman Brooches*, 1973
Mary Gibson, *Period Costume*, 1974
Salisbury Heritage, Illustrations from the Museum Collection, 1973

Matthew Smith, *Madame Ennui (Vera Cunningham)*, 1925 (Scarborough Art Gallery)

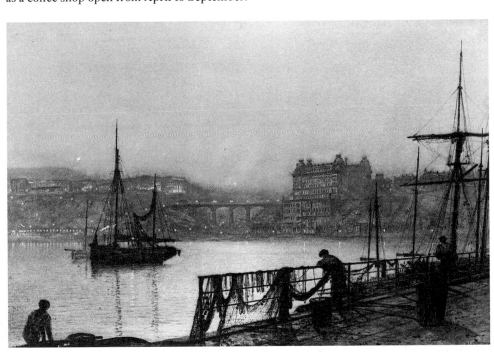

John Atkinson Grimshaw, *Scarborough Lights*, late 1860s (Scarborough Art Gallery)

SCARBOROUGH, *North Yorkshire*

Scarborough Art Gallery

The Crescent, Scarborough
tel. 0723-374753

Tues–Sat 10–1 pm, 2–5 pm; Sun 2–5 pm (summer). Closed Sun (winter)

Admission free

Housed in a small, elegant classical house, the architect of which is unknown, built in the 1830s, the Gallery was established in 1947.

The nucleus of the Gallery's collection is a group of 19thC and early 20thC watercolours of Scarborough and the vicinity, mainly by local painters, such as H. B. Carter and J. W.

Carmichael. There are also groups of local holiday and railway posters, and drawings by Brangwyn.

The best of the collection is a group of British paintings, mainly oils, given by Tom Laughton, a Scarborough hotelier, and brother of the actor Charles Laughton. These include important works from the 17thC to the 19thC, including work by William Etty, John Martin and others, and 20thC works including John Armstrong, Ivon Hitchens and Matthew Smith. The Gallery also has four oil paintings by Atkinson Grimshaw, who lived in Scarborough for several years, and a large painting of *Jezebel and Ahab* by Leighton who was born about two hundred yards away from the Art Gallery.

There is a small sales desk with publications of local interest, including a history of the Crescent Houses and Rotunda and photographs of some of the paintings in the collection.

PUBLICATIONS
Tom Laughton, *The Tom Laughton Collection*, 1984

SCUNTHORPE, *South Humberside*

Scunthorpe Borough Museum and Art Gallery [1]

Founded in 1909, Scunthorpe Museum was first housed in a room above Scunthorpe Public Library. It has now moved to an ironstone and brick vicarage built in 1875 under the patronage of the Winn family. Additions to the Museum building include a reconstructed ironstone cottage (formerly at 15 Church Street, Scunthorpe) and various modern extensions.

The collections include paintings, drawings and prints mostly by local artists, but also including local views such as *The Smug and Silver Trent* by J. A. Arnesby Brown, and portraits of local people such as the pair by J. Callcot Horsley of Mr W. H. Dawes, founder of the Trent Ironworks, and his wife. There is a group of drawings and engravings by William Fowler, the local antiquary, and three 17thC portraits.

The archæological collections include a fine Romanesque (*c.* 1170) font from Barnetby-le-Wold and the J. A. Jackson collection of ivories. There are also some 18thC and 19thC ceramics including items commemorating John Wesley.

Period rooms have been reconstructed with panelling and appropriate furniture.

Scunthorpe Museum Society provides voluntary receptionists for the Museum as well as pursuing its own activities, e.g. holding lectures, running practical art lessons and holding exhibitions of members' own work.

There is a small Museum shop.

Local history, art and archæology

Oswald Road, Scunthorpe
tel. 0724-843533

Mon–Sat 10–5 pm; Sun 2–5 pm

Admission free except at weekends

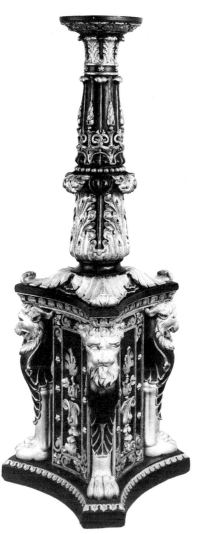

English pine and gesso torchère decorated in dark green and gold-leaf, *c.* 1810 (Normanby Hall, Scunthorpe)

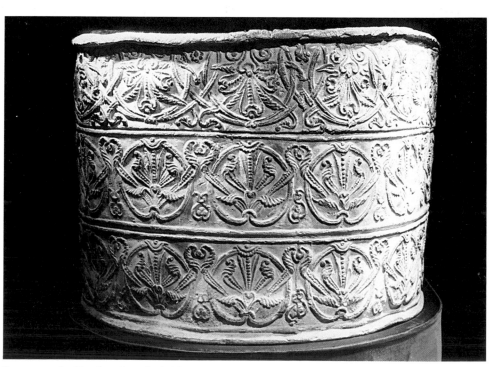

Romanesque lead font from Barnetby-le-Wold, *c.* 1170 (Scunthorpe Borough Museum and Art Gallery)

Scunthorpe Borough Council also administers:

Normanby Hall [2]

17thC–20thC paintings including portraits and marine paintings; decorative and applied arts; Regency furniture; English pottery and porcelain, predominantly Regency in date and including a few commemorative pieces; costume, particularly 19thC and 20thC

Normanby, Scunthorpe
tel. 0724-720215

Mon, Wed, Sat 10–12.30 pm, 2–5.30 pm; Sun 2–5 pm; closed Tues, Thurs, Fri (April–Oct); Mon–Fri 10–12.30 pm, 2–5 pm; Sun 2–5 pm; closed Sat (Nov–Mar)

Admission charge

Although the Sheffield family has owned Normanby since 1589, the present Hall was built for Sir Robert Sheffield between 1825 and 1830, to a modern design based on rectangles by the architect Sir Robert Smirke. In 1906 the Hall was altered by Walter Brierley, a York architect, by the addition of a new wing containing a Corinthian baroque ballroom and by the replacement of one of the original internal walls with an Ionic colonnade. The house still retains its 1825–30 staircase and some of its original ceilings and fireplaces.

Scunthorpe Museum has concentrated on acquiring Regency furniture dated between 1795 and 1835, together with portraits, landscapes, ceramics, chandeliers and other items of the same period in order to furnish Normanby Hall in period. The wide variety of Regency furniture in the collection ranges from an oak study table from Marlborough House dated *c*. 1816 and a bookcase and other items by Gillows of Lancaster, to sofas inlaid with boulle marquetry, tiny drawing-room chairs for children and elaborately carved and gilt torchères. The paintings acquired for Normanby Hall include a few Sheffield family portraits; Regency portraits, for instance *Mrs Alice Wood* attributed to Lawrence's workshop; a collection of 19thC marine paintings, including a coastal scene attributed to R. P. Bonington; and some Edwardian paintings on loan from the Ferens Art Gallery, Hull, which grace the 1906 ballroom (now used as a banqueting hall).

Scunthorpe Museum's costume collection is housed at Normanby Hall, with about a dozen dresses and some military uniforms usually on display in showcases and in the period rooms on the first floor. The costume has been donated by many different local families. It mostly comprises 19thC and 20thC ladies' and children's wear, but there is in addition one lady's dress of the 18thC, a collection of military uniforms, and a collection of late 18thC clothes worn by the Rev. Dr John Parkinson (1745–1840).

A few souvenirs are on sale at the Hall. Craft pottery is sold by the resident potter in Normanby Stable-block. Meals may be obtained at Normanby Hall Golf Clubhouse. There is a large car-park.

SHEFFIELD, *South Yorkshire*

Sheffield City Museum [1]

Local antiquities and products; natural sciences

Weston Park, Sheffield
tel. 0742-27226

Mon–Sat 10–5 pm; Sat 11–5 pm.
Late opening until 8 pm June–Aug.
Closed 24–26 Dec

Admission free

The Museum opened in Weston Park in 1875, in a house that was previously owned by the Harrison family. This was subsequently demolished to make way for purpose-built galleries in 1937, designed by W. G. Davies and paid for by Alderman John George Graves (1866–1945), a local businessman and benefactor, and founder of the Graves Art Gallery in Surrey Street. The Museum shares its premises with the Mappin Art Gallery in Weston Park.

The collections, which were built up by the Sheffield Literary and Philosophical Society, date back to the 1820s. Local antiquities include those of the Bateman Collection, the items from the excavations of barrows in Yorkshire, Derbyshire and Staffordshire, and the rare Anglo-Saxon helmet from Benty Grange. The Museum also houses a collection of clocks and watches, local cutlery, ceramics, silver and Old Sheffield Plate, in particular, a turtle tureen and a table. Other bequests include those of the Page Collection of cutlery and the Bradbury Collection of Old Sheffield Plate. In 1933 the Museum acquired the W. Sanders Fiske Collection of nearly two hundred specimens of English and Continental knives and forks displaying a wide range of fine craftsmanship, particularly the twelve, possibly French, ivory-hafted knives with Apostle figures of *c*. 1600.

The Museum has an association of Friends. A shop sells publications, souvenirs, information sheets, slides and postcards.

Graves Art Gallery [2]

British painting (18thc–20thc); British
watercolours (18thc–20thc); Oriental art

Surrey Street, Sheffield
tel. 0742-734781

Mon–Sat 10–8 pm; Sun 2–5 pm

Admission free

North-East Persian ceramic bowl, 9thc–10thc
(Graves Art Gallery, Sheffield)

The Graves Art Gallery was named after Alderman John George Graves (1866–1945), a Sheffield businessman and benefactor, who established the country's first mail order firm. His gift of £30,000 founded the Art Gallery and contributed to the cost of the City Library whose building the Gallery shares. Designed by the City Architect, W. G. Davies (1888–1967) and opened in July 1934 by the Duchess of York, the building occupies a prime site in the city centre.

J. G. Graves's initial gift of four hundred paintings was later increased to over a thousand; in each case the works came from his own collection which numbered around three thousand paintings. Although his taste was mainly for 19thc and early 20thc British art, Graves was eclectic in his purchasing: Burne-Jones's *The Hours* stands out in the British 19thc group, which also contains works by Arthur Hughes, David Roberts, Millais, James Collinson and the Sheffield artist Thomas Creswick. Neither did Graves neglect the art of his own time: his gift of works by Sickert, Lavery, Fry and Eric Ravilious laid the foundations for later purchases.

Boudin, Daubigny and Legros are represented in the 19thc French collection, Legros by his fine canvas *Blessing the Sea*; and the Gallery's group of 17thc European paintings is greatly enhanced by Murillo's *Christ asleep on the Cross*.

The Gallery's first Director, Sir John Rothenstein, initiated a cohesive purchasing policy and established a programme of loans and temporary exhibitions which is continued to this day. The Sheffield Art Collections Fund was founded in 1936 (now the Sheffield Society for the Encouragement of Arts and organised in the same way as the NACF), and this body made several important donations to the nascent collection. J. G. Graves continued to be active in the Gallery's development and in 1937 three new galleries were added to the Mappin Art Gallery, Weston Park, Sheffield (sister to the Graves), to house over three hundred more paintings from his collection. In 1939 Graves presented an outstanding collection of Chinese ivories which he had purchased from a Dr Grice, who had in turn acquired them while working in China. This proved the starting point for a collection of Oriental and African art which now encompasses Persian pottery and miniatures, Indian miniatures and sculpture,

Christopher Wood, *La Plage Hôtel, Ty-Mad, Tréboul*, 1930 (Graves Art Gallery, Sheffield)

Japanese prints, African sculpture and masks and Græco-Roman antiquities.

Judicious purchasing by successive directors has secured works of outstanding merit for the City, and the collections have now expanded to over 6,500 works. While the majority of purchases have been in the field of British painting to the present day, recent collecting policies have encompassed 19thC and 20thC printmaking from Europe and America, and photography; both areas are now strongly represented. Amongst the collections of British and European fine art are the following: Daniel Mijtens (*The Marquis of Hamilton*), Giulio Cesare Procaccini (*The Flagellation*), Ribera (*Monk and Skull*), Aert van der Neer (*Frozen River Scene*, one of a small, but interesting group of 17thC Dutch landscapes), Francis Wheatley (*The Return from the Shoot*), J. M. W. Turner (*The Festival of the Vintage at Macon*, presented by the NACF in 1955), Corot (*Landscape*), Cézanne (*Jardin à Jas de Bouffon*) and Gwen John (*Corner of an Artist's Room*). The last named is a jewel in the crown of the Gallery's collection of 20thC British art, which includes works by Sickert, Gilman, Gore, Orpen, Stanley Spencer, Paul Nash, Christopher Wood, Graham Sutherland, Keith Vaughan, John Bratby, David Hockney, Peter Blake, John Hoyland and Allen Jones.

In May 1985 Sheffield Art Galleries incorporated the former Ruskin Museum; founded by John Ruskin in 1876, originally housed in Walkley and later in Meersbrook Park, the Museum is now sited in the City centre. The collection includes illuminated MSS, early printed books, a library, an extensive collection of minerals, and watercolours and drawings by Ruskin, by early Italian masters and by artists commissioned by Ruskin to copy architectural details. These artists include Fairfax Murray, Burne-Jones and T. M. Rooke; their commissions came either from Ruskin himself or from the Guild of St George, which he founded and to whom the collection still belongs.

There is a bookstall and a coffee bar in the Graves Art Gallery.

PUBLICATIONS
Catalogue of the City's Permanent Collection, Artists born after 1850, 1981
Handbook of the Graves Art Gallery (to celebrate its fiftieth anniversary), 1984
Janet Barnes, *J. G. Graves*, 1984

Mappin Art Gallery [3]

Situated in Weston Park, the Mappin Art Gallery shares its premises with the City Museum. The building, designed by Sheffield architects Flockton and Gibbs in 1887, has a fine neo-classical façade with an elegant range of Victorian galleries and large modern galleries. It was built in accordance with the will of John Newton Mappin (1800–84), a local brewer, who bequeathed his collection of paintings and a sum of £15,000 to the Corporation of Sheffield. The Gallery was further enriched by his nephew, Sir Frederick Thorpe Mappin (1821–1910), who at the opening of the Gallery made over some of his works and later made further gifts. This was the only public collection in Sheffield until 1934, when Alderman J. G. Graves (1866–1945) gave to the City his collection and a sum of money to build the Graves Art Gallery. In 1937, with the opening of the new City Museum, Graves financed an extension to the Mappin, and his collection of about three hundred works augmented the Mappin collection, to form the City Art Galleries collection.

J. N. Mappin's bequest, largely of Victorian narrative and genre paintings, was enhanced by the collection of his nephew, F. T. Mappin, of late Victorian art, such as works by Millais and Landseer. Other 19thC painters represented are Constable, Turner, Gainsborough and the Pre-Raphaelites. There is a fine collection of some of the best known watercolourists of the 18thC and 19thC, such as Alexander Cozens, J. R. Cozens, Cotman, Girtin, Turner and Samuel Palmer. British 18thC and 19thC sculpture is well represented, with works by Chantrey, Watts and Stevens.

A major feature of Sheffield's Art Gallery activities is its wide programme of important exhibitions, together with lively smaller displays. It is administered, together with the Graves Art Gallery, Ruskin Gallery and other arts bodies in Sheffield, by Sheffield Arts Department, Sheffield City Council.

The Gallery has a café and bookstall and is easily reached by public transport from the City centre.

British paintings and sculpture (18thC–20thC); British watercolours (18thC–19thC)

Weston Park, Sheffield
tel. 0742-26281/754091

Mon–Sat 10–5 pm (Sept–May);
10–8 pm (June–Aug); Sun 2–5 pm

Admission free

PUBLICATIONS
Sheffield City Art Galleries: Concise Catalogue, 1981

Exhibition catalogues:
Artist in Industry, 1983
Into the Open: New Paintings, Prints and Sculpture by Contemporary Black Artists, 1984
James Hamilton, *The Misses Vickers: The centenary of the painting by J. Singer Sargent*, 1984

SHREWSBURY, *Shropshire*

Rowley's House Museum [1]

Archæology; costume; local history

Barker Street, Shrewsbury
tel. 0743-61196

Mon–Sat 10–5 pm; Sun 12–5 pm
(May–Sept). Closed Sun (Oct–Apr)

Admission charge

Housed in a splendid timber-framed and brick building of the 1590s and 1616, built by the draper and brewer Robert Rowley and his son, is a large collection of Roman material excavated at Wroxeter. Particularly fine and unique is a silver mirror of the 2ndc AD. Also displayed are items of local historical and geological interest and a good collection of costume, including a gown worn by a Maid of Honour at Queen Victoria's coronation.

A shop sells postcards, books and souvenirs.

The District of Shrewsbury and Atcham also administers:

Clive House Museum [2]

British porcelain and pottery (18thc–19thc)

College Hill, Shrewsbury
tel. 0743-61196

Mon–Sat 10–5 pm. Closed Sun

Admission charge

Lord Clive (1725–74, Clive of India) was Member of Parliament for Shrewsbury from 1761–74 and lived in this handsome 18thc brick house. It now contains a fine collection of Coalport and Caughley ware and some Maws' ceramics and tiles.

There is an Association of Friends for both museums in Shrewsbury.

SOUTHAMPTON, *Hampshire*

Southampton Art Gallery

European painting from 14thc to Monet; Burne-Jones's *Perseus* series; British 20thc painting, Camden Town Group and contemporary art

Civic Centre, Southampton
tel. 0703-223855

Tues–Fri 10–5 pm; Sat 10–4 pm; Sun 2–5 pm

Admission free

The Gallery was founded in 1939 and occupies part of Southampton's Civic Centre. Robert Chipperfield (1817–1911), a Southampton councillor, provided money for the building of

Edward Burne-Jones, *Perseus and the Graiae*, 1876–88 (Southampton Art Gallery)

258

Coalport pink-ground porcelain ice-pail, possibly by William Billingsley, *c.* 1800–10 (Clive House Museum, Shrewsbury)

an art school and gallery as well as a trust fund for purchases. The central gallery is of imposing 1930s design, an appropriate setting for the remarkable collection built up by the Gallery in a comparatively short time. The Chipperfield Fund, which was augmented later by a fund for purchasing from Frederick William Smith (1861–1925), was deployed with considerable acumen by Southampton, with advice from Lord Clark, under the stimulating curatorship first of G. L. Conran and later of Maurice Palmer. In 1963 Arthur Jeffress, a leading dealer in the Modern field, bequeathed the Gallery his private collection.

Southampton Art Gallery's purchasing policy, formulated from the very start with the help of Sir James Matthews, Chairman for many years of the Art Gallery Committee, and Sir Philip Hendy, concentrates on the acquisition of major contemporary paintings and sculptures which have included recent purchases of works by Barry Flanagan, Kenneth Martin, Richard Long, Frank Auerbach and Antony Gormley. Sculpture is a particular strength. Other notable areas are the Camden Town Group—this is reputedly the most representative collection outside the Tate Gallery—and British Surrealists. Individual works of merit include Stanley Spencer's *Patricia Preece*, Graham Sutherland's *Arthur Jeffress* and *Red Landscape*, Gwen John's *Girl in a Mulberry Dress*, and W. R. Sickert's *The Mantlepiece* and *The Juvenile Lead*. Southampton's collection of 20thC portraits, particularly of significant figures in the art world, is outstanding.

The choice Old Master collection includes a 14thC altarpiece by Allegretto Nuzi, an extensive landscape by Philips Koninck, *The Holy Family* by Jordaens and *Lord Vernon* by Gainsborough.

The 19thC in England and France is represented by Turner, John Martin and the Pre-Raphaelites (particularly Burne-Jones's *Perseus* series) and French Impressionists including Pissarro, Renoir, Sisley and Monet. The Burne-Jones series is hung in a special wood-panelled room. When this series was commissioned by the politician and statesman Arthur Balfour, the artist insisted that the room in which the completed work was to be installed should be panelled in pale oak with ornamental plasterwork designed by William Morris. The *Perseus* cycle was never finished: the Southampton series consists of the full-size cartoons for this ambitious work.

All of these areas are enhanced by a remarkable collection of loans from private collectors which currently include paintings and drawings by Picasso, Bonnard and Monet.

The Art Gallery has an Association of Friends. There is a shop with a selection of cards, prints, frames, jewellery and pottery. Publications include: *A Catalogue of the Art Gallery Collection* 1980, *Perspectives I—Frederick Lee Bridell* and *Perspectives III—The Growth of a Gallery*.

SOUTHEND-ON-SEA, *Essex*

Beecroft Art Gallery

18thC & 19thC British watercolours; 16thC–20thC European paintings

Station Road, Westcliff-on-Sea
tel. 0702-347418

Mon–Thurs 9.30–1 pm, 2–5.30 pm; Fri 9.30–1 pm, 2–5 pm (occasional Sat opening; please telephone in advance). Closed Sun

Admission free

PUBLICATIONS
Catalogue of the Permanent Collection in the Beecroft Art Gallery, 1969
Select Catalogue of the Thorpe Smith Collection, 1969

Housed in two seaside houses, the Art Gallery was established in 1953 by W. G. Beecroft and the Friends of the Gallery. The Thorpe Smith Gallery was opened in 1960, a purpose-built extension to house Sydney Thorpe Smith's collections of local topographical works. Sadly, he did not live to see his gallery, but as well as giving his collection, he left the balance of his estate to enable the Gallery to continue purchasing works with a view to building up a comprehensive pictorial record of Southend-on-Sea.

The collection contains works from 16thC to 20thC; Old Master paintings include Gerrit Willemsz. Heda, Claes Molenar, Antonio Puga and 17thC Dutch portraits; 18thC and 19thC works include a French landscape by the Barbizon School painter Henri Harpignies, an English landscape by Constable and no less than three by his present-day East Anglian successor, Edward Seago, as well as watercolours by John Warwick Smith, Myles Birket Foster and John Varley. There is also a collection of prints, drawings, paintings and maps of local topographical interest.

A sales counter stocks publications and postcards. There is car-parking in a side street.

SOUTHPORT, *Merseyside*

Atkinson Art Gallery [1]

18thc & 19thc British watercolours;
19thc & 20thc British painting; 19thc
French bronzes; 20thc British sculpture;
Chinese ceramics

Lord Street, Southport
tel. 0704-33133, ext. 129

Mon, Tues, Wed, Fri 10–5 pm;
Thurs, Sat 10–1 pm. Closed Sun

Admission free

A resolution to establish a public library was taken by Southport Corporation in 1875. When William Atkinson JP, a retired cotton manufacturer, offered to finance the project, it was decided to build an art gallery on the same site. The foundation stone was laid in 1876 and the building finally opened two years later. The building was designed by Messrs Waddington and Son of Burnley and combines elements of classical and romanesque design. Among its special features are six relief carved plaques symbolising Poetry, Drama, History, Painting, Sculpture and Architecture, and a group of sculpted figures in the pediment representing Art, Science, Literature, Commerce and Inspiration. Three further rooms were added to the five original galleries in 1926.

The first paintings to join the collection were received in 1879 through a bequest of eighteen oils and twenty-one watercolours from a local collector, Miss Ball. These included works by Edwin Hayes, Benjamin Leader and Cooper. In 1923 the Gallery received from F. Hindley Smith a group of forty-three oils and watercolours, among them works by David Cox, Ford

Augustus John, *The Red Toque*
(Atkinson Art Gallery, Southport)

Henry Herbert La Thangue, *The Artist's Wife* (Atkinson Art Gallery, Southport)

Madox Brown, J. S. Cotman, McTaggart and Wilson Steer. The John Henry Bell Bequest of 1929, by far the most substantial both in quantity and quality, added a further 178 paintings to the collection. It included Benjamin West's *The Death of General Wolfe* and some fine watercolours by Copley Fielding, Varley, Bonington, William Henry Hunt, Danby, Linnell, Roberts and Martin. Also in the painting collection are a few 17thc and 18thc paintings, including Lely's *Duchess of Portsmouth* and substantial holdings of Victorian genre painting. Also represented are the artists associated with the New English Art Club, notably Sickert (*The Little Theatre, 1890*), Steer, Brangwyn, Orpen and Augustus John. Probably the Gallery's most popular modern painting is L. S. Lowry's *Street Scene*, purchased in 1939.

The sculpture collection contains a small collection of 19thc French bronzes and modern sculpture, including Epstein's *Maria Donska*, Henry Moore's *Three Way Piece* and Elisabeth Frink's *The General*. There is a collection of British 19thc and 20thc etchings and engravings, including works by Méryon, Whistler, Seymour Haden, Strang and D. Y. Cameron, as well as thirty-three 18thc English drinking glasses from Dr Arthur Jackson in 1944; and a bequest of Roman coins and Chinese porcelain from Gilbert Dethick Brown in 1954. Recent acquisitions include works by John Piper, Gaudier-Brzeska and Carel Weight.

The Museum has an Association of Friends. The shop sells postcards, local history leaflets and catalogues, including duplicated catalogues of special displays from the permanent collection, e.g. *The Painted Face* (1980), *Scottish Artists* (1981). A bar and buffet are situated in the Arts Centre adjacent. There is public car-parking in the street parallel.

The Metropolitan Borough of Sefton also administers:

The Botanic Gardens Museum [2]

PUBLICATIONS
Centenary Catalogue: A Selection of Victorian Oil Paintings, 1978
The Literal Landscape: A Selection of Victorian Oils, 1979
Print-Making—Making Prints (catalogue of a print exhibition), 1984

Local history; social history; natural history; 19thc & 20thc porcelain; dolls

Churchtown, Southport
tel. 0704-27547

Tues–Sat 10–6 pm (May–Sept);
10–5 pm (Oct–April); Sun 2–5 pm. Closed Mon except Bank Holidays, Fri following Bank Holidays & Good Friday

Admission free

In 1874 the Southport and Churchtown Botanic Gardens and Museum Company was formed and in 1875 the Gardens were opened by the Rev. Charles Hesketh, who then laid the foundation stone for the Museum and principal conservatory. Messrs Mellor and Sutton were the architects. The cost was £18,000 and the Chairman of the Company was Walter Smith, being an ex-mayor and promoter of trams, railways and the Southport Winter Gardens.

The main collections are those of local history, natural history, especially the Pennington Collection of British birds and the Botanic Gardens Museum. Others include an interesting collection of Egyptology and Prehistory and 270 paintings of plant illustrations. There is a costume collection, a small amount of 18thc Liverpool porcelain, over two hundred pieces of Goss porcelain and the Cecily Bate doll collection.

An Association of Friends is to be established. A small shop sells publications, leaflets and postcards. There is a cafeteria adjacent and some car-parking outside the Museum.

STALYBRIDGE, *Greater Manchester*

Astley Cheetham Art Gallery

19thc & 20thc British painting

Trinity Street, Stalybridge
tel. 061 338–2708

Mon, Tues, Wed, Fri 1–7.30 pm;
Sat 9–4 pm. Closed Thurs, Sun

Admission free

The nucleus of the collection is formed by works purchased by the local Member of Parliament and millowner, John Frederick Cheetham, who with his wife Beatrice Astley Cheetham funded the building of the Library and Art Gallery. The building was officially opened in 1901 and the present Art Gallery was used as a lecture hall. The building, with a hammer-beam roof in the gallery, was designed by J. Medland Taylor.

In 1932 the hall was designated as an art gallery when, on the death of his sister, Agnes, Cheetham's collection of pictures was handed over to the Corporation of Stalybridge. Amongst this collection are some fine Italian works including *Madonna and Child with Angels and Saints* by the Master of the Straus Madonna, *Madonna and Child* by Girolamo Siciolante da Sermoneta, and *Portrait of a Young Man* by Alessandro Allori. A number of 19thc works also feature in this collection, which holds landscapes by David Cox, John Linnell and Bonington, Watts's *Sir Perceval* and Burne-Jones's *St Nicholas* and *Head of a Princess*.

20thC works include *Kings Lynn Harbour* by Duncan Grant, landscapes by Adrian Stokes, *Daffodils* by Mark Gertler and a number of works by the important local artist and pupil of Sickert, Harry Rutherford.

In 1975 the Art Gallery was completely refurbished and in addition to exhibitions of pictures from the permanent collection, temporary exhibitions covering all aspects of the visual arts are displayed.

The Gallery has an Association of Friends. There is a sales desk, and a municipal car-park near the Gallery.

PUBLICATIONS
Works by L. S. Lowry in Public and Private Collections in the North-West, 1983

Exhibition catalogue.
Harry Rutherford, n.d.

STOCKPORT, *Greater Manchester*

Bramall Hall [1]

The Manor House of Bramall, dating from the 14thC, was the home of the Davenport family from the 14thC to 19thC. It became the home of a wealthy industrialist, Charles Neville, in 1883 and passed into public ownership in 1935 and opened as a Museum the following year.

It is noted chiefly for its timber construction. The South Wing includes an early carved oriel incorporating a coat of arms and a green man. The roof has cambered tie beams, arched braces and two and a half tiers of wind braces. The spandrels are carved and include a very fine griffin.

There are also 16thC wall-paintings in the South Wing and a pre-Reformation wall-painting, partly overpainted, in the Chapel.

The Withdrawing Room features a pendant plaster ceiling and overmantel with the coat of arms of Elizabeth I. The north doorcase of this room is late 16thC and includes classical Renaissance detail and fine inlay.

The Hall houses the collections of fine and decorative arts of the Vernon Park Museum. The furniture includes a 16thC oak refectory table, and early 16thC box pew, a 17thC dower chest and an inlaid credenza and side tables designed by Pugin and made by the Crace Bros in the mid-19thC for Abney Hall. The Davenport family portraits are displayed, dating from the 17thC and 18thC.

Bramall Hall has an Association of Friends. A shop sells an illustrated guidebook and publications of local interest. There is a cafeteria, and car-parking is available.

16thC–19thC British furniture

Bramall Park, Bramhall, Stockport
tel. 061-485 3708

Tues–Sun 12–5 pm (April–Sept);
12–5 pm (Oct–Mar). Closed Dec & Mon
(except Bank Holidays)

Admission charge

Stockport Metropolitan Borough also administers:

Stockport Museum [2]

Established in 1860, the Museum was one of the earliest to be built in this part of the country. It was the gift to the town of James Kershaw and John Benjamin Smith, both Liberal Members of Parliament. The architect was Alexander William Mills (d. 1905).

Mostly local and social history, natural history and botanical collections, the Museum also houses items relating to local industries, hat-making, engineering and textiles.

Amongst leaflets available are the *History of Stockport Museum* by H. Fancy (1971), also books and postcards.

Vernon Park, Turncroft Lane, Stockport
tel. 061-480 3668

Mon–Sat 1–4 pm (Oct–Mar);
1–5 pm (April–Sept). Closed Sun

Admission free

Stockport War Memorial and Art Gallery [3]

Samuel Kay gave land to Stockport in 1925 to build an Art Gallery and Exhibition Hall and the local War Committee decided to incorporate a War Memorial on the site. The architects were Halliday, Paterson and Agate, and in the Hall of Memory there is a sculpture group by Gilbert Ledward. The collection of paintings includes works by Whistler, Leader, Lowry and Bratby and the sculpture includes a bust of *Yehudi Menuhin* by Epstein. There is a modern print collection.

19thC & 20thC British painting

Wellington Road South, Stockport
tel. 061-480 9433

Mon–Fri 12–5 pm; Sat 10–4 pm.
Closed Sun

Admission free

STOCKTON-ON-TEES, *Cleveland*

Preston Hall Museum

Local and social history; arms and armour; snuff-boxes

Yarm Road, Stockton-on-Tees
tel. 0642-781184

Mon–Sat 9.30–5 pm; Sun 2–5 pm

Admission free

Preston Hall was opened as a museum in 1953. The house, set in 112 acres of parkland and completed in 1825, was formerly the home of the Burton-Fowlers and later the Ropner family. Robert Ropner came from Prussia and was a local shipbuilder and owner. He was responsible for adding the conservatory and entrance porch. The house was abandoned in the 1940s and purchased in 1948 by the local council to house the contents of two important bequests. The Clephan Bequest of 1930 brought to Stockton a fine collection of watercolours, which includes Turner's *Mustering of the Warrior Angels* of 1833. Of particular interest as a rarity in this country is the late painting by the 17thC French artist Georges de la Tour of *The Dice Players*. The second bequest was that of Colonel Gilbert Ormerod Spence (1879–1925), a local resident whose extensive collection of arms and armour, snuff-boxes and pewter is on display or available in the reserve collection.

Beyond the Hall is a series of Victorian period rooms, 'Period Street', an assortment of reconstructed shops and areas demonstrating the history of local industrial life.

There is a shop where a guidebook to the Hall is available. In the park are a cafeteria and car-parking

STOKE-ON-TRENT, *Staffordshire*

City Museum and Art Gallery [1]

Pottery and porcelain;
costumes; jewellery;
British painting and sculpture (20thC)

Bethesda Street, Hanley
tel. 0782-273173

Mon–Sat 10.30–5 pm (Sun opening under review)

Admission free

The Museum was founded in 1826 but is now housed in a spacious new building, designed by the City Architects Department, and officially opened by H.R.H. The Prince of Wales in June 1981. Given a special award for outstanding enterprise by the British Tourist Authority, the City was further recognised in 1982 with the 'Museum of the Year' award. A feature of the main façade is the vast brick mural over the entrance.

The most important holding in this museum is, appropriately to its location in 'The Potteries', one of the largest and finest collections of pottery and porcelain in the world. The ceramic collections, with their unparalleled representation of Staffordshire wares, follow the history of the subject in chronological sequence, showing the importance of Stoke-on-Trent as the centre of English ceramic production and its expansion from the 17thC to the present day. The introductory technical gallery anticipates many of the questions likely to be posed by the non-specialist visitor. Examples of early slipware include documentary pieces from the 17thC, among them a large dish, which has trailed decoration of the royal arms of Charles II and which is inscribed 'Thomas Toft', the name of the Staffordshire potter and outstanding maker of slipware (d. 1689). Thirty-one large dishes and three pots inscribed with his name have survived (see also Temple Newsam House, p. 199). For the 18thC there are displays of salt-glazed stoneware and lead-glazed earthenware, with examples moulded in fantastic shapes—a teapot in the form of a house and a coffee-pot in the form of a cauliflower—and imitating other materials, such as agate or shell. There is a fine group of Wedgwood and the products of the Staffordshire porcelain factories of Longton Hall and New Hall, as well as of Staffordshire bone china made by the Spode, Davenport, Ridgway and other local factories. Also on display is an outstanding group of Staffordshire figures from the late 18thC–19thC, which includes the Gordon Pugh collection of Staffordshire portrait figures acquired as recently as 1980. The Victorian and Art pottery represented is of great technical sophistication, including a porcelain plaque decorated with *pâte-sur-pâte* by Louis Solon for Minton's, and two vases with tube-lined decoration, infilled with coloured glazes in a wisteria pattern, designed by William Moorcroft for MacIntyre's *c.* 1910. The collection continues up to the present with, for instance, Michael Cardew and Susie Cooper.

The collections also include ceramics from the Continent, the Near and Far East and South America. All study collections may be viewed by prior appointment.

The archæology displays are related to Staffordshire sites of all periods from the Mesolithic to the 18thC, but are unusual in that the emphasis is on the post-mediæval period, since much of the initiative in this area has been towards the understanding of the local ceramic

Staffordshire pottery group of two pugilists, John Heenan and Tom Sayers, 1860
(Stoke-on-Trent City Museum and Art Gallery)

263

industry and its origins. Nonetheless, the Museum has a gold bracelet of *c*. 800 BC from Stanton in North Staffordshire; early Bronze Age objects and pottery; a hoard of coins and jewellery, including silver bracelets of the mid-3rdC AD; mediæval pottery and floor tiles; and a late 15thC gold and sapphire ring from Hulton Abbey.

There is also an extensive costume collection, including the Bagot Collection of male and female clothes and accessories (1775–1965) presented by Nancy, Lady Bagot, as well as some glass, furniture, enamels and Oriental antiquities.

The fine art collections are concentrated on British painting and sculpture of the modern period, with a notable group of works by the Camden Town Group: Sickert, Ginner, Bevan, Gilman, etc.

The Museum has a very active Society of Friends. The Museum shop sells a range of books, exhibition pamphlets, postcards and souvenirs. There is a cafeteria and a bar in the Museum and ample car-parking facilities within a short distance.

PUBLICATIONS
Recent exhibition catalogues:
Wedgwood of Etruria and Barlaston, 1980
Bow Porcelain, 1981
Mason: A Family of Potters, 1982
Spode-Copeland, 1733–1983: Potters to the Royal Family, 1983
Minton Tiles, 1835–1935, 1984

Royal Doulton pottery and porcelain (early 19thC–present day)

Nile Street, Burslem, Stoke-on-Trent
tel. 0782-85747

Mon–Fri 9–12.30 pm, 1–4.15 pm.
Closed Sat, Sun

Admission free; charge for factory tours

The Sir Henry Doulton Gallery [2]

The Royal Doulton factory was founded in 1815 by John Doulton in Vauxhall Walk, Lambeth. Doulton was only twelve when he began his apprenticeship at the Fulham Pottery, an excellent training ground for the ambitious young man, whose factory under the management of his son Henry was to become one of the most successful and innovative of the 19thC. Henry Doulton gathered a team of ceramic artists whose work is now eagerly collected. The Royal Doulton Gallery owns examples of pottery and terracotta sculptures by George Tinworth; salt-glazed incised wares by Hannah Barlow; as well as elaborate modelled wares by C. J. Noke, who was also responsible for the dramatically coloured flame wares based on the adaptation of glazing and colour techniques from the Chinese Song and Ming dynasties. Among the most widely collected of all Royal Doulton productions are the figures and animal models. These, too, owe their initial invention to Charles Noke, who showed matt ivory-glazed models of jesters, minstrels and characters from Shakespeare and Gilbert and Sullivan at the 1893 Chicago Exposition. *Jack Point*, originally introduced in 1918, is still in production. The subsequent models are the work of a number of specialist sculptors, among them such well-known names as Phoebe Stabler, Albert Toft and Charles

Earthenware life-sized model of a peacock decorated with maiolica glazes by Paul Comolera, 1873 (Minton Museum, Stoke-on-Trent)

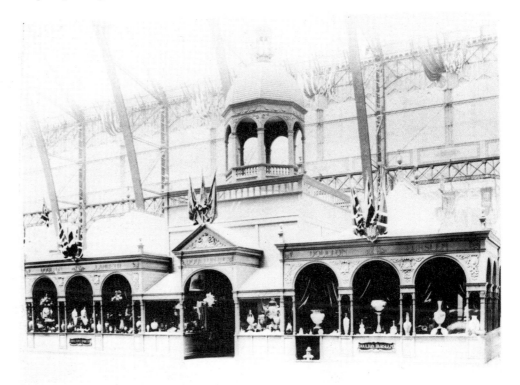

Doulton pavilion at the Chicago Exhibition 1893 (The Sir Henry Doulton Gallery, Stoke-on-Trent)

264

Vyse. The Gallery owns a world-famous collection of over three hundred of these figures, as well as a representative coverage of the complementary Character Jugs and Toby Jugs.

There is a handbook published by the Gallery which gives a brief outline history of the factory, as well as listing a number of specialist books for the collector.

Minton Museum [3]

Minton ceramic wares, *c.* 1800–present day

Minton House, London Road,
Stoke-on-Trent
tel. 0782-49171

Mon–Fri 9–12.30 pm, 2–4.30 pm.
Closed Sat, Sun & factory holidays

Admission free

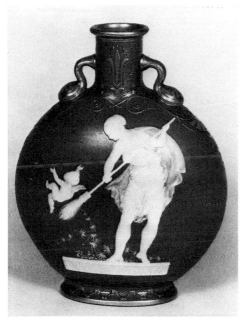

Minton pâte-sur-pâte pilgrim flask decorated by Louis Solon, 1878 (Minton Museum, Stoke-on-Trent)

Spode ceramic wares 18thc–present day

Church Street, Stoke-on-Trent
tel. 0782-46011
Mon–Fri (by appointment only).
Closed Sat, Sun

Admission free

PUBLICATIONS
Spode: Never out of Fashion (a chronological history and details of manufacturing processes), n.d.

The main collections consist of wares produced by the Minton factory from 1800 to the present day, arranged in chronological display, with many large free-standing ornaments. The collection includes early tablewares, figures, hand-painted plaques, tiles and other decorative objects in bone china, bisque, stoneware, redware and earthenware.

The Minton Museum is one of three collections within the Royal Doulton Group, (see also the Sir Henry Doulton Gallery and the Royal Crown Derby Museum). The Minton Factory was founded in 1793, and the Minton archives are now housed in the same building as the Museum. The archive material is fully catalogued and includes all sales correspondence, indentures, purchase records, share and debenture transactions, providing a complete commercial history of the Minton Company. The archive also has valuable source material in the form of original designs by A. W. N. Pugin, Christopher Dresser, etc., as well as pattern-books for the earlier wares, all of which can be made available to serious researchers by prior appointment with the Curator.

Among the exhibits, notable items include: examples of Parian Statuary porcelain figures such as 'Dorothea' from Don Quixote, modelled by John Bell for Summerly's Art Manufactures (1847); a dessert service painted with scenes to commemorate Lord Milton's expedition through Canada, commissioned by him in 1865; a vase in tinted, glazed Parian with polychrome *pâte-sur-pâte* decoration by L. M. Solon (1878 Exposition, Paris); Paul Colomera's Peacock, a life-size model in earthenware decorated with maiolica glazes (1873); a ewer in the Renaissance style decorated with inlaid clays by Charles Toft (*c.* 1870) and a bone-china tray in the 18thc Sèvres manner by J. E. Dean, embellished with elaborate raised gilding (*c.* 1900).

Slides and 'Story of Minton' tourist information leaflets are available at the Minton Museum. The Minton factory shop stocks best-quality and limited quantities of seconds of Minton ware and wares of Royal Doulton (UK) Limited.

Tours of the Minton Factory are available from Monday to Friday.

Spode Museum [4]

The Spode Museum is attached to the world-famous bone china manufactury, and the collection is displayed in two galleries: the Blue Room, on the second floor, is furnished with antique oak dressers and tables on which the extensive collection of Spode blue and white transfer-printed wares is laid out. The main Museum gallery on the ground floor contains a large collection of Spode wares (1785–1833), especially strong in bone china, as is proper as Josiah Spode I (1733–97) is regarded as the perfector of this characteristic English porcelain. Dessert wares and ornamental pieces from the Copeland period of the Spode factory form a large part of the display: many of these objects are signed by the artists. A representative collection of Parian statuary is held in the reserve collection due to insufficient display space. Many examples of wares made to commemorate Royal occasions, anniversaries of foundation of cathedrals and other commemorative items are displayed.

The Museum was founded in 1925 on the initiative of R. Ronald Copeland and A. Gresham Copeland. In 1972 much of the collection of blue and white ware formed by the late Major A. J. Bather was added, making this the largest group of Spode blue and white available for public viewing.

A restaurant and some car-parking facilities are planned.

STRATFORD-UPON-AVON, *Warwickshire*

Arms and Armour Museum [1]

Poet's Arbour, Sheep Street,
Stratford-upon-Avon
tel. 0789-293 453

Daily 10–6 pm. Closed Christmas Day

Admission charge

PUBLICATIONS
A catalogue of the Museum is in preparation

The Collection was started by a private collector and his family in 1932 and opened as a museum in 1982. Of unusual interest in the collection are the firearms of Tipu Sultan of Seringapatam (1750–99), comprising flintlock guns and pistols, which were made for his personal use and which are fully inscribed.

Amongst many other edged weapons is a group of thirty small-swords largely with silver hilts and dating from 1680 to 1800, the most notable one being of twenty-two-carat gold and enamel, presented in 1796. There is also a collection of over 150 guns and pistols ranging in date from a 'Hand Gonne' of *c.* 1380 to a fine pair of sporting guns by James Purdey of *c.* 1925. Another rarity is an Indian 9 pounder Howitzer complete with original carriage and limber from the orderly battery of the Maharajah Rungit Singh of the early 19thC.

The shop sells only genuine old items of arms and armour, ranging from swords to complete suits of armour. No reproduction items are stocked. There is parking in the town nearby.

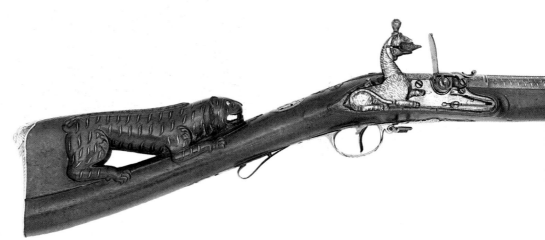

Stock of a flint-lock sporting gun decorated in gold and silver, made for Tipu Sultan in Seringapatum by Asad Khan Muhammad, 1793 (Arms and Armour Museum, Stratford-upon-Avon)

Royal Shakespeare Theatre Gallery [2]

18thC–20thC British painting;
19thC–20thC British sculpture

Stratford-upon-Avon
tel. 0789-296655

Mon–Sat 9–6 pm; Sun 12–5 pm

Admission charge

The Shakespeare Memorial conceived and built by Charles Edward Flower, designed by William Frederick Unsworth (1850–1912), comprised a theatre which opened 1879, a Library and Picture Gallery opened in 1881 and a Lecture Hall which opened in 1885. Built in red brick with stone banding, decorated Gothic arches, terracotta panels and mock Tudor timbering, the Library/Gallery section of the Memorial was the principal entrance to the theatre.

A fire in 1926 burnt out the auditorium, the remaining walls were then incorporated into the design for the 1932 theatre building by Elizabeth Scott. A new auditorium within the walls of the first building is planned to open in 1986. The Library/Gallery building will once more provide the main entrance.

The collection covers a wide variety of theatrical and associated items. 18thC and 19thC imaginative scenes from Shakespeare include a number commissioned by Alderman John Boydell for his Shakespeare Gallery, such as *The Return of Othello* by Stothard and Northcote's *Hubert and Arthur* from *King John*. Other painters represented are Fuseli (*Henry V discovering the Conspirators* and *The Weird Sisters*), de Loutherbourg (*The Tempest*), Maclise (*Miss Priscilla Horton as Ariel*) and Reynolds (*The Death of Cardinal Beaufort*). Later painters include Millais (*Lord Ronald Sutherland Gower*), John Gilbert (*Cardinal Wolsey and Buckingham*) and Pettie (*Romeo and Juliet*). More recent works include those by Peter Greenham and Ralph Steadman, the political cartoonist.

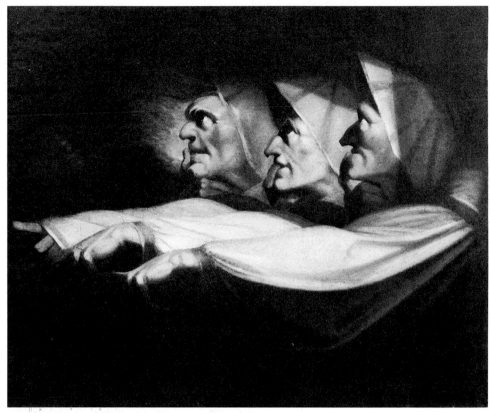

Johann Heinrich Fuseli, *The Weird Sisters*, 1792 (Royal Shakespeare Theatre Gallery, Stratford-upon-Avon)

The sculpture collection ranges from the work of Roubiliac (*Shakespeare*) to Frampton (*Sir John Martin-Harvey*) and David Wynne (*Sir John Gielgud*).

Costumes worn by Henry Irving are in the collection but not on permanent display, and many representative of more recent performances, theatre properties, set and costume designs, prompt books and photographs also make up the collection.

There is a shop, restaurant and cafeteria, and a car-park. A small booklet is available at the shop, which lists works in the collection, and more publications are in preparation.

STREET, *Somerset*

The Shoe Museum

Shoes from the Roman period to the present day

Messrs C. & J. Clark Limited, Street tel. 0458–43131

Mon–Sat 10–4.45 pm (Easter Mon– 31 Oct); closed Sun.
Winter by appointment only

Admission free

The Museum, founded by C. & J. Clark Limited in 1950, is situated in the oldest part of the factory in fine 19thC industrial buildings which include the 1829 building for Cyrus Clark's sheepskin works and the block built in 1898 by William Reynolds. On display are over a thousand shoes from all over the world, also 19thC hand-tools, machinery, advertising material, fashion plates and a collection of 18thC shoe buckles.

A small shop sells books, particularly relating to shoemaking and local history, posters and postcards.

SUDBURY, *Suffolk*

Gainsborough's House

Material associated with Thomas
Gainsborough (1727–88)

46 Gainsborough Street, Sudbury
tel. 0787-72958

Tues–Sat 10–5 pm; Sun and Bank Holiday
Mon 2–4 pm (Easter–Sept); Tues–Sat
10–4 pm, Sun and Bank Holidays 2–5 pm,
closed Mon (Oct–Maundy Thurs)

Admission charge

This delightful house, where Thomas Gainsborough was born, was originally mediæval. The façade is of 1723 and later additions were incorporated, mostly in about 1790. Gainsborough's House Society was founded to purchase the House, to use it to commemorate the artist and as an art centre. The purchase was made possible by generous donations from Sir Alfred Munnings (1878–1959), the horse painter who lived nearby at Dedham (paintings of his are to be seen there at Castle House, q.v.). Donations also came from local sources and a national appeal. The House was founded in 1958 and first opened to the public in 1961. The Museum is owned by Gainsborough's House Society, a private charitable trust (for which membership is available), with substantial grants from Suffolk County Council and the Eastern Arts Association towards its running costs.

The collection is centred around the work of Gainsborough at all stages of his career, as well as around his contemporaries. It is based on loan material and amongst the works by Gainsborough are, most notably, portraits of *Abel Moysey M.P.* of 1771, *Mrs Nathaniel Acton* of *c.* 1757–58 and *Mr and Mrs John Vere* of the late 1740s. A purchasing policy has recently been developed and acquisitions of works by the Norwich-based artist John Theodore Heins (portraits of two cousins of Gainsborough) and by Gainsborough Dupont have been made. A recent acquisition is a portrait of a boy of *c.* 1744–45, attributed to the young Gainsborough. A large collection of watercolours, mostly 18thc, are on loan to the House. These include the work of most artists of the period and have been in Sudbury since 1981. The House also contains 18thc furniture.

A small sales counter has a selection of catalogues of exhibitions held at the House since 1976. There are car-parking facilities in the town.

John Theodore Heins, *John and Thomas Gainsborough*, both 1731 (Gainsborough's House, Sudbury)

SUNDERLAND, *Tyne and Wear*

Sunderland Museum and Art Gallery

16thC–19thC English silver;
19thC English pottery;
19thC English glass;
19thC British painting

Borough Road, Sunderland
tel. 0783-41235

Mon–Fri 10–5.30 pm; Sat 10–4 pm;
Sun 2–5 pm

Admission free

PUBLICATIONS
*Collection Handlist, Fine and Applied Art,
Glassmaking on Wearside*, 1979
John Wilson Carmichael 1799–1866, 1982
Pyrex: 60 Years of Design, 1983
*Ship to Shore: Maritime Paintings from Seaham to the
Tyne*, 1984
Sunderland Pottery, 1984

The Museum was established in 1846 when Sunderland Corporation took over the collections of the Sunderland Natural History and Antiquarian Society. The present building was erected in 1879, and designed by J. and T. Tillman. A new extension was opened in 1964.

It holds the largest public collection of pottery produced in the town, notably purple lustre, also Sunderland glass, including the table service made for the Marquess of Londonderry in 1824 and a large collection illustrating the evolution of Pyrex. There is a good collection of English 16thC–19thC silver. The fine art collections are chiefly British, with a strong emphasis on local artists and a large local topographical collection. 19thC paintings include work by artists such as Landseer, Ernest Normand and Clarkson Stanfield, and drawings and watercolours include works by D. G. Rossetti, Burne-Jones and George Fennel Robson.

The 20thC collection ranges from paintings by Francis Dodd to L. S. Lowry and Allen Jones.

The Museum has an Association of Friends. A sales desk stocks publications. There is a tea-room and a multi-storey car-park nearby.

SWINDON, *Wiltshire*

Swindon Museum and Art Gallery

20thC British painting;
20thC British studio pottery

Bath Road, Swindon
tel. 0793-26161, ext. 3129

Mon–Sat 10–6 pm; Sun 2–5 pm

Admission free

The Museum was founded in 1920 on the geological collection of the first Curator, C. H. Gore, and local paintings and curiosities given by Alderman J. Powell. The permanent art collection was founded in 1945. Its principal donor was H. J. P. Bomford, who gave sixteen paintings which, together with a further six given between 1954 and 1978, still form the most significant part of the collection. For many years the collection was without a permanent home, and although it is now housed in the Museum and Art Gallery, it is not always on display.

The Museum occupies a fine neo-classical merchant's house built *c.* 1830 with a gallery added in 1963–64. The Collection is devoted to modern British art, although it does include the work of some foreign artists. The earliest works are a group of Clausen sketches of *c.* 1895 and the most recent is a portrait of *Leon Kossoff* by John Lessore. Works of major significance include Ben Nicholson's *Composition in Black and White* (1933), Henry Moore's *Three Women and a Child*, Sutherland's *The Dark Hill* (1940), Wadsworth's *Dunkerque, Barometer, Wool and Floats*, and Richard Hamilton's *Interior Study* (1964). There are also works of importance by Vanessa Bell, Robert Bevan, David Bomberg, Mark Gertler (a very early portrait), Roger Hilton, Richard Long, L. S. Lowry, John Nash, Mary Potter and Christopher Wood.

The studio pottery collection complements the paintings with good works by, among others, Hans Coper, Lucie Rie, and Katherine Pleydell-Bouverie who worked locally for many years.

The Museum also houses a major collection of pot lids and Pratt ware, including some unique pieces which came from Ernest Manners (1882–1971), a local agriculturalist collector. There are also minor collections including costume, musical instruments, Swindon crested china, local photographs, militaria, geology, archæology and natural history.

There is a shop. Car-parking is available nearby in public car-parks.

TAUNTON, *Somerset*

Somerset County Museum

Chinese ceramics; 19thC local history; natural history; geology

Taunton Castle, Taunton
tel. 0823-55504

Mon–Fri 10–5 pm. Closed Sat, Sun & Bank Holidays (check with Museum for Sat openings in summer)

Admission charge

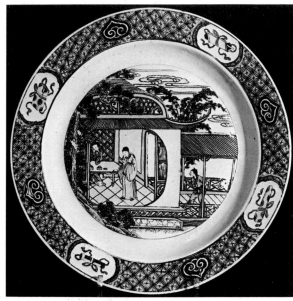

Chinese porcelain plate from the Kangxi period (Somerset County Museum, Taunton)

British paintings and watercolours 19thC; English drinking glasses 18thC; antique pewter; Watcombe and Torquay terracotta ware; Oriental snuff-bottles

The King's Drive, Torquay
tel. 0803-23593

Daily 10–5 pm (April–Oct). Nov–Mar by appointment

Admission charge

The Museum was founded in 1875 when the collections of the Somerset Archæological and Natural History Society were put on show in Taunton Castle, which has been leased since 1958 by the Somerset County Council. The collections are based upon those made by the Society from the mid-19thC to 1958. Taunton Castle was purchased by the Society in 1875 and dates back to Norman times. Having both contracted and enlarged over the centuries, it now consists of the Great Hall and adjoining buildings, inner bailey and encircling walls. The large windows were inserted in the latter half of the 18thC, and a foyer and new wing added in 1931–34; these were enlarged in 1974.

The collection is mixed; its main strength is in the decorative arts and includes Chinese ceramics, Nailsea glass, Donyatt ware, Elton, De Morgan and some Martinware. There is also a collection of costume and jewellery, and also 17thC silver spoons, many Taunton marked. The antiquities section includes items from Meare and Glastonbury Lake villages and the Low Ham Mosaic.

A ticket desk sells the available publications, a guide to the Museum and various of the collections, including the catalogue of the Colthurst Collection, *The Art of the Chinese Potter.* There is limited car-parking in the Castle courtyard.

TORQUAY, *Devon*

Torre Abbey

Founded by the then Torquay Borough Council (now Torbay) in 1930, Torre Abbey was purchased by the local authority and part of it redesigned to house the collection of works of art which the Council had been acquiring since about 1900. More items came in the 1930s from benefactors—furniture and silver, two groups of 19thC paintings, and so on—providing the nucleus of the varied collection which is now in the Abbey. The paintings include works by Charles Napier Hemy and W. L. Wyllie, as well as a pair of portraits by Valentine Prinsep and a remarkable group-portrait by Holman Hunt entitled *The Children's Party.* This shows the wife and children of Sir Thomas Fairbairn, Holman Hunt's patron and the one-time owner of *The Awakened Conscience* (now in the Tate Gallery, q.v.).

The decorative art collection has also been enriched by benefactors. In 1949 Mrs Penn Gaskell gave her large collection of antique pewter; this was followed in 1955 by the Meres' collection of English drinking glasses, with fine examples of engraved, cut, blown and air-twist decorated glasses mainly of 18thC date. Very recently, in 1983, the Museum was presented with the Brian Edmund Reade collection, consisting of an unrivalled representation of Watcombe and Torquay terracotta wares, as well as an interesing group of local paintings and graphics associated mainly with the Art School of the Vivian Institute of Science and Art, of which the donor's father was a master. This collection is the subject of an exceptionally interesting booklet, part catalogue, part reminiscence, by Brian Reade himself.

The Abbey itself was founded in 1196 by Lord William de Brewer for the Premonstratensian Order of Canons. By the time of the Dissolution in 1539, Torre Abbey was the richest Premonstratensian house in England, and the Abbey buildings were on a lavish scale. Most were left to fall into decay and eventual ruin after 1539, but parts were converted for use as a private residence at the end of the 16thC. The Abbey was extensively remodelled between 1700 and 1750 by the Cary family who had bought the Abbey in 1662. They remained in ownership until the purchase of the property by the local authority in 1930. The South elevation is mainly 18thC in character, while the West Wing is late mediæval. The ruins of the Abbey Church are on view, as is a magnificent early 13thC tithe barn. Internally, much work has been done recently in restoring parts of the Abbey to their 18thC appearance, notably the Entrance Hall, Dining-Room and Chapel. There are also extensive gardens and a large tropical Palm House.

There is a sales desk selling guidebooks and postcards.

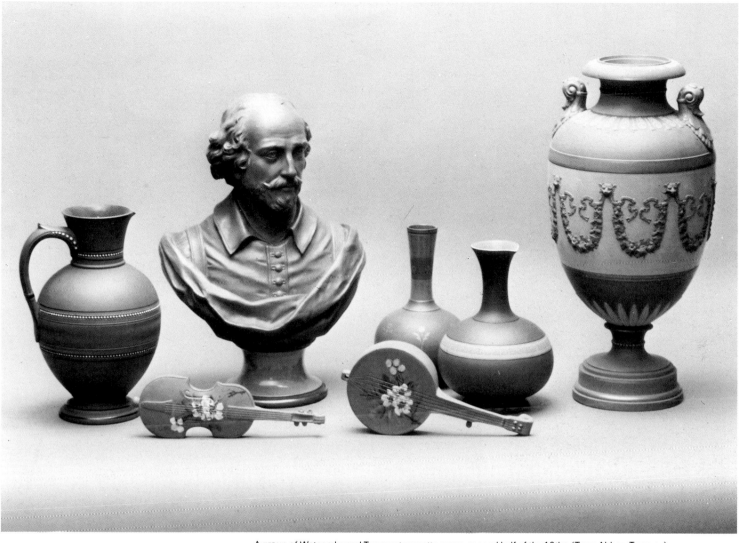

A group of Watcombe and Torquay terracotta wares, second half of the 19thc (Torre Abbey, Torquay)

TOTNES, *Devon*

Devonshire Collection of Period Costume

10a High Street, Totnes
tel. 0803-862423

Mon–Fri 11–5 pm; Sun 2–5 pm (Spring Bank Holiday–1 Oct). Closed Sat & Oct–Spring Bank Holiday

Admission charge

The Collection consists of English dress, mainly women's from 1750–1950, together with underwear, hats and accessories of all kinds. Everything in the collection has been donated by private individuals. Unusual pieces include dresses and other items from Liberty & Co., and a Fortuny evening coat.

The exhibition rooms are situated on the first floor of a Tudor building which is thought to have belonged to the first Mayor of Totnes. The ceilings are 16thc, in a formal design incorporating the Tudor Rose and fleur-de-lys. The rooms are panelled, and the windows have much of the original glass; scratched on one pane is the message 'J W and A dined here on 17th May 1765 on their way from Plymouth to Newton and Teignmouth.'

The Devonshire collection is a voluntary organisation administered by a Trust and registered as a Charity, which aims to collect and display examples of dress of all periods. In the summer months each year an exhibition with a particular theme is mounted—for example in 1984, *The Dear Departed 1860–1930*, on the subject of mourning costume. The catalogues of some of these exhibitions are still available with a small selection of postcards and booklets on relevant subjects.

The collection has an association of Friends.

John Opie, *Gentleman and a Miner*, 1786
(The Royal Institution of Cornwall, Truro)

Harold Harvey, *Apples*, 1912 (The Royal Institution of Cornwall, Truro)

TRURO, *Cornwall*

The Royal Institution of Cornwall

Local history; Old Master paintings and drawings

The County Museum, River Street, Truro tel. 0872-72205

Mon–Sat 9–5 pm. Closed Sun & Bank Holidays

Admission free but under review

The Royal Institution of Cornwall was founded in 1818 and a new building erected to house the collections in 1919 behind a Savings Bank of 1845 built by a local architect, Sambels.

The collections are predominantly those of the prehistory and history of Cornwall, and contain a very fine collection of mineral specimens. The decorative arts include ceramics, Japanese ivories and lacquers, and pottery and pewter. Alfred de Pass presented a fine collection of drawings, including examples by Rembrandt, Claude, Hogarth, Boucher and Géricault. Paintings include works by the local painter John Opie, a particularly interesting double portrait showing a *Gentleman and a Miner* of 1786 and *Sir David Wilkie*. The Newlyn School is represented.

The Institution has a membership which helps the Museum. There is a shop where a guidebook is available.

TUNBRIDGE WELLS, *Kent*

Tunbridge Wells Museum and Art Gallery

Victorian paintings (Ashton Bequest);
Tunbridge ware; local history

Civic Centre, Mount Pleasant,
Tunbridge Wells
tel. 0892-26121, ext. 171

Mon–Fri 10.5.30 pm (closed Tues after
Spring & Summer Bank Holidays);
Sat 9.30–5 pm. Closed Sun &
Bank Holidays

Admission free

The Museum developed from the Tunbridge Wells Natural History and Philosophical Society, founded in 1885. It was handed over to the Tunbridge Wells Borough Council in 1918 and is now housed in the Civic Centre, begun in the 1930s, but only completed in the 1950s.

The Museum has built up a collection of the famed Tunbridge ware, with its decoration often minutely detailed in wood mosaic. A number of examples are by named makers, such as the stationery box by Edmund Nye, the workbox by Henry Hollamby and the screen by Thomas Barton. There is a good collection of dolls and toys, local history, agricultural and domestic bygones and natural history.

In 1952 the Ashton Bequest of thirty-one Victorian pictures came to the Art Gallery from a local resident whose father had collected them in the decade between 1852 and 1863. The choice is representative of orthodox taste of the period: there are no Pre-Raphaelite works, nor any 'problem' pictures. Among the genre and landscape subjects are works by Charles Leslie, Thomas Creswick, Henry Nelson O'Neil, Abraham Solomon (*Waiting for the Verdict* and *The Acquittal*, subjects of which the Tate Gallery [q.v.] has recently acquired versions); the Gallery is notable for the representation of Cranbook Colony artists such as J. R. Horsley and F. D. Hardy (*The Young Photographers*, a sentimental narrative picture very much in the Cranbrook Colony spirit). There are also works by John Linnell (two landscapes from the latter half of his career), and a John Phillip entitled *The Bridesmaid*.

The local topographical collection includes a group of watercolours by Charles Tattershall Dodd (1815–78), who was Drawing Master at Tonbridge School.

Tunbridge ware jewel cabinet made by George Wise Jnr, mid-19thc (Tunbridge Wells Museum and Art Gallery)

Frederick Daniel Hardy, *The Young Photographers*, 1862 (Tunbridge Wells Museum and Art Gallery)

On sale at the Museum is a selection of postcards and publications, including pamphlets and catalogues on the collections, on Old Tunbridge Wells and on the most celebrated local architect, Decimus Burton, who was the subject of an exhibition in 1981 to mark the centenary of his death.

WAKEFIELD, *West Yorkshire*

Wakefield Art Gallery [1]

Old Master paintings; British 19thc & 20thc paintings, drawings and sculptures

Wentworth Terrace, Wakefield
tel. 0924-370211, ext. 8031

Mon–Sat 10.30–12.30 pm, 1.30–5 pm.
Closed Sun

Admission free

Wakefield Art Gallery is housed in an attractive Victorian house, once a vicarage, dating from 1885. Notable exhibits include *Wakefield Chantry Chapel and Bridge* by Philip Reinagle and J. J. Tissot's *On the Thames*. The 20thc is well represented with works by Bryan Kneale, Terry Frost, John Walker and William Pye, as well as groups by the best known British sculptors of this century, Henry Moore, who was born and brought up in nearby Castleford, and Barbara Hepworth, who was born and educated in Wakefield. Some sculpture is displayed in the garden.

There are a number of postcards, from both the Art Gallery and the Museum collections, and catalogues of past and present exhibitions for sale at the Gallery. There is an information sheet on Henry Moore and those of his works owned by the Gallery. A complete list of publications is available on request.

Barbara Hepworth, *Mother and Child* in pink Ancaster stone, 1934 (Wakefield Art Gallery)

James Tissot, *On the Thames*, c. 1876 (Wakefield Art Gallery)

Wakefield Museum [2]

Originally built as a Music Saloon and Public Rooms between 1820 and 1823, this interesting example of early 19thC architecture later became a Mechanic's Institution. It has been transformed gradually into a Museum since the mid-1950s, and work is still continuing on the progressive modernisation and re-display, as resources permit.

The collections are entirely concerned with the archæology and history of this area, including nearby Roman Castleford, Sandal Castle, and the 17thC potteries at Wrenthorpe. Changing displays illustrate other aspects of everyday life in the past and present centuries.

Local archæology and history, prehistoric–17thC; social history

Wood Street, Wakefield
tel. 0924-370211, ext. 7190

Mon–Sat 10.30–12.30 pm, 1.30–5 pm.
Closed Sun

Admission free

WALSALL, *West Midlands*

Walsall Museum and Art Gallery [1]

Founded in 1906, the Gallery was initially based on a collection of Victorian and Edwardian landscape and genre painting. However, in 1973 it was transformed by the acquisition of the Garman-Ryan collection, donated by Lady Epstein who, together with the sculptor Sally Ryan, had collected oils, watercolours, drawings and prints since the death of her husband, Sir Jacob Epstein. Kathleen Epstein (formerly Miss Garman) was the sculptor's second wife and had been his model and secretary before they were married in 1955. There is a bronze portrait of her, a version of the one in the Tate Gallery, which was begun the day after they first met in 1921. Having been born and educated in the West Midlands, Lady Epstein wished to donate the collection to a gallery in the area. Walsall was chosen since it could guarantee a permanent home with the collection shown in its entirety. It is administered by the Walsall Metropolitan Borough Council and housed above the Central Library, built by James S. Gibson (1861–1951) in 1906.

The collection of the work of Sir Jacob Epstein includes many of his bronze portrait busts (e.g. *T. S. Eliot* of 1952), but also watercolours and drawings made throughout his career (e.g. a drawing for *The Tomb of Oscar Wilde* of 1909). As a result of the nature of the collection, also included are works by Epstein's early acquaintances, for instance Picasso and Braque; by life-long friends such as Matthew Smith; and Lucian Freud is represented by three outstanding paintings. The collection is also of special interest outside these categories, including such diverse items as Van Gogh's drawing *Sorrow*, a preliminary study of 1882 for the lithograph of the same subject; and a watercolour by William Blake, *Christ in the*

British and Continental paintings, watercolours and drawings (19thC–early 20thC); the work of Sir Jacob Epstein (1880–1959)

Central Library, Lichfield Street, Walsall
tel. 0922–21244, ext. 3124/3115

Mon–Fri 10–6 pm; Sat 10–4.45 pm.
Closed Sun & Bank Holidays

Admission free

Carpenter's Shop of *c.* 1803. The scope of the collection is exceptional for a museum of this size, containing works by French artists as distinguished as Degas—a portrait of his sister *Marguerite*—or Delacroix, as well as Corot, Monet, Renoir and Robert Delaunay. The collection of drawings and watercolours includes works by many of the leading artists of the British and French schools, among them Turner, Rossetti, Ruskin, Burne-Jones, Whistler and Augustus John, Manet, Monet, Pissarro and Vuillard.

An illustrated catalogue is available, and a brief guide and a selection of postcards.

Walsall Metropolitan Borough Council also administers:

The Lock Museum at Willenhall [2]

The history of locks and lockmaking; keys

Walsall Street, Willenhall
tel. 0902-65613

Mon, Tues, Thurs, Fri 9–6 pm;
Sat 9.30–12.30 pm, 2–4.30 pm.
Closed Wed, Sun

Admission free

Lockmaking has been a local craft at Wolverhampton and Willenhall for more than four centuries; today the town of Willenhall is still the largest producer of locks in the country, and therefore is the most appropriate place for a Lock Museum. However, the present location of the Museum may change within the next year or so, as a trust is being formed for its management and new premises may be found.

The lock collection was begun by a Willenhall librarian, and was displayed in the Library for many years, but as the collection grew, interest in it increased and it was decided to form a separate display. The Lock Museum at present occupies the first floor of Willenhall Library, in the Old Town Hall, built in 1934, and was officially opened in 1979.

The collection consists of locks, keys and lockmakers' tools, illustrating all aspects of the craft and the history of the trade in Willenhall. There are examples of miniature padlocks, and an exhibition lock made by George Anslow Ltd in 1881. Special collections include the Carpenter & Tildesley collection of ornamental rim locks and the Dancer collection of naval, prison and asylum locks. In 1982 the Wellcome Institute, when dispersing its collection, gave its holdings of antique locks, keys and door furniture to the Willenhall Museum as being the most appropriate institution to house them.

Postcards and a booklet, *A Short History of Lock Making in Willenhall*, are available from the Museum or Central Art Gallery.

Padlock and key
(The Lock Museum at Willenhall, Walsall)

Natural history; local history (large photographic collection); geology; numismatics; antiquities, including a rare Roman actor's mask; ethnography; firearms; fine and decorative art

Bold Street, Warrington
tel. 0925-30550

Mon–Fri 10–5.30 pm, Sat 10–5 pm

Admission free

WARRINGTON, *Cheshire*

Warrington Museum and Art Gallery

The Museum opened on 20 September 1855, and its collections are based on those of the Warrington Natural History Society, founded in 1838. The Museum was created largely through the efforts of William Beamont (first Mayor of Warrington), who was one of the first in the country to favour the idea of a rates-supported Museum. The land for the building was offered by the Wilson Patten family. The architect was a local builder named Stone, who basically copied, though simplified, the plans designed by John Dobson who was employed in 1853 but whose more ambitious ideas, which included a lecture theatre, were rejected because of high cost. It is described by Pevsner as: 'An uncommonly dignified building with an unbroken cornice, tripartite ground floor windows, and on the upper floor, blank panels instead of windows. Simple pediment doorway.'

In 1877 an Art Gallery extension was built to house the work of a local sculptor, John Warrington Wood. He was commissioned to make a statue of his own choice for which £1,000 was raised. The statue was *Michael Slaying Satan* after Milton's *Paradise Lost*, now on permanent display at the Museum. At the same time, 1877, William Robson donated a large collection of his brother's work, the local artist Thomas Robson, consisting of a series of copies of works by Old Masters. In 1932 Colonel J. A. Edelsten, a local philanthropist, donated a considerable collection of English and Continental ceramics to the Museum. The following year a local collector, Mr F. C. Dale, donated his collection of local glass. More recently, in 1978, the Museum received a major gift of fine and decorative arts from Mr L. J. Gibson on behalf of his late wife. The donor spent part of his boyhood and working life in Warrington.

There are approximately a thousand works in all, oils, watercolours and prints mainly of 19thC date. Of the oils, the most interesting are those by local artists such as a portrait of *Thomas Patten* by Hamlet Winstanley, *Fair Quiet and Sweet Rest* by Luke Fildes, *The First Communion Veil* by Henry Woods, *Cheapside* by George Sheffield and *Our Poor* by James Charles. Other important oils include a still-life of *Fruit and Flowers* by Jan Van Os, *The Rescue* by Frank Brangwyn, and *Myrrh, Aloes and Cassia* by John Collier.

The watercolour collection contains numerous examples of the work of local artists Oswald Garside and George Sheffield, which are mostly charcoal sketches. In the 1970s the collection was broadened to embrace many of the major names in the history of watercolour painting of the late 18thC and 19thC.

The decorative arts include a moderately sized collection of table glass, mainly of 20thC date, which is of interest locally as it was nearly all manufactured by the Warrington firm of Thomas Robinson and Co. There is also a large ceramic collection which contains classic

Jan van Os, *Flowers and Fruit*,
(Warrington Museum and Art Gallery)

Lucian Freud, *Portrait of Annabel*, 1967 (Walsall Museum and Art Gallery)

Long Compton Windmill, detail from the Sheldon Tapestry map of Warwickshire, 1647 (Warwickshire Museum, Warwick)

Archæology, history, geology and biology of the County of Warwick

Market Place, Warwick
tel. 0926-493431

Mon–Sat 10–5.30 pm; Sun (May–Sept) 2.30–5 pm.
Closed Sun (Oct–April)

Admission free

Local history and costume

St John's, Warwick
tel. 0926-493431

Tues–Sat 10–5.30 pm;
Sun (May–Sept) 2.30–5 pm; open Bank Holidays except Christmas & New Year.
Closed Sun (Oct–April), Mon

Admission free

Local history; paintings, especially Sir Hubert von Herkomer (1849–1914) and his school and the Munro Academy run by Dr Munro

194 High Street, Watford
tel. 0923-32297

examples from most English factories, but also marked pieces from unusual firms. In addition there is a selection of later Oriental wares, Kutani and Satsuma and 20thC Delft ware. The Museum also houses a loan collection of over eighty pieces of Royal Lancastrian Pottery.

The Museum displays a small selection of publications, and replica jewellery and slides are obtainable from the Museum General Office.

WARWICK

Warwickshire Museum [1]

The Museum was founded in 1836 by Warwickshire Natural History and Archæological Society, whose most notable member was Rev. Peter Bellinger Brodie, the eminent amateur geologist. The collections were taken over by Warwickshire County Council in 1932, but were closed to the public from 1939 to 1951. The building, designed by William Hurlbutt in 1670, is a Market Hall of fine proportions, somewhat marred by insensitive Victorian infilling of the ground floor arcade.

Notable exhibits include the famous Sheldon Tapestry map of Warwickshire (1647) on permanent display. There is a fine collection of firearms by Warwick gunsmith Nicholas Paris (*c.* 1700) and a selection of Warwickshire church plate; examples of the work of the notable 19thC woodcarving firms of Warwick are often on display.

The Museum shop stocks the publications concerned with the collections as well as with St John's House (q.v.), and postcards and prints.

Warwickshire County Council also administers:

St John's House Museum [2]

The St John's House Museum is a branch of the Warwickshire Museum specialising in social history collections and displays—built up almost entirely since 1950. The important collection of costume comprises about four hundred dresses from 18thC–20thC (strong on 1930s) and includes a rare embroidered early 17thC man's shirt. Items from the collections are periodically on display and others can be viewed by appointment—the collection is exceptionally well documented and catalogues and copy catalogue sheets with drawings and measurements are available for purchase. There is also a small but important collection of musical instruments including recorders by Stanesby and a lute by Hans Frei. The House includes a replica Victorian classroom, parlour and kitchen.

St John's House was built in about 1600 by the Stoughton family and is a charming Jacobean mansion of modest but elegant proportions. It is approached through fine wrought-iron gates believed to have been made about 1700 by Nicholas Paris, a member of the Paris family of Warwick, clockmakers, gunsmiths, gilders, blacksmiths and wrought-iron gate makers.

There is a Museum shop where the booklets and leaflets published by Warwickshire Museums are available; a list can be obtained from the Museum.

WATFORD, *Hertfordshire*

Watford Museum

The Museum was founded by Watford Borough Council in 1981, with a nucleus of the collections previously housed in the Library, in particular the Burr Bequest of paintings. There are two main areas of specialisation: the local history of the area, with features on printing, brewing and life in wartime; and, in the Art Gallery, a particular emphasis on the work of Sir Hubert von Herkomer (who lived nearby at Bushy) and his school, as well as

Mon–Sat 10–5 pm. Closed Sun

Admission free

PUBLICATIONS
Helen Poole, *Here for the Beer* (a gazetteer for the brewers of Hertfordshire), 1984
Helen Poole and David Setford, *Watford Past and Present* (the official Museum guide), 1982

Exhibition catalogues:
A Passion for Work: Sir Hubert von Herkomer 1849–1914, 1982
Stand to your Work: Hubert Herkomer and his Students, 1983

the Munro Academy run by the celebrated Dr Munro. There is also a group of Epstein bronzes from the Thompson Collection given to the Museum by the Watford-born benefactor. The star of the local collections is Turner's beautiful watercolour of *Cassiobury House*, acquired in 1984.

One of the most recent additions to the collection is a poignant portrait of Herkomer's first wife, Anna, the mother of his two children, who died of consumption. Purchased in 1983, it joined other family portraits already in the collection. Recent exhibitions have drawn attention to the growing importance of this special collection, and the catalogues are available from the Museum.

The publications, along with postcards, souvenirs and publications by local societies and individuals, are available at the Museum shop. An informal group of interested individuals constitutes the nearest thing to an Association of Friends.

Hubert von Herkomer, *Portrait of Anna Herkomer*, 1876 (Watford Museum)

WEST BROMWICH, *West Midlands*

Wednesbury Art Gallery and Museum

Holyhead Road, West Bromwich
tel. 021-556 0683

Mon–Wed, Fri 10–5 pm; Thurs,
Sat 10–1 pm. Closed Sun

Admission free

An impressive 19thC municipal building houses the Edwin Richards Collection of Victorian paintings and watercolours as well as the local history collections. There are changing exhibitions throughout the year, some drawn from local sources.

WHITBY, *North Yorkshire*

Whitby Museum and Pannett Art Gallery

Geology and natural history; ship models; Captain Cook memorabilia; local history and bygones

Pannett Park, Whitby
tel. 0947-602908

Mon–Sat 9.30–5.30 pm; Sun 2–5 pm (May–Sept); Mon, Tues, Thurs, Fri 10.30–1 pm; Wed, Sat 10.30–6 pm; Sun 2–4 pm (Oct–April)

Admission charge

Whitby Museum is an independent, voluntary body run by the Whitby Literary and Philosophical Society. The Society was founded in 1823 by the Rev. George Young DD, and a small group of enthusiasts who wished to benefit the town of Whitby by 'supporting a Museum and promoting the interests of Science and Literature by such other means as may be found practicable.'

At first the Museum was housed in rooms over a shop in Baxtergate, but soon moved to premises on the Quayside where it remained for more than a century. In 1931 new premises were built behind the Pannett Art Gallery; these are maintained by the Whitby Town Council, while the Society remains responsible for the exhibits which are held in trust for the people of Whitby. All the curatorial staff at the Museum are voluntary workers, members of the Society, which acts as an association of Friends.

The Museum has a fine collection of fossils and a section devoted to natural history. The shipping wing has a collection of sailors' models and builders' models, as well as one of the best collections in the country of bone models made by French prisoners-of-war during the Napoleonic period. Included in the display with these models is an incredibly detailed scale model made by the ivory-workers of Dieppe, a noted centre for ivory-work in the 17thC–19thC. There is also a model of HM Barque *Endeavour*, the Whitby-built ship in which Captain Cook explored the South Seas, in the room devoted to memorabilia of Cook and the whaling Captains, William Scoresby and William Scoresby Jnr, all three seafaring men with Whitby associations. The work of George Chambers, the Whitby-born marine artist, is represented in the collection. Chambers died in 1840, aged only thirty-seven.

In the section devoted to domestic and agricultural bygones and toys there is a display of objects carved from Whitby jet, the ubiquitous mourning ornaments of the Victorian period. Further displays deal with local and maritime history and include paintings and models, photographs by the incomparable F. M. Sutcliffe, excavated objects and costumes.

The Museum has a small shop selling postcards and the excellent *Whitby Museum Guide*.

Pannett Art Gallery houses English oil paintings and watercolours from the 18thC to the present day, including works by Turner, Bonington, David Cox, Peter de Wint, as well as the Weatherills, who were local artists.

WHITEHAVEN, *Cumbria*

Whitehaven Museum and Art Gallery

Paintings and drawings with local connections; significant pottery collection (19thC–mid–20thC), representative of the development in the 19thC of local potteries

Market Place, Whitehaven
tel. 0946-3111, ext. 307

Mon, Tues, Thurs–Sat 10–5 pm.
Closed Wed, Sun & Bank Holidays

Admission free

The present Whitehaven Museum was established as a result of local government reorganisation under the auspices of Copeland Borough Council in 1974, although the upper gallery displaying the permanent collection was not officially opened until 1977. The Museum is in the former Market Hall, designed by a local architect, T. L. Banks (d. 1920), in 1883.

The Museum incorporates parts of four local collections built up during the 19thC, with the emphasis on local history. A bird's eye view of Whitehaven, painted by Matthias Read in *c.* 1736 for the Lowther family, and one of four known versions, is an important document illustrating the town which was planned and built on a grid pattern from the late 17thC and still retains much of its original character. The town's maritime history is recorded in the

Matthias Read, *A View of Whitehaven*, 1736 (Whitehaven Museum and Art Gallery)

Museum's permanent displays, including a Delftware bowl of 1756 commemorative of a Whitehaven ship, the *Love*. The town's pottery factories, active from 1740 to 1915, are represented by a number of items from the 19thC and 20thC, as well as the earliest surviving example, of *c.* 1820. The Museum also houses the archæologically unique specimens of two shrouds of *c.* 1300, found in a local burial ground at St Bees.

There is an active society of Friends of the Museum who organise their own programme of lectures and events. A sales desk provides information sheets and booklets. Restaurant and car-parking facilities are available within fifty yards of the Museum.

WINCHESTER, *Hampshire*

Winchester City Museums (comprising City Museum, Westgate Museum and Guildhall Gallery)

Archæology and history of Winchester

Hyde Historic Resources Centre,
75 Hyde Street, Winchester
tel. 0962-68166, ext. 269

Mon–Sat 10–5 pm; Sun 2–5 pm (summer);
Tues–Sat 10–5 pm; Sun 2–4 pm;
closed Mon (winter)

Admission charge
(Guildhall Gallery admission free)

In 1847 'The Hampshire Museum' was founded, financed by private subscription, but in 1851, owing to financial difficulties, it was transferred to the City Corporation. The impetus for founding it had come in 1845 when Winchester was host to two national archæological congresses, the annual meetings of the recently formed British Archæological Association and the Archæological Institute. This led in 1846 to a group of local gentlemen resolving to establish a general public museum, which had the distinction of being amongst the earliest of those institutions whose founding impulse came from the establishment of the Archæological Associations. Winchester is, in itself, a rich archæological site, and the Museum is particularly strong in Anglo-Saxon material. Among the objects worthy of special mention are a portable 9thC reliquary; an Anglo-Saxon wall-painting fragment on stone; Anglo-Saxon

Walrus ivory carved with two descending angels, second half of the 10thc (Winchester City Museums)

George Frederick Prosser, watercolour of *View of Winchester*, 1848 (Winchester City Museums)

English illuminated initial letter, 12thc
(Winchester City Museums)

decorative metalwork and sculpture, including a narrative frieze possibly illustrating the story of Sigmund in the Volsunga Saga; polychrome relief tiles; and a panel of walrus ivory carved with two angels.

The collection of local topographical prints and watercolours includes a group of views of the town by G. F. Prosser, who worked in Winchester from the late 1840s.

The present City Museum building was opened in 1903. The architect is unknown, but it was purpose-built. The Westgate Museum is the Westgate of the City and was opened in 1897.

There is a guide to the City Museum, *A Prospect of Winchester* (1978), which is available at the Museum sales point along with a selection of postcards and souvenirs. A full-scale account of the Winchester excavations 1949–69 is in the process of being published; two volumes have already appeared (1964 and 1978) and a third is in preparation.

WOLVERHAMPTON, *West Midlands*

Wolverhampton Art Gallery [1]

British paintings (18thc–19thc), including a representative selection of the work of the local artist Edward Bird (1762–1819) and painters of the Cranbrook Colony; British and American figurative art ('Pop' era–present day)

Lichfield Street, Wolverhampton
tel. 0902-24549

Mon–Sat 10–6 pm. Closed Sun & Bank Holidays

Admission free

Founded on 30 May 1884, the Art Gallery was built in a neo-classical style by the Birmingham architect Julius A. Chatwin (1829–1907) and donated by Philip Horsman who bequeathed his picture collection to the town two years later. In 1887 the Gallery was further endowed with the bequest of Mr and Mrs Sidney Cartwright consisting of over 280 pictures. The opening of the Gallery in 1884 coincided with the launching of a large Fine Arts and Industrial Exhibition for Wolverhampton and South Staffordshire, which emphasised a greater awareness of the value of art and design for local manufacturing industries.

The Gallery has had a good collection of 19thc British paintings since the 1880s, which includes an interesting variety of painters from the early part of the century, for example, Patrick Nasmyth and William Collins, and works by Francis Danby (*The Shipwreck*), J. F. Herring (*The Timber Wagon*). Also represented are David Cox, Landseer, David Roberts, John Faed and many others. But in the last fifteen years the British collection has been extended into the 18thc with works by Gainsborough, Fuseli, Raeburn and Richard Wilson (his most unusual *Niagara Falls*), as well as excellent paintings by Joseph Highmore (*The*

Family of Lancelot Lee), Francis Wheatley (*Portrait of Mrs Pearce*) and Johann Zoffany (*David Garrick in 'The Provok'd Wife'*), each of which was purchased with a supporting grant from the NACF. At the same time a collection of British and American figurative art has been developed, which includes works by Blake (*Cigarette Pack*), Hamilton (*Adonis in Y-Fronts*), Rosenquist, Lichtenstein and Warhol (*Jackie*). The Art Gallery also displays a selection of Oriental applied arts, covering netsuke, weapons, ceramics, bronzes and lacquer.

At the Art Gallery's Centenary celebration on 30 May 1984, the Mayor announced the decision of Wolverhampton Borough Council to extend the premises by taking over all the adjoining accommodation from Wolverhampton Polytechnic. This development will allow the Art Gallery to bring its public services up to a reasonable standard by adding a shop and coffee room to the present facilities and a gallery of local history will also be created.

The Art Gallery is governed by the local Leisure Services Committee and has an association of Friends.

PUBLICATIONS
Virginia Griffiths and David Rodgers, *Catalogue of Oil Paintings in the Permanent Collection*, 1974
Sarah Richardson, *Edward Bird RA, Life and Work*, 1981
Tom Jones, *W. H. Hunt (1790–1864)*, 1981
Yvonne Jones, *Georgian and Victorian Japanned Ware of the West Midlands*, 1982
B. P. Flynn, *R. J. Emerson FRBS (1878–1944)*, 1984

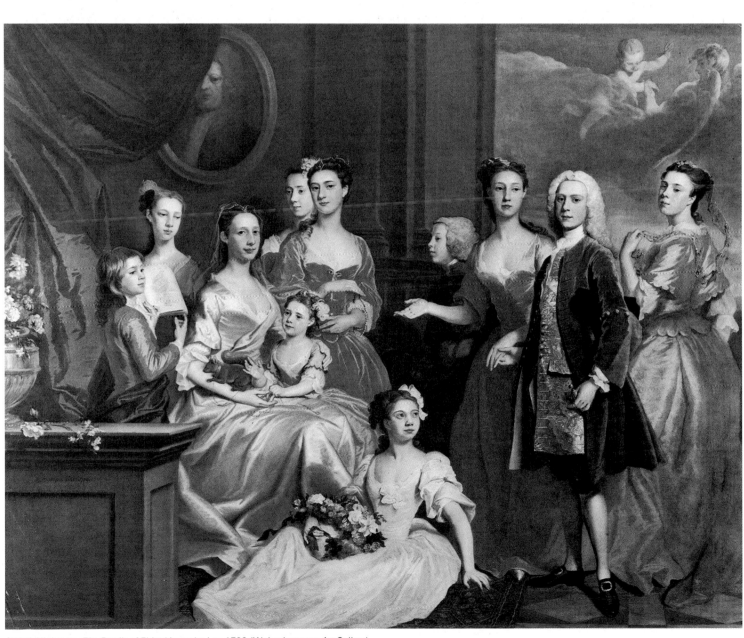

Joseph Highmore, *The Family of Eldred Lancelot Lee*, 1736 (Wolverhampton Art Gallery)

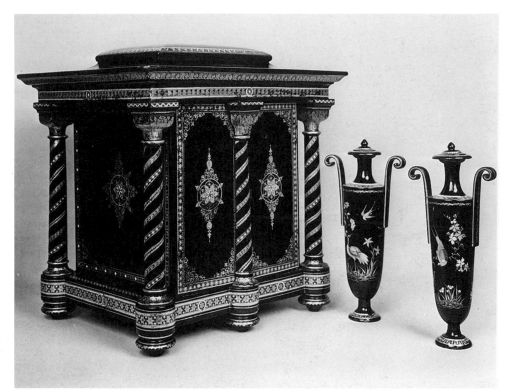

Japanned papier mâché cabinet and vases made by Frederick Walton & Co. of Wolverhampton, *c.* 1850
(Bantock House Museum, Wolverhampton)

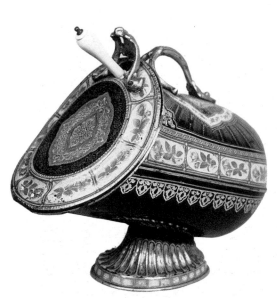

The Ruskin Persian Scoop in japanned tin made by
Henry Loveridge & Co. of Wolverhampton,
c. 1865–70 (Bantock House Museum, Wolverhampton)

Dolls (Daisy Mander Collection);
Bilston enamels; japanned wares;
ceramics (18thc–19thc)

Bradmore Road, Wolverhampton
tel. 0902-24548

Mon–Fri 10–7 pm; Sat 10–6 pm;
Sun 2–5 pm

Admission free

PUBLICATIONS
Catalogues of collections:
English Painted Enamels, 1973
*Georgian & Victorian Japanned Ware of the West
Midlands*, 1982
Dolls & Toys at Bantock House, 1984

Exhibition catalogues:
Lustre Ceramics from British Art Potteries, 1980
18th & 19th Century Japanned Ware (temporary
exhibition incorporated in permanent collection), 1982

Bantock House Museum [2]

Bantock House was bequeathed to the town by Alderman Bantock through his wife, Kate Phyllis. Mrs Bantock continued to live in the house for three years before handing it over to the City of Wolverhampton in 1941, together with collections of pottery and porcelain, enamels, japanned ware and ivories—the latter are now housed in the art gallery. It was opened as a museum in 1948 and incorporated many objects which had been acquired by both gift and purchase since the opening of the Art Gallery in 1884. Bantock House is basically an 18thc farmhouse but it was so extensively altered and extended during the last century that it now stands as an example of a prosperous and comfortable 19thc family home.

Bantock House is Wolverhampton's Museum of applied art and houses two important specialist collections based on once thriving local industries—enamelling and japanning. There is a significant collection of 18thc English enamels which includes a wide range of articles from each of the leading manufacturing centres: Battersea, Birmingham, Bilston, Liverpool and South Staffordshire. Of particular note is a set of enamel portraits of the celebrated Gunning sisters and a plaque signed and dated 'W. Craft 1782' and painted with the 'Judgement of Paris'.

There is a large and comprehensive collection of 18thc and 19thc japanned papier mâché, tin, wood, iron and slate, representing one of the staple industries of Wolverhampton, Birmingham and Bilston at that time. The collection includes a good range of painted and printed snuff-boxes, objects made for industrial exhibitions and a number of pattern books.

The ceramics collection includes a representative collection of First Period Worcester porcelain presented by Mrs K. P. Bantock in 1941, 19thc Wedgwood Jasperware and a particularly fine maiolica fountain made by Minton and exhibited at the Wolverhampton and Staffordshire Fine Arts and Industrial Exhibition held in 1884.

The Museum also houses a large collection of play-dolls, dolls in national and regional dress and ethnographic dolls, formed over a number of years by Miss Daisy Mander and presented to the Museum in 1952.

The Museum is part of the Association of the Friends of Wolverhampton Art Gallery.
Easy car-parking is available.

Bisque doll dressed as a bride, probably German,
c. 1905–10 (Bantock House Museum, Wolverhampton)

Oval plaques, transfer printed and overpainted with portraits of (*top*) Maria Gunning, (*bottom left*) Maria, Countess of Coventry in Turkish costume and (*bottom right*) Elizabeth Gunning, Duchess of Hamilton, all made in Birmingham, *c.* 1755 (Bantock House Museum, Wolverhampton)

Egg-shaped bonbonnières and egg-shaped nutmeg grater made in Birmingham, *c.* 1755
(Bantock House Museum, Wolverhampton)

Bilston Art Gallery and Museum [3]

Mount Pleasant, Bilston, Wolverhampton
tel. 0902-49143

Mon–Sat 10–5 pm. Closed Sun &
Bank Holidays

Admission free

Since 1937 the Museum has been housed in a building dating from about 1880, which was once the house of a local ironmaster. The Art Gallery was added to the existing building with the aid of a gift of £1,000 from Mr W. Thompson, a former townsman; he also gave his collection of works of art, mainly minor Victorian paintings. As the fine art collection, which includes works by James Webb, members of the Birmingham School and various local artists, is small and limited in scope, it is the policy to use the Art Gallery for temporary exhibitions.

The Museum collections are mainly of local significance and include English painted enamels of the 18thc; English japanned ware of the 19thc; cut steel jewellery and 'toys' of the 18thc and 19thc; and locally produced pottery, locks, keys and local memorabilia.

WORCESTER, *Hereford and Worcester*

Worcester City Museum and Art Gallery [1]

Foregate Street, Worcester
tel. 0905-25371

Mon–Wed, Fri 9.30–6 pm; Sat 9.30–5 pm.
Closed Thurs, Sun

Admission free

Although the Museum collections can be traced back to 1832, the Art Gallery and associated collections were not formally established until 1897. The purpose-built museum, an assymetrical red-brick and terracotta structure built in a mixed Tudor and baroque style, was designed by J. W. (later Sir John) Simpson and E. J. Milner Allen, the successful candidates of an architectural competition in 1890.

The Museum collections cover the natural sciences, archæology and social and military history. The fine art section contains a wide range of local topographical pictures, as well as mainly 19thC oil paintings and watercolours. Prominent amongst those represented are Benjamin Leader and David Cox. There are also examples by David Bates, William Callow, the Hon. John Collier, Julius Caesar Ibbetson, Dame Laura Knight, Peter de Wint and Thomas Woodward. There are prints and drawings by modern artists.

The Art Gallery exhibition space is limited and is devoted mainly to an extensive programme of temporary exhibitions.

There is a sales desk for publications, etc., and limited car-parking.

Dyson Perrins Museum Trust [2]

Worcester porcelain
(mid-18thC–present day)

Severn Street, Worcester.
tel. 0905-23221

Mon–Fri 9–5 pm (all the year round);
Sat 9–5 pm (April–Sept).
Closed Sat (Oct–Mar)

Admission free

The Dyson Perrins Museum is attached to the Royal Worcester Porcelain Company in a Victorian building which was once a school. It was founded in 1946 by C. W. Dyson Perrins and Mrs F. W. M. Perrins, and concentrates entirely on the history of ceramic manufacture in the city of Worcester. It is the most comprehensive collection of Worcester porcelain in the world, tracing the various Worcester companies from their beginnings in the 18thC to the present day. The collection contains the Wigornia Creamboat, universally regarded as the first piece of Worcester porcelain to be produced, in 1751. The wonderful group of early Worcester blue and white includes many rare patterns, as well as some unique dated and initialled pieces. The Chicago Vase, the largest vase Worcester has ever made, is also on display. Modelled by James Hadley and painted by Edward Raby in 1893, it reveals the distinguished workmanship for which Royal Worcester is renowned throughout the world. Being Royal Warrant holders for almost two centuries, Worcester has made several fine services for the Royal Family during its time, among them the magnificent service for the Coronation of William IV. Examples from most of these services are shown, up to and including those from the service made for the present Prince and Princess of Wales.

All non-ceramic items, that is, pictures, literature, photographic records and general ephemera, are directly related to the ceramic collection, but obviously the vast majority of holdings are ceramic.

Although the Museum is independent, factory tours are run from the Museum desk by the staff of the Worcester Royal Porcelain Company. There is a Museum shop, a restaurant, a company showroom and factory shops where 'seconds' of the current production may be bought. Car-parking is available.

Worcester 'Wigornia' creamboat, probably the original piece by the Worcester Porcelain Co., 1751 (Dyson Perrins Museum Trust, Worcester)

English paintings and watercolours
18thC–20thC; English pottery, porcelain
and glass 18thC–20thC; costumes, juvenilia
including a fine doll collection; archæology,
including the Highdown Anglo-Saxon glass
and jewellery

WORTHING, *West Sussex*

Worthing Museum and Art Gallery

The Museum and Art Gallery was founded in 1908, occupying a building designed by H. A. Crouch and given to the town by an anonymous donor who was subsequently discovered to be the first Mayor, Alderman Alfred Cortis.

The painting collection includes a handsome work by Holman Hunt, *Bianca*, a woman in Renaissance costume playing a lute, as well as a representative collection of Camden Town pictures such as Harold Gilman's *Mountain Bridge, Norway* (1913), Charles Ginner's

Keith Vaughan, *The Trial*, 1950 (Worthing Museum and Art Gallery)

Chapel Road, Worthing
tel. 0903-39999, ext. 121/0903-204229 (Sat)

Mon–Sat 10–6 pm (April–Sept);
Mon–Sat 10–5 pm (Oct–Mar). Closed Sun

Admission free

Rottingdean (1914), Spencer Gore's *The Pond*, Lucien Pissarro's *Cottage at Storrington* (1911), and a Sickert. Later 20thC artists represented include Ivon Hitchens, and Keith Vaughan with an important and uncompromising work entitled *The Trial After Kafka* (1949–59). There is a fine group of English watercolours including work by Rowlandson, Sir William Russell Flint and Claude Muncaster.

The costume collection is large, with an extensive coverage of accessories.

There is an Association of Friends, a Museum shop and car-parking nearby.

YORK, *North Yorkshire*

York City Art Gallery [1]

European painting 14thC–present day;
watercolours, drawings and prints primarily
of York topography; 20thC artists' pottery

Exhibition Square, York
tel. 0904-23839

Mon–Sat 10–5 pm; Sun 2.30–5 pm (last
admission 4.30 pm)

Admission charge

The Gallery was built, in the appropriately named Exhibition Square, for the second Yorkshire Fine Art and Industrial Exhibition in 1879 (the first having been held in 1866). The building, designed in the Italian Renaissance style with an arcaded loggia by Edward Taylor, evolved into the City Art Gallery in 1890s when the Yorkshire Fine Art and Industrial Institution was purchased by the City Council in 1892.

York City Art Gallery is remarkable among the smaller provincial art galleries in having a collection of paintings which covers most developments in European and British art from the 14thC to the present. The nucleus is the Lycett Green collection of Old Masters given through the NACF in 1955, while other areas of strength include paintings by the York-born artist William Etty RA (1787–1849); Victorian genre paintings bequeathed by John Burton in 1882; and late 19thC and early 20thC British paintings given by the Dean of York, Eric Milner-White, during the years 1948 to 1963. Highlights include Bernardino Fungai's *A Miracle of St Clement* and *The Martyrdom of St Clement* (the latter purchased in 1980 with NACF help, to be reunited with the former which was given by Lycett Green); Domenichino's *Monsignor Agucchi*; Bellotto's *Piazza San Martino and Duomo*; Lucca Baburen's *Roman Charity*; Melendez's *Still Life with Lemons and Nuts*; Lely's *Lady Charlotte Fitzroy*; Soldi's *Self Portrait* and *Portrait of Robert Hay Drummond*; John Martin's *Christ Stilleth the Tempest*; F. D. Hardy's *The Volunteer's*; Gwen John's *Young Woman in a Red Shawl*; Gilman's *Interior with Nude* and Nash's *Winter Sea*.

There is an interesting group of watercolours, drawings and prints devoted primarily but

Joseph Mallord William Turner, watercolour of *The Dormitory and Transept of Fountains Abbey—Evening*, 1797 (York Art Gallery)

not exclusively to the topography of York and based on the collection of Dr W. A. Evelyn purchased in 1931. There are extensive holdings of work by William Etty, John Flaxman, Francis Place, and other York artists. Highlights include Cotman's *Kirkham Abbey Gateway* Turner's *Fountains Abbey—Evening* and *Constance*, a very recent acquisition.

An unusual feature is the outstanding collection of 20thC stoneware pottery given and bequeathed by Eric Milner-White, Dean of York. This includes about thirty works apiece by Bernard Leach and William Staite Murray and examples by Norah Braden, Michael Cardew (and his African followers), Shoji Hamada, Katherine Pleydell-Bouverie, Charles Vyse and other British, French and Scandinavian potters.

The Association of Friends of York Art Gallery was founded in 1948 to support the Gallery principally by helping to make acquisitions, for example the charming portrait of *Miss Elizabeth Heathcote* painted in Bath in 1788 by Lewis Vaslet, a fashionable miniaturist who was born in York in 1742. The Friends also act as voluntary guides during the summer months and operate the admissions desk for special exhibitions.

There is a sales counter for publications, but a shop is planned.

PUBLICATIONS
Catalogue of Paintings, vol. i, *Old Masters*, 1961; vol. ii, *English School*, 1963; vol. iii, *19th/20th Centuries*, 1974; *Catalogue Supplement*, 1974, 1975
Visitor's Guidebook, 1975

National Railway Museum [2]

History of railways; 19thC & 20thC British painting

Leeman Road, York
tel. 0904-21261

Mon–Sat 10–6 pm; Sun 2.30–6 pm.
Closed 1 Jan, Good Friday & May Day Bank Holiday

Admission free

The Museum was opened in 1975 and replaced both the Museum of British Transport at Clapham and the former York Railway Museum. The building was adapted by British Railways from a former steam locomotive maintenance depot and handed over to the Science Museum, whose Trustees govern the Museum at York. Most of the items originated with the former railway companies and were transferred from British Rail and the British Transport Historical Relics Collection.

In addition to the full-size exhibits, the pictorial collections form a small but important part of the Museum collections as a whole. There are notable paintings by Solomon, Collinson and Stanhope Forbes and recent acquisitions have included *Letchworth Station* by Spencer Gore. Amongst contemporary railway artists there are works by Hamilton Ellis, Shepherd, Cuneo and Fearnley. There is a fine collection of 19thC watercolours and prints including

William Etty, *The Bridge of Sighs*, 1833–35 (York Art Gallery)

Spencer Frederick Gore, *Letchworth Station*, 1912 (National Railway Museum, York)

works by Bourne, Bury, Tait, Carmichael and Russel, and an extensive collection of posters dating largely from the 1920s, with Newbould, Taylor, Mason, Cooper, Wilkinson, Purvis and Buckle particularly well represented. In addition, there is much original artwork for posters including works by Clausen, Jack and Wilkinson.

The Museum also has a fine collection of silver-plated railway catering holloware, together with china and glass, all badged for, or otherwise marked with insignia of, the railway company of origin. Many pieces carry their maker's name and date from the late 19thC and early 20thC. The collection includes a part set of Minton china used by the Queen Mother in her royal saloons, which she expressly wished to stay with the vehicles when they were preserved by the Museum. There are, amongst others, rare pieces of silver plate from the famous Midland Grand Hotel at St Pancras, definitive pre-war crockery from the Gleneagles Hotel and a unique set of point-engraved crystal glassware made for Queen Victoria.

The Museum has an Association of Friends. The shop sells a comprehensive range of books related to railway history, guides, souvenirs, records, prints and postcards.

There is a refreshment room and pay car-parking.

PUBLICATIONS
J. A. Coiley and P. W. B. Semmens, *National Railway Museum Guide*, new edn, 1985
G. F. Wescott, *The British Railway Locomotives 1803–1853*, 1959 (new edn 1972)
C. P. Atkins and T. J. Edgington, *North London Railway: A Pictorial Record*, 1979 (out of print)
Michael Darby, *Early Railway Prints*, 1974 (new edn 1979)

The Yorkshire Museum [3]

The Museum was founded in 1827 by the Yorkshire Philosophical Society; the architect was William Wilkins (1778–1839), who designed a simple two-storey building in the Greek revival style, reusing the existing foundations of the ruined St Mary's Abbey. Despite a drive for economies, the cost of the final building left the Philosophical Society in debt until the end of the century.

The Museum houses geological and Natural History exhibits, as well as decorative arts, especially Rockingham. The strength of the Museum's holdings are archæological, including rich collections of Roman, Anglo-Saxon, Viking and mediæval antiquities, among which the head from a statue of the Emperor Constantine (*c.* 306) and an Anglo-Saxon silver-gilt bowl from Ormside (late 8thC) are particularly notable.

The grounds of the Museum encompass the ruins of St Mary's Abbey and the late mediæval Hospitium.

Archæology; decorative arts; pottery

Museums Gardens, York
tel. 0904-29745

(map p. 00)

Mon–Sat 10–5 pm; Sun 1–5 pm

Admission charge

PUBLICATIONS
Peter Brears, *Catalogue of English Country Pottery in the Yorkshire Museum*, 1968
A. Hurst, *Catalogue of the Boynton Collection of Yorkshire Pottery*, 1922

Scotland

ABERDEEN, *Grampian*

Aberdeen Art Gallery and Museum [1]

British and European painting (19thC);
British painting and sculpture (20thC);
British watercolours (18thC–19thC)

Schoolhill, Aberdeen
tel. 0224-646333

Mon–Wed, Fri, Sat 10–5 pm;
Thurs 10– 8 pm; Sun 2–5 pm

Admission free

The Museum was founded and built as the result of a competition, in a neo-classical style, by Messrs Matthews & Mackenzie in 1885, coinciding with the opening of a major Fine Art Exhibition organised under the auspices of the Aberdeen Artists Society. It was used principally as a venue for exhibitions until 1900 when the collection of Alexander Macdonald (1837–84), a local granite merchant, was bequeathed. The collection contained a number of contemporary pictures, including a large group of portraits and self-portraits of artists commissioned by Macdonald. The terms of his bequest stipulated that pictures bought with his endowment should not have been painted more than twenty-five years before; consequently, those purchased included works by Sickert, Stanley Spencer, Paul Nash and Leger. In 1901 the Gallery received paintings and funds from Sir James Murray (1850–1932), including the popular painting *The Tennis Party* by Lavery. In 1925 Murray contributed towards the cost of an extension to the Gallery, and he was instrumental in building up a collection of casts of Greek and Roman sculpture. Another important bequest, that of the advocate Alexander Webster, was received in 1921 and included porcelain and a large number of watercolours, more of which were subsequently purchased with funds provided by him. Among the further bequests were those of Sir Alexander Lyon in 1927, Sir Thomas Jaffrey

John Phillip, *Baptism in Scotland*, 1850 (Aberdeen Art Gallery)

Stanley Spencer, *Southwold Beach, c.* 1937 (Aberdeen Art Gallery)

in the following year, and the James Cromar Watt Collection of Chinese lacquer, enamels, bronzes and other decorative art in 1940. A magnificent collection of etchings and drypoints by James McBey, an Aberdeenshire artist, was presented in 1959 by H. H. Kynett of Philadelphia, and two years later, with the help of McBey's widow, a permanent gallery was opened to house the collection, which was to include paintings, drawings and other items.

The main emphasis of the Gallery's holdings is on British paintings of the last three centuries, with some French 19thc pictures, such as the Barbizon painters Rousseau and Daubigny; Boudin, Monet (*La Falaise á Fècamp*) and Renoir (*La Roche Guyon*). Of the British pictures, the earliest represented are works by George Jamesone, Ramsay and Nasmyth. The 19thc collection is very fine and is perhaps best known for the ninety-one portraits and self-portraits of British artists and architects from the Macdonald Bequest, a group which Macdonald had been encouraged to assemble by Millais when he stayed with him. There are portraits of Frith, Watts, Alma-Tadema, Orchardson, Pettie, etc. Other paintings include the Pre-Raphaelite *Mariana* by Rossetti, the Aberdeen artist Dyce's *Titian's First Essay in Colour*, Watts's *Orpheus and Eurydice*, Herkomer's *Our Village*, as well as examples of the Glasgow School. A recent acquisition was Dyce's *The Lamentation Over the Dead Christ*, a rare example of religious 19thc painting. There is an outstanding representation of British 20thc art from the New English Art Club and Camden Town Group members, which includes Sickert's *Pimlico*, Augustus John's *The Blue Pool*, Robert Bevan's *Ploughing the Downs* and Spencer Gore's *The Blue Petticoat*, to Francis Bacon's *Pope–Study after Velasquez*, Frank Auerbach's *Portrait of JYM Seated* and David Hockney's *Blue Guitar No 1*. The Gallery is especially proud of its collection of 20thc British sculpture, which includes works by Epstein, Barbara Hepworth, Henry Moore and more recent pieces by Reg Butler, Anthony Caro, Paolozzi and Lilian Lijn. There is also a good collection of watercolours by Turner, Cozens, Blake, Girtin, Cox and Bonington, as well as a large collection of 19thc and 20thc prints, particularly by leading Scottish etchers.

The Gallery holds a wide variety of decorative art, including a large Chinese collection of paintings, bronzes, carvings and porcelain. There is a representative collection of British ceramics to the present day and of British and Continental glass (18thc and 20thc). Metalwork is represented by early pieces of pewter, silver and Sheffield plate, with particular emphasis on Scottish silver, as well as modern silver and jewellery. There are collections of furniture, textiles and costume.

The Gallery has an Association of Friends, which includes all the other Aberdeen museums. It has a shop and a coffee shop and car-parking is available.

Items from the collections of Aberdeen Art Gallery are exhibited in James Dun's House at Schoolhill and Provost Skene's House at Guestrow.

292

David Farquharson, *The Herring Fleet Leaving the Dee*, 1888 (Aberdeen Maritime Museum)

Aberdeen Maritime Museum [2]

Provost Ross's House,
Shiprow, Aberdeen
tel. 0224-585788

Mon–Sat 10–5 pm. Closed Sun

Admission free

The Museum, which was opened in 1984, is housed in the former residence of Provost Ross, a local merchant, who lived during the 18thc. Built in 1593, it is the third oldest building in the city. The exhibitions trace Aberdeen's maritime history of ship-building, fishing and North Sea oil. There are ship models of famous clippers, including *Thermopylae*, an engineering model of an oil production platform and a Votive ship model of 1689.

ARBROATH, *Angus*

Arbroath Art Gallery [1]

Old Master paintings

Public Library, Hill Terrace, Arbroath
tel. 0674-73232

Mon–Fri 9.30–6 pm; Sat 9.30–5 pm

Admission free

The Art Gallery has recently been closed for renovations, but is now open. It was originally opened to the public in the Library by the Arbroath Town Council in 1876. The most notable pictures in the quite extensive collection are the two works by Pieter Bruegel the Younger, the *Adoration of the Magi* (1618) and *St John Preaching in the Wilderness*. All the paintings are listed in a provisional catalogue available from the Montrose Museum and Art Gallery.

Arbroath Museum [2]

Local material covering the history of Arbroath from prehistoric times to the Industrial Revolution

Signal Tower, Ladyloan, Arbroath
tel. 0674-73232

Mon–Sat 10.30–1 pm, 2–5 pm (April–Oct);
Sun 2–5 pm (July–Aug); Mon–Fri 2–5 pm;
Sat 10.30–1 pm, 2–5 pm (Nov–Mar)

Admission free

In the late 1830s a fishwife donated her collection of seashells to the Mechanics Institute forming the basis of the first museum. In 1840, Lieutenant Medley RN donated his collection of curios and on 18 November 1843 a Museum Society was formed. The Museum moved in 1857 to public buildings and on 14 September 1918 was given to Arbroath Town Council. Closed in 1939, it did not reopen until 1 August 1974 in 'new' premises in the old Bellrock Signal Tower.

Both the Arbroath Art Gallery and the Arbroath Museum are administered by Angus District Museums at Montrose, who also administer the Brechin Museum and Forfar Museum and Art Gallery.

The Patrick Allan-Fraser of Hospitalfield Trust [3]

19thc British painting and sculpture

Hospitalfield House, Arbroath
tel. 0241-72333

By appointment only, for groups, or
individually for special academic reference

Admission charge

The Hospitalfield Collection is a not a public collection but a private assembly of paintings, sculpture and artefacts which reflects the taste and patronage of Patrick Allan-Fraser of Hospitalfield (1813–90), who designed the present house and embellished it with the work of his friends. The building is in the Scottish baronial style and incorporates exceptional stone and wood carving, leatherwork and antique tapestries. Allan-Fraser was influenced by the writing and social commentary of Walter Scott, who wrote about Hospitalfield as 'Monkbarns' in his novel *The Antiquary*.

The works were gathered from associates or acquaintances during the founder's early career as an artist and illustrator in the 1830s and 1840s, or by direct patronage of a younger generation of painters.

After forty years' gestation, the Patrick Allan-Fraser School of Art was founded at his death in 1890 and although under a new constitution, remains a teaching establishment. The Trust (1980) is a self-financing charity.

DUMFRIES, *Dumfries and Galloway*

Gracefield Arts Centre [1]

20thc British painting

28 Edinburgh Road, Dumfries
tel. 0387-63822

Daily 2–5 pm (Oct–Mar);
Mon–Sat 10–1 pm, 2–5 pm,
closed Sun (April–Sept)

Admission free

Founded in 1951, this collection includes works by Frank Brangwyn, F. C. Cadell, George Clausen, the Faed family, William Gillies, Mark Gertler, George Henry, E. A. Hornel, Dame Laura Knight, W. M. McTaggart, Arthur Melville, S. J. Peploe, Robin Philipson, John Piper, Anne Redpath, Joan Eardley and Alan Davie.

A catalogue of the permanent exhibition is in preparation. Car and coach-parking are available.

Shambellie House Museum of Costume [2]

European costume (18thc–20thc)

New Abbey, Dumfries
tel. 0387-85275

Thurs–Sat, Mon 10–5.30 pm,
Sun 12–5.30 pm.
Closed Tues, Wed

Admission free. Large parties should book

PUBLICATIONS
Alistair Rowan, *The Creation of Shambellie: The Story of a Victorian Building Contract*, 1982
Charles Stewart, *Holy Greed: The Forming of a Collection*, 1982

Charles Stewart donated his private collection of costume to the Royal Scottish Museum in 1977, with his family home, Shambellie House, in which to store and display it. The house, built by David Bryce (1803–76) in the 1850s, is typical of his vernacular country house style. Its original character has been preserved while converting the three principal reception rooms into display areas. The Museum, opened in 1981, is an outstation of the Royal Scottish Museum; it complements their costume collection but is kept distinct.

The collection of over two thousand items consists of European costume of the last two hundred years, specialising in women's fashionable dress and showing the work of many noted dressmakers. It also contains children's and men's costume, and hundreds of accessories. The displays, which are changed frequently, are thematic and draw on material from both collections.

There is a small sales desk. Car-parking is available near the house.

DUNDEE, *Tayside*

Dundee Art Galleries and Museums

19thc and 20thc Scottish painting

McManus Galleries, Albert Square,
Dundee
tel. 0382-23141, ext. 137

Mon–Sat 10–5.30 pm. Closed Sun

Admission free

The Founders were the Directors of the Albert Institute Company Ltd which existed between 1863 and 1879. They were a group of enlightened businessmen, notable citizens and philanthropists. Their aim was to commemorate the life of the Prince by establishing an Institute dedicated to science, literature and the arts and crafts. The Chairman was Sir David Baxter, an important linen manufacturer. The Museum and Gallery were added on to the Albert Institute (Library and Albert Hall) in 1871–73. The original foundation of the Museum incorporated the collections of the Watt Institute which was founded in Dundee in 1824.

William Powell Frith, *Self-portrait*, 1875 (The Patrick Allan-Fraser of Hospitalfield Trust, Arbroath)

Thomas Faed, *Visit of the Patron and Patroness to the Village School*, 1851 (Dundee Art Gallery)

This was wound up in 1869 and the collections handed over to the Free Libraries Committee to be run as a museum along with the Library.

Sir George Gilbert Scott (1811–78) designed the Institute. Particular features include two rose windows in the Albert Hall in which he 'followed the best period of pointed architecture'. The Gothic entrance hall is embellished with marble pillars with carved stone capitals, a vaulted ceiling, a stencilled dado and encaustic tiles based on mediæval floral designs. The four Victorian Galleries were built on in 1887 to mark the Queen's Golden Jubilee. In 1978 the Libraries Department vacated their end of the building, allowing for the expansion of the Art Galleries and Museum into the whole space.

Major bequests were received from George Duncan (1791–1878), a local Member of Parliament, in 1878; in 1896 John Morris (1819–96) bequeathed a sum of money to be spent on paintings; and in 1917 the widow of A. A. Watt (d. 1883) left the Gallery his collection.

The main strength is Scottish paintings of the 19thc and 20thc, although the earliest painting is *Dead Poultry* of 1665, by William Gouw Ferguson. There are a few good 18thc portraits, notably by Allan Ramsay, David Martin, and David Allan. From the early 19thc there is a fine portrait by Henry Raeburn and a good Alexander Carse, *The Village Ba'Game* of 1818, which was purchased with the help of the NACF in 1983. 19thc paintings of note include *Christ on the Way to Emmaus* of 1850 by Robert Scott Lauder, Thomas Faed's superb *Visit of the Patron and Patroness to the Village School*, 1851 (NACF grant 1975), and two John Phillips, *Mitherless* of 1863 and *A Scotch Fair* (1847). There are good examples from the Scott Lauder group—W. McTaggart, G. P. Chalmers, W. Q. Orchardson, J. Pettie, P. Graham, H. Cameron, J. Burr and A. H. Burr. The Glasgow School is represented by E. A. Hornel, G. Henry, J. Crawhall (*A Lincolnshire Pasture*, 1882–83), A. Melville and T. M. Dow, and the Scottish Colourists by S. J. Peploe, J. D. Ferguson (*A Lowland Church*, 1916), G. L. Hunter and F. C. B. Cadell.

Two Dundee artists active at the turn of the century were George Dutch Davidson, known for his Art Nouveau-style ink drawings and watercolours, and John Duncan, whose interest in the Celtic Revival movement is seen here in his large *Riders of the Sidhe* of 1912. Anne Redpath, James Cowie and William Gillies represent a later generation, while the work of contemporary artists is well covered. There are works by J. McIntosh Patrick (*Autumn, Kinnordy* of 1936), Robin Philipson and Elizabeth Blackadder amongst others. There is a scattering of English painting in the Gallery, including work by Morland, Paul Sandby, David

Georges Seurat, *La Luzerne, St-Denis c.* 1885 (National Gallery of Scotland, Edinburgh)

Cox, Frank Holl, D. G. Rossetti (*Dante's Dream on the Death of Beatrice* of 1880), Landseer, Munnings, Sickert, Wilson Steer, Laura Knight, Edward Burra, Stanley Spencer and many works by Frank Brangwyn.

A quantity of European paintings range from Italian religious paintings (e.g. *Sacra Conversazione* of *c.* 1540 by Studio of Bonifazio de'Pitati) to Dutch still-lifes (*Still-Life with Lobster* of *c.* 1660 by A. van Beyeren) and French 19thc works (e.g. Boudin and Boilly).

There are assorted bronzes, including busts by Rodin, Epstein and Benno Schotz and a few contemporary works, e.g. *Ettso* of 1967, chromed steel by Paolozzi, and *War Goddess*, 1956, a bronze by W. Turnbull, a native of Dundee.

In the collection of decorative arts there are several fine pieces of Edinburgh silver, a strong emphasis on Dundee silver, a silver-gilt Doncaster cup by Paul Storr of 1816 and a silver-gilt rosewater basin made in London in 1683. There is also Scottish pottery, some English 18thc porcelain figures, Satsuma ware and 18thc British blown and cut glass including three Jacobite wine glasses.

The furniture includes long-case clocks, notably one lacquer clock by Alex Smith of Dundee (*c.* 1720), and three 18thc spinets and several early pianos of *c.* 1790–1810. Outstanding is the world's oldest complete mariner's astrolabe, a bronze instrument used to fix latitude which was made in Portugal in 1555 by Lopo Honem. There are also good collections of numismatics, ethnography and Greek and Egyptian antiquities.

The Gallery has an Association of Friends. The shop sells postcards, booklets, souvenirs and reproductions of paintings in the Gallery collection. There is car-parking nearby in the City centre car-parks.

The Orchar Gallery at Broughty Ferry has been closed since 1980. Provost James Guthrie Orchar (1825–98), whose fortune came from engineering, left 150 oils, 250 watercolours and prints, including 36 Whistler etchings, to the Town on his death. This magnificent collection is outstandingly strong in works from the Scott Lauder School, Pettie, Orchardson, Cameron, McTaggart and Chalmers. A decision is pending concerning the future of the collection, and in the meantime it is cared for by the City of Dundee District Council.

PUBLICATIONS
Dundee City Art Gallery Catalogue: the permanent collection of Paintings, Drawings and Sculpture, 1973
Simple, Bold and Effective: An Architectural History of the Albert Institute, Dundee, 1978

EDINBURGH, *Lothian*

National Gallery of Scotland [1]

Old Master, French Impressionist, British and Scottish paintings; Old Master, British and Scottish prints, drawings and watercolours

The Mound, Edinburgh
tel. 031-556 8921

Mon–Sat 10–5 pm, Sun 2–5 pm, extended during Edinburgh International Festival. Closed Christmas, New Year and May Day. Some rooms may be closed at lunchtime Oct–April for reasons of economy

Admission free, but a charge is made for some special exhibitions

A Parliamentary bill for the erection of a National Gallery on The Mound was passed in 1850; the permanent collection first opened to the public in 1859. The Mound, which makes a causeway between the Old and New Town, was formed of earth and rubbish—some two million cartloads—from the building of the New Town between 1781 and 1830. The National Gallery occupies a very severe but elegant neo-classical building which was originally shared with the Royal Scottish Academy. The architect, William Henry Playfair (1790–1857), was constrained by considerations of cost, largely because of the enormous expense of preparing foundations. All extraneous ornamentation was eliminated, although the first scheme, which had a Doric rather than an Ionic order, was considered too strictly neo-classical for the increasingly flamboyant taste of the late 1840s. The Mound is conspicuous, in spite of the looming heights of the Old Town and Castle behind, and the credit for the successful architectural exploitation of the site must go to Playfair. A feature of the interior is the sequence of octagonal rooms with Corinthian columns on the four central archways added in 1938–39. A cleverly inconspicuous new wing has been constructed, opened in 1978.

Edinburgh has a perfect National Gallery: the collection is representative and the individual works of art are of impressively fine quality. In spite of the fact that the masterpieces on long-term loan since 1946 from the Duke of Sutherland inevitably dominate the galleries in which they hang, the permanent collection includes outstanding examples by, among others, Cézanne, Chardin, Claude, Courbet, Cuyp, Degas (*Portrait of Diego Martelli*), Delacroix, Domenichino, Van Dyck (*The Lomellini Family*), Elsheimer, Gauguin (*The Vision after the Sermon*), Van Gogh, Goya (*El Medico* with his brilliantly red cloak), El Greco,

Hilaire-Germain-Edgar Degas, *Portrait of Diego Martelli*, 1879 (National Gallery of Scotland, Edinburgh)

Jean-Auguste-Dominique Ingres, a drawing of
Mlle Albertine Hayard, 1812 (National Gallery of
Scotland, Edinburgh)

Guercino, Hals, Hobbema, Holbein, Monet, Pissarro, Poussin, Rembrandt (*A Woman in Bed*), Rubens, Saenredam (a soaring interior of *St Bavo, Haarlem* bought with NACF help in 1983), Seurat, Steen, Tintoretto, Velasquez (*An Old Woman Cooking Eggs*), Vermeer (*Christ in the House of Mary and Martha*), Watteau (*Fêtes venetiènnes*) and Zurbaran.

The English collection is represented by Constable (*Dedham Vale*, another one of the many works purchased with the aid of the NACF), Gainsborough (*The Hon. Mrs Graham*), Reynolds (*The Ladies Waldegrave*) and Turner. The broad scope of the Scottish collection of paintings is indicated by the works of Alexander, David Allan, Dyce, Geddes, Guthrie, Hornel, Robert Scott Lauder, McCulloch, Macgregor, McTaggart, Phillip, Raeburn, Ramsay, Wilkie and many others.

The Sutherland Loan includes Poussin's magnificent series of *The Seven Sacraments*, noble compositions of almost geometric severity; Raphael's *Bridgewater Madonna* (which came to the Sutherland family by inheritance from the last Duke of Bridgewater); a Rembrandt *Self-Portrait*, painted when the artist was fifty-one; and five works by Titian. On loan from Her Majesty the Queen is *The Trinity Altarpiece* by Hugo van der Goes, originally commissioned for the Church of the Holy Trinity, Edinburgh.

In the Prints and Drawings Department there are some 7,500 drawings, of which the largest representation is of the Scottish School, closely followed by the Italian and then the English, Dutch and Flemish Schools. It represents one of the most important collections in this country outside London and includes sheets by many of the major masters such as Poussin, Barocci, Rembrandt, Seurat, Guercino, Blake, Turner, Ingres and Rubens. Works may be seen without appointment in the Print Room, and small displays drawn from the Prints and Drawings Collection are changed every three months. (The Print Room is open Mon-Fri 10–12.30, 2–4.30 pm.)

Three existing collections were incorporated by the original National Gallery, those of the Royal Institution for the Encouragement of the Fine Arts in Scotland (Old Masters), the Royal Scottish Academy (mostly Scottish artists) and Sir James Erskine of Torrie.

Since its foundation there have been numerous bequests and gifts to the Gallery. In the field of paintings major early benefactions included that of Lady Murray of Henderland in 1861, comprising the collections of the painter Allan Ramsay and his son General John Ramsay, which included an important group of French 18thc pictures. The Royal Association for the Promotion of the Fine Arts in Scotland, founded in 1834, acquired works by contemporary Scottish artists and, by the time of its dissolution in 1897, had presented twelve

PUBLICATIONS
General:
C. Thompson, *Pictures for Scotland, The National Gallery of Scotland and its Collection*, 1972
Paintings in the National Gallery of Scotland, an illustrated guide, updated periodically

Paintings:
C. Thompson and H. Brigstocke, *Shorter Catalogue*, 1978 (in course of revision)
H. Brigstocke, *Italian and Spanish Paintings in the National Gallery of Scotland*, 1978
H. Brigstocke, *French and Scottish Paintings, The Richmond-Traill Collection*, 1980

Paintings (loan):
C. Thompson and L. Campbell, *Hugo van der Goes and the Trinity Panels in Edinburgh*, 1974

Diego Velasquez, *Old Woman Cooking Eggs*, 1618 (National Gallery of Scotland, Edinburgh)

Gerard David, *Three Legends of St Nicholas*, 1500–10 (National Gallery of Scotland, Edinburgh)

Prints and drawings:
K. Andrews and J. R. Brotchie, *Catalogue of Scottish Drawings*, 1960
K. Andrews, *Catalogue of Italian Drawings*, 2 vols, 1968
K. Andrews, *Catalogue of Netherlandish Drawings*, 1985
K. Andrews, *Old Master Drawings from the David Laing Bequest*, 1976
K. Andrews, *English Watercolours and other Drawings, The Helen Barlow Bequest*, 1979
J. Dick, *The Vaughan Bequest of Turner Watercolours*, 1980
K. Andrews, *Drawings from the Bequest of W. F. Watson, 1881–1981*, 1981

Exhibition catalogues:
R. Pickvance, *Degas 1879*, 1979
L. Errington, *The Artist and the Kirk*, 1979–80
L. Errington, *Sir William Quiller Orchardson, 1832–1910*, 1980
C. Thompson, *Lookalike, Themes and Variations in Art*, 1982
L. Errington, *Master Class, Robert Scott Lauder and his Pupils*, 1983
H. Macandrew, M. Kemp and P. Williams, *Dutch Church Painters*, 1984

such works to the Gallery. Two bequests of predominantly French 19thC paintings were those of Hugh Laird in 1911 and John Kirkhope in 1920. Outstanding pictures, for example Turner's *Somer Hill* and Chardin's *Vase of Flowers*, were bought with the money left to the Gallery by James Cowan Smith in 1919. Further significant bequests of Old Masters were made by Miss Nisbet Hamilton Ogilvy in 1920 and the 11th Marquess of Lothian in 1941. Since the Second World War the scope of the Gallery's holdings has been greatly increased by major benefactions of Impressionist art from the collections of Sir Alexander Maitland QC (gifts of 1958 and 1960), Mrs Isabel M. Traill (gift of 1979) and Mrs Anna Kessler (for example, Cézanne's *The Big Trees*).

The collection of drawings is founded on the bequests of two Edinburgh booksellers, David Laing in 1878 and William F. Watson in 1881. A beautifully preserved group of Turner watercolours was bequeathed in 1901 by Henry Vaughan, on condition that they were only exhibited in January each year to protect them from the harmful effects of daylight. The care with which the Turners were kept impressed Miss Helen Barlow to leave her fine collection of English watercolours to the Gallery in 1975.

The Gallery is about to inaugurate an association of friends to be called The Patrons of the National Galleries of Scotland. There is a shop where the Gallery's publications and a selection of postcards may be obtained.

National Museum of Antiquities of Scotland [2]

Scottish history and culture over 10,000 years

Queen Street, Edinburgh
tel. 031-557 3550

Mon–Sat 10–5 pm; Sun 2–5 pm

Admission free, except for some special exhibitions

Founded in 1817 by the 11th Earl of Buchan (1742–1829), who was also the founder of the Society of Antiquaries of Scotland with which the Museum still retains a close contact, the collections were at first meant to deal with antiquities from all over the world but in time became more and more concentrated on the story of Scotland and her people. The present premises, designed by Sir Robert Rowand Anderson (1834–1921), were completed in 1890. The Museum occupies, with the Scottish National Portrait Gallery (q.v.), a distinctive

The 'Strathmore' English 'Turkeywork' table carpet, *c.* 1620 (National Museum of Antiquities, Edinburgh)

building in the Franco-Italian Gothic manner; like an orange-red Venetian palace, it is elaborately embellished with sculptured figures of historic personages and heraldry, and Ruskinian foliate ornament.

The exhibits cover the culture and history of man in Scotland since prehistoric times. There are major prehistoric, Viking and Roman collections, unique early sculptured stones, mediæval material including relics of the Celtic church, numismatics, silver, bagpipes, costume, Lorimer furniture and country life collections (displayed in the Scottish Agricultural Museum). Notable exhibits include the St Ninian's Isle Treasure of twenty-eight silver and silver-gilt objects ranging from decorated bowls and brooches to a spoon and a sword pommel; the engraved brass belt-pistols once owned by Louis XIII of France, which are covered with scrolling foliage; and the Monymusk Reliquary of the early 8thc AD, one of the most precious treasures in the National Collections.

There are three Museum shops: in the main building, in York buildings and at the Scottish Agricultural Museum at Ingliston.

PUBLICATIONS
J. Close-Brooks, *St Ninian's Isle Treasure*, 1981
J. Close-Brooks, *Dark Age Sculpture*, 1982

Exhibition catalogues:
Angels, Nobles and Unicorns, 1982
Vienna 1900, 1983
At Home, 1984

Royal Scottish Museum [3]

Archæology; European ceramics, glass, metalwork, arms and armour, coins and textiles; European sculpture, late Gothic–19thc; natural history and geology

Chambers Street, Edinburgh
tel. 031–225 7534

Mon–Sat 10–5 pm; Sun 2–5 pm

Admission free except for occasional special exhibitions

The Museum grew out of the bringing together of the Edinburgh University Natural History Museum and a new Industrial Museum founded in 1854. Built by Captain Francis Fowke (1823–65) and inspired by the Crystal Palace of 1851, the building, begun in 1861, was designed with a glass, wood and iron roof. Its most striking feature is the light and spacious Main Hall. The façade is in the Venetian Renaissance style, and subsequent additions to the building have not interfered with it. With the completion of the first part of the building in 1865, the two collections, Natural History and Industrial, were united under one roof. The Museum was renamed the Museum of Science and Art. The development of the art collection grew from the existence of ethnographic material in the University's Natural History collections and from a concern with the industrial processes that produced glass, ceramics, metalwork, etc. This extended into an interest in architecture and archæology and the decorative arts worldwide. By the end of the 19thc an art-collecting policy had evolved. The Museum was renamed the Royal Scottish Museum in 1904.

The Museum is a comprehensive science and art museum with Departments of Technology, Natural History and Geology as well as Art and Archæology. The Department

The 'Monymusk' reliquary, 13thc
(National Museum of Antiquities, Edinburgh)

of Art and Archæology has major collections of European ceramics, glass, metalwork, arms and armour, coins, costume and textiles, including the collection of the painter Noel Paton (1821–1901) of arms and armour, sculpture and decorative arts, acquired in 1905. The European sculpture collection includes examples from the late Gothic period to the 19thc. The large collection of costume and textiles is complemented by the Charles Stewart collection of European fashionable dress housed at Shambellie House Museum of Costume, near Dumfries (q.v.). Oriental material includes ceramics, glass, metalwork, arms and armour, ivories, jade and costume and textiles from the Near, Middle and Far East, and an important collection of Hindu and Buddhist sculpture. Highlights of this part of the collection on display include material from Tibet, Chinese decorative arts, and ceramics, glass and metalwork from the World of Islam.

There is a strong ethnographic collection of material from Africa, the Pacific and the Americas, which includes some 18thc objects, for example material collected by Captain Cook on his final voyage. The archæological material is mainly from the Greek and Roman periods and the ancient Near East, with an especially significant Ancient Egyptian collection.

The Art Collections have benefited greatly from Scots who have travelled abroad, and have been steadily augmented by purchase, especially in the last hundred years.

The Museum has an Association of Friends. There is a shop and cafeteria. There is no car-parking, although there is public parking nearby. The publications are numerous and cover all aspects of the Museum's collections, particularly of ethnography and costume.

Scottish National Gallery of Modern Art [4]

International 20thc paintings, sculpture and graphics

Belford Road, Edinburgh
tel. 031-556 8921

Mon–Sat 10–5 pm; Sun 2–5 pm

Admission free

The Scottish Modern Art Gallery is able to celebrate its first quarter-century in premises more appropriate and spacious than those in which the early years were spent. The inadequate premises in the Botanic Gardens obscured to a certain extent the importance of the collection.

Henri Gaudier–Brzeska, bronze
Bird Swallowing a Fish, 1914
(Scottish National Gallery of Modern Art, Edinburgh)

Ernst Ludwig Kirchner, *Japanese Theatre*, 1909 (Scottish National Gallery of Modern Art, Edinburgh)

PUBLICATIONS
*Checklist of Paintings, Sculpture and Drawings in the
Scottish National Gallery of Modern Art*, 1984
*Fifty 20th Century artists in the Scottish National
Gallery of Modern Art*, 1984
Alberto Giacometti's Woman with her throat cut, 1980
*Concise Catalogue of Scottish National Gallery of
Modern Art*, 1977
Sir William MacTaggart and Sir Robin Philipson, 1977

Exhibition catalogues:
Creation: Modern Art and Nature, 1984
Wilhelm Lehmbruck, 1979
James Cowie, 1979
Joan Eardley, 1979
Alastair Morton and the Edinburgh Weavers, 1978

William Nicholson, *Sir James Barrie*, 1904
(Scottish National Portrait Gallery, Edinburgh)

Scottish history and the history of
Scottish portraiture 16thC–present day;
now also commissions portraits of eminent
contemporaries

1 Queen Street, Edinburgh
tel. 031-556 8921

Mon–Sat 10–5 pm; Sun 2–5 pm (April–
Sept). Closed 12.30–1.30 pm (Oct–Mar)
Extended hours during Edinburgh Festival

Admission free but special exhibition
charges under consideration

Now installed in the one-time John Watson's School is the remarkable collection of 20thC art with international breadth which has been built up in such a short time.

The establishment of a gallery of modern pictures for Scotland was envisaged as early as 1827, but more than 130 years were to pass before the present institution came into being. The Gallery was founded on 10 August 1960, and almost on the anniversary date, on 14 August 1984, moved to its first permanent home in Belford Road. The original building, called John Watson's Hospital, was designed by William Burn (1789–1870) in 1825 for destitute children, and became a school in 1935. The imposing classical portico and façade remain unchanged and the sympathetic conversion of the building in 1984 by the Property Services Agency with Robert Matthew, Johnson, Marshall and Partners has retained all the original woodwork and introduced a staircase and doorways that complement the classical proportions of the interior spaces. The Gallery is well set back from the the road in pleasant grounds. At present large outdoor sculptures by Moore, Hepworth, Epstein, Bourdelle, Turnbull and George Rickey are placed in front of the Gallery.

Although not yet 'historically representative', it is none the less a well balanced collection with the emphasis on the main 20thC European art movements. Highlights include Cubism, German Expressionism, Surrealism and post-war art in Paris (e.g. Leger). There are strong holdings of British post-1900 wood engravings, Wilson Steer watercolours, and works by Ben Nicholson, the St Ives School and Epstein. The Scottish collection has large groups of works by Gillies, Eardley, Redpath, Peploe, Cadell, Fergusson, Hunter and the printed work of I. Hamilton Finlay. Since its foundation, three bequests have enriched the growing collection: the Maitland Gift of 1960 and Bequest of 1965 of works by Matisse, Picasso and Rouault (the earlier works were given to the National Gallery of Scotland); the Bequest of Dr R. A. Lillie in 1977 of works by Gillies, Hunter, Cadell, Peploe, Blackadder, Redpath, Fergusson, Walker and Wilson Steer; and the Scott-Hay Bequest in 1967 of works by Eardley, Redpath, Philipson, W. McTaggart and Gillies.

It is difficult to pick notable items from a collection of such wide-ranging works, as there can as yet be no objective view of this period, but amongst an impressive representation of such major 20thC artists as Braque, Derain and Kitaj might be remarked: Paul Klee's *Threatening Snow Storm* of 1927; Max Ernst's *Mer et Soleil* and *The Great Lover*; *Cross on Grey*, a Tapies of 1959; and an arresting image by Gaudier-Brzeska, the bronze *Bird Swallowing a Fish* dating from 1914. Items from the Prints and Drawings study collection are shown in the corridor galleries, without any natural light.

There is a Gallery bookshop and an excellent café with food of an unusually high standard. There is adequate car-parking in the grounds.

Scottish National Portrait Gallery [5]

The Portrait Gallery was founded in 1882 by John Ritchie Findlay (1824–98), a senior proprietor of the *Scotsman* newspaper and a notable public benefactor in the Edinburgh area. His donations to the Board of Manufactures, who then administered the National Gallery of Scotland and the Portrait Gallery, totalled over £70,000. The building, which houses the National Museum of Antiquities of Scotland, was designed by the official architect to the Board, Sir Robert Rowand Anderson (1834–1921) and constructed in red Dumfriesshire sandstone between 1885 and 1890. Anderson's style was eclectic, although essentially Italianate secular Gothic of the 13thC, with obvious allusions to the Doge's Palace in Venice. The façade was elaborately ornamented with sculpted figures from Scottish history, erected between 1891 and 1906. The main architectural feature of the interior is the imposing two-storeyed central entrance hall. From 1898 to 1901 the first floor ambulatory was richly decorated by William Hole (1846–1917) with a processional frieze of Scottish historical figures, murals representing episodes from early Scottish history and a profusion of heraldic ornament, an outstanding example of late 19thC mural painting in Scotland.

The collections provide a highly important and representative range of Scottish historical portraits. Among the earliest are a bronze bust of Mary, Queen of Scots as Queen of France by Ponce Jacquio, Hans Eworth's portrait of Henry Stewart, Lord Darnley, two unique portraits on copper of the Earl and Countess of Bothwell and a Bronckorst panel portrait of James VI as a boy. The Gallery's comprehensive collection of Jacobite portraiture has

Agostino Masucci, *The Marriage of James Francis Edward Stewart*, after 1719
(Scottish National Portrait Gallery, Edinburgh)

recently been supplemented by two outstanding examples of Jacobite propaganda—the
Marriage of James Francis Edward Stewart by Agostino Masucci (acquired with help from
the NACF) and the *Baptism of Prince Charles Edward Stewart* by Pier Leone Ghezzi. Of
particular note among the later works is a sizeable group of portraits by Raeburn. Those
of Sir Walter Scott and of John Rennie were purchased with a contribution from the NACF.
The Gallery's 19thc holdings include an impressive collection of portrait busts by Francis
Chantrey, William Brodie, John Steell, Patric Park and others. Portrait medallionists,
especially the Glaswegian modeller James Tassie, are equally well represented. The Gallery
owns a near-complete set of Tassie gem-stone reproductions, bequeathed by his nephew
William Tassie. Among the 20thc collection William Nicholson's telling portrait of James
Barrie represents another major acquisition secured with NACF funding.

Significant areas of development within the Gallery's collecting policy range from
topographical painting (of which the most important example is a *View of Falkland Palace*
by Alexander Keirincx commissioned by Charles I) to Scottish miniatures and the history
of Scottish photography. In 1984 the Gallery initiated the Scottish Photography Archive
as a centre for the collection and dissemination of information about Scottish photography.
At the same time, the Gallery is rapidly expanding its already significant holdings of early
Scottish photographs which include the single largest collection of the calotypes by D. O.
Hill and Robert Adamson.

Some temporary exhibition catalogues and publications about the collections and the Gallery
itself are available from the Gallery bookshop or by post from the Publications Department
of the National Galleries of Scotland at the National Gallery of Scotland.

PUBLICATIONS
Sheila Bruce Lockhart and Duncan Thomson, *Scottish
National Portrait Gallery Concise Catalogue*, 1977
Sara Stevenson, *David Octavius Hill and Robert
Adamson. Catalogue of their calotypes*, 1981
James Holloway, *Great Scots*, 1984 (colour illustrations
of the most important portraits in the collection, with
brief texts)
Helen Smailes, *A Portrait Gallery for Scotland*, 1985

Anon. Neapolitan School, *Interior, Naples showing Sir William Hamilton with a group of friends, c.* 1770 (Scottish National Portrait Gallery, Edinburgh)

Scottish United Services Museum [6]

The Castle, Edinburgh
tel. 031-226 6907

Mon–Sat 9.30–5.30 pm; Sun 11–5.50 pm (April–Sept); Mon–Sat 9.30–5.05 pm; Sun 12.30–4.20 pm (Oct–Mar)

Admission free

The Museum occupies three separate parts of Edinburgh Castle, the East and West Palace Block in Crown Square and the North Hospital Block in Hospital Square. The West Palace Block of Crown Square was formerly officers' barracks, built in 1708 by Captain Theodore Dury (1661–1742), who was responsible for other building operations at the Castle. The interior was converted in 1928–30 by John Wilson Paterson (1887–1970) to house the Museum. The Museum is administered as an outpost of the Royal Scottish Museum. The principal founder was the 8th Duke of Atholl (1871–1942) and the Museum was opened in 1930.

The Museum specialises in interpreting the history of the Armed Services as they pertain to Scotland, and includes displays on the Scottish regiments and the Royal Navy and Royal Air Force in Scotland. The collections of uniform from the late 18thc to 1914 are particularly fine and representative, and those of presentation swords and medals unmatched elsewhere in Scotland. The Palace Blocks contain displays on the Scottish regiments, the Royal Navy and Royal Air Force, the Royal Scots Greys, the Scottish yeomanry regiments and sections devoted specifically to firearms, edged weapons and medals. Displays in the North Hospital Block, which also houses the Museum offices, conservation studio, library and storage units, are scheduled to open in 1986 and will illustrate, in chronological format, the history of the Scottish soldier from *c.* 1600 to 1914.

PUBLICATIONS
W. A. Thorburn, *Uniform of the Scottish Infantry 1740–1900,* 1970

The Castle has a shop, limited car-parking is available on the Castle esplanade and a restaurant/cafeteria is planned.

Talbot Rice Art Centre [7]

Old Master paintings and bronzes

University of Edinburgh, Old College, South Bridge, Edinburgh
tel. 031-667 1011, ext. 4308

Mon–Sat 10–5 pm. Closed Sun

Admission free

The Centre was permanently established in 1971 in the 'Old College' of the University of Edinburgh, founded by James VI in 1582. This part of the University was built by Robert Adam (1728–92), who designed the outer quadrangle in 1789, and William Playfair (1790–1857), who was responsible for the interiors from 1819 to 1827. One of the rooms of the Gallery has a fine neo-classical interior, the original Upper Museum by Playfair, with top lighting and Ionic screen columns at each end.

The collection includes paintings by Willem van der Velde and Pynacker and bronzes by Giovanni da Bologna and Adrian de Vries.

The Centre has an Association of Friends. Catalogues, posters, etc., are for sale on the premises. Publications include recent catalogues, such as: *The Torrie Collection*; *Masterpieces of Scottish Portrait Painting*; *Walter Geikie 1795–1837*; *A Middle Eastern Journey*; *Gavin Scobie, Architect*; and *Thomas Hamilton, Architect, 1784–1856*.

FORRES, *Grampian*

Falconer Museum

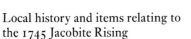

Local history; natural history; ethnography

Tolbooth Street, Forres
tel. 0309-73701

Daily 9.30–6.30 pm (May–Sept);
Mon–Fri 10–12.30 pm, 1.30–4.30 pm;
Closed Sat, Sun (Oct–April)

Admission free

The Museum was named after Alexander Falconer (1791–1856) and his brother Hugh (1808–65), both of whom were born in Forres. Alexander was a merchant in Calcutta and his brother was the well-known geologist and botanist, after whom the *Rhododendron falconeri* was named. Following their deaths, the money they both left for the establishment of a museum was put into building and by 1871 the Museum, designed by Alexander Reid (1816/17–97) of Elgin, was completed. In an Italianate style, the structure sports a row of sculptured heads of famous scientists by the sculptor Thomas Goodwillie of Elgin along the façade and includes one of Hugh Falconer. Further sums were donated by other members of the family, and gifts and bequests began to be received from 1868 onwards, mostly those of natural history, local antiquities and curiosities.

The Museum today exhibits items connected with Hugh Falconer, as well as a collection of drawings by Sir Thomas Dick Lauder and Daniel Alexander for Lauder's *Account of the Great Floods in the Province of Moray* of 1829 and a series of drawings by John Flaxman, including *Alceste about to Preserve the Life of her Husband*. There is also a collection of local Forres and Elgin silver.

Information sheets, books and postcards are available for sale, and there is free car-parking at the rear of the building.

FORT WILLIAM, *Highland*

West Highland Museum

Local history and items relating to the 1745 Jacobite Rising

Cameron Square, Fort William
tel. 0397-2169

Mon–Sat 9.30–5.30 pm (June & Sept);
9.30–9 pm (July & Aug), 10–1 pm, 2–5 pm
(Oct–May). Closed Sun

Admission charge

The Museum is housed in a former branch of the British Linen Bank, one of the town's earliest buildings, the architect of which is unknown. It was founded in 1922 and contains a wide variety of items of interest, particularly those related to the turbulent history of the Scottish Highlands: weapons of all kinds, medals, bagpipes, snuff-boxes and mulls. The most unusual item is an anamorphic painting of Charles Edward Stuart. There is a fine collection of tartans—plaids, kilts and trews.

There is a sales point where a guidebook, postcards and booklets are available.

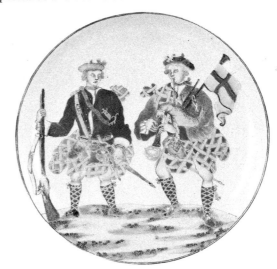

Chinese export bowl, 18thc (West Highland Museum, Fort William)

GLASGOW, *Strathclyde*

Glasgow Art Gallery and Museum [1]

Continental 16thc–20thc paintings;
British 17thc–20thc paintings; European
arms and armour; British and Continental
15thc–20thc ceramics; British
18thc–20thc silver; jewellery from
the Hull Grundy Gift; Continental and
British glass; British 19thc & 20thc
furniture; natural history; archæology;
ethnography

Kelvingrove, Glasgow
tel. 041-357 3929

Mon–Sat 10–5 pm; Sun 2–5 pm

Admission free

The Glasgow Art Gallery is the perfect complement to the National Gallery in Edinburgh. With collections of equally impressive quality but very different emphasis, the elaborately ornamented environment presents a complete contrast to the monumental neo-classical design of the National Gallery. The two buildings might be seen as text-book examples of two radically different approaches to the design of this distinctive architectural type, and proof of the diversity of appropriate solutions.

The Museum was established in 1870 and originally housed in the old Kelvingrove Mansion House. The art collection is older, dating from 1854, the bequest of over four hundred pictures from a local coachbuilder, Archibald McLellan (1797–1854). The present building, funded by public subscription and from the profits from the 1888 International Exhibition held in Kelvingrove Park, was designed by John W. Simpson (1858–1933) and E. J. Milner Allen (1859–1912), who won the contract by competition, and who were also the architects of Worcester City Art Gallery and Museum (q.v.) and Cartwright Hall, Bradford (q.v.). It was opened in 1902 and houses a very varied, large and important collection of archæology, history and works of art.

Further to the McLellan Bequest, Glasgow benefited in 1877 from the collection of the Scottish portrait painter John Graham-Gilbert (1794–1866) which consisted mostly of 17thc Dutch and Flemish paintings, for example, Rubens's *Nature Adorned by the Graces*, c. 1615, and two Rembrandts, *The Carcase of an Ox* of the late 1630s and *Man in Armour* of ?1655. This bequest was followed in 1905 by that of James Donald, a chemical manufacturer, who owned a fine selection of Dutch, French and British 19thc paintings. The Hamilton Bequest of money in trust from a local family, established in 1927, enables the Museum to purchase works, and so far seventy-three pictures, including, for example, Signac's *Le Quai de Clichy* of 1884 and Sisley's *Boatyard at Saint-Mammès* of c. 1885–86, have been added to the collection. The McInnes Bequest in 1944 contained seventy paintings, for example, Cézanne's *Overturned Basket of Fruit*, c. 1873–77, Monet's *Vétheuil*, c. 1880, Seurat's study for *Baignade à Asnières*, c. 1883, Degas's *Dancers on a Bench*, 1898, and Matisse's *The Pink Table-Cloth*, 1925.

One of the most important pictures in the collection is Giorgione's *The Adulteress Brought Before Christ*, c. 1508–10, from the McLellan Bequest, which was later joined by the *Head of a Man* from the figure originally on the right side of the painting. Acquired in 1971, this was also formerly in the collection of Queen Christina of Sweden, who was known to cut paintings to fit different spaces. Recent acquisitions have also included the controversial purchase of Dali's *Christ of St John of the Cross* in 1952. More recently Van Gogh's *Portrait of Alexander Reid* (1887), the dealer, and Faed's *The Last of the Clan* have been acquired.

The Art Gallery and Museum houses the main collection of ceramics, glass, silver and jewellery and some furniture while costume and textiles are in a branch museum as yet not open to the public except by arrangement for specific study.

The ceramic collections illustrate western European wares from the 15thc to the 20thc. There is a special interest in tin-glazed ceramics with pieces from the Glasgow Delftfield Pottery and a strong selection of Italian maiolica. British ceramics are broadly represented, with an emphasis on Scottish pottery. Art and Studio ceramics from 1880 to the present are collected.

The silver collection is mainly British after 1700, and is particularly strong in Scottish material, the majority the gift of Victor J. Cumming. In recent years an active policy of purchasing silver with a Scottish provenance or origin, particularly Glasgow, has been pursued. There are interesting groups of Scandinavian silver purchased between 1896 and 1903, and of tablewares from British colonies. An important collection of jewellery of over nine hundred pieces was given by Professor and Mrs John Hull Grundy. The glass collections have largely been acquired by purchase and contain the Riano collection of Spanish glass. There are good collections of Scottish and English glass and representative examples of wares from other European countries, including important holdings of Venetian glass. The furniture collections largely comprise work of Charles Rennie Mackintosh and his Glasgow contemporaries, though earlier furniture is included in the picture galleries, while the reserve collections include other 19thc and 20thc material.

The history collections comprise those of folk life and Scottish history, and include material

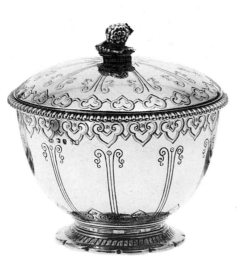

Silver-gilt preserve dish from the 'Beckford' silver, made by Paul Storr, 1813 (Glasgow Art Gallery and Museum)

PUBLICATIONS
Dutch and Flemish Paintings, 1961
British Paintings, 1971
Mackintosh Watercolours, 1978
Jewish Art, 1979
Glasgow School of Art Embroidery 1894–1900, 1980
European Arms and Armour at Kelvingrove, 1980

relating to the Western Isles, Orkney and Shetland and an especially interesting collection from the island of St Kilda. There are important collections of pewter and snuff-boxes, also clocks and watches and Scottish treen, including Mauchline ware.

The Egyptian collections, ranging from pre-Dynastic to the Roman period, include part of the Rev. Colin Campbell's Collection and material acquired through the Egypt Exploration Fund. There are two other important ceramic collections, prehistoric pottery from Cyprus, collected by Sir Robert Hamilton-Lang and Greek pottery from Lipari, Sicily, collected by James Stevenson. Both collections were originally deposited on loan in the 1880s and bequeathed in the first decade of the 20thc. The collection of Ludovic McLellan Mann forms the basis of the extensive Scottish prehistoric material in the Museum.

There have been four bequests of European arms and armour since 1911 which include many Scottish weapons and firearms, many with unusual actions. The collection covers a period from the early mediæval period to the early 20thc. There are many superb examples, the most famous of which is the Milanese Armour of *c*. 1450 which is the most complete early full plate armour in Britain. There is also a complete Greenwich armour for man and horse of *c*. 1550.

The Glasgow Museums have an Association of Friends. There is a shop, self-service restaurant and coffee bar, and car-parking in the grounds.

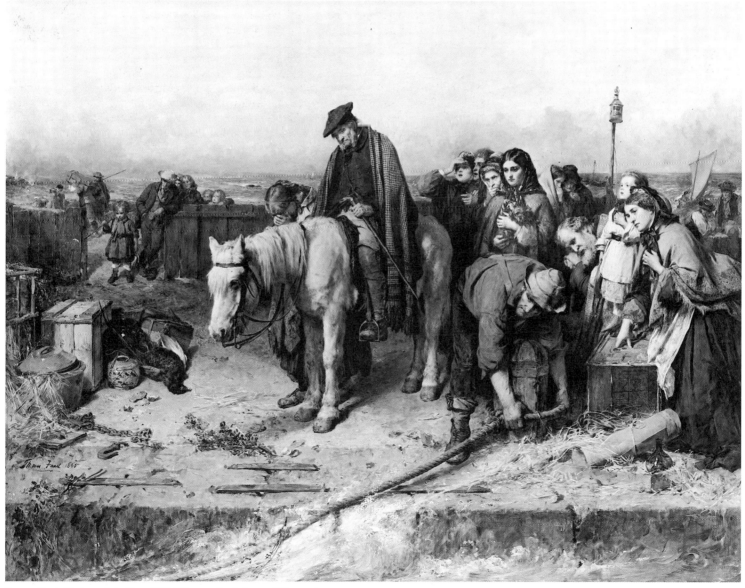

Thomas Faed, *The Last of the Clan*, 1865 (Glasgow Art Gallery and Museum)

Jules Breton, *The Reapers*, 1860 (Glasgow Art Gallery and Museum)

Giorgione, *The Adulteress brought before Christ*, c. 1508–10 (Glasgow Art Gallery and Museum)

The Burrell Collection [2]

Oriental art; 12thC North European arts, particularly tapestries and stained glass; 15thC–20thC European painting

Pollok Country Park,
2060 Pollokshaws Road, Glasgow
tel. 041-649 7151

Mon–Sat 10–5 pm; Sun 2–5 pm

Admission free

Sir William and Lady Burrell presented their outstanding and huge collection to Glasgow in 1944. Sir William (1861–1958), a shrewd and successful ship-owner, collected over a period of eighty years a total of more than eight thousand objects, taking considerable trouble and interest in all that he bought, both from the scholarly and financial point of view. Glasgow was a particularly good place to buy; the Scots pioneered an interest in 19thC French painting, particularly the dealer Alexander Reid (1854–1928) who played an important role for many collectors in Scotland, and Burrell bought from him over a period of thirty years. Burrell's range of knowledge and choice was immense, from the earliest examples of the ancient world to the latter part of the 19thC and early 20thC. Reproductions of the three principal rooms, the hall, drawing-room and dining-room, from his home at Hutton Castle, near Berwick-on-Tweed, have been incorporated into the Museum, together with their furniture and fittings, including stained glass.

During the 1930s Burrell decided to leave his collection of over 6,000 items intact to the Nation, but it was not until 1944 that he chose Glasgow, his native city, for its future home, on the condition that the gallery to house it should be within four miles of Killearn in Stirlingshire and not less than sixteen from the Royal Exchange in Glasgow, away from the pollution of the City. This was followed in 1946 and 1948 by gifts totalling £450,000 for this building. The period between that time and Burrell's death in 1958 was spent in buying still more works, over two thousand in number, and transferring those from Hutton Castle to Glasgow. He bought with the establishment of a new museum in mind, to enrich the collection and broaden its coverage. In particular he secured a number of architectural fixtures, doorways, windows, screens and so on from the collection of the American newspaper magnate, William Randolph Hearst, to build in to the fabric of the building. When Burrell died in 1958, aged ninety-six, the problem of where to house his magnificent collection was still unsolved. In 1967 Mrs Anne Maxwell Macdonald gave her family home, Pollok House, and the surrounding estate on the outskirts of Glasgow to the City which thus provided a setting for an entirely new building in which to house the Burrell Collection.

In 1972, following a competition, Barry Gasson Architects won the commission which took eleven years to complete. The collections, meanwhile, were either stored or at times loaned out temporarily. The building commands a splendid site amidst fields with two sides set against woodland, which results in a most unusual and natural juxtaposition between the immediate proximity of the trees to the display of the works of art. It succeeds as one of the most carefully designed purpose-built structures of this country, with many considerations to be borne in mind, including the limitation of only part of the collection to be shown at one time. The internal space has been conceived to be as flexible as possible in order to overcome this.

The Burrell has a unique distinction in being the only private collection formed on such a wide basis as to be susceptible of being divided into clearly defined sections: for example, Antiquities, the last area of the collection to be amassed by Burrell, to which the magnificent Warwick Vase was added by purchase in 1979; Oriental Art, with Chinese ceramics, bronzes and jades, Japanese prints and Near Eastern ceramics and carpets; and Mediæval Europe, incorporating the unrivalled collection of stained glass which is one of the most comprehensive to be found outside a major cathedral, and the most beautiful tapestries. Decorative Arts include European silver, ceramics, glass, needlework, furniture and arms and armour; and last, but not by any means least, the paintings, with their span from Memling and Cranach to the highly important representation of the 19thC in France.

Particularly noteworthy items are the very early ceramics from, for example, the Chinese neolithic Yangshao culture—a strikingly ornamented pot—and the fine group of 15thC–17thC blue and white porcelains. The Eastern carpets are outstanding and constitute one of the few important collections in the British Isles. The mid-16thC Luttrell Table Carpet is a great rarity: only one other tapestry woven 16thC table carpet survives, now in the Metropolitan Museum in New York. The wall-hangings are of stunning quality and in a remarkable state of preservation, with the colours still glowingly bright. Burrell regarded them as the most valuable part of his collection.

The paintings collection is dominated by the 19thC and the French 19thC in particular. An important Courbet of 1868, *The Charity of a Beggar at Ornans*, extends the representation of peasant life into the grotesque, a step beyond the heroic or idyllic visions of Millet or Breton. Degas is represented by outstanding examples of his three main preoccupations:

The 'Warwick' vase, Roman marble of the 2ndc AD with 18thc restoration (Burrell Collection, Glasgow)

The Rehearsal (*c.* 1877), is one of the most famous of the ballet subjects; this is matched by the brilliantly original portrait of *Edmond Duranty* (1879) and the fascinating *Jockeys in the Rain* (*c.* 1886). The impressive Cézanne landscape of the *Château de Médan, c.* 1880, was painted while the artist was staying with Emile Zola in his house in Médan. The sculpture and the prints and drawings collection supplement and complement the paintings: indeed, many of the 19thC and 20thC bronzes, like *The Blacksmith* by Constantin Meunier, were bought because they explored those themes which had caught Burrell's imagination when he was acquiring paintings. There are also fourteen bronzes by Rodin including a version of *The Thinker* (1880–81), from the monumental *Gates of Hell*, the great bronze doors which were only finally cast nine years after his death. The collection of prints and drawings is varied, covering a wide spectrum with some fine but isolated examples of Old Master etchings and woodcuts by, for example, Dürer and Rembrandt, and a substantial group of watercolours and drawings of the 19thC French School. The only instances of contemporary patronage by Burrell are his acquisition of works by the Scot Joseph Crawhall and the group of 147 lighthearted sketches and cartoons by the *Punch* artist, Phil May.

There is a shop and ample car-parking, and a self-service restaurant and licensed bar.

PUBLICATIONS
The Burrell Collection (with an introduction by John Julius Norwich), 1983
Richard Marks, *The Burrell Collection: A Souvenir Guide*, 1985
Richard Marks, *Burrell: Portrait of a Collector*, 1983
Richard Marks and B. J. R. Blench, *The Warwick Vase*, 1979
Ann Scott, *Sam Goes to the Burrell Collection*, 1980
William Wells, *Stained and Painted Glass, Burrell Collection*, 1965
William Wells, *Stained and Painted Heraldic Glass, Burrell Collection*, 1962
Crawhall in the Burrell Collection, 1953

Joseph Crawhall, brush drawing of a *Girl riding a bicycle, c.* 1895 (Burrell Collection, Glasgow)

Mahogany cabinet designed by E. W. Godwin, decorated with Japanese motifs by James McNeill Whistler, 1878 (Hunterian Art Gallery, Glasgow)

Hunterian Art Gallery [3]

Major collection of J. M. Whistler and
C. R. Mackintosh; Old Master paintings;
large 15thC–20thC print collection;
18thC British paintings; 19thC & 20thC
Scottish painting

University of Glasgow, 82 Hillhead Street,
Glasgow
tel. 041–339 8855, ext. 7431

Mon–Fri 10–5 pm; Sat 9.30–1 pm.
Main gallery closed Mon–Fri 12.30–1.30,
3–3.30 pm, Sat 11–11.30 pm & Sun
Mackintosh house closed Mon–Fri
11.30–12.30 pm & Sun

Admission free, except for the Mackintosh
House which charges on weekday
afternoons and Sat mornings

The Art Gallery is housed in the University of Glasgow (founded in 1451), in a new building designed by Whitfield Partners of London and opened in 1980. The ribbed concrete exterior incorporates at the south-east section the windows and front door from the Mackintosh House. The Mackintosh House comprises the four principal interiors from the Glasgow home of the Scottish architect and designer Charles Rennie Mackintosh (1868–1928), reconstructed on three levels in their original orientation as an integral part of the Gallery. The rooms have been furnished with the architect's own furniture and decorated as closely as possible to match the original. Huge cast aluminium doors commissioned from Eduardo Paolozzi stand at the entrance to the Main Gallery.

The nucleus of the University's collections is the bequest to the University from Dr William Hunter (1718–83), former student of the University and Physician Extraordinary to Queen Charlotte. This is now divided between the Hunterian Museum, the Departments of Zoology and Anatomy and the University Library, with the paintings from his collection housed in the Art Gallery.

The growth of the University's Art Collection has depended almost entirely on gifts and bequests. Following the Hunter Bequest of 1783, the next major augmentation of the University Collection came over 150 years later with a succession of major additions to the Paintings, Prints and Drawings and Decorative Art collections. In 1935 and 1958 Miss Rosalind Birnie Philip (1873–1958) gave and bequeathed the estate of her brother-in-law, James McNeill Whistler. This included some 80 oil paintings, 120 pastels, several hundred prints and drawings and the contents of the artist's studio at his death. During the last nine years of his life James A. McCallum (1862–1948) donated an extensive and representative collection illustrating the history of printmaking from the work of Schongauer to Picasso, while in 1940 Professor W. R. Scott (1868–1940) bequeathed an important collection of several thousand 16thC and 17thC Italian prints. In 1946 Hamish and Cameron Davidson presented some forty pieces of furniture and decorative art objects designed by Charles Rennie Mackintosh from his Glasgow home at 78 Southpark Avenue. In the same year Mackintosh's nephew Sylvan MacNair donated his uncle's estate, comprising over six hundred drawings and designs, decorative art objects and archival material. Three further important

Jean-Baptiste Siméon Chardin, *A Lady taking Tea*, 1738 (Hunterian Art Gallery)

benefactions have since been received: the bequest of Miss Ina J. Smillie in 1963, which comprised an unusual and highly interesting group of twenty-six Dutch and Flemish 17thc paintings, including works by A. and J. Leemans, Colyer, de Vries, and Maes; the gifts of Dr Charles Hepburn who from 1959 to his death in 1971 presented and bequeathed a fine collection of over twenty mainly British 18thc portraits, comprising works by Raeburn, Romney, Hudson, Ramsay and Lawrence; and most recently, between 1966 and 1979, the gifts of Emeritus Professor A. L. Macfie (1898–1980) of over 130 late 19thc and early 20thc Scottish paintings.

The Hunterian's collections are quite exceptional. The Old Masters include *The Entombment of Christ* by Rembrandt and Koninck's *Panoramic Landscape*. Of the 18thc paintings two are by Stubbs, *The Nylghau* of 1769 and *The Moose* of 1770, and three by Chardin, *A Lady Taking Tea* (1735) and *The Cellar Boy* and *The Scullery Maid*, both of ?1738. Portraits include Raeburn's *Mrs John Hamilton of Northpark*, Reynolds's *Nelly O'Brien* and Allan Ramsay's *Mrs Tracy Travell* of 1769. As in the Burrell Collection (q.v.) there is a fine collection of French 19thc painting—Pissarro's *Misty Morning, Rouen* of 1896, Corot, Fantin-Latour and Boudin, as well as many Scottish paintings of about the same date. McTaggart, Walton, Pringle, Hornel and Guthrie are well represented.

The Gallery was awarded the Scottish Museum of the Year Award in 1981. There is a shop where an impressive selection of publications is available, including a catalogue of the pictures shown at Colnaghi's in 1973, the *Guidebook to the Mackintosh House* and catalogues for the individual collections, and exhibition catalogues since 1946. The University refectory is nearby, as is pay car-parking.

Hunterian Museum [4]

Geology; archæology; ethnography; Roman material; coins and medals

University of Glasgow (Main Building), Glasgow
tel. 041-339 8855, ext. 221

Mon–Fri 10–5 pm; Sat 9.30–1 pm. Closed Sun

Admission free

Named after Dr William Hunter (1718–83), physician, anatomist, medical teacher, collector and former student at Glasgow University, the Museum was opened in 1807 in a fine neo-classical domed 'temple' designed by William Stark (d. 1813) which was demolished in 1870. It was one of the earliest public museums to be established in the British Isles and was transferred to its present home on the western outskirts of Glasgow in 1870. The Museum is now housed in halls within the massive neo-Gothic buildings of the University of Glasgow, designed by Sir George Gilbert Scott (1810–78), and dominated by a tower, topped in 1887 by a spire designed by John Oldrid Scott (1841–1913). The interior of the Museum has recently been repainted to emphasise the architectural details.

Dr Hunter bequeathed a wide range of material in 1783 although some of the collections predate this, the University having been founded in 1451 by Bishop Turnbull of Glasgow. The University memorabilia include a finely worked 15thc mace and scientific instruments. The Museum has outstanding holdings of geological and archæological items, especially those relating to Scotland. The Roman material from the Antonine Wall includes some beautifully sculptured 'distance slabs'. The Greek, Roman and Scottish coins constitute one of the world's richest collections and number more than 30,000, which Hunter spent over £20,000 in amassing from 1770–83, a huge sum for that time. The collection was second in importance to the French Royal collection at the time of his death. There are also fine Renaissance medals and communion tokens. The ethnographical collections hold items which Captain James Cook, the circumnavigator, brought back from the South Seas in the 1770s.

The Museum was Scottish Museum of the Year in 1983 for its exhibition of University History and won a special prize in the same competition in 1984 for the Coin Gallery.

PUBLICATIONS
A. Ross and J. Hume, *A New and Splendid Edifice, the Architecture of the University of Glasgow*, 1975
A. Ross, *1577, New Life for the University*, 1977
L. Keppie, *Roman Distance Slabs from the Antonine Wall*, 1979

There is a bookshop which sells slides, replicas and souvenirs and the Museum boasts 'Dr Hunter's Coffee House'. There is nearby pay car-parking.

The People's Palace Museum [5]

Local and social history

Glasgow Green, Glasgow
tel. 041-554 0223

Mon–Sat 10–5 pm; Sun 2–5 pm

Admission free

The Museum was originally intended as a cultural centre for Glasgow's East End. It was designed by the City Architect, A. B. Macdonald, and built from 1895–97 and opened in the following year. The building is of red sandstone in the French Renaissance style and is surmounted by sculptures of figures representing Art and Industry by Kellock Brown.

El Greco, *Lady in a Fur Wrap, c.* 1577–79 (Pollok House, Glasgow)

Adjoining the Winter Gardens is the largest glass house in Scotland. The main emphasis of the collection is on the history of Glasgow spanning a period from the 12thC to the present. There is a specialist collection of stained glass produced in Glasgow from *c.* 1870 to 1930.

The Museum has an Association of Friends. There is a shop, snack bar in the Winter Gardens and free car-parking in the grounds.

Pollok House [6]

Mrs Anne Maxwell Macdonald gave her family home to Glasgow in 1966 with the surrounding parkland and gardens. The House, the architect for which is unknown, dates from the mid-18thC, with additional wings on either side designed by Sir Robert Rowand Anderson (1834–1921) *c.* 1890–1910. The plasterwork is possibly by Thomas Clayton.

Outstanding in the collections are the Spanish paintings collected by Sir William Stirling-Maxwell (1818–78), the historical writer and pioneer enthusiast and collector of Spanish art. He published some of the first works on the subject and was unusual for his choice of these pictures. Particularly noteworthy are El Greco's *Lady in a Fur Wrap* of *c.* 1577–79 and *Portrait*

PUBLICATIONS
Exhibition catalogues:
Scotland Sober and Free: The Temperance Movement 1829–1979, 1979
Glasgow Stained Glass, 1981

16thC–19thC Spanish paintings

Pollok Country Park,
2060 Pollokshaws Road, Glasgow
tel. 041-632 0274

Mon–Sat 10–5 pm; Sun 2–5 pm

Admission free

of a Man of the 1590s, both from King Louis Philippe's Spanish Gallery in the Louvre, and works by Murillo (*Madonna and Child with St. John, c.* 1645–50), Alonso Sanchez Coello and Goya. Other European painters of importance represented are William Blake, Hogarth and Mengs

The house has some original furnishings and more have been added. They mostly date from *c.* 1750 to 1820 and include furniture, silver (a Hester Bateman tea-urn of 1786), ceramics and glass.

There is a shop, tea-room and car-parking next to the House.

PUBLICATIONS
William Blake (catalogue of the artist's work in the Stirling-Maxwell Collection), n.d.
Pollok House: A History of the House and Gardens, 1983
Pollok House Room Guide, 1983
Checklist of Paintings and Sculptures, 1983

GREENOCK, *Strathclyde*

McLean Museum and Art Gallery

19thC & 20thC Scottish paintings; Japanese tsuba, netsuke and inro

9 Union Street, Greenock
tel. 0475-23741

Mon–Sat 10–12 pm, 1–5 pm. Closed Sun

Admission free

The Museum was founded by James McLean (d. 1877), a local timber merchant and member of the Greenock Philosophical Society. The Museum, which includes the Watt Lecture Hall, was built to accommodate the Philosophical Society's collection of antiques and house its lectures. The architect was named Adamson and the building was opened to the public in 1876. An extension was built in 1958. The collection includes bequests from the Caird family of shipowners and shipbuilders, particularly that of Stuart Anderson Caird of 1917, who also bequeathed £6,000 to establish a Trust to purchase further works of art. Colin Young Caird (d. 1928), his nephew, bequeathed his collection of etchings and a sum of £1,000, also to purchase further works. Additional gifts have been received from other members of the Caird family. There are also relics of James Watt (1736–1819), the steam engineer, inventor and native of Greenock.

The collection principally consists of 19thC and 20thC Scottish works. Amongst the artists represented are McTaggart (*The Wind Among the Grasses*), Hornel (*Spring*), Peploe (*Still Life*), Cadell (*Crême-de-Menthe*) and Leighton (*Yasmeenah*). In addition, there are a few notable works by French 19thC painters, for example, Corot (*Evening*), Boudin (*Bordeaux*) and Courbet. The Museum also holds a splendid collection of Japanese objects.

There is a small shop which sells cards, books and posters and the catalogue for the Caird Collection, published in 1972. Free car-parking is available in the street.

INVERNESS, *Highland*

Inverness Museum and Art Gallery

Local history, archæology and natural history

Castle Wynd, Upper Bridge Street, Inverness
tel. 0463-237114

Mon–Sat 9–5 pm. Closed Sun

Admission free

The Northern Institution for the Promotion of Science and Literature was founded in 1825 and although it survived only ten years it formed the nucleus of the Art Gallery and Museum. Its aim was to collect MSS and information on antiquities, as well as to build up the collections generally, the earliest of which contained such items as coal deposits, coins and even the skull of a polar bear from Hudson's Bay. After a chequered history a Museum in Castle Wynd was opened in 1881, built by a local architect, Alexander Ross (1834–1925), in conjunction with the Fine Arts Exhibition. This was a loan exhibition of Old Masters and contemporary paintings and other objects, which proved a resounding success. The building survived until 1963 when it was demolished to make way for a new and larger structure to house the collections, which was completed three years later.

The collections range over a huge assortment of items but are particularly strong in those associated with Highland history and archæology, as well as an important collection of Inverness silver, part of which is on loan. The painting collection includes work by Alexander Nasmyth, Jane Nasmyth, Mary Bird, Patricia Douthwaite and Keith Henderson and a collection of watercolours of Inverness by W. Glashan.

There is a Museum Club, a shop and a coffee shop. Publications available at the shop include a Museum Centenary booklet and *Inverness Silversmiths.*

Christening robe decorated with Ayrshire embroidery, *c.* 1840 (Dick Institute, Kilmarnock)

Silver candlestick made by Alexander Macleod of Inverness, *fl.* 1827–41 (Inverness Museum and Art Gallery)

18thC–20thC British Painting

Elmbank Avenue, Kilmarnock
tel. 0563-26401

Art Gallery (all year): Mon, Tues, Thurs, Fri 10–8 pm; Wed & Sat 10–5 pm. Closed Sun
Museum: Mon, Tues, Thurs, Fri 10–8 pm; Wed & Sat 10–5 pm (April–Sept); Mon–Sat 10–5 pm (Oct–March). Closed Sun

Admission free

KILMARNOCK, *Strathclyde*

Dick Institute [1]

The Institute was founded by James Dick and the neo-classical building, designed by an architect named Ingram, was opened in 1901. The collections were originally based on geology and archæology, but these soon expanded to include art. Among the many benefactors of the art collection, Sir Alexander Walker and Mr and Mrs Dunlop, contributed significantly.

The paintings collection concentrates mainly on 18thC, 19thC and 20thC Scottish and English work, but there are also works by Corot (*Harvesting*), Teniers, Herrera and Lairesse. Scottish artists include Raeburn (*Mrs Mary Anderson*), McCulloch, Ramsay, Scott Lauder, D. Y. Cameron and Colquhoun (*Women in Ireland*), and the Glasgow School is strongly represented, especially by Hornel (e.g. *Gaggle of Geese*), Henry, McGeorge, Park and Gould. Major works by English artists are those by Leighton (*Greek Girls Playing Ball*), Alma-Tadema (*Audience with Agrippa*), Constable (*View of Hampstead Heath*), Millais (*Daydreams*) and Brangwyn. The varied collection of prints, drawings and watercolours includes an interesting group of designs and proof prints by William Bell Scott and bronzes by McGill and Schotz. The Institute also has examples of Ayrshire embroidery, printed calico, pottery and porcelain.

There is a shop during special exhibitions, and catalogues for the exhibitions *Robert Colquhoun* (1962 and 1982) and *Western Approaches* (1985) are available. A handlist of the painting collection is in preparation. Car-parking is available.

Kilmarnock and Loudoun District Council also administers:

Dean Castle

[2]

16thc European arms and armour;
15thc & 16thc tapestries

Dean Road, Kilmarnock
tel. 0563-2460

Mon–Fri 2–5 pm; Sat & Sun 12–5 pm
(12 May–22 Sept and by arrangement with
the Curator throughout the year)

Admission free

The Castle, formerly the home of the Barons de Walden, dates from the 14thc and 15thc, and was restored by James Richardson in 1930–39. The collection is based on those of the 8th Lord Howard de Walden, Charles van Raalte and the 9th Lord Howard de Walden who gave the Castle to the Corporation. In 1975 it opened as a public museum.

The arms and armour collection is mainly 16thc and there are particularly fine examples of helmets, rapiers and early mediæval swords.

The Charles van Raalte Collection of Early European Musical Instruments includes several fine 16thc lutes by Tiffenbrucker and Unverdorben and early 17thc lutes and guitars, with pieces by Sellas and Stregher. There are also a number of early keyboard instruments.

The most notable tapestries are Brussels pieces of the late 15thc and early 16thc, particularly a nativity by the Master of St Gudule, *c.* 1475.

A shop sells a leaflet on the Castle, handlists for the musical instruments and arms and armour and tapestries, as well as information sheets, postcards and slides. There are snack bars, a tea-room and a car-park.

KIRKCALDY, *Fife*

Kirkcaldy Art Gallery

Scottish 19thc & 20thc painting;
local pottery 1850–1930

War Memorial Gardens, Kirkcaldy
tel. 0592-260732

Mon–Sat 11–5 pm; Sun 2–5 pm

Admission free

The Gallery was founded in 1925 as part of the war memorial and financed by John Nairn, a local industrialist.

The strength of the Gallery's holdings is its Scottish painting. In 1963 the NACF helped purchase the John W. Blyth collection of 116 pictures which included thirty paintings by S. J. Peploe and twenty-one by William McTaggart and resulted in a special gallery devoted to McTaggart's work. The collection also contains a wide range of the 'Glasgow Boys': W. Y. Macgregor, John Lavery, E. A. Hornel and George Henry. There is an interesting group of Camden Town paintings with five works by Sickert, for example *Summer Afternoon* (*c.* 1909), also Gore, Gilman and William Nicholson (*Sheffield Plate*). The Gallery has

Silver Communion cup made by William Lindsay II of Montrose, 1688 (Montrose Museum and Art Gallery)

William MacTaggart, *Consider the Lilies*, 1898 (Kirkcaldy Art Gallery)

316

benefited from donations, such as John Martin's *The Garden of Eden* and the Harley Bequest, with works by Boudin and Fantin-Latour.

Recent purchases of contemporary Scottish artists have included Anne Redpath, Joan Eardley and Robin Philipson.

There is a catalogue of the collection available and small gallery guides at the shop. Car-parking is available.

KIRKWALL, *Orkney*

Tankerness House Museum

5,000 years of Orkney archæology and history

Broad Street, Kirkwall
tel. 0856-3191

Mon–Sat 10.30–12.30 pm, 1.30–5 pm;
Sun 2–7 pm

Admission free

The Museum was founded in 1968 and occupies a building which dates from the 16thC with crow-stepped gables and ingle-nook fireplaces. It houses the Westray Stone, the finest example of Neolithic spiral carving in the United Kingdom, and the St Magnus reliquary.

There is a shop and car-parking nearby.

MILNGAVIE, *Strathclyde*

Lillie Art Gallery

Scottish paintings, sculpture and ceramics (20thC)

Station Road, Milngavie, Glasgow
tel. 041-956 2341, ext. 46

Tues–Fri 11–5 pm, 7–9 pm;
Sat–Sun 2–5 pm. Closed Mon

Admission free

The Gallery was built in 1962 by Michael Bowey with funds bequeathed for the purpose by Robert Lillie (1867–1949) of Milngavie. From 1962 to 1980 the Gallery received an important group of Scottish paintings from the collections of Professor A. L. MacFie (1898–1980) and Major-General J. M. MacFie (b. 1891), both of whom lived in the town.

The main emphasis of the collection is on Scottish 20thC paintings, sculpture and ceramics, including such examples of the Glasgow School as works by C. B. Cadell, G. Leslie Hunter and S. J. Peploe. It also contains important examples of work by 20thC painters, such as Alan Davie, Robin Philipson and Joan Eardley.

There is a Gallery shop and car-parking facilities are available. The Gallery has published a catalogue of part of the MacFie Collection.

MONTROSE, *Tayside*

Montrose Museum and Art Gallery [1]

Local material; maritime history

Panmure Place, Montrose
tel. 0674-73232

Mon–Sat 10.30–1 pm, 2–5 pm (April–Oct);
Sun 2–5 pm (July–Aug only);
Mon–Fri 2–5 pm, Sat 10.30–1 pm, 2–5 pm;
closed Sun (Nov–Mar)

Admission free

On 20 August 1818 a local taxidermist offered his museum of natural curios to the Town Council. This was eventually purchased in 1836 by the Montrose Natural History and Antiquarian Society, formed on 15 August that year expressly for the purpose of founding a museum. The Museum opened on 2 January 1837 in temporary accommodation and on 27 October 1842 the purpose-built Museum, designed by John S. Henderson of Edinburgh (1804–62), was opened on the site. Although extended in 1890, it still occupies the original building. The Society administered the Museum until 1974, when it was sold for a nominal fee to Montrose Town Council. Following local government reorganisation, Angus District Council completely renovated the building and the new displays were opened in 1981.

Extensive local collections cover the history of Montrose from prehistoric times to the present day, notably the maritime history of the port and the natural history of the region. The collections include three Pictish stones, one known as the Inchbroach Stone; the sword of James Graham, Marquis of Montrose, Scotland's most famous soldier (after Robert the Bruce), who was born at Old Montrose in 1612; and displays of Montrose pottery and silver. The silver collection includes a great rarity in the form of a Communion Cup by William Lindsay Jnr of Montrose, dated 1688, one of a pair made for Laurencekirk Parish Church.

The Museum has a shop and car-parking facilities.

William Lamb Memorial Studio [2]

24 Market Street, Montrose
tel. 0674-73232

Sun 2–5 pm (Sept–June); Wed 2–5 pm
(July–Aug)

Admission free

This is the working studio of the Montrose sculptor William Lamb (1893–1951), bequeathed to the Montrose Town Council at the time of his death. It opened to the public in 1955 and has since undergone extensive renovations. This display now includes sculptures, paintings and drawings by the artist, his workroom and tools and his living-room with furniture which he devised himself.

A catalogue is available.

PAISLEY, *Strathclyde*

Paisley Museum and Art Galleries

19thc British painting; 18thc & 19thc
ceramics; 19thc & 20thc pottery;
19thc textiles (history of the Paisley shawl)

High Street, Paisley
tel. 041-889 3151

Mon–Sat 10–5 pm. Closed Sun

Admission free

Sir Peter Coats, head of the giant Paisley firm of J. & P. Coats, threadmakers, announced in 1867 that he would provide the finance for a public museum and library building. This was designed by John Honeyman (1831–1914) in 1867 and opened to the public four years later. Sir Peter continued to give financial support until his death in 1890. The Art Galleries were extended by his son Peter Coats in 1892 and by Peter's son James Coats in 1904. The architect responsible at both dates was William Abercrombie. It is a Greek revival building with a portico and rotunda. In 1911 the Paisley Art Institute Collection, founded in 1876, was transferred to the Corporation together with four additional galleries.

The paintings are mainly by Scottish artists, but there is a selection of paintings by members and associates of the French Barbizon School: two cattle scenes by Constant Troyon, a landscape by Theodore Rousseau, *Le Couchant de Soleil* by Daubigny, *The Windmill* by Charles Emile Jacque, and two works by Diaz. Among other French pictures are *Un Matin Brumeux* by Corot and works by Boudin, Monticelli, Fantin-Latour and Eugene Carrière.

To be noted among the Scottish paintings are a *Portrait of a Lady* by Allan Ramsay, *Mrs Forbes* by Henry Raeburn, *A Veteran Highlander* by David Wilkie and a landscape by Patrick Nasmyth. There is considerable representation from the 19thc, for example, *Church of the Nativity* by David Roberts, *Dark Beauty* by Andrew Geddes, several romantic paintings concerned with the defence of Scotland by David Scott, and paintings by Noel Paton, William Quiller Orchardson, William McTaggart and others. The Glasgow School is represented by for instance *Nethy Bridge* by William York MacGregor, the pupil of Alphonse Legros (many of whose etchings are here), a group of works by George Henry and further collections by James Guthrie and William Kennedy. A later generation of painters who studied in Paris and were associated with the Fauves also figures in the Gallery, among them S. J. Peploe and J. D. Fergusson.

The Museum is famous for its collection of detailed information on the history of the Paisley shawl industry, which flourished from 1805 to 1870. Many specimens of the shawl can be seen, together with the sample books, tools and various types of loom.

The collection of ceramics at Paisley is also highly notable, with fine examples from the factories of Wedgwood, Minton and Doulton to be found alongside a sizeable collection of other British and Oriental wares. The Studio pottery collection is of great importance. Now used as a study centre in Scotland, it includes the work of the most important and influential artist/potters in Britain since 1920. Many early examples and outstanding works by potters such as Bernard Leach, Shoji Hamada, William Staite Murray, Lucie Rie, Hans Coper and Michael Cardew are represented in this collection.

John Henning, the sculptor, a native of Paisley, is represented by an extensive collection of documents, i.e. moulds for his portrait reliefs and casts of them, as well as letters and drawings. Shown with the sculptures of Henning's fellow natives, James Fillans and his brother John, are the casts of the Parthenon and Bassae friezes which he laboured to perfect (even allowing himself the liberty of improving on the original), one of the principal channels in the 19thc for the dissemination of these influential works of art.

Museum publications available at the shop include: *Paisley Shawl Book; Paisley Shawl Booklet; John Henning 1771–1851* (a catalogue); and *The Studio Ceramics Collection at Paisley Museum and Art Galleries*.

PERTH, *Tayside*

Perth Museum and Art Gallery

19thc & 20thc British painting; 16thc & 17thc Dutch painting; 19thc Scottish silver

76 George Street, Perth
tel. 0738-32488

Mon–Sat 10–1 pm, 2–5 pm. Closed Sun

Admission free

The present Museum was opened in 1935, though its origins can be traced back to the founding in 1784 of the Literary and Antiquarian Society of Perth, which in 1824 transferred to its new building, the Marshall Monument. It was designed by David Morison of Perth (1792–1885) as a memorial to Thomas Hay Marshall of Glenalmond, a Provost of Perth. That building was incorporated into a new one in 1935 by Smart, Stewart and Mitchell who retained its impressive classical domed rotunda fronted by a colonnaded portico to which the extension, described in 1935 as 'marking a distinction in modern museum arrangement and design', had been successfully added. The early date of 1824 makes the building one of the first museum structures in the country.

The collections began with books, MSS and ethnographical specimens. The painting collection grew gradually from 1785 with particular emphasis on Scottish works, both portraits and landscapes. Two important bequests were received from local patrons, those of R. Hay Robertson (1857–1926) and Robert Brough (d. 1926), a local merchant. In addition to giving his fine collection of Dutch, Scottish and English pictures, Brough's bequest provided £30,000 for the building of a new museum and art gallery, a competition for which was held in 1931.

John Everett Millais, *Effie Millais*, 1873 (Perth Museum and Art Gallery)

These bequests were followed by that of Sir David Young Cameron (1865–1945), the painter, which consisted mostly of silver, British and Oriental ceramics and British and French paintings. The collections have since grown considerably to the benefit of the 19thC and 20thC holdings, particularly Scottish pictures.

Especially noteworthy in the 19thC and 20thC collections are Horatio McCulloch's *Loch Katrine*, David Young Cameron's *The Wilds of Assynt*, Millais's *Just Awake* and Landseer's study sketch for *The Keeper John Crerar with his Pony*, purchased with the aid of the NACF. Other artists included are McTaggart, Hornel, Henry, Peploe, Cadell, Beatrix Potter and Amelia Long. There is a small but good collection of 16thC and 17thC Dutch paintings from the Brough Bequest. Local artists are well represented, as are views of Perth and Perthshire. There is also a collection of prints and drawings including works by Millet and Daumier.

The applied art collection is particularly strong in Perth silver which has a well-established tradition since the 12thC and flourished until the 1930s, and there are several good early examples including communion plate, as well as a strong collection of 19thC pieces. Glass has been made locally since 1865 for the production of laboratory glass, and safety lamps. The output and variety grew rapidly and 'art' and studio glass were marketed under the trade-names of Monart and Vasart, both of which are well represented in the Museum. There are also collections of Venetian glass, ceramics and furniture.

There is a small shop which sells publications, prints and postcards.

PUBLICATIONS
Joanna Mundy, *Catalogue of the Permanent Collection of Paintings and Drawings*, 1981
Joanna Mundy, *A History of Perth Silver*, 1980

STIRLING, *Central*

Stirling Smith Art Gallery and Museum

Scottish painting (19thC); local and Scottish history

40 Albert Place, Dumbarton Road, Stirling
tel. 0786-71917

Wed–Fri 2–5 pm; Sat 10.30–5 pm;
Sun 2–5 pm

Admission free

Thomas Stuart Smith (d. 1869) of Glassingall left an endowment and his own collections to establish a museum in Stirling. Built by John Lessels (1808–83) of Edinburgh, it was opened in 1874 and in 1905 incorporated the collection of Stirling Natural History and Archæology Society. The Museum was forced to close in 1973 due to deterioration of the building. A donation of £12,000 from the Friends facilitated one room to be reopened in 1978. Further extensive restoration work has taken place. In 1984 it was awarded a major prize in the Scottish Museum of the Year awards.

The Art Gallery holds paintings, watercolours and prints, with particular emphasis on Scottish 19thC works. The Museum has collections of archæology, natural history and a good Scottish local and social history section.

The Museum has an actively supporting Association of Friends. There is a shop, and car-parking is available.

STROMNESS, *Orkney*

Stromness Museum [1]

Maritime history and natural history

52 Alfred Street, Stromness
tel. 0856-850025

Mon–Sat 11–12.30 pm, 1.30–5 pm.
Closed Sun

Admission charge

The Orkney Natural History Society was founded in 1837 and has excellent collections of birds, eggs, butterflies and moths, fossils, including Hugh Miller's Asterolepis of Stromness, shells and so on. Orkney's fascinating maritime history is represented by displays illustrating local fishing, whaling, Hudson's Bay connection, with a special feature on the First World War, Scapa Flow and the scuttled German fleet.

A shop sells booklets concerning the temporary exhibitions.

Ben Nicholson, *Still-life* 1932–40 (Pier Arts Centre, Stromness)

Pier Arts Centre [2]

British 20thC painting and sculpture

Victoria Street, Stromness
tel. 0856-850209

Tues–Sat 10.30–12.30 pm, 1.30–5 pm.
Closed Sun, Mon

Admission free

The Centre was founded in 1978 as a result of a gift of the collection of Margaret Gardiner of British and European 20thC art, to be held in trust for the people of Orkney. She was a friend of many of the artists whose work she collected. Space was converted by Kate Heron and Axel Burroughs of Levitt Bernstein Associates in a 19thC merchant's house, a coal store and fishermen's sheds.

The works include Ben Nicholson's *Painted Relief* of 1939 and a *Still Life* of 1932–40, Barbara Hepworth's *Oval Sculpture* and *Two Heads*, Naum Gabo's *Linear Construction No. 1* and Alfred Wallis's *St Ives Harbour* and *White Sailing Ship*.

The Centre has an Association of Friends. Publications for sale on the premises include a catalogue of the collection as well as those for temporary exhibitions, and a history of the building and postcards of the collection.

Wales

ABERYSTWYTH, *Dyfed*

National Library of Wales [1]

Welsh artists, principally topographical
drawings and prints

Aberystwyth
tel. 0970–3816

Mon–Sat 10–5 pm. Closed Sun

Admission free

David Jones, MS 'Cara Wallia Derelicta', 1959
(National Library of Wales, Aberystwyth)

This is a copyright library which received its Charter of Incorporation in 1907. The building was designed by Sidney Kyffin Greenslade (1874–1955), but there have been many subsequent additions.

Particular acknowledgement must be made of the Library's first President, Sir John William, Bt, who presented several thousand topographical drawings, prints, portraits and maps, a magnificent beginning.

The collection consists of topographical drawings, watercolours, oil paintings and prints; the earliest date from the 17thc, but most belong to the late 18thc and the first half of the 19thc. Many famous names are represented, for example, Richard Wilson, Paul Sandby and Thomas Rowlandson. There are numerous watercolour drawings by Samuel H. Grimm, John 'Warwick' Smith, John Ingleby and Moses Griffith, all of whom made important contributions to topographical art in the late 18thc; Moses Griffith was illustrator to the naturalist and antiquary, Thomas Pennant. Other watercolour artists include David Cox Snr, David Cox Jnr, John Varley and Nicholas Pocock. There are collections by two prolific artist-clergymen: the Reverend E. Pryce Owen, Vicar of Wellington (Shropshire) from 1823 to 1840, and his contemporary, the Reverend John Parker, Rector of Llamyrewig and Vicar of Llanyblodwel, who died in 1860.

The Library collects works by contemporary Welsh artists and artists from outside Wales who take their inspiration from the Welsh scene. Some of the better-known are Brenda Chamberlain, David Jones, Ray Howard Jones, John Petts, Kenneth Rowntree, Kyffin Williams and Charles F. Tunnicliffe, but in the 1970s a host of new artists began to emerge, and their work, too, is being sought. The Library's interest can extend to distant lands. Kyffin Williams was awarded a Winston Churchill Fellowship to visit the areas of Welsh settlement in Patagonia in 1968. He recorded his impressions of the Welsh settlers' descendants and presented sixty drawings to the Library. Some countries are fortuitously represented through a link with a Welsh artist or benefactor. The E. P. Owen Collection contains drawings of north-east France, Belgium, Holland, Switzerland, Italy, and Austria, while that of John Parker includes views of Antwerp, the Rhine, the Alps and the Black Forest. Special attention has been given to graphic material and maps dealing with Brittany, a land settled some fifteen centuries ago by people from western Britain speaking a Brythonic language.

Library publications are available from a small booth; there is a cafeteria for staff and readers.

Arts Centre and Catherine Lewis Gallery [2]

Welsh ceramics; studio pottery; prints

University College of Wales, Penglais,
Aberystwyth
tel. 0970-4277

Mon–Sat 10-5 pm. Closed Sun

Admission free

Part of the University College of Wales, the present building dates from 1970, but the collections were started earlier, mainly in the 1920s and 1930s.

The collection contains British Studio pottery from 1900 onwards, including a particularly fine collection of Michael Cardew Winchcombe pottery and Bernard Leach St Ives pottery; 18thc and 19thc Welsh slipware and some British and Oriental ceramics from the 17thc to the 19thc. The Print Collection includes 19thc wood engravings and etchings, and contemporary prints.

There is a bookshop where catalogues of recent special exhibitions may be obtained, for example, *William Pye—a retrospective* (1980), *Superhumanism in Wales* (1983), and *Michael Cullimore—paintings and drawings* (1984).

There is a café and a theatre and concert hall. Car-parking is available.

CARDIFF, *South Glamorgan*

Cardiff Castle [1]

The spectacular transformation of Cardiff Castle by the 3rd Marquess of Bute and his architect, William Burges (1827–81), has established its collections of the arts and crafts of the 19thC high Gothic Revival in Europe within the fabric of the architecture itself. It is also perhaps unique in that surviving 3rdC Roman works remain incorporated within the modern architecture. Successive periods of architectural development are apparent, from Norman and later mediæval periods to the 19thC, when passages and even rooms were quarried from the thickness of the Romano-Norman retaining walls of the mediæval lodgings. Burges built upwards from the earlier additions to the great hall of the Middle Ages to create what must be one of the most exciting skylines in the country.

Arts and crafts of the 19thC high Gothic Revival, including drawings, cartoons, furniture, stained glass, sculpture, etc. by William Burges and others

Castle Street, Cardiff
tel. 0222-31033, ext. 716

Daily 10–6 pm (May–Sept); 10–5 pm (Mar–April, Oct); 10–4 pm (Nov–Feb). Closed on the Christmas and New Year Bank Holidays

Admission charge for conducted tours. Research facilities may be made available in respect of collections upon receipt of written application to the Chief Executive

William Burges and H. W. Lonsdale, cartoon for stained glass, *Edward le Despenser*, for the Banqueting Hall (Cardiff Castle)

Designs for the Clock Tower by William Burges, *c.* 1868 (Cardiff Castle)

Illustrating the Gothic Revival movement, there are, for instance, nearly two hundred panels of richly-coloured stained glass, produced to Burges's design principles by the leading glassmakers of the period: Lavers, Barraud, Westlake, Saunders and Worrall. In this century further glass was added by Paul Woodroffe. The encaustic pavements are by the principal tile makers: Maw, Godwin and Simpson. Simpson was also responsible for the narrative friezes to three of the main rooms; the tiles were painted by Frederick Smallfield, Fred Weekes and H. W. Lonsdale with scenes from mythology, fairy-tales and the Bible.

These artists, with another, Charles Campbell, were amongst a number responsible for the beautifully executed mural decorations and painted and gilded ceilings to the fourteen decorated rooms at Cardiff Castle. The rooms are further embellished with massive sculptured and painted chimneypieces that are an acknowledged part of Burges's design *ouvrage*. Every surface is carved with heraldic emblems and with reptiles, mice, frogs and insects, creating what might be described as a secret world of small creatures within the opulence of a 'Gothic' palace.

The principal sculptor was Thomas Nicholls, who was also responsible for the 'Animal Wall'. Other sculptors included Ceccardo Fucigna and James Redfern. With Nicholls they were responsible for the ornamental bronzework in the Castle interiors: gilded and damascened doors, chandeliers, grilles, altar sets, statuary and the 'Beaver' fountain in the Roof Garden at the top of the Bute Tower.

A number of pieces of furniture survive that were designed by Burges for the Castle and ornamented with rare marbles, mosaics, silver, bronze and marquetry of ivory and rare woods. Made by Gillow and by Walden, the marquetry was executed in the Bute Workshops, Cardiff. The Workshops were also responsible for the marquetry panels to the doors and for the panelling in certain of the rooms.

The Castle continues to develop with each century. The new drawing-room, built in 1931, has mural decorations by Harry Holland, completed in 1983. A section of the Roman remains to the south of the curtain wall was complemented in 1983 by a painted low-relief mural frieze sculpted by Frank Abraham and erected facing the Roman works.

The Cardiff Castle Collection of Drawings and Cartoons contains 2,652 works by Burges and others, recording 116 years of the architectural and decorative development of the Castle. Beginning in 1985, exhibitions of drawings and cartoons from the collection will be held annually at the Castle for a limited season. In addition to this collection, which forms the bulk of the designs for the 19thC transformation of the Castle, there is a small collection of easel paintings (late 17thC–20thC) pertaining to the history of the Castle.

Pierre Auguste Renoir, *The Parisian Girl*, 1874
(National Museum of Wales, Cardiff)

National Museum of Wales (Department of Art) [2]

European paintings 14thC–present day;
Welsh archæology, decorative arts

Cathays Park, Cardiff
tel. 0222-397951

Mon–Sat 10–5 pm, Sun 2.30–5 pm

Admission free (currently under discussion)

The National Museum of Wales was founded by Act of Parliament in 1907, and granted a Royal Charter. Designed as an integral part of the new Cardiff Civic Centre at Cathays Park by Messrs Brewer and Smith, it is of Portland stone, and has an exceptionally fine main hall rising to the full height of the building. The galleries radiate from the hall through openings with massive square columns.

Based on the Cardiff municipal museums collections, the James Pyke Thompson Collection was added when Turner House, Penarth, became a branch museum in 1921. The principal bequests are: the De Winton Collection of European ceramics (1918); the W. Goscombe John Collection (1938–46); the Gwendoline and Margaret Davies Collection (1951 and 1963); and the E. Morton Nance Collection of Welsh ceramics (1953).

During the first phase of the formation of the National Museum of Wales collections, from foundation until the arrival of the first portion of the Davies Bequest in 1951, the acquisitions policy was directed towards building up the most comprehensive Welsh collections possible, as befitted a national museum dedicated to 'telling the world about Wales, and the Welsh about their fatherland.' The acceptance of the Davies Bequest, one of the finest collections of French 19thC art in the United Kingdom which was strictly speaking outside the terms of the Charter, led to more broadly-based collections. Approximately half the public areas of the Cathays Park building are at present used for the display of works of art, but, owing to the chronic lack of funds, the North Wing, with two floors of art galleries, has never been built. Thus only a small, and decreasing, proportion of the collections can be displayed. During 1984–85 the De Winton Collection of European ceramics has been

Paul Cézanne, *Mountains at L'Estaque*, 1878–80 (National Museum of Wales, Cardiff)

redisplayed with an increased number of pieces on show, and a similar redisplay of the British and Welsh ceramics is in hand, whilst much of the silver lent from the Jackson Collection is displayed in the paintings galleries. From early 1985, the programme of art exhibitions at Cathays Park, due to the building work, has been curtailed, but a continuous programme is mounted in Turner House, Penarth, some five miles from Cathays Park.

The Welsh National Collection is best known for the superb series of French 19thc paintings and sculptures bequeathed by Gwendoline and Margaret Davies which includes Renoir's beautiful lady in a brilliant blue dress, *La Parisienne*, as well as the powerful *Mountains Seen From L'Estaque* by Paul Cézanne. The extensive collections of works by Welsh masters include Richard Wilson's *Caernarvon Castle*; works by Thomas Jones, such as the almost abstract *Buildings in Naples*; and examples of William Goscombe John, Augustus John, Gwen John and Ceri Richards. There are very fine groups of Continental and Welsh ceramics—the delicately painted wares of Nantgarw and Swansea are supported by the Jacobson Collection of silver. Also part of the silver collection is the Williams Wynn toilet service of rococo form made by Thomas Heming, goldsmith to George III. On loan from Her Majesty the Queen is the regalia used at the investiture of the Prince of Wales in 1911 as well as the coronet made for the investiture of the present Prince of Wales in 1969. During the last fifteen years considerable efforts have been made to consolidate the 20thc collections, with major works by Kokoschka, Lipchitz, Hepworth, Bacon, and others, and to establish an important group of works by Old Masters, including the Allendale Claude and four great tapestry cartoons attributed to Rubens.

There is an Association of Friends.

The Museum has a bookshop located in the Main Hall, selling a selection of appropriate publications as well as a wide range of books published by the Museum. Over a hundred titles are now in print, of which those listed here are of interest in the context of this guide.

PUBLICATIONS
John Steegman and P. J. Barlow, *Catalogue of Oil Paintings*, 1955
John Steegman, *A Survey of Portraits in Welsh Houses*, 1957
John Ingamells, *Catalogue of the Margaret S. Davies Bequest: Paintings, Drawings and Sculptures*, 1963
John Ingamells, *The Davies Collection of French Art*, 1967

HAVERFORDWEST, *Dyfed*

Castle Museum and Art Gallery [1]

Register of Pembrokeshire artists

The Castle, Haverfordwest
tel. 0437-3708

Tues–Sat 10–5.30 pm (summer),
11–4 pm (winter). Closed Sun, Mon

Admission charge

Housed at the Castle, the Museum specialises in paintings, drawings and prints by artists particularly connected with Pembrokeshire, and a register is maintained with relevant details and slides of their work. Painters represented in the collection are Frederick Könekamp, John Piper, Ceri Richards, Gwen John, Ray Howard-Jones and John Knapp-Fisher.

The Museum has an Association of Friends. A shop sells catalogues for exhibitions which are held regularly, and car-parking is available.

Graham Sutherland Gallery [2]

Works by Graham Sutherland (1903–80): oil paintings, drawings, prints, posters, book illustrations, designs

Picton Castle, The Rhos, Haverfordwest
tel. 043-786 296

Mon–Sat 10.30–5 pm (April–Sept).
Closed Mon (except Bank Holidays)

Admission charge

The Gallery was founded by Graham and Kathleen Sutherland in 1976 and is now administered as an independent charity. It is housed within the confines of Picton Castle; the original gallery was adapted from an old laundry in the courtyard by a local architect, and further space has been created for new galleries as the collection has more than trebled since its conception.

It is the largest collection of works by Sutherland available to the public and covers a wide range of his output. The earliest works are the etchings from 1924, and those done in Wales from 1934 to 1947, as well as later oils painted there. Special exhibitions are mounted at various times: in one year loans of famous portraits by him included those of *Somerset Maugham*, *Lord Goodman* and *Lord Clark*, which complemented the holding of portrait sketches in the Gallery. Graphic works in the collection include etchings, aquatints, lithographs, posters and book illustrations. There are also some of Sutherland's designs for textiles and for his 'Bestiary series' of 1967, the 'Bees' of 1977 and 'Apollinaire' of 1979.

The Gallery has an Association of Friends. A sales counter mainly stocks books, catalogues for special exhibitions, postcards and posters. A catalogue is being prepared, and the Gallery has already published Sutherland's *Correspondences* (1982). There is a tea-room in the courtyard and car-parking at the Castle entrance.

MERTHYR TYDFIL, *Mid-Glamorgan*

Cyfarthfa Castle Museum

Welsh artists, Welsh ceramics and Crawshay family items

Cyfarthfa Park, Merthyr Tydfil
tel. 0685-3112

Mon–Thurs, Sat 10–1 pm, 2–6 pm;
Fri 10–1 pm, 2–5 pm (April–Sept),
10–1 pm, 2–4 pm (Oct–Mar); Sun 2–5 pm

Admission charge

The Museum is housed in the main reception rooms of the Castle, a Gothic-style building designed by Robert Lugar (1773–1855) in 1824, the former home of the Crawshay family, ironmasters at Cyfarthfa. It was opened in 1910, and many of the objects on display are donations from notable local families.

The collections comprise pictures; ceramics (particularly examples from Welsh factories, i.e. Nantgarw and Swansea); silver; industrial and local history; and natural history. Among the paintings are a portrait, *Mrs Thompson of Kendal*, by George Romney; William Muller's *The Splügen Pass with Travellers Attacked by Bandits*; the celebrated *Marriage of Convenience* by John Collier and *Procession to the Christening* by Penry Williams, a local artist whose talent was recognised by William Crawshay who paid for his art training.

In the first Round Room is a display of contemporary paintings including work by Welsh artists such as Kyffin Williams, David Bell, William Roberts, Allan Gwynne-Jones, Sir Cedric Morris and others.

Postcards and a short general guide to the Museum are on sale. The grounds are a public park and there is adequate car-parking.

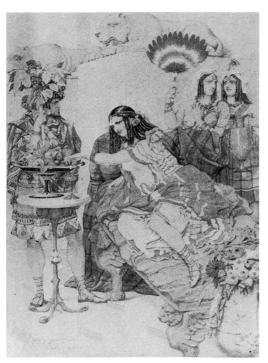

Richard Dadd, watercolour to illustrate 'Splendour and Wealth', *Cleopatra dissolving a Pearl*, 1853 (Newport Museum and Art Gallery)

John Sell Cotman, *The Quay at Fécamp, c.* 1820 (Newport Museum and Art Gallery)

NEWPORT, *Gwent*

Newport Museum and Art Gallery

18thc–19thc English watercolours; Staffordshire figures (Irene de Paula Collection); Royal Commemorative pottery; contemporary prints

John Frost Square, Newport
tel. 0633-840064

Mon–Thurs 10–5.30 pm; Fri 10–4.30 pm; Sat 9.30–4 pm. Closed Sun

Admission free

The Museum and Art Gallery was founded in 1888, but is now housed in a modern, open-plan building. The Museum has displays devoted to archæology, including the nationally important collection of material excavated from Venta Silurum (Roman Caerwent) of ornaments, tools, household utensils, painting, sculpture and mosaics, as well as local history and natural history.

The Gallery has a permanent collection, including a collection of 18thc and 19thc English watercolours with examples by Richard Dadd (*Splendour and Wealth*) and Thomas Rowlandson (a pair, *Four o'clock in the Town* and *Four o'clock in the Country*); British 20thc paintings by Stanley Spencer, Merlyn Evans, John Minton among others; and a growing collection of Welsh paintings.

The ceramic collections are remarkable for the Staffordshire figures given to the Museum in the 1950s, and for the group of Royal Commemorative pieces and the studio ceramics mainly by Welsh craftsmen.

There is a shop for postcards and publications where a guidebook will shortly be available.

SWANSEA, *West Glamorgan*

Glynn Vivian Art Gallery and Museum [1]

British paintings, drawings and sculpture; ceramics, including Welsh pottery and porcelain; glass; paperweights; miniatures

Alexandra Road, Swansea
tel. 0792-55006

Mon–Sat 10.30–5.30 pm. Closed Sun

Admission free

In 1911 the Gallery was founded as a result of £10,000 being offered in 1905, by Richard Glynn Vivian, a copper manufacturer in the Swansea Valley, for the building of an Art Gallery. The foundation stone was laid by the donor in 1909 and the Gallery was completed in 1911 for a cost of just over £9,000. Richard Glynn Vivian also endowed the new Gallery with his own collection of paintings, drawings and china.

Designed by Glendinning Moxham in the style described as 'Edwardian Baroque', there is a large entrance hall with a balcony all around on the first floor, and a glass roof above.

On 13 October 1984 Her Royal Highness The Duchess of Gloucester officially opened the New Sculpture Court which lies to the east of the main building.

The Gallery includes a wide range of temporary exhibitions in its programme—for example, the recent 'Turner in Wales' show—but the permanent collections include a number of special groups bequeathed and presented, such as the Herbert Eccles Collection and Sidney Heath bequest of Swansea porcelain; the Alban Evans and Eustace Calland Collections of 18thc glass; and the Colin Christison collection of toby jugs. There is a growing representation of local views and works related to the history of the town and port.

There is a Museum shop selling postcards, catalogues and prints. The foyer exhibition area sells original art/craft works, including prints, ceramics, bronze sculptures, jewellery, etc. (the display changes). There is a comprehensive selection of magazines on art on public display, and access to the library of reference works is by appointment.

Swansea City Council also administers:

Swansea Maritime and Industrial Museum [2]

Maritime and transport history

Museums Square, Maritime Quarter, Swansea
tel. 0792-50351

Mon–Sat 10.30–5.30 pm. Closed Sun

Admission charge

The Museum, which is housed in a converted dockside cargo warehouse dating from 1900, was founded in 1974 and opened to the public in 1977. It is concerned with the maritime and industrial history of this major port and iron-founding area, and the exhibits include a lightship, steamtug and Bristol Channel Pilot Cutter (sail)—all floating—as well as a working woollen mill (producing traditional woven material); Mumbles Railway items (the first passenger railway in the world); and agricultural and maritime displays.

The Friends of the Maritime and Industrial Museum have an association with the Railway Club of Wales. The Museum shop is open from April to October.

Henry Bright, watercolour of *Caerphilly Castle*, mid-19thc (Glynn Vivian Art Gallery and Museum, Swansea)

Henry Thomson, *Daedalus finding the Body of Icarus*, 1810 (Glynn Vivian Art Gallery and Museum)

TENBY, *Dyfed*

Tenby Museum

Welsh artists and Tenby local history

Castle Hill, Tenby
tel. 0834-2809

Daily 10–6 pm (Easter–Oct);
Mon–Sat
2–4 pm; closed Sun (Nov–Easter)

Admission charge

This is a private museum administered by trustees on behalf of the town of Tenby. It was founded in 1878, and the main part is in a mediæval castle. The collections comprise local history, geology, archæology and natural history; the picture gallery is mainly devoted to works of artists with local connections, including Augustus and Gwen John. The collection includes Gwen John's portrait of her sister Winifred, Augustus John's portrait of Richard Hughes and a sketch of Gwen.

The Tenby Borough archives covering the period from Norman times to 1947 are housed here.

There is an association of Friends. The Museum shop sells books, postcards, prints and medallions. A new edition of the Museum Guide appeared in 1985.

Northern Ireland

Ulster Folk and Transport Museum [1]

Irish folk life, textiles and crafts

Cultra Manor, Holywood,
Witham Street, Belfast
tel. 02317-5411

Cultra: Mon–Sat 11–5 pm; Sun 2–5 pm
Witham Street: Mon–Sat 10–5 pm;
closed Sun

Admission charge

This national institution was created by Act of Parliament in 1958 to collect, preserve and exhibit material related to the life and traditions of the people of Ulster. In 1967 the Belfast Transport Museum was amalgamated with the Folk Museum to create the Ulster Folk and Transport Museum.

The open-air Folk Museum and the new Transport Galleries are sited on the 176-acre estate of Cultra Manor some eight miles from Belfast. The old Transport Museum premises at Witham Street, Belfast, are still in use. The transport collection is displayed in the two galleries.

In the Folk Museum some twenty-five buildings have so far been re-erected and care has been taken to create appropriate environments for each. Their furnishings date from the turn of the century. Specially designed galleries interpret aspects of Ulster life based on the Museum collections of artefacts relating to agriculture, textiles, crafts and domestic life. These galleries won the Museum the 'Museum of the Year' award in 1983.

The transport collection, the widest ranging in the UK, records all forms of transport used in Ireland by road, rail, water and air. It encompasses a range of technologies from donkey creels to vertical take-off aircraft. As well as vehicles imported over the past hundred years, examples of locally-built motor cars are displayed. They are put in context historically and internationally with the collections of horse-drawn vehicles, bicycles, boats, trains and aircraft.

The Ulster Folk and Transport Museum has a library and both photographic and audio archives to record all forms of evidence of the areas of its interest. There is a restaurant open during the summer months.

The Ulster Museum [2]

Irish art (including work of Ulster-born painters) and archæology; Irish silver and glass; portraits and topographical works by British artists with Irish associations; British and American paintings (1900–present day); Spanish Armada treasures; Irish Williamite glass; Irish lace; costume; Belleek pottery

Botanic Gardens, Belfast
tel. 0232-668251

Mon–Fri 10–5 pm; Sat 1–5 pm;
Sun 2–5 pm

Admission free

The Museum was founded in 1831 by the Belfast Natural History and Philosophical Society, and the Art Gallery by the Belfast Corporation in 1890. The Grainger Collection and Art Gallery joined with the Belfast Natural History and Philosophical Society to form a new Municipal Museum and Art Gallery in 1909. A new building was designed by James Cumming Wynnes in 1929, and extended in 1972 by Francis Pym. The Sir Robert Lloyd Patterson Collection of British painting 1900–47 was purchased with the money from a bequest of a local connoisseur and named after him.

The geographical position of the town makes it desirable that this Museum should, in spite of limited resources, present a picture of European culture throughout the centuries, so, while the greatest strengths of the collection lie in the field of contemporary British and American painting and in the representation of all fields of Irish fine and decorative art, none the less opportunities to build up the holdings of European Old Master paintings have been seized whenever possible. Such acquisitions include *St Christopher Carrying the Christ Child* (c. 1625) by Jacob Jordaens (acquired in 1966) and Turner's *Dawn of Christianity*. The Lloyd Patterson Collection of modern British painting includes a representative selection of London Group artists. Walter Sickert's *Suspense* and Stanley Spencer's *Betrayal* are two undoubted masterpieces and there are interesting examples of works by Wilson Steer, Augustus John, Paul Nash and Matthew Smith. Subsequent purchases of pictures by Christopher Wood, Charles Ginner, C. R. Nevinson, Ivon Hitchens and Frank Brangwyn have augmented the already interesting representation of an important phase of 20thc painting. Contemporary British art is exemplified by Francis Bacon's *Head II* (1949) as well as works by William Scott, Bridget Riley, Robyn Denny, Patrick Caulfield and Allen Jones. Intrepid buying in the field of modern American painting has added a further dimension to the collection. It is unusual to find major works by, for example, Sam Francis or Morris

Thomas Lawrence, *Harriet Anne, Countess of Belfast*,
before 1825 (Ulster Museum, Belfast)

The Adam Loftus Great Seal of Ireland Cup, an
Elizabethan silver-gilt standing cup and cover, 1593
(Ulster Museum, Belfast)

Louis of the quality of these outside the Tate Gallery in London. Note particularly Louis's *Golden Age* (1961) from his 'Veil' series, one of the best examples of American Abstract Expressionism in a public collection. Apart from an important series of sculptures by T. E. MacWilliam, who is a native of County Down, the outstanding piece of contemporary sculpture is Anthony Caro's *Rainy Day* of 1971. In the field of Irish painting the Museum has a group of his works given by Sir John Lavery, who was born in Ulster (including *The Orangeman's Annual 12 July Procession in Woodhouse Street, Portadown*; *Under the Cherrytrees*; *My Studio Window* and *Self-Portrait*), as well as examples by the still too-little-

Jacob Jordaens, *St Christopher Carrying the Christ Child, c.* 1625 (Ulster Museum, Belfast)

known Post-Impressionist, Roderic O'Conor (*Field of Corn, Pont Aven*), a friend of Gauguin and the Pont Aven artists, who was born in Roscommon. Another Irish artist who was recently the subject of an exhibition, Walter Osborne, is represented by fine works (for example, the popular *Cherry Ripe*).

The collections of silver and glass contain rare pieces with Irish associations, notably the engraved Williamite glass. When the Belfast Museum was raised to National status in 1962 as the Ulster Museum the authorities set out to build up a collection of Irish plate of the finest quality. With this intention they acquired in 1956 a two-handled porringer and cover by John Phillips of Dublin, dated 1685. In 1958 a toilet-box by John Humphreys, with a Dublin hallmark for 1696–99, was bought. Separated by less than twenty years, these two important examples present a contrast in taste between the highly ornamental raised and sculptured decoration of the porringer and the plain form, boldly edged with gadrooning of the rectangular toilet-box. In 1968 the Museum acquired the massive Cavan Mace of 1723–24. The Mace, which is 5 ft (1.52 m) long, was made by John Hamilton of Dublin and cost £70. Fine silver from the 16thC onwards includes the important Adam Loftus Great Seal of Ireland Cup and Cover dating from 1592–93, which was purchased in 1960, a Dublin silver tankard of 1679 and 18thC rococo-style dish rings.

In 1972, with the aid of a large grant from the Government of Northern Ireland and a contribution from the NACF, the Museum bought the Girona Treasure, a dazzling array of gold and silver jewellery and coins, as well as bronze cannons and such ordinary objects as gold toothpicks, religious medals, and leather bootsoles. The treasure, from the 1588 wreck of the Spanish Armada galleas *Girona*, was recovered off the North Antrim coast between 1967 and 1969 by the Belgian underwater archæologist Robert Stenuit. This is the most important Armada collection of any size in a museum. To this was added, in 1971, the very different finds of the *Trinidad Valencera*, including articles of clothing and domestic items.

Recently the Museum has received, in the form of the Hull Grundy Gift, a collection of 17thC–19thC jewellery with a representative group of Victorian replicas of Irish archæological pieces, c.f. the 'Tara' brooch; the 'County Cavan' or 'Queen's' brooch, which were greeted with such interest in the Great Exhibitions (1851, 1857, 1862, etc.) of the period. The 'Tara' brooch copies are essential reference documents as they show it in a better state of preservation than it now is.

The Museum has a shop with a selection of catalogues relating to the collections. There is a restaurant and an enquiry service.

ENNISKILLEN, *Fermanagh*

Fermanagh County Museum

Archæology, natural history and local history

Castle Barracks, Enniskillen
tel. 0365-25050

Mon–Fri 10–12.30 pm, 2–5 pm; Sat 2–5 pm (April–Sept); Mon–Fri 10–12.30 pm, 2–5 pm (Oct–Mar); Sun 2–5 pm (July & Aug). Closed Sat (Oct–Mar), Sun (Sept–June)

Admission free

The Museum is situated in a mediæval castle, built in the 15thC, rebuilt in the 17thC and renovated in the 18thC. Founded in 1976, its primary function is to illustrate the history of the County from the earliest times by means of a wide variety of items. Of particular interest from the prehistoric section is the fine Celtic stone idol from Beltany, Co. Donegal. The painting collection contains three works by the locally raised contemporary painter William Scott, and there is also a small amount of Belleek pottery from the factory founded locally by David McBirney in 1857.

The Museum has an Association of Friends. There is a small sales counter for local guidebooks, postcards, slides and books of special interest.
 Car-parking is adjacent.

Republic of Ireland

CORK

Crawford Municipal Gallery

19thC & 20thC Irish paintings and
sculpture; 20thC British painting and
sculpture; casts from the Vatican collection
of sculpture

Emmet Place, Cork
tel. 021-965033

Mon–Fri 10–5 pm; Sat 10–1 pm.
Closed Sun

Admission free

PUBLICATIONS
Exhibition catalogues:
Irish Art in the 19th century (Cork Rosc Exhibition),
1971
Irish Art 1900–1950 (Cork Rosc Exhibition), 1975

The Gallery was founded in 1825 by the Royal Cork Society for the Promotion of Fine Arts, which amalgamated with the Royal Cork Institution in that year. In 1884 William Horatio Crawford funded the rebuilding and extending of the Gallery and School of Art, and the work was carried out by Arthur Hill. The North Wing of the Gallery is the old Cork Customs House dating from 1724.

The Collection is built around a good holding of Irish 19thC painting and very good Irish and British 20thC painting and sculpture, particularly by native artists. Two Cork painters, Daniel Maclise and James Barry, are represented, as are the sculptors John Hogan and Seamus Murphy. Notable works include Wilhelm van de Velde's grisaille *Dutch War Vessels*; *Domino!* by Frank Bramley and *Off the Donegal Coast* by Jack Yeats.

There is a small Gallery shop, with postcards and catalogues on sale.

DUBLIN

Chester Beatty Library [1]

Islamic, Chinese, Japanese, Indian and
other Eastern MSS; paintings and
works of art

20 Shrewsbury Road, Dublin
tel. 0001-692 386

Tues–Fri 10–1 pm, 2.30–5.15 pm;
Sat 2.30–5.15 pm. Closed Sun

Admission free

Sir Alfred Chester Beatty (1875–1968) bequeathed to the Irish nation his enormous collection of international importance, centred on a remarkable group of Islamic material. Among notable items are the earliest known example of the technique of printing, a Buddhist charm of 768 AD; 2ndC New Testament texts, also the oldest known; a fine Koran collection; Chinese jade books with their beautifully executed characters and ornamental stands; and examples of carved rhinoceros-horn cups.

The library sells a selection of publications and catalogues.

The Hugh Lane Municipal Gallery of Modern Art [2]

European and Irish art (19thC–20thC)

Charlemont House, Parnell Square, Dublin
tel. 0001-741 903

Tues–Sat 9.30–6 pm; Sun 11–5 pm.
Closed Mon.
(Visitors are advised to check the present
whereabouts of individual items from
the Lane Bequest as to whether they are
on view in Dublin or at the
National Gallery, London)

Admission free

Formerly known simply as the Municipal Gallery of Modern Art, it was renamed in 1975 in honour of the principal benefactor, Hugh Lane (1875–1915), to commemorate the centenary of his birth. The Gallery has a complicated but fascinating history. The first municipal exhibition of modern works was held in Clonmell House, Harcourt Street, in January 1908 when, in the catalogue introduction, Hugh Lane announced his intention to donate his collection of seventy British and Irish paintings and drawings to the Corporation. This was to be followed by the gift of his collection of thirty-nine European pictures, an offer that was, however, entirely dependent on the building of a new gallery to house them. When the new building failed to materialise, Lane sent his European pictures on loan to the National Gallery in London. The decision not to build a gallery caused great consternation, and Lane was further insulted when the Trustees of the National Gallery agreed to exhibit only fifteen of the thirty-nine pictures, while at the same time insisting that the collection be presented in its entirety. Amongst the pictures the Trustees refused to exhibit were Renoir's *Les Parapluies*, Monet's *Vétheuil: Sunshine and Snow* and Daumier's *Don Quixote and Sancho Panza*. Disaster followed when in 1915, the year after Lane was appointed Director of the National Gallery of Ireland, he died in the sinking of the *Lusitania*. His death caused enormous confusion, as he had left a codicil to his will changing his plans for the disposal of his collection. The codicil, in which he revived his earlier intentions to leave the Continental pictures to Dublin, was, however, ignored as legally invalid, and in

1924 a committee was formed by the British Government to solve the endless wrangle.

The eventual outcome was the foundation of a gallery of modern art in Charlemont House in Parnell Square on a ninety-nine year lease from the Government to the Dublin Corporation. Charlemont House was built from 1762–70 for the Earl of Charlemont by Sir William Chambers (1723–96); an extension was added by Horace O'Rourke in 1933 when the new gallery opened. In 1959 a complex arrangement was reached with the National Gallery in London as to the division and display of the thirty-nine disputed pictures over a twenty-year period. A new agreement was made in 1979 for Dublin to exhibit thirty-one paintings for fourteen years, and it was further agreed that Renoir's *Les Parapluies* would be included in the group, but only for a seven-year loan.

A purchasing policy has enabled the Gallery to continue to build up a collection of modern pictures. The Gallery is particularly strong in 19thc European paintings and drawings, with emphasis on the French Impressionists and the Barbizon School. Included are works by Manet (*Eva Gonzales*) and Monet (*Waterloo Bridge, London*), as well as by Renoir, Pissarro, Degas, Daumier, Corot and Courbet. One of the most interesting works from the Lane Bequest is the large and unfinished work by Puvis de Chavannes, *Beheading of St John the Baptist* (at the National Gallery, London, until 1993), of which there is a smaller and dissimilar version in the Barber Institute, Birmingham. Irish painters are represented by works of J. B. Yeats, John Lavery, Roderic O'Conor and William Orpen; and British painters by G. F. Watts, Constable, Albert Moore, Whistler and Henry Moore.

The 20thc is also well represented, with works by such Irish artists as Sean Keating, Paul Henry, Louis le Brocquy, Cecil King, Michael Farrell, Robert Ballagh, etc. Recently purchased was Niki de St Phalle's *Big Bird*. There are also interesting examples of stained glass by the Irish artist Harry Clarke.

There is an Association of Friends of the National Collections of Ireland which plays an important and continuing role in the support of the Gallery. A reception desk sells publications, posters and slides. The Gallery has a licensed restaurant. There is no car-parking available at the Museum.

PUBLICATIONS
The City's Art, The Original Municipal Collection, 1908 (repr. 1984)

The National Gallery of Ireland [3]

European paintings 15thc–present day, with a notable group of Irish work; sculpture 18thc–20thc; graphic art and miniatures 16thc–20thc

Merrion Square, West Dublin
tel. 0001-608533

Mon–Wed, Fri, Sat 10–6 pm; Thurs 10–9 pm; Sun 2–5 pm

Admission free except for exhibitions

Founded by the Irish Institution and established by Act of Parliament in 1854, the momentum was provided by the interest expressed in the Fine Arts section of the Great Industrial Exhibition held in Dublin in 1853. The Exhibition had been financed largely by the railway magnate William Dargan, and £5,000 collected from the citizens of Dublin to honour his memory was donated to the National Gallery. Additional finance for the building, administration and purchasing funds was granted by the Government. The National Gallery was opened in 1864.

The building was executed according to the design of the architect Captain Francis Fowke (1823–65) who worked here in his capacity as Inspector with the Science and Art Department, London. Fowke, who was a native of Ballysillan, Co. Tyrone, was a Captain with the Royal Engineers who had been in charge of the machinery at the Paris Exhibition of 1854. From 1857 he was Inspector for Science and Art, and from 1860 Architect and Engineer in the Science and Art Department, London. In 1862 he became Superintendent of the construction of the South Kensington Museum. His name is closely associated with that of Henry Cole, of the Victoria and Albert Museum in London (q.v.).

An outstanding feature of the interior is the staircase designed by Fowke which rises in a perron from the ground-floor gallery to a mezzanine landing. From here a broad flight of steps leads to the main picture gallery above. Another notable feature of Fowke's design is the free-standing Corinthian columns surrounding the main hall on the ground floor. The extension to the Gallery was built in 1968 and includes a grand marble spiral staircase rising the height of the building. The external façade of the building has a central portico balanced on either side by two recessed annexes. The use of reinforced concrete in the structure of the building is one of the earliest known examples in Ireland.

The beautifully balanced collection boasts over 2,500 paintings, where every major European School of painting is extensively represented by masters such as Fra Angelico,

Salomon van Ruysdael, *The Halt, c.* 1650 (National Gallery of Ireland, Dublin)

El Greco, Mantegna, Titian, Rembrandt, Rubens and Hogarth to mention just a few. The Gallery also houses many paintings of high quality by minor artists who are not so well known. This is particularly true of the Italian School. There is a display of icons, and a room devoted to American painting. Not unexpectedly, an important display of Irish paintings is permanently on exhibition.

On the cold January day in 1864 when the National Gallery opened to the public for the first time, the collection of paintings numbered just 138. Somewhat over a century and eleven directors later there are well over two thousand, as well as the extensive graphic collection and the sculptures. Many of the finest of the Old Masters are here due to the perspicacious purchasing policy of one of the earliest of these directors, Henry Doyle (Director from 1869–92), who had at his disposal a purchase grant of just over £1,000. The delicately graphic panel by Fra Angelico of the *Martyrdom of SS. Cosmas and Damian* was secured for only £73 10s; the Frans Hals of a *Fisherboy* cost £400. Doyle was building on a nucleus of 17thC Italian pictures purchased *en bloc* before the opening of the Gallery, pictures not then fashionable, but which now give the Gallery a decided edge on many of the public collections in this country where this phase of Italian painting is remarkably ill-represented. The two Lanfrancos, *The Miracle of the Loaves and the Fishes* and *The Last Supper*, are enormous, almost overwhelming; they are notable even in this exceedingly choice selection. Doyle's successor, Walter Armstrong, added a Chardin, *Les Tours des Cartes*, a standing

335

George Frederic Watts, *Mrs Louis Huth*, *c.* 1858 (Hugh Lane Municipal Gallery of Modern Art, Dublin)

Jan Mijtens, *A Lady playing a Lute*, c. 1650
(National Gallery of Ireland, Dublin)

Baron Gérard, *Julie Bonaparte, Queen of Naples with her two children*, c. 1805 (National Gallery of Ireland, Dublin)

saint by Rubens, the *Grisaille* Mantegna, and a wonderfully powerful Goya portrait, as well as Troost's *Dilettante* group. One of the most outstanding works added during Armstrong's directorship was the Rembrandt, *Rest on the Flight into Egypt*, from the Stourhead Heirlooms Sale at Christie's.

The name of Sir Hugh Lane is most usually associated with Impressionist paintings, but his Old Master collection was of a quality that far exceeded even that of the Impressionists; these Old Masters were left to the Dublin National Gallery. Although it is not possible to enumerate these in detail, mention should be made of the outstanding, brilliantly coloured El Greco and the surpassingly charming Hogarth of *The Mackinnon Children*.

In the present day the Gallery has a third share in the estate of George Bernard Shaw, with which the purchase of some outstanding works has been achieved, notably French

paintings, by Boucher, Fragonard, Nattier, Gérard—a stately neo-classical portrait group of *Julie Bonaparte, Queen of Naples*, with her daughters—as well as a crowded and dramatic composition by J. L. David, *The Funeral of Patrochlus.*

Over five thousand drawings, watercolours and miniatures are now housed in the Print Room where specific items can be seen without appointment from 10.30–5.30 pm (Mon–Fri). There are Italian, Dutch, Flemish and French Old Masters, fine 18thC British watercolours and a wide range of Victorian artists. The Turner collection (publicly exhibited in January each year) is of world renown. The modern Irish stained glass artists Nathaniel and Evie Hone, and John Butler Yeats and Jack Yeats are well represented. Three thousand prints, including numerous 18thC mezzotints from the Chaloner Smith Collection, and a major series of British and Irish portraits to the present century, can also be consulted here.

The sculpture collection comprises over three hundred pieces principally by Irish and British sculptors, in particular Foley, Kirk, Moore and Hogan; there is also a fine bust by Duquesnoy.

An Association of Friends is still in its formative stages. The Gallery has a bookshop and a self-service restaurant.

PUBLICATIONS
Illustrated Summary Catalogue of Drawings, Watercolours and Miniatures, 1983
Illustrated Summary Catalogue of Paintings, 1981
Icons: The National Gallery of Ireland, 1968
Jeanne Sheehy, *Walter Osborne, 1983*
Julian Campbell, *The Irish Impressionists: Irish Artists in France and Belgium 1850–1940, 1984*
Raymond Keaveney, *Master European Drawings, 1983*

National Museum of Ireland [4]

The Museum was founded by Act of Parliament in 1877; the original collections came from the Royal Dublin Society (zoology) and the Royal Irish Academy (archæology). The building was designed by Thomas Newenham Deane (1851–1933) with the National Library of Ireland, as matching buildings on either side of Leinster House (1745), which faces Kildare Street and backs onto Merrion Square. The Museum was completed in 1890 and is little changed, being arranged round a rotunda and decorated with heavy marble columns and mosaic floors. The Museum's annexe in Merrion Row houses an exhibition 'Viking Dublin.'

The archæological collections are rich in gold personal ornaments from the Bronze Age (*c.* 2,000–400 BC). Chief among these are gorgets—massive crescent-shaped collars, elaborately ornamented with raised ribs. The display of early Christian metalwork is also noteworthy. This includes the Ardagh and Derrynaflan chalices, as well as the Tara Brooch. The Cross of Cong from the 12thC exhibits the final flowering of the native Irish traditions of metalworking. The decorative arts display includes a comprehensive collection of Irish silver from the 17thC to the 20thC. The displays of Belleek porcelain and antique Irish lace are also worthy of attention. The decorative arts collection includes much non-Irish material such as the Fonthill Vase (Yuan Dynasty), regarded as one of the most important pieces of early porcelain in the world. The zoological display is representative of every aspect of Irish fauna, including such extinct species as the Giant Irish Deer.

There is a Museum sales desk.

Archæology, history and zoology; decorative art, including Irish silver, Belleek porcelain and Irish lace; Oriental art (Augusta H. Bender Collection)

Kildare Street, Dublin, and 7–9 Merrion Row and Merrion Street, Dublin
tel. 0001-765 521

Tues–Sat 10–5 pm, Sun 2–5 pm. Closed Mon

Admission free

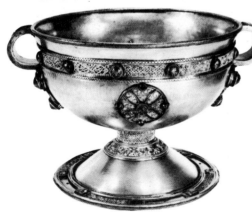

The 'Ardagh' Chalice, *c.* 700 AD
(National Museum of Ireland, Dublin)

Personal collection of paintings and decorative items from Derek Hill (b. 1916)

Churchill, Letterkenny
tel. 0934-71

Daily 10–6 pm (April–Sept). Closed Oct–March

Admission charge

LETTERKENNY, *Co. Donegal*

The Glebe Gallery (The Derek Hill Collection)

Derek Hill donated his art collection and his house, St Columb's, and its contents and the surrounding gardens to the Irish Nation. Outbuildings behind the house have been converted to form what is now the Glebe Gallery, which was opened in 1983. The house itself will be open to the public in 1986. The Regency house and the gallery are set in informal gardens on the shores of Lough Gartan, surrounded by stunning countryside in the mountains of Donegal.

Derek Hill, portrait and landscape painter, was born in England in 1916 but is now resident in Donegal. His collection of decorative arts, especially Islamic art, includes fabrics and Kashan, Rayy and Isnik ceramics, together with Morris wallpapers, De Morgan tiles and Wemyss ware. The collection of paintings is an eclectic and personal choice. It includes a corpus of works by Irish painters, such as Yeats, Hone, Henry, O'Conor and Orpen, and

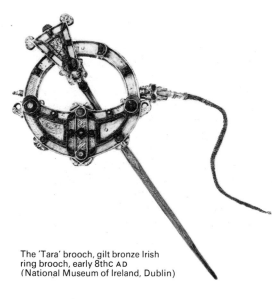

The 'Tara' brooch, gilt bronze Irish
ring brooch, early 8thc AD
(National Museum of Ireland, Dublin)

works by the 1950s generation of English and Italian artists which were collected by Derek Hill while he was Artistic Director of the British School in Rome. These include works by members of the 'Kitchen Sink' School, John Bratby and Edward Middleditch. Such internationally known artists as Picasso, Kokoschka, Braque, Sutherland, Tchelitchev and Pasmore are also represented.

The house and Gallery are run by the National Parks and Monuments Branch of the Office of Public Works, and are state-owned. The renovations are being funded by the EEC in order to encourage co-operation and development in the Border Region.

There is a car and bus-park and tea and restaurant facilities are available in the nearby Glenveagh National Park. There is a small printed catalogue available of a limited number of works in the collection, and it is planned to develop further publications.

LIMERICK

Municipal Art Gallery [1]

Pery Square, Limerick
tel. 01035361-310633

Mon–Fri 10–1 pm, 2.30–8 pm;
Sat 10–1 pm. Closed Sun

Admission free

The Gallery has a representative collection of 18thc and 19thc Irish masters as well as a small group of works by living Irish artists, but the Art Gallery building, which dates from 1948, is at present being extended into the area previously occupied by the Limerick City Library. It will be some time before the work is completed and prospective visitors are advised to telephone before attempting to see the collection.

The Hunt Museum [2]

Irish archæology; Greek and Roman antiquities; Irish and European works of art, Middle Ages–18thc

National Institute for Higher Education, Plassey House, Limerick
tel. 01035361-333644

Daily 10–5.30 pm (April–early Oct).
Closed early Oct–Mar

Admission charge

The collection, its form and its didactic aims, owes its origins to the collector John Hunt and his wife Gertrude. As an art historian he had a vision beyond the mere assembling of works of art, and he wished to place Irish cultural history in the wider European context. Irish early and late Bronze Age objects are here, as are antiquities from Greece and Rome. Notable items are the 9thc Cashel Bell; a fine 12thc limewood figure of the Virgin from Western Germany, which still retains much of its original paint; the 17thc Galway Chalice; and many other works of art from the Middle Ages, the Renaissance and the 17thc and 18thc. There is a special group of ivory and bronze crucifix figures and a good representation of Irish and European pottery.

Publications of various kinds are available from the Museum, as are refreshments. There is adequate car-parking.

SLIGO

Sligo Museum and Art Gallery

Stephen Street, Sligo
tel. 071-2212

Daily 10.30–12.30 pm, 2.30–4.30 pm

Admission free

Founded in 1955, the Sligo Museum has a representative selection of modern Irish Art, with a special Jack B. Yeats Collection.

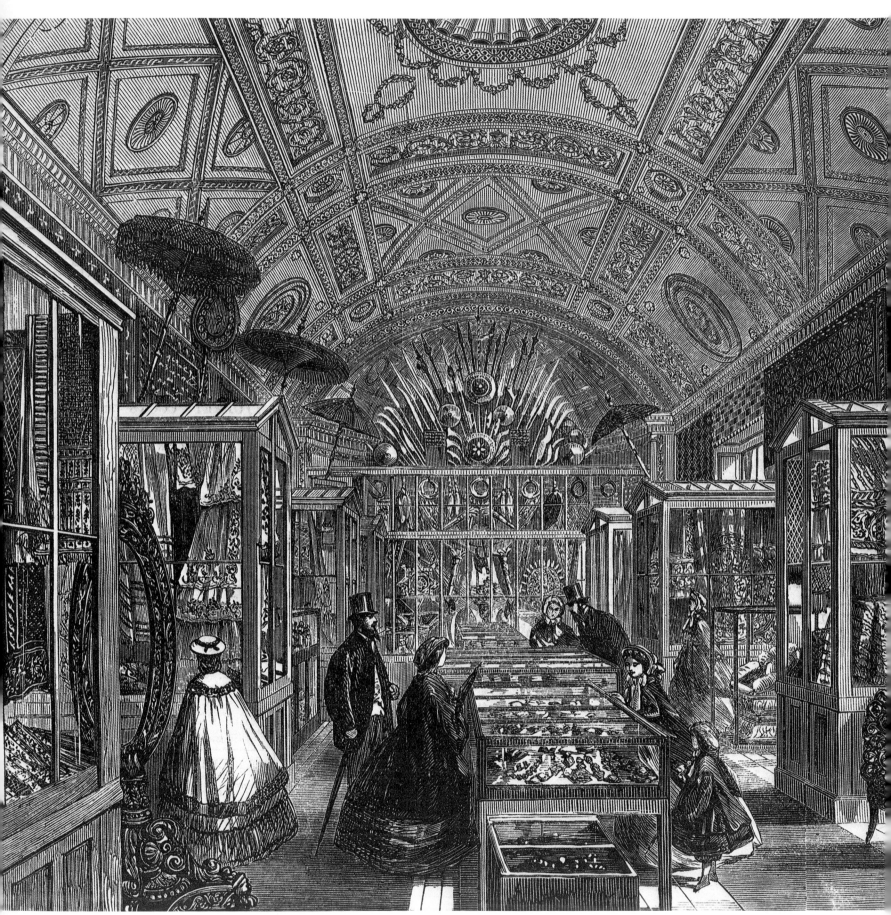

John Watkins, etched interior view of gallery at the Victoria and Albert Museum in the late 19thc
(Victoria and Albert Museum)

List of Museums

in alphabetical order

Abbot Hall Gallery: Kendal
Aberdeen Art Gallery and Museum (Scotland)
Aberdeen Maritime Museum (Scotland)
Aberystwyth University College of Wales,
 Arts Centre (Wales)
Alderney Museum
Allhallows Museum: Honiton
American Museum: Bath
Angel Corner (Gershom Parkington Collection):
 Bury St Edmunds
Apsley House, The Wellington Museum: London
Arbroath Art Gallery (Scotland)
Arbroath Museum (Scotland)
Archæology and Ethnology, University Museum of:
 Cambridge
Arms and Armour Museum: Stratford-upon-Avon
Ashmolean Museum: Oxford
Astley Cheetham Gallery: Stalybridge
Astley Hall Museum and Art Gallery: Chorley
Aston Hall: Birmingham
Athelstan Museum: Malmesbury
Atkinson Art Gallery: Southport

Bagshaw Museum: Batley
Banbury Museum
Bankfield Museum: Halifax
Bantock House: Wolverhampton
Barber Institute: Birmingham
Barlow Collection of Chinese Ceramics: Brighton
Bath Museum of Costume
Bath Preservation Trust
Baysgarth Museum: Barton-on-Humber
Beecroft Art Gallery: Southend-on-Sea
Belgrave Hall: Leicester
Berwick-on-Tweed Museum and Art Gallery
Bethlem Royal Hospital Museum: Beckenham
Bethnal Green Museum of Childhood: London
Beverley Art Gallery and Museum
Bexhill Manor Costume Museum
Bilston Art Gallery and Museum: Wolverhampton
Birmingham City Museums and Art Gallery
Blackburn Museum and Art Gallery
Bolling Hall: Bradford
Bolton Museum and Art Gallery
Botanic Gardens Museum: Southport
Bourne Hall Museum: Epsom
Bowes Museum: Barnard Castle
Bramall Hall: Stockport
Bridport Museum and Art Gallery
Bridlington Museum and Art Gallery
Brighton Museum and Art Gallery
Bristol City Museum and Art Gallery
British Library: London
British Museum: London
British Museum, Museum of Mankind: London
British Museum, Natural History Museum: London
Broadfield House Glass Museum: Dudley
Buckingham Palace: London, Queen's Gallery
Buckinghamshire County Museum: Aylesbury
Burges Drawings Collection: Cardiff Castle (Wales)
Burrell Collection: Glasgow (Scotland)
Burton Art Gallery: Bideford
Bury Art Gallery and Museum
Buxton Art Gallery and Museum

Cambridge University Museum of Archæology and
 Ethnology
Cannon Hall Art Gallery: Barnsley
Cardiff Castle, Burges Drawings Collection (Wales)
Carlisle Museum and Art Gallery
Cartwright Hall: Bradford
Casa Magni Shelley Museum: Bournemouth
Castle Cornet: Guernsey
Castle House: Dedham, Sir Alfred Munnings Art
 Museum
Cecil Higgins Art Gallery: Bedford

Chair Museum: High Wycombe
Cheltenham Art Gallery and Museum
Chertsey Museum
Chester Beatty Library: Dublin (Rep of Ireland)
Christ Church Mansion: Ipswich
Christ Church Picture Gallery: Oxford
Churchill Gardens Museum: Hereford
Cliffe Castle Museum: Keighley
Clifton Park Museum: Rotherham
Clive House Museum: Shrewsbury
Clock and Watchmaking, Museum of: Prescot
Colchester and Essex Museum
College of Arms: London, Heralds' Museum at the
 Tower of London
Cook Birthplace Museum, Captain: Middlesbrough
Cooper Art Gallery: Barnsley
Costume Museum: Bath
Costume, Shambellie House Museum of: Dumfries
 (Scotland)
Costume and Textiles, Museum of: Nottingham
Courtauld Institute Galleries: London
Crawford Municipal Gallery: Cork (Rep. of Ireland)
Crescent Art Gallery: Scarborough
Cromwell Museum: Huntingdon
Curtis Museum & Allen Gallery: Alton
Cyfarthfa Castle Museum: Merthyr Tydfil (Wales)

Darlington Art Gallery
Darlington Borough Museum
Dartmouth Museum and Art Gallery
Dean Castle: Kilmarnock (Scotland)
Derby Museums and Art Gallery
Devizes Museum
Devonshire Collection of Period Costume: Totnes
Dick Institute: Kilmarnock (Scotland)
Doncaster Art Gallery and Museum
Dorchester County Museum
Doulton Gallery, Sir Henry: Stoke-on-Trent
Dove Cottage: Grasmere
Dover Museum
Dublin Municipal Gallery of Modern Art (Rep. of Ireland)
Dudley Museum and Art Gallery
Dulwich Picture Gallery: London
Dundee Museums and Art Galleries (Scotland)
Durham University Oriental Museum
Dyson Perrins Museum: Worcester

East, Alfred, Art Gallery: Kettering
Egham Museum
Elizabethan House Museum: Great Yarmouth

Falconer Museum: Forres (Scotland)
Falmouth Art Gallery
Fashion Research Centre: Bath
Ferens Gallery: Hull (Kingston upon Hull)
Fermanagh County Museum (N. Ireland)
Fitzwilliam Museum: Cambridge
Fletcher Moss Museum and Art Gallery: Manchester
Folkestone Museum and Art Gallery
Fort Grey Maritime Museum: Guernsey
Forty Hall: Enfield
Foundling Hospital Art Treasures: London, Thomas
 Coram Foundation for Children
Fox Talbot Museum of Photography: Lacock
Freemason's Hall: London, United Grand Lodge
Fulham Public Library, Cecil French Bequest:
 London, Hammersmith and Fulham Archives
 Department

Gainsborough's House: Sudbury
Geffrye Museum: London
Geological Museum: London
Georgian House, The: Bristol
Gershom Parkington Collection, Angel Corner: Bury
 St Edmunds
Glasgow Museum and Art Gallery (Scotland)

Glebe Gallery (The Derek Hill Collection):
 Letterkenny (Rep. of Ireland)
Gloucester City Museum
Glynn Vivian Art Gallery and Museum: Swansea (Wales)
Gracefield Arts Centre: Dumfries (Scotland)
Graves Art Gallery: Sheffield
Gray Art Gallery: Hartlepool
Great Yarmouth Museum Exhibition Galleries
Greek Museum, University: Newcastle upon Tyne
Grosvenor Museum: Chester
Grundy Art Gallery: Blackpool
Guernsey Museum and Art Gallery
Guildford Museum
Guildhall Art Gallery: London
Guildhall Library Print Room: London
Guildhall Museum: Carlisle

Hammersmith and Fulham Archives Department,
 Cecil French Bequest: London
Hampton Court Palace, Lower Orangery: London
Harris Museum and Art Gallery: Preston
Harrogate Art Gallery
Harveys Wine Museum: Bristol
Hastings Museum and Art Gallery
Hatton Gallery: Newcastle upon Tyne
Hauteville House: Guernsey
Haverfordwest Castle Museum and Art Gallery (Wales)
Haworth Gallery: Accrington
Heaton Hall: Manchester
Hepworth Museum and Sculpture Gardens, Barbara:
 St Ives
Heralds' Museum, Tower of London
Herbert Art Gallery and Museum: Coventry
Hereford City Museum and Art Gallery
Hobbergate Art Gallery: Newcastle-under-Lyme
Holburne of Menstrie Museum: Bath
Holst Birthplace Museum, Gustav: Cheltenham
Horniman Museum and Library: London
Hospitalfield: Arbroath (Scotland)
Hove Museum of Art
Huddersfield Art Gallery
Hugh Lane Municipal Gallery of Modern Art: Dublin
 (Rep. of Ireland)
Hull (Kingston upon Hull) University Art Collection
Hunt Museum, The: Limerick (Rep. of Ireland)
Hunterian Art Gallery: Glasgow (Scotland)
Hunterian Museum: Glasgow (Scotland)

Imperial War Museum: London
India Office Library and Records: London
Inverness Museum and Art Gallery (Scotland)
Ipswich Museum
Ironbridge Gorge Museum

Jersey Museum
Jewish Museum: London
John George Joicey Museum: Newcastle upon Tyne
John Rylands Library: Manchester
Johnson Birthplace Museum, Samuel: Lichfield
Judges' Lodgings: Lancaster

Kensington Palace Court Dress Collection: London
Kenwood, The Iveagh Bequest: London
Keswick Museum and Art Gallery
Kettering, Alfred East Art Gallery and Museum
Kettle's Yard: Cambridge
Kidderminster Art Gallery and Museum
Kingston upon Thames Museum and Art Gallery
Kirkcaldy Art Gallery (Scotland)

Lady Lever Art Gallery: Port Sunlight
Laing Art Gallery: Newcastle upon Tyne
Lancaster City Museum and Art Gallery
Leamington Spa Art Gallery and Museum
Leathercraft, Museum of: Northampton
Leeds City Art Gallery
Leicester Museum and Art Gallery
Leighton House: London
Leominster Folk Museum
Lillie Art Gallery: Milngavie (Scotland)
Limerick Municipal Art Gallery (Rep. of Ireland)
Liverpool University Art Gallery

Lock Museum, The: Walsall
London Museum: London, Museum of London
Lotherton Hall: Leeds
Luton Museum

Maidstone Museum and Art Gallery
Manchester City Art Gallery
Mander and Mitchenson Theatre Collection, Beckenham
Mansfield Museum and Art Gallery
Manx Museum: Douglas
Mappin Art Gallery: Sheffield
Marble Hill House: London
Maritime and Industrial Museum: Swansea (Wales)
Maritime Museum: Aberdeen (Scotland)
Maritime Museum of East Anglia: Great Yarmouth
Maritime Museum, National: London
Martinware Pottery Collection: London
McLean Museum and Art Gallery: Greenock (Scotland)
Merseyside County Museum: Liverpool
Merthyr Tydfil, Cyfarthfa Castle (Wales)
Middlesbrough Art Gallery
Middlesex Polytechnic, Silver Studio Collection: London
Minories, The: Colchester
Minton Museum: Stoke-on-Trent
Monks Hall Museum: Eccles
Montrose Museum and Art Gallery (Scotland)
Morris Gallery, William: London
Moyses Hall: Bury St Edmunds
Munnings Art Museum, Sir Alfred: Dedham
Museum of London
Museum of Mankind: London, British Museum
Museum of the Order of St John: London

National Army Museum: London
National Gallery: London
National Gallery of Ireland: Dublin (Rep. of Ireland)
National Gallery of Scotland: Edinburgh (Scotland)
National Library of Wales: Aberystwyth (Wales)
National Maritime Museum: London
National Museum of Antiquities: Edinburgh (Scotland)
National Museum of Ireland: Dublin (Rep. of Ireland)
National Museum of Photography: Bradford
National Museum of Wales: Cardiff (Wales)
National Portrait Gallery: London
National Railway Museum: York
Natural History Museum: London, British Museum
Newarke Houses Museum: Leicester
Newcastle-under-Lyme Borough Museum
Newlyn Art Gallery
Newport Museum and Art Gallery (Wales)
Newstead Abbey: Nottingham
Nicholson Institute: Leek
Normanby Hall: Scunthorpe
Northampton Central Museum and Art Gallery
Norwich Castle Museum
Nottingham Castle Museum and Art Gallery
Nottingham Museum of Costume and Textiles
Nuneaton Museum and Art Gallery

Oakwell Hall and Country Park: Batley
Oldham Art Gallery and Museum
Ordsall Hall Museum: Salford
Oriental Museum, The: Durham, University of
Orleans House Gallery: London
Oxford, Museum of

Paisley Museum and Art Gallery (Scotland)
Pannett Art Gallery: Whitby
Passmore Edwards Museum: London
People's Palace Museum: Glasgow (Scotland)
Percival David Foundation of Chinese Art, University
 of London
Perth Museum and Art Gallery (Scotland)
Peterborough City Museum and Art Gallery
Petrie Museum of Egyptian Archæology, University of
 London
Photography, National Museum of: Bradford
Photography, RPS National Centre of: Bath
Pier Art Centre: Stromness (Scotland)
Pilkington Glass Museum: St Helens
Pitt Rivers Museum: Oxford (see also Salisbury and
 South Wilts)

Pittville Pump Room Museum, Gallery of Fashion: Cheltenham
Plassey House: Limerick, The Hunt Museum (Rep. of Ireland)
Platt Hall: Manchester
Plymouth City Museum and Art Gallery
Pollok House: Glasgow (Scotland)
Pontefract Museum
Portsmouth City Museum and Art Gallery
Preservation Trust: Bath
Preston Hall Museum: Stockton-on-Tees
Preston Manor: Brighton

Queen's Gallery: London
Queen's House: London, National Maritime Museum

Railway Museum, National: York
Ranger's House: London
Reading Museum and Art Gallery
Red Lodge, The: Bristol
Ribchester Independent Museum of Roman Antiquities
Rochdale Art Gallery
Rochdale Museum
Rossendale Museum
Rotherham Museum
Rothesay Museum: Bournemouth
Rowley's House Museum: Shrewsbury
Royal Academy of Arts: London
Royal Air Force Museum: London
Royal Albert Memorial Museum: Exeter
Royal College of Music Museum, Department of Portraits: London
Royal College of Music Museum, Museum of Instruments: London
Royal Crown Derby Museum: Derby
Royal Holloway and Bedford New College Picture Gallery: Egham
Royal Hospital Museum, Chelsea: London
Royal Institute of British Architects: London
Royal Museum and Art Gallery: Canterbury
Royal Naval College: London
Royal Naval Museum: Portsmouth
Royal Pavilion: Brighton
Royal Pump Room Museum: Harrogate
Royal Scottish Museum: Edinburgh (Scotland)
Royal Shakespeare Gallery: Stratford-upon-Avon
RPS National Centre of Photography: Bath
Ruskin Gallery: Bembridge
Ruskin Museum: Coniston
Russell-Cotes Art Gallery: Bournemouth
Rutland County Museum: Oakham
Rye Museum

Saffron Walden Museum
Sainsbury Centre for Visual Arts: Norwich
St Helens Museum and Art Gallery
St John's House Museum: Warwick
St Nicholas Church Museum: Bristol
Salford Museum and Art Gallery
Salisbury and South Wiltshire Museum
Scarborough, Crescent Art Gallery
Science Museum: London
Science, Museum of the History of: Oxford
Scottish National Gallery of Modern Art: Edinburgh (Scotland)
Scottish National Portrait Gallery: Edinburgh (Scotland)
Scottish United Services Museum: Edinburgh (Scotland)
Scunthorpe Borough Museum and Art Gallery
Shakespeare Gallery, Royal: Stratford-upon-Avon
Shambellie House Museum of Costume: Dumfries (Scotland)
Sheffield City Museum
Shipley Art Gallery: Gateshead
Shoe Museum, The: Street
Silver Studio Collection, The: London, Middlesex Polytechnic
Sligo Museum and Art Gallery (Rep. of Ireland)
Smith Art Gallery: Brighouse
Smith Art Gallery and Museum: Stirling (Scotland)
Soane Museum: London, Sir John Soane's Museum
Somerset County Museum: Taunton

South London Art Gallery: London
Southampton City Museum and Art Gallery
Spencer Gallery, Stanley: Cookham
Spode Museum: Stoke-on-Trent
Stained Glass Museum: Ely
Stockport Museum
Stockport War Memorial and Art Gallery
Stoke-on-Trent City Museum and Art Gallery
Stratford-upon-Avon Arms and Armour Museum
Stromness Museum (Scotland)
Sudley Art Gallery: Liverpool
Sunderland Museum and Art Gallery
Sutherland Art Gallery, Graham: Haverfordwest (Wales)
Swansea Maritime and Industrial Museum (Wales)
Swindon Art Gallery and Museum

Talbot Rice Art Centre: Edinburgh (Scotland)
Tankerness House Museum: Kirkwall (Scotland)
Tate Gallery: London
Temple Newsam House: Leeds
Tenby Museum (Wales)
Theatre Museum: London
Thomas Coram Foundation for Children: London
Tolson Memorial Museum: Huddersfield
Torre Abbey: Torquay
Tower of London, The Armouries
Tower of London, The Heralds' Museum
Town Docks Museum: Hull (Kingston upon Hull)
Towneley Hall Museum and Art Gallery: Burnley
Towner Art Gallery: Eastbourne
Transport and Archæology Museum: Hull (Kingston upon Hull)
Truro County Museum and Art Gallery and Royal Institution
Tunbridge Wells Municipal Museum and Art Gallery

Ulster Folk and Transport Museum: Belfast (N. Ireland)
Ulster Museum: Belfast (N. Ireland)
United Grand Lodge of England, Library and Museum: London
Ure Museum of Archæology, University of Reading
Usher Gallery: Lincoln

Valence House Museum: London
Verulamium Museum: St Albans
Victoria and Albert Museum: London
Victoria and Albert Museum, Theatre Museum: London
Victoria Art Gallery: Bath

Wakefield Art Gallery
Wakefield Museum
Walker Art Gallery: Liverpool
Wallace Collection: London
Walsall Art Gallery and Museum
Warrington Museum and Art Gallery
Warwickshire Museum and Art Gallery: Warwick
Watford Museum
Watts Gallery: Compton
Wedgwood Museum: Barlaston
Wednesbury Art Gallery and Museum
Wellington Museum, The: London, Apsley House
West Highland Museum: Fort William (Scotland)
West Park Museum and Art Gallery: Macclesfield
Whipple Science Museum: Cambridge
Whitby Museum
Whitehaven Art Gallery and Museum
Whitworth Art Gallery: Manchester
Wilberforce House and Georgian Houses Museum: Hull (Kingston upon Hull)
William Lamb Memorial Studio: Montrose (Scotland)
William Morris Gallery: London
Williamson Art Gallery: Birkenhead
Willis Museum and Art Gallery: Basingstoke
Winchester City Museum
Wolverhampton Art Gallery
Worcester City Museum and Art Gallery
Worthing Museum and Art Gallery
Wythenshawe Hall: Manchester
Wygston's House Museum of Costume: Leicester

York City Art Gallery
Yorkshire Museum: York

Index of Special Collections

This Index is selective and should be used as a guide only to the major collections in each of the categories listed. Good local collections are assumed; factories and makers associated with particular towns will be found in the text for the museum concerned.

For ease of reference the museums in each town, except London, have been given numbers. For example, The Whitworth Gallery in Manchester is 'Manchester 6', as this is its place in the alphabetical sequence under that city.

London

AMERICANA
British Museum (John White & artists' prints)

ANTIQUITIES
British Museum; Soane Museum

ARCHÆOLOGY
British Museum (esp. Prehistoric & Romano-British); Museum of London; National Maritime Museum; Passmore Edwards Museum; Petrie Museum (Egyptology)

ARMS AND ARMOUR
Museum of London; Tower of London; Victoria and Albert Museum; Wallace Collection

CERAMICS
General
British Museum; Museum of London; Victoria and Albert Museum; Wallace Collection
Mediæval
British Museum (esp. tiles); Victoria and Albert Museum
15thC–17thC
Science Museum (Wellcome Coll.); Victoria and Albert Museum; Wallace Collection (maiolica)
18thC–20thC
Apsley House (Wellington presentation services); Courtauld Institute Galleries (maiolica); Martinware Pottery Collection; Victoria and Albert Museum; Wallace Collection (esp. 18thc Sèvres); William Morris Gallery (De Morgan & Martin Brothers)
Commemorative
British Museum
Tiles
British Museum; Leighton House (Isnik); Victoria and Albert Museum

CHILDREN'S TOYS, DOLLS, ETC.
Bethnal Green Museum (esp. dolls' houses)

CLOCKS AND WATCHES
British Museum; Science Museum; Victoria and Albert Museum; Wallace Collection

COINS
British Museum; Museum of the Order of St John

COSTUME
Bethnal Green Museum (esp. children's); Kensington Palace Court Dress Collection; Museum of London (inc. ceremonial); National Army Museum (military); Theatre Museum (theatrical); Victoria and Albert Museum

DRAWINGS AND WATERCOLOURS
Old Master
British Museum; Courtauld Institute Galleries; Museum of London (topographical); National Maritime Museum (esp. Van de Veldes); Victoria and Albert Museum (inc. Raphael cartoons)

British 18thC–20thC
British Museum; Guildhall Library (London topographical); Imperial War Museum; Middlesex Polytechnic (Silver Studio); Museum of London (topographical); National Maritime Museum; Orleans House (Ionides Coll. of local views); Soane Museum; Tate Gallery; Victoria and Albert Museum; Wallace Collection
Continental 18thC–20thC
British Museum; Courtauld Institute Galleries; Tate Gallery (20thc); Victoria and Albert Museum
Architectural
British Museum; Courtauld Institute Galleries; Guildhall Library; Royal Institute of British Architects; Soane Museum; Victoria and Albert Museum
Botanical and Natural History
British Museum (Natural History Museum)

ECCLESIASTICAL ART
British Museum; Victoria and Albert Museum

EMBROIDERY
United Grand Lodge (ceremonial); Victoria and Albert Museum

ENAMELS
British Museum; Courtauld Institute Galleries; United Grand Lodge; Victoria and Albert Museum; Wallace Collection

ENGRAVED AND CARVED GEMS
British Museum; Geological Museum; Victoria and Albert Museum

ETHNOGRAPHY
British Museum (Museum of Mankind); Horniman Museum

FANS
British Museum; Kensington Palace Court Dress Collection; Victoria and Albert Museum

FOLK ART
British Museum (Museum of Mankind); Horniman Museum

FURNITURE AND WOODWORK
Courtauld Institute Galleries (Omega Workshops); Geffrye Museum; Kenwood; Victoria and Albert Museum; Wallace Collection (esp. 18thc French Royal pieces); William Morris Gallery (esp. Arts & Crafts)

GLASS
General
British Museum; Victoria and Albert Museum
17thC–18thC
British Museum (esp. Venetian); Victoria and Albert Museum
19thC–20thC
Museum of London (inc. Whitefriars archive); Victoria and Albert Museum

HERALDRY
British Museum; Heralds' Museum; Museum of London; Museum of the Order of St John; Tower of London

IRONWORK
Victoria and Albert Museum; Wallace Collection

IVORIES
British Museum; Courtauld Institute Galleries; Victoria and Albert Museum; Wallace Collection

JEWELLERY

British Museum (7,000 years); Kenwood (18thC & shoe buckles); Museum of London (esp. Cheapside hoard); Tower of London; United Grand Lodge (ceremonial); Victoria and Albert Museum; Wallace Collection

JUDAICA

Jewish Museum

LACE

Museum of London; Victoria and Albert Museum

MANUSCRIPTS, ILLUMINATED

British Library; Heralds' Museum; Soane Museum; Victoria and Albert Museum

MAPS

British Library; Geological Museum; Guildhall Library (London); National Maritime Museum

MARITIME ART

National Maritime Museum

MEDALS AND PLAQUETTES

British Museum; Victoria and Albert Museum; Wallace Collection

METALWORK AND GOLDSMITHS' WORK (BOXES, ETC.)

Apsley House (orders & decorations); British Museum; National Army Museum (esp. orders & decorations); National Maritime Museum; Tower of London; United Grand Lodge (ceremonial); Victoria and Albert Museum; Wallace Collection (esp. gold boxes)

MINIATURES

British Museum; National Portrait Gallery; Victoria and Albert Museum; Wallace Collection

MUSICAL INSTRUMENTS

Horniman Museum (see also Ranger's House); Royal College of Music, Museum of Instruments; Victoria and Albert Museum

ORIENTAL

British Library (MSS); British Museum; Courtauld Institute Galleries (Turkish Rhodian ware and Islamic metalwork); India Office Library; Leighton House (Isnik tiles); Percival David Foundation (Chinese ceramics); Science Museum (Islamic glass); Victoria and Albert Museum; Wallace Collection (arms and armour)

PAINTINGS

European Old Masters up to and including 17thC
Apsley House; Courtauld Institute Galleries; Dulwich Picture Gallery; Kenwood; Museum of London; National Gallery; National Maritime Museum; National Portrait Gallery; Queen's Gallery; Ranger's House (Suffolk Coll.); Tate Gallery (British); Wallace Collection
British 18thC–19thC
Dulwich Picture Gallery; Guildhall Art Gallery; Kenwood; Leighton House (esp. Lord Leighton); Museum of London; National Gallery; National Maritime Museum; National Portrait Gallery; Orleans House (Ionides Coll. of local views); Queen's Gallery; Tate Gallery; Victoria and Albert Museum; Wallace Collection
Continental 18thC–19thC
Courtauld Institute Galleries (esp. French Impressionist); National Gallery; Queen's Gallery; Victoria and Albert Museum; Wallace Collection
20thC
Courtauld Institute Galleries (esp. Post-Impressionist and Bloomsbury Group); Imperial War Museum; National Portrait Gallery; Tate Gallery

PHOTOGRAPHY

British Museum (inc. Sir Henry Stone National Photographic Record); Guildhall Library (London); Museum of London; National Army Museum; National Maritime Museum; National Portrait Gallery; Science Museum; Victoria and Albert Museum

PLAYING CARDS

British Museum; Guildhall Library; Victoria and Albert Museum

PRINTS

Illustrated Books
British Library; British Museum; India Office Library; Victoria and Albert Museum
Original
British Museum; Guildhall Library; Imperial War Museum; Tate Gallery; Victoria and Albert Museum
Ornament
British Museum; Victoria and Albert Museum
Posters
Imperial War Museum; Museum of London; Theatre Museum; Victoria and Albert Museum
Reproductive
British Museum (esp. mezzotints); India Office Library (topographical); National Army Museum (military); National Maritime Museum (marine); National Portrait Gallery (esp. Vanity Fair); Science Museum; Victoria and Albert Museum

SCIENTIFIC INSTRUMENTS

National Maritime Museum; Science Museum

SCULPTURE

British Museum; Imperial War Museum; National Portrait Gallery; Soane Museum; Victoria and Albert Museum; Wallace Collection (esp. Renaissance bronzes)

SILVER

Apsley House (Wellington presentation); British Museum; Jewish Museum (ritual); Museum of London; Museum of the Order of St John; Science Museum (medical, Hull Grundy gift); Tower of London; Victoria and Albert Museum

STAINED GLASS

Museum of London; Victoria and Albert Museum; William Morris Gallery (Christopher Whall designs & cartoons)

TEXTILES

General
British Museum (inc. Coptic); Victoria and Albert Museum
Carpets
Victoria and Albert Museum
Tapestries
Victoria and Albert Museum; William Morris Gallery
Woven and printed textiles
Horniman Museum; Middlesex Polytechnic (Silver Studio); Victoria and Albert Museum; William Morris Gallery

THEATRE

Bethnal Green Museum (toy theatres & puppets); Guildhall Library (London playbills); Museum of London (inc. costume); Theatre Museum

WALLPAPER

Middlesex Polytechnic (Silver Studio); Victoria and Albert Museum; William Morris Gallery

Other Regions

AMERICANA
Bath 1

ANTIQUITIES
Barnsley 1 (Roman and Syrian glass); Batley 1 (Egyptology); Bristol 1 (Roman glass); Cambridge 1 & 3; Durham (Egyptology); Edinburgh 2; Glasgow 4; Limerick 2; Liverpool 1 (Ince Blundell marbles); Macclesfield (Egyptology); Newcastle upon Tyne 3 (Greek and Etruscan); Oxford 1 (esp. Arundel marbles); Reading 1; Reading 2 (Greek painted pottery); Ribchester; St Albans; Shrewsbury 2

ARCHÆOLOGY AND ETHNOGRAPHY
Batley 1; Brighton 2; Bury St Edmunds 1 (esp. Bronze Age); Cambridge 3; Canterbury (Roman glass); Colchester; Devizes; Douglas; Dublin 4; Edinburgh 2 & 3; Exeter; Forres; Glasgow 4; Hull 3; Ipswich 2; Lancaster 2; Leicester 1; Liverpool 1 (esp. Anglo-Saxon); Luton; Maidstone; Northampton 1; Norwich 1 & 2; Oakham (esp. Anglo-Saxon); Oxford 1 & 5; Saffron Walden; Salisbury (Pitt Rivers Coll.); Stoke-on-Trent 1 (South American pottery); Winchester (esp. Anglo-Saxon); Worthing (esp. Anglo-Saxon)

ARMS AND ARMOUR
Edinburgh 2 & 3; Fort William; Glasgow 1; Kilmarnock 2; Newcastle upon Tyne 1; Oxford 5; Stratford-upon-Avon 1; Stockton-on-Tees; Warwick 1 (firearms by Nicholas Paris)

CERAMICS
General
Alton; Bath 2 (esp. Italian maiolica); Bedford; Bristol 1 (esp. Bristol Delftware and porcelain); Cambridge 1; Exeter (esp. North Devon pottery); Glasgow 1; Hastings (inc. Continental porcelain); Hove (esp. Wedgwood); Hull 5 (Chinese); Liverpool 1 (esp. Liverpool wares); Manchester 1; Norwich 1; Nottingham 1; Oxford 1; Plymouth; Preston; Stoke-on-Trent 1, 2, 3 & 4; Worthing
Mediæval
Leamington Spa; Northampton 1; Rye; Salisbury; Winchester; York 3
18thc–20thc
Aberystwyth 1 (20thc studio pottery); Barlaston (Wedgwood); Barnard Castle (Continental porcelain); Barnsley 1 (esp. Doulton); Bath 7 (Worcester & Bristol porcelain); Birkenhead (esp. Liverpool porcelain & Della Robbia ware); Birmingham 3 (esp. William De Morgan); Bournemouth 1 (esp. Wedgwood); Brighton 2; Burnley (esp. Royal Lancastrian); Bury (esp. Royal Lancastrian); Cardiff 2 (esp. Swansea); Derby 1 & 2 (esp. Derby porcelain); Doncaster (esp. Rockingham & Leeds); Dublin 4; Gloucester; Halifax (20thc); Ironbridge (esp. Coalport); Kendal (20thc studio pottery); Kingston upon Thames (Martin Brothers & 20thc studio pottery); Kirkcaldy (esp. Wemyss ware); Leamington Spa; Leeds 2 (20thc studio pottery); Leeds 3 (esp. Leeds creamware); Newport (Staffordshire figs); Portsmouth 1; Port Sunlight; Plymouth; Rotherham (esp. Rockingham); Shrewsbury 1; Stoke-on-Trent 1 (inc. Staffordshire figs), 2 (Doulton), 3 (Minton), 4 (Spode); Swansea 1 (esp. Swansea porcelain & Toby jugs); Swindon (esp. pot lids, Prattware & 20thc studio pottery); Torquay (Watcombe & Torquay terracotta ware); Wolverhampton 2 (inc. Worcester porcelain); Worcester 2 (Worcester porcelain); York 1 (esp. 20thc studio pottery)
Tiles
Ironbridge; Liverpool 1 (esp. Delftware); Stoke-on-Trent 1 (inc. Mediæval)
Commemorative
Brighton 2; Newport; Southport 2

CHILDREN'S TOYS, DOLLS, ETC.
Alton (dolls and dolls' houses); Barnard Castle (toys & automata); Bridport (dolls); Derby 1 (toys and model theatres); Eccles (dolls & toys); Hull 4; Lancaster 1 (dolls, etc.); Southport 2 (dolls); Tunbridge Wells (toys & dolls); Wolverhampton 2 (dolls); Worthing (esp. dolls & mechanical toys)

CLOCKS AND WATCHES
Basingstoke; Bury St Edmunds 2; Cambridge 1; Colchester 1; Leicester 3 (inc. reconstructed workshop); Lincoln; Liverpool 1; Luton (Thomas Tompion); Oxford 1 & 3; Prescot

COINS
Birmingham 2 (Roman & Byzantine); Cambridge 1; Canterbury; Chorley (Chester mint); Edinburgh 2 & 3; Glasgow 3; Lincoln; Northampton 1; Norwich 1; Oxford 1; Ribchester (Roman); Winchester

CONTEMPORARY CRAFTS
Gateshead (British); Leeds 2

COSTUME
Bath 4; Belfast 2; Bexhill-on-Sea; Bradford 1; Brighton 2; Cheltenham 3; Dumfries 2; Edinburgh 2 & 3; Exeter; Hereford 1 (esp. occupational and agricultural); Ipswich 1; Leicester 4 (inc. corsetry coll.); Liverpool 1; Manchester 5 (inc. occupational); Northampton 1 & 2 (shoes); Nottingham 2; Scunthorpe 2; Stoke-on-Trent 1; Street (shoes); Totnes (inc. underwear); Warwick 2 (esp. 1930s); Worthing (inc. accessories)

DRAWINGS AND WATERCOLOURS
Old Master
Cambridge 1; Dublin 3; Edinburgh 1; Halifax; Oxford 1 & 2; Plymouth (Cottonian coll.); Truro (de Pass coll.)
Botanical and Natural History
Liverpool 3 (John James Audubon); Southport 2
British 18thc–20thc
Aberdeen 1; Aberystwyth 1 (Welsh topographical); Barnsley 2; Bedford; Bembridge (John Ruskin); Birmingham 3; Blackpool (esp. Eric Ravilious & Paul Nash); Bolton; Cambridge 1; Cambridge 2 (20thc); Cardiff 1 (esp. William Burges designs); Carlisle (esp. Pre-Raphaelite); Coniston (John Ruskin); Douglas (Archibald Knox design archive); Dublin 3; Eastbourne (esp. Eric Ravilious); Edinburgh 1 & 4; Exeter (esp. John White Abbott); Hereford 2; Kendal (esp. Lakeland, John Harden); Leeds 1; Lincoln (esp. Peter de Wint); Manchester 1 & 6; Newcastle upon Tyne 2; Oxford 1; Stockton-on-Tees
Continental 18thc–20thc
Edinburgh 1 & 4; Oxford 1; Walsall 1

ECCLESIASTICAL ART
Bristol 5; Burnley (esp. vestments); Manchester 6 (vestments); Nottingham 1; Norwich 1

ENAMELS
Cambridge 1; Lincoln; Wolverhampton 2 & 3 (Bilston wares & japanned wares)

ENGRAVED AND CARVED GEMS
Buxton (Blue John); Cambridge 1; Edinburgh 5 (James and William Tassie); Oxford 1; Port Sunlight

FANS
Hereford 1 (Oriental); Manchester 5

FURNITURE AND WOODWORK
General
Barnard Castle; Birmingham 1 (English); Birmingham 3 (esp. Pinto Coll. of treen); Bradford 1; Burnley; Leeds 3
18thc
Barnard Castle; Bedford; Coventry (English); Leeds 3; Leicester 2; Port Sunlight

PEWTER
Berwick-on-Tweed; Glasgow 1; Stockton-on-Tees;
Torquay; Truro

PHOTOGRAPHY
Bath 6; Bradford 2; Devizes; Edinburgh 5;
Kingston-upon-Thames (Eadweard Muybridge);
Lacock (Henry Fox Talbot); Manchester 2 (old
Manchester); Oxford 3 (photographic apparatus);
Whitby 2 (F. M. Sutcliffe)

PRINTS
Illustrated Books
Blackburn (early printed books); Colchester 2 (esp.
Paul and John Nash); Eastbourne (esp. Eric
Ravilious)
Original
Aberdeen 1; Bradford 2 (20thc); Cambridge 1 (esp.
Rembrandt); Dublin 3; Edinburgh 1; Falmouth;
Glasgow 4; Leicester 1; Manchester 1 & 6;
Newcastle upon Tyne 1 (Thomas Bewick); Oxford 1
Posters
York 2 (railway interest)
Reproductive
Dublin 3 (esp. 18thc mezzotints); Maidstone
(Baxter); Reading (Baxter)

SCIENTIFIC INSTRUMENTS
Cambridge 4; Gloucester (barometers); Oxford 3

SCULPTURE
General
Dublin 3; Glasgow 2; Limerick 1; Liverpool 1 (Ince
Blundell marbles)
Medieval
Norwich 1 (esp. English alabasters); Nottingham 1
(esp. English alabasters)
Renaissance
Oxford 1 (esp. bronzes); Port Sunlight
17thC–19thC
Birmingham 3; Edinburgh 5; Leeds 1 (esp. 'new
sculpture'); Leeds 2; Liverpool 4 (esp. 'new
sculpture'); Manchester 1; Paisley (John Henning);
Plymouth (Rysbrack drawings); Port Sunlight;
Preston (esp. 'new sculpture')
20thC
Bolton (esp. Jacob Epstein); Cambridge 2;
Edinburgh 4; Hull 1 & 5 (British); Leeds 1 (esp.
Henry Moore); St Ives; Wakefield 1; Walsall 1

SHIPWRECKS
Belfast 2 (Spanish Armada); Guernsey 3

SILVER
Alton; Bath 2; Belfast 2 (Irish); Birmingham 3;
Brighton 4; Cardiff 2; Cheltenham 1 (esp. Arts &
Crafts); Chester; Chorley (esp. racing trophies);
Doncaster (racing trophies); Dublin 4; Edinburgh
2 & 3; Exeter; Glasgow 1; Huddersfield 2 (Sheffield
plate); Leeds 3; Liverpool 1; Manchester 1;
Newcastle upon Tyne 2; Nottingham 1; Oxford 1;
Plymouth; Sheffield 1 (esp. cutlery & Sheffield plate)

STAINED GLASS
Birmingham 3 (esp. Edward Burne-Jones);
Canterbury (Dutch); Cardiff 1 (esp. William Burges);
Dublin 3; Ely; Glasgow 2 & 5

TEXTILES
General
Barnard Castle; Bath 1 (American quilts & rugs);
Belfast 2; Bolton (esp. textile machinery); Halifax
(inc. textile machinery); Hereford 2 (esp. quilts);
Ipswich 1; Kendal (20thc wall hangings); Leicester
4; Manchester 6; Paisley (esp. shawls)
Carpets
Glasgow 2; Kidderminster
Embroideries (see also ECCLESIASTICAL ART)
Basingstoke; Birmingham 1; Edinburgh 3;
Guildford; Leek (Leek Embroidery Society);
Manchester 6; Nottingham 2; Saffron Walden
Tapestries
Barnard Castle; Birmingham 1; Glasgow 2;
Guernsey 4; Kilmarnock 2; Manchester 6 (Morris &
Co.); Nottingham 2; Oxford 1; Warwick 1 (Sheldon
tapestry map)
Woven and printed textiles
Belfast 2; Hereford 2

THEATRE
Beckenham 2; Bournemouth 1 (Henry Irving);
Derby 1 (model theatres & juvenile drama material);
Hull 5 (stage & costume design); Stratford-upon-
Avon 2 (inc. 18thc & 19thc paintings)

WALLPAPER
Epsom (17thc); Leeds 3; Manchester 6

WINE LABELS
Bristol 3

Index of Architects

FRANCIS GRAHAM

ADAM, Robert (1728–92)
Son of William Adam, a successful builder and the foremost architect practising in Scotland at the time. Robert did the Grand Tour (1754–58). On return, became the head of the family firm of architects, builders and entrepreneurs. Published *The Ruins at Spalatro*, a manifesto challenging the Palladianism of the day in favour of a muscular picturesque style. Innovative and influential interior decorator.

London, Kenwood House, remodelling, addits of library and portico (1767–69). George Saunders altered some of the house (1793–96).
Apsley House, Wellington Museum (1772–78).

ADAMS, Maurice Bingham, FRIBA (1849–1933)
Draughtsman, the 'recognized perspective artist of his day.' Architectural Editor of the *Building News*. Served as Architect to the Brighton Borough Council. Completed Norman Shaw's garden suburb of Bedford Park.

London, South London Art Gallery (1902), exts built as a memorial to Lord Leighton.

AITCHISON, George the Younger, RA (1825–1910)
Pres. RIBA 1896–99
Royal Gold Medal 1898
R.A. Professor of Architecture (1887–1905).
Succeeded his father as architect to London and Victoria Dock Co., after travelling from 1853–55.

London, Leighton House, Holland Park Rd (1865). Addits later of the glasshouse, Arabian Hall and Picture Gallery. Aitchison also designed the furniture.

ALEXANDER, Daniel Asher (1768–1846)
Surveyor to the London Dock Co. (1796). He 'specialized in the designing of large utilitarian buildings such as prisons and warehouses' (Colvin).

London, National Maritime Museum (1807–10). Originally addits to the Queen's House for Royal Naval Asylum.

Edinburgh, National Portrait Gallery and Museum of Antiquities, R. Rowand Anderson

ALLISON, Sir Richard (1869–1958)
Sir Henry Tanner's successor as the Chief Architect at the Ministry of Works (1914–34).

London, The East block of the Science Museum (1914–28).
The Geological Museum (1929–35). The work was supervised by Allison's assistant and successor, J. H. Markham. Some of the details are the latter's, but the overall design is by Allison.

ALLOM, Thomas (1804–72)
A talented draughtsman. Architect of the Kensington Workhouse (1847–48). Responsible for laying out and 'covering the Kensington Park Estate with mansions.'

Liverpool, Merseyside County Museum (1857–60). Its design is seemingly modelled after Elmes and Cockerell's adjoining St George's Hall. The interior was rebuilt after bomb damage.

ANDERSON, Sir Robert Rowand, FRIBA (1834–1921)
First Pres. of the Scottish Institute of Architects. Worked in Gothic, Italian and classical styles; his best known and best work is the Medical School and McEwan Hall at Edinburgh University.

Edinburgh, National Portrait Gallery and Museum of Antiquities (1884).

ASHLEY, Henry V. (1872–1945)
Vice-Pres. RIBA 1929–31
A traditionalist, 'a well-known figure in the world of Masonry,' from 1907 in partnership with Francis Winton Newman (1878–1953). Their practice included many inter-War housing schemes.

London, Freemason's Hall: The Library and Museum (1927–33).

ATKINSON, Robert, FRIBA (1883–1953)
Studied Nottingham School of Art, then in Italy, Paris and N. America. Principal of the Architectural Association (1913–20). A pioneer of cinema design, especially the 'luxury' cinema such as The Regent, Brighton. He was 'a modernist in principles, but one who knew tradition and could expound its lessons.'

Birmingham, The Barber Institute (1935–39). A purpose-built gallery that won the Birmingham and Five Counties' A. A. bronze medal.

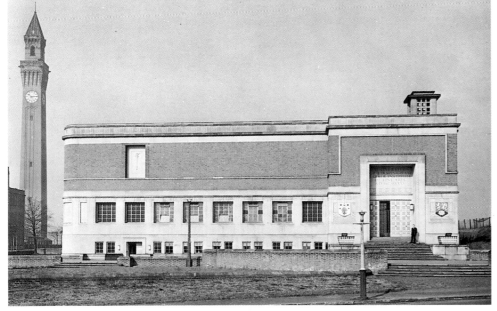

Birmingham, Barber Institute, R. Atkinson

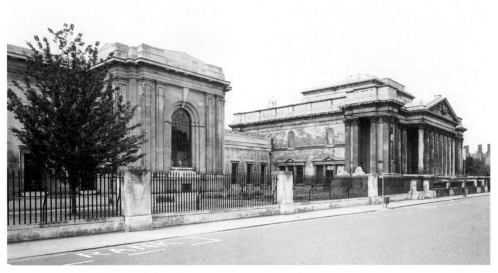

Cambridge, Fitzwilliam Museum, G. Basevi

BANKS, Thomas Lewis, FRIBA (1842–1920)
Travelled in Italy, France and Germany (1869–70).
Offices in Cumberland and London, had a line in
Metropolitan chapels, both in the North and in
London.

Whitehaven Art Gallery (1880–83). Formerly the
Market Hall.

BARRY, Sir Charles, RA (1795–1860)
Best known as the head of the office that won the
competition to rebuild the Houses of Parliament.
Noted also for his successful adaptation of the Italian
Palazzo prototype for public buildings. Loudon
complimented Barry on having 'as just a taste in
Landscape gardening,' as in architecture he was
'refined and correct.' Barry's other great skill, as
Digby Wyatt pointed out, was his eye for 'the
satisfactory working of utilitarian necessities' and 'the
perfection of domestic arrangements' (from *Br.*
1860).

Manchester City Art Gallery (1824–35), formerly the
Royal Institution of Fine Arts. The Art Gallery
annexe was originally the Athenaeum (1837–39).

BARRY Charles E. (1824–1900)
Pres. RIBA
Institute Gold Medal 1877
Eldest son of the above. Articled in his father's office.
In partnership with R. R. Banks. Surveyor to the
Dulwich Estate (1858), designed Dulwich College
School.

Alton, Curtis Museum (1869–80). Purpose-built
addits to a 17thC building.

BASEVI, George, FRIBA (1794–1845)
Articled to Sir John Soane. Travelled to Greece and
Asia Minor (1816–20). Did work for the Church
Commissioners, including St Thomas's, Stockport
and St Jude's, Chelsea. Designed Belgrave Sq.
(1825–40 — not the corner mansions). Died falling
through the roof of Ely Cathedral.

Cambridge, Fitzwilliam Museum (1837–48). A
purpose-built museum, competition winner of 1835,
whose design 'entitles him to a high rank as a classic
architect.' (Library and staircase completed by C. R.
Cockerell.)

J. W. BEAUMONT & SONS
Manchester, Whitworth Gallery (1894–1908).
Purpose-built: the winner of a competition assessed
by Waterhouse, and very much designed *á la*
Waterhouse in red terracotta, etc.

BELLAMY, Pearson (1821–1901)
Of Bellamy and Hardy of Lincoln.
Responsible for many Town Halls, such as Ipswich
(1865–68). Cemeteries at Leicester and
Loughborough. Corn Exchanges in Lincoln,
Grimsby and Retford.

Hull, Museum of Commerce and Transport (1856).
Formerly the Corn-Exchange.

BINYON, Brightwen, ARIBA (1845/6–1905)
Pupil of Waterhouse and remained in his office
(1863–71). Travelled in Europe, Egypt and Palestine.
Returned to settle in Ipswich. Employed in
development of Stanmore Park Estate. Other works:
Sunderland Town Hall (1887), he was 'an able
decorative architect,' also designed liner interiors,
notably those for the *Serapis* that took Edward,
Prince of Wales to India. Retired in 1897.

Folkstone Museum and Art Gallery (1888).

BLOMFIELD, Sir Arthur (1829–99)
Vice-Pres. RIBA 1886–89
Institute Gold Medal 1891
Pupil of P. C. Hardwick. His own practice was
churches and church restorations. A 'firm ally of
Gothic architecture, Gothic was also the best friend
to him.' His work was characterised by a 'feeling for
refined and reticent detail.' The reconstruction of the
nave of Southwark Cathedral was his most celebrated
achievement.

London, Royal College of Music, Dept of Portraits
(1883–84).

BLOMFIELD, Sir Reginald, RA (1856–1942)
Pres. RIBA 1912–14
Of an Arts and Crafts background, but became a
leading Classicist and key figure in the 'Wrenaissance'
of the early 20thC. Writer on architecture and gardens.

Bath, Holburne of Menstrie Museum (1911). Alts
and conversion of an 18thC house by Masters (q.v.).
Lincoln, Usher Gallery (1927). Purpose-built in the
Beaux-Arts manner, a compact, two-storey block,
Doric pilasters and red-brick panels, pedimented
centre.

BOWEY, Michael
Milngavie, Lillie Art Gallery (1962).

BRADSHAW, GASS & HOPE
Bolton Art Gallery and Museum (1883).

BRIERLEY, Walter Henry (1862–1926)
Ran a North of England practice embracing country
houses, racecourses, churches and commercial
buildings. Worked in mediæval and Renaissance
styles, 'a master of detail.' His buildings are marked
by their 'sound constructional qualities, dignified
restraint and avoidance of over-elaboration.'

Scunthorpe, Normanby Hall (1906) alts and exts.
Accrington, Haworth Gallery (1908–9). Built
originally as a private house.

BRYDON, James McKean (1840–1901)
Vice-Pres. RIBA
Assistant to Shaw and Nesfield. Began as a designer
of furniture, then moved into domestic practice 'and
at length found his range in the planning and
designing of public buildings.'

Bath, Victoria Art Gallery (1900). A purpose-built
gallery that stands at the corner of the 18thC block
containing Guildhall and Municipal Offices. Brydon
continued the style of the older buildings though with
some Baroque motifs.

BUNCH, Arthur Charles (1879–1950)
Vice-Pres. RIBA 1940–44
Warwick County Architect 1921–45. His most
notable work is the County Offices of 1921–32.

Cardiff Castle, W. Burges

Barnsley, Cannon Hall, J. Carr

Leamington Spa Museum and Art Gallery (1928).

BURGES, William (1827–81)

Architect-designer who took the mediæval fantasies of High Victorian England to extravagant lengths. Most of his later career was occupied with the design and decoration of the Marquess of Bute's palace in Cardiff and summer house of Castle Coch.

Cardiff Castle (1866–1928) completed posthumously by other hands working to Burges's designs.

BURN, William (1789–1870)

Worked in the office of Sir Robert Smirke, returned to Edinburgh where he built up an extensive practice later opening an office in London. His 'speciality was Domestic architecture,' their designs being 'models of simplicity, compactness, and convenience.'

Edinburgh, Scottish National Gallery of Modern Art (1825). Originally John Watson's Hospital. A low, plain block with a hefty Doric portico.

BURNET, Sir John James, FRIBA, RA (1857–1938)

Royal Gold Medal 1923
Son of John Burnet (1816–1901). Ecole des Beaux-Arts pupil (1874–77). Took over from his father as head of the practice, moved from Glasgow to London in 1905. Worked in various styles, being 'at once a Victorian and a modernist.'

London, British Museum, The King Edward VII Galleries (1905–14).

CACKETT & BURNS-DICK

Newcastle upon Tyne, Laing Art Gallery (1904)

CAMPBELL, A. H.

Canterbury City Surveyor

Canterbury, Royal Museum and Art Gallery (1899).

CAMPBELL, Colen (1676–1729)

Scotsman of a legal background who became one of the prime movers of the Palladian revival of the early 18thc. Published *Vitruvius Britannicus* by subscription (1715, 1717, 1725), a work whose illustrations represented contemporary buildings that also served as propaganda for neo-Palladian simplicity and self-marketing for Campbell himself.

London, Royal Academy of Arts. Originally Burlington House (1718–19).

CARR, John (1723–1807)

A self-taught architect, working mainly in the Palladian manner, he was 'one of the most competent and successful of Georgian architects. His practice was based on the patronage of the Yorkshire gentry, and country houses formed the bulk of his work.' (Colvin).

Kendal, Abbot Hall Gallery (1759).
Barnsley, Cannon Hall Art Gallery (1764–68), addits of wings, stables and further works (1778).
Bradford, Bolling Hall (1779–80), restoration of the east wing of a 17thc house.
Rotherham, Clifton Park Museum (1783).

Rotherham, Clifton Park, J. Carr

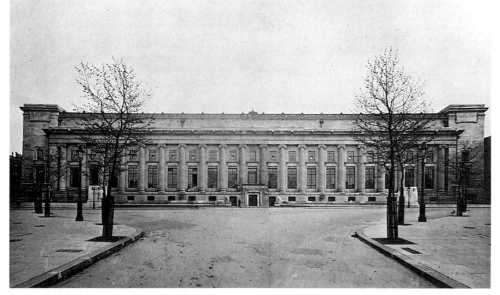

London, British Museum, North Entrance, J. Burnet

Bradford, Bolling Hall, J. Carr

Wolverhampton Art Gallery, J. Chatwin

CHAMPNEYS, Basil (1842–1935)

Royal Gold Medal 1912
Articled to John Pritchard of Llandaff. From 1867 on
his own. He was 'learned and correct, refined and
scholarly rather than highly original,' and in
continuing old work 'he strove rather for harmony
than for the assertion of his own personality.'

Manchester, John Rylands Library (1890–1900).

CHATWIN, Julius Alfred, FRIBA (1829–1907)

Articled to Sir Charles Barry in 1851, from being
associated with the Barry/Pugin designs for the
House of Commons, he 'imbibed an admiration for
the features of the perpendicular style' (*B.N.*). His
later practice was centred on Birmingham, where he
was successful as a church restorer; also did
commercial buildings, including many of the Lloyds
banks in the Birmingham area.

Wolverhampton Art Gallery (1884). Purpose-built in
a classic design, in Bath stone, a portico of six red
granite monoliths.

CHESTON, Horace, FRIBA (1850–1919)

Had a general practice in the City of London. During
the 1914 War worked on East Anglian dockyards.
Ipswich Museum (1881). Purpose-built exts to an
older building (illus. *B.N.* 29.VII.1879).

CHRISTIAN, Ewan (1814–95)

Pres. RIBA 1884–86
Institute Gold Medal 1887
A large practice doing mainly Church restorations,
'also many new churches, parsonage houses and
schools.' Consulting Architect to Ecclesiastical
Commissioners (1850) and to the Charity
Commissioners (1888).

London, National Portrait Gallery (1890–95). A
purpose-built museum following a standard model
and style of such public buildings of the time.

CLARKE, Sir Caspar Purdon, FRIBA (1846–1911)

Trained as an architect, better known as one of the
creators of the Victoria and Albert Museum and its
collections. Director of the South Kensington
Museum (1895–1905), Director of the Metropolitan
Museum, New York (1905–10).

Macclesfield, West Park Museum (1898). Originally
built as a single gallery; done with Ruabon pressed
bricks and roofed in Westmorland green slates.

COCKERELL, Charles Robert (1788–1863)

Articled to Robert Smirke, succeeded his father S. P.
Cockerell as Surveyor to the Fabric of St Paul's
Cathedral. Appointed Professor of Architecture at the
R.A. in 1839, his lectures were well-attended and
from 1842 on were published in *The Builder*. He was
a distinguished classical archæologist; had an
admiration for the then unfashionable architecture of
Wren. His career was mainly devoted to writing and
lecturing on art and architectural subjects; what few
buildings he did mark him as one of the most
imaginative of neo-classical architects.

Oxford, Ashmolean and Taylorian Institution (1841–45).
Cambridge, Fitzwilliam Museum. After the death of
Basevi in 1845, Cockerell undertook the completion
of the work. His Library remains, but his staircase
was changed when the entrance hall was remodelled
by E. M. Barry in 1870–75.

COOKE, Samuel Nathaniel, FRIBA (1882–1964)

Practised in Birmingham, in partnership with W. N.
Twist. Responsible for the Leamington Spa Police
and Fire Station.

Hull, Ferens Art Gallery (1923). Purpose-built,
designed in partnership with E. C. Davies.

COX, Alfred, ARIBA (1868–1944)

Kingston-upon-Thames, Museum and Art Gallery
(1904).

CRICKMAY, George Rackstrow (1830–1907)

Practice based in and around Weymouth; the firm
also had London offices.

Dorchester, Dorset County Museum (1881–83). 'The
design of the building has been governed by the old
church of St Peter's,' which stands next to the
Museum, 'and is seen in connection with it.' The
exterior is of a late Gothic style, the inside of the
Museum has a church-like quality, being 'lofty and
well-lighted by a clerestory' (*B.N.* 26.1.1883, plus
illus.). The Museum was redecorated in the original
colour schemes, also extended by Michael Brawne
(1968–70).

CROSSLAND, William Henry, FRIBA (1823–1909)

Practised in Huddersfield. Won the competition for
Rochdale Town Hall (1871).

Halifax, Bankfield Museum. Originally the home of
Edward Ackroyd, a local worsted manufacturer, who
employed George Gilbert Scott to draw up plans.
Work began in 1861. Crossland was employed to
supervise the building on the spot.
Egham, Royal Holloway and Bedford College Picture
Gallery (1879–86).

CROUCH, Henry Arthur, FRIBA (1871–1955)

Studied Queensland Institute, awarded its Gold
Medal (1891). Returned to England in 1893. From
1909–25 Consultant Architect to the Government of
Bengal.

Worthing, Museum and Art Gallery (1908).

CULLEN, LOCKHEAD & BROWN

Blackpool, Grundy Art Gallery (1911).

DAVIES, W. G. (1888–1967)

Chief Architect for Sheffield Borough Council

Sheffield, Graves Art Gallery (1934).
City Museum (1937).

DEANE, Sir Thomas Newenham (1828–99)

From Cork. The pupil of his father Sir Thomas
Deane. The firm of Sir Thomas Deane, Son and
Woodward moved to Dublin. Deane the Younger and
Benjamin Woodward won the competition for the
Oxford Museum; from this commission and their
being lionised by Ruskin, the partnership did much
work in Oxford. Woodward died in 1858. In
partnership with his son T. M. Deane, from 1878, ran
a big practice doing work in Ireland and Great
Britain.

Dublin, National Museum of Ireland (1890). Purpose-
built as the Science and Art Museum and the
National Library of Ireland.

DOBSON, John, FRIBA (1783–1865)

A watercolourist of skill, an ingenious engineer, a
designer and restorer of churches. Responsible for
many of the finest buildings of 19thc Newcastle.
Adept at the Greek revival style, in his domestic work
favouring the Tudor, the catalogue of Dobson's
'works would be the history of nearly every territorial
residence in the county.' Won a medal at the Paris
Exhibition of 1858 for his design of Central Station,
Newcastle.

Warrington Museum and Art Gallery (1853).

FERGUSON, Charles John, ARIBA (1839–1904)

Worked in the offices of George Gilbert Scott. Later
practice centred in and around Carlisle.

Carlisle Art Gallery and Museum (1892–93). Tullie House dates from 1689, Ferguson made extensive alts and adds (illus. *B.N.*9.v.1891).

FLOCKTON, Thomas James, FRIBA (1824–99)

Senior partner of Flockton & Gibbs of Sheffield. Trained under his father William Flockton (1804–64). Also worked in the offices of George Gilbert Scott. William Emerson, the Pres. of RIBA, eulogised Flockton as being 'almost an embodiment of Sheffield. He built half of the town; wherever they went in Sheffield they met his work.'

Sheffield, Mappin Art Gallery (1886–88). A purpose-built Gallery in the neo-classical taste. Wings added in 1903 by Flockton, Gibbs & Flockton.

FORBES, John (b. 1795?)

Associated with the development of the Pittville Estate in Cheltenham (1822–32). His promising career was cut short when he was convicted for forgery in 1835.

Cheltenham, Pittville Pump Room (1825–30). Intended as the focus of the planned new town of Pittville. A two-storey building of mixed Greek and Roman elements. An Ionic colonnade on three sides. A central hall rising through the second floor to the dome.

NORMAN FOSTER ASSOCIATES

Norwich, Sainsbury Centre for the Visual Arts (1978)

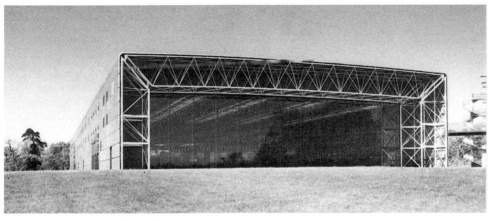

Norwich, Sainsbury Centre, Norman Foster Associates

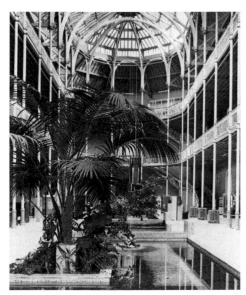

Edinburgh, Royal Scottish Museum, F. Fowke

FOWKE, Captain Francis (1823–65)

Commissioned Royal Engineers in 1842. Inspector of the Science and Art Dept (1853). Joint designer with Maj.-Gen H. G. D. Scott of the Royal Albert Hall. *The Builder* lamented that his career had 'prematurely ended' and went on: 'Much of Fowke's work was tentative; he was not afraid of trying; not afraid of new materials or new modes. He was gradually, too, improving his taste; acquiring a better perception of beauty in form.'

Dublin, National Gallery (1859–60), remodelling and addits.
Edinburgh, Royal Scottish Museum (1860–61), originally the Museum of Science and Art (illus. *Br.* 1862, p. 841).

FREEMAN, R. Knill (1838–1904)

Began in Derby, moved to Bolton 'where he established a leading and extensive practice in Lancashire and adjoining counties.'

Derby Library and Museum (1876). A large Romanesque and French Gothic purpose-built Museum. The Art Gallery was added in 1883 by Story.

FRY, DREW & PARTNERS

St Helens, Pilkington Glass Museum (1961–64). Part of the Head Office complex, the interior was designed by James Gardner Studios.

BARRY GASSON ARCHITECTS

Glasgow, Burrell Collection (1983).

GETHING, Josiah Morris (1830–1919)

Kidderminster, Art Gallery and Museum (1887). Purpose-built; competition winner.

GIBBS, James (1682–1754)

Abandoning an intended career in the Roman Church, he became a pupil of Carlo Fontana. His buildings in England retained some of the spirit of his Roman training, such as St Mary-le-Strand. His other works include the Radcliffe Camera, Oxford, as well as many country houses. His style mellowed with the change in English taste away from Wren and the Baroque towards Palladianism.

London, Orleans House, the Octagon Room, built in the grounds of Orleans House (1720).

GIBSON, James Glen Sivewrite (1861–1951)

Vice-Pres. RIBA 1906–10
Worked in the office of T. E. Collcutt, in partnership with Samuel Bridgman Russell from 1890–99. On his own until 1907, then in partnership with W. S. A Gordon. The architect of Caxton Hall, and, with Gordon, of Arding and Hobbs, Clapham Junction.

Walsall, The Library (1906): Gibson's designs won the competition of 1900. Art Gallery exts by A. T. Parrot, the Borough Architect (1965).

GREENSLADE, Sydney Kyffin, FRIBA (1874–1955)

An 'artist architect. He did not carry out much work, but what he did was in excellent taste.' Associated, too, with Eton College War Memorial.

Aberystwyth, National Library of Wales (1907).

HALLIDAY, James Theodore, FRIBA (1882–1932)

Of Halliday and Agate. Sometime Pres. of the Manchester Society of Architects. Interested in housing reform. Lectured on town-planning, also influential in the new-town development of Wythenshawe. Work in Manchester includes Oxford Hall, Oxford Rd. At the time of Halliday's death, his office was engaged in the building of Battersea Power Station in conjunction with C. S. Allott & Sons.

Stockport War Memorial Gallery (1925).

HANNAFORD, Leonard G. and THEALE, Herbert G.

Birkenhead, Williamson Art Gallery (1928).

HARE, Henry Thomas (1860–1921)

Pres. RIBA 1917–19
Studied at Ecole des Beaux-Arts; in practice on his own from 1891. Noted for his large public buildings and 'played a prominent part in the development of the English Classic: he used it broadly and freely.'

Oxford, Museum of Oxford (1892), part of the Town Hall.
Harrogate, Carnegie Library and Art Gallery (1904).

HARRISON, Thomas (1744–1829)

Son of a joiner whose talents caught the eye of Sir Lawrence Dundas. He financed Harrison to tour Italy, who returned to establish a successful practice in and around Chester. Adept at neo-classical forms and masses, but also worked in the Gothic taste.

Lancaster City Museum (1788–99). A reconstruction of the Castle with addits of Shire Hall, completed by J. M. Gandy (1802–23).

HAYS & GREY, FFRIBA

Of Wingate and North Shields.

Whitby, Pannett Art Gallery (1929). A purpose-built ext. to the original Pannett Galleries. A simple and dignified block in a Greek revival-ish style.

HAYWARD, John (1808–91)

Of Exeter.

Exeter, Royal Albert Memorial Museum (1868), addits in 1897. A purpose-built museum in the French Gothic. A contemporary critic commended 'the zeal of the architect who has spared no pains in instilling true artistic feeling into his carver, encouraging him . . . to visit the rich Cathedrals of Normandy' (illus. *Br.* 4.VI. 1864).

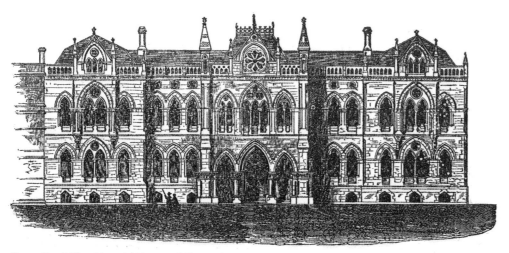

Exeter, Royal Albert Memorial Museum, J. Hayward

HENDERSON, John (1804–62)

Assistant to Thomas Hamilton. Set up practice on his own in Edinburgh. Better known for his works in Gothic and his many churches and chapels in Edinburgh.

Montrose, Natural History Museum (1836). A purpose-built museum using an individual treatment of Greek elements that seems to echo the style of Thomas Hamilton's Royal High School on Calton Hill in Edinburgh.

HIBBERT, James (1833–1903)

Alderman of Preston: designed Preston and County of Lancaster Royal Infirmary (1868–69). Save for this and the Preston Museum, he remains, in Pevsner's words, 'widely unknown.'

Preston, Harris Free Library and Museum (1882–93). Hibbert visited 'several buildings of a similar character' at home and abroad before being appointed as architect. The design, in his own words, is 'academical.' 'Influenced by studies of Ionian art, its chief features are simplicity and symmetry of plan.' The principal front is 130 ft long with a massive hexastyle portico; the north and south frontages are 170 ft long, while the height to the top of the central lantern is 112 ft. The building stands at the east end of the market-place, town improvements having been carried out simultaneously with the Museum (*Br.* 9.IX. 1882, plus illus.).

HICKS, James (1845–96)

Of Redruth. The architect and prime mover of the Passmore Edwards Free Library at Redruth.

Newlyn Art Gallery (1895). Purpose-built of local stone with granite dressings, the ground floor houses 'commodious reading and committee rooms.' On the outside 'the Newlyn artists intend decorating the panels around the building with "Gesso"' (*B.N.* 8.11. 1895).

HINE, Thomas Chambers (1814–99)

Responsible for numerous domestic and commercial buildings in and around Nottingham, also Church restorations. A 'leader of the revived Gothic architecture in the Midland counties; but of late years, in his domestic work, he adopted a style bordering on the Renaissance.'

Nottingham Castle Museum (1875). The restoration of the Castle after it had been severely damaged in the Riots of 1831.

HOLDEN, Charles FRIBA (1875–1960)

Partner of Adams, Holden and Pearson. Assistant to C. R. Ashbee. Then as partner with Percy Adams. Holden is best known for his work for London Transport, notably its headquarters at St James's Park Station with its impressive Epstein sculptures. He believed in 'the interplay of architecture and sculpture,' using Epstein also on the façade of The British Medical Association building in the Strand.

London, Courtauld Institute Galleries (1958).

HONEYMAN, John (1831–1914)

Private practice from 1854, a thorough-going Gothicist, and ran a successful office based on Church restorations. Architect to Glasgow Cathedral, and responsible for the restoration of Iona Monastery (1904–5).

Paisley Museum and Art Gallery (1867). Addits by William Abercrombie in 1892 and 1904.

HORSFALL, Jesse, FRIBA (d. 1910)

Of Manchester. On the staff of the Rochdale Borough Surveyor's Office, then set up in private practice.

Rochdale Art Gallery (1903). A purpose-built extension to the Free Library of 1884 also by Horsfall when he worked for the Borough.

HOSKINS, George Gordon (1837–1911)

Pupil of W. D. Haskoll of Westminster. Settled in Darlington. Developed his own version of a Waterhousian Gothic. Outside Darlington, his works include the Middlesbrough Municipal Buildings and Town Hall (1884).

Darlington Art Gallery, originally the Public Library of 1885.

HOWELL, William Rowland, FRIBA (1867–1940)

Of Howell and Cooper of Reading. Assistant to J. A. Gotch of Kettering, but returned and stayed to practice in Reading until his death.

Reading Museum and Art Gallery (1896–97). Ext to the building of 1882 by Thomas Lainson (q.v.) on the adjoining site that had not been available in the 1870s.

HURLBUTT, William

A master carpenter working in Warwickshire during later 17thC.

Warwick Market Hall (1670).

JACKSON, Sir Thomas Graham, RA (1835–1924)

Royal Gold Medal 1910
Articled to George Gilbert Scott as a draughtsman (1858). On his own in 1862. Travelled widely on the Continent. Author on architecture, his favoured style was English Renaissance or Jacobean, also called 'the Anglo-Jackson style'.

Cambridge Museum of Archæology and Ethnology (1904–11). Beresford Pite noted its 'prominent anachronisms,' but declared, nevertheless, after his Oxford Colleges, 'it may be judged to be his most successful work.' (Illus. *Br.* 7.V. 1910.)

JARRAT, Major Thomas

An amateur architect.

Lancaster City Museum (1781). His design for a cupola was replaced with one by Thomas Harrison.

JONES, Inigo (1573–1652)

Began his career as designer of sets for Court masques. Visiting Italy for the second time in 1613–14 furnished him with a working knowledge of Classical and Palladian architecture. Returned to England and became Surveyor-General (1615).

During his tenure of this office (Jones fell from favour alongside his Royal master, Charles I), he was responsible for the layout of the piazza of Covent Garden and the design of the Church of St Paul; the Banqueting House; the remodelling of St Paul's Cathedral, adding a giant Corinthian portico. Jones's influence was restricted at the time since his labours rarely went beyond Court patronage. Later in the 17thc his ideas were picked up enthusiastically by Wren, and in the 18thc Lord Burlington inaugurated a Palladian movement largely focused on the work of Inigo Jones.

London, Queen's House, Greenwich (1611–19).

KEMPE, Charles Eamer (1837–1907)

His architectural works are rare. After Morris & Co, Pevsner called Kempe 'the other familiar name in later Victorian glass.' He was a 'clever draughtsman and possessed scholarly tastes,' being 'widely known for his works in painted glass in which a German influence was often apparent.' (*B.N.*)

Leeds, Temple Newsam House (1894), remodelling and addits.

KEMPSON, F. R.

Hereford Art Gallery (1912).

KNIGHT, W. H. (1814–95)

Cheltenham Art Gallery and Museum. Housed in the former Library and Art School of 1889.

LAINSON, Thomas, FRIBA (d. 1898)

The architect of buildings in Brighton and Hove, his own curriculum vitae mentions work for the Valance Estates, Lansdowne Mansions, W. Brighton, 'large additions to the Royal Hotel,' as well as the Middle Street Synagogue.

Reading Museum and Art Gallery (1879–82).

LESSELS, John (1809–83)

Of Edinburgh. Trained in the office of Burn. Own practice in 1846. His most successful works were in the Scottish Baronial Style.

Stirling, Smith Art Gallery (1874). Purpose-built in the neo-classical taste.

LEWIS, James (*c.* 1751–1820)

Travelled in Italy 1770–72. Appointed Surveyor to Christ's Hospital; his plan for its rebuilding remained unexecuted. Surveyor to Bridewell and Bethlehem Hospital (1793). He was 'an elegant neo-classical architect whose best works were country houses such as Bletchingdon (Oxon.), Eydon (Northants)' (Colvin).

London, Imperial War Museum (1812–15). A competition was held for the rebuilding of Bethlehem Hospital; Lewis's designs were plundered from the three premiated entries.

LIGHTOLER, Timothy (or Thomas) (d. 1770s)

A trained carver who turned to architecture. A draughtsman and author of pattern books, including *The Gentleman and Farmer's Architect* (1762). Worked both in Gothic and the neo-classical taste.

Bath, R.P.S. National Centre of Photography. Originally the Octagon Chapel (1766–67). *Manchester*, Platt Hall Gallery of English Costume (early 1760s). Attributed design.

LOCKWOOD, Philip C. (1821–1908)

Brighton Borough Surveyor (1858–1905). Clerk of works at Arundel Castle. Also responsible for converting the Dome (Porden's Stables and Riding School) into a concert hall.

Brighton Art Gallery and Museum (1871–73).

LOCKWOOD, Thomas Meakin, FRIBA (1830–1900)

Practised in and around Chester and N. Wales. He belonged to the 'old school of Gothic revivalists.'

Chester, Grosvenor Museum (1885–86) (illus. *Br.* 21.IV.1886).

LUGAR, Robert (*c.* 1773–1855)

A master of the rural picturesque, whose ideas for the then fashionable *cottage ornée* and other more or less fanciful buildings were celebrated in his pattern books, including *The Country Gentlemen's Architect* (1807). Unlike some pattern book authors, many of his creations were built in practice.

Merthyr Tydfil, Cyfarthfa Castle Museum (1825).

MACDONALD, A. B.

City Architect of Glasgow.

Glasgow, The People's Palace Museum (1898). A red sandstone block in the French Renaissance style.

MARTIN, Sir Leslie (b. 1908)

Hull University Art Collection (1967). *Cambridge*, Kettle's Yard (1970).

MASTERS, Charles Harcourt (b. 1759)

(also used the surname Harcourt)

Practised as Architect and Surveyor in Bath. The Sydney Hotel was his most important work.

Bath, Holburne of Menstrie Museum (1796–97). Originally the Sydney Hotel at one end of the hexagonal Sydney Gardens. Heightened by J. Pinch in 1836, remodelled by Blomfield (1911–15).

ROBERT MATTHEW, JOHNSON-MARSHALL & PARTNERS

Guernsey Museum and Art Gallery (1978).

MATTHEWS, James (1820–98)

Of the Aberdeen practice of Matthews and McKenzie. Pupil of Archibald Simpson; also worked in the office of Gilbert Scott. In 1845 formed partnership with A. Marshall McKenzie, which was responsible for many commercial and public buildings as well as domestic work in Aberdeen.

Aberdeen Art Gallery and Museum (1885). The competition winner of 1883. An Italian Renaissance style granite building (illus. *Br.* 21.X.1883). Extended in 1925 by A. Marshall McKenzie & Sons.

MELLAR & SUTTON

Southport, Botanic Gardens Museum (1875).

MIDDLETON, FLETCHER & PARTNERS

Of Middlesbrough.

Durham, University Oriental Collection (1960).

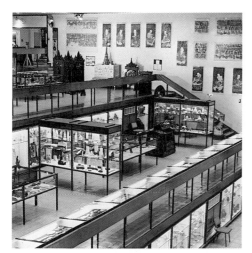

Durham, University Oriental Museum, Middleton, Fletcher & Partners

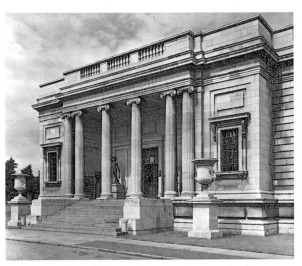

Port Sunlight, Lady Lever Art Gallery,
William & Segar Owen

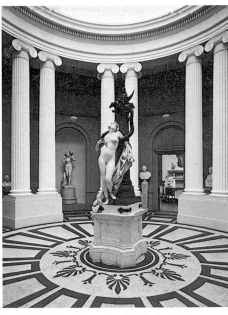

Port Sunlight, Lady Lever Art Gallery, the hall,
William & Segar Owen

MILLS, Alexander William, FRIBA (d. 1905)

Pres. of the Manchester Soc. of Architects 1869–71
In 1838 appointed architect to enlarge the
Manchester Royal Exchange; in partnership with
James Murgatroyd won the competition for the
rebuilding in 1869–74.

Stockport, Vernon Park Museum (1860). Purpose-
built, in the so-called 'domestic style': probably
influenced by Peel Park at Salford, the nearest
museum to Stockport at that date.

MITCHELL, Thomas, FRIBA in 1876

Worked in Oldham, a large practice mainly of
commercial buildings.

Oldham Art Gallery (1885). A purpose-built gallery,
described by Pevsner as vaguely Gothic.

MORISON, David (1792–1885)

Of Perth.

Perth Museum and Art Gallery (1824).

MOXHAM, H. Glendinning, FRIBA (1865–1946)

Student at the Nottingham School of Art. Travelled
on the Continent, settled to practice in Swansea.

Swansea, Glynn Vivian Art Gallery and Museum
(1909–11).

NASH, John (1752–1835)

After a bad start as architect/speculator, he became
the Prince Regent's architect. An accomplished
practitioner of the Picturesque, both in domestic
work (in partnership with the landscape designer
Humphry Repton) and in his Metropolitan
Improvement scheme for Regent Street.

Brighton Royal Pavilion (1815–21). Remodelling the
Prince Regent's house at Brighton. An Indian
extravaganza designed in keeping with Porden's
vaguely Hindu-style Dome. The Indian taste was
encouraged by Repton and the advent of
archæologically accurate drawings of Hindustan
architecture by such artists as Thomas Daniel.

NEVILL, Ralph, FRIBA (1846–1917)

Articled to Giles Gilbert Scott and became his
assistant. Author of *Old Cottage and Domestic
Architecture in S.W. Surrey* (1889).

Guildford, Museum New Gallery (1911). Single-
storeyed with a single hall, designed to avoid
'interference with the view from the road of the
present picturesque buildings' (*Br.* 28.VII.1909).

OWEN, William & Segar

Port Sunlight, Lady Lever Art Gallery (1914–22).
The Gallery was designed by Geoffrey Owen,
William's son.

PATY, William (1758–1800)

From a large family of masons, carvers and architects
working in Georgian Bristol. He entered the R.A.
Schools in 1775, and continued his father's and elder
brother's practice.

Bristol, Georgian House Museum (1789–91).

PELLECHET, Jules (1829–1903)

Barnard Castle, The Bowes Museum. Opened in
1892. 'Extending to a length of over 300 ft, built in
stone with all the grace and strength characterising
the best period of the French Renaissance.' The
galleries, 'it may be said, are copies of one at Munich.
Altogether there are over 100 rooms in the Bowes
Museum. The Masonry was finished five years after
the building was commenced, and the last three have
been spent fitting up the interior' (*Br.* 2.11.1878). The
building works were supervised by Mr Watson of
Newcastle.

PENNETHORNE, Sir James, FRIBA (1801–71)

Royal Gold Medalist 1865
Assistant to John Nash, whose practice he inherited
in 1835. Engaged in Metropolitan Improvements
both in private practice then as surveyor to Woods
and Forests (1840).

London, Museum of Mankind, Burlington Gardens
(1866–69). Originally for the Univ. of London,
described in *The Builder* as 'not only the *chef d'oeuvre*
of the master, but is one of the most successful of the
public buildings of the metropolis' (vol. XXX, p. 717).

PLAYFAIR, William Henry (1790–1857)

Pupil of William Stark whose ideas on town planning
Playfair put into practice as Architect to the Calton
Hill Estates (*c.* 1821 on). With C. R. Cockerell, he
designed the unfinished National Monument on
Calton Hill (1824–27). Responsible for many of the
finest Greek Revival buildings in Edinburgh, but also
worked in Gothic, Baroque and Jacobean.

Edinburgh, National Gallery of Scotland (1850–57).

POWELL & MOYA

London, Museum of London (1976).
Oxford, Christ Church Picture Gallery (1967).

REID, Alexander

Of Elgin.

Forres, Falconer Museum (1871). Purpose-built in
the Italian style. Shortage of funds prevented the
building of a dome and a tower.

SCOTT, Elizabeth, FRIBA (1898–1972)

Student at the Architectural Association (1924).
Assistant to Maurice Cheston. Also responsible for
Newnham College Cambridge exts (1938).

Stratford-upon-Avon, The Shakespeare Memorial
Gallery (1932). The competition winner of 1928.
Scott went into partnership with Cheston to complete
the plans and build it.

SCOTT, Sir George Gilbert, RA (1811–78)

Pupil of Henry Roberts, a classicist and the architect
of the Fishmongers' Hall. *The Builder*'s obituary
noted that Scott's designs had a 'balanced and
symmetrical character.' In his early work he was
'almost entirely a reproducer of ancient Gothic,' his
later works are the quintessence of the High Victorian
ethos, as typified in St Pancras Hotel (1868–74), and
the Albert Memorial in Kensington Gardens.

Dundee Museum and Art Gallery (1867).

SIR GILES SCOTT, SON & PARTNER

London, Guildhall Library (1974).

SCOTT, John Oldrid (1841–1913)

Son of Sir George Gilbert Scott, entered his father's
office in 1860; the professional inheritor in 1878. He
'belonged wholeheartedly to the Gothic revival' and
especially 'in the phase of 14thc Gothic' which 'he
had made peculiarly his own.'

London, Museum of the Order of St John (1893) with
R. Norman Shaw (illus. *Br.* 24.VI.1893).

SCOTT, McKay Hugh Baillie (1865–1945)

Architect-designer. Practised on the Isle of Man,
moved back to the mainland in 1901. His designs for
a pair of cottages attracted great acclaim at the
Letchworth Exhibition (1905). For the next nine years,
hundreds of cottages and small buildings were built to
his designs all over Europe and as far afield as Kharkov,
Russia. The designs were published in *Houses and
Gardens* (1906) and were 'conceived with originality and
individuality of quaintness.' (*B.N.* 4.1.1907).

Bembridge, Ruskin Galleries. Culver Cottage was
originally a miner's cottage of 1914–15, and was re-
erected at Bembridge. Other buildings there were
designed largely by the founder, J. Howard
Whitehouse.

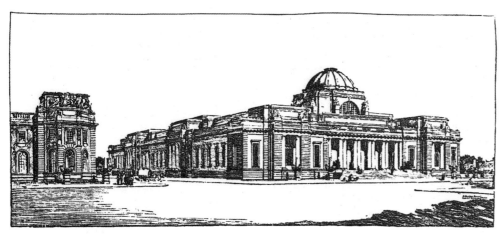

Cardiff, National Gallery of Wales, A. Dunbar Smith

SEIFERT, Richard (b. 1910)

Bradford, National Museum of Photography, Film and Television. Originally designed as a theatre in 1963–64 in association with the city architect.

SHEPPARD, John Mortimer, FRIBA (1880–1956)

Worked in the office of Frank Verity, then in the Architects Dept of Great Western Railway. On his own from 1911. Won the competition for the mental colony at Meanwood, Leeds. From then on specialised in that field, becoming the 'recognized authority on the planning and design of mental institutions.'

London, The Thomas Coram Foundation for Children (1937).

SHERLOCK, Cornelius, FRIBA (1823–88)

Of Sherlock, Wood and Keef, Liverpool. An extensive Merseyside practice. 'Most of his works were in some phase of the Classic styles.'

Liverpool, Walker Art Gallery (1874–77). Designed in conjunction with H. H. Vale (q.v.).

SHUTT, Isaac (1816–79)

Harrogate, Royal Pump Rooms (1842).

SIMPSON, John W. (1858–1953)

Pres. RIBA 1919–21

With MILNER ALLEN, Edmund John, FRIBA (1859–1912)

Worcester, Victoria Institute. Opened in 1898. Purpose-built in the 'Queen Anne Style with Italian modifications' (*Br.* 23.X.1896).
Bradford, Cartwright Hall (1902).
Glasgow Art Gallery and Museum, Kelvingrove (1902).

SMIRKE, Sir Robert, RA (1781–1867)

Retired from practice in 1845 after a profitable career mainly under Tory patronage. While his designs lacked artistic inspiration, 'he possessed a great constructive ability,' and was 'the first to apply concrete systematically for architectural purposes in this country.'

London, British Museum (1825–47). His brother, Sydney Smirke, oversaw the completion of the Museum and designed the Reading Room.
Scunthorpe, Normanby Hall (1825–30), enlarged by W. H. Brierley (1906).

SMIRKE, Sydney, RA (1798–1877)

Brother to Robert, much of whose work and patronage Sydney inherited on Robert's retirement in 1845. Like his brother an able constructor, the British Library Reading Room, his most acclaimed work, for which he was awarded the RIBA Gold Medal, was an advanced structure of cast iron. His other works are mainly in the classical style, including the now demolished Carlton Club, a rich treatment of the clubland palazzo.

London, Imperial War Museum. Formerly Bethlehem Hospital. Smirke added the dome and the portico to Lewis's original block.

SMITH, A. Dunbar, FRIBA (1866–1933)

In partnership with Cecil Brewer (1869–1918). In the inter-war years Smith designed many extensions to older art galleries, including the Fitzwilliam. The architect of Heal's in the Tottenham Court Road.

Cardiff, National Gallery of Wales, Cathays Park (1907–27)

SMITH, George

Of Bradford.

Keighley, Cliffe Castle Museum. Originally 'a manufacturer's mansion' of 1880, 'with asymmetrically placed tower, and shaped Jacobean gables' (Pevsner).

SMITH, Sydney Robert James, FRIBA (1857/8–1913)

Worked in the offices of Coe and Robinson. Responsible for a Tube station at Paddington.

London, Tate Gallery (1892).

SOANE, Sir John, RA (1753–1837)

In 1768 entered the office of George Dance the Younger, the man Soane was to call his 'revered master.' In 1771 entered R.A. Schools, and became assistant to Henry Holland. Travelling scholarship 1778–80. Soane worked in all the styles of his time including neo-classical, Gothic and picturesque, eventually developing a highly individual style that is usually termed 'Romantic Classicism'.

London, Sir John Soane's Museum (1792–1824). His own house which he rebuilt and redesigned to display his collection of paintings and sculpture. Dulwich Picture Gallery (1811–14) with the Bourgeois family Mausoleum, described by John Summerson as 'the quintessence of the Soane style.'

London, Sir John Soane's Museum, J. Gandy

SORBY, Thomas Charles, FRIBA (1836–1924)

In 1883 moved to Canada.

Luton Museum and Art Gallery. Originally a mansion built in 1874.

STOCKWELL, A.

Of Newcastle.

Gateshead, Shipley Art Gallery (1915).

TANNER, Sir Henry (1849–1935)

Took his examinations to enter the Office of Works in 1871. The Chief Architect in 1901. Set up in private practice in partnership with his sons. Responsible for the first official use of reinforced concrete in the G.P.O's King Edward Block in Newgate Street, although the building was ashlar-faced to comply with Edwardian tastes.

London, Science Museum. Tanner designed the East block (1914–28). The central block (1949–59) was built by W. Kendal.

TAYLOR, Edward (1830–1908)

Articled to Fowler Jones of Lendal. Worked for a time in London, then in York, where he was noted for his large number of Wesleyan Chapels in the City and district.

York City Art Gallery (1878).

TAYLOR, James Medland (1834–1909)

Of Manchester.

Stalybridge, Astley Cheetham Gallery (1901). Opened at first as a Library and Art Gallery; the Cheetham Collection was installed in 1932.

THOMAS, James A.

University Architect and Engineer at Sussex.

Brighton, Barlow Collection (1974).

THOMASON, Henry Yeoville, FRIBA (1826–1901)

Worked in the Birmingham Borough Surveyor's Office, then took up private practice.

Birmingham, City Art Gallery (1881–85). A purpose-built Gallery that was an extension to the Council House also by Thomason.

THORNLEY & ROOKE

Of Plymouth.

Plymouth Art Gallery and Museum (1910). Winners of a competition assessed by H. T. Hare open only to Plymouth architects. The Museum, Art Gallery and Library were specified to be 'planned so as to be entirely separate and distinct, but at the same time form a complete architectural composition' (*B.N.* 12.IV.1907, plus illus.).

THORPE, John (1565–1655?)

Son of Thomas Thorpe, a master mason. Entered the Office of Works (1583–1601). After that became a land and building surveyor. His interest in architecture is attested by a folio of plans and survey drawings in his book, now at the Soane Museum. His status as a practising architect is problematic in so far as it is unclear whether plans included in his *Book of Architecture* are his own or are surveys of the existing house.

Birmingham Aston Hall (1685–35). There are two drawings of Aston Hall in Thorpe's Book, of the ground and first floors, and attribution rests on these.

THORPE, William Henry, FRIBA (1853–1944)

Architect to the Borough Surveyor's Office.

Leeds City Art Gallery (1882). Extended in 1972, to house the Moore Sculpture, by John Thorp of the City Architect's Dept, in consultation with Neville Conder.

TOWNSEND, Charles Harrison (1851–1928)

One of the great exponents of the *fin de siècle* 'Freestyle' design. Combining a complex symbolic language with a strong desire to be 'original', Townsend produced a handful of very striking buildings, remarkable for the use of so-called 'organic' forms and the integration of mosaics and carvings into the design. His other works include the Bishopsgate Institute (1892–94), and the Whitechapel Art Gallery (1899–1901).

London, Horniman Museum (1896–1901).

London, Horniman Museum, C. H. Townsend

TRESS, Richard, FRIBA (1810–75)

Ran a varied London practice. Surveyor to several City parishes, architect to the City of London Union Workhouse and of warehouses and commercial building in and around the City.

Huddersfield, Tolson Memorial Museum (1860). Originally a private mansion.

TUCKER, L. J., ARIBA

Doncaster Borough Architect.

Doncaster Museum and Art Gallery (1964).

TURNOR, Christopher

A protégé of Edwin Lutyens.

Compton, Watts Gallery (1903), called by Pevsner 'a weak blend of Voysey and Lutyens.'

VALE, Henry Hill, FRIBA (1831–1875)

Of Liverpool. Joint architect with Cornelius Sherlock (q.v.) of the Walker Art Gallery. Vale, in ill-health, with an 'over-worked brain,' and having 'trouble connected with his business,' took his own life (*B.N.*).

Liverpool, Walker Art Gallery (1874–77).

WALLER, Frederick William (1846–1933)

With his father, Frederick Sanderson, ran a thriving office in Gloucester, mainly based on church restorations and rectories. F. S. Waller was appointed Surveyor to the Fabric of Gloucester Cathedral (1852). Both were successively Diocesan Surveyor.

Gloucester City Museum (1896). A purpose-built museum in the Elizabethan style.

WATERHOUSE, Alfred (1830–1905)

Pres. RIBA 1888–91
Institute Gold Medal 1878
Worked in the Venetian Gothic style, with his trademark of red terracotta. Architect to the Prudential Assurance Co., also designed Manchester Town Hall. His work represented a high-point of the integration of Gothic architecture into the townscape.

London, British Museum, Natural History Museum (1866–81).

WEBB, Sir Aston (1849–1930)

Pres. RIBA 1902–4
Pres. RA 1919–24
Royal Gold Medal 1905
In partnership with Ingress Bell (1837–1914) designed the Victoria Law Courts, Birmingham (1887–91), which show Webb's leanings towards late French Gothic and François I styles. However, he followed the trend of the era towards Classicism, but, as Lutyens remarked, he was 'not an entire classicist,' and Webb's eclecticism excited much criticism at the time.

London, Victoria and Albert Museum (1891–1909).

WEBBER, Ernest Berry, FRIBA (1896–1963)

Specialised in local Government buildings.

Southampton Art Gallery. Competition winner, part of the civic centre complex (1929–39). It suffered bomb damage and was restored by Webber.

WHITFIELD PARTNERS

Glasgow, Hunterian Museum (1981)

WILD, James William (1814–92)

His early work was in the Gothic taste, but in 1842 he joined an expedition to the Near East and developed a love of Arab and Byzantine architecture. On his return to Britain his designs tended to the Byzantine; sometime consultant at the South Kensington Museum for Arabian Art. From 1878–92 he was Curator of the Soane Museum.

London, Bethnal Green Museum (1872). Wild designed the brick façades about the notorious 'Brompton Boilers', a cast-iron building by Charles Young and Co. that had reused materials from the South Kensington Museum.

WILKINS, William, RA (1778–1839)

Son of William Wilkins (1751–1815), an East Anglian architect, who educated his son in architecture while the latter was a student at Cambridge University. An arch Greek revivalist, his best-known and most successful work being Downing College, Cambridge. He was an able scholar and had an eye for archæological detail, but was lacking in mastery of overall planning and massing.

Norwich Castle Museum (1824–28). Originally the County Gaol.
York, Yorkshire Museum (1827)
London, National Gallery (1834–38).

WILLS, Sir Frank, FRIBA (1852–1932)

A well-known Bristol Architect. Designed buildings for the Imperial Tobacco Co. at Bedminster.

Bristol City Art Gallery (1899–1904). Designed in conjunction with Messrs Houston & Houston of London.

WOOD, John (1704–54)

Wood was born in Bath, but his first architectural works were in Yorkshire, supervising the laying out of Lord Bingley's garden at Bramham. Also employed in London. In 1727 Wood settled in Bath

permanently. Began rebuilding sections of the old town; his designs for the new town met opposition in his lifetime and were completed by his son.

Bath, Costume and Fashion Research Centre. Begun in 1754, completed by his son.

WOOD, John the Younger (1728–81)

Son of the above, and inherited his father's mantle as the creator of Georgian Bath.

Bath, Bath Preservation Trust, The Royal Crescent (1767–75), one of the most impressive streets in Europe and gave rise to imitation 'Royal Crescents' in many British towns.
Museum of Costume. Housed in the New Assembly Rooms (1769–71). Wood's 'second masterpiece, [that] provided the city with a public building worthy of its domestic architecture' (Colvin).

WOOD, Thomas (c. 1644–95).

Oxford Master mason and sculptor, but 'the Old Ashmolean Museum shows that he had some understanding of classical architecture' (Colvin).

Oxford, The Old Ashmolean (1673–83). 'A contemporary print by M. Burghers has the inscription "T. Wood Archt.", and as the building accounts contain no payments for designs to anyone else, it is safe to assume that they were made by Wood himself' (Colvin).

WOODHOUSE & WILLOUGHBY

Of Manchester.

Bury Art Gallery and Museum (1899–1901). Competition winner. Pevsner calls it 'probably the best building in Bury.' (Illus. *B.N.* 3.XII.1897.)

WOODZELL & COLCUTT

Blackburn Museum and Art Gallery (1872–73). The winner of a competition assessed by Waterhouse (illus. *B.N.* 3.I.1873).

Bury Art Gallery and Museum,
Woodhouse & Willoughby

WORNUM, G. Grey, FRIBA (1888–1957)

Royal Gold Medal 1952
Early work included redecoration of The Palais de Danse, Derby. Winning the competition for the design of the RIBA in Portland Place brought him to the fore of the architectural profession. Responsible for the replanning of Parliament Square (1952). Appointed by Cunard to oversee the decoration of their passenger liners (1936).

London, Royal Institute of British Architects (1932). Exts designed by Wornum and his partner Edward Playne and were in progress at the time of Wornum's death.

WRAY, Christopher George, FRIBA

The early part of his career was in England. Sometime Civil Architect to the Govt of Bengal; responsible for numerous churches and public buildings for the Govt of India.

Hull, Town Docks Museum (1867–71). Originally Hull Dock Co. Offices. In the Venetian Renaissance style with three domes raised on high drums, irregular triangle in plan. Its silhouette and massing are effective from all sides of approach.

WREN, Sir Christopher (1632–1723)

A polymath who came late to architecture, his early designs for buildings at Oxford were academical and somewhat uninspired, but innovative in their construction. Asked to continue the restoration of St Paul's Cathedral when, in 1666, the Great Fire of London razed the City and all but destroyed old St Paul's. Wren was appointed as one of the 'Commissioners' to plan the rebuilding of the City, but his elaborate and expensive schemes were never built. In 1688/9 Wren became Surveyor-General to the King's Works, a post he occupied actively into the second decade of the 18thc. As well as St Paul's, numerous City Churches, and works at Oxford, Wren rebuilt and remodelled most of the Royal residences of the time. A Wren style is hard to pin down, since he retained a scientist's empirical attitude to the problems of a design; he began with an academical classical approach and moved towards a Baroque expression, embracing Gothic forms as in Tom Tower at Christ Church, Oxford.

London, Kensington Palace (1689–96). Royal Naval College, Greenwich (1696 onwards).

WYATT, Benjamin Dean (1775–c. 1850)

Eldest son of James Wyatt. Succeeded his father as Surveyor to the Fabric, Westminster Abbey (1813). Interested in theatre design. An uninspired practitioner of the neo-classical, but his interior designs are of 'interest and merit . . . [and] in collaboration with his brother Philip he achieved strikingly effective recreations of the French rococo style' (Colvin).

London, Apsley House, Wellington Museum, remodelling and addition of portico and Waterloo Gallery (1828–29).

WYATT, James (1746–1813)

Ran an extensive, if sometimes badly-run, practice. Worked in the neo-classical style; was fluent in the picturesque; achieved greatest fame for his handling of Gothic, culminating in such works as Fonthill.

Manchester, Heaton Hall (1772). The remodelling of an early 18thc building. The works were supervised by Samuel Wyatt who designed the Stable-block in 1777.

WYATVILLE, Sir Jeffry (1766–1840)

Apprenticed to his uncle, Samuel Wyatt, in 1784–85, then moved to the office of James Wyatt (1792–99). Ran an efficient practice, with a sideline as a speculative builder in partnership with John Armstrong, a Pimlico building contractor. 'Best known as an expert purveyor of the picturesque country house, usually in a Tudor Gothic or "Elizabethan" dress' (Colvin).

Bath, The American Museum. Formerly Claverton House, *c.* 1820.

WYNNER, James Cumming

Belfast, Ulster Museum (1929). Exts by Francis Pym (1972).